THE VISUAL MIND

LEONARDO BOOKS

Editorial Board

Craig Harris Roger F. Malina Pamela Grant-Ryan Robert Prior

Leonardo, The International Society for the Arts, Sciences and Technology, is dedicated to promoting and supporting the work of artists and others involved with the integration of art, science and technology. The society's publications include the journal *Leonardo* (founded in 1968 by kinetic artist and scientist Frank J. Malina), the *Leonardo Music Journal,* the electronic newsletter *Leonardo Electronic News,* the *FAST Database and Archive* and the Leonardo Book Series. Additional activities of the society include the Leonardo Awards Program, involvement in symposia and collaboration with individuals and organizations. *Leonardo/ISAST, 1442A Walnut Street, Box 75, Berkeley, CA 94709, U.S.A.*

Titles

The Leonardo Almanac: International Resources in Art, Science and Technology, 1993
 Craig Harris, editor

The Visual Mind: Art and Mathematics, 1993
 Michele Emmer, editor

THE VISUAL MIND: Art and Mathematics

Edited by Michele Emmer

The MIT Press
Cambridge, Massachusetts
London, England

Third printing, 1995

This book was typeset by Craig Johnson, Chris Lippert and Reyna Cowan and was printed and bound in the United States of America.

Library of Congress Cataloging-in-Publication Data

The Visual mind: art and mathematics / edited by Michele Emmer.
 p. cm.—(The Leonardo book series)
 Includes bibliographical references and index.
 ISBN 0-262-05048-X
 1. Art—Mathematics. 2. Computer drawing. 3. Geometry.
I. Emmer, Michele. II. Series.
N72.M3V58 1993

701'.05—dc20
 93-21599
 CIP

Some of the chapters of this book are reprinted from *Visual Mathematics,* special issue of *Leonardo* **25**, Nos 3/4 (1992): Ch. 4–9, 11–18, 22–25, 29, 31, 34, 36.

Some of the chapters of the book are reprinted from other issues of *Leonardo:* Ch. 3, *Computer Art in Context Supplemental Issue* (1989); Ch. 19, *Leonardo* **25**, No. 1 (1992); Ch. 20, *Leonardo* **23**, No. 4 (1990); Ch. 21, *Leonardo* **20**, No. 4 (1987); Ch. 26, *Leonardo* **24**, No. 1 (1991); Ch. 30, *Leonardo* **15**, No. 4 (1982); Ch. 32, *Leonardo* **21**, No. 2 (1988).

Some of the chapters of the book are reprinted from other sources:

Ch. 2, Max Bill, "The Mathematical Way of Thinking in the Visual Art of Our Time", *Werk* **3** (1949) © Max Bill.

Ch. 5, Roger Penrose, "On the Cohomology of Impossible Figures", *Structural Topology* **17** (1991) © 1991 Revue Topologie Structurale.

Ch. 10, Helaman Ferguson, "Computer Interactive Sculpture", *1992 Symposium on Interactive 3D Graphics* © 1992 Association for Computing Machinery.

Ch. 33, Linda Dalrymple Henderson, "The Fourth Dimension and Non-Euclidean Geometry in Modern Art: Conclusion", *The Fourth Dimension and Non-Euclidean Geometry in Modern Art* © 1983 Princeton University Press.

About the Cover:
Max Bill, *Variation 12,* 1937. Inscribed and circumscribed circles form thick circular rings. These are shown in their appropriate colors, while those parts where overlapping occurs appear black.
Variation 12 is part of *Quinze variations sur un même thème* (Fifteen Variations on a Single Theme), 16 lithographs with text in English, French and German, edition of 220, 30.5 148 32 cm, 1934–1938. (Paris: Editions des Chroniques du Jour, 1938) This series illustrates the creative process by starting with a single fundamental idea that leads to 15 very different developments—proof that concrete art holds an infinite number of possibilities. *The Theme* consists of the continuous development of an equilateral triangle to a regular octagon. The third side of the triangle, which would close it, is moved outward so as to form one of the sides of the quadrilateral (square). In this way, the area of the triangle remains open and is merely suggested. The transition from one polygon to the next are all made in the same fashion. The resultant figure is a spiral composed of straight lines of equal length. The angles and the areas between these lines show a great variety of form and tension. (Text reprinted from E. Hüttinger, *Max Bill* [Zurich: ABC Editions, 1978])

Dedication

This volume is dedicated to the memory of Frank J. Malina, founder of *Leonardo* and editor of the book *Visual Art, Mathematics and Computers: Selections from the Journal LEONARDO* (Oxford: Pergamon, 1979). Malina's book and several meetings with him in Paris during the years 1978–1981 were the starting points of my interest in Visual Mathematics.

Michele Emmer

Contents

Series Foreword

Many years of exploration in art, science and technology have brought us such fields as computer graphics, computer animation and music, scientific visualization and multimedia design—all of which are having a tremendous impact in the artistic, educational, research and commercial communities. The Leonardo Book Series is designed to provide comprehensive resources for orientation in and navigation through the fields in which art, science and technology converge. The series includes detailed perspectives on selected topics and on the areas where these topics intersect—with a healthy balance among philosophical, theoretical and historical perspectives and the practical applications of new ideas. The content of the series extends naturally from the long history of the journal *Leonardo* and from the activities of Leonardo, the International Society for the Arts, Sciences and Technology (Leonardo/ISAST). The goal of the series is to provide a guide through a complicated set of intersecting fields, reflecting the depth and scope of activities that will carry contemporary human perspective into the future.

Craig Harris
Series Editor

We live in a world inevitably affected by developments in science and technology. Our knowledge of ourselves expands as discoveries in biology, neurobiology, psychology and the other sciences of living organisms are made. Technologies provide us with new tools for personal expression, but also provide a context for our existence. The linking of modern communications systems and networks places us in possible contact with a global community. Yet, within these advances, inequalities in the quality of life and access to the benefits of science and technology create human and social crises. The growing world population and the increasing burden of a technological society now leads to unacceptable burdens on the biosphere. In this changing world, the work of artists changes. Leonardo/ISAST seeks through its activities to document and communicate the work of artists who are cognisant of these changes—truly contemporary artists, who today are frequently also scientists or engineers.

Roger F. Malina
Chairman of the Board, Leonardo/ISAST

Collaboration between artists and mathematicians is of greater interest today than at any time since the Renaissance. Mathematicians are looking at visual representations in new ways, while many artists today have profound interest in new technologies and new approaches. The computer revolution is very much a part of this increased fascination—as computers are used increasingly to connect the talents of artists and scientists in multidisciplinary areas of research. Various aspects of Visual Mathematics—discussions of aesthetic issues, historical perspectives and practical applications—are included in this volume, along with chapters by mathematicians who create artworks and chapters by artists who use Visual Mathematics as the basis for their art. Through discussions of the methods used to create these works, the reader will be introduced to a new universe of mathematical images, forms and shapes in media ranging from drawings to computer graphics.

Patricia Bentson
Book Production Editor

Foreword

There has always existed an interesting dichotomy both within the ranks of mathematicians and, independently, in the world of art as to the respective relevance and importance of either field to members of the other one. Broadly speaking, the percentage of individuals in either field who profess a *love-hate* relationship to the other field seems to be quite comparable. But even if the expression love-hate is too strong and should be modified to *love-irrelevance*, there has also existed a very significant and influential minority both in the arts and in mathematics for whom it is clear that the relationship is and must be one of *love-love*. I hope and trust that this book will strengthen this belief considerably.

In his most unusual essay, *The Mathematical Way of Thinking in the Visual Art of Our Time* (reprinted in this volume), Max Bill sets forth in a lucid and comprehensive way the artist's point of view. He is echoed by many other 'modern' artists in their philosophical credos—by Vasarely, Escher, Sonia and Robert Delauney, Agam, Lohse and many, many others. For instance, the young Croatian-American painter Marko Spalatin writes: "Influences in my work can be more directly attributed to my continuous fascination with the geometric aspects of origami, mosaics, tribal art, floor tiles, patterns, ancient as well as modern architecture, and so forth" [1].

Yet, although most of these artists claim to have derived at least some of their inspiration from sources that are quite old, it is a fact that abstract art, in general, and geometric art, in particular, are rather new developments. Advances in photographic art have allowed many artists to turn toward nontraditional forms of expression, while developments in computer science have also provided means of visualization not previously available. It may be easy to conclude, therefore, that although artistic inspiration may have utilized geometric sources in the past, the most tangible and concrete connections between art and mathematics are a recent development. Witness this book itself and its contents under the titles of its sections: Geometry and Visualization; Computer Graphics, Geometry and Art; Symmetry; and Perspective, Mathematics and Art. Practically every one of the chapters in these sections has a direct connection to recent, modern developments in art, in computers, in computational geometry and the like. Are we then to conclude that what I called earlier a love-love affair is just a recent, perhaps transient, development? I submit that this is not the case, that the ties have always existed and that modern developments have merely brought into the open what had only been felt in earlier times.

At the same time, one must also look at the other side of the coin: how do mathematicians view art? Is it only a means for them to advance specific aspects of their own endeavors? Perhaps a rather poignant quote about a unique individual will illuminate the comparative, emotional aspect of this issue.

Early this century there arose a mathematician of wondrous capabilities, intuition and insight. Ramanujan was a practically unschooled railroad clerk in India whose principal mathematical background was his incredible intuition. In fact, his discoveries are still studied and wondered at by mathematicians. Thus it may be very much to the point to hear what one of the most distinguished mathematicians of the early twentieth century, G. N. Watson, had to say about some of Ramanujan's singular mathematical accomplishments:

> The study of Ramanujan's work and of the problems to which it gives rise inevitably recalls to mind Lamé's remark that, when reading Hermite's papers on modular functions, 'on a la chair de poule'. I would express my own attitude with more prolixity by saying that such a formula as
>
> $$\int_0^\infty e^{-3\pi x^2} \frac{\sin h\pi x\, dx}{\sin h3\pi x}$$
>
> $$= \frac{1}{e^{2\pi/3}\sqrt{3}} \sum_{n=0}^\infty \frac{e^{-2n(n+1)\pi}}{\left(1+e^{-\pi}\right)^2 \left(1+e^{-3\pi}\right)^2 \ldots \left[1+e^{-(2n+1)\pi}\right]^2}$$

gives me a thrill which is indistinguishable from the thrill which I feel when I enter the Sagrestia Nuova of the Capella Médici and see before me the austere beauty of the four statues representing 'Day', 'Night', 'Evening' and 'Dawn', which Michelangelo has set over the tomb of Giuliano de' Médici and Lorenzo de' Médici [2].

Clearly, no higher accolade can be given to the field of art by one from the field of mathematics: that the only possible comparison of superlative achievement in mathematics is with what might be considered as the ultimate in art.

However, this is still 'only' emotional. I believe that one must go considerably deeper to search for the reasons for the fundamental attraction of art for mathematicians. Perhaps the words of physics Nobel laureate C. N. Yang come closest to finding some of the reasons:

> The general structure of the periodic table is essentially a direct and beautiful consequence of symmetry. . . . The isotropy of the Coulomb force; the existence of the antiparticles . . . were anticipated in Dirac's theory, which was built on the principle of relativistic symmetry. In both cases, as in other examples, nature seems to take advantage of the simple mathematical representation of the symmetry laws. The intrinsic elegance and beautiful perfection of the mathematical reasoning involved and the complexity and depth of the physical consequences are great sources of encouragement. . . . One learns to hope that nature possesses an order that one may aspire to comprehend [3].

Yang singles out here the concept of symmetry as being a fundamentally important concept from a physical and mathematical point of view—but note the adjectives and descriptors that he is using in this purely scientific context: "beautiful", "simple", "elegance", "perfection", and so on.

Beginning with the year of 1986, I published a very well received series of special issues in my journal, *Computers and Mathematics with Applications,* on the subject of symmetry. I used the above quote of Yang in my foreword to that series and followed up by saying, among other things:

> The notion of symmetry may be one which plays an ephemeral, but yet absolutely essential role in our understanding of the physical universe and our role in it. To pursue the Kantian view, perhaps symmetry is playing a role complementary to space and time. We do not do anything with space and time; but all of our understanding is couched in terms of them. They are a framework within which all else has to be placed.
>
> It must be true that whatever is placed in this space-time framework has to be put there according to certain rules.
>
> Symmetry could possibly be one of the axiomatic rules of that portion of space-time in which we exist.
>
> But, as we said, it is an ephemeral rule—it makes its appearance here and there—once we notice it and once we do not. Having noticed, we may remember the event—or it may become so commonplace in our minds that we may forget. We do not particularly think of the symmetries of flowers or other things that we are in day-to-day contact with—we just admire their beauty. But upon looking at a picture of Escher's, its very unusual nature impels us to ask: why is it so interesting? And we will definitely remember it as an object having the property of symmetry [4].

Symmetry is, of course, one of the subjects and also one of the sections of this book. The notion itself is clearly one of the important points of contact between art and mathematics; whether in its direct or in its negated (antisymmetry) form. But there are several other notions and points of contact—as general as symmetry—that are influencing the art-mathematics relationship, in ways that are perhaps much more subtle. I will mention here one of them: (quasi) periodicity and repetition.

Until quite recently one of the only art forms in which we could readily discern periodicity was a time-dependent one: namely, music (of course there are others as well: for instance, poetry). Composers have always produced works in which one or more motives (e.g. the leitmotifs of Wagner, as an example *par excellence*) ran through their oeuvres, in different cadences, tonal variations or with instrumental changes; and there is a multitude of compositions entitled "Variations on a Theme by. . . ." None of this is quite periodic, for the composer rarely repeats the same identical passage in exactly the same way; rather, these works can be called quasi-periodic.

Now the notion of quasi-periodicity is well known in mathematics: for instance, it appears in such classical places as Bessel functions: entities that are 'almost' periodic, or, roughly speaking, periodic for most intents and purposes. The well-known trigonometric functions, on the other

hand, are strictly periodic. What then is the formal difference between these two classes of important mathematical building blocks?

One of the ways to define these functions, perhaps the most natural way, is by means of the differential equations that they satisfy. The strictly periodic trigonometric functions are defined by means of linear equations with constant coefficients. On the other hand, while the quasi-periodic Bessel functions are also defined by linear equations, their equations have nonconstant coefficients. And, if we continue our search for quasi-periodic phenomena, we find by far the greatest abundance (and some of the most interesting ones) in the realm of nonlinear mathematics within the phenomena of the so-called 'phase plane'. Indeed, it is well known that one of the ways in which scientists attempt to approximate nonlinear problems is by replacing them with time-dependent but still linear ones (that is, ones with nonconstant coefficients). They seem to serve a purpose somewhat like halfway houses. The problem is that, although we know that the 'real stuff' is within the world of nonlinearity, we really are able to handle only linear problems.

The notion of nonlinearity and, consequently, of its various technical aspects used to be the private domain of specialists. But, during the past few years, the use of words related directly to this notion, such as 'strange attractors', 'Mandelbrot set', 'chaos', 'limit cycles', 'fractals' and many more, became so prevalent that they almost became standard staple, even in the daily press. I believe that, to a certain extent, this 'popularity' derives from the strange beauty of and the fascination with the various wonderful color photographs of fractal domains. But the main reason, I think, was that in this instance the enthusiasm of scientists concerning many wonderful hoped-for developments was capable of being transmitted to the public domain because an actual visualization of these things was possible! Of course, the effect on scientists is equally powerful: for them the possibility of visualization allows for the weaving of new theories and for the dreaming of new dreams. In other words, computer visualization put such a powerful tool into our hands that now we are beginning to get at least a glimpse of the heretofore mostly hidden but wonderful world of nonlinear phenomena. And I repeat here: quasi-periodicity is only one aspect, one small corner, of this still mostly hidden world.

In this context I should also mention—somewhat parenthetically—the cinematographic *tours de force* that are making appearances more and more frequently, accomplished in most instances by the mathematical technology of ray tracing and exemplified for instance in films such as *Terminator* and *Terminator 2* [5].

We have known for a long time that the world—and consequently its mathematical descriptions, the various conservation laws, string theories and other mathematical models—is nonlinear. However, up through the middle of the twentieth century all (at least all experimental) scientists worked with linear models; because there were no tools available to study nonlinear phenomena. I will never forget an annual meeting of the Society for Industrial and Applied Mathematics, which took place in Boston, Massachusetts, early in the 1960s, at which—for the first time—an actual movie of some special (so-called soliton) solutions of the famous Korteweg de-Vries nonlinear partial differential equation was shown. Interest was so great that practically all of the many other simultaneous sessions emptied out: everyone wanted to see the tremendous novelty of wonderful graphic representations for an entirely new aspect of nonlinearity.

For ages, mathematicians and other scientists lived in their linear world with two-valued logic, crisp decisions, sequential processes and absolute optimality. But now new vistas are opening up: nonlinearity is beckoning; we begin to understand fuzzy logic and use it to great advantage; our decisions now have to be based on multiple criteria and are not crisp anymore; and our sequential processes and thinking are also beginning to change, helped along by interconnected multiprocessing computers and by concepts such as neural networks. Optimality itself is no longer the main aim in many instances: that notion often gets replaced by feasibility and suboptimality.

But these new vistas for mathematicians and scientists contain concepts and ideals that we,

mathematicians and others, used to use in a derogatory sense vis-a-vis our artist friends. "Their thinking is fuzzy"; "they go about this or that in convoluted ways"—these are things many of us used to say.

Not anymore. The genius of the artist now serves as an inspiration for us to understand and explore our nonlinear world better. And our own discoveries and developments allow our artist friends to express today, in more and more ways and in their inimitable intuitive fashion, some of the truths we will stumble upon tomorrow.

ERVIN Y. RODIN
Leonardo Editorial Advisor
Educator and Director
Center for Optimization and Semantic Control
Box 1040, Washington University
St. Louis, MO 63130-4899
U.S.A.

References

1. Marko Spalatin, "Artistic Credo", in *Marko Spalatin: Graphic Work 1968–1978* (Madison, WI: Madison Art Center, 1979) p. 7.

2. G. N. Watson, "The Final Problem: An Account of the Mock-Theta Functions", *London Mathematical Society* **9** (1936) p. 55.

3. Chen Ning Yang, *Elementary Particles* (Princeton, NJ: Princeton Univ. Press, 1962).

4. E. Y. Rodin, "Foreword", in I. Hargittai, ed., *Symmetry: Unifying Human Understanding*, a special issue of *Computers and Mathematics with Applications* **12B**, No. 1/2, xi–xii (1986); and in E. Y. Rodin, series ed., *Symmetry: Unifying Human Understanding, Modern Applied Mathematics and Computer Science Series* **10** (1986) pp. ix–x.

5. *Terminator* (1989) and *Terminator 2* (1992), Mario Kassar Productions, directed by James Cameron, produced by James Cameron, B. J. Rack and Stephanie Austin.

Acknowledgments

I wish to thank for their great and essential help (words are inadequate) Pamela Grant-Ryan, Becky Neeley and last, but not least, Patricia Bentson; I wish also to thank Patricia for her patience with this project. A special thanks to Lisa Bornstein, Silvio Levy, Marjorie Malina and Valeria Marchiafava Emmer; a very special thanks to Roger Malina for his encouragement.

Michele Emmer

THE VISUAL MIND

Introduction to
The Visual Mind: Art and Mathematics

Michele Emmer

Surely, among the most important goals of every geometrical instruction is the strengthening of the faculty for spatial imaging and the power for spatial modelling.

—Artur Schoenflies, 1908 [1]

Visualization has played an important role in the history of mathematics. In the last several years, new visual techniques in mathematics have resulted from the continuously increasing diffusion of new visual tools. A similar phenomenon is becoming more and more apparent in the visual arts. It is often said that the art of the future will depend on new technologies, computer graphics in particular. It is interesting to note that, in considering problems in which visualization plays an important role, mathematicians in the last few years have obtained images whose aesthetic appeal has also interested people who are not strictly concerned with the scientific questions that originated them. Thus it is worthwhile, in my opinion, to investigate the possible connections between artistic and mathematical research by looking at recent developments in both fields and by highlighting interactions between artists and mathematicians—not only to describe new phenomena but also to present possible directions for future cooperation between both groups.

Many changes have occurred in the field of mathematical visualization in the past several years. In May 1988 a conference took place at the Mathematical Sciences Research Institute (MSRI) at the University of California in Berkeley. The theme of the workshop was Differential Geometry, Calculus of Variation and Computer Graphics. It was attended by geometers and applied mathematicians, along with experts in the field of computer graphics [2]. A large portion of the conference was devoted to images, in particular those obtained by computer-graphics techniques— techniques that have made a number of interesting *new* results possible in mathematics. Mathematicians at the meeting were able to give formal proofs of the existence of some, but not all, of the images shown. The year before, the Geometry Supercomputer Project (now known as the Geometry Center) had been started at the University of Minnesota in Minneapolis. The first images produced by project participants were shown at the MSRI workshop. It is interesting to note that the mathematicians who were not able to show slides, videocassettes or graphics software apologized to the participants while promising to produce images the next time.

I first started thinking about proposing a special issue of the journal *Leonardo* dedicated to new mathematical images [3] at the meeting in 1988. I discussed the idea with executive editor Roger Malina at the San Francisco International Airport, while waiting for a flight to Europe. A few years before, in 1985, I had organized the conference M. C. Escher: Art and Science, a section of which was devoted to computer graphics [4]. At the time, I thought it was important to point out the possible connections between some of the most recent mathematical research and the work of artists using visual techniques influenced by mathematical ideas.

Many excellent papers were submitted for the special issue of *Leonardo;* but, due to limits on the number of pages, it was not possible to publish them all. More importantly, it was not possible to introduce and connect the papers into thematic groups. So this new book is allowing me not only to add new papers to the special issue collection, but also to rethink the project completely and ask several scientists to write original introductions to the different sections. This book is not just an enlarged version of the *Leonardo* special issue, but a new project that takes up where the special issue left off.

I had in mind two important examples of connections between mathematics and art: the pictorial art and theoretical essays of Piero della Francesca, in particular, his masterpiece *The Flagellation of Christ,* as well as a paper by contemporary artist Max Bill, "The Mathematical Way of Thinking in the Visual Art of our Time" [5].

I was thinking that, even though it may be excessive to speak of a 'New Renaissance', nevertheless there is great interest today in collaboration between artists and mathematicians. One of the main reasons for this is the new way of looking at *visual representations* by mathematicians. In addition, artists have shown a profound interest in the 'new' technologies based on a visual approach.

Morris Kline, a well-known mathematician, in *Mathematics in Western Culture* describes Piero della Francesca as one of the greatest mathematicians of the fifteenth century:

The artist who perfected the science of perspective was Piero della Francesca. This highly intellectual painter had a passion for geometry and planned all his works mathematically to the last detail. The placement of each figure was calculated so as to be correct in relation to other figures and to the organiza-

Michele Emmer, Dipartimento di Matematica, Università Ca' Foscari, Dorsoduro 3825 Ca' Dolfin, 30123 Venice, Italy.

tion of the painting as a whole. He even used geometry forms for parts of the body and objects of dress and he loved smooth curved surfaces and solidity [6].

It is well known that Renaissance artists received their training in an atmosphere of artists and mathematicians studying and learning together. "Although the mathematicians often undeniably furnished the lead, this background is as revealing for artists who developed their mathematical skills independently as for those who were trained and encouraged to formulate mathematical inventions by mathematics teachers", according to Davis [7]. Similar concepts are expressed by Kline:

> The artist was even expected to solve problems involving the motion of cannon balls in artillery fire, a task which in those times called for profound mathematical knowledge. It is no exaggeration to state that the Renaissance artist was the best practising mathematician and that in the fifteenth century he was also the most learned and accomplished theoretical mathematician [8].

The possible reciprocal influences between art and mathematics did not end with the important and peculiar age called the Renaissance. It is not by chance that the first paper contained in this volume is the reprinted English version of the previously mentioned paper by Max Bill, in which a very clear analysis of the possible connections between mathematics and the arts is discussed. Bill begins:

> By a mathematical approach to art it is hardly necessary to say I do not mean any fanciful ideas for turning out art by some ingenious system of ready reckoning with the aid of mathematical formulas. . . . I am convinced it is possible to evolve a new form of art in which the artists's work could be founded to quite a substantial degree on a mathematical line of approach to its content. This proposal has, of course, aroused the most vehement opposition. It is objected that art has nothing to do with mathematics; that mathematics, besides being by its very nature as dry as dust and as unemotional, is a branch of speculative thought and as such in direct antithesis to those emotive values inherent in aesthetics; and finally that anything approaching ratiocination is repugnant, indeed positively injurious to art, which is purely a matter of feeling.

He states furthermore that

> mathematics itself had arrived at a stage of evolution in which the proof of many apparently logical deductions ceased to be demonstrable and theorems were presented that the imagination proved incapable of grasping. Though mankind's power of reasoning had not reached the end of its tether, it was clearly beginning to require the assistance of some visualizing agency. Aids of this kind can often be provided by the intervention of art.

Bill added that "it must not be supposed that an art based on the principles of mathematics . . . is in a sense the same thing as a plastic or pictorial interpretation of the latter. Indeed, it employs virtually none of the resources implicit in the term pure mathematics".

It is important to note that computer-graphics techniques have been used by mathematicians not only to visualize already known phenomena but also, more interestingly, to understand how to solve problems not yet completely solved. In some cases such techniques have provided a *new way* of proving results in mathematical research. The computer has become an instrument that allows mathematical experiments to be conducted in a sense and a dimension that is wholly new.

R. Hersh's *Some Proposals for Reviving the Philosophy of Mathematics* [9] was published in 1979, and then, 2 years later, came P. J. Davis and R. Hersh's *The Mathematical Experience* [10]. One of the chapters of the volume by Davis and Hersh is entitled: "Why Should I Believe a Computer?" [11]. The two authors recalled a *rare* event that took place in 1976—an announcement of the proof of a theorem in pure mathematics broke into the news columns of the *New York Times*. The occasion was the proof by K. Appel and W. Haken of the *Four-Color Conjecture:*

> The occasion was newsworthy for two reasons. To begin with, the problem in question was a famous one. . . . But the method of proof in itself was newsworthy. For an essential part of the proof consisted of computer calculations. That is to say, the published proof contained computer programs and the output resulting from calculations according to the programs. The intermediate steps by which the programs were executed were of course not published; in this sense the published proofs were *permanently and in principle* incomplete [12].

Davis and Hersh pointed out that

> in applied mathematics, the computer serves to calculate an approximate answer, when theory is unable to give us an exact answer. . . . But in no way [does] the theory depend on the computer for its conclusions; rather, the two methods, theoretical and mechanical, are like two independent views of the same object; the problem is to coordinate them. . . . The rigorous mathematics of proof remains uncontaminated by the machine. . . . In the Haken-Appel four-color theorem, the situation is totally different. They present their work as a definitive, complete, rigorous proof. In an expository article on their work, Appel and Haken wrote that most mathematicians who were educated prior to the development of fast computers tend not to think of the computer as a routine tool to be used in conjunction with other and more theoretical tools in advancing mathematical knowledge [13].

Davis and Hersh were thinking of high-speed computers and the possibility for doing thousands of calculations in a short time. Thomas Banchoff and Charles Strauss at Brown University at the end of the 1970s had the idea of using computer-graphics animation to *visually* investigate the geometrical and topological properties of three-dimensional surfaces. This use of computers in mathematical research was new. It became possible to construct a surface on the video terminal and move it and transform it in order to better understand its properties. As well as acting as an aid to intuition, computers have resulted in new ways of constructing models.

Computer graphics allows not only pure visualization of well-known phenomena but also new ways of studying mathematical problems, in particular geometrical ones. It can be said that a new branch of mathematics has been developing in the last few years that can be called *Visual Mathematics* [14]. The great potential of computer graphics as a new exploratory medium was recognized by mathematicians soon after the relevant technology became available. As display devices and programming methods grew more sophisticated, so did the depth and scope of applications and computer graphics to mathematical problems, such as the discovery of a new type of minimal surface by William Meeks III and David Hoffman. In this case the use of computer graphics was essential to obtaining a formal proof of the existence of the new surfaces [15].

Another important outcome of the Berkeley workshop in 1988 was the publication in the Summer of 1992 of the first issue of a new scientific journal by the expressive title *Experimental Mathematics*. Some of the members of the editorial staff were participants in the Geometry Project in Minneapolis in 1987; the same people were among the organizers of the workshop in Berkeley. The following is from the introduction to the first issue of *Experimental Mathematics:*

Experiment has always been, and increasingly is, an important method of mathematical discovery. Yet this tends to be concealed by the tradition of presenting only elegant, well-rounded and rigorous results. . . . It is to our loss that most of us in the mathematical community are almost always unaware of how new results have been discovered. . . . Experimental mathematics was founded in the belief that theory and experiment feed on each other, and that the mathematical community stands to benefit from a more complete exposure to the experimental process [16].

Even if it is clear that the definition of 'experimental mathematics' includes not only the use of computer techniques but also the traditional way of obtaining new results (by the use of a pen and a piece of paper), there is no doubt that the starting point for the new journal has been the modification in the working methods of quite a number of mathematicians due to the use of computer-graphics techniques. In October 1992 a new workshop was organized, again at the MSRI in Berkeley. The theme very explicitly was *The Visualization of Geometric Structures.* The same week, by chance, the special issue of *Leonardo* dedicated to *Visual Mathematics* was published. The 500th anniversary of the death of Piero della Francesca was 12 October of that year. While only 30% of the mathematicians giving presentations at the 1988 workshop had shown images, it was not surprising that none of the speakers (with the exception of William P. Thurston, director of the MSRI) used merely blackboard and chalk at the 1992 workshop. All presentations were presented at computer-graphics workstations showing in real time the various software produced to investigate particular geometrical problems. Four years earlier, when a mathematician showed images of new surfaces, audience members asked questions such as "Are you able to give formal proof of the existence of these surfaces?" The 1992 participants were much less troubled by these kind of problems.

The use of 'visual computers' gives rise to new challenges for mathematicians—at the same time, computer graphics might in the future be the unifying language between art and science. It is difficult to predict future directions and relationships between the arts and mathematical research—the role of *Leonardo* is to attempt to provide possible interpretations of phenomena that are before our eyes today. In any case, this volume is the result of my proposition to compare the research of mathematicians and the works of artists in order to discover what interesting results we can expect, in both the arts and the sciences, from the burgeoning field that we can call *Visual Mathematics.*

References

1. G. Francis, *A Topological Picturebook* (New York: Springer-Verlag, 1987) p. vii.

2. P. Concus, R. Finn and D. A. Hoffman, *Geometric Analysis and Computer Graphics,* MSRI Series No. 17 (New York: Springer-Verlag, 1991).

3. M. Emmer, ed., *Visual Mathematics,* special issue of *Leonardo* **25**, No. 3/4 (1992).

4. H. S. M. Coxeter, M. Emmer, R. Penrose and M. Teuber, eds., *M. C. Escher: Art and Science* (Amsterdam: North-Holland, 1986, 1987, 1988).

5. M. Bill, "Die mathematische denkweise in der kunst unserer zeit", *Werk* **3** (1949); English version published with the title "The Mathematical Approach in Contemporary Art", in E. Huttinger, *Max Bill* (Zurich: ABC Edition, 1978) pp. 105–116. Reprinted in this volume with the new title "The Mathematical Way of Thinking in the Visual Art of our Time", by request of Max Bill.

6. M. Kline, *Mathematics in Western Culture* (Harmondsworth, U.K.: Penguin, 1953) p. 166.

7. M. D. Davis, *Piero della Francesca's Mathematical Treatise* (Ravenna: Longo Editore, 1977) p. 3.

8. See Kline [6] p. 151.

9. R. Hersh, "Some Proposals for Reviving the Philosophy of Mathematics", *Advances in Mathematics* **31** (1979) pp. 31–50.

10. P. J. Davis and R. Hersh, *The Mathematical Experience* (Boston: Birkhauser, 1981).

11. See Davis and Hersh [10] pp. 380–386.

12. K. Appel and W. Haken, "The Four-Color Problem", in L. A. Steen, ed., *Mathematics Today* (New York: Springer-Verlag, 1978) pp. 153–190.

13. Davis and Hersh [10].

14. M. Emmer, *La perfezione visibile: arte e matematica* (Rome: Theoria edizioni, 1991).

15. M. J. Callahan, D. Hoffman and J. T. Hoffman, "Computer Graphics Tools for the Study of Minimal Surfaces", *Comm. ACM* **31**, No. 6, 648–661 (1988).

16. *Experimental Mathematics* **1**, No. 1 (Boston, MA: Jones and Bartlett, 1992); director David B. A. Epstein.

The Mathematical Way of Thinking in the Visual Art of Our Time

Max Bill

By a mathematical approach to art it is hardly necessary to say I do not mean any fanciful ideas for turning out art by some ingenious system of ready reckoning with the aid of mathematical formulas. So far as composition is concerned every former school of art can be said to have had a more or less mathematical basis. There are also many trends in modern art which rely on the same sort of empirical calculations. These, together with the artist's own individual scales of value, are just part of the ordinary elementary principles of design for establishing the proper relationship between component volumes; that is to say for imparting harmony to the whole. Yet it cannot be denied that these same methods have suffered considerable deterioration since the time when mathematics was the foundation of all forms of artistic expression and the covert link between cult and cosmos. Nor have they seen any progressive development from the days of the ancient Egyptians until quite recently, if we except the discovery of perspective during the Renaissance. This is a system which, by means of pure calculation and artificial reconstruction, enables objects to be reproduced in what is called 'true-to-life' facsimile by setting them in an illusory field of space. Perspective certainly presented an entirely new aspect of reality to human consciousness, but one of its consequences was that the artist's primal image was debased into mere naturalistic replica of his subject. Therewith the decadence of painting, both as a symbolic art and an art of free construction, may be said to have begun.

Impressionism, and still more Cubism, brought painting and sculpture much closer to what were the original elements of each: painting as surface design in colors; sculpture as the shaping of volumes to be informed by space. It was probably Kandinsky who gave the immediate impulse towards an entirely fresh conception of art. As early as 1912, in his book on *The Spiritual Harmony in Art,* Kandinsky had indicated the possibility of a new direction which, if followed to its logical conclusion, would lead to the substitution of a mathematical approach for improvisations of the artist's imagination. But as he found out other ways of liberating painting from romantic and literary associations he did not adopt this particular line in his own work.

If we examine a picture by Klee or one of Brancusi's sculptures we shall soon discover that, though the 'subject' may be an indeterminable echo of something or other in the actual world about us, it is an echo which has been transmuted into a form that is original in the sense of being elemental. Kandinsky confronted us with objects and phenomena which have no existence in ordinary life, but which might well have meaning or be portents on some unknown planet; a planet where we should be quite unable to gauge their purpose or relevance. Yet it was undoubtedly Mondrian who went furthest in breaking away from everything that had hitherto been regarded as art. If the technique of structural design may seem to have inspired his rhythms the resemblance is fortuitous and one which was not present in his own intention or consciousness. Although the specific

ABSTRACT

This paper, originally published in 1949, outlines the author's ideas for the evolution of a new form of art based on a mathematical way of thinking. The author points out that mathematical inspiration provides fresh ideas and context, while aiding the creation of artworks with universal scope.

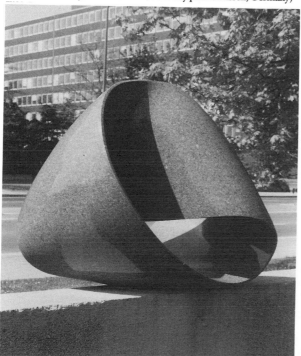

Fig. 1. *Endless Ribbon,* red tranas granite, 120 × 100 × 150 cm, 1935/ 1953. (Donated by Ferrostahl Co. to the city park of Essen, Germany)

Max Bill, Rebhusstr. 50, CH-8126 Zumikon, Switzerland.

This essay was originally published in *Werk* **3** (1949) and has been reprinted in several countries and languages. It has also been published with the title "The Mathematical Approach in Contemporary Art".

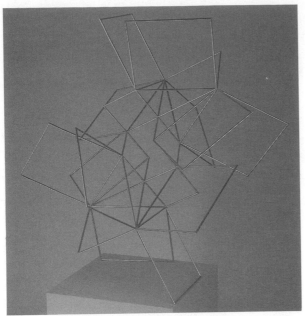

Fig. 2. *Monument for Pythagoras*, gilt brass, 90 × 90 × 80 cm, 1939–1941.

content of his work is constricted with the utmost discipline, the horizontal-vertical emphasis represents a purely emotional factor in his composition. It is not for any whimsical reason that he called his latest pictures *Broadway Boogie-Woogie* and *Victory Boogie-Woogie*, but simply to stress their affinity with jazz rhythms.

If we can agree that Mondrian realized the ultimate possibilities of painting in one direction—that is by his success in eliminating most of the remaining elements which are alien to it—two others still lie open to us: either we can return to traditionalism (in its wider sense), or else we can continue the quest for subjects with a content of a new and altogether different nature.

Let me take this opportunity to explain why it is impossible for many artists to go back to the old type of subjects. In the vast field of pictorial and plastic expression there are a large number of trends and tendencies which have all more or less originated in our own age. Different people look at modern painting and sculpture with different eyes because what they recognize as significant of our age is necessarily various. Clergymen have a different idea of art from scientists. Peasants and factory-hands live under radically different conditions. There are inevitable variations in standards of living and levels of culture. Similar differences can be found among artists. They, too, come from different walks of life, and their work reflects different emotional and intellectual undercurrents. There is another attitude to modern art which must not be overlooked as its now numerous followers can always be relied upon to take their stand against every disinterestedly progressive movement. I mean the much-boosted school which demands that, since art itself cannot perhaps solve social and political problems, these shall at least be made dramatically 'actual' and suitably glorified through its medium. We have good reason to be skeptical about any 'political art'—regardless of whether it emanates from right or left; especially when, under the cloak of antagonism to the prevailing social order, its aim is to bring about a new, but in all essentials, almost identical structure of society—because this is not art at all but simply propaganda.

After this digression into the potential alternatives which may be said to have existed prior to somewhere about 1910, let me try to make clear why some of us were unable to rest content with what had then been achieved. That would have meant going on marking time over the same ground during the last forty years and painting in one or the other of those manners which may be called 'à la Klee', 'à la Kandinsky', 'à la Mondrian', or, what was more usual, 'à la Picasso', 'à la Braque', and 'à la Matisse'. A great many gifted and intelligent artists are still wearing out their talents in ringing the changes on these modern masters. In fact this sort of painting has now become something in the nature of a substitute

Fig. 3. *Rhythm in Space*, 230 × 75 × 225 cm, 1947–1948; executed in granite, 1963. (Estate of the city/state of Hamburg, Germany)

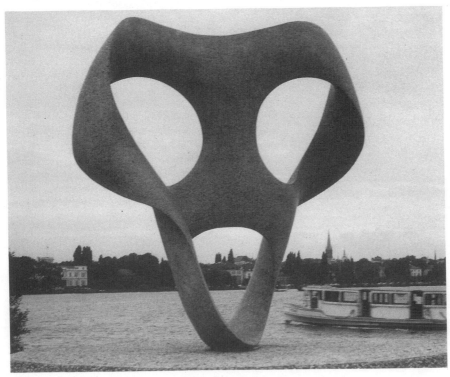

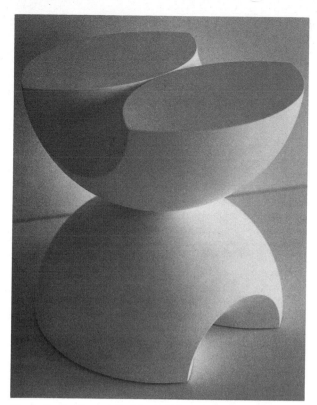

Fig. 4. *Construction out of a Spherical Ring,* white silicon, 26.5 × 26.5 cm, 1965–1966. Executed for a sculpture award, Carborundum Company, Niagara Falls, NY, U.S.A., 1967.

for the masters themselves, and 'à la' pictures begin to rank as interesting variants of their originals. To acquiesce in this state of stagnation was impossible because we have no right to allow a halt to be called in any genuinely creative field of human activity.

We can safely assume that all the various forms of expression open to painting and sculpture at the present day are now sufficiently known, and that the techniques they postulate have been sufficiently demonstrated and clarified in the work of their respective pioneers (except perhaps for a very few which can be anticipated, but which have not so far been realized). What, then, it may be asked, are the possibilities of further development? But there are two other important points which must be dealt with before that question can be answered: namely, whether the several idioms just referred to can claim general validity in the plastic arts; and whether there is reason to enlarge the existing limits of their content. Careful study of those forms of expression has led me to the conclusion that all of them were the discoveries of individual artists, either born of their will to overcome particular problems or else expedients called forth by exceptional circumstances; and that therefore they cannot be considered universally applicable or appropriate. As regards content, most of the modern work which is often held to have been largely inspired by mathematical principles cannot, in point of fact, be identified with that entirely new orientation I have called the mathematical way of thinking in visual art. And as this needs to be more nearly defined, I will now endeavor to elucidate it, and at the same time answer the question I have left in suspense.

I am convinced it is possible to evolve a new form of art in which the artist's work could be founded to quite a substantial degree on a mathematical line of approach to its content. This proposal has, of course, aroused the most vehement opposition. It is objected that art has nothing to do with mathematics; that mathematics, besides being by its very nature as dry as dust and as unemotional, is a branch of speculative thought and as such in direct antithesis to those emotive values inherent in aesthetics; and finally that anything approaching ratiocination is repugnant, indeed positively injurious to art, which is purely a matter of feeling, yet art plainly calls for both feeling and reasoning. In support of this assertion the familiar example of Johann Sebastian Bach may be credited; for Bach employed mathematical formulas to fashion the raw material known to us as sound into the exquisite harmonies of his sublime fugues. And it is worth mentioning that, although mathematics had by then fallen into disuse for composition in both his own and the other arts, mathematical and theological books stood side by side on the shelves of his library.

It is mankind's ability to reason which makes it possible to coordinate emotional values in such a way that what we call art ensues. Now in every work of art the basis of its composition is geometry or in other words the means of determining the mutual relationship of its component parts either on plane or in space. Thus, just as mathematics provides us with a primary method of cognition, and can therefore enable us to apprehend our physical surroundings, so, too, some of its basic elements will furnish us with laws to appraise the interactions of separate objects, or groups of objects, one to another. And again, since it is mathematics which lends significance to these relationships, it is only a natural step from having perceived them to desiring to portray them. This, in brief, is the genesis of a work of art. Visualized presentations of that kind have been known since antiquity, and like those models at the Musée Poincaré in Paris where conceptions of space have been embodied in plastic shapes or made manifest by colored diagrams, they undoubtedly provoke an aesthetic reaction in the beholder. In the search for new formal idioms expressive of the technical sensibilities of our age these borderline exemplars had much the same order of importance as the 'discovery' of

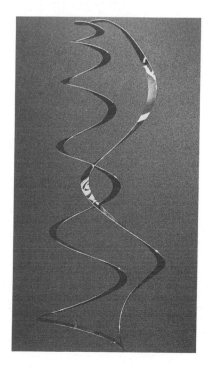

Fig. 5.
Endless Spiral Surface, chromium nickel steel, 420 × 150 cm, 1973–1974. (Rickles Hall, Tel Aviv Museum, Israel)

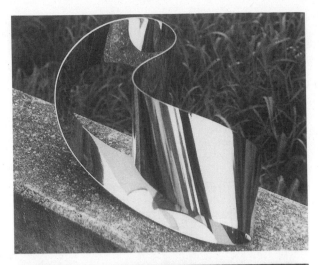

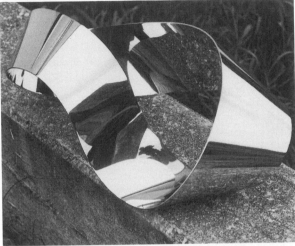

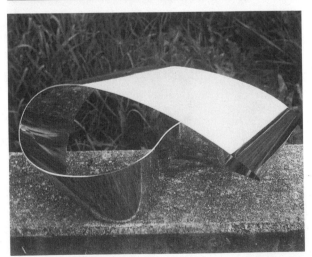

Fig. 6. *Endless Ribbon for Three Positions*, **chromium plated brass, 20.5 × 15 × 41 cm, 1974–1975. (top) Position I; (center) Position II; (bottom) Position III.**

native West African sculpture by the Cubists; though they were equally inapt for direct assimilation into modern European art. The first result of their influence was the phase known as Constructivism. This, together with the stimulus derived from the use of new materials, such as engineering blueprints, aerial photographs, and the like, furnished the necessary incentive for further developments along mathematical lines. At about the same time mathematics itself had

arrived at a stage of evolution in which the proof of many apparently logical deductions ceased to be demonstrable and theorems were presented that the imagination proved incapable of grasping. Though mankind's power of reasoning had not reached the end of its tether, it was clearly beginning to require the assistance of some visualizing agency. Aids of this kind can often be provided by the intervention of art.

As the artist has to forge his concept into unity, his vision vouchsafes him a synthesis of what he sees which, though essential to his art, may not be necessarily mathematically accurate. This leads to the shifting or blurring of boundaries where clear lines of division would be supposed. Hence abstract conceptions assume concrete and visible shape, and so become perceptible to our emotions. Unknown fields of space, almost unimaginable hypotheses, are boldly bodied forth. We seem to be wandering through a firmament that has had no prior existence; and in the process of attuning ourselves to its strangeness our sensibility is being actively prepared to anticipate still further and, as it were, as yet inconceivable expanses of the infinite.

It must not be supposed that an art based on the principles of mathematics, such as I have just adumbrated, is in any sense the same thing as a plastic or pictorial interpretation of the latter. Indeed, it employs virtually none of the resources implicit in the term 'pure mathematics'. The art in question can, perhaps, best be defined as the building up of significant patterns from the ever-changing relations, rhythms and proportions of abstract forms, each one of which, having its own causality, is tantamount to a law unto itself. As such, it presents some analogy to mathematics itself where every fresh advance had its immaculate conception in the brain of one or other of the great pioneers. Thus Euclidian geometry no longer possesses more than a limited validity in modern science, and it has an equally restricted utility in modern art. The concept of a finite infinity offers yet another parallel. For this essential guide to the speculations of contemporary physicists has likewise become an essential factor in the consciousness of contemporary artists. These, then are the general lines on which art is daily creating new symbols; symbols that may have their sources in antiquity but which meet the aesthetic-emotional needs of our time in a way hardly any other form of expression can hope to realize.

Things having no apparent connection with mankind's daily needs—the mystery enveloping all mathematical problems; the inexplicability of space—space that can stagger us by beginning on one side and ending in a completely changed aspect on the other, which somehow manages to remain that selfsame side; the remoteness or nearness of infinity—infinity which may be found doubling back from the far horizon to present itself to us as immediately at hand; limitations without boundaries; disjunctive and disparate multiplicities constituting coherent and unified entities; identical shapes rendered wholly diverse by the merest inflection; fields of attraction that fluctuate in strength; or, again, the square in all its robust solidity; parallels that intersect; straight lines untroubled by relativity, and ellipses which form straight lines at every point of their curves—can yet be fraught with the greatest moment. For though these evocations might seem only the phantasmagorical figments of the artist's inward vision they are, notwithstanding, the projections of latent forces; forces that may be active or inert, in part revealed, inchoate or still unfathomed, which underlie each manmade system and every law of nature it is within our power to discern.

Hence all such visionary elements help to furnish art with a fresh content. Far from creating a new formalism, as is often erroneously asserted, what these can yield us is something far transcending surface values since they not only embody form as beauty, but also form in which intuitions or ideas or conjectures have taken visible substance. The primordial forces contained in those elements call forth intimations of the occult controls which govern the cosmic structure; and these can be made to reflect a semblance of the universe as we have learned to picture it today: an image that is no mere transcript of this invisible world but a systematization of it ideographically conveyed to our senses.

It may, perhaps, be contended that the result of this would be to reduce art to a branch of metaphysical philosophy. But I see no likelihood of that for philosophy is speculative thought of a special kind which can only be made intelligible through the use of words. Mental concepts are not as yet directly communicable to our apprehension without the medium of language; though they might ultimately become so by the medium of art. Hence I assume that art could be made a unique vehicle for the direct transmission of ideas, because if these were expressed by pictures or plastically there would be no danger of their original meaning being perverted (as happens in literature, for instance, through printer's errors, or thanks to the whim of some prominent executant in music) by whatever fallacious interpretations particular individuals chance to put on them. Thus the more succinctly a train of thought was expounded and the more comprehensive the unity of its basic idea, the closer it would approximate to the prerequisites of the mathematical way of thinking. So the nearer we can attain to the first cause or primal core of things by these means, the more universal will the scope of art become—more universal, that is, by being free to express itself directly and without ambivalence; and likewise forthright and immediate in its impact on our sensibility.

Although this new ideology of art is focused on a spectral field of vision, this is one where the mind can still find access. It is a field in which some degree of stability may be found, but in which, too, unknown quantities, indefinable factors will inevitably be encountered. In the ever-shifting frontier zones of this nebular realm new perspectives are continually opening up to invite the artist's creative analysis. The difference between the traditional conception of art and that just defined is much the same as exists between the laws of Archimedes and those we owe Einstein and other outstanding modern physicists. Archimedes remains our authority in a good many contingencies though no longer in all of them. Phidias, Raphael and Seurat produced works of art that characterize their several epochs for us because each made full use of such means of expression as his own age afforded him. But since their days the orbit of human vision has widened and art has annexed fresh territories which were formerly denied to it. In one of these recently conquered domains the artist is now free to exploit the untapped resources of that vast new field of inspiration I have described with the means our age vouchsafes him and in a spirit proper to its genius. And despite the fact that the basis of this mathematical way of thinking in art is in reason, its dynamic content is able to launch us on astral flights which soar into unknown and still uncharted regions of the imagination.

Fractals and an Art
for the Sake of Science

Benoit B. Mandelbrot

ABSTRACT

A new form of art redefines the boundary between 'invention' and 'discovery', as understood in the sciences, and 'creativity', as understood in the plastic arts. Can pure geometry be perceived by the 'man in the street' as beautiful? To be more specific, can a shape that is defined by a simple equation or a simple rule of construction be perceived by people other than geometers as having aesthetic value—namely, as being at least surprisingly decorative—or perhaps even as being a work of art? When the geometric shape is a fractal, the answer is yes. Even when fractals are taken 'raw', they are attractive. They lend themselves to 'painting by numbers' that is surprisingly effective, even in the hands of the rank amateur. And the true artist's sensibility finds them a novel and attractive support.

The artist and the artisan are often hard to tell apart. For example, objects that were in principle meant to be utilitarian—be it folk architecture, religious imagery, or drawings and photographs of flowers, birds or water eddies—often end up being regarded as genuine works of art. It may become hard to distinguish them from works in which science was used almost as an excuse for artistic creativity. Thus, art faces us with broad possibilities. We are presented with innumerable works of art for the sake of commerce: objects have been commissioned under precise specifications to be useful—to decorate, to educate, to flatter, to entertain, to impress or to persuade. We are also presented with a few works created strictly as art for art's sake. And we also know of many possibilities that lie, so to say, in-between.

Does mathematics relate in any way to these familiar forms of plastic art? The classic shapes of geometry are hailed for their conceptual beauty, but they seem mostly to reside in the imagination of skilled practitioners. Although the popular poet Edna Saint Vincent Millay proclaimed that "Euclid Gazed on Beauty Bare" and although Euclid's geometry was of central importance to painters of the Italian Renaissance during the brief period when perspective was being 'invented', to the eye of those unschooled in mathematics, the beauty of Euclid's geometry is bare and dry to a fault. At the least it lacks scope and visual variety when compared with those excesses of either nature or the fine arts, which everyone seems tempted to call 'baroque' or 'organic'.

Today, however, there is more to geometry than Euclid. During the 1970s it was my privilege to conceive and develop fractal geometry [1], a body of thoughts, formulas and pictures that may be called either a new *geometry of nature* or a new *geometric language*. And the reason why it is worth discussing here is that I have discovered that, most surprisingly and without any prodding, this new geometric language has given rise to a new form of art. I propose here to make a few disjointed comments on its account. Many readers are bound to be familiar with fractal art; nevertheless, close familiarity with the subject is not expected from the reader.

The bulk of fractal art has not been commissioned for any commercial purpose, even though all the early work was done at IBM. And it has not necessarily been touched by esthetic sensibility. Therefore, we shall argue that fractal geometry appears to have created a new category of art, next to art for art's sake and art for the sake of commerce: art for the sake of science (and of mathematics).

Fractal art for the sake of science is indissolubly based on the use of computers. It could not possibly have arisen before the hardware was ready and the software was being developed; that is, before the decade of the seventies. What a profound irony that this new geometry, which everyone seems spontaneously to describe as 'baroque' and 'organic', should owe its birth to an unexpected but profound new match between those two symbols of the inhuman, the dry, and the technical: namely, between mathematics and the computer.

Before we describe the peculiarities of fractal geometry in more detail, it is good, for the sake of contrast, to comment on examples of similar matches that have arisen in areas such as the study of water eddies and wakes. In these cases, the input in terms of reasoning and programs is extremely complicated, perhaps more complicated even than the output. In fact, one may argue that, overall, complication does not increase but changes over from being purely conceptual to being partly visual, a change that is important practically and interesting conceptually. Fractal geometry, however, gives us something quite different. In fractal geometry, the inputs are typically so extraordinarily simple as to look positively simple-minded. The outputs, to the contrary, can be spectacularly complex. Again, while a contribution from an artistic sensibility is not necessary, it is well rewarded.

Let us hasten to raise a question. Since the inputs are so simple, why is it that fractal art failed to appear earlier and in more traditional ways? The answer lies in a 'Catch 22' situation. To draw the simplest fractal picture 'by hand' would have been feasible in principle, but would have required many person-years and would have been ridiculously expensive. Consequently, no one would have considered undertaking this task without having a fair advance knowledge of the result; yet the result could not even be suspected until one actually had performed the task. And a sure way

Benoit B. Mandelbrot (mathematician, research fellow), Physics Department, IBM T.J. Watson Research Center, Yorktown Heights, NY, 10598, U.S.A.; Mathematics Department, Yale University, New Haven CT 06520, U.S.A.

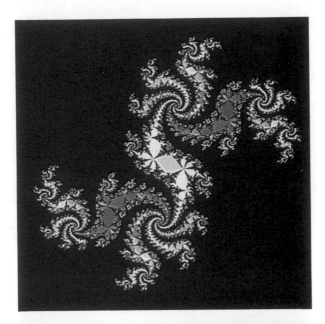

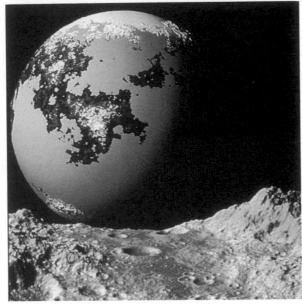

Fig. 1. The two faces of fractal art. (above) M. R. Laff and A. V. Norton, *Fractal Dragon,* **1982. (below) R. F. Voss,** *Fractal Planetrise,* **1982. This** *Fractal Dragon* **and** *Fractal Planetrise* **may be the best known of all fractals, since they appear on the two halves of the jacket of** *The Fractal Geometry of Nature* **[4]. Their being set as neighbors is meant to illustrate the basic fact that fractal art straddles the boundary between art that is, and is not, representational.**

of being discouraged from ever undertaking it would have been to begin with any one of the various definitions of fractals. Here is one informal definition I often use:

Fractals are geometric shapes that are equally complex in their details as in their overall form. That is, if a piece of a fractal is suitably magnified to become of the same size as the whole, it should look like the whole, either exactly, or perhaps only after a slight limited deformation.

Are we not right in the middle of dry geometric principles? An artist could expect nothing from fractals defined in this fashion, hence no one attempted to draw them carefully. The few old fractals that had been known under various names (and depicted for at least a century) are also the least interesting esthetically because one glance shows

that everything about them has been obviously put in by hand; they are orderly to excess. These images, however, began to grow in number and in variety after they were picked up and made into the first few 'words' in the new geometric language of fractals. This happened with my first book in 1975 [2].

What were the needs that led me to single out a few of these monsters, calling them *fractals,* to add some of their close or distant kin, and then to build a geometric language around them? The original need happens to have been purely utilitarian. That links exist between usefulness and beauty is, of course, well known. What we call the beauty of a flower attracts the insects that will gather and spread its pollen. Thus the beauty of a flower is useful—even indispensable—to the survival of its species. Similarly, it was the attractiveness of the fractal images that first brought them to the attention of many colleagues and then of a wide world.

Let me tell how this started happening. In the 1960s, the basic idea of the theory of fractals was already present in my mind, having been devised to study such phenomena as the erratic behavior of stock prices, turbulence in fluids, the persistence of the discharges of the Nile, and the clustering of galaxies, which manifests itself with the presence of great intergalactic empty spaces. But society seemed to think that my theories, their mathematical techniques and their goals were strange, as opposed to simply new. As a result, my attempts to make my thoughts accepted as sound seemed always to encounter a wall of hostility that words and formulas failed to circumvent.

One day it became necessary to convince Walter Langbein, the editor of a water resources journal, to accept a paper I had co-authored. He was a skilled and able scientist, but not one to gamble on wild, unproven ideas. I decided to resort to a tactical detour, presenting him with two images in the hope that Langbein would find it impossible to distinguish between reality and 'forgeries' that were based solely upon an early fractal theory. If this were to happen, he would no longer be able to view this theory as irrelevant to his work, he could not and would not reject our paper outright, and he might eventually accept fractals. This is indeed what happened: the detour through the eye turned out to be successful, and its offspring grew beyond expectation.

What happened next to fractal art as it evolved brings us to the traditional dichotomy between representational and nonrepresentational art. In the well-recognized forms of art, this dichotomy no longer seems so strongly etched, and fractal art straddles it very comfortably. The earliest explicit uses of fractals gave me the privilege of being the first person to tackle in a new way some problems that must be among the oldest that humanity had asked itself: how to obtain 'figures' that represent the shapes of mountains, clouds and rivers? It turns out that, when the representation of nature by fractal is perceived as successful, it also tends to be perceived as beautiful. Unquestionably, the fractal 'forgeries' of mountains and clouds are examples of representational art.

The skeptic will immediately raise another question. Is it not true that the colors used to render these mountains and clouds are chosen by rules that have nothing to do with any geometry? If this is so, these 'forgeries' are not purely fractal. What precise role, then, does color play in the acceptance of what you call 'fractal art'? This may sound like a very strong objection, but in fact it is easy to answer.

First of all, the question did not and could not arise with the first fractal pictures, simply because they were in black

and white. I might also add that in many cases this supposedly obsolete palette is the one I continue to favor.

When the use of color did arise, Richard Voss and I worried that it might detract from our primary concern with the geometry. Thus, initially he decided to color his art simply, as in the *London Times World Atlas*; but in landscapes viewed from an angle instead of the zenith, this proved to be visually unacceptable. However, we continued to avoid excessive artistic intervention, and Voss kept his esthetic urges under the tightest of control. This, in my opinion, helped fractal geometry make its intended point. Once that point was achieved, however, a completely different situation was created in which reserve was no longer an overriding obligation. In the recent crop of pictures by F. Kenton Musgrave, 'SIGGRAPH tricks' are allowed, but one *absolute* constraint remains. Every surface that is depicted must be a fractal surface, and all commands that are used to improve the rendering must be global commands. To 'fix' an unsatisfactory corner of a piece by a local patch is not permitted. Many computer artists would find this constraint to be quixotic, but it is essential if fractal art is to preserve its integrity.

While dealing with fractals intended as forgeries of nature, we found that cases soon began to multiply in which this intent failed. The result, however, remained just as beautiful, and occasionally even more so. Happy errors! Furthermore, a person fascinated by shapes could not avoid forgetting on occasion the original goals of the fractal geometry *of nature* and would play on with fractal algorithms just to find where they might lead. Thus as a fractal model of mountains is deformed by changing the values given to one or a few numbers that characterize the fractal's form, the picture becomes less and less 'realistic' as a mountain and gradually becomes altogether 'surreal'.

Even more striking surrealism prevails within the second major aspect of fractal geometry. Fractal 'dragons', of which the 'oldest' are reproduced here (see Fig. 1 and Color Plates I Nos 1 and 2)—and of which millions seem to have been drawn since—have never been meant to represent anything in nature. Their intended usefulness concerned mathematics, since they helped me investigate a process called the 'dynamics of iteration'. Early in the century, the mathematicians Pierre Fatou and Gaston Julia had found that this process presents a deep and surprisingly intellectual challenge. Then for 60 years hardly anyone touched the problem because even the most brilliant mathematicians, when working alone with the proverbial combination of pencil-and-paper and mental images, found that its study had become too complicated to be managed. My fresh attack on iteration could rely upon the help of the computer, and it was effective: the new mathematical order was spectacular. For the purposes of this discussion, this does not matter at all, of course; but a side result does matter a great deal: the resulting balanced co-existence of order and chaos was found almost invariably to be beautiful.

As in the case of the fractal mountains, the new iteration-generated fractals were already perceived to be beautiful in their original black and white. More precisely, the output of my work was a collection of numbers that in the early stages had to be reduced to two possibilities, to be represented by black and white. After color became involved, these numbers were first represented by colors chosen more or less at random by color-blind hackers. (An awful case of painting by numbers!) Yet even these fractals were, in a way, beautiful. But when the coloring was placed in the hands of a true artist, we began to see true wonders.

Our skeptical critic will come back at this point to remind us that fractals should share the credit for this art with both

Fig. 2. Fractal landscapes. These illustrations exemplify three of many successive stages in the development of fractal landscapes. One may call these stages, respectively, 'archaic', 'classic' and 'romantic'.

The archaic wire model illustration (above) was done by S. W. Handelman (1974), who was then my programmer at IBM at a time when our work was dominated by the extreme crudeness of the tools.

The classic illustration (below) is by Richard F. Voss of IBM (1985). It is an improved form of one in a series he prepared for my book of 1982 [4]. By then, the computer tools had become less obtrusive, and allowing fancy to take over was a genuine temptation. But fantasy had to be resisted because these pictures were primarily tools of scientific discourse. The wonder is that these extreme constraints should have allowed the emergence of Voss's masterpieces of subdued elegance.

The romantic illustration shown in Color Plate I No. 3 is by my Yale student, F. Kenton Musgrave, and myself (1989). Today, wire models that are better than the archaic one take 1 second to be computed and drawn on a workstation, and the number of available colors has changed from being unmanageably small to being unmanageably large. The most innovative use of fractals now is to serve as support for an artist's inspiration and skill.

the computer and the programmer-artist who frames the object and selects the colors. These last two factors are the ones usually considered central to computer art; hence the critic's point concerns the significance of the fractal's additional input. In some cases (as in one of the illustrations of this paper) fractals' most obvious contribution is an obtrusive symmetry that may in fact be found to be very objectionable. In other cases, however, when the symmetry is hidden we see an interplay between strong order and just enough change and surprise. My readings on the meaning of art suggest that such an interplay is one of the basic prerequisites of plastic beauty.

Fig. 3. Two fragments of the Mandelbrot set. The Mandelbrot set is explained in Refs [4], [7] and [8]. The first fragment (above; R. F. Voss, 1988) was selected so as to include, near its center, a small replica of the whole, with its obvious symmetries and repetitions, and even to include additional symmetries that are not present in the whole set. This fragment, therefore, leans too far towards orderliness. The second fragment (below; B. B. Mandelbrot), which is from a generalized, not the 'ordinary', Mandelbrot set, was selected to provide contrast since it is devoid of obvious symmetries. (See also Color Plate I No. 4.)

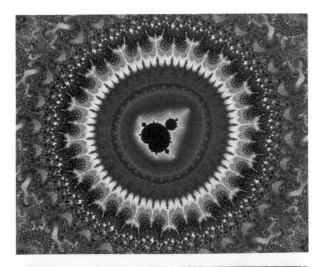

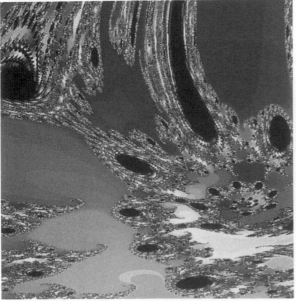

To summarize, the altogether new feature brought in by fractal art is that the proper interplay between order and surprise need not be the result either of the imitation of nature or of human creativity, and it can result from something entirely different. The source of fractal art resides in the recognition that very simple mathematical formulas that seem completely barren may in fact be pregnant, so to speak, with an enormous amount of graphic structure. The artist's taste can only affect the selection of formulas to be rendered, the cropping and the rendering. Thus, fractal art seems to fall outside the usual categories of 'invention', 'discovery' and 'creativity'.

All this seems to have happened long ago, and today fractal geometry is so well established that young people are astonished to find that the 'father of fractal geometry' (as I am delighted to be called) is still alive. But I hope to live long enough to really understand what has happened.

ENDNOTE

It is increasingly difficult to stress the specificity of fractal art without a proper term to denote it. In a way, it is a form of computer art, but the computer is only a tool, not the main point. What is most important is a fact that I continue to find surprising—even though I discovered it and have been working with it for decades. This fact is that astonishingly complex and beautiful graphics can be generated by surprisingly plain algorithms. Hence the term *algorithmic art,* which I use at present. These graphics give rise to a kind of turned-around Turing Test. Faced with pure algorithmic art, no experienced person will fail to realize eventually that the work is neither a painting nor a photograph nor any other fruit of conventional human creativity. Therefore, it certainly does not raise the issue of 'artificial creativity'. Yet, works of algorithmic art are often perceived as beautiful on their own terms. Therefore, creativity and beauty and the production and consumption of art must be viewed separately.

References and Notes

1. The first three books on fractals are Refs [2], [3] and [4]. Among later books, I recommend Refs [7] and [8], which are of higher graphic quality than mine, though of narrower focus. Of the approximately 40 books that have by now been written on fractals, nearly all are for mathematicians and/or physicists, and Refs [4], [7] and [8] are the only books written in English for a broad audience. Ref. [5] belongs here because of the journal in which it appeared and because it is my earliest statement on the issue of fractals and esthetics, and Ref. [6] can be viewed as a commentary on the present paper.
A Quandary and an Apology. It would have been nice also to recommend works with which I am less closely associated, but this would be very hard. Each quote creates one happy person and many unhappy ones. The time when my close associates were the only people involved with fractals passed years ago, and to write a balanced survey is not a task I enjoy.

2. B. B. Mandelbrot, *Les objets fractals* (Paris: Flammarion, 1975, 1984, 1989).

3. B. B. Mandelbrot, *Fractals: Form, Chance and Dimension* (San Francisco: W. H. Freeman and Company, 1977).

4. B. B. Mandelbrot, *The Fractal Geometry of Nature* (New York: W. H. Freeman and Company, 1982).

5. B. B. Mandelbrot, "Scalebound or Scaling Shapes: A Useful Distinction in the Visual Arts and the Natural Sciences", *Leonardo* **14**, No. 1, 45–47 (1981).

6. F. K. Musgrave and B. B. Mandelbrot, "Natura ex Machina," *IEEE Computer Graphics and Applications* **9**, No. 1, cover and 4–7 (1989).

7. H. -O. Peitgen and P. H. Richter, *The Beauty of Fractals* (New York: Springer, 1986).

8. H. -O. Peitgen and D. Saupe, eds., *The Science of Fractal Images* (New York: Springer, 1988).

Geometry and Visualization

Brent Collins states that the mathematical content of his work "originates in purely visual intuition, and the effort to subsequently become conscious of it in a way I can communicate in words has always been extremely difficult. . . . I was intuitively approximating the logic of soap-film minimalization". Later Collins refers to his "intuitive denouement", and continues, "My understanding of the mathematical content of my intuitive creations can grow only within the limits available to me as a nonmathematician". Collins's emphasis on intuition parallels R. Buckminster Fuller's use of the word for the title of one of his books (as well as for the name of his boat). Like M. C. Escher [1], Collins considers himself a nonmathematician, and like Fuller, Collins finds himself at a loss to use existing technical vocabulary to accompany his creations.

It may well be that intuition is nonverbalized knowledge [2]. Without a doubt Collins's sculptures, like Escher's prints, are the result of considerable abstract reasoning, resulting in images rather than in words or formulas.

Sculptor Charles O. Perry alludes as well to intuition when he states: "There is never enough information for us to absorb or understand. We gather smatterings of the latest gossip about ideas such as the big bang or string theories. We are unable to wrestle with the depth of these concepts mainly because real comprehension of the mathematics involved is beyond us. But we are dreamers—we are fraught with wishful 'intuitions'. . . . Visual art, our media, is our way of acting out our intuitions. It has always been my dream that just one of my intuitions would have some use or at least would be related to real life". In the same way as Angel Duarte, who discovered after the fact that his works of art parallel Schwarz's and Schoen's mathematical constructs, Perry was surprised when the form of his sculpture *Early Mace* was indeed very similar to the form of 'magnetic bottles' investigated by Richard F. Post.

Harriet Brisson discusses David Brisson's and Thomas Banchoff's and Charles Strauss's contributions to the visualization of higher-dimensional objects through the projection of such objects into two- or three-dimensional spaces. Harriet Brisson explains that, whereas her husband David based his work involving higher dimensions on his study of mathematics, she herself understands relationships through the actual manipulation of tangible form rather than as a result of an abstract or symbolic study of equations.

The artist Helaman Ferguson is a trained mathematician who either chose sculpture to express his mathematical concepts or chose mathematics to expand his artistic repertoire (Koos Verhoeff is another example of this kind of artist/mathematician). Only the artists themselves can tell us which is true, although one might surmise that the truth is a combination of both. Our perception of the complexity of a configuration is altered when we can find an algorithm and a set of modules to generate that configuration [3]. Unless an artist is able to tell us the method by which he or she generated a pattern, one can only speculate about just how a work of art was generated.

Anthony Phillips, however, has been able to determine with a high degree of certainty the algorithms by which ancient unicursal mazes (mazes without bifurcations) that have been partially destroyed and/or restored were originally designed. Phillips has thus been able to extrapolate from the incomplete remains to recreate the original maze and to correct restorations that had been attempted without real understanding of the original structures. Even though these mazes differ in external appearance and to some extent also in internal structure, a sufficient number of them have survived to enable Daszewski [4] and Phillips to classify them according to their fundamental structure and thus to find their mutual structural relationship. The total collection of mazes may thus be regarded as a 'structure of structures': each maze is itself a pattern having well-defined structural relationships between its components, but the collection of mazes also has a structural order by which the mazes may be interrelated and compared.

Figure 6 in "Portraits of a Family of Complex Polytopes", by H. S. M. Coxeter and G. C. Shephard, illustrates that there is more than meets the eye. The authors have applied the power of computer graphics to make their abstractions visible. This figure is relatively simple because, although it represents a projection of an extremely intricate higher-dimensional construct, the Witting polytope, the visible lines exactly cover a multitude of hidden structural elements that are unveiled in full magnificent bloom when the polytope is rotated. Significantly, the authors cared enough to expend considerable ingenuity to allow the reader to visualize these abstract concepts and to display a beauty that can be appreciated even by those unable to follow every detail of the mathematical argument.

The mathematician Roger Penrose and his father L. S. Penrose strongly influenced Escher in the creation of the latter's 'impossible object' prints. Both Escher [5] and the Basque artist José Yturralde [6] have stated that their two-dimensional prints were perfectly possible, but that our acculturated extrapolation into three dimensions creates the impossibilities. Roger Penrose shows that ambiguity is due to the fact that in one context some points in the plane of the print would be interpreted to be at a given distance from the viewer, but that the same points would appear to be at a different distance in a different context. By putting these ambiguities on a quantitative basis through the use of cohomology groups, Penrose expects to open up further exotic types of impossible figures.

Note the spectrum of practitioners of Visual Mathematics. At one extreme are artists who claim to be nonmathematicians and who allude to intuition as their guiding spirit. This intuition appears to operate at a highly abstract but nonverbal level. Escher, Collins, Duarte and Perry have expressed themselves so similarly about this aspect of their work that we can group them together at this end of the spectrum.

Conversely, Coxeter, Shephard and Penrose, as well as Banchoff, are mathematicians who are sensitive to visual and artistic interpretations and realizations of their abstractions. They have thus been able to open new vistas for artists. The Brissons are somewhere in the middle. The interaction between the Penroses and Escher and between the Brissons and Banchoff have resulted in well-known contributions to the new field of Visual Mathematics.

Harriet Brisson has, in the present volume, chronicled some of the activities that may be considered germinal in the development of Visual Mathematics. To these should be added the publication by Braziller books of the *Vision and Value Series,* under the editorship of Gyorgy Kepes, and the establishment of the journal *Leonardo* by Frank Malina, both in the 1960s.

A scientific theory does not need to be completely understood to inspire a great piece of art [7]. Linda Henderson exhaustively researched an exciting period in art

history [8] and demonstrated how new mathematical concepts about geometrical space influenced the second generation of Cubists. The present volume, containing many personal statements from visual mathematicians, should prove invaluable to future historians probing the complex interactions leading to new forms of art and of mathematics around the turn of the twenty-first century.

ARTHUR L. LOEB
Design Scientist, Artist, Musician
Department of Visual and Environmental Studies
Carpenter Center for the Visual Arts
Harvard University
Cambridge, MA 02138
U.S.A.

References

1. A. L. Loeb, "Some Personal Recollections of M. C. Escher", *Leonardo* **14**, No. 4, 318–319 (1981); and A. L. Loeb, "On My Meetings and Correspondence between 1960 and 1971 with the Graphic Artist M. C. Escher", *Leonardo* **15**, No. 1, 23–27 (1982).

2. E. Haughton and A. L. Loeb, "Symmetry, the Case History of a Program", *J. Res. in Science Teaching* **2** (1964) pp. 132–145; A. L. Loeb and E. Haughton, "The Programmed Use of Physical Models", *J. Progr. Instr.* **3** (1965) pp. 9–18.

3. A. L. Loeb, "Algorithms, Structures and Models", in David W. Brisson, ed., *Hypergraphics,* AAAS Selected Symposium Series No. 24 (1978) pp. 49–64.

4. Wiktor A. Daszewski, *La Mosaique de Thésée* (Warsaw: PWN-Editions Scientifiques de Pologne, 1977).

5. Loeb [1].

6. Personal communication, ca. 1975.

7. Note the quote from Charles O. Perry above.

8. Linda Henderson, *The Fourth Dimension and Non-Euclidean Geometry in Modern Art* (Princeton, NJ: Princeton Univ. Press, 1983).

Portraits of a Family of Complex Polytopes

H. S. M. Coxeter and
G. C. Shephard

Beside the actual universe I can set in imagination other
universes in which the laws are different.

—J. L. Synge

A regular *q-gon*, denoted by {*q*} or 2{*q*}2, has *q* vertices (or corners) and *q* edges (or sides). Each vertex belongs to two edges, and each edge joins two vertices. The vertices on an edge may be identified with the points on the real line with coordinates 1 and −1, the two square roots of 1. Accordingly we call this a 2-*edge* (or, sometimes, an *ordinary* edge) and generalize it [1] to a *p-edge* whose *p* vertices may be identified with the *p* points on the complex line whose coordinates are the *p*th roots of 1, namely

$$e^{2v\pi i/p} = \cos(2v\pi/p) + i\sin(2v\pi/p) \ (v = 0, 1, \ldots, p-1).$$

These are the roots of the algebraic equation $x^p - 1 = 0$ or

$$(x-1)(x^{p-1} + \ldots + x + 1) = 0.$$

Such a set of points (the vertices of a *p*-edge) are represented in an Argand diagram by the vertices of a regular *p*-gon {*p*}.

More generally, a complex polygon $p_1\{q\}p_2$ is a polygon in the unitary plane (whose coordinates are (z_1, z_2) where z_1 and z_2 are complex numbers) with p_1-edges (each with p_1

vertices), and each vertex belongs to p_2 of these edges [2]. The middle number *q* can still be described as the length of a minimal cycle of vertices such that every consecutive two, but no three, belong to an edge [3]. Such a generalized polygon is represented (as explained below) in the real Euclidean plane by a set of regular p_1-gons, one for each p_1-edge, arranged in such a way that each vertex belongs to p_2 of the p_1-gons. The cycle of *q* vertices forms an ordinary *q*-gon that is usually not regular. For instance, in the simplest drawings of $p\{4\}2$ and $2\{4\}p$ ($p > 2$) [4], the *q*-gon is a rhomb and a trapezium (or rectangle or kite), respectively. We have here an instance of two *reciprocal* (or *dual*) polygons, $p_1\{q\}p_2$ and $p_2\{q\}p_1$ such that the vertices of each correspond to the edges of the other.

ABSTRACT

Regular complex polytopes in unitary space have been studied since the 1950s. The advent of computer graphics has enabled us to represent these on the real plane in a meaningful way with very little effort. Here we are chiefly concerned with a particular sequence of complex polytopes in two, three and four dimensions and with some associated real polytopes.

H. S. M. Coxeter (mathematician), Department of Mathematics, University of Toronto, Toronto M5S 1A1, Canada.

G. C. Shephard (mathematician), School of Mathematics, University of East Anglia, Norwich NR4 7TJ, United Kingdom.

Fig. 1. Four projections of the Möbius-Kantor polygon 3{3}3, showing how its appearance gradually changes while it is rotated.

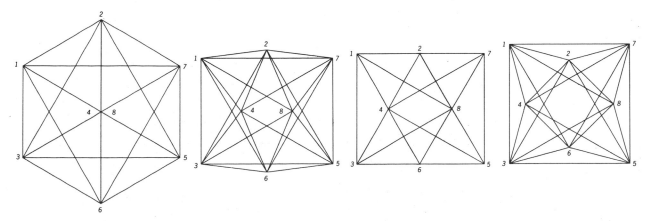

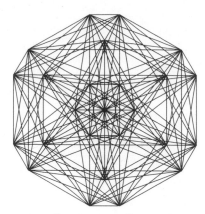

Fig. 2. The Hessian polyhedron 3{3}3{3}3 with projection vector (√3, 1, 1). The 3-edges appear as equilateral triangles of various sizes.

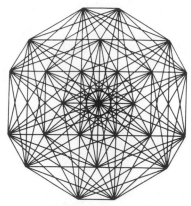

Fig. 3. The Hessian polyhedron 3{3}3{3}3 with projection vector (2, 1, 1).

A Self-Reciprocal Complex Octagon

The self-reciprocal polygon 3{3}3 was discovered by Shephard [5], who called it 3(24)3 (because its symmetry group, the 'binary tetrahedral group' has order 24). It may be described combinatorially by the cyclic triple system

124 235 346 457 568 671 782 813.

Each of the eight triples corresponds to a 3-edge, and the numbers show which of the eight vertices *1, 2, . . . , 8* lie on that edge. A typical *q*-cycle (determining the middle 3 in the symbol 3{3}3) is *123*. Clearly, each vertex belongs to three edges (the last 3 in the symbol). Apart from *15, 26, 37, 48,* each pair of vertices determines a unique 3-edge. Accordingly, the eight edges may be denoted by

24, 35, 46, 57, 68, 71, 82, 13,

and we may regard them as forming two 'quadrangles' *1357* and *2468*, each inscribed in the other. (The vertices *1, 3, 5, 7* of the first lie on the sides *24, 46, 68, 82* of the second, and the vertices *2, 4, 6, 8* of the second lie on the sides *35, 57, 71, 13* of the first.) The problem of constructing such a pair of 'mutually inscribed quadrangles' was proposed in 1828 by A. F. Möbius (who found it to be impossible in real geometry) and was solved in 1881 by S. Kantor [6]. Accordingly let us name 3{3}3 the *Möbius-Kantor polygon.*

One solution to the problem, different from Kantor's, uses the three-dimensional complex coordinates

$$(0, \omega, -\omega^2), (0, \omega^2, -\omega), (-\omega^\lambda, 0, 1), (\omega^\lambda, -1, 0) \quad (1)$$
$$(\lambda = 0, 1, 2)$$

where $\omega = (-1 + i\sqrt{3})/2$, so that $\omega^3 = 1$ [7,8]. More precisely, coordinates (u_1, u_2, u_3) for the eight vertices can be assigned as shown in Table 1.

Since all these lie in the plane $u_2 + 1 = u_3$, one further equation is needed to determine a line. For instance, the line *13* is given by $u_2 + 1 = 0$ (or $u_3 = 0$), and we see at once that this line passes through a third vertex, namely *8.*

In Fig. 1, the Möbius-Kantor polygon has been 'projected' in such a way that the edges appear as regular 3-gons, that is, equilateral triangles of various sizes because of the different degrees of 'foreshortening'. We will proceed to explain how these pictures are drawn.

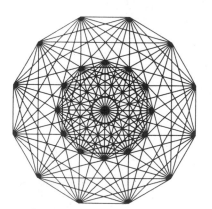

Fig. 4. The Hessian polyhedron 3{3}3{3}3 with projection vector (1 + √3, 1, 1). This vector happens to yield a more symmetrical picture.

The Process of Projection

Since the polytopes we are considering lie in unitary space of two, three or four dimensions, the coordinates of their vertices are complex numbers. One may well ask how it is possible to represent such an object, in a meaningful way, in the real plane. The procedure involves projection onto a complex line through the centre (the origin of the coordinate system). For this purpose we choose a complex vector (v_1, v_2, v_3) along the line and associate with each vertex (u_1, u_2, u_3) of the polytope the complex number

$$z = x + iy = u_1\bar{v}_1 + u_2\bar{v}_2 + u_3\bar{v}_3. \quad (2)$$

The complex number z, represented on an Argand diagram, or equivalently the point (x, y) in the real plane, will be called the *projection* of the point (u_1, u_2, u_3) using the *projection vector* (v_1, v_2, v_3).

To see what this means, consider what happens if we rotate the coordinate axes (that is, apply a unitary transformation) so that the first axis lies in the direction of the projection vector (v_1, v_2, v_3). Since the Hermitian inner product is invariant under the transformation, the value of z is unchanged. In the new coordinate system the projection vector becomes $(1, 0, 0)$ and let us suppose (u_1, u_2, u_3) is transformed into (u_1', u_2', u_3'). Then the inner product on the right side of (2) becomes u_1', so we are simply replacing the point (u_1', u_2', u_3') by its first coordinate. In other words, we are projecting the point onto the first axis. Transforming back to the original coordinate system, we see that the mapping $(u_1, u_2, u_3) \rightarrow z$ defined by (2) may be described as a projection onto a line through the origin in direction (v_1, v_2, v_3); hence the terminology we have adopted.

Having thus found real points to represent the vertices of the given polytope, all that remains to be done is to join certain pairs of these real points by line segments so as to represent the edges of the complex polytope. To do this we

Table 1. Coordinates for the eight vertices of 3{3}3.

1	*2*	*3*	*4*
$(\omega, -1, 0)$	$(0, \omega, -\omega^2)$	$(\omega^2, -1, 0)$	$(-1, 0, 1)$
5	*6*	*7*	*8*
$(-\omega, 0, 1)$	$(0, \omega^2, -\omega)$	$(-\omega^2, 0, 1)$	$(1, -1, 0)$

$m = 9$

$m = 10$

$m = 11$

$m = 12$

$m = 13$

$m = 14$

$m = 15$

$m = 16$

$m = 17$

$m = 18$

Fig. 5. Ten different projections of the Hessian polyhedron 3{3}3{3}3, showing how its appearance changes while it is rotated.

join two points if they represent vertices of the complex polytope that lie on the same edge and are a minimum distance apart. In this way a p-edge is represented by a regular p-gon.

If we apply this procedure to the eight vertices (1) of 3{3}3 using, in turn, the projection vectors $(v_1, 1, 1)$ with

$$v_1 = 1, \quad \sqrt{3}, \quad 2, \quad 1 + \sqrt{3}, \tag{3}$$

we obtain parts (a), (b), (c) and (d) of Fig. 1. Table 2 gives the corresponding values of $z = x + iy$, where, to simplify the last row, we have multiplied each entry by the real number $1 - 1/\sqrt{3}$; this merely reduces the size of the drawing.

Looking at Fig. 1 we can imagine the gradual transition

(or 'rotation') from (a) through (b) and (c) to (d), while v_1 increases from 1 to $1 + \sqrt{3}$ with $v_2 = v_3 = 1$. The diagrams of complex polytopes in Shephard's article in the *Proceedings of the London Mathematical Society* [9] are projections in the sense described here; unfortunately, the projection vectors are not indicated.

THE HESSIAN POLYHEDRON AND THE WITTING POLYTOPE

Regular complex polytopes occur in unitary space of any number of dimensions. It seems appropriate to refer to those in three dimensions as *complex polyhedra* (just as the

Fig. 6. The Witting polytope 3{3}3{3}3{3}3 with projection vector (1, 0, 0, 0), deceptively simple because many lines are hidden behind others.

two-dimensional figures are usually called *complex polygons*). The natural analogue in three dimensions of the Möbius-Kantor polygon 3{3}3 is the *Hessian polyhedron* 3{3}3{3}3 [10], which is again self-reciprocal (since its symbol is palindromic). It has 27 vertices, 72 edges (3-edges) and 27 faces. Each face is a 3{3}3 sharing each of its 3-edges with two other 3{3}3s. Each vertex belongs to eight edges and eight faces corresponding to the eight vertices and eight edges of 3{3}3, usually referred to as its 'vertex figure'. Coordinates of the 27 vertices of 3{3}3{3}3 can be taken in the form [11,12]:

$$(0, \omega^\lambda, -\omega^\mu), (-\omega^\mu, 0, \omega^\lambda), (\omega^\lambda, -\omega^\mu, 0) \ (\lambda, \mu = 0, 1, 2).$$

Projections of this polyhedron (as described in the previous section) using projection vectors (3) yield Figs 1(a), 2, 3 and the highly symmetrical Fig. 4 [13]. In the first of these diagrams, each of the six peripheral vertices represents three vertices of the Hessian polyhedron, and the centre represents nine vertices. The centres of Figs 2 and 3 each represent three vertices of the polyhedron. Again we may regard these diagrams as 'snapshots' of the Hessian polyhedron as it is slowly rotated.

A particularly interesting series of projections is shown in Fig. 5 where the projection vector

$$(1, \eta^m, \eta^{2m}) \qquad (\eta = e^{\pi i/27})$$

is used with m = 9, 10, 11, 12, 13, 14, 15, 16, 17, 18. In every case except the first and last, all 27 vertices of the polyhedron project into distinct points, and all 27 equilateral triangles corresponding to the 3-edges can be clearly seen. It is interesting to compare the case m = 11 with a projection drawn by J. G. Sunday [14] without the aid of a computer. He carefully distorted the enneagonal projection [15] that corresponds to m = 12.

The four-dimensional analogue of the Hessian polyhedron is the Witting polytope 3{3}3{3}3{3}3 [16], which is again self-reciprocal. It has 240 vertices, 2160 3-edges, 2160 faces and 240 facets (three-dimensional faces). Each facet

shares each of its faces with two other 3{3}3{3}3s. Each vertex belongs to 27 edges, 72 faces and 27 facets, corresponding to the 27 vertices, 72 edges and 27 facets of a 3{3}3{3}3, which is its vertex figure.

The coordinates of the 216 + 24 = 240 vertices of the Witting polytope may be taken as shown in Table 3 [17,18]. The real projection of a vertex is defined by taking the Hermitian inner product with the projection vector as in (2). If the projection vector (1, 0, 0, 0) is chosen, then the projections of the 240 vertices are, in the Argand diagram, the 13 points

$$\pm i\omega^\lambda\sqrt{3}, \pm\omega^\lambda, 0 \qquad (\lambda = 0, 1, 2).$$

One vertex projects into each of the first six of these, 27 vertices project into each of the next six, and 72 project into the origin O. Accordingly, in the projection shown in Fig. 6, each of the six vertices of the outer hexagon is counted once, each of the six vertices of the inner hexagon is counted 27 times, and the centre is counted 72 times.

Since $(i\sqrt{3}, 0, 0, 0)$ is one of the vertices of the Witting polytope, Fig. 6 is a 'vertex first' projection, that is, its projection vector is one of the diameters of the polytope.

If we choose

$$(\varepsilon - \varepsilon^2, \varepsilon^{-5} - \varepsilon^{-7} - \varepsilon^{-1}, \varepsilon^{-6} - \varepsilon^{-7}, 1) \qquad (\varepsilon = e^{\pi i/15})$$

we obtain the remarkably symmetrical projection of the Witting polytope shown in Fig. 7. Here, all the 240 vertices map into distinct points neatly distributed by thirties on eight concentric circles [19]. The 27 edges meeting at each vertex of the Witting polytope are represented in Fig. 7 by equilateral triangles.

REAL REPRESENTATIVES

Given a complex n-dimensional polytope P, we can interpret the real and imaginary parts of the coordinates of each vertex of P as a point in $2n$-dimensional real Euclidean space. Any real $2n$-dimensional polytope Q that has these points as vertices will be called a *real representative* of P. If, in addition, two vertices lie on an edge of P and are at a minimum distance apart whenever the corresponding vertices of Q are joined by an edge, then we say that Q is a *true* (real) representative of P. It turns out that in almost all cases, and certainly those we are considering here, each regular complex polytope has a real representative which is a well-known real regular or uniform polytope. In some cases these are true representatives.

If, in (2) we write $u_\nu = a_\nu + ib_\nu$ and $v_\nu = c_\nu + id_\nu$ ($\nu = 1, 2, 3$) and separate real and imaginary parts, we obtain

vertex	1	2	3	4	5	6	7	8
Table 2. Complex numbers representing the eight vertices.								
(a)	$-1 + \omega$	$i\sqrt{3}$	$-1 + \omega^2$	0	$1 - \omega$	$-i\sqrt{3}$	$1 - \omega^2$	0
(b)	$-1 + \omega\sqrt{3}$	$i\sqrt{3}$	$-1 + \omega^2\sqrt{3}$	$1 - \sqrt{3}$	$1 - \omega\sqrt{3}$	$-i\sqrt{3}$	$1 - \omega^2\sqrt{3}$	$-1 + \sqrt{3}$
(c)	$-2 + i\sqrt{3}$	$i\sqrt{3}$	$-2 - i\sqrt{3}$	-1	$2 - i\sqrt{3}$	$-i\sqrt{3}$	$2 + i\sqrt{3}$	1
(d)	$-1 + i$	$(-1 + \sqrt{3})i$	$-1 - i$	$1 - \sqrt{3}$	$1 - i$	$(1 - \sqrt{3})i$	$1 + i$	$-1 + \sqrt{3}$

Fig. 8. The truncated Hessian polyhedron 3{3}3{4}2, whose faces are 54 Möbius-Kantor polygons.

Fig. 9. The real six-dimensional polytope 1_{22}, whose 54 facets ($1_{21} = 1_{12}$) are all alike, though not regular. (Drawn by Edward Pervin)

$$x = \sum_{v=1}^{3} (a_v c_v + b_v d_v),$$

$$y = \sum_{v=1}^{3} (-a_v d_v + b_v c_v)$$

which are the coordinates of the orthogonal projection of

$$(a_1, b_1, a_2, b_2, a_3, b_3)$$

onto the plane spanned by the two orthogonal vectors

$$(c_1, d_1, c_2, d_2, c_3, d_3) \quad (-d_1, c_1, -d_2, c_2, -d_3, c_3).$$

We deduce from this that a projection of the vertices of a complex polytope (with any projection vector) coincides with the orthogonal projection of the vertices of a real representative onto a suitably chosen real plane. Thus the vertices in each of our projections of complex polytopes (see Figs 1–8) can be regarded as representing the vertices of a real polytope. In the case of true representatives, the edges also are faithfully indicated.

We shall now consider each of the polytopes in turn. A real representative (in fact a true representative) of the Möbius-Kantor polygon 3{3}3 is the regular four-dimensional cross polytope or 16-cell $1_{11} = \{3, 3, 4\}$ [20]. This polytope has eight vertices and 24 edges corresponding by threes to the eight edges of 3{3}3. The 16 facets (three-dimensional faces) are regular tetrahedra, one of which is the real representative of *1234*, and the remaining 15 can be derived by replacing *1* by *5*, *2* by *6*, *3* by *7*, and *4* by *8* independently. Since each vertex of 3{3}3 belongs to three 3-edges, in the 16-cell each vertex belongs to six ordinary edges, two for each of three equilateral triangles representing the 3-edges. Thus the four drawings in Fig. 1 are orthogonal projections of the 16-cell onto real planes.

In a similar way, the real regular 24-cell {3, 4, 3} is a true representative of the complex polygon 4{3}4 [21]. It is also a real representative of the simpler polygon 3{4}3, but in this case the representation is not true. This is easy to see because, whereas three 3-edges meet at each vertex of the

complex polygon, eight (ordinary) edges meet at each vertex of the 24-cell. Consequently, to derive the drawing of 3{4}3 from the drawing of {3, 4, 3} or 4{3}4, we must remove 24 edges, namely the edges of four hexagons, two inscribed in each of the two concentric decagons.

In a similar manner, the real regular four-dimensional 120-cell {3, 3, 5} is a real representative of the complex polygon 5{3}5 but not a true representative [22]. To obtain the projection of {3, 3, 5} from that of 5{3}5, it is necessary to adjoin 120 edges, namely 12 decagons, three inscribed in each of the four concentric 30-gons.

The real uniform polytope 2_{21} in six dimensions is a true representative of the Hessian polyhedron 3{3}3{3}3. This real polytope 2_{21}, which has 27 vertices and 216 edges (meeting by sixteens at each vertex) was discovered by Th. Gosset in 1897, rediscovered by E. L. Elte in 1911, and again rediscovered by Coxeter about 1925 [23]. This uniform polytope is *not* regular since its facets (five-dimensional faces) are of two different kinds: simplexes $2_{20} = \{3, 3, 3, 3\}$ and cross polytopes $2_{11} = \{3, 3, 3, 4\}$ [24]. This example shows that a true representative of a regular complex polytope need not be regular.

The centres of the 72 3-edges of the Hessian polyhedron (appearing in the projections as the centres of the equilateral triangles representing the edges) are the 72 vertices of the 'truncation' 3{3}3{4}2 (Fig. 8) [25]. The real uniform polytope 1_{22} in six dimensions is a real representative of 3{3}3{4}2, and a projection of 1_{22} is shown in Fig. 9 (drawn by Edward Pervin). Comparing Figs 8 and 9, we see immediately that 1_{22} is not a true representative; to obtain Fig. 9 from Fig. 8 we must adjoin 72 edges, namely 12 regular hexagons, three inscribed in each of the four concentric

Table 3. Coordinates for the 240 vertices of 3{3}3{3}3{3}3.

$(0, \pm\omega^{\mu}, \mp\omega^{\nu}, \pm\omega^{\lambda})$	$(\mp\omega^{\mu}, 0, \pm\omega^{\nu}, \pm\omega^{\lambda})$
$(\pm\omega^{\mu}, \mp\omega^{\nu}, 0, \pm\omega^{\lambda})$	$(\mp\omega^{\lambda}, \mp\omega^{\mu}, \mp\omega^{\nu}, 0)$
$(\pm i\omega^{\lambda}\sqrt{3}, 0, 0, 0)$	$(0, \pm i\omega^{\lambda}\sqrt{3}, 0, 0)$
$(0, 0, \pm i\omega^{\lambda}\sqrt{3}, 0)$	$(0, 0, 0, \pm i\omega^{\lambda}\sqrt{3})$

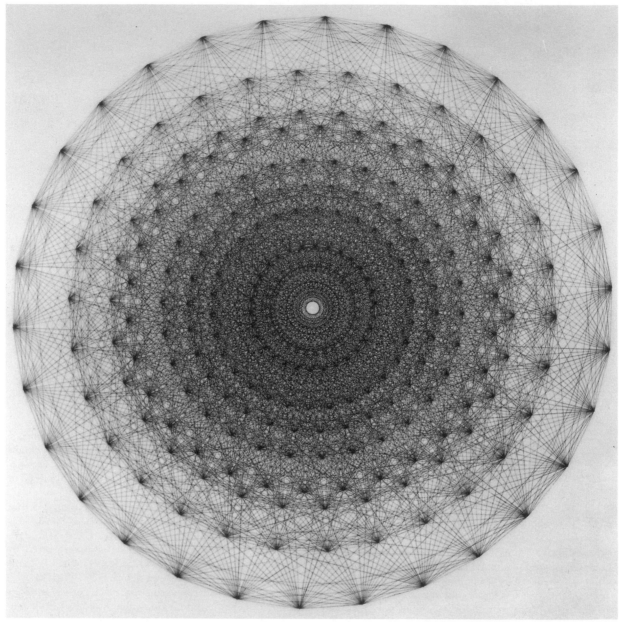

Fig. 7. The most symmetrical projection of the Witting polytope 3{3}3{3}3{3}3.

18-gons. (Each vertex of 3{3}3{4}2 belongs to nine 3-edges, whereas each vertex of 1_{22} belongs to 20 ordinary edges.)

The real eight-dimensional uniform polytope 4_{21} is a real representative (but not a true representative) of the Witting polytope 3{3}3{3}3{3}3. The real polytope has, meeting at each vertex, 56 ordinary edges, whereas the Witting polytope has 27 3-edges [26]. It follows that we must add 240 edges to Fig. 7 to obtain Fig. 10, namely the edges of 40 regular hexagons, five inscribed in each of the eight concentric 30-gons.

CONCLUSION

Consider the family of complex figures

3, 3{3}3, 3{3}3{3}3, 3{3}3{3}3{3}3, 3{3}3{3}3{3}3{3}3.

The first is a 3-line (which projects into an equilateral triangle) and the second, third and fourth are the regular complex polytopes of two, three and four dimensions described above. The last is a four-dimensional infinite honeycomb [27] whose four-dimensional cells are Witting polytopes fitting together in such a way that each three-dimensional face (Hessian polyhedron) is shared by two others.

The number of vertices of each polytope in the above family is given by the beautiful formula

$$6(n+1)(6-n)^{n-1}/(5-n)^n \tag{4}$$

for $n \le 4$. This is not empirical, but derived as the quotient of the orders of two groups [28]. It is interesting to note that for the fifth member of the family the formula (4) gives the value ∞ as we should have expected for a honeycomb, and for $n = 6$, it gives the value 0, which confirms that the family is finite. The value 1, which corresponds to $n = 0$, merely reflects the fact that the only zero-dimensional polytope (in the sense we use the term here) is a single point.

24

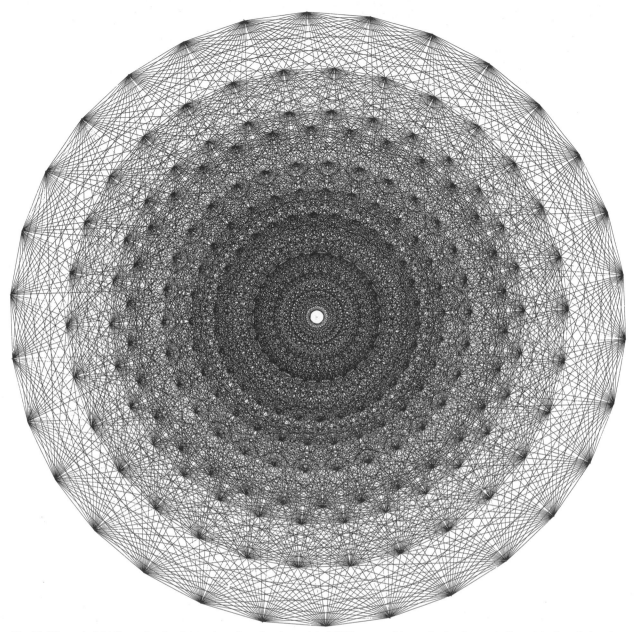

Fig. 10. The real eight-dimensional polytope 4_{21}, whose facets consist of 2160 cross polytopes 4_{11} (analogous to the octahedron 0_{11}) and 17280 simplexes 4_{20} (analogous to the tetrahedron 0_{20}).

References and Notes

1. G. C. Shephard, "Regular Complex Polytopes", *Proceedings of the London Mathematical Society*, Series 3, **2** (1952) pp. 82–97.

2. H. S. M. Coxeter, *Regular Complex Polytopes*, 2nd Ed. (Cambridge: Cambridge Univ. Press, 1991) p. 47.

3. J. G. Sunday, "Hypergraphs and Abstract Polygons", *Geometriae Dedicata* **4** (1975) pp. 363–371.

4. See Coxeter [2] pp. 108–109.

5. See Shephard [1] p. 93.

6. See H. S. M. Coxeter, *Twelve Geometric Essays* (Carbondale, IL: Southern Illinois Univ. Press, 1968) p. 123.

7. See Coxeter [2] p. 119.

8. H. S. M. Coxeter, "The Pappus Configuration and the Self-Inscribed Octagon III", *Proceedings of the Koningklijke Nederlandse Akademie van Wetenscappen, Amsterdam*, Series A, **80** (1977) pp. 285–300; see p. 292.

9. See Shephard [1].

10. See Coxeter [2] pp. 119–124.

11. H. S. M. Coxeter, "The Polytope 2_{21} Whose Twenty-Seven Vertices Correspond to the Lines on the General Cubic Surface", *American Journal of Mathematics D* **62** (1940) pp. 457–486; see display 5.3, p. 469.

12. See Shephard [1] p. 94.

13. See Coxeter [11] p. 463.

14. H. S. M. Coxeter, "The Equianharmonic Surface and the Hessian Polyhedron", *Annali di Matematica pura ed applicata*, Series 4, **98** (1974) pp. 77–92; see p. 88.

15. See Coxeter [11] p. 462.

16. See Coxeter [2] pp. 132–134, 180.

17. See Coxeter [11] p. 480.

18. See Coxeter [2] p. 132.

19. This figure was drawn by a Calcomp 1051 graph plotter in about 4 hours on a sq m of paper. It scarcely differs from the frontispiece of Coxeter [2], which Peter McMullen drew by hand during 3 days in 1964, using a steel ruler and ordinary pen.

20. See Coxeter [2] p. 31.

21. See Coxeter [2] Fig. 4.2D on p. 33 and Fig. 4.8A on p. 47.

22. See Coxeter [2] Fig. 4-7A on p. 42 and Fig. 4-8C on p. 49.

23. H. S. M. Coxeter, "The Pure Archimedean Polytopes in Six and Seven Dimensions", *Proceedings of the Cambridge Philosophical Society* 24 (1928) pp. 1–9.

24. See Coxeter [11] pp. 464, 468.

25. First appearing in Coxeter [2] as Fig. 12-4B on p. 126.

26. See Coxeter [2] p. 134.

27. See Coxeter [2] p. 135.

28. See Coxeter [2] Eq. 13.691 on p. 152.

On the Cohomology of Impossible Figures

Roger Penrose

In a recent article [1], presented in honour of M. C. Escher, I hinted at a relationship between cohomology and certain types of impossible figure. It is the purpose of this note to explain this relationship more fully.

I shall be concerned with the concept of *first* cohomology group

$$H^1(Q, G); \quad\quad\quad (1)$$

the basic meaning of this concept should emerge during the course of the discussion. Here Q is some (non-simply connected) region of the plane—which I shall take to contain the 'support' (i.e. the region of the plane where the drawing occurs) of some impossible figure—and G is a (normally Abelian) group, which I shall refer to as the *ambiguity group* of the figure. (For those readers not familiar with the mathematical concept of a group, it may be taken that G is just some set of numbers closed under multiplication and division. Thus if a and b belong to G, then so do ab and a/b.) To fix ideas, let us consider two examples. The first is the

Roger Penrose (mathematician), Mathematical Institute, University of Oxford, 24–29 St Giles', Oxford OX1 3LB, United Kingdom.

This article was originally published in *Structural Topology* 17 (1991) pp. 11–16. Reprinted with permission.

tribar, illustrated in Fig. 1. Here, Q can be taken to be, say, the region of the plane (paper) on which the tribar is actually drawn, or else some slightly larger region such as the annular region depicted in Fig. 2. In the second example, illustrated in Fig. 3, I have drawn a version of impossible figure that I introduced in my earlier article.

Consider first the tribar. We may regard the region Q as being pasted together from three smaller regions Q_1, Q_2, Q_3, as indicated in Fig. 4. There are overlapping pars of Q_1, Q_2, Q_3, which are to be pasted together.

The drawing, on each of Q_1, Q_2, Q_3, is a perfectly consistent rendering of a three-dimensional structure that is unambiguous in its natural interpretation—except for the essential ambiguity present in all pictures: one does not know the *distance* away from the observer's eye that the object being depicted is supposed to be situated (Fig. 5). Of

ABSTRACT

The close relationship between certain types of impossible figure and the mathematical idea of cohomology is explained in relation to the tribar and to another type of impossible figure related to the Necker cube.

Fig. 1. An impossible figure, the tribar, drawn in perspective.

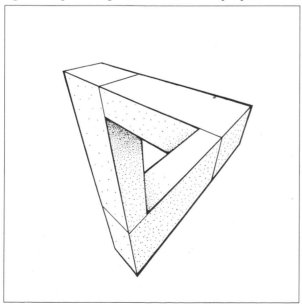

Fig. 2. The tribar, drawn on an annular region of the plane.

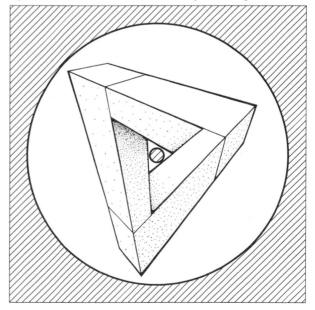

Fig. 3. A more subtle impossible figure with local Z_2 ambiguity, drawn on an annular region of the plane.

Fig. 4. The tribar shown pieced together out of overlapping smaller drawings, each of which depicts a possible structure.

course there are always other ambiguities, such as the fact that the picture could be depicting a *picture* of another picture, for example, rather than a three-dimensional object (a feature that Escher often put to paradoxical use, e.g. in his lithograph *Drawing Hands* and woodcut *Three Spheres I*). I am excluding this and other possible ambiguities here by my use of the phrase 'natural interpretation'. This distance can be described in terms of positive real numbers d, the set of all possible real numbers being denoted by \mathbf{R}^+. I am thinking of \mathbf{R}^+ as a multiplicative (Abelian) group, so in this case we have the ambiguity group $G = \mathbf{R}^+$. Let us see how this comes about.

Consider the portion of the figure drawn in region Q_1, and fix a point A_{12} on this portion where it overlaps with Q_2, and a point A_{13} on it where it overlaps with Q_3. Let A_{21} be that point of the figure, as drawn on Q_2, that is to be matched with the point A_{12} on Q_1, and similarly let A_{31} be the point on Q_3 that is to be matched with A_{13}. Finally fix a point A_{23} on the part of the figure on Q_2 that is to be pasted on Q_3, and the corresponding point A_{32} on Q_3 that is to be matched with it. See Fig. 4 for the entire arrangement of points.

Let us suppose that there is an actual three-dimensional object O_1, which the drawing on Q_1 depicts and, similarly, actual objects O_2 and O_3, which the drawings on Q_2 and Q_3 depict (see Fig. 5). The point on O_1 that is depicted by A_{12} may not be the same distance from the observer's eye E as the corresponding point on O_2, depicted by A_{21}. Let the ratio of these distances be d_{12}, and similarly for other pairs of matched points. Thus we have

$$d_{ij} = \frac{\text{distance from E to point on } O_i \text{ depicted by } A_{ij}}{\text{distance from E to point on } O_j \text{ depicted by } A_{ji}} \quad (2)$$

We note first that d_{ij} does not actually depend on the particular matched pair of points A_{ij}, A_{ji}, which are chosen on the overlap between Q_i and Q_j. We get the same d_{ij} whichever such matching pair we choose. This d_{ij} represents the factor that we must move out by when we pass from O_j to O_i at the region of overlap.

Note also that

$$d_{ij} = 1/d_{ji} \quad (3)$$

and that if we change our minds about the object O_i that is being depicted in Q_i (i.e. if we change its chosen distance from the observer's eye) then the pair (d_{ij}, d_{ik}) is replaced according to

$$(d_{ij}, d_{ik}) \rightarrow (\lambda d_{ij}, \lambda d_{ik}), \quad (4)$$

for some positive number λ.

If, instead of the tribar, we had had some drawing of a figure that could be consistently realized in three-dimensional space, then we could have moved the objects O_1, O_2 and O_3 in and out until they all came together as one consistent structure. This amounts to the fact that by rescalings of the above type we can reduce the three ratios d_{12}, d_{23} and d_{31} simultaneously to 1. Another way of saying this is that there exist three (positive) numbers q_1, q_2, q_3 such that

$$d_{ij} = q_i/q_j \quad (5)$$

for each different i, j. In the terminology of cohomology theory, the collection $\{d_{ij}\}$ is, in the general case, referred to as a *cocycle*. If (5) holds, the cocycle is called a *coboundary*. The replacement (4) provides the *coboundary freedom*, and we regard cocycles as *equivalent* if they can be converted to one another under this freedom. Under this equivalence, we obtain the *cohomology group elements*, i.e. the elements of

$$H^1(Q, \mathbf{R}^+). \quad (6)$$

The coboundaries provide the *unit* element of (6), and we see from the above discussion that the test for whether or not the figure depicted in Q is 'impossible' is whether or not the resulting element of (6) is indeed the unit element.

I have been discussing impossible figures of the kind that I described earlier [2] as 'pure', i.e. for which the only local ambiguity in the figure is the *distance* from the observer's eye

Fig. 5. There is a local R^+ ambiguity in any plane drawing as to the distance from the observer's eye to the object depicted.

Fig. 6. Necker cubes, with Z_2 ambiguity.

of the object being depicted. Often there are other ambiguities of relevance. For the type of impossible figure depicted in Fig. 3, the relevant ambiguity is that of the 'Necker cube', see Fig. 6. Here the ambiguity is just a twofold one, and we can use the numbers +1 and −1 in place of the distance ratios d_{ij} defined in (2), where +1 means that the depicted three-dimensional object O_i *agrees* with O_j where the drawings overlap, and −1 means that the objects *disagree*. The discussion proceeds exactly as before, except that d_{ij}, λ and q_i now all belong to Z_2 (the multiplicative group consisting of +1 and −1 alone), and the cohomology group element we obtain belongs to

$$H^1 (Q, Z_2). \tag{7}$$

If we cut Fig. 3 into three pieces analogous to those of Fig. 4 and follow the corresponding procedure through, we indeed find an element of (7) that is *not* the unit element, whereas if Fig. 3 has been drawn 'consistently' (e.g. with a hexagon—or, indeed, an octagon—at the centre, rather than a heptagon), then the unit element would have been

obtained. I leave the detailed verification of these facts to the interested reader.

More complicated figures with 'multiple impossibilities' [3] can also be analyzed in this way, but for this we should require a more complete description of what a (Cech) cohomology group actually is. In general, the figure would need to be divided up into more than three pieces, but the essential idea is the same as before [4]. I believe that considerations such as these may open up intriguing possibilities for further exotic types of impossible figure. I hope to be able to consider such matters at a later date.

References

1. R. Penrose, "Escher and the Visual Representation of Mathematical Ideas", in H. S. M. Coxeter, M. Emmer, R. Penrose and M. L. Teuber, eds., *M. C. Escher: Art and Science* (Amsterdam: North Holland, 1986) pp. 143–147.

2. See Penrose [1].

3. See, for example, L. S. Penrose and R. Penrose, "Impossible Objects: A Special Type of Visual Illusion", *Brit. J. Psych.* **49** (1958) pp. 31–33.

4. For further information, see P. Griffiths and J. Harris, *Principles of Algebraic Geometry* (New York: Wiley, 1978) p. 34.

On the Edge of Science: The Role of the Artist's Intuition in Science

Charles O. Perry

All manner of dreamers are gathered around the frayed edges of the truths of today's sciences. Among these are some visual artists. I consider myself one of them.

There is never enough exciting scientific press to satisfy our needs, and there is far too much real scientific information for us to absorb or understand. We gather smatterings of the latest gossip about ideas such as the big bang or string theories. We are unable to wrestle with the depth of these concepts mainly because real comprehension of the mathematics involved is beyond us. But we are dreamers—we are fraught with wishful 'intuitions' or 'theories' about the universe and about a simple truth that would make sense of it all.

Visual art, our media, is our way of acting out our intuitions. It has always been my dream that just one of my intuitions would have some use or at least would be related to real life.

MORPHOLOGY AS ART

D'Arcy W. Thompson's *On Growth and Form* [1] was my bridge from real life to art. This book on morphology showed how the exquisite designs of nature follow the laws of mathematics. Somehow the structures of shells, leaves, bubbles and bones depicted in this book had far more natural beauty to me than did the sculpted bronze buttocks of a horse. My early opinion of sculpture was that it was cluttered with yesterday's gestures. The timeless beauty of the world around was not expressed as it is in reality but rather as a frozen shadow of its emotional content.

I was eventually encouraged by finding that throughout history there has been an inherent interest in primary forms. The beauty of the cube, pyramid, dome and spiral were often expressed in architecture and adornment. This led me to ask questions such as: How are things made? How does something become its own self? How does an object aspire to its own life and soul? How does a human-made thing speak of God-made things?

My pieces have their own order, as though space had a set of rules similar to those of counterpoint in music theory. Each piece is, therefore, a composition of the interplay of its own logic, the sculptural process and its environment. I present here some of my sculptures and the intuitions from which they came.

ABSTRACT

The author describes his sculptures, their related mathematical origins and his 'intuitions' that led to his creation of them. He also describes how the artist and the scientist differ in their treatments of intuition.

COINCIDENCE OF ART AND SCIENCE

A surprising relation to real-life science occurred when I installed my piece *Early Mace* at Peachtree Center, Atlanta, Georgia (Fig. 1). The basis for the sculpture is the form created when the arcs on the face of a sphere are inverted, along the lines of the stitching on a baseball. It turned out that the form of this sculpture was very similar to the form of the 'magnetic bottles' investigated by Richard F. Post. A magnetic bottle suspends plasma in a vacuum (which is necessary for fusion) by pressing it on all sides with a magnetic field—I discovered his work, 6 months after creating my sculpture, from an article in *Scientific American* [2]. Later, in 1980, T. Kenneth Fowler, associate director for Magnetic Fusion Energy at Lawrence Livermore Laboratory

Fig. 1. *Early Mace*, stainless steel sculpture, 13 ft, 1971. The ribs of this sculpture, which is installed at Peachtree Center, Atlanta, Georgia, coincidentally form the same shape as that of the magnetic bottle investigated by Richard Post, Lawrence Livermore National Laboratory. (Photo: Rafael Baldi)

Charles O. Perry (sculptor), 20 Shorehaven Road, Norwalk, CT 06855, U.S.A.

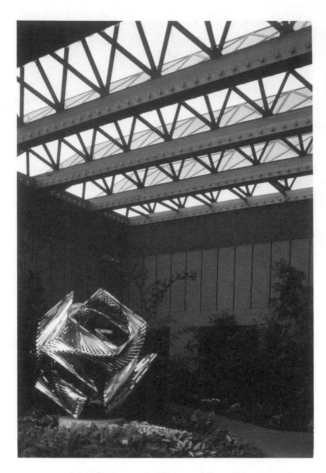
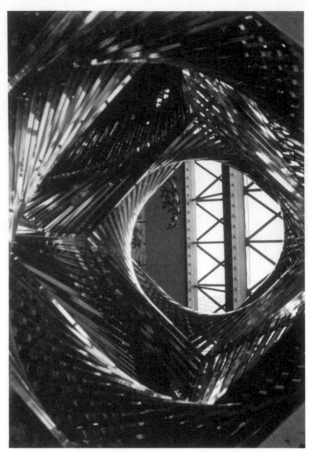

Fig. 2. *Cruciform*, chrome-plated brass sculpture, 7 ft, 1972. In this sculpture, installed at the Equitable Building, St. Louis, Missouri, the sides of a cube rotate away from each other in a left-hand helic motion until they reconnect to form a cuboctahedron, then the sides continue outward to define the small rhombicuboctahedron (triangles are formed between the square apexes). (Photo: Rafael Baldi)

confirmed this similarity. I had the opportunity to meet these two men for the first time in October 1991. By this time we had a number of topics to discuss concerning the points where intuition meets the edges of scientific thought.

In the fall of 1964 I saw an exhibit by Duncan Stuart at Carpenter Hall, Harvard, which showed the rotation-translation of geometric solids [3]. From this exhibit I became convinced that all geometric regular solids can 'explode' or 'implode' to become all other regular solids. Imagine the apex of a cube breaking into three separate points, each attached to its rotating face. I first illustrated this idea in my piece *Cruciform* at the Equitable Life Building in St. Louis, Missouri, in 1972 (Fig. 2).

My view of exploding and imploding solids differs from the work of Stuart in that he showed each face of a given solid rotating in the opposite direction of the adjacent face, while the apexes remain connected. *Cruciform* shows the faces rotating in the same direction away from each other in a helical motion until they reconnect to form a cuboctahedron. The faces then break away again and continue outward to define a small rhombicuboctahedron.

If we were to consider each corner of every square face of the cube as a point in space, then three points come together at each of the cube's eight apexes. When each face is rotated outward along an axis through its center, they meet again as pairs of points forming the 12 apexes of a cuboctahedron. When they explode again, they form 24 separate apexes of a small rhombicuboctahedron.

The most widely known of my sculptures is *Eclipse,* installed in the lobby of the Hyatt Regency Hotel, San Francisco (Fig. 3, Color Plate D No. 1). It embodies the same principle as does *Cruciform*. The piece starts on the inside as a pentagonal dodecahedron. As it explodes, each face rotates outward in the same helical direction until the apexes meet again. Now the 12 pentagonal faces meet point to point so that triangles are created between their faces, forming an icosidodecahedron. At this point, a geodesic spherical truss has been created, forming the structure of the sculpture.

The 12 pentagons continue outward in the same helical rotation and stop when the sides become parallel, forming the small rhombicosidodecahedron. If they were to continue outward, they would form a truncated icosahedron—also known as the 'Buckminster Fullerene'. This name is appropriate as the method of generating polyhedra by rotation (in opposite directions) was proposed by R. Buckminster Fuller and formulated into a theory by Stuart [4,5]. This theory is also called the Jitterbug Transformers, which implies a back-and-forth motion from one regular polyhedron to the next and back.

In a treatise on the Fullerene molecules in *Scientific American,* a series of carbon molecules are shown [6]. Through the method of continuous rotation-translation from the 60 carbon molecule (C_{60} or Buckminster Fullerene) to the 240 carbon molecule (C_{240}), I find additional polyhedra made of 140 and 180 carbon molecules. To arrive at these extra polyhedra, I rotate the 12 pentagons outward along their

respective axes. Similarly, if I rotate only two opposing pentagons on the same axis, C_{70} is produced.

I have always seen transformation as a method for points in space to maintain equilibrium as they move from the balance of one regular configuration (e.g. pentagonal dodecahedron) to the next (e.g. icosidodecahedron). The intuition that intrigues me here is that the *constant* in all of these figures is the helical rotation of the separate faces as they implode or explode.

This idea suggests all sorts of fantasies to my artist's mind. Could this helical movement be occurring in chemical reactions? Or could it explain how atoms or molecules exert their influence on each other to remain in balance while moving from one equilibrium to another? Maybe this helical movement is the constant of the universe. Could it be the source of gravity? Is it the 'glue' of the atom?

I see geometric figures as points in space; the lines connecting these points to form edges or faces are arbitrary or human-made. When we think of these polyhedra as space-filling solids and fit them into a lattice, we can imagine the kaleidoscopic effect of all these cubes becoming octahedra and tetrahedra, but first it must be shown that polyhedra not only explode, they implode. After all we are really showing that regular organizations of points can move outward or inward through these helical movements to arrive at new positions that match any regular geometric solid.

My sculpture *Da Vinci* (1975), at Northbrook Court, Northbrook, Illinois (Color Plate D No. 2), is based on the implosion of the pentagonal dodecahedron. In Alan Holden's *The Nature of Solids* [7], I found that photographs of his work on implosions (which he later referred to as 'polylinks') were similar to *Da Vinci*. This inspired me to meet the author. We met and discussed the possibility that these changes from one figure to another could have some connection to atomic structure [8]. He was most encouraging, but, alas, my limits seemed to prevent me from 'catching the butterfly'—discovering whether these helical movements specifically relate to molecular structural changes. Every time I would think about this exciting intuition, my mind would produce new sculptures, diverting me from this more elusive goal.

The beauty of these spatial gyrations convinced me that this notion had to be true. It certainly displayed itself clearly in sculpture, but when I finally put the idea to the test of moving from four-fold to five-fold symmetry, the method earlier portrayed by Stuart achieved the transition, and my method did not. I recently found that the work of H. F. Verheyen shows that all of these methods are co-existent.

Often when people try to be specific about an intuition, it seems to drift from their grasp as they reach to gather it in. Somehow leaving the idea out there in 'notionland' and portraying it at a distance seems a better alternative. In my

Fig. 3. *Eclipse*, aluminum sculpture, 35 ft, 1973. This sculpture, at the Hyatt Regency Hotel, San Francisco, shows a helical explosion of every face, rotating from a dodecahedron through a icosidodecahedron to a small rhombicosidodecahedron. (Photo: Balthazar Korab)

Fig. 4. *Continuum*, bronze sculpture, 15 ft, 1976. The center of this sculpture, which is installed at the National Air and Space Museum, Smithsonian Institution, Washington, D.C., symbolizes a black hole; its edge shows the flow of matter through the center from positive space to negative space and back again in a continuum. (Photo: Balthazar Korab)

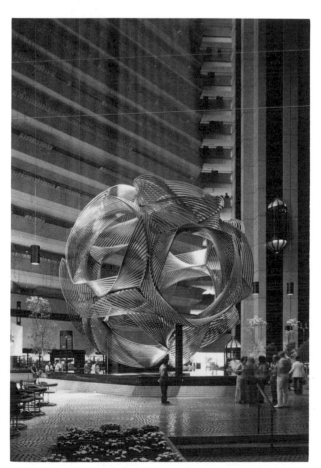

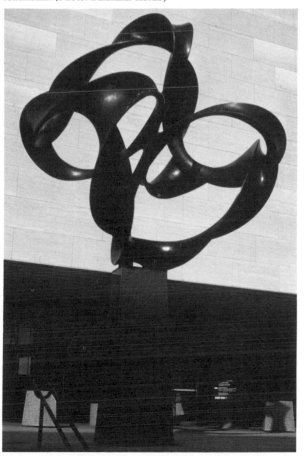

sculpture *Continuum*, installed at the National Air and Space Museum (Fig. 4), I portrayed another of my intuitions at a distance.

This museum displays the highest forms of human achievements in space, hence I felt it would be best honored by a sculpture portraying the mystery of the cosmos. My convictions led me to create a Möbius (seven saddled), with an edge that flows through a center 'black hole' out into space, then orbits back through the black hole again, portraying the life-cycle of stars passing from positive to negative space. I could not believe that the cosmos starts with a point reference in time. I was convinced that it is a continuum.

The important point here is that intuitions are excellent stimulations for art and science, but we must recognize that they are conceived from a lack of information. Sometimes in science one attempts to make the facts fit one's notions. The difference between the artist and the scientist is that the scientist uses intuition to look toward finding the facts, while the artist uses intuition to intrigue others.

Thus I remain here on the edge of science, encouraged to make these sculptures that attempt to speak of the orders of our universe.

References and Notes

1. W. Thompson, *On Growth and Form* (New York: Macmillan, 1943).

2. T. K. Gowler and Richard F. Post, "Progress toward Fusion Power", *Scientific American* 215, No. 6, 2–39 (1966).

3. Robert Williams, *The Geometrical Foundation of Natural Structure* (New York: Dover, 1979) pp. 218–220.

4. See Williams [3] p. 218, note 10.

5. H. F. Verheyen, "The Complete Set of Jitterbug Transformers and the Analysis of their Motion", *Computers Mathematical Applications* 17, Nos 1–3, 203–250 (1989).

6. Robert F. Curl and Richard E. Smalley, "Fullerenes", *Scientific American* 265, No. 4, 54–56 (1991).

7. Alan Holden, *Shapes, Space and Symmetry* (New York: Columbia Univ. Press, 1971) p. 183.

8. Alan Holden, *The Nature of Solids* (New York: Columbia Univ. Press, 1965).

Interactivity and Plastic Space: From the Minimal Unit of Movement to the Modulus

Angel Duarte

My work as a painter began to have certain similarities to mathematics in 1955. My paintings at that time (greatly inspired by Poliakof) show an interest in space and its distribution on surfaces.

This interest increased and became more established in my work with my meeting, in 1956, with the future members of Equipo 57 in Paris. From that meeting and our following discussions, a theory was born, which we called 'Interactivity of Plastic Space' (Fig. 1) [1].

After the dissolution of Equipo 57 in 1962, I continued with this research, working on the passage from the minimal unit of movement to the modulus (which allows complex structures to be constructed), its relationships with minimal surfaces and its relations with the structures of crystals.

The following section presents extracts from our published work that illustrate the theory of interactivity (Fig. 2) [2].

EQUIPO 57

Interactivity is based on a unitary conception of space and maintains that everything is only space that is quantitatively differentiated.

Fig. 1. *E. 24 A. 1.*, **four paraboloids of stainless steel, 84 × 60 × 60 cm, 1963/1971.**

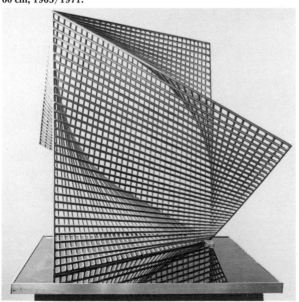

ABSTRACT

This article outlines some of the ideas of the author, an artist who, both with the group Equipo 57 and on his own, has worked with the relationships of art and mathematics.

These quantitative differences are expressed in the plane (space of two dimensions) by space-colours [3]. These space-colours cannot appear as isolated entities as each of them is the result of an interdependence of all the spaces being considered, and they have, therefore, the same nature and the same characteristics. These characteristics are continuity and unity, both of which are necessary. The loss of unity creates the appearance on the plane of spaces and elements of a different nature and unit. This unit does not exist in the Euclidean concepts of space and closed form since in these, they acquire an irreducible duality.

Plastically, any closed form in a space of two dimensions (a plane) breaks up the spatial unity of the plane, thus creating a sensation of aerial space.

The form, as a concrete value, establishes itself in terms of reference between itself and an indefinite term, the background. Consequently, the plane loses its bidimensionality and its dependence on its own limits.

Spatial unity can only be established when one creates a theoretical plane, that is to say, one that is independent of the real plane. The unity in the interactivity is not created in the kinetic formula: 2 = 1, rather in n = 1, in which n represents the number of spaces not inferior to 3.

Unity is determined in the interactivity by the inflexions; and continuity, by the incidences.

Inflexions are the zones in which movement changes direction. An inflexion is, therefore, the zone that contains the points in which the tangents are common to the two spaces in contact. In an inflexion, the two spaces that determine it are in the same term.

An incidence zone is one where the three spaces that determine it are in contact. These three spaces are situated in three different terms.

Interactivity responds to a logical operations outline, which allows a system of annotations to designate the topological relationships of the spaces that intervene in any unity to be established.

We will designate inflexions by the letter (x) and incidences by the letter (k). If we consider the common limit of two spaces (A) and

Angel Duarte (artist), 28 rue de Scex, 1950 Sion, Switzerland.

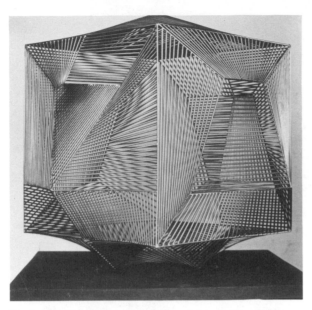

Fig. 2. *Cube faces avec des paraboloides*, stainless steel, maquette, 60 × 60 × 60 cm, 1967.

The fact that a space contains the tangents of another space with which it has a common limit indicates to us that between them both a relationship of contents and container has been established, in such a way that the space-colours considered, each and at the same time, occupy the front position and back position terms.

From all this we can deduct that: (1) The degree of forward position depends upon the degree of convexity. (2) The spaces do not appear in these limits of concavity since they always appear in a state of convexity, which signifies that for these visible limits the space-colours appear in terms of forward position (in relation to the spectator).

The incidence zones (k), as well as creating three different terms in the theoretical plane (Fig. 3) [4] and thus the principle of continuity, must necessarily be situated surrounded by three inflexions (x).

Two incidences must necessarily be separated by one inflexion.

Interactivity could be expressed in units of movement (um), that is to say, the most simple set of elements (incidences and inflexions) that define various types of movement.

The most simple set or the minimum unit of movement (um) is the one formed by two incidences and their three space-colours.

WORK ON THE HYPERBOLIC PARABOLOID

Equipo 57 began its research on the hyperbolic paraboloids in the beginning of the Summer of 1958 in Cordoba, Spain. This research was undertaken in order to find a measurable geometric form capable of expressing the principles that define the theory of interactivity of space in the space of three dimensions, which had been stated by Equipo 57.

The result of this research was the theoretical and practical discovery, using the hyperbolic paraboloid, of a surface that met the requisite conditions for a definition of space in accordance with the basic interactivity postulates, that is to say, continuity and unity of space.

As far as we know, this was the first time that it had been possible to create, through a geometrical form, unity and continuity of three-dimensional space.

Works relevant to the hyperbolic paraboloids, published by Candelas and other architects and engineers, do not

Fig. 4. *E. 11P*, stainless steel and polyester, 300 × 300 × 300 cm, 1972/1973. (Courtesy of Bourgeoisie de Sion, Switzerland)

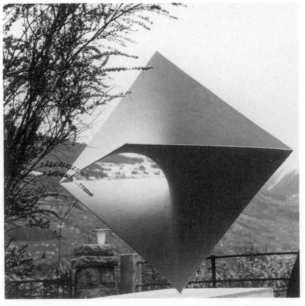

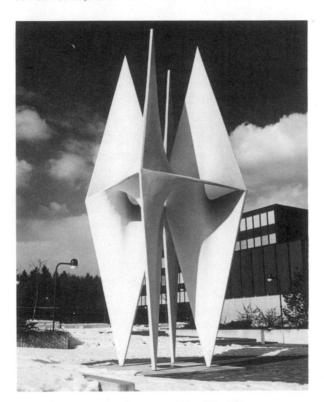

Fig. 3. *E. 2A. B.*, steel and concrete, 900 × 330 × 330 cm, 1962/1979. (Courtesy of Langenthal, Switzerland)

(B), represented by the sinusoid (ab), which is (being geometrically defined as a concavo-convex line) considered as a limit and not as a line and expresses the two spaces defined by this limit reciprocally occupy the front position and back position terms through the zone x, we can say that these spaces have imbricated in depth in that zone. If we draw the successive tangents in the proximity of x, we can observe that the tangents corresponding to the convexity of space A are situated on space B and, that at x, that tangent is common to both. If we continue drawing tangents towards the extremity opposite, we shall see them change fields, and eventually they will be situated or contained in the space A.

tackle this problem, due to the fact that hyperbolic paraboloids are being used either as isolated elements or in a contiguous fashion, by putting the paraboloids next to one another by one of their directrix. However, since the colateral directrix corresponding to each of the hyperbolic paraboloids were not respectively co-planed with their common directrix, neither continuity nor unity was produced.

The results of the research undertaken at that time were published in Madrid during an exhibition at the Urbis Club in April 1959 and in the exhibition catalogue created in Darro in May 1960 in Madrid. As I am not a mathematician, my work was carried out rather slowly and in a dispersed order. It was only during the 1970s, through H. U. Nissen of Zurich Polytechnic, that I learned that my work was related to the work of others, Schwarz and Schoen in particular (Fig. 4) [5].

References and Notes

1. See the booklet *Equipo 57: Travaux sur l'interactivité de l'espace, 1957–1962*, exh. cat. (Sion, Switzerland: Galerie d'Art Actuel, 1966). This is the catalogue of Equipo 57's exhibition at the Galerie d'Art Actuel, Geneva and Bern. Equipo 57 was composed of Juan Cuenca, Angel Duarte, José Duarte, Augustin Ibarrola and Juan Serrano.

2. See *Equipo 57* [1].

3. Space-colour is a term, defined as one of the coloured areas of a painting, that was coined in 1957 by the members of Equipo 57.

4. The theoretical plane is the set of incidences and inflexions through which the three spaces are situated in the same term.

5. See A. H. Schoen, "Infinite Periodical Minimal Surfaces without Self-Intersections", NASA Technical Note TN D-5541 (Washington D. C.: NASA, 1970); A. H. Schoen, "Honeycomb Core Structures of Minimal Surfaces Tubuke Sections", NASA Patent ERC-10, 363 (Washington, D. C.: NASA, 1970); H. A. Schwartz, *Gesammelte Mathematische Abhandlungen*, Bd. 1 (Berlin: Springer-Verlag, 1890); S. Andersson, S. T. Hyde and H. G. von Schering, "The Intrinsic Curvature of Solids", *Zeitschrift für Kristallographie* 168, Nos 1–4, 1–17 (1984); S. Andersson and S. T. Hyde, "A Systematic Net Description of Saddle Polyhedra and Periodic Minimal Surfaces", *Zeitschrift für Kristallographie* 168, Nos 1–4, 221–254 (1984). Regarding saddle polyhedra, Hyde and Andersson wrote: "These polyhedra have been studied by Pearce and Schoen. Approximately 10 years earlier (in the early 1960s), the Spanish sculptor Angel Duarte constructed steel-frame models of polyhedra consisting of hyperbolic paraboloid faces." See also M. Emmer, "From Chemistry to Labyrinth", in *Bolle di sapone: Un viaggio tra arte, scienza e fantasia* (Florence: La Nuova Italia, 1991).

Visualization in Art and Science

Harriet E. Brisson

It is misleading to divide human actions into 'art', 'science', or 'technology', for the artist has something of the scientist in him, and the engineer of both, and the very meaning of these terms varies with time so that analysis can easily degenerate into semantics. Nevertheless, one man may be mainly motivated by a desire to promote utility, while others may seek intellectual understanding or aesthetic experience. The study of interplay among these is not only interesting but is necessary for suggesting routes out of our present social confusion.

—Cyril Stanley Smith [1]

For at least two decades, groups of artists, scientists and engineers have gathered to participate in symposia, conferences and exhibitions devoted to the examination of the latest research in their specific disciplines. In addition, these events have focused on the exploration of the means by which the arts and humanities may be integrated with mathematics and science. Although these events have mostly been located at universities and colleges, they have also taken place wherever there have been groups of people with such interests in common. Harvard University has hosted several Design Science Conferences at the Carpenter Center; Smith College sponsored Shaping Space: An Interdisciplinary Conference on Polyhedra [2], which was accompanied by an exhibition; and Brown University celebrated the 100th anniversary of the publication of *Flatland* with its symposium entitled Visualizing Higher Dimensions: Flatland 1884, and the exhibition Hypergraphics 1984, held in conjunction with it at Rhode Island School of Design. The International Conference on Engineering and Computer Graphics was held in Beijing, China, in 1984 [3]. The

Third International Conference on Engineering Graphics and Descriptive Geometry [4] occurred in Vienna, Austria, 1987; and in the same year Attilio Pierelli organized Dimensionalism: Advanced Interdisciplinary Art, which took place in Rome. L'occhio di Horus: Itinerari nell'immaginario matematico exhibition was sponsored by the Istituto della Enciclopedia Italiana. These publishers produced a book [5], with the same title, in conjunction with this exhibition that opened in Bologna and travelled to Parma, Milan, Naples and Rome. This list includes only a few of the many similar events that have taken place in the United States, Europe and China.

The focus of the programs has been the integration of the arts and the sciences. One had polyhedra as its primary focus, while others have concentrated on the potential of computers as powerful design tools in engineering as well as in art. Investigation, exploration and research into higher dimensions have formed the main thrust of several of the symposia and exhibitions.

ABSTRACT

Visualization is basic to the understanding of our world; thus, it has played a dominant role in the historic development of scientific thought and artistic endeavor. Artists, scientists and mathematicians are concerned with visualization in many different forms in order to more fully comprehend the true nature of reality. The author discusses her own artwork and that of mathematician and artist David Brisson, in the context of these ideas and the new forms with which both artists have worked.

Harriet E. Brisson (artist, educator), Rhode Island College, Providence, RI 02769, U.S.A.

Ω

Fig. 1. David Brisson, *Hyperstereogram*, drawing, 5 × 10 in, 1976. Hyperstereograms were developed by David Brisson to make it possible for viewers to have a closer approximation of the experience of four-space than can be achieved in traditional two-dimensional representation.

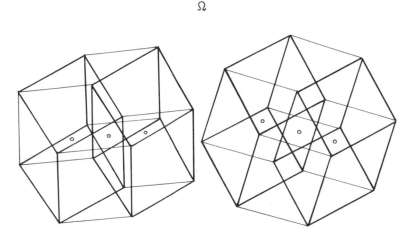

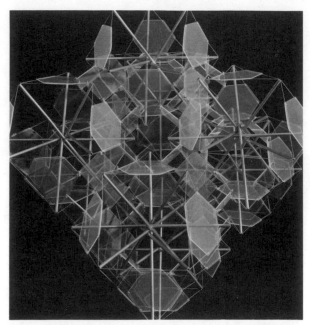

Fig. 2. Harriet E. Brisson, *Great Rhombicuboctahedra and Octagonal Prisms*, tensegrity structure of plexiglass, aluminum tubes and nylon cord, 24 × 24 × 24 in, 1975. This space-filling structure divides space in half. It is impossible to differentiate the form from the space between, since the two are identical.

THE FOURTH DIMENSION

For centuries the idea of a fourth dimension has interested philosophers, scientists and mathematicians. However, it was not until the end of the nineteenth century that a clear graphic system for describing the fourth dimension was developed. In 1880 Washington Irving Stringham published one of the earliest known sets of illustrations of hypersolids in "Regular Figures in *n*-Dimensional Space" in the *American Journal of Mathematics* [6]. Both mathematicians and nonmathematicians have indicated a strong interest in the possibilities of higher dimensions. In the early twentieth century, the Cubists may have based their multi-imaged paintings on mathematical discoveries such as this, and similar theories developed during their time. Stringham's depiction of the hypercube has been developed into a standard projection used by many who are attempting to represent the fourth dimension.

My late husband, David Brisson, was an artist on the faculty of the Rhode Island School of Design for 18 years. He studied mathematical concepts of higher dimensions, which resulted in his producing perspective and orthogonal projection drawings as well as three-dimensional models of four-dimensional polytopes. His depiction of the *Hypercube* (Color Plate B No. 1) resembles Stringham's, for both had developed their representations based on the way in which the eight cubes of the hypercube can be drawn to fit symmetrically within an octagon.

David went beyond the two-dimensional representation of the hypercube and developed the hyperstereogram (Fig. 1) to visualize the hypersolids of four dimensions. David's hyperstereograms differ from ordinary stereograms in that they consist of projecting a four-dimensional figure onto a surface, then rotating the four-dimensional object around one of its planes 15° and reprojecting the figure onto another surface to develop a system in which one eye

sees one of the images and the other eye sees the other image. The two images converge, producing an illusion of three dimensions. These images have two axes of parallax, a horizontal one and a vertical one, making it impossible to see the total figure in focus all at once. For example, in the hypercube only one of its cubic cells will be in focus at a time. In order to see the whole form, viewers must cross their eyes and simultaneously rotate their head to bring the various sections of the hyperstereogram into focus.

In order to produce a more complete experience of the fourth dimension, David developed the *Hyperanaglyph* (Color Plate B No. 2), a four-dimensional form projected onto three dimensions. The hyperanaglyph consisted of two hyperfigures constructed of rods, with one hyperfigure painted red and the other painted blue. After construction of the first hyperfigure, a second projection was created by rotating the form 6–8° around one of the planes of the first. The shared plane was painted white. The hyperanaglyphs were placed on a turntable that turned slowly while viewers looked at them through red and blue filters. As they revolved, after a short time they appeared to turn inside out, and different parts of them seemed to rotate in the opposite direction, thus apparently collapsing inward and then unfolding. This was a fuller experience of an approximation of the fourth dimension than that which had been produced by the hyperstereogram. David wanted to make it possible for everyone to truly 'see' multidimensions to a greater extent than that derived from reading abstract mathematical theories. At the time of his death in 1982, David was considered to be a leader in the visualization of higher dimensions.

HYPERGRAPHICS

In 1975 he coined the term *hypergraphics,* combining the meaning of *hyper* (above, extra, beyond) with the meaning of *graphics* (writing and drawing in both two and three dimensions) and thereby defining a concept of work that transcended traditional methods of making images. In very specific terms, he meant the term to refer to *n*-dimensional descriptive geometry. In a broader sense, he used the term to describe any system of thought, technical process or philosophical attitude that extended methods of visualization. He conceived of it as a means to blend contemporary thinking in art and science by developing methods whereby visualization could be brought into active cooperation with one's ability to reason abstractly, thus integrating those two modes of human thought and consciousness.

David and I worked together on many projects [7]; in 1976 we were invited to show our work in the Virtual Realities Exhibition held at Carpenter Center, Harvard University. David showed many different means of representation that he had developed for visualizing higher dimensions, while José Yturralde of Barcelona, Spain, exhibited his 'impossible figures', and I showed my tensegrity sculptures. Computer-generated films, such as *The Hypercube: Projections and Slicing* by Thomas Banchoff and Charles Strauss [8] were also on view. This was the first of many similar exhibitions.

In 1977 we organized the first exhibition and symposium based specifically on the concept of hypergraphics at the Rhode Island School of Design. Included on the programs were Cyril Smith of Massachusetts Institute of Technology; Alan Schoen, physicist and artist at Southern Illinois Univer-

sity; Tullio Regge of the Institute of Advanced Studies at Princeton University; Toshi Katayama, designer at Harvard University; Thomas Banchoff, mathematician at Brown University; David Brisson, Chung-Up Kim and Tom Ockerse of Rhode Island School of Design; and myself, of Rhode Island College.

The Hypergraphics II Symposium and Conference was held in 1978 at the Annual Conference of the American Association for the Advancement of Science in Washington, D.C. *Hypergraphics: Visualizing Complex Relationships in Art, Science and Technology* [9], edited by David Brisson, was a direct outgrowth of that event. Similar events have continued to attract participants and audiences to hypergraphics symposia and exhibitions held at Princeton University, Newport Art Museum and Rhode Island College. After David's death, I was the guest curator of the Hypergraphics 1984 exhibition at the Rhode Island School of Design, held in conjunction with Brown University's symposium Visualizing Higher Dimensions: Flatland 1884, organized by Thomas Banchoff [10].

All of the conferences and exhibitions on hypergraphics had the common theme of transcending traditional methods of making images and forms. This involved going beyond the mathematical model, and it clearly illustrated ways in which art and science may intersect to produce new forms, based on beautiful concepts that exist in both art and science. Much of the hypergraphics artwork is mathematically precise and enhanced by the materials, colors, surfaces, textures, methods of construction and so forth. Most of these finished pieces, created by artists, physicists, computer scientists, engineers, and mathematicians, combine emotional and intellectual approaches, in varying degrees. To document both the concept and the visual qualities that had developed as a result of this approach to collaborative thinking and working, I made a video in 1986 entitled *Hypergraphics*, with the assistance of Lawrence Budner [11].

David and I studied art together at the Rhode Island School of Design. While he based his work involving higher dimensions on his study of mathematics (which he began in 1960), I had utilized the visual and conceptual aspects of geometry as the genesis for much of my work for many years.

I understand relationships through the actual manipulation of tangible form, rather than as a result of an abstract or symbolic study of equations. Twenty-five years ago, I made a three-dimensional representation of an unfolded hypercube, without realizing that I had done so—apparently by accident. However, this form was not purely a chance phenomenon, for I had been systematically truncating and manipulating polyhedra in much the same way as had Wentzel Jamnitzer, the Nuremberg goldsmith who published a set of perspective engravings of variations on the theme of regular polyhedra in *Perspectiva Corporum Regularium* in 1568 [12].

According to Rudy Rucker in *The Fourth Dimension*, "If a hypercube is cut in the proper way, then it can be unfolded and 'flattened down' into a connected three-dimensional pattern of eight cubes. One unfolding of the hypercube produces a sort of three-dimensional cross" [13]. Salvador Dalí used this unfolded hypercube in *Crucifixion (Corpus Hypercubicus)*, painted in 1955 [14]. My representation of the unfolded hypercube is similar to this, with the exception that one of the cubes has been eliminated to produce a symmetrical form consisting of seven cubes; that is, it has one cube placed on the surface of each of the six faces of the central cube. It is a three-dimensional version of the drawing by Theo van Doesburg, *A New Dimension Penetrates Our Scientific and Plastic Consciousness* [15]. Although I was not aware of this at the time that I made the hypercube in clay, it demonstrates how a geometric approach to form development by an artist may result in an accurate mathematical form.

SPACE-FILLING STRUCTURES

This led to an exploration of a variety of polyhedra through truncation and instellation, and eventually to space-filling forms, which comprise most of the basic building blocks of crystalline structures and natural form. Robert Williams, in *Natural Structures*, writes that according to H. S. M. Coxeter, "there is evidence that identical polyhedra can pack to fill some kind of space, whether it be curved, finite or hyperspace". Williams continues, "In three-dimensional Euclid-

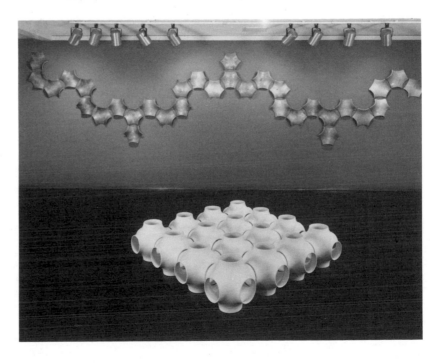

Fig. 3. Harriet E. Brisson, (foreground) *Sixteen Schwarz Surfaces*, close-packed face-centered cubic lattice of white cast clay, 48 × 48 × 12 in, 1986; (on wall) *Unfolded Schwarz Surfaces*, wood-fired clay with ash glaze, 32 ft × 7 ft × 3 in, 1986. The Schwarz Surface divides space in half equally such that it is not possible to distinguish whether one is experiencing the space or the form. Represented here are 16 Schwarz Surfaces showing how they close-pack in a face-centered cubic lattice. On the wall are four unfolded Schwarz Surfaces arranged so that, if they were hinged, they could be folded into four complete Schwarz Surfaces like the ones in the foreground.

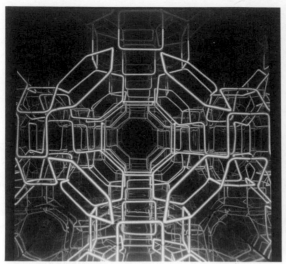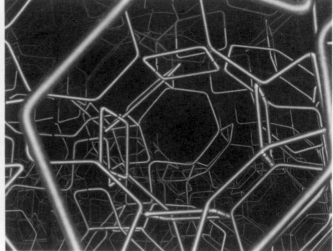

Fig. 4. Harriet E. Brisson, *Infinity Box*, great rhombicuboctahedra and octagonal prisms of neon tubes and mirrored cube with front surface of two-way mirror, 36 × 36 × 36 in, 1978. (left) This piece appears to extend infinitely in reflections of the mirrored cube that is viewed through the front surface of two-way mirror. It is related to the Schwarz Surface in that it divides space in half equally, but its surface is made up of flat planes, so that it might be considered a 'Cubist' representation of the form. (right) Detail.

ean Space, however, not all packings of identical polyhedra will fill space, but every polyhedron in combination with assorted non-regular polyhedra can satisfy space-filling requirements" [16]. For example, the icosahedron will close-pack with distorted forms of tetrahedra and octahedra to fill space, but will not fill space when packed with tetrahedra and octahedra themselves.

Close-packings are interesting not only for their geometry, but because these infinite structures have the potential of producing a strong visual impact. I made many of the close-packings as discontinuous-compression, or tensegrity, structures using plexiglass, aluminum tubes and nylon cord. They have no rigid joints, but are held in position entirely by the geometrical configuration of the relationship of the compression members to each other, pulled together in a perfectly balanced manner by the tension on the cord. This method of construction makes it possible to create sculpture that has an intricacy of form, everchanging in unexpected and mysterious relationships, through which the planes of the form may align themselves to produce the illusion of solid surfaces or, when rotating, may change into a series of lines in space, then change again to become a combination of lines and planes.

One result of my research with space-filling polyhedra was the discovery of a close-packing that I had not previously seen published or described in any of the literature on the subject. It is composed of *Truncated Close-Packing Octahedra, Rhombidodecahedra and Cubes* (Color Plate B No. 3). Another tensegrity sculpture that I constructed was the *Great Rhombicuboctahedra and Octagonal Prisms* close-packing (Fig. 2). It produces an interesting relationship between forms in that it divides space equally in half. The space between the forms is identical to the form itself, making it impossible to determine if one is experiencing the form or the space, giving it a quality of ambiguity so important to art. It might be considered a Cubist interpretation of the Schwarz Surface, to which it is so closely related, for it has flat planes that are analogous to the smooth flowing curves of that form.

MINIMAL SURFACES

The Schwarz Surface is a periodic minimal surface named after its discoverer, German mathematician Karl Hermann Amadus Schwarz (1843–1921). It can perhaps be most easily visualized as described by physicist Alan Schoen:

Imagine a jungle-gym made of soft, hollow thin rubber tubes. Next, imagine them being slowly inflated. At a certain point, the space inside the tubing is exactly the same as that outside of the tubing. In fact, it is somewhat meaningless to identify an inside or outside to the space, unless you happen to be in the structure. In that case, you could wander around on the surface forever and only be able to investigate one-half of the total space, because the surface divides three-dimensions exactly in half. Yet the surface is variable, formed of 'bubbles' that interlock and that is why it is called periodic. Further, the surface is the smallest possible that can so divide the space and is thus called minimal. A peculiarity of the minimal surface is that although it is clearly 'curved', it is a special surface said to have zero curvature, for curvature along one axis is exactly the opposite in quality to the curvature along the axis at a right angle to the first axis. The flat plane, for example, is a special case of the surface of zero curvature, the 'middle' case [17].

Michele Emmer traced the history of minimal surface films in his *Leonardo* article "Soap Bubbles in Art and Science: From the Past to the Future of Math Art", citing numerous examples of paintings of soap bubbles and showing that such surfaces are visually and mathematically exciting. He notes that "the sphere is the simplest minimal surface formed: it has the least area among all deformed images subject to the constraint of enclosing the same volume" [18].

The shape of the Schwarz Surface is truly fascinating to me; thus, I have made several different interpretations of the form in clay. This medium has the plasticity necessary to be easily manipulated into the continuously flowing curves required to accurately describe the form. The Schwarz Surface fills space with units that close-pack in a face-centered cubic lattice. Continued exploration proved that it was a potentially rich source of sculptural form. David discovered that, when the Schwarz Surface was divided into eight equal parts, each section (each $\frac{1}{8}$th of the whole) was related to the Petrie Hexagon in that the surface meets the Petrie

Hexagon at the centers of its edges, therefore defining a flat hexagon. This discovery inspired my *Unfolded Schwarz Surfaces*, the units of which I displayed on the wall (Fig. 3), positioned such that it was possible to visualize the way in which the units could be reconstructed to form the original Schwarz Surface. The quality of the clay surface was extremely important and needed to be as rich as the form itself. All of the units, the original whole and the $\frac{1}{8}$th sections, were wood-fired at 2400° Fahrenheit (1320° Celsius) to develop a natural glaze that resulted from the interaction of the clay with the ash when it was deposited on the clay surface during the firing process.

I made the companion piece, *Sixteen Schwarz Surfaces* (see Fig. 3), to illustrate the way in which these forms close-pack. White clay was used for these because the repetition of the complex form did not seem to call for the same rich surface as the units on the wall.

As noted earlier, the great rhombicuboctahedron and octagonal prism close-packing is topologically and visually related to the Schwarz Surface. Returning to this space-filling form, I constructed *Infinity Box* of mirrored plexiglass, in which I placed neon tubes that were bent so as to produce the great rhombicuboctahedron and six octagonal prisms (Fig. 4). These polyhedra, in combination, illustrate how they become an infinite structure through reflection. It was highly ordered, yet appeared from some angles as a tangle of lines that filled the space completely. This piece could only be viewed through its single front surface, which utilized two-way mirror.

To broaden the experience of multiple reflections that apparently extend to infinity, I built another neon sculpture with two-way mirrored plexiglass on the four vertical surfaces of a cube, making it possible to walk around the form and see it completely in the round. A single truncated octahedron bent in neon was repeated indefinitely by reflections in the mirrors on all six surfaces of the cube showing the way in which they close-pack. The two-way mirror appears to be solid to a viewer behind the form, but becomes transparent when the viewer moves in front of it. As a result, it becomes a *Magic Box* (Fig. 5, Color Plate B No. 4) with sides that are opaque from one view but dissolve when the stronger light behind them turns them into 'glass', through which the infinite structure can be seen.

In all my work, I am attempting to extend pure mathematical models beyond traditional means, to a point where science and art intersect to create new forms. Recently, I made *Pentahedroid* (Fig. 6) of neon, which I placed within a two-way mirrored tetrahedron. It has an element of mystery that is one essential aspect of art; the knowledge of geometric form makes it possible to produce this kind of magic more completely than would a random grouping of neon tubes in the same kind of space.

Scale provides enormous impact on everything, whether natural or human-made. Monumental rock formations exist in the American Southwest, in Kweilin in China, in the Canadian Rocky Mountains and other places too numerous to name. Sculpture large enough for people to enter may provide an exhilarating experience, similar to that of driving on super-highways and through interchanges, of ascending and descending spiral ramps in parking garages, or of moving through space in an airplane. By adding the element of scale to my sculpture and combining it with David's work involving visualizing higher dimensions, I found it was possible to move a step beyond where he had gone. Instead of creating a hyperfigure to be viewed from outside, as in the

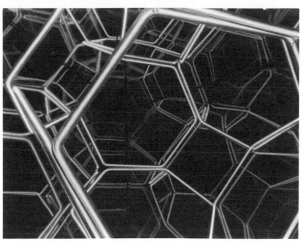

Fig. 5. Harriet E. Brisson, detail of *Magic Box*, truncated octahedra of neon tubes in two-way mirrored cube on four vertical sides with mirrored top and bottom, $22 \times 22 \times 22$ in, 1978. This is one of the self-packing polyhedra—this single form will fill space completely. Here it is reflected indefinitely in a cubic kaleidoscope of two-way mirrors that are opaque when behind the form but become transparent when in front of it.

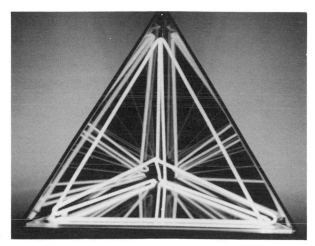

Fig. 6. Harriet E. Brisson, *Pentahedroid*, neon tubes in two-way mirrored glass, $25 \times 25 \times 20$ in, 1987. Also known as the Simplex or four-dimensional tetrahedron, here it is shown in blue neon within two-way mirrored glass.

case of his sculpture, I wanted to make forms that were large enough for people to experience the interior of a multidimensional polytope.

This was accomplished with the engineering-design assistance of Olle Johanson of Stockholm, Sweden. Together we built a large tetrahedron, 9 ft high, and placed 12 fluorescent lights defining an octahedron within its mirrored interior. The octahedral arrangement of lights was reflected continuously by the tetrahedral relationship of the mirrors until the form completed itself as the four-dimensional *Truncated 600-Cell* (Fig. 7). By mathematical definition, it is the analogue of the regular icosahedron in three-space. It has 600 regular tetrahedral cells, five of which fit together around each edge.

Viewers enter the form through one open triangular face and become surrounded by an approximation of the fourth dimension. It is impossible to describe the impact of this, just as it is impossible to fully comprehend the magnitude of a mountain landscape in its totality through a two-dimensional representation. Viewers cannot see the form in its

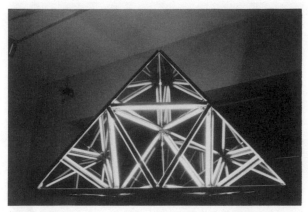

Fig. 7. Harriet E. Brisson, *Truncated 600-Cell,* **12 fluorescent tubes in the shape of an octahedron placed within a mirrored tetrahedron, 9 × 9 × 9 ft, 1989. (left) This is a four-dimensional analogue of the regular icosahedron in three-space. Through reflection, it shows 600 regular tetrahedral cells, five of which fit together around each cell. (right) Detail.**

entirety, because it completely envelops them. Looking in one direction, one sees a symmetrical arrangement of lines; from another vantage point it appears to be completely asymmetric. It is constantly changing in much the same manner as David's hyperanaglyphs did when rotating. The difference in this case is that viewers constantly move or rotate themselves, in order to see all aspects of this ever-changing form. They become part of it, reflected indefinitely by the mirrored tetrahedron and lighted octahedron.

Each person perceives the world differently; each brings a personal background to this unique experience. The *Truncated 600-Cell* functions on an emotional level that extends beyond the mathematical concept of its being a four-dimensional form. Upon entering the form, people find themselves reflected in a totally unfamiliar fashion and perceive themselves in unusual orientations because of reflections off surfaces that are at less than 90° angles to each other. The effect is disorienting and exciting at the same time. Some are excited by the vastness of the mirrored reflections; others feel lost in space; some feel claustrophobic, as though the lights were closing in on them; others are exhilarated by the novelty of the space.

If the fluorescent lights had been randomly placed in the mirrored tetrahedron, a similar emotional response could have been evoked. However, the use of the octahedral arrangement of lights within the tetrahedron produced a mathematically accurate four-dimensional polytope. This form brings together the intuitive and the intellectual, the two halves of the bicameral brain. It is an intersection of art and science that transcends the mathematical model; it is both a beautiful concept and an elegant form.

CONCLUSION

The convergence of science and art is viable; artists and scientists are able to interact while preserving their respective methods and attitudes. The artist can learn from the mathematician, as can the scientist from the artist. Visual imagery may serve as a bridge between the human spirit and the complicated technical language of the twentieth century.

References and Notes

1. Cyril Stanley Smith, *A Search for Structure: Selected Essays on Science, Art, and History* (Cambridge, MA: MIT Press, 1981) p. 191.

2. See Marjorie Senechel and George Fleck, eds., *Shaping Space: A Polyhedral*

Approach (Boston, MA: Birkhauser Boston, 1988). This volume was produced as a result of the Shaping Space Conference held at Smith College, in April 1984, at which I presented a paper on "Polyhedra and Close-Packing Structures as Art Forms".

3. Zhu Yuwan and Steve M. Slaby, eds., *Proceedings: International Conference on Engineering and Computer Graphics* (Beijing, China, 1984). Sponsored by China Engineering Graphics Society and Engineering Graphics Division, American Society for Engineering Education. My paper "Hypergraphics" is included in this book, pp. 11–19.

4. Steve M. Slaby and Hellmuth Stachel, eds., *Proceedings of the Third International Conference on Engineering Graphics and Descriptive Geometry* (Vienna, Austria, 1988). This conference was sponsored by the Engineering Design Graphics Division of the American Society for Engineering Education. My presentation on "Geometrical Modeling and Visualization in Art and Science" is included in this book, pp. 48–50.

5. Michele Emmer, ed., *L'occhio di Horus: Itinerari nell'immaginario matematico* (Rome: Istituto della Enciclopedia Italiana, Fondata da Giovanni Treccani, 1989). See my chapter in this book, "Rendere visibile l'invisibile (Visualizzare lo spazio a piu dimensioni)", pp. 177–181.

6. Linda Dalrymple Henderson, *The Fourth Dimension and Non-Euclidean Geometry in Modern Art* (Princeton, NJ: Princeton Univ. Press, 1983) plates 3 and 4.

7. Michele Emmer, *Dimensions*, 16mm color-sound film (Rome: FILM 7 International). This movie was filmed at various locations including the studio of David Brisson and Harriet Brisson, in Rehoboth, MA.

8. Thomas Banchoff, *The Hypercube: Projections and Slicing*, film, 1978, created in collaboration with Charles Strauss at Brown University's Computer Graphics Laboratory. This film was honored with an award at the International Festival of Scientific and Technical Films in Brussels. In 1985 Thomas Banchoff also filmed *Topology and Mechanics: Flows on the Torus* and *Hypersphere: Projections and Foliations* (in collaboration with Huseyin Koçak, Fred Bisshop, David Laidlow and David Margolis) at Brown University's Computer Graphics Laboratory.

9. David W. Brisson, ed. *Hypergraphics: Visualizing Complex Relationships in Art, Science and Technology* (Boulder, CO: Westview Press, 1978). See my essay "Randomness and Order in Sculptural Form", pp. 169–176.

10. Thomas Banchoff, *Beyond the Third Dimension* (New York: Freeman, 1990).

11. Harriet E. Brisson, *Hypergraphics*, videotape, filmed with the assistance of Lawrence Budner at the Rhode Island College Television Studio. This work included a section from Michele Emmer's film *Art and Mathematics: Attilio Pierelli* (Rome: FILM 7 International, 1986).

12. Wentzel Jamnitzer, *Perspectiva corporum regularium* (Paris: Gutenberg Reprints, 1981). This is a reprint of the Nuremberg 1568 edition, with an introduction by Albert Flocon.

13. Rudy Rucker, *The Fourth Dimension: Toward a Geometry of Higher Reality* (Boston, MA: Houghton Mifflin, 1984) p. 34.

14. See Thomas Banchoff, "Illustrating *Beyond the Third Dimension*", in this issue for discussion and reproductions of Dalí's painting *Corpus Hypercubicus*.

15. Henderson [6] plate 107.

16. Robert Williams, *Natural Structures: Toward a Form Language* (Moorpark, CA: Eudaemon Press, 1972) p. 164.

17. David W. Brisson, *The Hyper-Schwarz-Surface* (Providence, RI: privately published, 1976) p. 1.

18. Michele Emmer, "Soap Bubbles in Art and Science: From the Past to the Future of Math Art", *Leonardo* **20**, No. 4, 327–334 (1987).

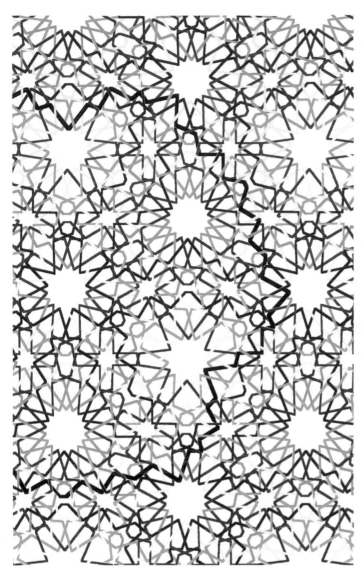

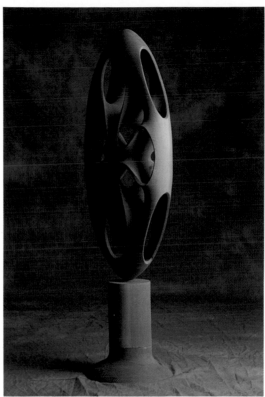

No. 2. (above) Brent Collins, *Two-Sided Surface with Cruciform Pattern*, wood, 47 × 16 × 6 in, 1991. The fifth piece in a series, this sculpture preserves the symmetries of the ellipsoid. Its six border curves are nearly planar and could be regarded as the rims of transparent windows into this closed, orientable surface of genus six. (See article by George K. Francis.)

COLOR PLATE A

No. 1. (above) Branko Grünbaum and G. C. Shephard, example of a colored interlace pattern. Six colors are used systematically, and one strand is thickened and shown in black for better visibility. Some colored interlace patterns appear in Islamic ornamentation, but are not very common. The coloring used is said to be 'perfect'; this means that every symmetry of the interlace pattern changes the colors of the strands in a consistent way.

No. 3. (right) Lucio Saffaro, *Platonic Forms*, computer graphics, 1986. A first-order dodecahedron is shown on the left, made of six regular dodecahedra rotated 36° with respect to axes passing through the middle points of a starting dodecahedron. A cross-section of the same dodecahedron, showing its interior, is shown on the right.

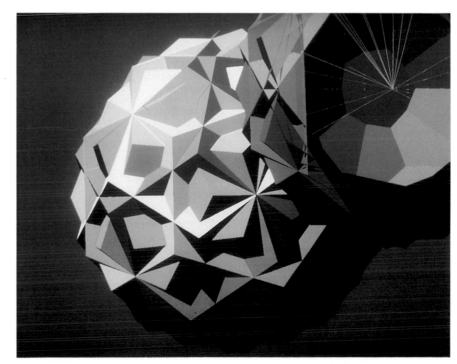

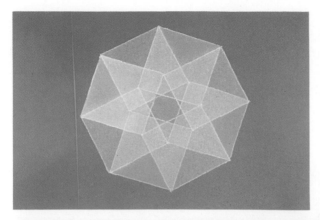

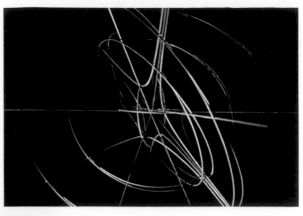

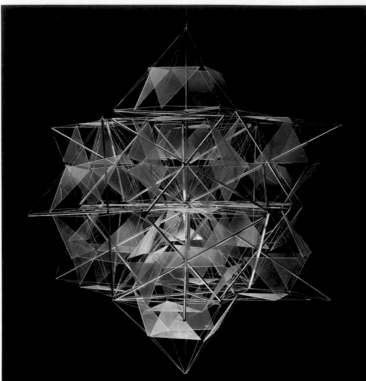

Color Plate B

No. 1. (top left) David Brisson, *Hypercube*, watercolor, 10×15 in, 1967. This representation of the hypercube is similar to the one drawn by W. I. Stringham in 1880. This representation incorporates color to assist in form definition. (See article by Harriet E. Brisson.)

No. 2. (top right) David Brisson, *Hyperanaglyph*, red, blue and white painted metal rods on rotating turntable, $18 \times 18 \times 18$ in, 1975. This is a 3D drawing of the two equations $z^2 + w^2 = 1$ (red) and $z^2 + w^2 = -1$ (blue), plotted for complex values of z and w in a 4D space of two real and two imaginary coordinates. (See article by Harriet E. Brisson.)

No. 3. (left) Harriet E. Brisson, *Truncated Close-Packing Octahedra, Rhombidodecahedra and Cubes*, tensegrity structure of plexiglass, aluminum tubes and nylon cord, $28 \times 28 \times 28$ in, 1976. This form differs from other space fillings in that the close-packing octahedron is not a Platonic or an Archimedean Solid.

No. 4. (left) Harriet E. Brisson, *Magic Box*, truncated octahedra of neon tubes in two-way mirrored cube on four vertical sides with mirrored top and bottom, 1978. This is one of the self-packing polyhedra—this single form will fill space completely. Here it is reflected indefinitely in a cubic kaleidoscope of two-way mirrors, which are opaque when behind the form but become transparent when in front of it.

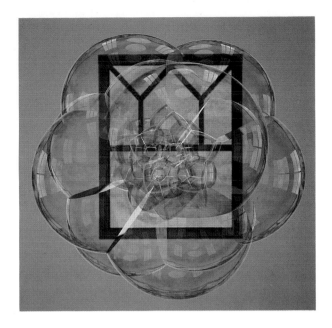

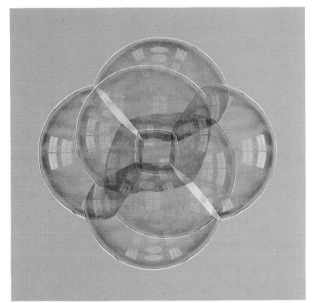

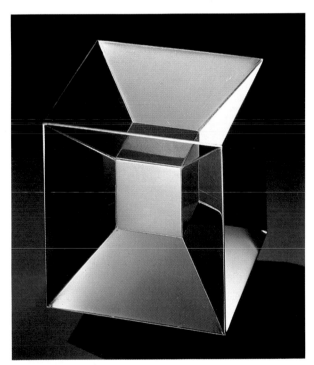

COLOR PLATE C

No. 1. (top left) **Fred Almgren and John Sullivan, computer graphics.** A large soap bubble cluster illustrating the computer-graphics techniques that accurately model the Fresnel effect of decreased transparency at oblique angles and the colored interference patterns in a thin film. This is the most intricate soap bubble geometry that has been rendered by such techniques. It is the stereographic projection into three-space of a regular 4D polytope called the dodecaplex. The soap films in this cluster are all pieces of spheres and meet at the correct angles for a physical soap film.

No. 2. (top right) **Fred Almgren and John Sullivan, computer graphics.** A hypercube, when stereographically projected to three-space, forms this cluster of seven bubbles. The center bubble is a cube with spherical faces, meeting at 120° angles as sheets of soap film must. It was rendered by the techniques the authors describe, modeling the optics of thin films.

No. 3. (center) **Attilio Pierelli,** *62–63 Ipercubo 1*, **stainless steel, 8 × 8 × 8 in, 1974.** This sculpture depicts a central projection of the hypercube from a point in four-space. (See article by Thomas Banchoff and Davide P. Cervone.)

No. 4. (bottom) **Thomas Banchoff and Nicholas Thompson,** *Torus Stereographically Projected from Four-Space*, **computer-graphics, 1989.** This image shows a banded torus projected from the hypersphere in four-space, stretching to infinity and separating space into two congruent pieces.

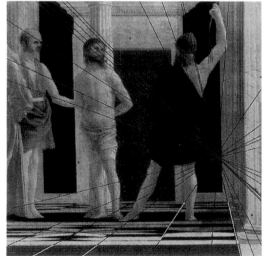

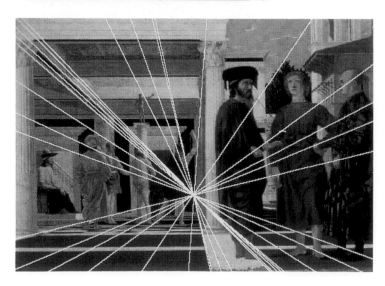

COLOR PLATE D

No. 1. (top left) Charles O. Perry, *Eclipse*, aluminum sculpture, 35 ft, 1973. This detail of a sculpture installed in the Hyatt Regency, San Francisco, allows a close-up view of the helical explosion of its faces, rotating from a dodecahedron through an icosidodecahedron to a small rhombi-cosidodecahedron.

No. 2. (top right) Charles O. Perry, *Da Vinci*, steel sculpture, 24 ft, 1974. (Photo: Balthazar Korab) Twelve pentagonal shapes are interlocked in a regular pattern as if the sides of a dodecahedron were rotated inward. A second figure repeats this form inside this sculpture at Northbrook Court, Northbrook, Illinois.

No. 3. Laura Geatti and Luciano Fortunati, perspectival analysis of Piero della Francesca's *The Flagellation of Christ*. (left) A digitization of the painting, with the indicated vanishing point discovered by the authors' computer-aided method of perspectival analysis. (center left) Detail.

No. 1. (top right) Stewart Dickson, *Knot*, stereolithograph, 3 × 8.5 × 8.5 in, 1990. (Photo: Gordon Padwick. Collection of 3D Systems, Inc.) The form was realized by the author in a C-language program implementing parametric equations.

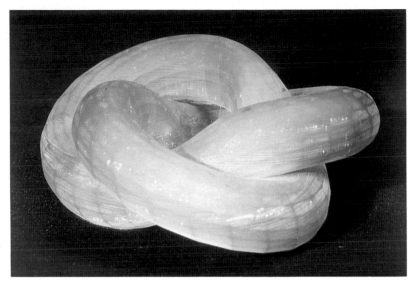

No. 2. (center right) Stewart Dickson, *Genus 4, Three-Ended Minimal Surface*, stereolithograph, 2.7 × 4.75 × 4.75 in, 1990. (Photo: Gordon Padwick. Collection of 3D Systems, Inc.) The database for this surface originated from a Visual Progamming Language (VPL) implementation by James Hoffman of the global Enneper-Weierstrass parameterization of the surface by David Hoffman.

No. 3. (bottom right) Stewart Dickson, *Jorge-Meeks Trinoid*, stereolithograph, 8 × 6 × 6 in, 1991. The surface was generated from an implementation of the global Enneper-Weierstrass form in 12 lines of Mathematica code on a Silicon Graphics Personal Iris 4D/25TG graphical workstation. Mathematica programming was performed by the author with assistance from Igor Rivin, Wolfram Research, Inc.

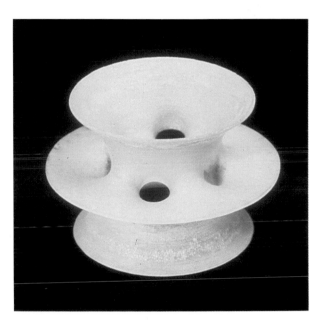

No. 4. (bottom left) Stewart Dickson, *Virtual Gallery*, computer rendering, 1990. This image was computed at 1536 × 2048 pixels in the Wavefront Advanced Visualizer on a Silicon Graphics Iris 4D/60T Compute Server. Object databases include three-, four- and infinite-ended minimal surfaces of various genera (prepared for stereolithography by the author from data supplied by James Hoffman) as well as those of the author's own design.

No. 1. (right) Brian Evans, *Marian Vectors*, musical computer-graphics animation, 1989. End frame from the *adagio* movement.

No. 2. (left) Brian Evans, Untitled, 15 × 15 in, cibachrome print, 1990. A digital image showing a proportional expression of additive color primaries red:blue:green as 3:5:8.

No. 3. (left) Brian Evans, *Penrose Green*, acrylic on canvas, 36 × 36 in, work in progress. A digital study for this painting shows that the inherent φ relationship in Penrose tiles is applied to color proportions.

No. 1. (right) Silvio Levy, computer graphics, 1991. (© 1959 M. C. Escher Foundation - Baarn - Holland. All rights reserved.) This replica of Escher's *Circle Limit III* was entirely generated by computer.

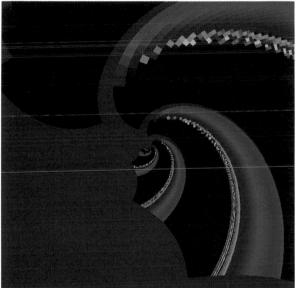

No. 2. (left) Herbert W. Franke and Horst S. Helbig, computer graphics. Conformal mapping of the complex plane is well adapted for the generation of spiral figures. In the equation $w = a \cdot z^b$, the shape of the spiral can be changed by the variation of parameters a and b.

No. 3. (right) Herbert W. Franke and Horst S. Helbig, computer graphics. In contrast to computer-aided design (CAD), in which features are described by a vector, raster images were used to produce this image. Each picture element (pixel) has an attribute for its represented gray value or color tone.

No. 1. (right) Donna Cox, Robin Bargar, Chris Landreth, Robert Patterson, et al., *Venus & Milo*, computer-graphics animation, 1990. A close-up view of Milo looking at the audience, with Venus, a topological surface, floating on a pedestal behind.

No. 2. (left) Donna Cox, Robin Bargar, Chris Landreth, Robert Patterson, et al., *Venus & Milo*, computer-graphics animation, 1990. Milo is flanked by goddesses from art history: in the back of the art museum is a detail from Botticelli's *Birth of Venus*; at the left is Andy Warhol's *Marilyn*. At the far right is the mathematical, synthetic Venus on a pedestal. Behind Milo is a representation of Marcel Duchamp's *Bicycle Wheel*. (*Marilyn* © 1993 The Andy Warhol Foundation for the Visual Arts, Inc. *Bicycle Wheel* © 1993 ARS/New York)

No. 3. (right) Donna Cox, Robin Bargar, Chris Landreth, Robert Patterson, et al., *Venus & Milo*, computer-graphics animation, 1990. Milo has an idea. A representation of a Duchamp 'readymade' is in view.

No. 1. (right) M. R. Laff and A. V. Norton, *Fractal Dragon*, non-representational fractal image, computer graphics, 1982. Fractal dragons (also called *Julia sets*) help scientists investigate the dynamics of iteration. (See Benoit B. Mandelbrot, "Fractals and an Art for the Sake of Science".)

No. 2. (left) R. F. Voss, *Fractal Planetrise*, fractal space and landscape, computer graphics, 1982. Fractal 'forgeries' like this one help scientists model reliefs of Earth and of the planets. (See Benoit B. Mandelbrot, "Fractals and an Art for the Sake of Science".)

No. 3. (right) B. B. Mandelbrot and F. Kenton Musgrave, *The Red Island*, fractal landscape, computer graphics, 1989. Representational fractals serve as innovative support of artistic inspiration and skill.

No. 4. (left) B. B. Mandelbrot, Untitled, nonrepresentational fractal image, computer graphics, 1989. This is a fragment of a generalized Mandelbrot set. The Mandelbrot sets help scientists investigate the dynamics of iteration. Nonrepresentational fractals such as this one have their own special artistic value; they are best when devoid of obvious symmetries.

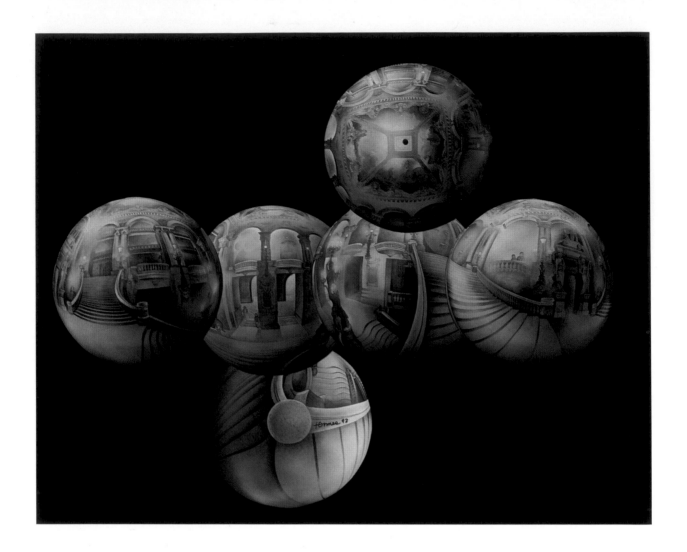

COLOR PLATE J

No. 1. (above) Dick Termes, *Paris Opera*, acrylic on polycarbonate sphere, 16-in diameter, 1992. The painting on this sphere shows a six-point perspective view of Charles Garnier's design of the Paris Opera.

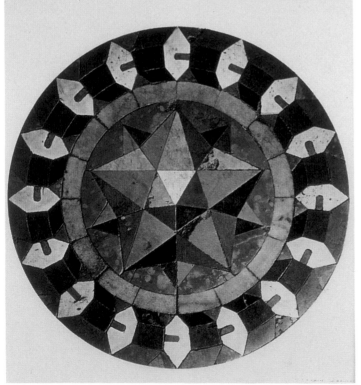

No. 2. (left) P. Uccello, Untitled, mosaic, 80 × 80 cm, 1425–1430. San Marco Cathedral, Venice. (See Michele Emmer, "Art and Mathematics: The Platonic Solids".)

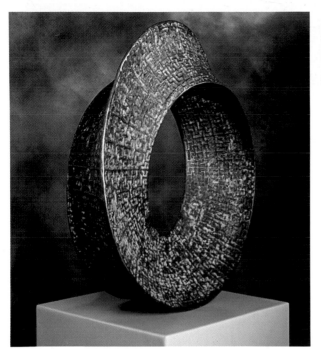

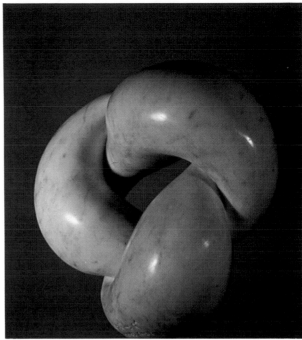

COLOR PLATE K

No. 1. Helaman Ferguson, computer interactive sculpture, bronze and marble, 1990. (above left) *Umbilic Torus NC (3,1)*; (above right) *Umbilic Torus NIST (1,3)*. Each of these sculptures is the inside-out of the other—one is bronze, the other marble; one has the form of a right-hand screw; the other, a left-hand screw. They fill space together. The numbers (3,1) mean that the closed curve of cusps goes three times around the torus the long way and once the short way; the numbers (1,3) mean that the closed curve of cusps goes once around the torus the long way and thrice the short way.

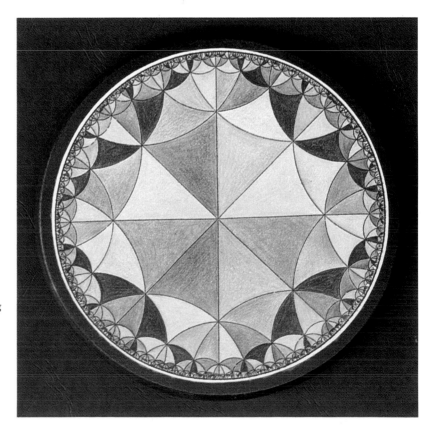

No. 2. (right) J. F. Rigby, *Hyperbolic Tiling*, india ink and coloured pencil, 1988. This is a colouring in seven colours of the regular hyperbolic tiling {3,8} with eight triangles meeting at each vertex. The colouring is said to be semi-perfect because half of the direct and opposite symmetries of the tiling permute the colours, while the remaining symmetries mix them up.

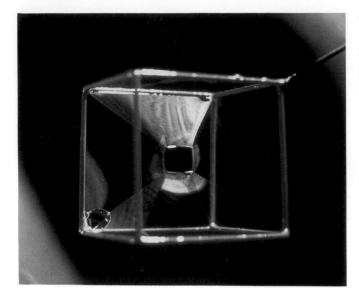

No. 1. (left) Soapy films inside a cubic wire, 1986. (Photo copyright © 1986 Bisignani-Emmer. Reprinted by permission.) (See Michele Emmer, "Soap Bubbles in Art and Science".)

No. 2. (right) D. Hoffman, W. Meeks III and J. T. Hoffman, computer rendering of a completely embedded minimal surface of finite topology, based on the equations of C. Costa, 1985. (Photo copyright © 1985 Hoffman, Meeks, Hoffman. Reprinted by permission.) (See Michele Emmer, "Soap Bubbles in Art and Science".)

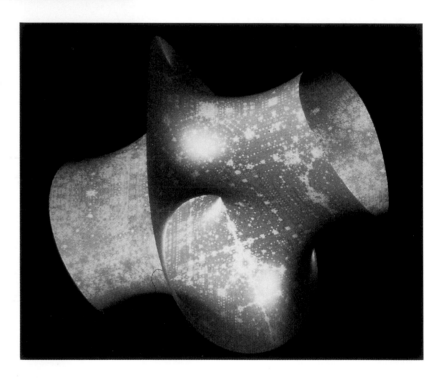

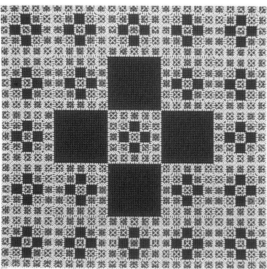

No. 3. Dann E. Passoja and Akhlesh Lakhtakia, $G = 5$ (cool series), Group 2 carpet design, inkjet print, 1990. This carpet was produced through the authors' algorithm, with $Q = 5$.

Two Conformal Mappings

Robert Dixon

In his Harvard lecture on the aesthetics of music, Leonard Bernstein emphasised the fundamental role played by *transformation,* while he described the compositions of Mozart, Beethoven and Mahler as paralinguistic patterns of repetition and variation. In passing, he claimed the same would be found true for the other arts. We can immediately confirm that this is clearly true in visual art, in which we find a fundamental presence of certain geometric transformations: projective transformations in pictorial art and symmetry transformations in ornamental art. Conversely, mathematical studies of geometric transformations are frequently of great visual interest [1]—this is certainly so for the two geometric mappings that I propose to discuss here, *inversion* and *antiMercator.* Our discussion starts by recalling in a systematic way the list of elementary *plane transformations,* enabling us to reach inversion and antiMercator at ninth and eleventh places. Later we shall bring in three-dimensional considerations.

PLANE COLLINEATIONS

Mathematicians classify and subclassify transformations in terms of their invariant properties. Any systematic list is likely to begin with an enumeration of *collineations,* the transformations that preserve straightness: with lines mapped to lines. The class collineation contains all the most familiar transformations and subdivides into various subclasses of transformation as shown in Table 1.

Note that Table 1 is also a Venn diagram, that is, all members of the class isometry are members of the class similarity but not vice versa. Note also that each class is closed under the operation of combined transformation—

so that, for example, one similarity followed by another similarity is also a similarity.

In a description of spatial mappings it is sometimes illuminating to adopt the language of geometry; at the same time it is almost always necessary to specify them in terms of coordinate algebra. Certainly for the purposes of computer graphics, we need to specify coordinate transformations. The points in a plane may be given coordinates in a variety of ways, but principally in Cartesian form (x, y) or in polar form (r, θ). The simplest arithmetical possibilities for defining changes to coordinate-number pairs correspond to the various elementary transformations. Here, for example, are specifications for similarities:

translation	$(x,y) \rightarrow (x + a, y + b)$
rotation	$(r,\theta) \rightarrow (r, \theta + c)$
reflection	$(x,y) \rightarrow (x, -y)$
dilatation	$(r,\theta) \rightarrow (dr, \theta)$

and so forth, where a, b, c and d are real constants.

Note that in complex number notation, all similarities can be expressed in the form

$$z \rightarrow az + b \quad \text{or} \quad z \rightarrow a\bar{z} + b,$$

with suitable choices of complex constants a and b.

ABSTRACT

Following his discussion of the classificational place of conformal mappings among elementary transformations, the author describes and illustrates two particular conformal mappings, *inversion* and *antiMercator,* in order to draw attention to the symmetry implications of their combined use.

Table 1. Plane collineations.

transformation	class	invariants
translation rotation reflection	isometry	length
dilatation	similarity	shape
stretch shear	affinity	parallels (line ratios)
projection	projectivity	cross-ratio

CIRCLE-PRESERVING TRANSFORMATIONS

A transformation that is circle-preserving is classed as *homography* or *antihomography,* depending on whether sense is, respectively, preserved or reversed. In complex number notation, all circle-preserving transformations can be expressed as linear fractional functions [2]:

homography	$z \rightarrow (az + b)/(cz + d)$
antihomography	$z \rightarrow (a\bar{z} + b)/(c\bar{z} + d)$

Robert Dixon (mathematician, artist), 125 Cricklade Avenue, London SW2, United Kingdom.

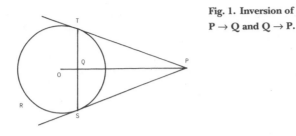

Fig. 1. Inversion of
P → Q and Q → P.

points of tangency, S and T, for the two tangents drawn from P to the circle of inversion. Points O, P and Q are collinear, with P determining Q or vice versa by this equation:

$$OQ \cdot OP = OR^2.$$

Note that the formula $z \rightarrow 1/z$ specifies inversion in the circle of unit radius centred at the coordinate origin. Any other inversion is equivalent to this inversion combined with suitable translations and/or dilatations. Moreover, any homography/antihomography is either a similarity or a combination of one inversion and an isometry.

In polar coordinates, inversion in the unit circle centred on the coordinate origin is given by

inversion $\qquad (r,\theta) \rightarrow (1/r,\theta).$

It is an easy matter to show that inversions preserve circles, with arguments that flow straight from Euclid's *Elements*. However, we need to qualify this claim in view of the fact that some circles turn into lines. We secure complete generality for the claimed circle-preserving property by regarding lines as circles of infinite radius. Let us summarize the possibilities for an inversion in any circle C with centre O: circles not passing through O invert into circles: circles passing through O invert into lines not passing through O; lines and circles cutting C orthogonally map into themselves. Each of these facts is illustrated in Fig. 2, which may be regarded as something of a puzzle picture: a single inversion has taken place, and each line, arc and region depicted is accompanied by its image under the inversion.

The general effect of an inversion may be judged by its effect on a chess board, as illustrated in Fig. 3, showing the image of a chess board under inversion in a circle centred on the centre of the chess board. The combination of two identical inversions is the identity, the combination of two concentric inversions of differing radii is a dilatation, and

where a, b, c and d are complex constants, with $ad - bc \neq 0$.

The class homography/antihomography includes, of course, all similarities, but no other collineations. On the other hand, not all homographies/antihomographies are similarities. A homography/antihomography is a similarity if $c = 0$. A homography/antihomography is not a similarity if $c \neq 0$. When $c = 0$, the fractional functions reduce to linear equations. When $c \neq 0$, an additional transformation is involved that is not a similarity or collineation—it is called an *inversion:*

inversion $\qquad z \rightarrow 1/\overline{z}.$

Like reflection, inversion reverses sense. And just as reflection is determined by reference to a given mirror line, so inversion is determined by reference to a given circle. Points *on* the circle of inversion remain where they are while all points *inside* the circle exchange one-to-one with all points *outside* the circle. Figure 1 illustrates this principle. Although inversion was first conceived of in the nineteenth century by Jakob Steiner, its geometry provides a perfectly natural extension to Euclid's *Elements*, Book III [3].

Inversion in a circle, with centre O and radius OR, maps all exterior points P to all interior points Q as indicated, and vice versa. To complete the picture, the centre O is said to exchange with the *point at infinity*. For all given exterior points P, Q is the centre of the chord that connects the

Fig. 2. Inversion of various lines and circles [10].

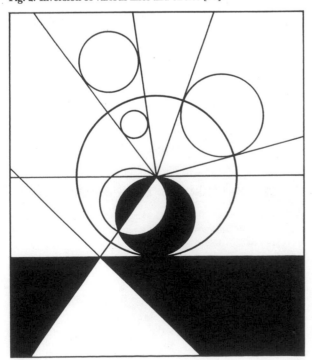

Fig. 3. Inversion of a chessboard in a circle centred on the chessboard [11].

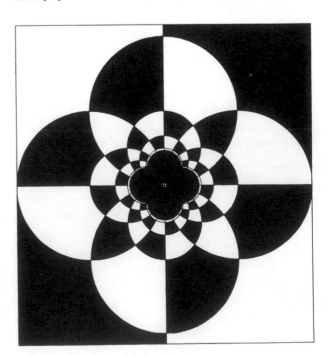

Fig. 4. The image of a row of ellipses under an anti-Mercator [12].

the combination of two non-concentric inversions is a homography.

ANGLE-PRESERVING TRANSFORMATIONS

A transformation that preserves an angle is classed as *conformal*. All circle-preserving transformations are angle-preserving, but not all angle-preserving transformations are circle-preserving. To explore this proposition we must first clarify the meaning of the conformal property.

When we describe a transformation as angle-preserving, we do not mean that any three points A, B and C are mapped to A′, B′ and C′ such that triangles ABC and A′B′C′ are similar. Of course this latter condition does apply in the case of a similarity, but it does not hold in the case of inversion. We mean something more specific. We mean the angle between any two intersecting curves at their point of intersection is preserved.

To demonstrate that inversion is conformal we can consider its effect on any equiangular spiral whose pole lies at the centre of inversion. Placing our coordinate origin at this centre allows us to formulate all such equiangular spirals thus:

$$r = e^{\theta \cot a + b}$$

where a is the constant angle made between the radius and tangent at any point on the spiral. Inversion in the unit circle centred on the pole maps r to $1/r$, and so maps

$$r = e^{\theta \cot a + b} \rightarrow r = e^{-(\theta \cot a + b)}.$$

We see that the image of such an equiangular spiral is also an equiangular spiral with the same constant angle, except that it winds in the opposite sense. And, what applies to the momentary direction of an equiangular spiral at any point applies to the momentary direction of any curve: at any given point on a curve, the angle between the curve and direction of the centre of inversion is the same after inversion, except that the sense is reversed.

All conformal mappings that map the whole plane onto the whole plane in a one-to-one manner are also circle-preserving: they are homographies or antihomographies. However, if we drop the requirement that the whole plane be mapped on to the whole plane in a one-to-one manner, then we encounter the numerous possibilities of conformal mappings that are not circle-preserving [4,5]. For example, the *quadratic* mapping

$$z \rightarrow z^2 + c$$

that is used iteratively to generate the Julia and Mandelbrot

sets [6,7] is conformal. More generally, any power of z gives a conformal mapping,

$$z \rightarrow z^n, \ (n \neq 0).$$

This transformation maps a sector of the plane with angle A on to a sector of the plane with angle nA, and so perhaps deserves to be called a *fanning*. In polar coordinates a fanning looks like this:

$$(r, \theta) \rightarrow (r^n, n\theta),$$

so that an equiangular spiral whose pole lies at the coordinate origin is mapped to a similar equiangular spiral, and into itself if it contains $(1, 0)$:

$$r = e^{\theta \cot a + b} \rightarrow r = e^{\theta \cot a + nb}.$$

Note that $z \rightarrow z^n$ is circle-preserving in the special cases of n = 1 and n = −1, where the fanning degenerates to, respectively, identity and inversion.

Another conformal mapping is the *Mercator* and its inverse, the *antiMercator* [8]:

| Mercator | $z \rightarrow$ lnz |
| antiMercator | $z \rightarrow$ e^z. |

My aim here is to focus attention on the antiMercator and its use in conjunction with inversion. The antiMercator maps an infinite parallel strip of the plane of width 2π onto the whole plane. Points given in Cartesian coordinates (x, y) are mapped to points given in polar coordinates by

$$(r, \theta) = (e^x, \ y \bmod 2\pi).$$

Under the antiMercator, all lines are mapped to equiangular spirals with a common pole at the coordinate origin. Radial lines through the coordinate origin, and circles concentric to it, are special cases of such spirals and are the

Fig. 5. The image of stars with lattice arrangement under an anti-Mercator [13].

Fig. 6. Inversion of Fig. 5 [14].

images of lines parallel with and lines perpendicular to the strip domain, respectively. The angle made by an object line with respect to the direction of the domain is preserved in the angle made by its image spiral with respect to the radius vector. The main property of the antiMercator to which I wish to draw attention here is this: plane patterns of transitional symmetry are mapped to plane patterns of periodic point symmetry, dilatational symmetry and inversive symmetry. Lattice patterns are turned into radial patterns. Various parts of this proposition are illustrated in Figs 4 and 5.

THREE DIMENSIONS

The scope for conformal transformation of three-dimensional space is much more restricted than that of the plane and includes only the similarities and inversion. The principle of space inversion (not to be confused with point reflection, which happens also to be called 'inversion' on occasion) is an exact counterpart to plane inversion, as follows: Inversion in a sphere of centre O and radius OR maps any point in space P to Q such that O, P and Q are collinear and

$$OP \cdot OQ = OR^2.$$

Space inversion maps circles to circles and spheres to spheres. Again the generality of this claimed property is secured by regarding lines and planes as, respectively, circles and spheres of infinite radius. Planes through the centre of inversion are mapped to themselves and undergo plane inversion as described earlier. Planes not through the centre of inversion are transformed into spheres—this is of special interest. Mapping from spheres to planes or vice versa is an age-old geometric challenge, and of course it cannot be done without rupture and distortion of the surface transformed.

Figure 6 shows a space inversion of Fig. 5 and indicates the visually striking possibilities for combining antiMercator and inversion. We may imagine in a sequence of two transformations how a plane pattern of lattice symmetry is turned into a plane pattern of radial symmetry by an antiMercator, which is then turned into a symmetrical spherical pattern. In such a combination of these two transformations, the centre of the inversion is located directly 'above' the centre of the antiMercator. Notice in particular that the inversion transforms plane equiangular spirals into loxodromes—which, in geographical terms, are paths on the surface of the globe of constant compass bearing.

CONCLUSION

Geometric transformations are key tools in the mathographical artist's kit. The aim of this paper has been to describe two nonlinear mappings, antiMercator and inversion, by relating them via the classificational scheme to the more familiar linear transformations—isometries, similarities, affinities and perspective—and also by describing their invariant properties, listing their formulae, and illustrating their use in combination. When we employ an antiMercator to a plane lattice pattern, followed by a space inversion above its centre, we reverse the steps taken by Mercator [9] in his famous projection of the globe onto a flat map, but discover symmetry implications that go entirely unnoticed in geographical maps and that more than make up for the waning navigational utility of this projection.

References and Notes

1. R. A. Dixon, *Mathographics* (New York: Dover, 1991).

2. H. S. M. Coxeter, *Introduction to Geometry* (New York: Wiley, 1961).

3. T. L. Heath, *The Thirteen Books of Euclid's Elements* (New York: Dover, 1956).

4. D. Hilbert and S. Cohn-Vossen, *Geometry and the Imagination* (New York: Chelsea, 1952).

5. A. I. Markushevich, *Complex Numbers and Conformal Mappings* (Oxford: Pergamon Press, 1962).

6. B. Mandelbrot, *The Fractal Geometry of Nature* (San Francisco, CA: Freeman, 1982).

7. H.-O. Peitgen and D. Saupe, *The Science of Fractal Images* (Berlin: Springer-Verlag, 1988).

8. R. A. Dixon, "To AntiMercator", *Mathematics Teaching* **122** (1988) pp. 21–23.

9. Gerhardus Mercator (1512–1594) was a Flemish mathematician, geographer and cartographer.

10. Dixon [1].

11. Dixon [1].

12. Dixon [1].

13. Dixon [1].

14. Dixon [1].

Computer Interactive Sculpture

Helaman Ferguson

CENTRAL PURPOSE

As a sculptor I want to experience and avail to others vital compelling forms. I desire access to quantitative measured forms as well as qualitative expression. Computers offer powerful tool possibilities. Other sculptors find this so [1–3]. It is not enough for me to make models of mathematical equations or CAD [computer-aided design] structures, although the capability to do that is sometimes important. I invest my sculpture with a wide range of knowledge. My sculpture process tends to involve direct carving or cutting away of material. It is more fashionable in sculpture today to do constructions or additions. I prefer the more interesting and difficult subtraction processes. While I make aesthetic artifacts, many of our functional artifacts are made by industrial cutting processes that are relevant to me.

As a research mathematician I have had the good fortune to discover mathematics as a design language for sculpture [4,5]. My use of this design language folds naturally into our current computer technology. Mathematics is an invisible art form of profound social and scientific significance. Computer graphics makes mathematics visible; I take the next step.

In this paper I discuss two of my successful sculptural forms, *Umbilic Torus NC* and *Umbilic Torus NIST* (Color Plate K No. 1). I have done a series of each using two different kinds of computer interaction. These and my related sculp-

tures are in permanent collections [6–9] and have been exhibited widely [10–12].

MATHEMATICAL DESIGN

I begin by plunging directly into the design considerations for *Umbilic Torus NC* and *Umbilic Torus NIST*. This looks like raw mathematics—it is, but not in the usual sense because my motivations in writing it down are sculptural [13,14]. The setting is the stratification of the space \mathbf{R}^4 of real coefficients of binary cubic forms by the action of the general linear group. Stratification means the orbits and the relationship among them. The correspondence between the points in \mathbf{R}^4 and the cubic forms is given by

$$(a,b,c,d) \in \mathbf{R}^4 \leftrightarrow f = ax^3 + bx^2y + cxy^2 + dy^3.$$

The general real linear group $G = GL(2, \mathbf{R})$ consists of the real invertible 2×2 matrices,

$$\begin{pmatrix} \alpha & \beta \\ \gamma & \delta \end{pmatrix},$$

where the condition of invertibility of this matrix is that the determinant $\alpha\delta - \beta\gamma$ be non-zero. These matrices will be regarded as acting on the two-variable vector (x, y) as a column vector by left matrix multiplication. The group action is defined by the mapping

$$\begin{pmatrix} \alpha & \beta \\ \gamma & \delta \end{pmatrix} : \begin{pmatrix} x \\ y \end{pmatrix} \rightarrow \begin{pmatrix} \alpha & \beta \\ \gamma & \delta \end{pmatrix}\begin{pmatrix} x \\ y \end{pmatrix},$$

or

$$\begin{pmatrix} x \\ y \end{pmatrix} \mapsto \begin{pmatrix} \alpha x + \beta y \\ \gamma x + \delta y \end{pmatrix}.$$

This in turn gives an action on cubic forms by substituting these images in the cubic form and multiplying out. Thus the form $ax^3 + bx^2y + cxy^2 + dy^3$ becomes

ABSTRACT

The author describes the design and creation of two of his computer-interactive sculptures, *Umbilic Torus NIST* and *Umbilic Torus NC*. The mathematics underlying both of these works and the sculptural process are discussed.

Fig. 1. Hypocycloid of three cusps.

Helaman Ferguson (sculptor, mathematician), 10512 Pilla Terra Court, Laurel, MD 20723-5728, U.S.A. E-mail: <helamanf@super.org>

This paper was first published in *1992 Symposium on Interactive 3D Graphics.* Copyright © 1992, Association for Computing Machinery, Inc. Reprinted by permission.

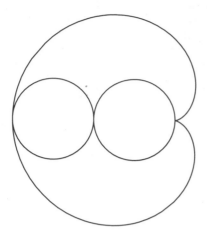

Fig. 2. Epicycloid of one cusp, or a cardioid.

$(a\alpha^3 + \alpha^2 b\gamma + \alpha c\gamma^2 + d\gamma^3)x^3 +$

$(3a\alpha^2\beta + \alpha^2 b\delta + 2\alpha b\beta\gamma + 2\alpha c\delta\gamma + \beta c\gamma^2 + 3d\delta\gamma^2)x^2 y +$

$(3a\alpha\beta^2 + 2\alpha b\beta\delta + \alpha c\delta^2 + b\beta^2\gamma + 2\beta c\delta\gamma + 3d\delta^2\gamma)xy^2 +$

$(a\beta^3 + b\beta^2\delta + \beta c\delta^2 + d\delta^3)y^3.$

These four coefficients are linear in the four original coefficients a, b, c, d and define a 4×4 matrix

$$\begin{pmatrix} \alpha^3 & \alpha^2\gamma & \alpha\gamma^2 & \gamma^3 \\ 3\alpha^2\beta & \alpha^2\delta + 2\alpha\beta\gamma & 2\alpha\delta\gamma + \beta\gamma^2 & 3\delta\gamma^2 \\ 3\alpha\beta^2 & 2\alpha\beta\delta + \beta^2\gamma & \alpha\delta^2 + 2\beta\delta\gamma & 3\delta^2\gamma \\ \beta^3 & \beta^2\delta & \beta\delta^2 & \delta^3 \end{pmatrix}.$$

This matrix has the determinant $(\alpha\delta - \beta\gamma)^6$ which is the sixth power of the determinant of the original real invertible 2×2 matrix. This new 4×4 matrix is invertible if and only if the original matrix it is representing is invertible. This 4×4 matrix is an important example of a *group representation*.

The cubic $ax^3 + bx^2 y + cxy^2 + dy^3$ can be completely factored over the complex numbers **C**,

$ax^3 + bx^2 y + cxy^2 + dy^3 =$

$(r_1 x + s_1 y)(r_2 x + s_2 y)(r_3 x + s_3 y),$

for $r_1, s_1, r_2, s_2, r_3, s_3 \in$ **C**. This gives three ratios or lines given by the pairs $r_j, s_j, j = 1, 2, 3$. We can think of them as lines because non-zero scaling of the form corresponds to non-zero scaling of the pairs. The ratios correspond to roots of the cubic and can be classified into five types: hyperbolic umbilics, two complex, one real root, e.g. $x^3 + xy^2$; elliptic umbilics, three real distinct roots, e.g. $x^3 - 3xy^2$; parabolic umbilics, three real, two equal roots, e.g. $x^2 y$; exceptionals, three real equal roots, e.g. x^3, and the origin. These root types correspond to orbits of the group of dimensions 4, 4, 3, 2, 0, respectively.

The discriminant of the cubic is an invariant under the linear changes of variable we have been considering. The cubic discriminant is

$-(b^2 c^2) + 4ac^3 + 4b^3 d - 18abcd + 27a^2 d^2.$

The parabolic umbilics are those (a, b, c, d) such that

$-(b^2 c^2) + 4ac^3 + 4b^3 d - 18abcd + 27a^2 d^2 = 0.$

The 'hyperbolic umbilics at infinity' and 'elliptic umbilics at infinity' are those (a, b, c, d) such that

$-(b^2 c^2) + 4ac^3 + 4b^3 d - 18abcd + 27a^2 d^2 < 0$

$-(b^2 c^2) + 4ac^3 + 4b^3 d - 18abcd + 27a^2 d^2 > 0$

respectively. The root types and orbits amount to the same things. The discriminant is homogeneous in the four vari-

ables so it suffices to look at orbits of forms represented by points on the 3-sphere,

$$\left\{ [a, b, c, d] \mid a^2 + b^2 + c^2 + d^2 = 1 \right\}.$$

This reduces the dimensions above to 3, 3, 2, 1, ignoring the origin. The situation is now in a sculpture-appropriate space.

In the complex number representation for the real cubic forms; the four real coefficients can be replaced by two complex numbers. Consider the real part of the complex cubic form

$$\Re\left(uz^3 + vz^2 z^* \right),$$

where $z = x + yi$, the complex conjugate $z^* = x - yi$, and $u = u_1 + u_2 i$, $v = v_1 + v_2 i$. The linear transformation relating the a, b, c, d and the u, v coefficient sets

$$\begin{pmatrix} a \\ b \\ c \\ d \end{pmatrix} = \begin{pmatrix} 1 & 0 & 1 & 0 \\ 0 & -3 & 0 & -1 \\ -3 & 0 & 1 & 0 \\ 0 & 1 & 0 & -1 \end{pmatrix} \cdot \begin{pmatrix} u_1 \\ u_2 \\ v_1 \\ v_2 \end{pmatrix}$$

has determinant 16 and inverse

$$\frac{1}{4} \cdot \begin{pmatrix} 1 & 0 & -1 & 0 \\ 0 & -1 & 0 & 1 \\ 3 & 0 & 1 & 0 \\ 0 & -1 & 0 & -3 \end{pmatrix}.$$

There are two interesting planes of forms here, $u = 0$ or the v-plane or the $\Re(vz^2 z^*)$ form and $v = 0$ or the u-plane or the $\Re(uz^3)$ form. They are interesting because the group \mathbf{C}^\times contains the rotations $e^{i\theta}$, which acts on each of these forms and corresponding planes in a simple way. At least it looks simple when written as complex multiplication instead of matrix multiplication. Here is the action of this circle group on the form as it acts by complex number multiplication

$$e^{i\theta} : z \mapsto e^{i\theta} z,$$

to give

$$e^{i\theta} : \Re\left(uz^3 + vz^2 z^* \right) \mapsto$$

$$\Re\left(ue^{3i\theta} z^3 + ue^{i\theta} z^2 z^* \right).$$

Geometrically this means

$$(u, v) \mapsto \left(ue^{3i\theta}, ve^{i\theta} \right),$$

or that u gets rotated thrice whilst v is rotated once. We will use this observation below twice.

Consider the plane $u = 1$, the unit translate of the v-plane, or the real cubic forms $\Re(z^3 + vz^2 z^*)$. The question is how

Fig. 3. Hilbert surface-filling curve in the domain of the *Umbilic Torus NC.*

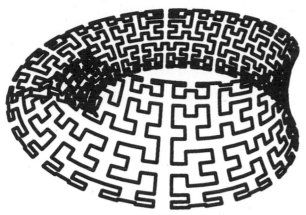

Fig. 4. Hilbert surface-filling space curve in the image of the *Umbilic Torus NC*.

does the discriminant variety intersect this plane or these forms. The discriminant variety consists of those forms having double roots at least. For which v's will there be double roots? Since $\Re(z^3 + vz^2z^*)$ is homogeneous in z and $z = 0$ is accounted for, we may suppose that the roots have absolute value one, $|z| = 1$, or that $z = e^{i\theta}$. In this case

$$\Re\left(z^3 + uz^2z^*\right) =$$
$$\frac{1}{2}\left(e^{3i\theta} + e^{-3i\theta} + v\left(e^{i\theta} + e^{-i\theta}\right)\right).$$

For what v's does this form have a double root and hence be on the discriminant variety? This is the same form after multiplying by $e^{i\theta}$ to get

$$\frac{1}{2}\left(e^{4i\theta} + e^{-2i\theta} + v\left(e^{2i\theta} + 1\right)\right).$$

The derivative of this form is supposed to vanish since we want v's giving a double root, so, after solving for v, we have

$$v = -2e^{2i\theta} + e^{-4i\theta}.$$

A more recognizable version of this equation is had by rewriting the variable $\theta = \frac{1}{2}(\phi - \pi)$,

$$v = 2e^{i\phi} - e^{-2i\phi}, 0 \le \phi < 2\pi.$$

This is the locus of a point on a circle of radius 1 rolling inside a circle of radius 3, otherwise known as a hypocycloid of three cusps (Fig. 1). This includes the case of all three roots of the cubic form being identical. In this case the second derivative of the form vanishes,

$$\frac{dv}{d\phi} = 2ie^{i\phi} - 2ie^{-2i\phi},$$

which when set equal to zero gives

$$e^{3i\phi} = 1 = e^{2i\pi k}$$

and

$$v = 3e^{\frac{2i\pi k}{3}}, k \in \mathbb{Z},$$

which latter is the set of the three cube roots of unity scaled by three.

These scaled cube roots of unity are cusps of the curve because tangent lines are defined there, but not tangent circles.

Cycloids in general are defined in terms of a circle of radius B rolling without slippage inside or outside a circle of radius A. The equation in complex variable form is

$$z = (A + B)e^{iB\varphi} - Be^{i(A+B)\varphi},$$

where $B < 0$ gives an epicycloid (the smaller circle rolling outside the larger circle) and $B > 0$ gives a hypocycloid (the

smaller circle rolling inside the larger circle). If $B = 0$ we just get the point $z = 0$. If $(A, B) = (3, -1)$ we get the hypocycloid of three cusps above. If $(A, B) = (1, 1)$ we get the cardioid which we shall see below.

We have chosen to look at those of the form $\Re(z^3 + vz^2z^*)$. This says that the form $(u, v) = (1, 0)$ or $(a, b, c, d) = (1, 0, -3, 0)$ is included which has negative discriminant -108 and the form has three distinct real roots and is therefore an elliptic umbilic. The hypocycloid we have discovered lies in the plane given by $u = 1$ or the v-plane. This plane gets moved by the unit circle group. Recall that the u gets rotated thrice while v once. Otherwise said, a one-third rotation of v takes place while u rotates once. This means that the hypocycloid rotates one cusp over while $u = 1$ moves to $u = e^{2i\pi}$. The hypocycloid has three-fold symmetry, so the resulting surface closes. We are looking at this torus with a hypocycloid cross-section from the point of view of the $(e^{2i\theta}, v)$ geometry. This torus does indeed present us with a picture of the parabolic umbilic surface, but keep in mind that we are looking at this singular set from a chosen perspective, one where the elliptic umbilic point $(u, v) = (1, 0)$ and all other elliptic umbilic points are inside the bounded part of the hypocycloid; the hyperbolic umbilic points are all outside the hypocycloid and this is the unbounded part of the space.

Could we choose instead of $(u, v) = (1, 0)$ the case of $(u, v) = (0, 1)$? This gives us the forms in the plane $v = 1$, the unit translate of the u-plane, or the real cubic forms $\Re(uz^3 + z^2z^*)$. The question is how does the discriminant variety intersect this plane or these forms. The discriminant variety consists of those forms having double roots at least. For which u's will there be double roots? Since $\Re(uz^3 + z^2z^*)$ is homogeneous in z and $z = 0$ is accounted for, we may suppose that the roots have absolute value one, $|z| = 1$, or that $z = e^{i\theta}$. In this case

$$\Re\left(uz^3 + z^2z^*\right) =$$
$$\frac{1}{2}\left(u\left(e^{3i\theta} + e^{-3i\theta}\right) + e^{i\theta} + e^{-i\theta}\right).$$

For what u's does this form have a double root and hence

Fig. 5. A bronze *Umbilic Torus NC* sitting on an enlarged Carrara marble quotation of a fragment of itself. Note the Hilbert curve articulation in the marble.

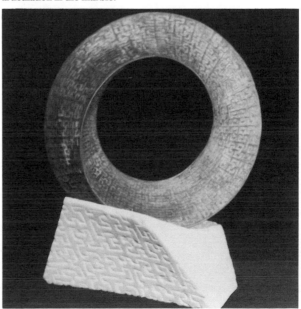

Fig. 6. SP 1, the ceiling triangle with string potentiometers at the end points.

Fig. 7. Note the plectrum forming a vertex of a tetrahedron under tension and the registration point labelled 3.

be on the discriminant variety? This is the same form after multiplying by $e^{3i\theta}$ to get

$$\frac{1}{2}\left(u\left(e^{6i\theta}+1\right)+e^{4i\theta}+e^{2i\theta}\right).$$

The derivative of this form is supposed to vanish since we want u's giving a double root, so, after solving for u, we have

$$-3u=-2e^{-2i\theta}+e^{-4i\theta}.$$

To recognize this equation as a cycloid, rewrite the variables $\theta=-\varphi/2$ and $u=-w/3$ to get

Fig. 8. The block has now been turned over. The three labelled registration points are clicked off in order, so that the virtual image is also 'turned over'.

$$w=2e^{i\varphi}+e^{2i\varphi},0\leq\varphi<2\pi.$$

This is the locus of a point on a circle of radius 1 rolling outside a circle of radius 3, otherwise known as an epicycloid of one cusp, or a cardioid (Fig. 2). This includes the case of all three roots of the cubic form being identical. In this case the second derivative of the form vanishes,

$$\frac{dw}{d\varphi}=2ie^{i\varphi}+2ie^{-2i\varphi},$$

which when set equal to zero gives

$$e^{i\varphi}=-1=e^{(2k+1)i\pi}$$

and

$$v=-\frac{1}{3}e^{(2k+1)i\pi},$$

for k in the integers \mathbf{Z} and v is the single point $^1/_3$.

This scaled fraction point is a cusp of the curve because a tangent line is defined everywhere on the curve, and there is a tangent circle defined everywhere but at that point.

This time we have chosen to look at those of the form $\Re(uz^3+z^2z^*)$. This says that the form $(u, v) = (0, 1)$ or $(a, b, c, d) = (1, 0, 1, 0)$ is included which has positive discriminant 4 and the form has one real root and two distinct complex roots and is therefore a hyperbolic umbilic. The epicycloid we have discovered lies in the plane given by $v=1$ or the u-plane. This plane also gets moved by the unit circle group. Recall that the u rotates thrice while v once—otherwise said, there is one-third rotation of v while u rotates once. This means that the epicycloid in the u-plane rotates once while $v=1$ moves to $v=e^{2\pi i/3}$. The epicycloid has bilateral symmetry, and this puts the epicycloid in the same position. Moving through the next two thirds puts the epicycloid back twice again to its original position. We are looking at this torus with a hypocycloid cross-section from the point of view of the $(u, e^{2i\varphi})$ geometry. This torus does indeed present us with a picture of the parabolic umbilic surface, but keep in mind that we are looking at this singular set from a chosen perspective, one where the hyperbolic umbilic point $(u, v) = (0, 1)$ and all other hyperbolic umbilic points are inside the bounded part of the epicycloid; the elliptic umbilic points are all outside the epicycloid and they form the unbounded part of the space of forms.

I have summarized symbolically a collection of perhaps 10K years of some of the most important ideas in mathematics. Indeed, many of these ideas are foundation stones of contemporary computer graphics. I have reformulated

Fig. 9. One side of the block has been excavated to the depths of the holes drilled in the stone to the nearest distance to the virtual image. The virtual image is becoming less virtual.

Fig. 10. The block face with holes drilled to the millimeter depths indicated.

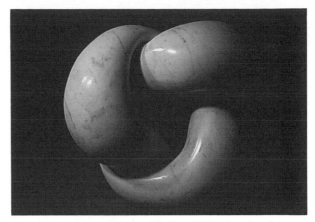

Fig. 11. Frontal view of the *Umbilic Torus NIST*. Note that the curve of cusps goes once the long way and thrice the short way.

them in a way to express them in three-dimensional (3D) or physical materials. These are priceless ideas that I work into otherwise worthless stone or bronze.

NC: NUMERICAL CONTROL

The initials 'NC' represent 'numerically controlled', a phrase that originated in 1952 at the Servomechanisms Laboratory of MIT which was subcontracted by Parsons, Inc., who was commissioned by the U.S. Air Material Command to automate helicopter rotor blade manufacture. SL-MIT modified a Cincinnati Hydrotel milling machine to operate from binary punched tape. *Umbilic Torus NC* is more complex than the early rotor blades, but owes its existence to the continued development of this technology.

By 1988 when I was ready to do the *Umbilic Torus NC* at the Brigham Young University Robotics Laboratory, the largest machine available there was a Cartesian 3-axis Kearney and Trekker, VB-2. This machine could still read paper tape. Fortunately it was also interfaced with a personal computer (PC). As it was we had to install an on-board hard disc to accommodate all of the quill moves for the *Umbilic Torus NC*. The source of the data load arose from the fact that, while the *Umbilic Torus NC* has spatial symmetry, that symmetry is not particularly compatible with the Cartesian structure of the 3-axis machine.

The central problem in any NC application is tool path. The ball end mill approximates a sphere of positive radius, and tool offsets had to be computed in advance whatever tool path was selected. Since the *Umbilic Torus NC* is a complex surface, the normals to this surface at any point were computed symbolically and parametrically prior to computing the tool offsets.

For aesthetic and, it turned out, practical reasons [15], I selected the tool path for the *Umbilic Torus NC* to be a surface-filling curve (Figs 3 and 4). The parametric single domain for the vector valued function defining the *Umbilic Tori* is essentially a square. It is not enough to define this domain square with inequalities. To machine the torus, points within the square domain have to be accessed in an ordered path. This ordered path is to be followed by a cutting tool. The surface-filling curves offer effective ways of covering a single domain square and hence of covering the image object.

The Hilbert curve, which is a 2-adic version of Peano's suite of q-adic curves, is defined (up to scale) recursively by

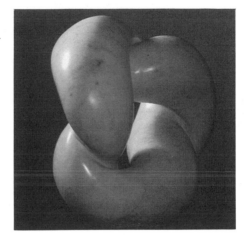

Fig. 12. Quarter view of the *Umbilic Torus NIST*. Note the cardioid cross-section devolving about the curve of cusps.

the following set of ordered points. Begin with $H[0] = (0, 0)$. Then for $n \geq 1$, define

$$H[n] = H[n-1] \cdot \begin{pmatrix} 0 & 1 \\ 1 & 0 \end{pmatrix}$$

$$\sqcup$$

$$\left(2^{n-1}, 0\right) + H[n-1]$$

$$\sqcup$$

$$\left(2^{n-1}, 2^{n-1}\right) + H[n-1]$$

$$\sqcup$$

$$\left(2^{n-1}-1, 2^n-1\right) - H[n-1] \cdot \begin{pmatrix} 0 & 1 \\ 1 & 0 \end{pmatrix}$$

where \sqcup is an ordered union of the sets of points. The straight line segments which join the points in order become space curves on the *Umbilic Torus NC* (Fig. 5) [16].

I encountered two difficulties with this NC technology: rigidity and scaling. The computer-driven milling machine is essentially a mindless robot, the tool path and trajectory have to be specified in complete detail in advance. While it can do certain kinds of elegant, accurate and reproducible work very well, it is very difficult to interrupt or reposition. After the programming is done you hope you like what you see. Once the general hardness, toughness, etc., of the material is to be cut is determined, the material is not relevant and not a part of the process. As for scaling, how big can a robot be? Milling machines tend to be built around

Fig. 13. Close view of the *Umbilic Torus NIST*. The natural veining of the Carrara marble is apparent.

the space in which they do the cutting; they do not reach out anywhere. They are profoundly expensive to build and maintain. The capital cost of equipment like the VB-2 used for the *Umbilic Torus NC* was between 1/8M\$ and 1/4M\$. This gives an active cutting region of 4 or 5 cubic ft maximum at a capital cost of 25K\$ per cubic ft.

The interactive aspect of NC milling of a three-dimensional object is limited to the computer-graphics previewing of the image, the tool path, the trajectory of the cutting apparatus.

VIP: VIRTUAL IMAGE PROJECTION

The concepts involved in the virtual image projection system were certainly motivated by the difficulties with rigidity and scaling described above. Addressing scaling, the active cutting region has increased to 27 cubic ft at a capital cost of 0.37K\$ per cubic ft. While there are sacrifices in accuracy in the present system, they are not there in principle [17].

The virtual image projection system offers the possibility of human interaction in a positive way. Software for selection of tool trajectories is difficult to develop and is not available in general. Yet the relative positioning involved in global tool trajectory selection is something humans are well equipped to do. Humans are less well equipped to do absolute quantitative positioning.

A virtual image projection system strengthens the latter and allows a wide range of interactive choices of when and where to approach the desired image. The software makes it very easy to reposition the virtual image after relocating the material. Also, the system is independent of any particular tool, so that a variety of tools can be used to address the material. This allows a sensitivity to the material, which is important for direct carving in natural stone. The process can be interrupted, new images superimposed, and 'quoted' in rescaled form.

The idea of the virtual image projector is simple yet powerful: invert a 3D digitizer. The computer is used as a kind of oracle. Inquiries are made about the location of the desired image, which can be thought of as present in the material. Specifically, give the computer the software capability of calculating the nearest distance from a point on the uncut material to the image. We will refer to the uncut material as 'the block' since the system has been used primarily for quantitatively carving stone.

On the ceiling of my studio is a fixed triangle with a string potentiometer at each vertex (Fig. 6). Three steel cables

under tension meet at a 'point' plectrum and can be pulled down to touch the block. The potentiometer outputs are digitized and the information interfaced with a Macintosh II personal computer. A foot mouse (rat) is used to click the points into the Mac II.

Three general position registration points are selected on the block (Fig. 7). These three points are labelled in some specific order. Three distinct labelled points in general position on a block suffice to determine the position and location of the block before and after a rigid motion. If the block is moved, then the three points are touched with the plectrum and clicked into the Mac II.

The three general position registration points in order can be thought of as rows of a 3×3 invertible matrix. The position and orientation of the block is implicit in this matrix. For example, think of the general decomposition of the $n \times n$ invertible matrices

$$GL(n, \mathbf{R}) = \Delta(n) \times D(n) \times SO(n)$$

into lower triangular unipotent, diagonal and orthogonal matrices, e.g. Gram-Schmidt orthogonalization. In the case of $n = 3$, dim $\Delta(n) = 3$ and dim $SO(n) = 3$ where the semi-direct product $\Delta(n) \times SO(n)$ corresponds to the group of rigid motions. There is software for relocating the three registration points on the block as well as for realigning the virtual image with the new block position (Fig. 8).

The virtual image in this application is resident in the Mac II in the form of parametric equations. An indication of how these parametric equations were designed is in the mathematical design paragraph above. Finding the right parametric equations to do specific things is nontrivial. The parametric equation set could be replaced by a previously digitized data set, systems of splines, nurbs, etc. The software includes an algorithm that calculates from any given point in space the nearest distance from that point to the virtual image.

Fig. 14. SP 2, a Stewart Platform structure coupling tool tip position and tool orientation with six digitized cable lengths.

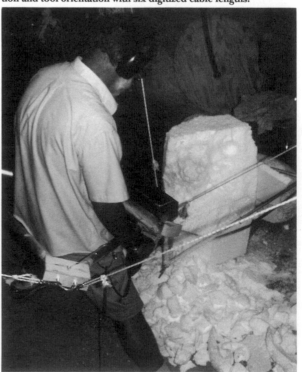

Given a point on the block and the nearest distance, one can safely remove an entire sphere of radius of that nearest distance, and center that point on the block. The closer to the virtual image one is, the smaller the sphere. In principle it does not matter what direction one drills from the point; in fact one drills short to account for the diameter of the drill (Figs 9 and 10).

The other side of the block has been quantitatively carved after drilling to an acceptable accuracy. With this equipment, accuracy can be achieved to a millimeter or two. This piece has some undercut features that were extrapolated. Three small registration holes that were drilled into the block were left as reminders of the quantitative origins of the piece (Figs 11–13).

FUTURE

The next generation of Virtual Image Projector, SP 2, scheduled to be installed in my sculpture studio for testing and evaluation, has six instead of three digitized cables. These are arranged in Stewart platform format (Fig. 14) [18]. The six cables terminate in pairs in the vertices of a ceiling triangle and in the vertices of a neutrally buoyant triangle with a rigidly affixed tool. The operator interactively flies the triangle. Tool tip position (x, y, z) coordinates and tool orientation (pitch, roll, yaw) are available from the digital readout mounted on the triangle. Software options include spatially parallel hole drilling to the depth of the virtual image. This system allows for an active cutting region (with undercuts possible) of 4 cubic yards at a capital cost of 0.25K\$ per cubic ft.

A 20-foot version of this Stewart platform with a chain saw attachment has been built at NIST. Larger systems with spans of hundreds of feet are feasible [19].

Acknowledgments

I wish to thank Professor Jordan Cox and his associates at the Robotics Laboratory, Crabtree Building, Brigham Young University, Provo, Utah, and Division Chief James Albus and his associates at Robot Systems, Computer Manufacturing Engineering, National Institute for Standards and Technology, Gaithersburg, Maryland, for their creative colleagial relationships.

References

1. Stewart Dickson, Chair, "The Third Dimension: It's Not a Virtual One", *Proceedings of ACM SIGGRAPH '91* (1991). Panel of Sculptors: Helaman Ferguson, Frank McGuire, Bruce Beasley, Rob Fisher, Stewart Dickson, Las Vegas, Nevada, 28 July–2 August 1991.

2. Helaman Ferguson, "Quantitative Direct Carving with the Albus-NIST Virtual Image Projector", Workshop at the University of Richmond, Sculpture Studio, Special Programs Building, 10 October, 1–3 p.m.

3. Michael Haggerty, "3D Mathematics in Wood and Stone", Charles A. Csuri, ed., *Displays on Display, IEEE Computer Graphics and Applications* 11, No. 5, 7–10 (1991).

4. James W. Cannon, "Mathematics in Marble and Bronze: The Sculpture of Helaman Rolfe Pratt Ferguson", *The Mathematical Intelligencer* 13, No. 1, 30–39 (1991) cover and 21 figures.

5. Ivars Peterson, "Equations in Stone", *Science News* 138, No. 10, 147, 152–154 (1990), cover and seven figures.

6. Helaman Ferguson, *Umbilic Torus NC*, Permanent Collections: The University of California at San Francisco, Medical School Library, Parnassus St., San Francisco, California; The Mathematical Association of America, 1529 Eighteenth Street N.W., Washington, D.C. 20007; Syracuse University, Department of Mathematics, Syracuse, New York; Chiron-Daiichi, Tokyo, Japan; Springer-Verlag, Heidelberg, Germany.

7. Helaman Ferguson, *Umbilic Torus NIST*, Permanent Collection: Institute for Defense Analyses, Alexandria, Virginia.

8. Helaman Ferguson, *Thurston Hyperbolic Knotted Wyes II*, 1500 lbs, Permanent Collection: Geometry Center, University of Minnesota, Minneapolis, Minnesota.

9. Helaman Ferguson, *Hyperbolic Figureight Knot Double Torus II*, 500 lbs, Permanent Collection: Mount Holyoke College, South Hadley, Massachusetts.

10. Helaman Ferguson, *Theorems in Stone and Bronze*, New York Academy of Sciences, 2 East 63rd Street, New York, New York, 10021, 2 May–16 July 1991.

11. Helaman Ferguson, *Umbilic Torus NC* and *Umbilic Torus NIST*, Infinite Illusions, exhibition at S. Dillon Ripley Center, The Smithsonian Institution, Washington, D. C., 10 September–10 October 1990.

12. Helaman Ferguson, *Theorems in Stone and Bronze*, The Marsh Gallery of the University of Richmond, Richmond, Virginia 23173, 10 October–10 November 1991.

15. Helaman Ferguson, "Two Theorems, Two Sculptures, Two Posters", *American Mathematical Monthly* 97, No. 7, 589–610 (1990), 75th Anniversary Issue of the Mathematical Association of America, cover and 16 figures.

16. For further details, see Dickson [1]; and Ferguson [15].

17. J. Albus, *A New Type of Robot Crane* (National Institute of Standards and Technology [NIST] 15 July 1991) preprint; J. Albus, H. R. P. Ferguson, S. L. P. Ferguson, et al., *String-Pot Measurement System* (National Institute of Standards and Technology [NIST], 1990) preprint.

18. See Albus [17].

19. See Albus [17].

On Knot-Spanning Surfaces: An Illustrated Essay on Topological Art

With an Artist's Statement by Brent Collins

George K. Francis with Brent Collins

In this essay I shall set forth basic vocabulary for a dialogue between artist and mathematician concerning certain kinds of mathematical art—in particular, the topological sculptures of Brent Collins. First, I establish some *coordinates* within aesthetic philosophy that will allow us to locate our subject relative to other mathematical art. Second, I introduce the language of topology and use it to analyze in some detail an early sculpture by Collins. In the course of this discussion, we will discover the true topological identity of the surface of this sculpture and its nonobvious affinity to another well-known piece of mathematical art.

As with all philosophy, it is appropriate to begin with some distinctions. There is 'implicitly' mathematical art and 'explicitly' mathematical art. In the former, the mathematical content or significance is chiefly in the 'eye of the beholder',

A B S T R A C T

The author discusses a type of visual mathematics known as topological sculptures, first by defining terms and ideas, and then by discussing the work of artist Brent Collins. An artist's statement by Collins is also included.

for the artist did not intentionally express mathematical ideas in an aesthetically informed manner. This does not mean that mathematical aspects in an implicitly mathematical artwork must be obscure, hidden or accidental. However, the mere use of spheres, regular polyhedra or spatial symmetry does not necessarily mean that the artist intended to impress some mathematical sense into his or her work.

Distinctions are best studied at their 'border'. Collins's sculpture is just on the explicitly mathematical side of it. Consider an artist's use of a natural or artificial form that has a long tradition in mathematical illustration—for example, a halved nautilus shell or a stellated dodecahedron. This is implicitly mathematical art if the artist intends to evoke a memory of mathematical cerebration, a flash of recognition. The same objects would be explicitly mathematical art if logarithmic self-similarity, in the first case, or Euclidean stereometry, in the second case, were the true subjects of the artwork. Compare Dürer's use of mathematical artifacts in *Melancholia 1* with his lesson on prospective geometry in his *Artist Drawing a Lute*.

Central to explicitly mathematical art is a second distinction that places such work along the spectrum of mathematical sophistication. At one end of this spectrum are subjects that are quite traditional, such as symmetry, Platonic solids and optical illusions, and subjects that are rather conventional, such as cubes, spheres, Möbius bands and the like. At the other end of this spectrum are mathematical diagrams, frequently called *schematic drawings*. The beauty of such explanatory illustrations is often in the eye of the beholder. Precision, information and lack of ambiguity are important here. I also exclude artworks that merely appear

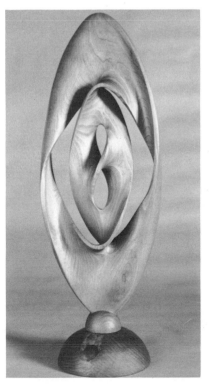

Fig. 1. Brent Collins, *One-Sided Surface with Opposed Cheiralities*, **oiled cedar, 30 × 12 × 4 in, 1984. This image shows a right-handed Haken surface spanning Listing's knot and with a disc removed.**

George K. Francis (descriptive topologist), Mathematics Department, University of Illinois, 1409 W. Green Street, Urbana, IL 61801, U.S.A.

Brent Collins (artist), RR #1, Box 146, Oakland, IL 61943, U.S.A.

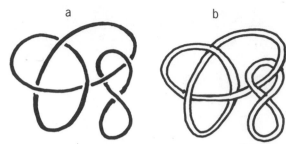

Fig. 2. Two ways of drawing an unframed link consisting of a trefoil knot and an unknot. (a) The 'interrupted underpass' convention is used for a left-handed trefoil simply linked to an unknot resembling a left-handed figure-8. (b) The 'thickened curve' convention is used for the right-handed trefoil.

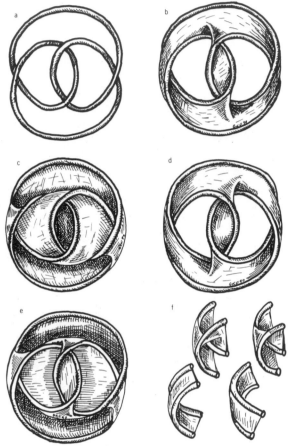

Fig. 3. (a) The figure-8 knot in a symmetric but peculiarly two-dimensional form. (b) A right-handed one-sided Haken surface spanning this knot. (c) An isotopic deformation of the surface shown in Fig. 3b. (d) A left-handed Haken surface spanning the knot. (e) The orientable surface spanning the figure-8 knot studied by Seifert [28]. (f) Half-twists of short ribbons illustrating graphic techniques.

mathematical to the observer—artworks in which the artist did not consciously impress a mathematical form into the work.

Let me describe the poles along this axis. An artificial object may be crafted in such a way that the abstract mathematical principle that it portrays can be unambiguously read from it. The artist makes the object appear to represent a phenomenon from which the principle could have been discovered empirically rather than through mathematical insight. I am referring to mathematical models, so popular

a century ago, that still grace the glass cases of a few mathematics departments in this world, as documented in Gerd Fischer's handsome volumes [1].

At the other extreme of this distinction, the artist, deeply involved with a profound mathematical theorem, fashions an impressionistic visual poem of undeniable aesthetic force. The mathematical initiate recognizes the theorem and is moved by the recollection of its significance. The lay observer senses the beauty but is puzzled by the meaning. This art form is rare—however, Anatoly T. Fomenko's imaginative chapter-title illustrations in the textbook *Introduction to Topology* [2] fit this category very well. The gamut of Fomenko's entire mathematical art is so vast that it defies easy classification. In his *Mathematical Impressions* [3] are representatives of all kinds of explicit mathematical art, from models to visual poems.

The work of Collins is somewhere *orthogonal* to Fomenko's, closer to implicitly mathematical art. It is intentionally mathematical at the level of precision, symmetry and definition, in terms of simpler constituent forms. In the process, Collins accidentally created beautiful mathematical models that serve more than one geometrical discipline. I next turn to his works, concentrating on their topological qualities. The metrical qualities will be considered in a subsequent study.

AN EXAMPLE OF MATHEMATICAL ART

Collins is a sculptor living in Oakland, a rural town in east central Illinois. He uses common shop tools, such as a hand-held router and a small, electric chainsaw, to fashion abstract shapes from single blocks of cedar wood. Many of his pieces are invariant under discrete spatial symmetry groups, and all of them involve continuously varying sectional curvatures. As a result, the precision and fidelity with which corresponding parts match, together with the subtle permutation of elementary constituent forms, are most attractive to mathematically educated viewers. Collins is not a mathematician.

The sculpture shown in Fig. 1 is representative of one of Collins's series of motifs. Apart from the base, it is clearly invariant under 180° rotations about all three principal axes—in a kind of three-dimensional (3D) playing-card symmetry. (For another example of this kind of symmetry, see Color Plate A No. 2.) Such symmetries are very helpful for inferring details of shape from only one picture. Naturally, it would be much more satisfactory to view the piece from all angles or, even better, to view it while rotating it manually.

The object is of uniform $1/4$-in thickness, and so may be regarded as a material realization of an abstract surface whose mathematical nature I shall explore presently. This abstraction does immediate violence to two further features of mathematical interest, the wood grain and the edge of the sculpture. The former has more aesthetic than technical value.

The wood grain frequently suggests the illustrations one finds in treatises on Morse Theory [4]. When the concentric cylinders of dicotyledonous wood are cut transversely by a plane, they form the familiar tree rings. Cutting by dome-shaped or saddle-shaped surfaces brings out the characteristic markings of a Morse function in the vicinity of its singularities.

The second feature has a technically highly interesting aspect that we shall ignore after this paragraph. From the sharp, uniformly $\frac{1}{4}$-in-wide edges of the artwork, we abstract closed, knotted and linked ribbons curving through space. The mathematical surface depicted by the artwork may thus be regarded as a spanning surface of a *framed link*. Rolfsen's *Knots and Links* is an authoritative treatment of this subject [5]. We shall ignore the question of how this ribbon is twisted along itself and consider the abstract surface ending along an unframed link (Fig. 2) as its border.

Collins's surface (see Fig. 1) has two border curves that are not linked. The little one in the center, shaped like the numeral 8, plays a special role. Imagine that the artist had not yet penetrated the center panel, but left a smooth sheet. This way, the surface spans a single, knotted curve. If it is carefully traced, it can be seen to be shaped like the knot shown in Fig. 3a. (As it will become necessary to compare the shapes in Fig. 3, they appear together in the same figure.) Collins's surface shown in Fig. 1, without the central detail, corresponds the surface shown in Fig. 3b. I shall discuss the significance of this surface later.

The knot spanned by Collins's surface shown in Fig. 1 goes by many names: *figure-8 knot*, *four-knot* and *Listing's knot*, whose namesake coined the term *topology* to describe the study of shapes and spatial transformations of abstract objects. This knot is a respectable character of an area of mathematics known, appropriately enough, as *knot theory*. Rolfsen's *Knots and Links* [6] is an ample portal to this fascinating kind of mathematics and its useful bibliography points to the remaining important references. However, a small subset of what there is to say about this knot can also be found in *A Topological Picturebook* [7].

A BRIEF TOPOLOGY LESSON

Wood is a rigid substance, so much so that it is difficult to imagine a surface carved from wood as having the quality of stretchable rubber. It also seems wasteful to forget the sensuous curvature Collins carves into his sculptures. Yet these operations are necessary for studying an object in topology. Two objects are topologically equivalent, or *homeomorphic*, if one can be distorted so as to correspond point for point with the other. Actually, this notion is more correctly a common description of an *isotopy*. The notion of topological equivalence is more generous, allowing for a temporary dismemberment of the object as long as corresponding 'rips' are faithfully 'sewn' together again. Moreover, an isotopy must be realizable in its entirety in space. A homeomorphism may be described piecemeal and unpictorially.

In deforming one topological object into an equivalent one, we do not allow knots to come apart, or surfaces to pass through each another. Within these tolerable restrictions, topologists have been able to solve the classification problem for knots and for the surfaces spanning them.

In order to understand just what it means to say that there are only six different surfaces spanning Listing's knot, we need to establish a few more notions from the topology of surfaces [8]. A surface is said to be *closed* if it has no boundary and fits into a finite portion of space. Thus a sphere is closed, as is a torus (Fig. 4a). There are infinite surfaces, with or without borders, such as a plane with or without a disc removed. Each portion extending to infinity is called an *end* of the surface. Among finite surfaces with borders, some are two-sided, such as a disc or a torus with a disc removed

(Fig. 4c). Some are one-sided [9], such as a Möbius band (Fig. 4b) or a Klein bottle (Fig. 4d).

(In addition to Fig. 1, Collins's piece in Fig. 7 is one-sided; the rest of his sculptures shown here are two-sided. The border curves of Fig. 8 naturally extend to infinity. Thus this may be regarded as a part of an infinite surface with three ends. The border curves of Color Plate A No. 2 and Fig. 9 look like the rims of discs that have been removed from two closed surfaces of higher *genus*.)

Compact surfaces, that is, finite surfaces that are either closed or bordered, are classified by three qualities: (1) by the number of component curves contained in their boundary, (2) by whether or not they are two-sided and (3) by an integer presently defined as the *Euler characteristic*. This means that any two compact surfaces are *topologically equivalent* or *homeomorphic* unless they differ in one or more of these qualities. This is the fundamental theorem of the theory of surfaces. To determine the orientability is a matter of tracing your mind's finger along the curve.

The Euler characteristic is more difficult to define. I shall first give an operational definition. Two other definitions follow. The disc, naturally, shall have Euler characteristic 1 [10]. Sewing two surfaces together along the entirety of a border circle on each produces a surface whose Euler number shall be the sum of the constituents. Hence, a sphere has Euler characteristic 2 (for the two hemispheres sewn on the equator), and the Euler characteristic of a surface decreases by one for each disc removed. Consistent with this is the rule that cutting across a ribbon increases the Euler characteristic by 1. Thus, the characteristic of a Möbius band is 0 (one less than that of the disc) [11].

Two surfaces can always be connected in the following way to produce a third surface. Replace two discs, one on each surface, by a cylindrical tube that connects their border circles. The result of such an operation is called the *connected sum* of the constituent surfaces. The Euler characteristic of the connected sum of two surfaces is two less than the sum

Fig. 4. (a) A torus, (b) a Möbius band, (c) another torus with a circular window removed and (d) a Klein bottle. The torus and the Klein bottle are closed surfaces; the Möbius band and holey torus have a single border curve. The Klein bottle and Möbius band are one-sided surfaces.

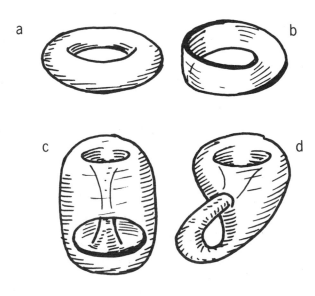

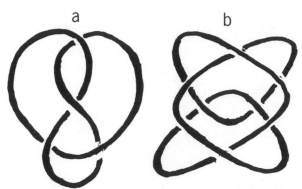

Fig. 5. Two further isotopes of Listing's knot. Two of its aliases, 'four-knot' and 'figure-8 knot' derive from its shape in (a). Its three-dimensional symmetries may be seen in (b), which is drawn in strong perspective.

of their Euler characteristics. Considering the flexibility of topological surfaces, it is easy to agree that the connected sum of a sphere with any surface does not produce a new surface at all. The sphere **S** acts like zero under this topological addition. Among closed surfaces the arithmetic is quite simple.

One must be careful to avoid an ambiguity when one connects a surface **F** to itself. The connection of two copies of the same surface differs from connecting a surface to itself. The latter surgery is equivalent to replacing two discs on a surface by a tubular handle. It is also equivalent to connecting **F** to a torus **T** (see Fig. 4a). The classification theorem for closed, two-sided surfaces states that every such surface is the connected sum of a certain number of tori. This number is called the *genus* of the surface. (For example, Collins's surfaces shown in Color Plate A No. 2 and Fig. 9 are homeomorphic to the connected sum of six, respectively four tori, each with six discs removed.)

There are closed, one-sided surfaces, but they are more difficult to imagine because they cannot be assembled in the 3D space of our experience. The simplest of these is called a *projective plane*, **P**, for historical reasons. Topologically speaking, this surface is a Möbius band sewn to a disc along the common boundary curve. Every good topology textbook will have instructions for visualizing this object [12,13].

We thus have a second elementary constituent surface, namely **P**. The connected sum of two copies of **P** yields a famous one-sided surface, the *Klein bottle* **K** (see Fig. 4d) [14]. A common way of visualizing the connected sum of a

Fig. 6. The double cover of a Möbius band is a two-sided ribbon with a full twist: (a) shown retaining the shape of the Möbius band, and (b) shown farther away from the (invisible) Möbius band so that its twists can be more easily counted.

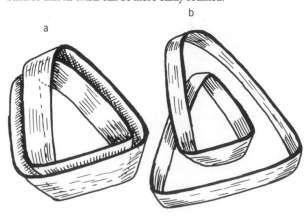

projective plane to a given surface is to remove a disc and sew a Möbius band back into the surface. Note how this operation subtracts 1 from the Euler characteristic. If this is too hard to imagine, try visualizing a structure like the one in the very middle of Collins's surface shown in Fig. 1 and then imagine a disc sewn in along the figure-8-like border. Either way, this feat of haberdashery cannot be completed in three-space unless the to-be-added patch is allowed to penetrate the already-existing surface. In the latter case, the resulting figure is called a *cross cap*. Thus, sewing in a cross cap invariably renders a surface one-sided, while attaching a handle does not alter this condition. All one-sided, closed surfaces are obtained as connected sums of projective planes [15].

Finally, there is a most curious and remarkable theorem connecting the sums of tori **T** and projective planes **P**, such that

$$\mathbf{F} + \mathbf{T} + \mathbf{P} = \mathbf{F} + \mathbf{P} + \mathbf{P} + \mathbf{P} = \mathbf{F} + \mathbf{K} + \mathbf{P}.$$

This theorem states that sewing three cross caps into *any* surface **F** is equivalent to sewing in a handle and a cross cap, or a Klein bottle and a cross cap. The simplest case is for **F** to be a sphere. Then **F** can be canceled from all three sums. This remarkable surface (which is at once a torus with a cross cap, a Klein bottle with a cross cap, and a projective plane with two cross caps) was discovered by Walther von Dyck [16] but is rarely called by his name. Dyck's surface has most recently been celebrated in marble and onyx by sculptor and mathematician Helaman Ferguson [17]. Remove two discs, and it becomes Brent Collins's surface shown in Fig. 1. That these two so artistically different conceptions are of the same topological reality was a strong motivation for my writing this article.

HAKEN SURFACES FOR THE FIGURE-8 KNOT

We say that a surface *spans* a set of one or more closed curves in space—a knot or link, respectively—simply when the curve(s) form the border of the surface. It is always a nuisance to work informally with collective terms. A link consisting of a single curve is a *knot*. A knot that is not knotted, is called *the unknot* by topologists. We say 'the' unknot because all unknots are isotopic. Unfortunately, it is not easy to think inclusively. Recall that all squares are rectangles, and rectangles are trapezoids, yet the word 'trapezoid' never conjures up a picture of a square in our minds.

At issue here is the fact that the same link may be spanned by different surfaces. One can form the connected sum of one spanning surface with any number of tori or projective planes. So, we seek, in some sense, the simplest surfaces spanning a given knot [18], for example, those surfaces that are not obtained from another one by means of connected summation. Thus there are exactly six *Haken surfaces* spanning the figure-8 knot.

One of them is not a bordered surface—it merely manages to pass for one on technical grounds. It is a tube that runs along the knot. Again, think of the knot as thickened (as it must be to correspond to a real object), and then think of the toroidal tube corresponding to the surface of this thickened knot (Fig. 3a). So far, the original knot is not even on this surface, it runs along the center, inside of the tube. Now push the knot out to the surface. It still cannot be said

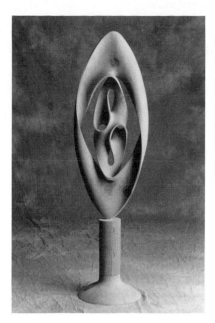

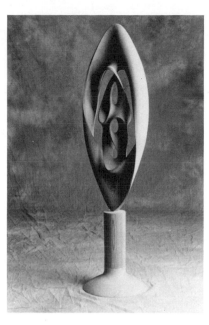

Fig. 7. Brent Collins, *One-Sided Surface with Efflorescent Centerpiece*, wood, 50 × 14 × 4 in, 1989. Both front and back views of this companion piece to Fig. 1 are shown to emphasize the pure symmetry expected of topologically significant art. Aesthetically, it is related to Collins's earlier piece by a variation on central connectedness. Topologically, it is quite different. This nonorientable surface spans a nontrivial link of two unknots. With a Euler characteristic of −6, it is too complex to be a Haken surface.

to be the boundary of the knotted torus (tori are closed surfaces) but the torus does qualify as spanning the knot under a more technical (and therefore more useful) definition of the term. There is no single way of pushing the original knot out to the surface of the tube. There are as many ways of doing this as there are framings for the figure-8 knot.

Three further Haken surfaces for the figure-8 knot can be readily drawn. These are the right-handed (Fig. 3b) and the left-handed Klein bottles with a disc removed (Fig. 3d), and the torus with a disc removed (Fig. 3e), studied originally by Seifert [19]. I use the irreverent neologism *holey surface* for such constructions; thus a disc is also a holey sphere [20]. The right-handed holey Klein bottle, seen in Fig. 3b, corresponds to Collins's surface shown in Fig. 1 [21].

Note that the knot projection used for Fig. 3d is the mirror image of the knot in Fig. 3a. The over- and under-crossings have been reversed. Sometimes this procedure changes the knot; when it does not, the knot is said to be *amphicheiral*. The figure-8 knot is amphicheiral; the common trefoil knot is not. By bending our knot into the shape shown in Fig. 5b, we can see how to move the figure-8 knot into its mirror image. A more difficult mental exercise is to imagine the deformation that takes the right-handed Haken surface as depicted in Fig. 3b to that of the view depicted in Fig. 3c.

The cheirality of the two holey Klein bottles may be read from the way the bridging ribbons twist (see the details in Fig. 3f). In Collins's surface shown in Fig. 1, they all twist to the right, except for the one in the center panel, which we are still ignoring. To check how a ribbon twists, imagine running a thumb and a finger along the two edges and noting whether the hand turns clockwise or counterclockwise. Three of the short ribbons twist to the left, while the one at '7 o'clock' twists to the right.

The Haken surface in Fig. 3e, spanning the figure-8 knot, twists both ways. Indeed it is two sided. Given our particular knot projection, it has to be drawn in this peculiar way to illustrate the topology unambiguously. In a sense, it is drawn in reverse perspective. Analogous features, the twisted bridges, become smaller as they come nearer. If this were a computer-graphics image, and we were to reverse the depth-

order in the *Z-buffer* [22], then we would obtain a view of Seifert's surface that extends more harmoniously in space. It would span the mirror image of our particular figure-8 knot. Unlike the case of the Klein bottles, these two Seifert surfaces are not actually different [23].

Figure 3 expresses the central problem of mathematical illustration. Realistically rendered objects that must remain faithful to the mathematics they display—whether drawn by hand or computer, or solid modelled of plaster, wood or stone—frequently make huge demands on the artistic abilities of the illustrator. I felt obliged to include the details shown in Fig. 3f to assist deciphering the drawings.

Among the six Haken surfaces, there are two more holey tori, one for each of the holey Klein bottles, from which they are obtained as follows [24]. A short, straight line-segment perpendicular to each point on a surface is called a *field of normal directions*. On a sphere, torus, disc or cylinder, there are two normal directions, one for each side of these two-sided surfaces. On a Möbius band, and hence on any surface that has a Möbius band running somewhere on the surface, there is globally only one such field. Locally, there are two representatives pointing in opposite directions. Suppose such a one-sided surface is split, and each point on it is simultaneously moved a little way out along both normal directions (Fig. 6). For an orientable surface, this operation produces two distinct, and usually linked, copies of the original surface. For a nonorientable surface, this operation produces an orientable surface that has an obvious 2:1 correspondence to the parent surface, called its *double covering*.

CONCLUSION

Collins's surface in Fig. 1, as we have seen, actually spans an 'unlinked link' consisting of an unknot, which looks like a figure-8, and Listing's knot, which is also called the figure-8 knot after the shape of the isotopic deformation of it. I have identified this surface as the right-handed nonorientable Haken surface spanning the figure-8 knot, but connected to a Möbius band whose border is the central unknot. It is thus an instance of Dyck's mysterious surface but with two discs removed. These two discs cannot be sewn into Collins's

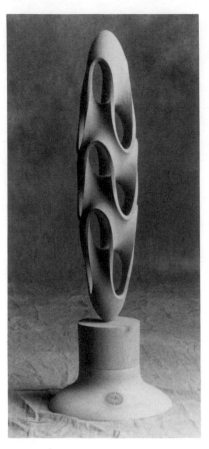

Fig. 8. Brent Collins, *Two-Sided, Trisymmetric Surface with Three Spanning Levels*, wood, 34 × 6 × 6 in, 1990. The three borders of this orientable surface of genus six are called 'ends' when, isotopically deformed to an area-minimizing surface, they extend naturally to infinity. The familiar Costa surface also has three ends, but has genus two. This is the initial piece of a series exploring surfaces that minimally span the interior of a border pattern drawn on the convex surface of ellipsoids.

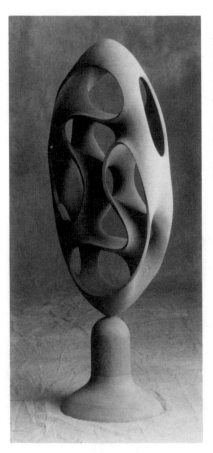

Fig. 9. Brent Collins, *Two-Sided Surface with Glyphic Pattern*, wood, 42 × 16 × 6 in, 1991. This sixth piece in the series breaks some of the symmetries. It is an orientable surface of genus four with six windows.

surface in Fig. 1 without penetrating it. Dyck's surface cannot be represented faithfully in our world [25]. Helaman Ferguson uses a different topological convention to evoke the presence of Dyck's abstraction in stone [26]. A kind of anatomical chart of Dyck's surface is in *A Topological Picture-book* [27]. These three examples, respectively, illustrate a passage from the familiar realm of implicitly mathematical art into that of explicitly mathematical art, which extends from its aesthetic to its utilitarian poles.

ARTIST'S STATEMENT BY BRENT COLLINS

I am a self-taught artist. After living and working quietly in the countryside for nearly two decades, I finally began bringing my sculpture to the attention of the science and mathematics community in the late 1980s. Given the mathematical sensibility of my work, I had long sensed a wedding of affinity, but it was not until then that I had come to feel I was achieving results persuasive enough to warrant this move. The dramatic surge of interest that followed and that, more than ever before, has given my work a niche, nonetheless was a surprise that nothing in my previous experience could have prepared me for.

Through the ensuing collaborations with scientists and mathematicians, I have gained a more specific and articulate awareness of the mathematical content of my work. This content originates in purely visual intuition, and the effort to subsequently become conscious of it in a way I can communicate in words has always been extremely difficult. At times I have nearly despaired of the very possibility. My collaboration with George Francis, in particular, has been critical for my understanding of the topologies of the two cycles of work I discuss at the conclusion of this statement. In one I did not realize at the time I created them that every composition was an elaborate nonorientable fabric of Möbius transitions, nor in the other, that I was intuitively approximating the logic of soap-film minimalization. And, at a more complex level, topologies such as these function as modules that are integrally woven into the high-order symmetries of the compositions themselves, bringing logical closure to the entire intuitive denouement.

In any event, my understanding of the mathematical content of my intuitive creations can only grow within the limits available to me as a nonmathematician. The more sophisticated thought that Francis employs as a professional is quite beyond this horizon. Therefore his analysis of one of my sculptural surfaces can only delight me as someone dazzled by the mathematical description of a seemingly exotic landscape otherwise familiar to me as my own creation. It is interesting, if not actually paradoxical, how forms amenable to highly abstract topological analysis can, at the same time, be emotionally and viscerally moving as art.

Actually I never intended to create mathematical artworks per se. What I have intuitively sought to create is sculpture of subtle analytic rigor and elegantly disciplined sensuousness that might in telling moments be cathartically restorative in aesthetic significance. The mathematical content of my work is simply that essential to this rigor, and is in turn necessarily intuitive in nature, since I do not have the formal literacy for it to be otherwise. In this sense, it is meant to serve the interests and ultimately be subsumed by the mystique of a larger aesthetic holism.

In the last several years, my work has undergone a metamorphosis. The earlier series of surfaces incorporated inte-

rior Möbius transitions that are woven into complexes through the continuities and/or intersections of their ribbon edges, which in furthest peripheral extension are also spanned by the exterior contours of these sculptures. The piece that Francis analyzes here in depth (see Fig. 1) is one of the earliest expressions of this motif (see Fig. 7 for a later work). All the sculptures in this cycle are one-sided inasmuch as every point on their broad surfaces can be connected by a continuous line to every other point, without crossing the ribbon edges formed by the uniform ¼-in thickness of the surfaces. Now I am working on a series of two-sided ellipsoidal pieces from whose ribbon edges three-dimensional linear patterns can be easily abstracted (see Figs 8 and 9 and Color Plate A No. 2). Since these edges conform to the exterior contour of the ellipsoid, we may think of this abstracted linear tracery as though simply drawn on the exterior itself. In these pieces, these linear patterns are then spanned through otherwise hollow interiors by ¼-in-thick surfaces tending toward collapse into a soap-film minimalization of saddle networks—though some positive exterior curvatures are kept to sufficiently preserve the enclosing ellipsoid.

For each sculpture in this latter series, I drew linear templates to scale, which were nothing more than 'cartographic' projections of the linear tracery abstracted from their ribbon edges. I began each piece by transcribing the linear pattern of its template in sequenced segments onto the plane surfaces of the large sawn timbers that I carve. In theory, the entire mathematical logic of a sculpture is legibly present in its template. However, there are a number of choices relating to aesthetic subtlety in the expression of this logic that can only be deciphered as the work progresses. From the template alone, I am only able to glimpse the desired gestalt of a sculpture's definitive resolution. In this way, the template does serve as the key to a spatial logic I intuitively follow. As I proceed, I am gradually able to feel and perceive its visual implications in a more focused way, occasionally pausing when necessary to wait for the process to further emerge before continuing.

References and Notes

1. G. Fischer, *Mathematical Models* (Braunschweig: Verlag Vieweg, 1986).

2. Y. Borisovich, N. Bliznyakov, Ya. Izrailevich and T. Fomenko, *Introduction to Topology* (Moscow: Mir, 1980).

3. A. Fomenko, *Mathematical Impressions* (Providence, RI: American Mathematical Society, 1990).

4. J. Milnor, *Morse Theory, Annals of Mathematics Studies* **51** (Princeton, NJ: Princeton Univ. Press, 1963).

5. D. Rolfsen, *Knots and Links* (Berkeley, CA: Publish or Perish, 1976).

6. Rolfsen [5].

7. The particular projection of the figure-8 knot used in this article (Fig. 3a) appears in G. Francis, *A Topological Picturebook* (New York: Springer-Verlag, 1987) p. 150. It is pictured there in the middle of the deformation or isotopy from the projection that gives the knot its name (Fig. 5a) to the projection that best shows its symmetries (Fig. 5b). Later in the *Picturebook* are the six Haken surfaces that span this knot. One of these is isotopic to Collins's surface shown in Fig. 1, without the central perforation. For the convenience of the reader, I have redrawn the Haken surfaces so that they look suspended from the figure-8 knot projection closest to Collins's outer border curve shown in Fig. 1. This is treated more completely in the article.

8. For a technical exposition, see J. Stillwell, *Classical Topology and Combinatorial Group Theory* (New York: Springer-Verlag, 1980) p. 69ff.

9. Topologists prefer to use the term 'orientable' for two-sided surfaces, and 'nonorientable' for one-sided surfaces. The reason is subtle and worth considering. The sides of a surface are apparent from a vantage point in a space in which the surface is located. This option is not available to a hypothetical being living entirely in the surface. Such a being might discover its space to be one-sided if a right-handed figure could be matched with a left-handed mirror image of itself, by taking the right-handed figure on a 'roundtrip'

through the surface. For such a one-sided surface, there would be no consistent way of defining model orientations throughout the surface. It was August Möbius who discovered this intrinsic distinction between surfaces. He illustrated this discovery by means of the closed surface obtained by sewing a disc to the single border of the band we now call by his name.

10. Of course, a square is topologically no different than a disc, nor is a triangle, a rhombus or a trapezoid. Hence a very long triangle, a ribbon, has Euler characteristic 1 also. Different branches of geometry may be characterized by what they consider to be inessential. Certain features of objects that are commonly held to be distinct will fail to differentiate these objects within the more abstract disciplines of topology. For *combinatorial topology*, the number of corners matters, and a triangle would no longer be considered equivalent to a rectangle. The Euclidean geometry studied in high school is the most rigid, in that even the size and shape of two rectangles must be the same for them to be *congruent*.

11. There is a more persuasive way of defining Euler's number, but it requires the surface to be 'triangulated'. This means that the surface is marked by a network of lines called 'edges', meeting at points called 'vertices', such that the complementary patches, called 'facets', are bounded by exactly three edges. Among the universally familiar Platonic polyhedra, the tetrahedron, the octahedron and the icosahedron are triangulated by their natural edges and vertices. The cube (hexahedron) becomes triangulated once each square face is marked by a diagonal. The 12 pentagonal faces of the dodecahedron would have to be similarly subdivided to obtain a triangulation. The Euler characteristic is the number of vertices plus the number of facets, minus the number of edges. An excellent mental exercise is to check that each Platonic polyhedron has Euler characteristic 2. Hence, each is, topologically speaking, the same as a sphere. Amateur topologists may notice that this way of counting vertices, edges and faces remains constant even if the subdividing diagonals are discarded again, leading to the same definition for a more general class of marked surfaces, the polyhedra. Next, calculate that the Möbius band, finite cylinder, torus and Klein bottle all have characteristic zero. Note how the other qualities, namely the number of borders and the number of sides, serve to distinguish these surfaces.

12. Two classical sources were deemed sufficiently important to the public interest that they were republished by the Attorney General of the United States. See D. Hilbert and S. Cohn-Vossen, *Anschauliche Geometrie* (Berlin: Julius Springer Verlag, 1932); published in English as *Geometry and the Imagination* (New York: Dover, 1944). See also H. Seifert and W. Threlfall, *Lehrbuch der Topologie* (Leipzig: Verlag Teubner, 1934); published in English as *Textbook of Topology* (New York: Chelsea, 1947) and (New York: Academic Press, 1980).

13. For a systematic introduction to the field, see Stillwell [8]. This volume, handsomely illustrated by author John Stillwell, is also an update of Seifert and Threlfall [12].

14. For conventional renderings of the Klein bottle, see Hilbert and Cohn-Vossen [12] p. 272f; Seifert and Threlfall [12] p. 13; Francis [7] p. 118; and Stillwell [8] p. 65.

15. We can now state yet another convenient way of computing the Euler characteristic. For an orientable surface obtained from a sphere by removing *d* disks, the characteristic is 2 − *d*. If *h* pairs of these holes are connected by a tube, we obtain an orientable surface with *h* handles, *b* = *d* − 2*h* borders, and characteristic 2 − 2*h* − *b*. If *k* additional holes are plugged by sewing on cross caps, leaving only *b* = *d* − 2*h* − *k* free border curves, the Euler characteristic is now 2 − 2*h* − *k* − *b*.

16. Every respectable topology text has a proof of this theorem, but it is not always easy to understand the argument—for example, see Seifert and Threlfall [12]. A rigorous and modern exposition can be found in Stillwell [8] p. 68. An easy-to-follow picture-proof is found in Francis [7] p. 118. The original paper is W. v. Dyck, "Beiträge zur Analysis Situs I", *Math. Ann.* **32** (1888).

17. See I. Peterson, "Equations in Stone", *Science News* **138**, No. 10 (1990) p. 264 and cover picture.

18. A geometer would have a different notion of a *geometrically* simplest spanning surface: one that, like a soap film, minimizes some measurable quantity, such as surface area. The correct topological notion was defined by the distinguished solver of intractable topological problems, Wolfgang Haken, who calls them 'incompressible and boundary incompressible surfaces'. See also in this issue, F. Almgren and J. Sullivan, "Visualization of Soap Bubble Geometries".

19. See H. Seifert, "Über das Geschlecht von Knoten", *Math. Ann.* **110** (1934).

20. For a recipe for figuring out how to draw these surfaces for a particular rendition of the figure-8 knot, see Francis [7]. In that volume, I chose the classic projection of a figure-8 knot shown in Fig. 5a.

21. For purposes of comparison, see Francis [7] p. 158, which shows the right-handed holey Klein bottle at row 3 places 1 and 2. Row 3 place 3 and row 4 place 1 are isotopes of the holey torus, as illustrated also on p. 156 of that volume. The left-handed holey Klein bottle is shown in the center of the bottom row.

22. Z-buffer is the mechanism whereby a graphics computer overwrites only those pixels that represent points *nearer* to the observer than those already drawn. This is an eminently practical way of drawing surfaces in any convenient order, and not by drawing the farthest ones first, as in the painter's algorithm.

23. For an illustrated description of how the deformation of one Seifert surface into the other fills up three-space, see Francis [7] chapter 8.

24. Strictly speaking, the physical surface of Collins's 'one-sided' surface (Fig. 1) is mathematically two-sided. One faces the outside world, the other faces the wood. Its border is also the border of the thin ribbon that is the sharp edge. This happens to be a Möbius band along the figure-8 knot but a two-edged ribbon along the little unknot in the center panel. Thus the physical surface, minus the edges, is a Klein bottle with three discs removed. If Fig. 3b and 3d are understood to represent physical objects with real thickness, then I have also drawn pictures of the two holey Klein bottles.

25. Topologists call the placement of an abstract surface into space an *embedding* if no two points of the surface occupy the same point in space. Thus a Möbius band can be embedded in space (Fig. 4b) but a projective plane, which is a sphere with a cross cap, cannot. No one-sided closed surface can be embedded in outer space, for otherwise we could distinguish its 'inner' side from its 'outer' side. There is, however, sufficient room in four-dimensional space to embed all of the one-sided closed surfaces. Cross cap and Klein bottle reside there as cleanly as sphere and torus do in our three-space. That is a story that has been told many times elsewhere—most recently, and perhaps most successfully, in Thomas Banchoff, *Beyond the Third Dimension* (New York: Freeman, 1990).

26. Dyck [16].

27. Francis [7] p. 101.

28. Seifert [19].

The Topology of Roman Mosaic Mazes

Anthony Phillips

To the memory of my father,
John Goldsmith Phillips,
1907–1992

Floor mosaics were a common form of interior decoration in Roman times, and a maze pattern was a perennial theme: the remains of some 57 maze-patterned Roman mosaic floors have been discovered, scattered over the territory of the Roman Empire from England to North Africa, and with assigned dates ranging from the first century B.C. to the fourth century A.D.

These mazes were catalogued in 1977 by Wiktor Daszewski, whose work *La Mosaïque de Thésée* [1] is my fundamental reference, along with Hermann Kern's encyclopedic *Labyrinthe* [2], which contains, in addition to all of those documented by Daszewski, another five items, [K:124a, 124b, 126, 132a, 162]. In general, I will refer to each mosaic maze both by its number in Daszewski's catalogue [D#*m*] and its figure number [K:*n*] in Kern's work.

Most of these 57 mosaic floors are still accessible today, although some have been wrecked and others were never more than fragments. In particular, there are five cases ([D#14, K:142], [D#35, K:152], [D#37, K:156], [D#54, K:165], [D#59, K:163]) in which a maze was dug up, drawn and then lost or destroyed; [D#6] has disappeared without being drawn; two English mazes [K:124a, 124b] were drawn and are now covered over; an Algerian maze [D#3, K:130] was photographed but its current state was unknown to my references; two mazes [D#5,13] are known or suspected to exist but information about them is incomplete or unavailable.

In this article we will study the 46 mazes that are well preserved and/or well documented enough in the two references for the maze-path to be intelligible. (There are cases in which ambiguities might have been resolved by access to better photographs or to the mazes themselves; I hope to return to these cases in the future with better documentation.) In particular we will examine the *topology* of these mazes, those properties that depend only on the relative position of the elements of the maze and are independent of whether the maze is large, small, round, square, and so forth. The idea of a classification of maze-path types goes back to Daszewski; the work presented here may be viewed as an elaboration and quantification of his work.

Because these mazes are unicursal (without bifurcation), the maze paths themselves have no interesting topology. But these mazes have the following additional property: the path lies on a certain number of distinct levels. We will consider two mazes to be topologically equivalent if one can be changed to the other by a *level-preserving* deformation. Then we will find that these mazes fall into 25 distinct topological types, which in turn can be built up out of seven elementary submazes. This understanding will allow us to reconstruct, on paper at least, some of the mazes that have been partially destroyed, and to detect instances of faulty restoration in some of those that appear more or less intact today.

ABSTRACT

The 46 Roman mosaic mazes that are well preserved and/or well documented enough for the maze-path to be intelligible fall into 25 distinct topological types, which in turn can be built up out of seven elementary submazes. This understanding allows the theoretical reconstruction of some of the mazes that have been partially destroyed and signals instances of faulty restoration in some of those that appear more or less intact today.

Anthony Phillips (mathematician), Mathematics Department, State University of New York, Stony Brook, NY 11794–3651, U.S.A.

Fig. 1. The Cretan maze drawn from a nucleus consisting of a cross, four L's and four dots. Beginning at the bottom, each free end is joined, around the bottom, to the next free end on the opposite side.

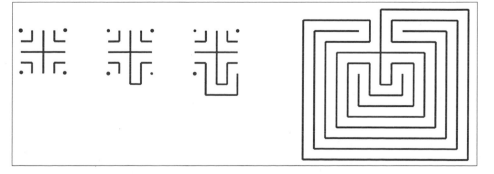

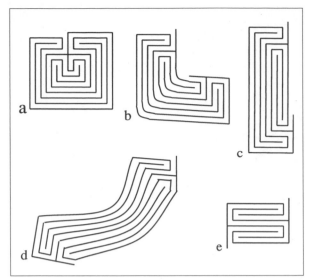

Fig. 2. The Cretan maze (a) is split down its axis and deformed through stages (b), (c), (d) to its unrolled form (e).

THE CRETAN MAZE

The simplest [D#49, K:119] and the oldest [D#62, K:160] mosaic mazes extant today are already essentially perfect forms. We have no record of the work that went into developing this concept, but there is a related class of figures going much farther back in history: various forms of the famous Cretan maze.

The earliest illustrations of this maze that can be securely dated are a pair of figures [K:102] on a clay pot from Tell Rifa'at, Syria (dated before 1200 B.C.), and a doodle [K:104] scratched on the back of a clay accounting tablet in King Nestor's palace in Pylos (Western Greece) and hardened by fire when the palace burned down around 1200 B.C. According to Kern, the scratchmarks in the second example strongly suggest that this maze was drawn from a nucleus as seen in Fig. 1 (see [K:6]). The game of drawing this nucleus

Fig. 3. Elementary meander mazes and how they are stacked. In this figure each maze is represented by its maze-path; the walls are not shown. (a) γ_2; (b) γ_4; (c) γ_6; (d) γ_8; (e) γ_{10}; (f) γ_{14}; (g) α_{10}; (h) γ_2^6; (i) γ_4^3; (j) γ_6^2.

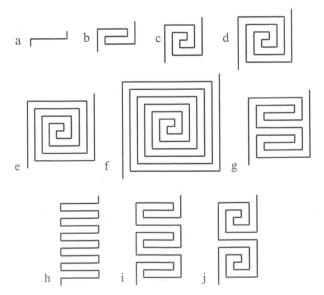

and completing it to a maze is still played today [3]. For future reference, note that if we number the levels in the maze-path beginning with zero on the outside and ending with 8 in the center, the thread through the maze will traverse these layers in the order 0 3 2 1 4 7 6 5 8. It turns out that this *level sequence* completely determines the topology of the maze, in the following sense. If we consider just the class of mazes that share with this design the following three properties: (1) there is a single path that runs from the outside to the center; (2) the maze is organized on concentric levels that we may number from zero on the outside to n, the *depth* of the maze, in the center, and the path fills out the levels one at a time; (3) the path changes direction whenever it changes level; then any maze with level sequence 0 3 2 1 4 7 6 5 8 can be deformed, without changing the relative position of the walls, to coincide with the figure from Nestor's palace or its mirror image. These mazes may be called *simple alternating transit mazes,* or SAT mazes. Their structure is analyzed more systematically in other sources [4].

The form of this maze has come to be called the Cretan Maze because of its association with Crete and with the legend of the Minotaur. It appears on coins minted for the Cretan city of Knossos [K:52–58], dating from 500 B.C. down to Roman times. This form was known to the Etruscans [K:112] and to the Romans, as can be seen by its appearance in graffiti on the walls of Pompeii [K:107,108] and in two of our mosaics ([D#17, K:147] and [K:126]).

The coins of Knossos bear at least two other designs relevant to this study. One [K:50] is the four-level maze with level sequence 0 3 2 1 4. It appears on a coin dated circa 431–350 B.C. and is evidence that the Cretans had gone beyond the labyrinth game to analyze the structure of the Cretan maze, because in fact the Cretan maze can be realized as two copies of 0 3 2 1 4, one nested inside the other. This example strongly suggests that the principle of combining mazes by unrolling (Fig. 2) and stacking (Fig. 3) was already understood at the time this coin was made. Otherwise it is difficult to understand how the second, smaller maze and its symbolic interchangeability with the first could have been discovered, since simplifying the game itself leads to the trivial maze 0 1 2 3 4, as in [K:6C]. As we shall see, this fact was certainly understood by the Roman mazemakers; the example points to an earlier understanding. Once the mazes are unrolled, it becomes obvious that they are intimately related to, and perhaps derived from, the meander patterns ubiquitous in primitive decoration. It should be noted that meanders and mazes appear interchangeably on the earliest coins from Knossos: a maze, a swastika-meander, a meander-frame (see below) all may occur, but never more than one form on any given coin, suggesting strongly that the three were equivalent symbols for the Labyrinth. Above all, it is remarkable that (see Fig. 3) *all the mazes occurring in antiquity are meander mazes.* (Since I will be arguing that many of the mazes have lost their original form, this needs to be clarified: every Roman mosaic maze that has survived intact is a meander maze, and I will make the case that the mazes that do not appear to be of this type fail to do so because of faulty restoration or recording.)

A second relevant design from Cretan coins [K:45, 46, 49] is shown on the left of Fig. 4. Kern calls it a 'swastika-meander'. This figure hints at the possibility that the linking of several SAT mazes into a larger, cyclic configuration, which as we shall see is the standard organizing principle for Roman mosaic mazes, was also of Cretan origin. This swastika-meander may in fact be read as the maze-path of

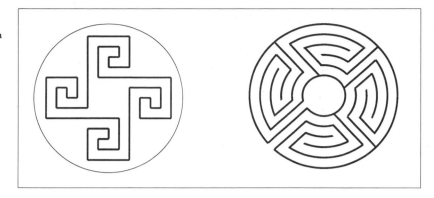

Fig. 4. (left) The 'swastika-meander' from a Cretan coin (reversed for comparison), with (right) the plan of the Roman mosaic in Avenches, Switzerland. The meander gives the exact path through the maze, except for the entrance and exit corridors.

four unrolled 0 3 2 1 4 mazes linked in a circle, almost exactly the plan of the Roman mosaic maze at Avenches, Switzerland [K:119]; only the entrance and exit corridors are missing.

THE 'STANDARD SCHEME'

Whether or not the Romans inherited this organizing principle from the Cretans, it seems that they came up with the idea of adding an extra corridor to give the maze-path two ends—one outside, one inside—and of choosing the repeated submaze from a wide range of SAT mazes. Cretan echoes include the number of copies used (still almost always four), the more-or-less symbolic representation of the fight between Theseus and the Minotaur (a frequent central element), and the typical framing of the entire maze by a crenelated wall with towers and gates, the line of the crenelation recalling the meander-frames that occur as yet another labyrinthine element on the coins of Knossos [K:42, 47, 48]. This *standard scheme,* which occurs in 42 of our 46 examples, has the submazes arranged radially around the central area (Fig. 5), so that their entrances are towards the center. The maze-path enters midway along one side, runs up to the wall enclosing the center, turns and enters the first of the submazes. After traversing the first maze, the path runs back towards the center, to the top of the second, and so forth. After traversing the last maze, the path runs again back to the center, and this time enters it. The overall path may run clockwise or counterclockwise. This scheme is explained by Daszewski [5]. The large maze at Mactar, Tunisia [D#57, K:143], has a variant appropriate for its semicircular, two-sector design.

Metaphorical explanations for this design, beyond its explicit connection with the Theseus myth, lead one into fascinating speculation [6]. Its decorative potential, however, is clear. The bulk of the floor area is covered with black (usually) and white square tiles laid in straight lines, with (usually) the freeform polychrome work reserved for the center. Most of this mosaic was therefore no more expensive to lay than the checkerboard pattern in a bathroom floor. But thanks to the maze design, this large black-and-white area can be read for an intricate, global meaning. (There is a small set of particularly lavish examples, [D#8, K:137], [D#11, K:136], [D#43, K:141], in which the walls or the path are indicated by a multicolored braid.) The division of the maze into consecutive sectors gives the plan an overall intelligibility, besides forcing the path into a large-scale meandering motion superimposed on that of the submazes themselves. That the division into four quadrants is arbitrary is attested by the existence of an eight-sector example [D#50,

K:132] and a three-sector one [D#60, K:133]. Clearly four is most natural when the overall shape of the maze is rectangular (in fact the eight-sector maze is round, and the three-sector hexagonal) but the Romans do seem to have preferred four sectors (the round, labyrinthiform decorative relief [K:113a] and the other eight round mazes, [D#8, K:137], [D#9, K:139], [D#14, K:142], [D#18, K:120], [D#44, K:161], [D#49, K:119], [D#56, K:131], [K:162], all have four sectors, while [D#57, K:143], mentioned above, is a semi-circular maze with two sectors).

THE POMPEIAN VARIATION

In the standard scheme with four sectors, the overall maze design had almost perfect four-fold rotational symmetry. It is only 'almost' perfect because the side holding the entrance gate has two paths running towards the center (the path going from the entrance to the top of sector 1, and the path from the bottom of sector 4 to the center), whereas each of the other three sides only has one. The maze-plan of the fountain [K:114] has a similar problem. An ingenious solution was found in a series of Italian mazes of the first centuries B.C. and A.D.—[D#25, K:151], [D#28, K:129], [D#30, K:153], and [D#36, K:155] (House VIII 2 16, shown in Fig. 6)—and in my reconstruction [D#35, K:152]. The earliest are in Pompeii. The first three sectors are arranged as in the standard scheme, but the fourth sector contains a different submaze, one in which the path enters *and exits* through the top [7]. This submaze was constructed so that along its edges it almost exactly matches the maze it replaces, so on cursory inspection the entire design seems exactly symmetrical. It is important to understand the contribution

Fig. 5. The 'standard scheme' in which four copies of a simple alternating transit maze are incorporated into a single design.

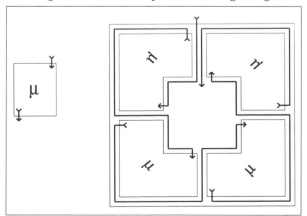

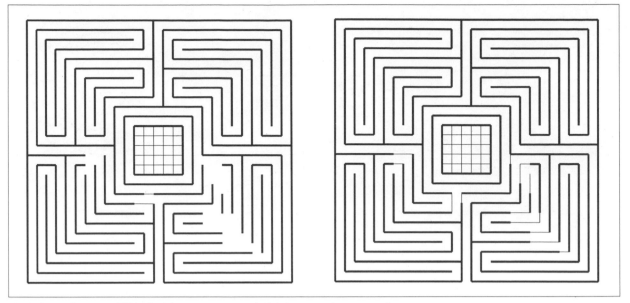

Fig. 6. Pompeii, House VIII 2 16: (left) current state and (right) proposed reconstruction.

of the artist/engineer who devised this alternative topology. This was not an impromptu modification of just one maze. Not only was it copied in several examples, but the theoretical principle involved was used to symmetrize two different designs (and, very likely, a third). (See my analysis of the maze in the Villa di Diomede [D#35] below.)

Every intact Roman mosaic maze follows the standard scheme or its Pompeian variation. The mazes we know of that do not follow this scheme have all been lost or damaged,

and I will argue that they only fail to follow the scheme because of incorrect repairs, in the case of those damaged, or incorrect recording, in the case of those lost. There are four exceptions: two Cretan-type mazes [D#17, K:147] and [K:126], the great double maze at Pula [D#61, K:158] and one of the two six-level mazes in [K:162], which seems in fact to have been incorrectly laid.

DECOMPOSITION INTO ELEMENTARY MAZES

The submazes in Roman mosaic mazes can be analyzed further into elementary mazes, which are composed into larger mazes by the same nesting operation that makes 0 3 2 1 4 7 6 5 8 out of two 0 3 2 1 4's. In the unrolled form, nesting becomes stacking, where the maze $\mu\mu'$ is formed by identifying the bottom layer of μ with the top (zeroth) layer of μ'. The elementary mazes that occur are shown in Fig. 3: these are the meander mazes $\gamma_2 = 0\ 1\ 2$, $\gamma_4 = 0\ 3\ 2\ 1\ 4$, $\gamma_6 = 0\ 5\ 2\ 3\ 4\ 1\ 6$, $\gamma_8 = 0\ 7\ 2\ 5\ 4\ 3\ 6\ 1\ 8$, $\gamma_{10} = 0\ 9\ 2\ 7\ 4\ 5\ 6\ 3\ 8\ 1\ 10$, $\gamma_{14} = 0\ 13\ 2\ 11\ 4\ 9\ 6\ 7\ 8\ 5\ 10\ 3\ 12\ 1\ 14$ (γ_{12} does not occur in this corpus) and $\alpha_{10} = 0\ 9\ 6\ 7\ 8\ 5\ 2\ 3\ 4\ 1\ 10$. (The maze γ_2 is not elementary in the same way as the others, since it can be written as $\varepsilon\varepsilon$, or ε^2, where ε is the one-level maze 0 1; in this corpus, however, ε always appears to an even power, and the γ_2 notation is more appropriate in this context.) In Daszewski's classification, powers of γ_2 are described as *serpentins*, powers of γ_4 (and also α_{10}) as *en méandres*, and the higher γ's as *en spirale*.

Table 1 enumerates the different submazes that occur, with their frequency; the five Italian mazes mentioned above are represented by their regular sectors. Not listed in this table are the two occurrences mentioned above of the Cretan maze itself, a round one [K:126] and a unique rectangular one [D#17, K:147]. Note in this table that the unrolled form of the Cretan maze, i.e. $\gamma_4^2 = 0\ 3\ 2\ 1\ 4\ 7\ 6\ 5\ 8$, is by far the most frequent, and that the various powers of the Cretan and half-Cretan maze ($\gamma_4 = 0\ 3\ 2\ 1\ 4$) account for 25 of the 39 examples. This fact underlines the intellectual continuity between the mazes on the coins of Knossos and these mosaic examples.

Table 1. Frequency of submazes occurring in standard-scheme Roman mosaic mazes. Not counted here are two mosaic mazes of pure Cretan type [D#17, K:147], [K:126] and the irregular double maze at Pula [D#61, K:158].

sub-maze	depth	number of examples
γ_2^2	4	1
γ_4	4	3
γ_2^3	6	1
γ_6	6	1
γ_2^4	8	2
γ_4^2	8	14
γ_{10}	10	1
γ_4^3	12	6
γ_6^2	12	1
$\gamma_6\gamma_8$	14	1
γ_{14}	14	1
γ_2^8	16	2
γ_4^4	16	4
γ_6^3	18	1
γ_4^5	20	2
α_{10}^2	20	1
Total		43

We may now describe the Pompeian variation more explicitly. When the first three sectors have $\gamma_4^2 = (0\ 3\ 2\ 1\ 4)$ $(0\ 3\ 2\ 1\ 4) = 0\ 3\ 2\ 1\ 4\ 7\ 6\ 5\ 8$, the standard fourth sector can be written as $0\ 3\ 2\ 1\ 4\ 7\ 6\ 5\ 8\ -1$, the $8\ -1$ representing the path into the center, while the Pompeian variation has $0\ 1\ 4\ 5\ 8\ 7\ 6\ 3\ 2\ -1$: the path is a γ_2^2 traced down and back, performed so to speak in augmentation. When the first three sectors have γ_4^3 and the standard fourth sector is $0\ 3\ 2\ 1\ 4\ 7\ 6\ 5\ 8\ 11\ 10\ 9\ 12\ -1$, the variation has $0\ 1\ 4\ 5\ 8\ 9\ 12\ 11\ 10\ 7\ 6\ 3\ 2\ -1$ (a doubled γ_2^3). If in fact the maze in the Villa di Diomede [D#35, K:152] was of this type, its fourth sector was $0\ 1\ 4\ 5\ 8\ 9\ 12\ 13\ 16\ 15\ 14\ 11\ 10\ 7\ 6\ 3\ 2\ -1$, and not the $\gamma_4^4 = 0\ 3\ 2\ 1\ 4\ 7\ 6\ 5\ 8\ 11\ 10\ 9\ 12\ 15\ 14\ 13\ 16$ shown in the picture.

Table 2 analyzes the corpus of known Roman mosaic mazes with legible maze-paths. I give for each maze the topological type of the path: $4 \times \gamma_4^2$ means a standard scheme with four linked copies of $0\ 3\ 2\ 1\ 4\ 7\ 6\ 5\ 8$, etc. The Pompeian variation is signalled by an asterisk (*). (Note that [D#57, K:143] is not quite standard, see the remarks above.) I also indicate whether, according to my analysis, there have been errors made in restoration, or in the recording of mazes that no longer exist. Each of the erroneous mazes will be analyzed in the next section.

ERRORS IN EXECUTION, RESTORATION, REPRESENTATION OR INTERPRETATION

Mosaics, while made of relatively indestructible material, are quite fragile; they share these qualities with pottery, but whereas the shards of a pot can usually be reassembled in only one way, once tiles get scrambled the pattern is lost. Several of the mazes in the form we know them today contain gross errors in the path layout. An entire sector may be inaccessible, or the maze may lack an entrance, an exit, or both. Since these were large, beautiful works, whose execution implies both artistic talent and engineering ability, it is very unlikely that this was their original condition. Daszewski gives a fascinating account of an ancient repair in the great Kata Paphos maze [D#8, K:137], noticeable on close observation because it occurred in the central pictorial

Table 2. The 46 Roman mosaic mazes of this study, in their order from Daszewski's catalogue [13], along with their figure number in Kern's book [14]. Each is listed with its topological type, and indicates whether errors have been made in execution, restoration, representation or interpretation.

D#	K:	Type	Errors?	D#	K:	Type	Errors?
1	118	$4 \times \gamma_4^2$	yes	37	156	$4 \times \gamma_4^2(*)$	
2	123	$4 \times \gamma_4^2$		41	167	$4 \times \gamma_6^2$	yes
3	130	$4 \times \gamma_{14}$		43	141	$4 \times \gamma_4^2$	
4	116	$4 \times \gamma_{10}$		44	161	$4 \times \gamma_2^8$	yes
7	171	$4 \times \gamma_4^3$	yes	46	125	$4 \times \gamma_4^3$	yes
8	137	$4 \times \gamma_4$		47	127	$4 \times \gamma_4^2$	
9	139	$4 \times \gamma_2^2$		49	119	$4 \times \gamma_4$	
11	136	$4 \times \gamma_4^2$		50	132	$8 \times \gamma_2^4$	yes
14	142	$4 \times \gamma_4^2$		51	148	$4 \times \gamma_4^3$	yes
15	124	$4 \times \gamma_4^2$	yes	52	135	$4 \times \gamma_2^8$	yes
16	157	$4 \times \gamma_4^2$		53	170	$4 \times \gamma_4^4$	
17	147	γ_4^2		54	165	$4 \times \alpha_{10}^2$	
18	120	$4 \times \gamma_4^2$		55	169	$4 \times \gamma_4^5$	
21	122	$4 \times \gamma_4^3$	yes	56	131	$4 \times \gamma_4^3$	
22	140	$4 \times \gamma_4^3$		57	143	$2 \times \gamma_4^3$	
24	121	$4 \times \gamma_4^3$		59	163	$4 \times \gamma_6^3$	
25	151	$4 \times \gamma_4^2(*)$		60	133	$3 \times \gamma_4^2$	yes
28	129	$4 \times \gamma_4^2(*)$		61	158	nonstandard	
29	134	$4 \times \gamma_6\gamma_8$		62	160	$4 \times \gamma_4^4$	
30	153	$4 \times \gamma_4^3(*)$			124a	$4 \times \gamma_6$	
34	149	$4 \times \gamma_4^2$	yes		124b	$4 \times \gamma_4$	
35	152	$4 \times \gamma_4^4(*)$	yes		126	γ_4^2	
36	155	$4 \times \gamma_4^4(*)$	yes		162	$4 \times \gamma_2^3$	yes

Fig. 7. Chusclan: (left) current state and (right) proposed reconstruction. Elements to be added to or removed from the current state are drawn in with fine lines.

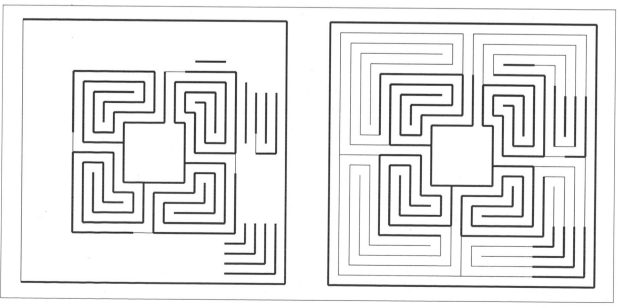

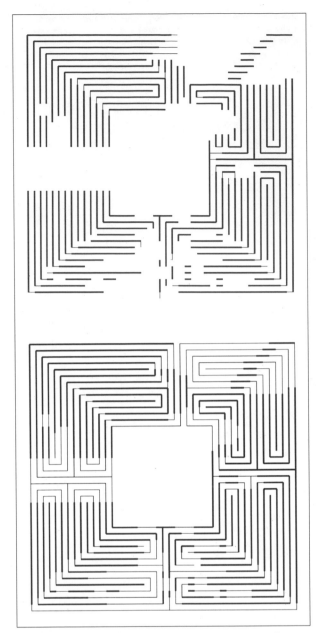

Fig. 8. Syracuse: (top) current state and (bottom) proposed reconstruction. The γ_6 submaze occurs in only one other standard-scheme maze. Elements to be added to or removed from the current state are drawn in with fine lines.

area: the repairers had not exactly matched the style of the original; deeper investigation revealed a corresponding perturbation of the substrate. Another old repair is mentioned by Tite in an 1855 article in *Archaeologia* [8]. How much less reliable are repairs made after two millennia, when perhaps one-half of the pattern is missing and what is left is scrambled around the edges! Furthermore it is very likely that the excavators who sketched their finds had to work by extrapolation from part of the pattern; this would explain some of the errors that we find in the drawings.

The rest of this article treats separately the 14 mazes for which I believe that errors occurred in execution (one case), in restoration, in representation or in interpretation, plus additional remarks on mazes [D#50] and [D#61].

D#1 Annaba, Algeria

Daszewski presents a drawing [1], plate 40a ([K:118]), of a rectangular maze of type $4 \times \gamma_2^4$, with the path interestingly adapted to the unusual nonsquare shape. An obvious error in sector 3 leads the path into the outer wall when it should double back on itself. It is not clear from my sources whether this is an error in the drawing or in the maze itself.

D#7 Vienna

This is a lavish polychrome square maze of type $4 \times \gamma_4^3$, illuminated by four mosaic pictures: in the center, Theseus fights the Minotaur; on the left Ariadne gives him the ball of thread; on top they embark; and on the right the abandoned princess sits on her rock. This maze is in excellent condition and correctly reproduced and analyzed in both my sources. The error I would like to signal is elsewhere. Matthews [9] reproduces a drawing of this maze in which there are four paths issuing from the Naxos picture: one leading to the center, one over to where Ariadne is shown giving Theseus the thread, and the other two leading back to each other. Similarly Theseus has four options. The maze has been ingeniously turned into a puzzle. The culprit for this substitution is presumably Matthews's source Georg Friedrich Creuzer, who admits to having abbreviated (*abgekurzt*) a larger representation of the maze [10]. In fact, besides the incongruity of these choices with what the pictures represent, a puzzle involving choices is totally alien to the spirit of mazes from antiquity. The mazes that have come down to us from prehistory, antiquity and, for that matter, the middle ages are all unicursal. What the ancients enjoyed in these mazes must have been akin to what people still enjoy in optical illusions. The paths are too complicated for the eye to follow, and yet they are right there on the page (or the floor) where the finger or the foot can trace them through. A nice modern example of this phenomenon is on the cover (and on p. 73) of Minsky and Papert's book *Perceptrons* [11].

D#15 Chusclan, Gard, France

The drawing, Daszewski [1], plate 58a ([K:124]), shows a square maze inside a wall with towers on each of three sides. Daszewski states that about one fourth of the mosaic is missing; the loss seems to be all in the maze, which is shown with five inner levels forming a $4 \times \gamma_4$, and bits of wall suggesting five more outer levels. This is all very unconvincing, especially since the entrance to the 'inner' $4 \times \gamma_4$ faces the one wall without a tower. The maze was surely a $4 \times \gamma_4^2$ (Fig. 7).

D#21 Caerleon, England

Plate 43 in Daszewski [1] ([K:122]) is a carefully executed drawing of a square mosaic maze. It shows about 40% of the maze as missing, and includes a hypothetical reconstruction of part of the center area. What is shown looks like sectors 2 and 3 of a clockwise $4 \times \gamma_4^3$ except that in sector 2 the path runs 0 3 2 1 6 5 4 7 8 11 10 9 12 instead of γ_4^3 = 0 3 2 1 4 7 6 5 8 11 10 9 12. This is very unlikely, since sector 3 has the second, standard form. Changing sector 2 to a γ_4^3 involves resetting a handful of tiles in an area close to the missing portion of the maze.

D#34 Ostia

Plate 47 in Daszewski [1] ([K:149]) shows a photograph of part of a square mosaic maze. Sectors 1 and 2 are shown

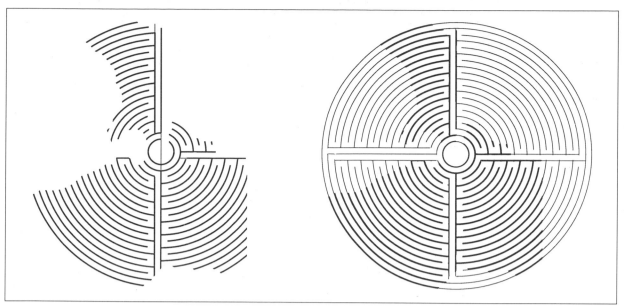

Fig. 9. Sabratha: (left) current state and (right) proposed reconstruction. Elements to be added to or removed from the current state are drawn in with fine lines.

along with half of sectors 3 and 4; the maze is a clockwise $4 \times \gamma_4^3$ with moderate damage, clumsily repaired. The restoration has perturbed the maze-path in sector 1, introducing two T's where the path would branch. The pattern may be corrected by a small reshuffling of tiles.

D#35 Pompeii, Villa di Diomede

This maze is only known to us through a drawing (Daszewski [1] plate 48a, [K:152]) published in 1841. The drawing shows a square maze of type $4 \times \gamma_4^4$, except that the four sectors are linked each to the next, counterclockwise, with no entrance from the outside nor exit into the center. The date assigned to this maze (80–60 B.C.) agrees with those of two other Pompeian mazes ([D#30, K:153] and [D#36, K:155]), which are of type $4 \times \gamma_4^3$ (*) and $4 \times \gamma_4^2$ (*), respectively. (The other Pompeian $4 \times \gamma_4^2$ (*) [D#37, K:156] has a later date.) This makes it very plausible that the original design was a $4 \times \gamma_4^4$ (*), with a fourth sector entered and exited through the top.

Why would this elaborate drawing have been made incorrectly? There are some internal clues. The mosaic as shown has suspiciously exact four-fold symmetry, down to the windows on the towers along the edges, which are drawn as rigorously identical from one side to the next. This suggests that much of the maze was missing when it first was excavated and that the artist copied one sector, saw that the sectors were similar and made them all exactly the same. Further evidence of damage is the blank center, incongruous with the elaborate treatment of the wall surrounding the maze. Most likely the center had earlier been torn from the maze to be marketed as a separate work of art, like the isolated polychrome Minotauromachies catalogued as [D#12, K:150], [D#58, K:108], [D#19, K:115], [D#26, K:145], [D#27, K:146], [D#31, K:144] and [D#45, K:168].

D#36 Pompeii, House VIII 2 16

Daszewski's plate 48b [1] shows a photograph ([K:155]) of a square mosaic maze. The maze was originally of type $4 \times \gamma_4^2$ (*), as evidenced by the single radial path on each side and by the diagnostic single non-nested radial segment to the left of the entrance (see [D#25, K:151], [D#28, K:129] and [D#37, K:156], where the entire design appears). A damaged area at the top of sector 4 was incorrectly restored: the entrance path bifurcates and sector 4 is a dead end. Rearranging a few tiles in the damaged area recreates the correct form. The path ends in a loop encircling the center, an unusual feature (see Fig. 6). Daszewski [1] gives this maze "*4 secteurs de méandres*" whereas his usual characterization of Pompeian-type mazes is "*3 secteurs de méandres et un de type serpentin*".

D#41 Syracuse/Taormina

This maze is documented in the sources only by the drawing Daszewski [1], plate 51 ([K:167]) of its ruins. It is badly damaged; in particular it now has 13 levels on the left and right but only 12 on the top and bottom. Measurements of the drawing show that the central area (almost always square) is exactly one row too tall, and the existing maze overall one too short. This suggests adding an extra level at the top of the center, and another at the bottom of the maze, as in Fig. 8. Furthermore, portions that seem unlikely to have been modern inventions strongly suggest that the maze was of type $4 \times \gamma_6^2$. This is a 13-level configuration with the compound nesting shown in sectors 1, 3 and 4 of the ruin. The γ_6 submaze is rare but it occurs in another insular Italian maze: [D#28, K:134] on Giannutri, and also, rather inexplicably, by itself, adjacent to a large, elaborate geometric mosaic floor in a villa in Halstock, Dorset [12].

D#44 Sabratha, Lybia

The photograph, Daszewski [1], plate 56a ([K:161]), shows a circular maze, badly damaged (Fig. 9). The submazes are clearly of type γ_2^8, but exactly how they were connected is difficult to determine. Most likely the entire center has been incorrectly restored: the central medallion should not be bisected by a wall, and the frame about the medallion is really a loop ending the maze-path. A similar loop runs around the outside of the maze, and probably joined the beginning of the path; such loops are somewhat unusual, but occur also in the great Kata Paphos maze [D#8, K:137],

in the Pompeian [D#36, K:155] and in the maze at Pula (see below).

D#46 Coimbra, Portugal (Museu Monografico)

This is a square maze, of type $4 \times \gamma_4^3$ (Fig. 10). The photograph reproduced as Daszewski [1] plate 40a shows that about 30% is missing: the corners of sectors 1 and 2 and the outer three levels along their common side. A small error just below the central field leads the path from the entrance directly across to sector 2. There also seems to be another error at the very edge of the photograph, creating a dead end in sector 2. Each of these errors can be corrected by repositioning a few tiles. The photograph suggests that a trench was dug at some time right across the middle of the maze. If so, it is amazing that these were the only errors produced.

D#50 Cormerod, Switzerland

There is no real error here, just a faked photograph. In Daszewski's plate 31a the central medallion has been rotated 90°, no doubt to give a more pleasing picture of the maze. The true configuration is shown in Daszewski [1] plate 32 and in [K:132].

D#51 Orbe, Switzerland

Daszewski presents a drawing [1], plate 58a ([K:148]), as well as a partial photograph (plate 58b). The maze is square, of type $4 \times \gamma_4^3$; the drawing shows an error in sector 1: the path from the entrance to the top of the sector is missing, and the sector begins in a dead end. The photograph does not show that part of the maze, but hints at considerable damage in the hidden area. It is likely that the error is in or near the damaged area and can be charged to faulty restoration or perhaps overgeneralization on the part of the artist who made the drawing.

D#52 Henchir el Faouar, Tunisia

The drawing, Daszewski [1], plate 18a ([K:135]), shows a square maze of type $4 \times \gamma_2^8$ set counterclockwise; a small error at the bottom of sector 2 leads that sector to a dead end and reopens the maze to the outside. The photograph

(Daszewski [1], plate 18b) reveals that the error was made by the artist in reinventing an area that had been destroyed.

D#60 Gamzigrad, Yugoslavia

This is a hexagonal maze of type $3 \times \gamma_4^2$, with no entrance into the maze nor exit into the center. Kern states that this is surely an error, and in this I believe he is mistaken. The maze is drawn so as to look like three faces of a cube seen from above one vertex, with one submaze occupying each face and the central field reduced to the width of the path, occupying the vertex. Surely the focus of this design was the effect of perspective and the perfect three-fold symmetry of the configuration; entrances and exits would have destroyed this. The labyrinthiform decorative element from Side, Turkey, [K:113a] is a round $4 \times \gamma_4^2$ with similarly perfect (here four-fold) rotational symmetry.

K:162 St-Cyr-sur-Mer

This mosaic is unique in this corpus in that it has two separate mazes. They are both of type $4 \times \gamma_2^3$ and appear as part of a large design incorporating a variety of decorative elements. One of the mazes, the left-hand one in [K:162], has an error: the path is not led back to the center after traversing the fourth sector. The photograph suggests that this was an error in execution. We can hypothesize that the right-hand design is the original, and that the left-hand one was executed by an apprentice as an (imperfect) copy.

THE GREAT DOUBLE MAZE AT PULA

The maze at Pula, Yugoslavia [D#61, K:158] deserves special mention. This is undoubtedly the most intricate of all Roman mosaic mazes. About one fourth of the maze is destroyed, but there is enough information left to allow the reconstruction (see Fig. 11) of the entire design (with the exception of an ambiguity near the entrance, which a better photograph might clear up). Although it has the overall appearance of the four-sector standard scheme (with an additional circuit of the entire maze and one of the center, like the Kata Paphos maze [D#8, K:138]), this maze clearly transcends the genre. It is in fact a double maze, where the

Fig. 10. Coimbra (Museu Monografico): (left) current state and (right) proposed reconstruction. Elements to be added to or removed from the current state are drawn in with fine lines.

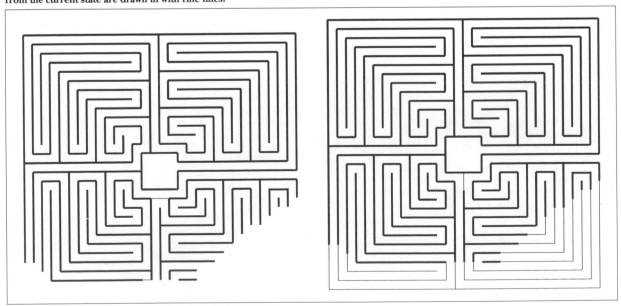

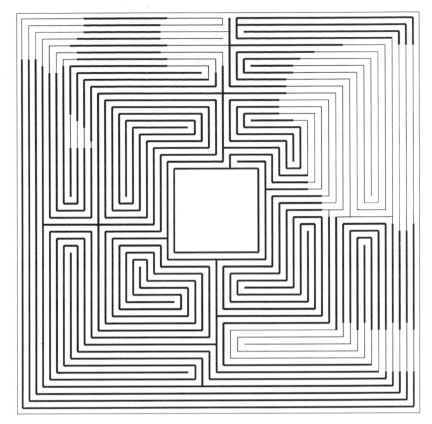

Fig. 11. Pula: proposed reconstruction. Elements to be added to the current state are drawn in with fine lines.

path runs from the outside to the center *and back out again* (by a different route). This can easily be seen from examination of the central area, which is intact. Numbering the sectors from 1 to 4 clockwise from the entrance, they are visited in the order 4 1 2 3 2 3 4 3 2 1. Other features include embedded meander mazes (a γ_8 and a γ_{10} in sector 4, a γ_6 in sector 1) and a mock doubled $\gamma_4\gamma_6$ in sector 3.

CONCLUSION

Devising a unicursal maze to fill out an area in an interesting and symmetrical way is a topological problem as well as an aesthetic problem. Given constraints on size and overall organization, there is only a small number of topologically distinct solutions; this has allowed our mathematical close reading of Roman mosaic mazes, an analysis of which could probably be extended to the rich corpus of mazes in Medieval manuscripts, architecture and works of art. Each of the solutions that occur was first discovered by someone, somewhere; a fascinating element of the study of ancient mazes is the contact with these ingenious, unsung topologists of the past.

References and Notes

1. Wiktor A. Daszewski, *La Mosaïque de Thésée. Etudes sur les mosaïques avec représentations du labyrinthe, de Thésée et du Minotaure (Nea Paphos II)* (Warsaw: PWN-Editions Scientifiques de Pologne, 1977). Daszewski catalogued all of the mazes that he knew and assigned a number to each one (alphabetically by country). Some of the mazes are illustrated; the illustrations appear separately and in a different order than in the catalogue. Daszewski includes tables to instruct the reader how to go back and forth from the catalogue to the illustrations.

2. Hermann Kern, *Labyrinthe,* 2nd Ed. (Munich: Prestel-Verlag, 1983). This is an expanded version of *Labirinti. Forme e interpretazioni. 5000 anni di presenza di un archetipo* (Milan: Feltrinelli, 1981). Kern lists mazes alphabetically by location, although only the illustrations are numbered. Kern includes illustrations all of the mazes discussed in this article except for one [D#58].

3. Jean-Louis Bourgeois, private communication.

4. For a determination of which permutations of $0, 1, \ldots, n$ are the level sequences of SAT mazes, and for a consideration of the problem of counting all possible SAT mazes with n levels, see Anthony Phillips, *Simple Alternating Transit Mazes* (forthcoming). See also A. Phillips, "La topologia dei labirinti", in M. Emmer, ed., *L'occhio di Horus: Itinerari nell'imaginario matematico* (Rome: Istituto della Enciclopedia Italiana, 1989) pp. 57–67; M. Emmer, *Labyrinths,* 16mm color-sound film from the series *Art and Mathematics,* 27 min (Rome: Film 7 International, 1984).

5. See Daszewski [1] p. 51; see also Daszewski's analysis of [D#24].

6. See Kern [2] p. 114. See also Penelope Reed Doob, *The Idea of the Labyrinth from Classical Antiquity through the Middle Ages* (Ithaca, NY, and London: Cornell Univ. Press, 1990).

7. This is explained in Daszewski [1] p. 82.

8. William Tite, "An Account of the Discovery of a Tesselated Pavement, 10th February 1854, under the Vaults of the South-Eastern Area of the Late Excise Office", *Archaeologia* **36** (1855) pp. 203–213.

9. W. H. Matthews, *Mazes and Labyrinths, a General Account of their History and Developments* (London: Longmans, Green, 1922). Reissued (Detroit, MI: Singing Tree Press, 1969; New York: Dover, 1970).

10. Georg Friedrich Creuzer, *Abbildungen zu Friedrich Creuzers Symbolik und Mythologie der alter Völker* (Leipzig and Darmstadt: Heyer und Leske, 1819) p. 29.

11. Marvin Minsky and Seymour Papert, *Perceptrons* (Cambridge, MA: MIT Press, 1969).

12. Anne Rainey, *Mosaics in Ancient Britain* (Totowa, NJ: Rowman and Littlefield, 1973) p. 87.

13. See Daszewski [1].

14. See Kern [2].

PART II

Computer Graphics, Geometry and Art

The following text was originally presented as a talk [1] in 1970 by my father Frank J. Malina, who was the founding editor of the journal *Leonardo,* as well as a kinetic artist and pioneering astronautical engineer. In this text, my father outlined, devoid of hyperbole, an artist's agenda for computer graphics and art. His text was written before the development of the personal computer, before the introduction of the computer-graphics workstation and before the advent of multimedia technologies. Yet most of today's developments in computer graphics and art are identified in this text of 1970—reference is even made to stereographics displays, predecessors of to-day's virtual-reality systems. Missing, however, from my father's vision, I feel, is any sense of the new symbiosis between art and mathematics. This symbiosis is provoked by the widespread use by both mathematicians and artists of the same computer systems and software tools, It may be true, in my father's words, "that computers available today do what man tells them to do", but it is also true that what computers can do affects what we can *imagine* doing. The use of computers can also alter our understanding and intuition about art and mathematics—these in turn define what we ask computers to do, as the following articles in this book make clear.

ROGER F. MALINA
Executive Editor, Leonardo
Executive Director
Center for Extreme Ultraviolet Astrophysics,
University of California, Berkeley, California, U.S.A.

COMMENTS ON VISUAL FINE ART PRODUCED BY DIGITAL COMPUTERS

I have had no direct experience with digital computers either in applied science or in art, mainly because they were developed too long after I was born. I have read technical and philosophical studies of this intriguing device [2–6] and, as the editor of *Leonardo,* I have struggled with manuscripts by artists who have used the computer to aid them in producing visual fine art [7–12]. Furthermore, since I make kinetic art objects utilizing electric light and mechanical or electronic systems to provide motion, as well as traditional static images with paints and pen, I have a very critical attitude towards the output of computers instructed by artists.

For the purpose of my discussion, it is not necessary for me to go into the principles of operation of a digital computer, the differences between hardware and software, and the methods of programming. It is important, however, to stress that computers available today do what man tells them to do, provided the instructions are compatible with the computer's internal construction. The computer can imitate only a very limited part of the potential of the human brain. It does this at speeds vastly greater than is possible with our brains or our hands. Results that would have taken years to obtain two decades ago can now be achieved in a few hours or days.

Scientific and mathematical problems can now be solved with the aid of computers that before were put aside because of the enormous number of calculations that were required. Subjects such as meteorology and economics, which daily involve a

great quantity of statistical analysis, may be expected to become more reliable in their power of prediction through the use of these machines. Astronauts have learned to depend on computers for the guidance and navigation of their space vehicles, although very reluctantly, for they at first feared that their skills as pilots were being taken over by a machine.

The computer, in response to appropriate programmed instructions, offers to the artist the following possibilities:

1. *Line drawings and compositions made up of typed symbols, in black and white or in color, on paper or a similar material, ready for framing*

Variations of these kinds of output of a computer can easily be made by changes in the instructions. One should bear in mind that these outputs can be produced without the computer, as far as the basic artistic conceptions of content are concerned. For example, the line drawings of a computer can be made by hand with a pen or pencil or by means of simple mechanical devices, such as the double pendulum [13]. Compositions of typed symbols can be made on a manually operated typewriter [14]. The advantage of computer graphic art is in the speed and quantity of copies that can be produced, perhaps at a lower price than by other traditional methods. This would allow a larger number of persons to purchase an example.

2. *Sculpture made by automatic machines controlled by a computer*

To make three-dimensional objects, a computer is provided with a program of instructions for conversion into commands to an automatic machine. A simple example is a symmetrical object turned in a wood or metal lathe. More complex cutting machines are available in industry for making irregular forms. Whether the traditional method in which the artist makes a prototype by hand, from which copies can be cast in plaster or metal, will be displaced by the new method is not obvious.

3. *Paintings made by an automatic machine controlled by a computer*

A computer would be used in the same manner as for making a sculpture, except that a special automatic machine would be required to apply paints to a surface. A painting machine is not at present available but perhaps a sufficiently flexible one could be constructed to give interesting results.

4. *Displays on a screen of a cathode ray tube*

A computer can be instructed to command the formation of black-and-white or colored, static or kinetic images on the screen of a cathode ray tube similar to that used in television sets. The images may be viewed directly or recorded on still photographs, cinema film or videotape. It is also possible to give a viewer the visual experience of three dimensions by stereoscopic separation of images through the use of auxiliary devices [15]. One can expect in the near future computer-produced visual art recorded on videotape for projection on the screen of a television set in the home, whenever desired. This kind of application of a computer may be the most promising one for the future of the visual arts.

5. *Compositions made up of a number of basic elements arranged according to a predetermined combinatorial principle*

A computer would provide instructions on the location of each basic element on a surface according to prescribed rules, for example, to avoid the same color in a part of an element touching the same color in neighboring elements and to avoid the same shape in a part of an element touching the same shape in neighboring elements. The artist (perhaps one should say craftsman) then takes the computer instructions and paints the composition or assembles previously prepared elements made to the desired scale. The computer only serves as a labor-saving device in arriving at combinations prescribed by the artist [16].

By the time computers became available to them, artists had already used other means to make static and kinetic, two- and three-dimensional visual art, including

audio-visual kinetic art. Since a computer must be told what to do in detail, artists are forced to fall back on images with visual conceptions of content that have already existed before—the computer then makes imitations of them. It does permit the production of many variations of the components of the programmed image or object—lines, areas, volumes and color—and time sequences, if they are kinetic, can theoretically be varied endlessly.

The capability of a computer to produce easily variations of an artist's basic artistic conception may be a blessing for some artists. The artist in the past, in order to earn his livelihood, has been forced to make by hand a large number of art objects that are but minor variations of a given prototype. The pressures on the artist from the commercializers of art to make quantities of variants of a prototype bearing a clearly recognizable 'trade-mark' further aggravate the 'production' dilemma of the creative artist. This consideration is based on the conviction that only the prototype can be considered a significant creative work of art and that the artist becomes frustrated when he must make repetitions of the prototype with only minor variations. The fact that the works of an artist are divided into 'periods' can be blamed on the above considerations, although it is quite possible that the very nature of the human brain limits an artist to one or very few significant creative visual ideas during his lifetime.

No computer exists today that can be told to produce an image containing a specific content, say a reclining nude or a geometrical 'landscape', with an original visual conception of its own invention or vice-versa that will be aesthetically satisfying. If a computer is given instructions that exceed its capability, it may either come to a stop or make something classifiable only as 'garbage'. Furthermore, a computer can neither provide the artist with any new physical dimension beyond the two dimensions of drawings and paintings, the three dimensions of sculptures and constructions, and the added time dimension of kinetic art, nor make available new optical illusions.

In spite of the limitations of present-day digital computers, artists will and, I believe, should make use of them. One cannot expect that, in the short time that a very few artists have had access to them, all of their possibilities have been explored. This exploration is severely limited by the high cost of computer time and by the reluctance of artists to learn the intricacies of computer operation and programming. Those artists who are interested in taking advantage of developments in a modern technology generally look upon scientists and engineers as magicians who can to anything imaginable. From my experience, artists consider them as uncooperative because they tell the artist that their ideas violate the laws of nature, demand inventions that have not been made or would cost vast sums of money to be accomplished. There are, of course, scientists and engineers who mislead the artist by telling him that 'the difficult we will do immediately, the impossible will take a little longer'.

I believe the most important benefit to be expected from the use of computers by artists will be sociological. They will help to dispel the not uncommon view that computers are monsters rather than highly sophisticated devices that can serve man, if intelligently used.

FRANK J. MALINA
Founder of Leonardo
1912–1981

References

1. The text was based on a talk given at Décade: L'homme devant l'informatique at the Centre Culturel International de Cérisy-la-Salle, Manche, France, 18 July 1970. It is reprinted from the book *Visual Art, Mathematics and Computers: Selections from the Journal* Leonardo (Oxford: Pergamon Press, 1979).

2. H. L. Dreyfus, "Philosophic Issues in Artificial Intelligence", *Publications in the Humanities* **80** (MIT, 1967).

3. L. Summer, *Computer Art and Human Response* (Charlottesville, VA: P. B. Victorius, 1968).

4. L. D. Harmon and K. C. Knowtton, "Picture Processing by Computer", *Science* **164** (1969) p. 19.

5. H. von Foerster and J. W. Beauchamp, eds., *Music by Computers* (New York: John Wiley, 1969).

6. M. J. Apter, *The Computer Simulation of Behavior* (London: Hutchinson Univ. Library, 1970).

7. R. I. Land, "Computer Art: Color-Stereo Displays", *Leonardo* **2**, No. 3 (1969) p. 335.

8. F. Hammersley, "My First Experience with Computer Drawings", *Leonardo* **2**, No. 4 (1969) p. 407.

9. J. Hill, "My Plexiglas and Light Sculptures", *Leonardo* **3**, No. 1 (1970) p. 9.

10. R. Mallary, "Notes on Jack Burnham's Concepts of a Software Exhibition", *Leonardo* **3**, No. 2 (1970) p. 189.

11. Z. Sykora and J. Blazek, "Computer-Aided Multi-Element Geometrical Abstract Paintings", *Leonardo* **3**, No. 4 (1970) p. 409.

12. K. Nash and R. H. Williams, "Computer Program for Artists: *ART* 1", *Leonardo* 3, No. 4 (1970) p. 439.

13. S. Tolansky, "Complex Curvilinear Designs from Pendulums", *Leonardo* **2**, No. 3 (1969) p. 267.

14. See Hammersley [8]; Hill [9]; and Nash and Williams [12].

15. See Land [7].

16. See Sykora and Blazek [11].

Visualization of Soap Bubble Geometries

Fred Almgren and
John Sullivan

Asingle soap bubble possesses an exquisite perfection of form. Soap bubbles are lovely physical manifestations of simple geometric relationships created by the principles of area minimization. Our goals in studying soap bubble problems are both to understand better the problems of area minimization and to use such problems as test cases for the computation and visualization of geometric structures that arise in other geometric optimization problems. In this article we report in particular on new techniques for displaying soap bubble geometries; these techniques incorporate both colored interference patterns and the Fresnel effect of decreased transparency at oblique angles.

MINIMAL SURFACE FORMS

A collection of surfaces, interfaces or membranes is called a 'minimal surface form' when it has assumed a geometric

configuration of least area among those into which it can readily deform. Of course there must be some constraints in the problem to keep the configuration from collapsing completely. Typical constraints might be a fixed boundary wire that the surface must span, or a volume that it must enclose. The sphere, the shape of a single soap bubble, seems the simplest minimal surface form; it has the least area among all surfaces that enclose the same volume.

Minimal surface forms arise not only in the surface tension phenomena of liquids and thin films, such as soap bubbles, but also in grain boundaries in metals, in radiolarian skeletons, in close-packing problems, in immiscible liquids in equilibrium, in sorting of embryonic tissues, in design, in art, and in mathematics [1].

ABSTRACT

The authors discuss mathematical soap bubble problems and a new technique for generating computer graphics of bubble clusters. The rendering program is based on Fresnel's equations and produces both the colored interference patterns of reflected light and the Fresnel effect of varying transparency.

Fig. 1. This cluster of six bubbles was generated by the Surface Evolver program. It was rendered by the computer-graphics techniques described, which model the Fresnel effect of decreased transparency at oblique angles. Note the saddle-shaped interface in the middle. Among all soap bubble clusters presently known that have such a non-spherical interface, this one—discovered by John Sullivan—has the smallest number of regions of trapped air.

MATHEMATICAL PRINCIPLES OF SOAP BUBBLE GEOMETRY

Soap bubble clusters consist of regions of trapped air separated from each other and from the outside by smoothly curved surfaces. Surface tension tends to minimize surface area, pulling each of these surfaces tight. This tendency of surface tension to collapse the cluster is held in balance by the differing pressures of the trapped regions of air and the outside atmosphere. A soap bubble in the shape of a sphere thus has higher-than-atmospheric pressure on its inside. If a soap bubble interface curves in two different directions (like the seat of a saddle), then the higher pressure lies on the side of the greater curvature and the difference in pressure is proportional to the difference between the two curvatures. The fact that pressures are constant within each region means that the average, or mean, curvature of the

Fred Almgren (mathematician), Department of Mathematics, Princeton University, Princeton, NJ 08544, U.S.A.

John Sullivan (mathematician), Geometry Center, University of Minnesota, 1300 South Second Street, Minneapolis, MN 55454, U.S.A.

interface surface between any two regions must be the same at each point on this interface: the net compressional force generated by such an interface is proportional to the mean curvature, and it must exactly balance the pressure difference.

As an example, if in (x,y,z) space an interface in a soap bubble cluster passes through the origin $x = y = z = 0$ and can be written nearby as the graph of the equation

$$z = f(x,y) = 9x^2 - 5y^2 + \text{higher-order terms in } x \text{ and } y$$

for small values of x and y (so that it is saddle-shaped, curving down in the y direction but more sharply up in the x direction), then it would have mathematical mean curvature equal to $9 - 5 = 4$, and the air pressure above the interface (i.e. for $z > f(x,y)$) would exceed the pressure immediately below by an amount proportional to this mean curvature. One of the central difficulties in the mathematical analysis of phenomena like soap films is that the functions that describe them (such as $f(x,y)$ above) usually cannot be written down completely in any finite way. Thus, theorems about such geometries say that such functions exist and have certain properties, but they rarely are able actually to exhibit the functions.

Notwithstanding the difficulties of writing down soap bubble configurations exactly, mathematical analysis has shown a great deal about the possible structure of minimal surface forms. It guarantees that any such form must consist of a finite number of smoothly curving sheets of surface, each with constant mean curvature. These are allowed to meet only along a finite number of smoothly curving arcs, where exactly three sheets must meet at equal angles of 120°. Finally, these arcs can meet only at a finite number of points, where four of these arcs come together, always in the same pattern. The three surfaces along each arc make a total of six surfaces meeting at the point. Since the sheets must meet at 120°, the arcs necessarily meet at approximately 109° angles—the dihedral angles of a regular tetrahedron. These principles were made mathematically rigorous by J. E. Taylor [2].

THE COMPUTATION OF SOAP BUBBLE GEOMETRIES

The problem of computing soap bubble geometries is a difficult one that has not yet been completely solved [3]. Because the surfaces usually cannot be described exactly, it is necessary to approximate them. One way to generate an approximate minimal surface is to guess what the configuration should be and write a simple combinatorial description of it as a triangulated surface, specifying which edges are to be fixed as boundary wires and which volumes should be maintained. Then, keeping the same combinatorial configuration, the vertices can be moved to decrease area.

A convenient computer program for doing this, the Surface Evolver, has been written at the Geometry Supercomputer Project [4]. The program is interactive—it can alternate between moving the vertices to minimize area and refining the triangulation to enable the surface made up of triangles to more closely approximate the true smooth surface.

Geometries generated by this evolver program should approximate smoothly curved mathematical minimal surfaces. But no test is known that could ensure this or determine when the computed geometries correspond to physical soap

bubble clusters. The latter is especially tricky because of the difficulty of blowing even relatively simple real soap bubble clusters.

RENDERING SOAP BUBBLE GEOMETRIES

An accurate computer approximation of a soap bubble configuration involves a list of the positions of several thousand vertices and the combinatorial relationships between the associated edges, triangles and solid regions. To make any sense of this information, it is necessary to translate it into pictures. (In an interactive program such as the Evolver, graphics are used extensively before the final data file is obtained.) Since there are a number of different surfaces in even simple soap bubble clusters, transparency is necessary in the rendering, in order to see the inner interfaces. Motion can be useful in visualizing any three-dimensional object: it helps the eye pick out the spatial relationships between different surfaces. The present article, of course, cannot illustrate the effect of motion on visual understanding [5].

Despite the importance of motion to the eye, there are ways to make even a static image more effective. One possible technique is the use of stereoscopic pictures [6]. For certain pictures (renderings of complex molecules, for example), the effects can be dramatic and sometimes indispensable. However, human eyes are very good at seeing in three dimensions even without stereoscopic information.

When one views a real three-dimensional scene, even though the image present on the retina is two-dimensional, the brain immediately reconstructs a three-dimensional mental picture. (Accurate perspective drawing is difficult because it is hard for the mind to recreate the two-dimensional image.) The cues to the eyes that make this possible are many and complex. Certainly, reflected highlights and textures on surfaces are important. A good artist can pick out these and other details and, with just a few strokes, can produce a picture that gives the eyes the necessary clues, while leaving out other details that would not help. Computers cannot yet do this difficult task, but often, if a computer image can be made more realistic, it will provide more subconscious clues to the eye, and the third dimension will be more apparent.

A SOAP-FILM–RENDERING ALGORITHM BASED ON FRESNEL'S EQUATIONS

Simply using 'flat transparency' to make the films in a cluster 80% transparent, say, makes inner interfaces visible, but does not make them look like real soap bubbles. One noticeable visual feature of a soap film is the Fresnel effect, which makes the film—like a piece of glass—less transparent when viewed edge-on. Reproduction of this effect [7] conveys the roundness of soap films much better than does flat transparency. In 1990 co-author John Sullivan utilized some fundamental equations of optics to model other features of soap film, creating what seem to us to be striking visual effects.

Most surfaces rendered in computer graphics are assumed to respond to ambient or diffuse light present in the scene. On the other hand, real soap films create nearly mirror-like reflections of objects around them, without any diffuse component. Highlights of windows or bright lights thus appear in curved patterns, which allow the shape of the surface to be seen. Also, optical interference between light

rays reflected from the inside and outside of thin soap films creates brightly colored stripes within highlights [8]. The computer images created by our special shading routine show both the highlights and colored bands of real soap bubbles [9].

Figure 1 shows a small cluster of six bubbles rendered by our technique. This cluster is interesting because, although clusters of up to five soap bubbles can be constructed with all the interfaces being pieces of spheres, this one cannot. The squarish interface between the two small bubbles in the center is evidently saddle-shaped, with Gaussian curvature less than zero, and is certainly not part of a sphere. We generated this geometry with the Evolver program mentioned before.

For our renderings of computer-generated soap films, we have used the RenderMan software from Pixar; it determines which interfaces are in front of which others and combines transparency information. We need merely to write code that, for any small patch on any individual piece of surface, will compute the transparency of different colors and the amount of reflected light to be added.

We have created an artificial environment that includes several bright windows on the walls and a pattern of lights on the ceiling to provide highlights in the soap film. The colors of soap film are caused mainly by the varying thickness of the film, so real soap bubbles have primarily horizontal color stripes, since gravity pulls the film toward the bottom of the bubble, making it thicker there. But these stripes develop in a complicated way and have many seemingly random perturbations. Since we know of no good physical model for predicting particular thicknesses at particular points of the film, we have specified the thickness using computer-generated random noise, weighted to give somewhat horizontal patterns. Knowing this thickness, together with the direction of the surface and the direction from which the computer's eye is looking at it, enables us to use physical laws to determine the amounts of transparency and reflected light. The basic laws of electromagnetic waves lead to Fresnel's equations in optics, which tell the fraction of light reflected at an interface. One of the things these equations describe at any boundary between different transparent materials is the Fresnel effect of varying transparency that we have already mentioned—this makes the surface of a pond, for instance, more reflective (and less transparent) at a shallow angle. In addition, when applied to a thin film with two nearby interfaces, the equations give rise to the colored interference patterns seen in oil slicks as well as in soap bubbles. The thickness is the main determinant of color, while the angle of view mainly determines overall opacity or reflectivity. These effects, however, are not really independent—they both arise from the same equations.

In more detail, if β is the coefficient of refraction (about 4/3 for a water-air interface), then Snell's law says that the angles of the incident and transmitted (or refracted) rays are related by $\beta = \sin \theta_i / \sin \theta_t$. If we define $\alpha = \cos \theta_t / \cos \theta_i > 1$, then Fresnel's equations say that the intensity of the electric field for the wave reflected off the interface is r times that of the incident wave, where $r = (1 - \alpha\beta)/(1 + \alpha\beta)$ for normal polarization, and $r = (\beta - \alpha)/(\alpha + \beta)$ for parallel polarization. By the principle of energy conservation, the transmitted field satisfies $t^2 = 1 - r^2$.

In our case, we have a second interface quite close to the first: a soap film is a narrow sheet of water with air on both sides. Transmitted light refracts back to its original direction, so we do not have to worry about bending light,

although we do calculate θ_t to compute the reflection coefficients. Light may bounce back and forth any number of times within the soap film, before being either transmitted or reflected. Rays of light with different numbers of internal reflections have a phase shift, proportional to the thickness (in the direction of the internal refracted rays) expressed in numbers of wavelengths. If this phase delay is ϕ for a single round-trip, then the strength of the overall transmitted electric field is obtained by summing the geometric series

$$t^2(1 + r^2 e^{i\phi} + r^4 e^{2i\phi} + \dots).$$

The intensity of transmitted light is the square norm of this sum:

$$T = 1 - \frac{t^4}{t^4 + 2(1 - t^2)(1 - \cos\phi)}.$$

We have used these equations of physics, derived from those of Fresnel, in our computer program to compute which colors are reflected and which are transmitted. For each piece of surface rendered, RenderMan invokes our program, giving it the incident and reflected directions. We use these to compute the transmission coefficient for both normal and parallel polarizations and for two different wavelengths of each color (red, green and blue). The average coefficient for each color gives the fraction of light transmitted, and goes directly back to RenderMan as the transparency. The reflection coefficient $R = 1 - T$ is multiplied by the intensity of that color of light from whatever window or other feature of our environment is present in the reflected direction, to yield the reflected light.

Computer graphics usually uses colors expressed in terms of red, green and blue. We do our calculations for two shades of each, which approximates more closely the full spectrum present in white light, to get accurate renditions of the rainbow of colors in real soap film.

Note that the algorithm used is not a ray tracer, so that, in particular, there are no reflections of reflections. The incoming light in the reflected direction is always assumed to be only that from the wall or ceiling in the environment.

A CLUSTER OF 120 REGIONS

Color Plate C No. 1 shows a cluster of 119 soap bubbles (plus one infinite region) rendered by our new technique. This highly symmetrical figure is a stereographic projection of a four-dimensional regular polyhedron. Its structure is perhaps most easily described by an analogy in one lower dimension.

The analogous three-dimensional polyhedron is the regular dodecahedron illustrated in Fig. 2a—it has 12 flat faces, each of which is a regular pentagon; the pentagons share 30 edges and 20 vertices. Figure 2b shows this dodecahedron pushed out to lie on a sphere. Here the edges meet at the 120° angles of a bubble cluster. In Fig. 2c, the spherical dodecahedron has been stereographically projected onto the plane. Since stereographic projection preserves circles and the angles at which they meet, this picture has the right geometry for a two-dimensional soap bubble cluster in the plane. If we lived in this plane, we would of course have to use transparency to see the many layers in this picture.

In our three-space we could make models of such planar clusters by blowing bubbles between two nearby flat sheets of glass. The films would extend between the two sheets,

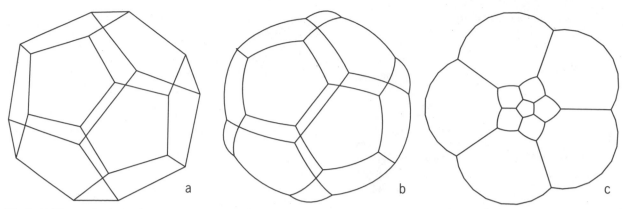

Fig. 2. (a) The regular dodecahedron in space. This is the starting point for the construction of a two-dimensional analog to the three-dimensional soap bubble cluster illustrated in Color Plate C No. 1. (b) The central projection of the dodecahedron (Fig. 2a) onto a sphere. The arcs of this figure on the sphere are segments of great circles. (c) The spherical dodecahedron (Fig. 2b) projected stereographically onto a plane. The arcs are still segments of circles and meet at the equal 120° angles of a bubble cluster.

meeting them at right angles, and could form a pattern like that in Fig. 2c.

The four-dimensional analogue of the dodecahedron is a regular polytope called the 120-cell or the dodecaplex [10]. This polytope is made up of 120 regular dodecahedra and includes 720 pentagons (the interfaces between the dodecahedra), 1200 edges and 600 vertices.

Color Plate C No. 1 is a picture of this polytope once it has been pushed out to lie on the sphere in four-space and then has been stereographically projected onto three-space. Again, because the correct number of dodecahedra meet around edges and vertices, and because stereographic projection preserves spheres and angles, this complicated figure satisfies both the combinatorial and the curvature requirements to be a soap bubble cluster. Our transparent rendering of it incorporates both the Fresnel effect and interference patterns. Not all the bubbles in the center can be seen in a picture this size—they are very small, just like the small pentagons in Fig. 2c.

Just as Fig. 2b in space has more symmetry than Fig. 2c in the plane, our cluster of soap bubbles has more symmetry in the sphere in four-space before the stereographic projection. If this sphere were rotated, the stereographically projected image in our cluster would swirl around. Each bubble would move and take the place of one of its neighbors [11].

We can start to understand the structure of this cluster by looking at the layers visible in the picture. The infinite region outside the cluster is the image of a dodecahedron near the north pole of the original sphere in four-space. It touches the 12 largest, round bubbles. Moving inward, we next find a layer of 20 pointed bubbles, each fitting between three of the largest ones. Further in, there is another layer of 12 bubbles, the smallest ones easily visible. Next comes a middle layer of 30 bubbles, which come from the equatorial plane of the original sphere. Inside this, we find the same layers repeated in opposite order: layers of 12, then 20, then 12, surrounding a single small dodecahedral bubble coming from the south pole of the original sphere.

In our rendering of this large cluster, as well as of the one in Fig. 1, we have chosen a point of view that is not along any of the many axes of symmetry. One can still see the symmetry of the overall object, but there is more information in the picture, since different parts are seen from different viewpoints. Also, part is rendered in front of a bright window, to better show the transparency, and part in front of a darker wall, to show off the highlights.

Color Plate C No. 2 shows the result of applying the same process to the hypercube, another regular polytope that projects to a soap bubble. The structure here is easier to see: a cube near the south pole in the hypercube projects to the central bubble, while the infinite outer region comes from a cube around the north pole. The other six cubes in the hypercube become the six bubbles surrounding the center.

WHERE DOES THIS LEAD?

The rapid development of computer graphics is especially exciting to mathematicians. It provides new ways to visualize mathematical objects that have been known for a long time and also, along with new computational tools, opens the door to new mathematical discoveries. Realization of these potentials will require new insights about the way we visualize geometric structures. This is an area in which artists may be able to help mathematicians. Hand drawings are superior to computer images for illustrating many ideas in geometry—especially in topology. The challenge is to program computers to extract the essential visual clues about a shape and to present these to the eye. Much modern geometry is done in higher dimensions, where visualization presents even more problems.

Advances in computation and graphics are changing the way mathematics is being done. As we build new mathematics on the foundations of the knowledge of several millennia, we must develop the potential inherent in computer-generated images and must find artistic methods of expressing mathematical visions.

Acknowledgment

We would like to thank Silvio Levy, Maggie Sullivan and Jean Taylor for their valuable comments on the first draft of this article and Pat Hanrahan for first suggesting an attempt to realistically model soap film with RenderMan. We have made use of software written by Charlie Gunn, Ken Brakke and others at the Geometry Supercomputer Project.

References and Notes

1. See F. J. Almgren, "Minimal Surface Forms", *The Mathematical Intelligencer* **4**, No. 4, 164–172 (1982), for a discussion of all these issues. Substantial portions of the classic work by D. W. Thompson, *On Growth and Form* (abridged edition, J. T. Bonner, ed. [Cambridge: Cambridge Univ. Press, 1961]) are devoted to geometries associated with minimal surface forms. The book of C. V. Boys, *Soap Bubbles: Their Colors and the Forces Which Mold Them* (New York: Dover, 1959) is a classic of scientific exposition that gives a wonderful introductory appreciation and understanding of surface tension phenomena in soap films. The article by Michele Emmer, "Soap Bubbles in Art and Science: From the

Past to the Future of Math Art", *Leonardo* **20**, No. 4, 327–334 (1987), discusses the history of soap bubbles in art.

2. J. E. Taylor, "The Structure of Singularities in Soap-Bubble-Like and Soap-Film-Like Minimal Surfaces", *Annals of Mathematics* **103** (1976) pp. 489–539. See also F. J. Almgren and J. E. Taylor, "The Geometry of Soap Films and Soap Bubbles", *Scientific American* (July 1976) pp. 82–93, for a more informal, expository discussion.

3. The special case of oriented surfaces of least area spanning boundary curves is in somewhat better shape because of the work of H. R. Parks, "Explicit Determination of Area Minimizing Hypersurfaces, II," *Memoirs of the American Mathematical Society* **60**, No. 342 (March 1986) and that of John Sullivan, "A Crystalline Approximation Theorem for Hypersurfaces", Ph.D. thesis, Princeton University, 1990 (also available as Research Report GCG 24 from the Geometry Center, 1300 South Second Street, Minneapolis, MN 55454, U.S.A.). For unoriented least area surfaces such as Möbius bands and for clusters including trapped volumes, the computational least area problem has not been solved.

4. The Surface Evolver computer program was written by K. Brakke and is available free of charge. Those with access to Internet can get it by anonymous ftp to <geom.umn.edu>. The file pub/evolver.tar.Z is a compressed tar file including source code and documentation for its use.

5. One of the most dramatic scenes in the motion picture *Soap Bubbles* (part of Michele Emmer's series on Mathematics and Art) shows real soap films rotating under bright lights to a musical accompaniment. The videotape *Computing Soap Films and Crystals* (1990) shows rotating transparent soap films computed by the Minimal Surface Team of the Geometry Supercomputer Project (principally Fred Almgren, Ken Brakke, John Sullivan and Jean Taylor). To obtain a copy of this VHS-format videotape, send a check for U.S. $20 (payable to the Geometry Center) to Angie Vail, Geometry Center, 1300 South Second Street, Minneapolis, MN 55454, U.S.A.

6. See, for example, the stereoscopic pair of X-ray photographs of the interior grain structure of an aluminum-tin alloy reproduced in Almgren [1] p. 166.

7. First done by Ken Perlin, "An Image Synthesizer", *Computer Graphics* **19**, No. 3, 287–296 (1985) and later used by P. Hanrahan in the videotape [5].

8. Boys [1] gives a clear explanation of this, without mathematical equations.

9. Striking pictures of real soap bubbles, showing these effects, were taken by science photographer Fritz Goro for *Scientific American* [2].

10. See H. S. M. Coxeter, *Regular Polytopes* (New York: Dover, 1973) for more discussion of this and other polytopes in higher dimensions. The article by John Sullivan, "Generating and Rendering Four-Dimensional Polytopes", *The Mathematica Journal* **1**, No. 3 (1991), explains how we used the symmetry group of this polytope to compute (in the computer language Mathematica) the geometry for Color Plate C No. 1.

11. Such motion would show the covering translations of another beautiful and related mathematical object, the Poincaré dodecahedral space or homology three-sphere. This manifold can be obtained by identifying opposite faces of one of the bubbles in the cluster.

Illustrating *Beyond the Third Dimension*

*Thomas Banchoff and
Davide P. Cervone*

On 20 June 1990, the first copies of *Beyond the Third Dimension* [1] came off the press. The production of this 210-page volume with 240 illustrations had followed a precise schedule with little variation from the time the preliminary manuscript was sent to the acquisitions editor in August 1989, until the computer disks containing all the finished text and completed line drawings were sent to the printer the following May. In the meantime, nearly every sentence had been rewritten, some of them several times, in response to a thorough editing job by the project editor, which was augmented in later stages by the additional comments of the production editor.

Equal scrutiny was given to the computer-generated artwork, created almost entirely at Brown University, Providence, Rhode Island, United States. In an earlier day, my student assistants and I would have submitted careful drawings to the publisher, who then would have sent them to a design house in New York for preliminary rendering. Then we would have made the corrections (and it is impossible for a design house without a professional geometer on its staff to produce finished drawings of complicated phenomena without introducing numerous mathematical errors). The corrected drawings would then go back to the designers, and this back-and-forth process would be repeated as often as necessary in order to converge to an acceptable

solution. In order for this process to be completed in time, the original drawings would have had to be in place before January of 1990. As it was, we contracted the production of computer files of the finished drawings, containing all the information for color separations, so that the final images were designed and implemented as the text was taking its final form in March 1990. This produced a double set of deadlines of which several people at the publishing house predicted we would never be able to meet. Although we seriously underestimated the amount of effort necessary to achieve the goals

ABSTRACT

Production of the images for the recent volume *Beyond the Third Dimension* involved the use of several new computer-graphics techniques for design of line drawings, and considerable interaction with artists who have worked with higher-dimensional geometric concepts. In this article, the authors describe the tools used and discuss connections with the works of a number of artists.

within the time-frame, we were able to do it, thanks to the hard work of several student assistants and the full cooperation of the production staff at the publishing company.

In this article, we describe some of the more interesting challenges provided by this project, and indicate the methods that we used to produce the original artwork in our volume. We also mention a number of interactions with artists whose work appears in this book, including Attilio Pierelli, Tony Robbin, Max Bill, Lana Posner, David Brisson and Salvador Dalí. Although we will not enter into a full discussion of the mathematical technicalities, we hope to include enough information so that interested persons with access to computer-graphics software can reproduce their own versions of the images described in this article. In our production of the line drawings with shading, we used the personal-computer drawing program Aldus FreeHand [2]. There are several other programs that offer features similar to the ones described below.

TWO-DIMENSIONAL GEOMETRIC DESIGN

Figures from plane geometry provide good exercises for any computer-graphics drawing program. Many such programs can implement familiar construction procedures that go

Fig. 1. The vertices of an enneagon can be separated into three groups, each group forming the vertices of a triangle, indicating a simpler structure underlying the more complicated one.

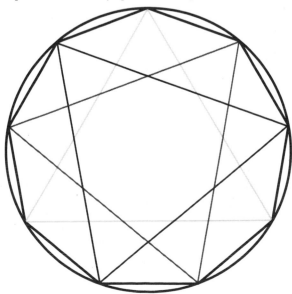

Thomas Banchoff (educator), Brown University, Mathematics Department, Box 1917, Providence, RI 02912, U.S.A.

Davide P. Cervone (student), Brown University, Mathematics Department, Box 1917, Providence, RI 02912, U.S.A.

equally spaced points determine three equilateral triangles is a good illustration of an investigation of a complicated figure by finding simpler figures contained within it (Fig. 1).

Preliminary work on the diagrams in our book was done in black and white, a simpler process than that required for color, which we wanted to do since we were also providing illustrations for an extended essay on dimensions for the volume *On the Shoulders of Giants,* published by the National Research Council under the direction of the Mathematical Sciences Education Board [3]. In this book, we had the great advantage of being able to render all diagrams in full color. In principle, our basic colors were restricted to a dozen, chosen in consultation with the members of the publisher's design staff; in fact, we were able to obtain a much larger range of colors by using each of the basic colors in several different concentrations. We used the basic color sequence to encode the steps of several of the more complicated constructions, so that any reader would know that the red portion was drawn first, then the orange, yellow, green, blue and violet portions in sequence. Later we used similar se-quencing to describe successive steps in one-parameter families of curves in the plane, when we dealt with wave-fronts emanating from a curve such as an ellipse (Fig. 2).

GEOMETRIC DESIGN IN DIMENSIONS THREE AND HIGHER

A number of the diagrams in the book were planar pro-jections of objects in three-dimensional (3D) and four-dimensional (4D) space. We accomplished most of them by traditional drafting procedures, building up orthographic pro-jections by using the machine to transfer segments to paral-lel positions, so that the squares in the projection of a subdivided cube could be represented by translates of a small number of parallelograms (Fig. 3). Again, the ability of the program to replicate units made it possible to gener-ate complicated objects like exploded views of decomposi-tions of cubes (Fig. 4) and hypercubes, or fold-out ver-sions of 3D polyhedra (Fig. 5) and 4D polytopes (Fig. 6).

Once again, color coding was important for expressing relationships of different parts of a figure or among figures in a family. For example, duals of regular polyhedra were always identified in complementary colors, and we carried the same pattern over as we investigated the regular poly-topes in four dimensions. Using various saturations of the basic colors, we could simulate the appearance of shading without having to go through the calculation of the precise

Fig. 3. A representation of a 4D hypercube with two sets of paral-lel faces highlighted. The figure is easily produced on a computer by duplicating and translating a single initial face in each set.

back to Euclid. We can also utilize computer approxima-tions to produce images that cannot be constructed by the traditional ruler-and-compass procedures, for example, a regu-lar heptagon or a regular enneagon. We can make use of the built-in approximation capabilities of a drawing pro-gram to achieve suitable geometric representations. For example, Aldus FreeHand enables us to rotate any figure by any desired angle, so we may rotate by 40° to produce a regular nine-sided polygon, even though it is impossible to construct the 40° angle using ruler and compass alone. That the nine

Fig. 4. An exploded view of a cube illustrating the formula for the cube of a binomial. The com-puter allows each portion of the cube to be treated as a unit, easily allowing its position to be adjusted relative to the other pieces.

Fig. 6. Just as a 3D cube can be unfolded into six squares that form a cross-shape in the plane, so can the 4D hypercube be unfolded into eight cubes in three-space.

Fig. 5. A planar template that can be folded into a 3D pyramid, which is one-third of a cube.

angle of inclination of each face of a polyhedron with the direction of a light source, especially since it is not clear how that shading should be represented in dimensions higher than three.

In only one place in the book did we use anything other than a solid color for each facet of a polyhedron; this was done in the section in which we discuss intersection of two-dimensional (2D) planes in four-space. If we color each point of a surface by its fourth coordinate, then a plane in three-space will appear in monochrome, say violet, while a plane extending into four-space will have a gradation of color expressed as a family of parallel lines going from red to violet to blue. If a two-plane in four-space intersects a plane in three-space at a single point, then the projection of this configuration into three-space will be a pair of intersecting planes, and exactly one point on the violet line in the second plane will intersect the violet plane. This is one of the best ways for identification of the intersection points of a pair of surfaces in four-space by looking at the intersection curves of their projections into three-space (Fig. 7).

A number of the figures in this book were produced through the use of other computer-graphics devices. Some of the most effective ones resulted from a project, carried out over several years with a student assistant, Nicholas Thompson, who programmed the PRIME PXCL5500 to produce fully rendered images of surfaces in 3D and 4D space. The primary advantage of this technology is its speed of display, permitting real-time rotations, slicing and one-parameter deformations of surfaces as the operator enters various parameters by means of analogue devices such as dials or slider bars. In our book, it was impossible to achieve these animation effects, but we did present storyboards to indicate various scenarios, such as perspective distortions of the images of surfaces rotating in four-space, which we used to illustrate a well-known sequence from the film *The Hypersphere: Foliation and Projections* [4,5].

We were able to use the full-color capabilities of this raster-graphics machine to present other aspects of the geometry of higher dimensions as well. For example, the graph of a complex-valued function of a complex variable requires four real dimensions. In this approach, the graph of the square-root relation is represented as a surface that intersects itself along a segment ending at a pinch point. By coloring the points of the original disc domain according to their angular coordinates, we may easily distinguish the two different sheets passing through a given intersection curve and even identify the coordinates of the angles, for example,

when a blue region intersects the orange region halfway around the disc.

CREATING THE ARTWORK FOR *BEYOND THE THIRD DIMENSION*

Two major processes were used to produce the line-art in *Beyond the Third Dimension*. One was to describe the shapes to the computer using mathematical formulas, and have the computer perform 3D-to-2D transformations in order to render a perspective drawing of the objects in question. The other was to use the computer as an electronic canvas with which the operator places each line or shaded region individually, with the precision and flexibility inherent in the computer. The former process might well be called computer-generated artwork, whereas the latter is more properly denoted computer-assisted art. Both processes were critical

Fig. 7. Two planes in four-space may intersect at a single point. Here, the two planes are shown in three-space with the fourth dimension represented by shading. Although the two planes appear to intersect along a line, the only intersection that occurs in four dimensions is at the point where the colors also match.

Fig. 8. When the apex of a pyramid is moved, it can be made taller, shorter or skewed. As the vertex is moved, all the lines joining it to the base are automatically redrawn by the computer.

to the production of the book, and each has its advantages and disadvantages.

The computer-generated diagrams appear primarily in chapter 3, simulating the water levels that would occur as different objects sink into a pool. The advantage here is that the computer can generate hundreds of lines and patches far more quickly and accurately than an artist could, and once drawn the picture can be rotated in three dimensions in order to get the best view (the importance of this ability should not be underestimated). There are a number of disadvantages, however. For best results, the computer needs to produce a large number of lines and patches; this requires that the shape of the object be given as a formula, and this may not be easy to do. Second, the artist usually has only global control over the object and cannot manipulate the lines or patches individually. In order to overcome this problem, we decided to combine the computer-generated approach with the computer-aided method—that is, we would use the computer to produce a draft image and then use the illustration program to add the final touches required for the finished piece.

This process introduced a whole set of problems of its own. To begin with, the program that generated the images did not run on a Macintosh personal computer, which we used for producing the text and other artwork, but rather on a Sun workstation. Furthermore, the image-generating program did not produce data files that could be used with our illustration program. Finally, the Macintosh we were using was not attached to the same network as the Sun workstation; this alone made getting the data files to the Macintosh difficult.

Fortunately, the program used to produce the computer-generated artwork was written here at Brown University, and the developers were able to modify it sufficiently to produce data files that could be used on the Macintosh. Only a limited amount of the visual information normally available in the program was transferable, however. The ability to shade the faces was not transportable, for example, which is why all the patches in the diagrams appearing in our book are of a single color. (We have since been able to remove this limitation, but not in time to get the results into the book.)

Once the files were produced, getting them to the Macintosh was not so much difficult as it was tedious. This is much easier now that we have the Macintosh properly networked, but the images for the book had to be moved by computer disk, and, since they were quite large files (on the order of 100K for a single diagram of a torus), this took some time. One reason for such large files is that each line segment and each patch is a separate object within a file, resulting in

thousands of individual items in each file. Furthermore, the files included every line and patch, even if they were completely hidden by other ones.

Despite these problems, however, the results were quite good. This combination of computer-generated and computer-aided artwork is very powerful—and is not fully utilized in the computing community. Further software development in this area could be very rewarding.

The remainder of the artwork was perfectly suited to the computer-aided approach. The difficulties here are the same as those faced by an artist using more traditional tools: finding the best view before the object is drawn, getting the perspective right, making sure the sides of a cube are really square, and so forth. Computer tools can be a big help in solving these problems.

Aldus FreeHand is an *object-oriented* drawing program, which means that when a line or a square is drawn on the page, it does not merely become a part of the picture, but retains its identity as a line or square. This means, for example, that the endpoint of the line can be moved, and the entire line will move to the new position. If a square is placed so that it obscures part of a line, the square can be moved to another part of the picture, and the line that was underneath the square will automatically be redrawn by the program. This sharply contrasts with traditional art tools, with which a line drawn on a piece of paper is only so much graphite on the page—if it is necessary to move it, the line must be erased and drawn again somewhere else, possibly destroying lines that intersect it.

Not only can the computer artist move the endpoint of a single line, the endpoints of many lines can be moved at once. For example, in a typical two-point perspective drawing of a cube, all four corners of one face can be selected and moved at once, stretching the cube into a rectangular box. Or the vertex of a pyramid can be moved to create a skewed pyramid or a taller pyramid or a shorter one (Fig. 8). For drawings made up of straight lines and regions filled with solid colors, this is an extremely flexible and powerful environment.

Another important feature of computer-aided illustration involves the ease of duplication of existing objects. For example, once the bottom face of a cube is drawn, the top face can be created simply by duplicating the bottom face and moving it vertically. The lower face itself can be built by drawing the front two edges, then duplicating them and moving the duplicates to form two back edges. Finally, the vertical edges can be duplicates of a single vertical edge at the front corner. We chose to use orthogonal projections rather than perspective drawings for most of the diagrams,

partly for mathematical reasons and partly for computational reasons: the procedure outlined above for producing an orthogonal projection of a cube is much easier than the one required to produce a picture of a cube in true perspective. The illustration program we used provides a number of crucial features, including the ability to duplicate movements of objects as well as the objects themselves.

These techniques are enhanced by a feature called *snap guides*. These are vertical or horizontal lines that can be placed anywhere within the picture and that act as magnets for objects; whenever an object is moved near enough to a snap guide, the object will 'snap' to the line. This way it is simple to align multiple objects horizontally or vertically. One of the hardest parts of drawing mathematical objects is getting the ends of lines to match up correctly. This is accomplished easily through the use of horizontal and vertical guides that cross at the point where the lines should join.

One of the most important features for our purposes is the program's ability to resize objects—not just by eye but by specific percentages of the original size—and to have the shrinkage occur toward a specific point. For example, it is simple to find the midpoint of a diagonal line in the following way: first duplicate the line, then shrink the duplicate toward one of its endpoints to 50% of its original size; the other endpoint will now be at the midpoint of the original line—no measurements or calculations are required. To divide a line into thirds, simply duplicate it, then shrink the duplicate to 33% its original size, but this time shrink it toward its center (the program provides this option, so we do not have to find its center first); the endpoints of the duplicate now divide the original line into thirds. For a final example, with a drawing of a pyramid, one can show a horizontal slice halfway up the pyramid, by simply duplicating the base and shrinking it by 50%, this time toward the vertex of the pyramid (Fig. 9). The duplicated base will shrink by 50% and move halfway up the pyramid, both at the same time. As this example indicates, the combination of duplication, alignment and resizing makes these software functions even more powerful.

Although we used a 2D drawing program, it is possible to use its features to produce 3D drawings without too much difficulty. The first step involves the choice of a line segment that represents a unit length in each of the three coordinate directions (for example, the front edge of a cube together with the front two edges of its base). This is one of the harder parts of drawing; it can either be done mathematically, by calculating the exact positions of these initial lines, or by estimating them by hand (in this case, it is usually easiest to draw a cube and adjust it until it looks right, then remove all but the edges described above). Once these lines have been produced, any point in three-space can be located by appropriately resizing and translating these line segments.

The process just described still requires calculating the three-dimensional positions of the points in the drawing (something that computers are well-suited to do, but that humans find tiresome). Fortunately for us, the very geometry of the problems we were illustrating provided much easier methods. For example, in chapter 5 we describe the duals to the regular polyhedra, and the diagrams were constructed in essentially the same way outlined in the text itself. Take, for instance, the cube and its dual, the octahedron. The cube is easily constructed from the three unit-coordinate line-segments, as indicated above; once we have the cube, it is easy to find the centers of its square faces by drawing a diagonal and sizing it to 50% toward one of its endpoints. It is then a simple matter to join these centers together to form the octahedron. The whole process should take only a few minutes for someone practiced in the art of computer-aided drawing, and the result is a beautiful and perfectly accurate mathematical drawing (Fig. 10).

For diagrams with filled-in patches, shading can help make an object look more three-dimensional, however, for objects only made of lines, this effect is harder to achieve. When two lines cross on the page but do not really cross in three-space, visual ambiguity can result. Artists have traditionally solved this problem by breaking the line that is farthest behind, leaving a slight gap around the top line. This makes it clear which line is on top. This effect is achieved on the computer in a surprisingly simple way. Unlike the traditional pencil, the computer can draw in white as well as black; one way to produce the desired broken line is to draw the back line first. Next, draw a wide white line where the top line is to cross the back line, then duplicate it on top of that as a thinner black line. The result will be a black line with a thin white border around it on top of another black line; the white border will obscure the black

Fig. 9. A pyramid can be cut in half by duplicating its base and shrinking it by 50% toward its apex.

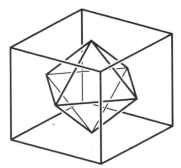

Fig. 10. Beginning with a cube, the centers of each face are found by shrinking a diagonal to 50%, and then these centers are joined to form an octahedron, dual to the cube.

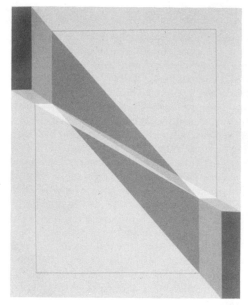

Fig. 11. Lana Posner, *Perspective Twist IV*, acrylic, 24 × 30 in, 1983. This painting shows true perspective in each portion of the figure, but an impossible configuration overall.

Fig. 12. James Billmyer, Untitled, oil, 30 × 30 in, 1970. Billmyer's linear paintings lead the viewer off the page and back again in four different directions.

line below, resulting in the desired effect of a break. There are a number of advantages to this approach: first, the ends of the broken line will be parallel to the line that crosses it. Second, if the upper line needs to be repositioned for any reason, it is simple to move both the black and the white lines together; thus the 'break' will move along with the line. This makes it convenient to update the picture. On the other hand, some care must be taken near the endpoints of the white line so as not to obscure lines that are supposed to meet at a corner.

This brings us to the final phase of production: corrections and updates. One of the real advantages we enjoyed with the use of computers for artwork production was the ease with which updates were accomplished. If the publisher requested a change to a diagram, it could usually be made the same day. Moreover, it is simple to produce more than one copy of a picture and modify each in slightly different ways in order to consider a number of possible modification options. Each is an original (no paste-ups or overlays), and the best one can be chosen purely on its visual merits. Our publishers were skeptical about our ability to produce the artwork in-house, and the rate at which we were able to produce corrections amazed them.

The original diagrams were drawn at whatever sizes were most convenient for the artist. The publisher used photo-reductions to lay out the book, and then gave us the measurements for the final diagrams. The ability of the

illustration program to resize objects (in this case, the entire diagram) came in handy again, as it allowed us to reduce the original drawings to exactly the required sizes. Photo-reducing would have reduced not only the overall size of the diagram, but also the width of each line and the size of the text in the picture. The illustration program, however, allowed us to reduce the size of the diagram while leaving the line widths unchanged; thus line-sizes were consistently maintained from figure to figure.

THE ARTISTS OF *BEYOND THE THIRD DIMENSION*

Many artists have permitted their work to be displayed in the book as illustrations of the interaction between dimensionality and art. Lana Posner and I began working together 10 years ago when her work was displayed at the Providence Art Club. The use of impossible figures to explore perception of form is illustrated most clearly in her painting *Perspective Twist* (Fig. 11). Although each portion of the painting suggests a natural three-dimensional interpretation, there is no consistent interpretation of the configuration as a whole, a phenomenon explored most completely and effectively by

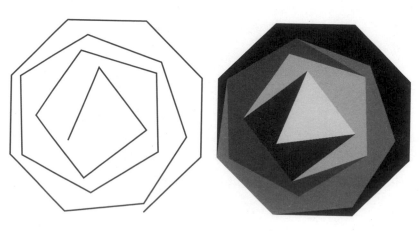

Fig. 13. Computer graphic based on Max Bill's forms depicted in his lithographs *The Theme* and *Variation 1* of 1938. Equal-sided polygons propose outward from a triangle in the center to a regular octagon.

M. C. Escher [6–9]. Using the computer, we investigated the challenge of realizing this image as the projection of a figure in space by arbitrarily assigning additional coordinates to vertices of the image, either preserving central symmetry or assigning the same additional coordinates to points situated symmetrically with respect to the center of the picture. The assigning of one additional coordinate to each point lifted the picture into three-space, necessarily introducing self-intersections, since no consistent lifting was possible. The assigning of two additional coordinates, however, made it possible for us to see the original image as the projection into the plane of a figure in four-space that had no self-intersections whatsoever. Rotation of this figure through different complete turns provided families of images, coalescing back to the original. We did not work long enough to determine which choices of additional coordinates would provide the most artistically pleasing four-dimensional sculpture based on the original image, but this does seem to be a good project.

Paintings that come off the canvas in different ways appear in other guises as well. The work of the late James Billmyer is a particularly impressive illustration of the way a two-dimensional oil painting can take on higher-dimensional significance. Billmyer worked for a number of years with Hans Hofmann, an artist who stressed the importance of having objects move out from the canvas and then resolve back into it. By dealing with multiple rhythms, each with its family of angles on the plane and each with its representative color, Billmyer created patterns that would take the viewer out of the plane in independent directions before resolving back to the plane (Fig. 12). Billmyer and I spent many fascinating hours examining the higher-dimensional patterns that arose from the canvas, reminiscent of the forms that appeared in the film *The Hypercube: Projections and Slicing* [10].

Max Bill carried out a series of investigations of polygonal forms in the 1930s, and one image in particular seems to illustrate the increasing sequence of n-gons, spiralling out from a generating triangle (Fig. 13) [11]. According to Bill, the original painting was inaccurately reproduced when it was first published in Paris in 1938. With his permission, my assistant and I created a version of his image with the colors in the palette selected for our volume.

We had originally intended to use a photograph of a Bill sculpture of a Möbius band as the opening image for the final chapter on non-Euclidean geometry and nonorientable surfaces [12–14]. Unfortunately the photolithograph of the artist's work that we purchased from the publisher turned out to be too large for our page, so it

could not be used. Fortunately there was a good replacement, the Klein bottle rendered in glass by William D. Clark, a retired physicist living in California. Over the years there have been any number of glass-blown realizations of this important surface, but none has been more effective than the one developed over many years by Clark. The photograph of his image with a blue background is especially effective for displaying its beautifully constructed form.

Also appearing in an extremely attractive photograph is the stainless steel sculpture, *Ipercubo*, (the hypercube) by Attilio Pierelli, a sculptor residing in Rome (Color Plate C No. 3). As the leader of the *Dimensionalismo* art movement in Italy, he remains at the forefront in rendering the central projections of four-dimensional figures in materials that bring out their structure in new ways, with multifaceted reflections that reveal new symmetries as the object turns or as the viewer walks around it. Some of these effects notably appear in the film *Dimensions* [15].

Fig. 14. Salvador Dalí, *Corpus Hypercubicus* (The Crucifixion), oil on canvas, $76\frac{1}{2} \times 48\frac{3}{4}$ in, 1955. (Metropolitan Museum of Art, gift of Chester Dale Collection)

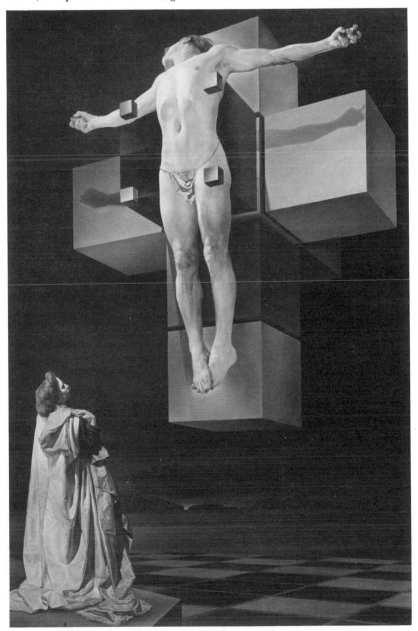

Tony Robbin's work is beautifully reproduced in a photograph in this volume, but no single picture can begin to do justice to the experience of viewing his structures from different angles [16]. As the viewer moves, the shadows of 3D wire figures emanating from the canvas play against the 2D acrylic painting. Other works of Robbin explore this phenomenon of the interaction of sculpture and painting more fully by allowing the viewer to see red or green shadows with anaglyph glasses, providing two different projections.

This concept of providing different images to the left and right eyes is, of course, the basis of ordinary stereoscopic viewing. Extraordinary, however, is the description of hyper-stereoscopic vision, as developed by the late David Brisson, founder of the Hypergraphics Group, which has brought together the efforts of many painters, sculptors and film-makers, all inspired by the challenge of representing geometry of one dimension in the medium of another [17] (Color Plate C No. 4). A single hyperstereogram represents the projection of a figure from four-space into a pair of planes that do not meet in a line parallel to the spine of the viewer, as in ordinary stereoptic viewing, but rather in a single point. In viewing such a hyperstereogram, the observer sees different parts of the object in focus depending on the sideways inclination. The insights to be gained by a systematic and complete investigation of this remarkable phenomenon are only beginning to be appreciated. The film *Dimensions* mentioned above is dedicated to Brisson, who appears in the film along with his wife, sculptor Harriet Brisson [18].

My most fascinating connection with artists interested in dimension is my association with Salvador Dalí, beginning in 1976 and extending over a series of a dozen visits until 1986, 2 years before his death. For a number of years, my computer-graphics colleague Charles Strauss and I had displayed Dalí's *Corpus Hypercubicus* (Fig. 14) as an example of the way artists use higher-dimensional imagery in conscious ways in their paintings. When the *Washington Post* ran a story on our work, they included in the background a photograph of that surrealist painting. Shortly after that, we received a call inviting us to New York to confer with Dalí, who was interested in ways of creating and presenting stereoscopic oil paintings. We were impressed by the level of his technical knowledge, and he was impressed in particular by the folding model of the hypercube that was devised as a part of my 1964 thesis on global differential geometry. He kept the model, and subsequently included a copy of it in his museum in Figueres, Catalonia, Spain. When he was asked about the inspiration for the *Corpus Hypercubicus*, he referred to the philosophy of Raimondo Lulio [19], coincidentally already familiar to me. That coincidence produced a mutual respect that led to a series of invitations from Dalí over the next few years to show our new slides, videotapes and films, and to see his new works in progress. Strauss and I began at this time to work on the project, described in detail in the book, on the use of perspective to explore illusions, not just in the plane but in three-dimensional space in a variety of scales. By the time we visited Dalí in Paris in 1981, the project had literally gone off the earth, never to be built. Although I discussed this and other projects with Dalí in three further visits to Spain, we never completed a project together. Dalí did always seem to enjoy viewing the films, and even toward the end he still delighted in identifying the elliptic and hyperbolic catastrophes that appeared as light caustics in computer-generated wire-frame images of surfaces projected from four-space.

CONCLUSION

Working on the production of images for *Beyond the Third Dimension* has given us an opportunity to develop a whole range of techniques for dealing with the geometry of different dimensions and, at the same time, establish new relationships with a variety of artists. We look forward to more experiences of the same sort in the future.

References and Notes

1. Thomas Banchoff, *Beyond the Third Dimension* (New York: Freeman, 1990). Article co-author Davide P. Cervone was in charge of image production for *Beyond the Third Dimension*.

2. Aldus FreeHand, published by Aldus Corporation for the Macintosh computer, is a powerful and full-featured two-dimensional drawing program.

3. Lynn Steen, ed., *On the Shoulders of Giants* (Washington, D.C.: Mathematical Sciences Education Board, National Academy Press, 1990).

4. T. Banchoff, H. Koçak, D. Laidlaw and D. Margolis, *The Hypersphere: Foliation and Projections*, 16mm color-silent film, 3 min (Providence, RI: Brown University, 1985).

5. For a description of a sequence from *The Hypersphere: Foliation and Projections*, see Michele Emmer, *Lo spazio tra matematica ed arte*, exh. cat. of the *Spazio* (space) section of La Biennale d'Arte di Venezia (Venice: Edizioni La Bienalle, 1986) pp. 37–39.

6. L. S. Penrose and R. Penrose, "Impossible Objects: A Special Type of Visual Illusion", *Brit. J. Psych* **49** (1958) pp. 31–33.

7. R. Penrose, "Escher and the Visual Representation of Mathematical Ideas", in H. S. M. Coxeter, M. Emmer, R. Penrose and M. L. Teubner, eds., *M. C. Escher: Art and Science* (Amsterdam: North Holland, 1988).

8. M. Emmer with R. Penrose, *M. C. Escher: Geometries and Impossible Worlds*, 16mm color-sound film from the series *Art and Mathematics*, 27 min (Rome: FILM 7 International, 1984).

9. M. Emmer, "*The Belvedere* by Escher: a Modest Hypothesis", *Structural Topology* **17** (1991).

10. T. Banchoff and C. Strauss, *The Hypercube: Projections and Slicing*, 16mm color-sound film, 9 min (Providence, RI: Brown University, 1978).

11. Max Bill, *Fifteen Variations on a Single Theme*, 16 lithographs, 30.5 × 32 cm, 1934–1938. Originally published as *Quinze variations sur un même thème* (Paris: Editions des Chroniques du Jour, 1938). Reprinted in E. Huttinger, *Max Bill* (Zurich: ABC Editions, 1978). See the front and back covers of this Special Issue of *Leonardo*, for *Variation 10* and *The Theme;* and p. iv for a description of Bill's series of lithographs.

12. M. Emmer with Max Bill, *Ars Combinatoria*, 16mm color-sound film from the series *Art and Mathematics*, 27 min (Rome: FILM 7 International, 1982).

13. M. Emmer with Max Bill, *Möbius Band*, 16mm color-sound film from the series *Art and Mathematics*, 27 min (Rome: FILM 7 International, 1982).

14. M. Emmer, "Visual Art and Mathematics: The Möbius Band", *Leonardo* **13**, No. 2, 108–111 (1980).

15. M. Emmer with Thomas Banchoff, *Dimensions*, 16mm color-sound film from the series *Art and Mathematics*, 27 min (Rome: FILM 7 International, 1984).

16. For a discussion of the four-dimensional elements in his paintings, see Tony Robbin, "Painting and Physics: Modeling Artistic and Scientific Experience in Four Spatial Dimensions", *Leonardo* **17**, No. 4, 227–233 (1984).

17. D. Brisson, ed., *Hypergraphics: Visualizing Complex Relationships in Art, Science and Technology* (Washington, D.C.: American Association for the Advancement of Science, No. 24, 1978).

18. See Harriet Brisson's article, "Visualization in Art and Science" in this issue of *Leonardo*.

19. For the work of the twelfth-century Catalonian, Raimondo Lulio, see Juan de Herrera, *Discurso de la Figura Cubica* (Madrid: Editorial Plutarco, 1935).

True 3D Computer Modeling: Sculpture of Numerical Abstraction

Stewart Dickson

The visual computer workstation is a radical novelty in human history [1]. The computer offers interactive visual feedback representing numeric data, symbolic processing of mathematical language and rapid prototyping technologies [2]. The combination of these new technologies has made a profound impression on the philosophy of many disciplines of study. I have initiated a project of combining these technologies and philosophies to create sculpture. The tradition of the mathematical approach to art is realized in a new way via the visual computer workstation.

My approach to making pictures with the use of a computer is to iteratively produce visual output from a computer-programming language. I can readily observe the changes in visual output caused by changes to the computer program. When I am implementing a mathematical formula in the programming language, programming computer graphics provides a dynamic visual concretization of the mathematics I am investigating.

In the course of programming pictures, I observe the connection between visual logic and abstract logic. The feedback loop provided by a concrete representation of numerical abstraction has enormous benefits for understanding the abstract language used to specify the visual imagery. This philosophy is central to many of the breakthroughs being made in mathematics by researchers such as Benoit Mandelbrot [3] and David Hoffman [4].

Concretization collapses the conceptual distance between that which is observed and that which is known abstractly. The mechanism between the endpoints is a series of translations necessary to implement the mathematics in a machine-executable form and to condense the abstract problem into a spatial representation. New compilers of natural mathematical language make the condensation transparent.

A two-dimensional (2D) picture representing three- or higher-dimensional form is a lower-dimensional abstraction of the higher-dimensional actuality. I claim that creating sculpture of numerical abstraction increases the immediacy of the abstraction over what a picture can convey. Computer-aided prototyping technologies make a direct projection of three-dimensional (3D) abstraction into physical reality.

An interactive computer graphic of a 3D space exists behind the glass front of a cathode-ray tube. Even a hologram or stereo projection is only an illusion in light. A sculpture occupies and shares the physical space occupied by the viewer. A sculpture has its own presence, one that dominates these alternate presentation media.

EARLY WORK

I saw my first interactive, visual computer workstation in 1984. It was a DEC pdp11/40 with a Vector General scope that ran Tom DeFanti's GRASS interactive graphical operating system [5] and programming language. The first incarnation of GRASS was known as the Graphics Symbiosis at Ohio State University. It later became the Circle Graphics Habitat at the University of Illinois at Chicago. This is the machine Larry Cuba used to create the *Death Star* hologram simulation sequence in the original *Star Wars* motion picture. My experience in computer graphics up to that time consisted of writing FORTRAN batch programs for an electrostatic plotter at AT&T Bell Labs in Naperville, Illinois.

Despite the fact that the pdp11/40 had only 32k bytes of magnetic core memory, the Vector General had hardware display capability for interactively manipulating 3D objects in vector-list form in real-time. The GRASS language also had some very interesting features. Among them were character string manipulation tools that allowed me to write primitive compilers, such as those for evaluating Lindenmayer [6] systems and Boolean operations.

The experience of GRASS was an immediate acceleration of all the techniques I had been developing for making pictures up to that time. From amidst the creative explosion, there emerged a technique of construction that is becoming increasingly important to me.

I discovered that aligning circular arcs with the vertices and edges of a polyhedron yields a shape that can be repeated in the manner of an atomic crystalline lattice, but that can define a smoothed topological surface of many handles. Achieving the surface requires triangulating closed wireframes made of connected circular arcs. In implementing the program to do this, I came up with a linear approxi-

ABSTRACT

The author gives an account of his experience in progamming interactive computer graphics. Observations are made of the logical connections between a computer-generated picture and the computer program that generated the picture. The action of condensing abstraction into visual form as an aid in understanding the abstraction is studied in the context of scientific visualization. The author presents his work in making sculptures of mathematically defined surfaces via direct, three-dimensional computer-printing technologies.

Stewart Dickson (computer-graphics progammer), The Post Group Digital Center, 6335 Homewood Avenue, Hollywood, CA 90028, U.S.A. Fax: (213) 464-1953. E-mail: <celia!tpg!dickson@usc.edu>

Fig. 1a. Circles oriented at the edges and vertices of a tetrahedron. Dots show edge-oriented circle centers at the points of intersection of vertex-tangent planes and edge-normal planes.

Fig. 1b. Circular arcs truncated at their points of intersection. Arcs are grouped to form piecewise-circular boundaries about each face of the polyhedron.

Fig. 1c. Six-arc boundaries triangulated to a depth of six.

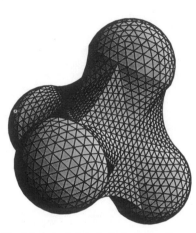

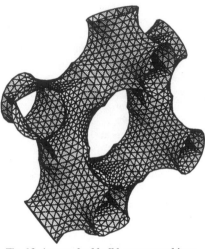

Fig. 1d. A single tetrahedral patch unit closed with geodesic hemispheres. The number of triangle edges around the edge of the hemisphere is a multiple of 10. The number of triangle edges around an end of the tetrahedral unit is a multiple of three. Thirty is the smallest number satisfying geodesic continuity from a tetrahedral unit to a geodesic hemisphere.

Fig. 1e. Six tetrahedra in the configuration of a benzene molecule.

Fig. 1f. A smoothed hull homeomorphic to a torus with 12 points removed.

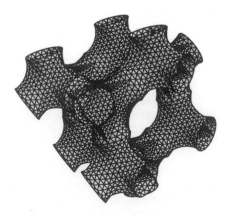

Fig. 1g. Ten tetrahedra. The edges of the tetrahedra form a large tetrahedron inscribed in the structure.

Fig. 1h. A smoothed hull homeomorphic to a sphere with six handles and 16 points removed.

mation for the task of drawing a minimal surface from the boundary. The general problem of finding a minimal surface defined by an arbitrary boundary is known as the Plateau Problem. I call my approximation a pseudo-minimal surface patch solution.

The resulting construction has a polygon net with the continuity properties of the geodesic dome [7], but has been extended to a nonspherical topology: a topology of many handles. Figure 1a shows circles oriented at the vertices and edges of a tetrahedron. Figure 1b shows circular arcs intersecting at the vertex-tangent and edge-normal planes of the tetrahedron. Figure 1c shows pseudo-minimal surface patches triangulated to a depth of six. Figure 1d shows pseudo-minimal surface patches triangulated to depth 10 and joined to geodesic hemispheres. Figures 1e through 1h show a surface with six handles constructed using this method. There exist similar constructions based on a simple cubic and an octet lattice structure [8]. The construction of the cubic case is shown in Fig. 2.

An energy-minimizing surface of identical topology to the tetrahedral lattice was independently discovered by David M. Anderson and David Hoffman [9] in 1988. This surface exists in the equiprobability surfaces of the covalent bonding electron orbitals between carbon atoms in block copolymer organic compounds. The octahedral infinite periodic minimal surface (IPMS) was shown by A. Schoen [10], in 1970, who attributed it to H. A. Schwarz [11] in the

1800s. I believe my drawing of geodesics on the surface is unique.

Minimal surfaces have a property known as vanishing mean curvature. The principal curvatures of a surface at a particular point on the surface are measured in two orthogonal planes intersecting at the line normal to the surface at the point [12,13]. On a minimal surface, the principle curvatures tend to become equal and opposite. This also means that the geodesic strut pattern of my construction not only has the multiple-arch property that made the geodesic dome important, but also has potential tensegrity properties of equally balanced tensions.

In 1985 I ported the programs I wrote in GRASS to a C-language object-modeling facility I have developed to complement the Wavefront Technologies software product. Among the techniques I developed in 1986 was one for creating a 3D object from a luminance contour graph of a digitally captured video image (Fig. 3). There is also, of course, interest in forming abstract representations of the observed or measured physical world. Three-dimensional robot vision is the reciprocal operation to direct 3D computer output.

In 1986 I experimented with making milled metal sculpture from objects I designed in the Wavefront interactive modeling environment (Fig. 4). This is an older technology, hence the realization in three-space of the abstract design was not as direct as it can be today.

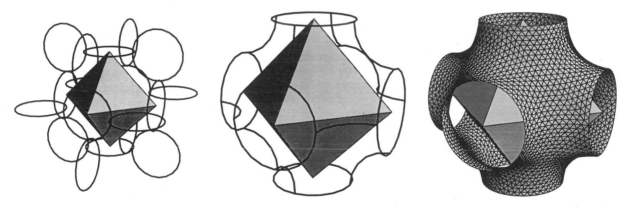

Fig. 2. (top, left to right) (a) Circles oriented at the edges and vertices of an octahedron. (b) Circular arcs truncated at their points of intersection. Arcs are grouped to form piecewise-circular boundaries about each face of the polyhedron. (c) Six-arc boundaries triangulated to a depth of 10. (bottom, left to right) (d) A single octahedral patch unit closed with geodesic hemispheres. The number of triangle edges around the edge of the hemisphere is a multiple of 10. The number of triangle edges around an end of the octahedral unit is a multiple of four. Twenty is the smallest number satisfying geodesic continuity from an octahedral unit to a geodesic hemisphere. (e) Eight octahedra in the configuration of a simple-cubic lattice. (f) A smoothed hull homeomorphic to a sphere with 12 handles and 24 points removed.

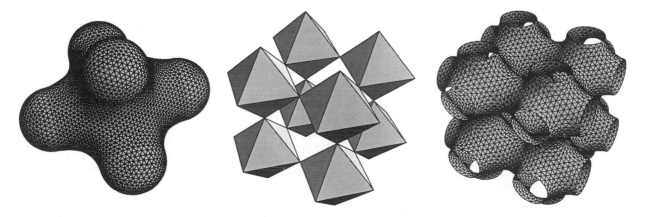

Fig. 3a. A color-resampled, digitally captured, video-camera image taken from a live model.

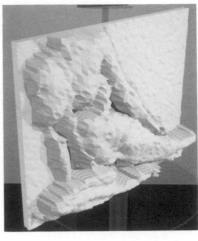

Fig. 3b. A wave-front advanced visualizer rendering of the three-dimensional numerical database of the luminance contour graph of the image in Fig. 3a.

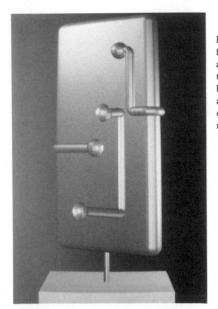

Fig. 4a. A wave-front advanced visualizer rendering of the numerical database of a sculpture as proposed for direct machining in metal.

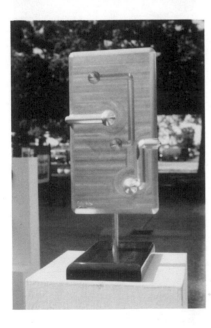

Fig. 4b. *Numb2.obj.*, milled aluminum on American black walnut base, 24 × 12 × 12 in, 1986. This object's features were milled from numerical templates and computer-generated images supplied by the artist [26].

COMPUTER-PRINTED SCULPTURE OF MATHEMATICS

Given:

$$10^0 \; pictures = 10^3 \, words \; [14];$$

$$1 \; picture = D^2; \; 1 \; sculpture = D^3;$$

$$1 \; sculpture = \left(D^2\right)^{\frac{3}{2}} = \left(10^3 \; words\right)^{\frac{3}{2}}$$

$$= 10^{\frac{9}{2}} \; words = 31622.766 \; words.$$

In 1988 I heard the first news of stereolithography, a revolutionary new process for 'printing' full 3D models from computer data. Developed by 3D Systems, Valencia, California, the process is based on a liquid plastic photopolymer resin that hardens under the influence of a computer-controlled laser. In an operation very much like a 3D laser printer, an elevated platform submersed in the liquid accomplishes a layer-by-layer building-up of a dimensional form from a 3D computer model.

I have used stereolithography to create physical replicas of 3D databases derived from mathematically described surfaces (Color Plates E No. 1, E No. 2, E No. 3) [15–17]. I have used computer-image-generating programs to render pictures of numerical models of these surfaces as sculpture in a proposed gallery installation (Color Plate E No. 4); I have used these pictures to promote the exhibition proposal before the sculptures actually existed.

I obtained polygon surface databases for three-, four- and infinite-ended minimal surfaces from James Hoffman, University of Massachusetts at Amherst, for my initial tests of my stereolithography apparatus data-interface programs. Part of this interface is facilities for adapting a surface of infinitesimal thickness to one of finite thickness that can physically exist. I have achieved a means for doing this that preserves the essence of the surface. Since this beginning I have added many objects of my own design to my catalogue of potential sculpture.

In the spring of 1990 I was hired as a freelance graphic artist to create illustrations using the Mathematica system for doing mathematics by computer for the book *Mathematica* by Stephen Wolfram (Figs 5–9) [18]. Programming in Mathematica has been a unique experience.

Mathematica is a very compact language. Recursive processing of each element of an expression or list of expressions is implicit in the language. Its syntax generally consists of punctuation symbols to accomplish things such as evaluating conditional statements and symbol-and-rule substitu-

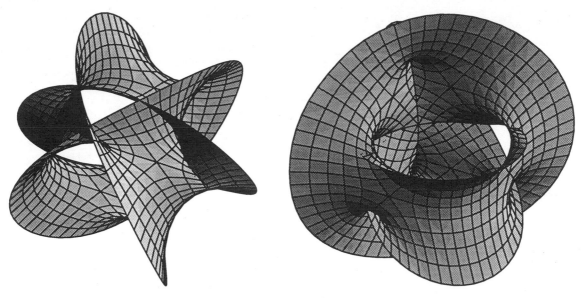

Fig. 5. Two views of complex projective varieties determined by $x^3 + y^3 = z^3$ projected into three-space, Mathematica Graphics3D[], 1990 [27,28].

tion. I have found that programs that run several hundred or even 1,000 lines in C language reduce to several dozen at the most in Mathematica.

Built-in numerical integration that accepts complex-valued functions has enabled me to reproduce some of the work of Hoffman and Meeks in less than 20 lines of code [19] (Figs 7–9). Symbolically solving systems of equations (not strictly linear ones) has enabled me to implement my manifold torus constructions, finding exact solutions for the centers of the circles and the intersections of the circular arcs and evaluating the subdivisions of arcs during triangulation. Previously I was constrained to achieving a 'visually correct' approximation to the construction using an interactive computer-aided design (CAD) program.

A variety of built-in graphics routines makes Mathematica a very versatile system for making pictures. As with GRASS, the most powerful feature of Mathematica is that it is an interactive interpreter with graphics. Interactively making pictures using a direct interpreter of mathematical language is the most direct link I have yet experienced between the abstract and sensual realms.

MATHEMATICS OR ART?

David Hoffman and James Hoffman have mounted exhibitions of the images they have made of minimal surfaces [20]. David Hoffman has referred to these as exhibitions of mathematics. Peter Richter and Hans-Otto Peitgen, on the other hand, have called their exhibitions of pictures from complex dynamics 'MAPART' [21]. The line between art and science blurs, and mathematicians do indeed begin to fancy themselves as artists.

The mathematical tradition in art has existed for a period of time much longer than the recent influence of graphical computing. The pursuit of representing 3D form through the intuitive mechanical process of printmaking, for example, has led artists such as M. C. Escher [22,23] to independently construct the same forms as mathematicians pursuing a purely logical, abstract approach.

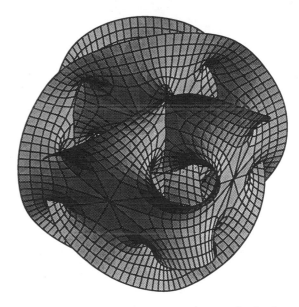

Fig. 6. Complex projective varieties determined by $x^5 + y^5 = z^5$ projected into three-space.

Artistic ideas borrowed from mathematics have traditionally been viewed as 'found ideas'. In these cases the selection of the particular idea, choice of materials, scale, quality of execution and presentation make the artwork the creation of the artist rather than the mathematician.

Mathematics has been invoked in art in an attempt to explain and encourage appreciation for the proportions of volumes of elements in visual composition. Artists have based their work on notions such as this. Thinking along these lines and anticipating concise and logical abstract languages of art, artists such as Max Bill [24] have prefigured the current popular emphasis on visualization in the sciences.

Mathematics is the urge to make a concise intellectual statement about something we have seen in nature. It is an attempt by the intellect to reach a complete understanding

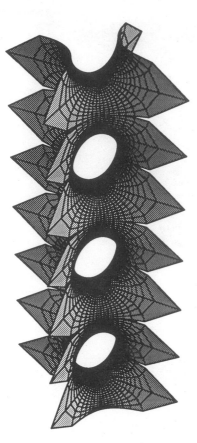

Fig. 7. Scherk's second minimal surface, Mathematica Graphics3D[] rendering from the global Enneper-Weierstrass form [29].

My goal is to create monumental structures in durable materials of the forms I have developed via visual computer programming. I wish also to continue developing recent advances in technology for art. Particularly attractive is a computer-aided prototyping technology known as ballistic particle manufacturing. Similar to stereolithography, ballistic particle manufacturing allows one to build a 3D object as a series of horizontal layers specified by computer-derived slices of a 3D data description.

Unlike stereolithography, ballistic particle manufacturing 'shoots' tiny polyethylene pellets that bond to each other upon impact. Because it does not necessarily build from a common reservoir of material, there exists the possibility of using multiple guns (five or more), each depositing a material that has been mixed with a different pigment. Thus, there is the capability to output an object that contains a colored surface texture that has been specified in the computer model. This affords the opportunity to apply procedural color generation, as well as electronic illustration techniques, directly to sculpture.

It appears that the application of mathematics to 3D surface-design techniques has only recently advanced to the point where we can readily achieve a surface of arbitrary topology with desirable geometry. Hoffman and Meeks used methods of differential geometry to find Enneper-Weierstrass parameterizations of minimal surfaces that were unsuspected before these mathematicians made pictures of them using the computer. They forged new parameterizations in order to achieve new pictures that they could imagine with the information supplied by their previous pictures. Creative mathematical methods of this kind are beyond the reach of most artists.

Three-dimensional computer graphics has a recently developed 'piecewise' approach to the problem of forming a smoothed surface of arbitrary topology [25]. The piecewise nature of the technique abstracts the geometric description from the topological description. There will also be some time before these techniques are reduced to intuitively understandable tools.

I am developing an aesthetic that establishes the emotional value of abstract logic as known to mathematics and

of a sensory experience. The mathematical approach to art is an attempt by the artist to sensually possess an elegant form that proceeds from abstract logic. This emotional impetus separates the act of creating art from the science.

Computer prototyping technology transmigrates the presence of a 3D entity from the vacuum of the cathode-ray tube to the physical space occupied by the viewer. The viewer's personal space encounters that which is occupied by the sculpture. The viewer compares the scale of the sculpture to his or her own scale. Virtual reality cannot compare to the experience of viewing a sculpture because the sensory element of touch is missing.

Fig. 8. Enneper's second minimal surface, Mathematica Graphics3D[] rendering from the global Enneper-Weierstrass form [30].

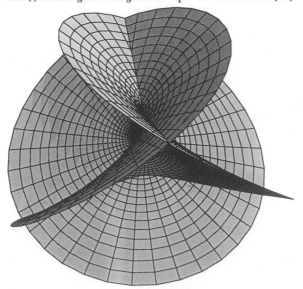

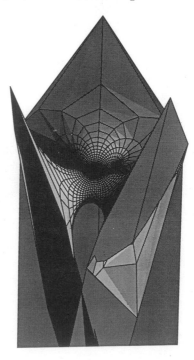

Fig. 9. Jorge-Meeks trinoid minimal surface. Mathematica Graphics3D[] rendering from the global Enneper-Weierstrass form [31].

graphical computer programming. I have found that this aesthetic need not be austere and mechanical. I am developing an alternative that still retains the elegance of its theoretical foundations.

Acknowledgments

This work has been supported in part by Rebecka Dickson, The Post Group, Inc., Silicon Graphics, Inc., Wavefront Technologies, Inc., 3D Systems, Inc., Wolfram Research, Inc., Hughes Aircraft Company, and the ACM/SIG-GRAPH organization. The objects depicted in the accompanying pictures are available as sculpture in various media by contacting the author or Williams Collection Gallery, 8 Chambers Street, Princeton, NJ 08540, U.S.A. TEL: 609-921-1142.

References and Notes

1. Edsger W. Dijkstra, "On the Cruelty of Teaching Computing Science", *Communications of the ACM* **32**, No. 12 (1989).

2. Terry T. Wohlers, "Practical Prototypes", *Computer Graphics World* **13**, No. 3 (1990).

3. Benoit B. Mandelbrot, *The Fractal Geometry of Nature* (San Francisco: Freeman, 1982).

4. David Hoffman, "New Embedded Minimal Surfaces", *The Mathematical Intelligencer* **9**, No. 3 (1987).

5. GRASS is a compiler, written in pdp/11 assembly language for the Vector General oscilloscope, which is connected via a parallel interface to a pdp11/40 minicomputer. The Vector General has Direct Memory Access (DMA) to the pdp11/40, which it uses to read the geometric vector list of the 3D object it is displaying. The Vector General also has control registers, accessible by the pdp11/40, which are loaded with values to use in geometrical transformations (e.g. translation, rotation, scale) that are performed at the rate at which the vector list is scanned onto the oscilloscope screen. The Vector General has a dial and button box and a data tablet for user interaction.

GRASS has an interactive interpreter with which the user communicates via an American Standard Code for Information Interchange (ASCII) data terminal. This user interface supports a graphic programming language, which was defined by DeFanti. GRASS was DeFanti's doctoral thesis project at Ohio State University, 1973, where GRASS was known as the Graphics Symbiosis. GRASS was documented under this name in *ACM Computer Graphics* **1**, No. 1 (1975). GRASS has also been documented as the digital component of the Circle Graphics Habitat.

6. Przemyslaw Prusinkiewicz and Aristid Lindenmayer, *The Algorithmic Beauty of Plants* (New York: Springer-Verlag, 1990).

7. R. Buckminster Fuller, "Building Construction", U.S. Patent 2,652,235, U.S. Department of Patents and Trademarks (29 June 1954).

8. Peter Pearce, *Structure in Nature is a Strategy for Design* (Cambridge, MA: MIT Press, 1978).

9. Michael J. Callahan, David Hoffman and James T. Hoffman, "Computer Graphics Tools for the Study of Minimal Surfaces", *Communications of the ACM* **31**, No. 6 (1988).

10. A. H. Schoen, *Infinite Periodic Minimal Surfaces without Self-Intersections*, NASA Technical Note TN-D-5541 (May 1970).

11. H. A. Schwarz, *Gesammelte Mathematische Abhandlungen*, Vol. 1 (Berlin: Julius Springer Verlag, 1890).

12. See Hoffman [4] p. 10.

13. D. Hilbert and S. Cohn-Vossen, *Anschauliche Geometrie* (New York: Dover, 1944).

14. See Callahan et al. [9] p. 648.

15. Stewart P. Dickson, "Manufacturing the Impossible Soap Bubble", *Iris Universe*, Silicon Graphics, Inc., No. 12 (Summer 1990).

16. *Knot* was created through these parametric equations:

$$X = \cos\frac{u}{3}(3 + \cos\frac{u}{2} + \cos v);$$

$$Y = \sin\frac{u}{3}(3 + \cos\frac{u}{2} + \cos v);$$

$$Z = \sin\frac{u}{2} + \sin v\,;$$

over the range:

$$u_0^{12\pi},\ v_0^{2\pi}.$$

17. The MESH program calculates the size of polygons on the surface to be inversely proportional to the curvature at every sample. The copyright for the database is held by David Hoffman and James Hoffman, 1985, 1986. The data was processed by the author to form a surface of finite thickness from one having no thickness as received. For information regarding the database, see Callahan et al. [9] p. 655; for information about the global Enneper-

Weierstrass form for minimal surfaces, see Hoffman [4] p. 11. The global Enneper-Weierstrass form for minimal surfaces is expressed as follows:

$$X(\zeta) = \mathrm{Re} \int_0^{re^{i\theta}} \phi\,.$$

where:

$$\phi = \left(1 - g^2, i\left(1 + g^2\right), 2g\right)\eta.$$

Historical examples of minimal surfaces can be achieved via the following substitutions.

Enneper's Minimal Surface (1864):

$$g = \zeta;\ \zeta = re^{i\theta};\ \eta = 1;$$

Scherk's Second Minimal Surface (1835):

$$g = i\zeta;\ \eta = \frac{4}{1 - \zeta^4};$$

Jorge-Meeks Trinoid (1983):

$$g = \zeta^2;\ \eta = \left(\zeta^3 - 1\right)^{-2}.$$

18. Stephan Wolfram, *Mathematica: A System for Doing Mathematics by Computer*, 2nd Ed. (Redwood City, CA: Addison-Wesley, 1991).

19. Stewart P. Dickson, "Minimal Surfaces", *The Mathematica Journal* **1**, No. 1 (1990).

20. Full-Color 20-×-25-in Minimal Surface Poster. Available for U.S. $6.50, payable to $H^2 0$ (for orders outside of U.S. add $1 for postage) from: POSTER, $H^2 0$, Box 818, Amherst, MA 01004-0818, U.S.A.

21. MAPART is the name Peitgen and Richter have given the Forshungsgruppe Komplexe Dynamik (Research Group for Complex Dynamics). See H.-0. Peitgen and P. H. Richter, *Frontiers of Chaos* (Bremen, Germany: Univ. of Bremen, 1985).

22. Arthur C. Loeb, "Polyhedra: Surfaces or Solids?", *Shaping Space: A Polyhedral Approach* (Boston, MA: Birkhauser, 1988).

23. H. S. M. Coxeter, M. Emmer, R. Penrose and M. Teuber, eds., *M. C. Escher: Art and Science* (Amsterdam: North Holland, 1988).

24. Max Bill, "The Mathematical Approach in Contemporary Art", *Werk*, No. 3 (1949).

25. Charles Loop and Tony DeRose, "Generalized B-Spline Surfaces of Arbitrary Topology", *ACM Computer Graphics* **24**, No. 4 (1990).

26. The object was milled by Randy Kohl at Isthmus Engineering Cooperative, Madison, Wisconsin, using a three-axis Numerically Controlled (NC) mill and an Atari minicomputer.

27. The image database exists in color Adobe PostScript® form. This is one element of a visualization of Fermat's Last Theorem: $x^n + y^n = z^n$ cannot be solved with nonzero integers (x,y,z) for $n > 2$. This visualization was derived by Andrew J. Hanson, Indiana University. The core Mathematica code for this visualization is copyright 1990 by Andrew Hanson. The picture was generated by the author using Mathematica on a Silicon Graphics Personal Iris 25/25TG. See A. J. Hanson, P. A. Heng and B. C. Kaplan, "Techniques for Visualizing Fermat's Last Theorem: A Case Study", *Proceedings of the First IEEE Conference on Visualization—Visualization '90* (Washington, D.C.: IEEE Computer Society, 1990).

28. The parametric plot is as follows:

$z_1^n + z_2^n = 1$ contains no rational points on the Unit Square for $n >$

$$X(a,b,n,k_1) = z_1;$$

$$Y(a,b,n,k_2) = z_2;$$

$$Z(a,b,n,k_1,k_2) = \cos\alpha\,\mathrm{Im}\,z_1 + \sin\alpha\,\mathrm{Im}\,z_2;$$

Where:

$$z_1 = \mathrm{Re}\, e^{\frac{i2\pi k_1}{n}}\, u_1^{\frac{2}{n}};$$

$$z_2 = \mathrm{Re}\, e^{\frac{i2\pi k_2}{n}}\, u_2^{\frac{2}{n}};$$

$$\alpha = \frac{\pi}{2};$$

$$u_1 = \frac{1}{2}e^{a+ib} + e^{-a-ib};\ u_2 = \frac{1}{2}e^{a+ib} - e^{-a-ib};$$

$$a_{-1.0}^{1.0};\ b_0^{\frac{\pi}{2}};\ k_{1_0}^{n-1};\ k_{2_0}^{n-1}.$$

29. Graphics3D[] is a Mathematica defined object that is a three-dimensional graphic entity. It can contain points, lines, polygons, surface coloration, drawing style and shading directives. Graphics3D[] is the output object of Mathematica and can be used to communicate surface form to computer-aided drafting (CAD) systems, stereolithography apparata and the like. See Wolfram [18].

30. See [29].

31. See [29].

Generative Mathematics: Mathematically Described and Calculated Visual Art

*Herbert W. Franke and
Horst S. Helbig*

Mathematical formulas, especially those of the type $z = f(x,y)$, can be a description of images, comparable to the description of music by notes. Through the use of formulas (software) we gain generative principles. Beyond formal descriptions, we obtain guides for the construction of images. For example, if we use a parametric representation of a curve, the result is similar to traditional methods of drawing and painting—we obtain the position of an image. We call this a *point-for-point* working method.

Other kinds of mathematical methods provide results that suggest other graphic methods. When each interference alters the entire image, we call this an *integral* method. Changes in an image are caused through variations of parameters or, more generally, through the use of a class of mathematical transformations. An image can be built up and optimized by starting with a simple formula and then applying a sequence of transformations.

The application of mathematics also alters another aspect of fine arts. Whereas traditional painting is limited by the size of the frame, mathematical methods allow image structures to expand to infinity, if necessary. We can consider the computer monitor to be a window that allows us to look at a part of the whole representation. This suggests a transition to an interactive way of seeing, by which the user can select

a sequence of images. The classical picture printed on paper or canvas is not equivalent to the computer medium. The potential of computer-graphics display is only fully realized when the computer is used as an interactive tool.

In addition, the application of mathematics can bring motion to static graphic images. Making small changes to a parameter can lead to an image sequence, which can be used as an animation. For a direct transition, a real-time computer and a mathematical description of the images are necessary.

Herbert W. Franke (art theorist, artist, cybernetician, physicist, writer), Puppling 40, D-8195 Egling, Germany.

Horst S. Helbig (physicist, computer scientist), Muehlaustr. 14, D-8913 Schondorf, Germany.

ABSTRACT

*O*ne of the main functions of the computer is the graphic display of results. Through the use of the computer, the visualization of mathematical relations can lead to new ways of comprehending mathematics. In addition, the resulting images can be remarkably attractive. The authors show how mathematics can be used as a tool for the creation of artistic images. They present examples of methods that illustrate how long-established relationships between art and mathematics can be brought up-to-date.

EXTENSION OF STRUCTURES

Art is a creative process, one that generates innovation. Some conventionally oriented artistic scientists and critics have expressed the opinion that fine art has exhausted all forms and structures, so innovation is not possible. The future of art production is limited to a revival of old styles, critics say. Results of visualized mathematics provide a great deal of evidence that this assumption is not valid.

If one is engaged, as we are, with an inventory of all mathematical branches and with an interest in visualizing

Fig. 1. Algebraic functions of the form $z = f(x,y)$ are best suited for spatial-perspectival views. The value z is defined as the height of the space plane z over the (x,y) ground plane. Special computer software allows a perspective view of the space plane.

Fig. 2. Programs for perspectival display allow changes in the viewing angle. An artificial light source can be introduced to simulate sun-illumination effects.

Fig. 3. The typical method of transformation for generative mathematics was used for this picture. Here we have used a conformal mapping through complex transformation functions. The complex numbers are pairs of real numbers $x + iy$, where i is the square root of -1.

The first experiments using computer systems for artistic design resulted in images that were formally similar to Constructivist design, because 25 years ago the limitations of computer tools allowed only simple line drawings. Even so, as it was for Constructivists, a mode of operation based on fixed proportions was facilitated. In a short time all possible features were exhausted, so it became an obvious goal to try to extend them. This was done first by the use of random generators—a highly interesting expansion of design principles that has recently gained new meaning in connection with fractals.

An extension of operations is also possible in another direction, mainly through changing elements from straight lines and circles to curves. The influence of tools is essential; compasses and rulers allow only a limited set of elementary forms. However, oscillating curves are easily obtained through mathematical formulas and computer-graphic systems. The results we achieve on this basis do not look like Constructivist presentations, but their rationality and precision derive from Constructivist principles.

all forms that come to light, one can obtain plenty of forms, shapes and structures never seen before—an expansion of our treasury of forms. Many of these forms have considerable aesthetic charm. According to the usual criteria we cannot call them original works of art. But they can be considered elements available for new creations and can be used to develop artworks. As described elsewhere [1], we also gain a new function for applied mathematics. It is possible to develop mathematical algorithms that have meaning only as aesthetic designs. Mathematical descriptions of images are valid for the full (x,y) coordinate plane, ranging for x and y from $-\infty$ to $+\infty$. The monitor's display is an arbitrary window of this unlimited plane [2,3]. Computer-generated products differ in some essential details from those of conventional origin. The differences are based mainly on the details just described—in the integral method of construction, in the lack of a limiting frame and in the possibility for transitions to movement and interaction.

MATHEMATICAL AND AESTHETIC OPERATIONS

The inventory of forms of visualized mathematics already mentioned is not yet an artistic opus, but it is a basis for the connection between mathematics and art. For nonprofessionals it is not always obvious whether a product of mathematical effort is merely visualized science or a mathematical artwork. The border is not precise; transitional forms exist. Perhaps the thesis of *Kreativer Aspektwechsel* (creative change of aspects) first formulated by Juliane Roh [4], is valid. It is related to the discrimination between natural and artistic objects, and purports that between them is a transitional group of objects called *objet trouvés*. This term arose during the period of Dadaism (1915–1922). It was usual for the Dadaists to exhibit natural objects such as stones or roots in a museum, presenting them as art objects. However, there is no fixed artistic definition for one of these objects, as it depends on the point of view. If we find aesthetic attributes in any object, we can consider it art. A similar approach may also be valid for visualization in the field of mathematics.

One criterion for art involves the process used by the artist

Fig. 4. The input image used to create this figure was the letter 'F', composed of quadratic pixels in black and white. This transformed output image is an ornamental creation that retains the asymmetry of the original.

Fig. 5. The letter 'G', composed of black-and-white quadratic pixels, prior to Fourier transformation. Shown here is a representation of the space frequencies contained in the original image.

Fig. 6. Fourier transformation of the letter 'G' (see Fig. 5). It is symmetrical in relation to the centerpoint by the addition of fictive negative frequencies [6]. The gray value provides the amplitude of the (x, y) space-frequency pairs.

Fig. 7a. Before reverse transformation, a function is applied that acts as a filter to eliminate some of a Fourier-transformed image's frequencies. Here the function is displayed as an image. In the center, the space frequency is zero. The gray value of this frequency corresponds to the average gray value of the entire image.

Fig. 7b. The result of reverse transformation after filtering the Fourier-transformed letter 'G'. Some space frequencies have been eliminated.

for shaping the work. In the special case of mathematically supported fine art, the artmaking process occurs in a mathematically defined operation that allows the generation and transformation of images, methods used for *picture processing*.

Some simple mathematical transformations are a good basis for aesthetic usage. We have developed certain methods that may be nonsense from a mathematical point of view, but that are interesting as aesthetic steps for creations. For our process, we first change gray-scale values into a color wedge by replacing a gray value with a hue or color tone. For our process we can select hues from a stock of about 16 million colors to replace 256 gray values. It is known that the human eye cannot discriminate 16 million hues, but this number of color tones is necessary to produce minute changes in the image. Another frequently used operation is *averaging*, the computation of a mean value of gray levels. This effect is useful only if we can choose from a great number of color tones. An averaging of a small number of picture elements (pixels) has the same effect as does a soft filter in photography and will remove small undesired *moiré* patterns.

When more than 10 pixels are smoothed over, fascinating graphic effects that alter the image occur at the edges of gray or color steps (Figs 1 and 2).

Linear and rational transformations, often used in mathematics, are useful for aesthetic purposes, especially if we need a change of scale. We have investigated other classes

of transformations with promising results for aesthetic applications, for example, transformations of complex numbers, i.e. conformal mappings (Fig. 3 and Color Plates G No. 2 and G No. 3).

The simplest way they can be used is for the generation of optical patterns of great variety. Through the selection of the input image that is to be transformed into an output image, the artist can realize his or her own ideas in a variety of ways.

A separate group are Fourier transformations, which are used in a great number of mathematical problems and applications [5]. They are based on the fact that any graph of a function can be represented by a sum of harmonic waves. This function is seen in the changing gray values for pixels in the lines and columns of an image. After a transformation, the amplitude of the two-dimensional frequency

Fig. 8b. Reverse transformation after filtering results in this different look for the Fourier-transformed letter 'G'. The procedure outlined here can be used to generate series of alphanumerical characters. The type of filter used provides a characteristic stylistic form.

Fig. 8a. A different function (here displayed as an image) than that used in Fig. 7a is applied to eliminate parts of the frequency spectrum of the image.

distribution of an image's harmonics is represented by these gray values. This is a complete description of the original image by space frequencies. In a Fourier-transformed image, also called a power spectrum image, the coordinates are not in the same positions as in an ordinary picture, but are space frequencies in the x and y directions.

In our work we often use images of single letters—they are well suited for a demonstration of the effect of Fourier transformations, because of the symmetrical behavior of the resulting images. The relations between the input image and the resulting output image are distinct.

From the point of view of modern art, Fourier transformations are not very productive, because they only lead to ornamental pattern. Yet the manifold results of computer graphics show that the new mathematically generated forms add a new aspect to the old art of ornamentation (Figs 4–6).

An additional application of Fourier transformations concerns styling. We have investigated picture processing methods for filtering Fourier-transformed images. The method is as follows: an image is transformed into the Fourier space, then filtered by cutting out some parts of the frequency spectrum, then transformed back into the local space. Filtration causes some frequencies to be suppressed or enhanced. Reverse transformation following filtration results in restoration of the original image but with some ornamental changes. The resulting image looks similar to the source image, but with some differences at the corners and edges. The differences depend on the filtering used, which parts of the Fourier spectrum are enhanced and which parts are reduced. It seems that a certain filter belongs to a particular ornamental style, and under some conditions the reverse is true—an ornamental style belongs to a type of filter. This provides the opportunity for analysis of the purity of style (Figs 7–8).

CONCLUSION

Mathematical methods of image generation widen our view into abstract fields. As these methods supply relevant aesthetic innovations, they are a solution to the dilemma of contemporary fine art. Despite the opinion of some critics, even a two-dimensional picture can have new aspects. More than this, computer-aided methods offer a smooth transition to movement and interaction.

The future will probably see many trends in computer-related art. Currently the greatest attention is on methods based on computer-aided design (CAD), which leads to a kind of *photorealism*. In addition, a branch of computer art can be established that will complete the activities of music in a pictorial space. Sound and picture will combine for a new style of concert performance.

References and Notes

1. H. W. Franke, "Mathematics As an Artistic Generative Principle", *Computer Art in Context, Leonardo* Supplementary Issue, SIGGRAPH '89 Art Show Catalog (1989) pp. 25–26.

2. Franke [1].

3. H. W. Franke and H. Helbig, *Mathematik als generatives Gestaltungsprinzip* (Berlin: Springer, 1985).

4. J. Roh, *Abstrakte Bilder der Natur* (Munich: Bruckmann, 1960).

5. E. H. Linfoot, *Qualitätsbewertung optischer Bilder* (Braunschweig: Vieweg, 1960).

6. The positive frequency axes are reflected at the origin to the negative axes. The result is an image that is symmetrical to the origin.

Caricature, Readymades and Metamorphosis: Visual Mathematics in the Context of Art

Donna J. Cox

ABSTRACT

Mathematical homotopies, metamorphosis and computer animation provide excellent avenues for the creation of innovative, phantasmagoric art forms. Unfortunately, mathematical and computer art forms remain outside of the mainstream fine-art world in the United States. Issues regarding visual mathematics and mainstream art in relation to the art market and popular culture are discussed by this author, in context of her computer-animation work, which was created as an artistic commentary on 'high' versus 'low' art. This interdisciplinary collaborative animation, *Venus & Milo*, which involves topological homotopy, filmmaking techniques and caricatural humor, is described.

HIGH AND LOW ART

The use of mathematics has been important to artmaking and art discourse for hundreds of years. From Renaissance architecture to M. C. Escher's graphic arts, aesthetic mathematical forms have evolved into important cultural icons [1,2]. With the advent of computer graphics, fractal geometry and computational geometry, the beauty of mathematics has become more accessible to mass culture today [3]. Chaos theory has penetrated popular science through mass media and best-selling books [4]. Public television brings these images and concepts before millions in nationally broadcast programs such as NOVA [5]. Many print publications and calendars abound with fractal, geometric and mathematical imagery.

However, the fine-art market continues to ignore most of these works or relegates them to 'nonserious' art [6]. A few mathematically oriented artists have succeeded in fine-art galleries to command art-market returns for their works. For example, the analytic approaches of Victor Vasarely and Bridget Riley do inspire the elite who purchase artworks in SoHo, New York. However, these artists are rare exceptions, and many important visual mathematics receive little recognition from 'high' art culture.

High art is called such, according to Varnedoe and Gopnik in *High and Low: Modern Art, Popular Culture*, "not to glamorize it or quarantine it (nor to deny that there are notable differences of purpose and of quality within that roster)", but to differentiate a select group of individuals whose "works are the primary material with which any history of art in this century must contend" [7]. These individuals, including Michelangelo, Rembrandt, Monet, Picasso, Duchamp and Pollock, are positioned in an art-historical framework that focuses on the significance of their contributions. The boundary condition for high art becomes fuzzy as we approach contemporary artmaking, where current American culture defines high art by the nature of the art market [8].

'Low' art, on the other hand, encompasses those art forms that are prevalent and appreciated by mass or popular culture. These low-art forms include caricature, filmmaking, advertising and graphic design. These "areas of representation [are called] 'low', not to denigrate them out of hand . . . but to recognize that they have traditionally been considered irrelevant to, or outside, any consideration of achievement in the fine arts of our time—and in fact have commonly been accepted as opposite to the high arts in their intentions, audiences and nature of endeavor" [9]. That these art forms appeal to the masses often categorizes them in low-art status. Mass media and advertising have been denigrated with acid commentary by contemporary art. "Something was conjured into being for the purposes of allowing artists to dissect and condemn it, and this was the 'media image'" [10]. In addition, the negative effects of technology have been a favorite subject of contemporary fine art.

Mathematical and scientific imagery currently have popular appeal, and this popular appeal can place them in low-art status. Who can deny that computer-generated fractal geometry proliferates in coffee-table books, music videos, calendars and posters? It is understandable why such popular attraction exists. This type of visual mathematics celebrates natural structures and their infinite capacity for subtle variation. In coastlines, riverbeds and hierarchical organizations of living systems, matter seems to be organized in similar patterns, regardless of scale. Fractal imagery reiterates the planned randomness of nature. Through modern computer graphics and mathematical techniques, visual representations bring us closer to a full appreciation of natural processes. However, the popularization of fractal imagery through mass media is potentially disadvantageous for visual mathematics in its relationship to high art in the United States.

In addition, some visual mathematics are created and explored for classical beauty, visual balance and aesthetics of pure form [11]. However, contemporary art criticism condemns work that focuses on the aesthetics of pure form. Abstract mathematics and geometric forms represent the epitome of 'purist' modernism and remain outside the

Donna J. Cox (artist, educator), National Center for Supercomputing Applications, University of Illinois, Champaign/Urbana, 605 E. Springfield, Champaign, IL 61820, U.S.A.

Fig. 1. *Venus & Milo*, computer-graphics animation, 1990. While Milo dodges a flying chocolate, Salvador Dalí's *Abraham Lincoln* is seen behind Milo. The Dalí painting appears to be a large 'pixelation' of Lincoln's face, but upon closer inspection, it resembles the back of a female nude. (© 1993 ARS, NY)

Fig. 2. *Venus & Milo*, computer-graphics animation, 1990. The Newell teapot is an important computer-graphics icon. It has been shared as a numerical database among researchers to test new algorithms such as texture- and bump-mapping. Behind the teapot is a portion of Seurat's *Sunday Afternoon on the Island of the Grande Jatte.*

current art dialogue that obsesses society and media [12]. Contemporary artmaking has evolved into social and media-image criticism [13]. "The art of the media image staked its claim to radical newness on its insistence that it had replaced the delusional purity of high modernism with a disillusioned and unsentimental impurity.... A new generation of radical artists expressed their contempt for modernist art only by taking over its ironic jokes and turning them into *memento mori*" [14]. Mass media and modern art have become raw material for contemporary fine artists who rehash media images into high art.

Evidence that popular mathematical concepts are being considered as media images is demonstrated in recent 'chaos' art exhibits in New York and Chicago. Images, paintings and multimedia sculptures were exhibited as metaphorical representations of chaos theory. These works were philosophical references with little, if any, involvement in pure mathematics. With the exception of the works by (Art)n Laboratory [15], true mathematical aesthetics were not present. Rather, the preponderance of these chaotic artworks were devoid of any serious investigation into mathematical or scientific theory. The popularization of chaos theory and its proliferation in mass media have become favorite

subject matter for high-art commentary, but this commentary is primarily superficial. "No period in modern history has seen so many artists involved with so many kinds of popular culture as has the last decade—and in no period has it been so difficult to discriminate between mere ideological parroting and art of real feeling and genuine intensity" [16].

The idea that art for the masses is low art relegates most Hollywood filmmaking and television production to this category (with the exception of experimental filmmaking, which is a reaction against popular styles) [17]. Like so many other low-art forms, popular filmmaking/television narratives are employed as raw material for today's high-art commentary on mass media [18].

Filmmaking and television productions are collaborative art forms. Collaboration is yet another distinguishing factor between high and low art. The fine-art world has been preoccupied with the cult of the individual and has had a long-standing bias against collaborative works. Fine art in Western culture is considered a product of individualism. The closer that a film is identified with an individual such as a director or producer, the more acceptable it is to consider the film to be a work of art. However, filmmaking

Fig. 3. *Venus & Milo*, computer-graphics animation, 1990. (top) The Venus prior to her metamorphosis. (center) The almost-complete formation of Steiner's Roman surface from the Romboy Homotopy. (bottom) Ida, an intermediate surface in the Romboy Homotopy. After the pinch-points cancel, the metamorphosis is complete and returns to the Venus surface seen in the top view.

is a complicated, collaborative process that requires the talents of many individuals. An organized, collaborative approach is necessary because of the technological requirements and complexity involved in filmmaking and in television production. For the same reason, many works in computer animation and/or visual mathematics are collaborative endeavors. According to Michél Segard, "the extensive use of high technology requires collaboration, a process that is in direct opposition to our tradition of creative individualism" [19]. The result is that most art critics do not comprehend that a group can work synergistically to create great art. And this lack of understanding affects the art market's perception of the work. Segard continues, "The inability of a collaborative group to fit into the superstar system of the gallery-museum marketing complex means that their works will have to be exhibited and sold outside of that system, at least for the near future. . . . This will put pressure on these collaborative groups to produce works of art that can co-exist as both institutional propaganda and art—a role that works of art have not played since the church and the ruling class ceased to be primary patrons of culture" [20].

VENUS & MILO

Venus & Milo is a computer animation that places mathematics in the context of art. The animation was developed using in-house software, Wavefront Technologies software, and Silicon Graphics workstations in the Renaissance Experimental Lab at the National Center for Supercomputing Applications. The narrative is set in a synthetic art museum where two characters interact. The museum is a pastiche of old and futuristic artifacts, real and simulated; each artifact relates in some way to the history of art, science, mathematics or technology. The narrative is centered around the Romboy Homotopy, a mathematical deformation between Steiner's Roman Surface and Werner Boy's Surface. The initial collaboration to visualize this homotopy was called the 'Venus' Project, which has served as a prototype for the Renaissance team that worked on *Venus & Milo* [21,22]. Collaboration is the essence of this Renaissance team.

The phantasmagoric, metamorphic character of Venus is one of two main characters in *Venus & Milo* (Color Plate H No. 1). The Venus is a one-sided, 10-dimensional mathematical surface from the Romboy homotopy; her name

Fig. 4. *Venus & Milo*, computer-graphics animation, 1990. (above) This low-camera view shows a vacuum that Milo has found to clean up the chocolate mess. (below) Milo is cleaning while Venus awaits on the pedestal. The chocolates, Marilyn Monroe's lips and Duchamp's readymade are also in view. (*Marilyn* © 1993 The Andy Warhol Foundation for the Visual Arts, Inc. *The Bicycle Wheel* © 1993 ARS, NY)

Fig. 5. *Venus & Milo*, computer-graphics animation, 1990. Milo lifts the vacuum to clean up the leftover chocolates on the pedestal under the floating Venus.

evolved from her resemblance to the hourglass—a classic female shape. The homotopy animation reveals a complete series of one-sided surfaces that visually transform into Jungian-like, archetypal forms. From this hermaphroditic metamorphosis, a whole cast of beautiful, synthetic characters have developed (Venus, Apollo, Cupid, etc.) [23]. An article in *National Geographic* described the Venus: "For eyes only, the Etruscan Venus . . . exists only in the untouchable world of computer graphics . . . the Venus and her companions are actually visualizations of complex equations created by a mathematician, an artist and a programmer working together" [24]. Through sensuous undulations, a purely mathematical surface is personified as a female symbol and reflects characteristics of something alive, a caricature. "Yet the distinctive creative process is the same: an artist looks at a form thought to be fantastic or dreamlike, and shows that it provides a model for organizing real experience" [25].

The mathematical transformation of the Venus is the centerpiece of the narrative. Venus floats above her pedestal in the futuristic art museum, next to Andy Warhol's *Marilyn*, Botticelli's *Birth of Venus* and the computer-graphics representation of Marcel Duchamp's *Bicycle Wheel* (Color Plate H No. 2). She takes her place both as an artwork and as a goddess by her juxtaposition with other goddesses and artifacts from art history.

Metamorphic imagery has been explored by artists for centuries. In particular, these works are inextricably linked to the history of caricature and female sensuality. "From Leonardo to Gillray, the story of caricature is like a variant of the Narcissus myth: an artist stares into a stream of form that seems completely independent of his own experience,

and cries out as he discovers there the face of something familiar staring back at him" [26]. During the French Revolution an anonymous artist joined the protest by creating a series of graphic prints in which peoples' faces were made from nude females in contorted positions. These images were satirical depictions of the faces of powerful aristocrats. When looking at these metamorphic forms, one's perception flips back and forth between the face and the erotic body parts, forming a kind of background/foreground transformation. Such face/body metamorphic imagery also permeated popular caricatural postcards in 1933. This low-art imagery later influenced the vanguard high art of the Surrealists. For example, René Magritte depicted a face made from the erotic parts of a female in *The Rape*, a perceptual metamorphosis. In *Venus & Milo*, Salvador Dalí's painting of a pixelated face of Abraham Lincoln is shown in the art museum. When viewed at close range, Lincoln's face reveals the sensuous shape of a female nude (shown on the right in the background of Fig. 1). Dalí and Magritte adapted their caricatures of face/body transformations from low art. Caricature and metamorphosis have passed between low and high art for centuries as re-adaptations of one another.

Milo, the other main character of *Venus & Milo*, is a semi-invisible character who functions as the janitor of this unusual art museum. Semi-invisible characters are psychosexual symbols in Freudian psychology. His face is defined by essential facial features, a mustache and a cigar; his skull is defined by a baseball cap. A belt with keys is a clue to the audience of his profession. In the beginning of the animation, Milo's eyes pan the darkened museum, past

sculptures, a Seurat masterpiece and other fine artworks, including the Newell teapot resting on a pedestal (Fig. 2). This synthetic, mathematical teapot, created from a numerical database, has become an important computer-graphics icon. The Seurat painting provides a reference to technology-and-science history. Seurat's art was influenced by color science, and this influence resulted in the painting style of *pointillism*, a visual technique that is analogous to the technology of computer screens for which color images are created from primary-colored phosphoric dots.

As the animation continues, Milo seems disinterested in great art objects; rather he is captivated by a box of cherry chocolates that he notices resting on a marble bench (see Color Plate H No. 2). Chocolate is considered to be an aphrodisiac by many cultures. While Milo is occupied with his salivating interest in the chocolates, the mathematical Venus comes alive. She finds both Milo and the chocolates interesting, but chooses the chocolates over Milo. With a strange, magical power, she activates the chocolates into flight as she surreptitiously gulps them. A collision-detection program was written to prevent the synthetic chocolates from flying through one another.

Venus ravenously gulps the chocolates as they disappear into her one-sided surface. When Milo finally notices her chocolate consumption, he explodes in shock then snaps back together. Venus begins her phantasmagoric metamorphosis while an ancient vessel rests on a pedestal to her right. Vessels have been symbols for females across cultures for thousands of years. Women from the Seurat painting are poised at Venus's left, as if they were part of the audience watching the metamorphosis (Fig. 3). During the homotopy, a neon sign flashes a signal to the audience that this

metamorphosis is, in fact, the 'scientific visualization' segment of the animation. Scientific visualization is an umbrella term that also incorporates visual mathematics.

After the metamorphosis, Venus gasps for breath and burps chocolates. This is the Venus dichotomy: she is as grotesque as she is beautiful. Milo turns to the audience in disgust (see Color Plate H No. 1), disappears from the scene, returns with an upright vacuum cleaner and proceeds to do his job and clean the chocolate mess (Fig. 4). He notices two chocolates on the pedestal where Venus is floating. In his attempt to get the chocolates (Fig. 5), he bumps the pedestal; in a frantic moment, Milo struggles to prevent the Venus from accidently disappearing into the vacuum, but he fails. Milo's eyes move in worried hesitation between vacuum and empty pedestal as the wailing sound of the machine diminishes to silence (Fig. 6). The precious art object is gone. A dark-chocolate light bulb pops above his head: Idea! (Color Plate H No. 3). He moves forward past the representation of Duchamp's *Bicycle Wheel* and lifts the vacuum cleaner onto the pedestal. Like a self-assured painter in the final sweep of the brush, he comments to himself and to the audience, "Yeh, Yeh, I like it." As Milo walks away satisfied, the vacuum turns 180° on the pedestal, switches on and swallows Milo. The camera zooms out of the art museum as the vacuum undulates in the distance. Credits roll.

During the final interplay between Milo and Venus, the representation of Duchamp's *Bicycle Wheel* is in view. This sculpture was intended as a conceptual statement by Duchamp that implied that art is defined by the context of the object, not by the object itself. Duchamp and many of his Dadaist colleagues, in their rebellious questioning of art, exhibited banal objects, such as toilet fixtures and bottle

Fig. 6. *Venus & Milo*, computer-graphics animation, 1990. Milo's eyes move in worried hesitation from vacuum to empty pedestal. The precious art object has disappeared. Marcel Duchamp's *Bicycle Wheel* and Botticelli's *Birth of Venus* detail are in view. (© 1993 ARS, NY)

holders. By placing them in the museum context, Duchamp transformed these 'readymade' objects into statements about the nature of art [27]. The readymade is a sophisticated 'in-joke', meant to engender discourse about the meaning of art. "Thinking about toilets as art was an already existing practice, but till then it had led only to show ribbons and hardware-trade critique; Duchamp saw that the same practice could work to make people think about art as toilets, and made it into a vehicle for some of the most tendentious and longest-burning intellectual debates in this society" [28]. Conceptually, Duchamp questioned institutionalized high art and the function of art within the art world. With the juxtaposition of the Venus as mathematical art next to Duchamp's readymade in *Venus & Milo,* a relationship is established between visual mathematics and the contextual meaning of art.

Milo's solution to the problem of the missing art object—placing the vacuum cleaner on the pedestal—makes further reference to high art versus low art. Jeff Koons, a contemporary fine artist, exhibits vacuum cleaners as art. Unlike Duchamp's everyday objects that were intended to provoke questions about the value system of high art, Koons employs popular-culture icons such as the vacuum cleaner to make a negative statement about popular culture and our consumer-glutted society. "Koons had managed to find the one thing for which no one had ever felt any emotion at all (the vacuum). He had a cruel eye for the dead zone of consumerism, for the moment in the evolution of an object when it had neither the energy of innovation nor the charm of nostalgic association" [29]. Koons criticizes media, advertising and mass culture by creating conceptual high art from a vacuum cleaner.

However, a vacuum is more than a symbol of consumerism, it is a symbol of mundane home maintenance in our industrialized society. It represents the promise of the Industrial Revolution to save countless hours of cleaning drudgery to free people for leisure. And, in fact, many of those technological promises have come true along with some negative aspects of modern living. Most people, male or female, can identify with Milo's experience; most people at one time or another have struggled with this labor-saving device as it devoured throw-rugs, jewelry or some favorite object. The audience identifies with Milo's struggle while appreciating his solution to the problem. Those within high-art circles will recognize the Koons reference next to the representation of the Duchamp readymade; however, the untrained eye would not see this relationship. To the average person-on-the-street, Milo represents the uninformed person who sees many of the so-called art objects in the room as familiar, everyday things (teapots, bicycle wheels, etc.). By filling the empty space on the pedestal, Milo creates an inversion of the Koons vacuum cleaner. Rather than creating high art with a negative reference to consumer culture, Milo simply displaces high art with a tool from his profession and provides justification to mass culture for a banal object exhibited on a pedestal in an art museum. Milo's solution probably makes more sense to most people than the accumulated pompous art rhetoric of the past 100 years. Such irony transcends culture and language.

CONCLUSION

Interaction between popular art and fine art has become one of the most important issues of contemporary art. In many ways, visual mathematics is considered low art because of its recent popularity with mass audiences, and because visual mathematics is identified with modernist 'aesthetics of form', which is now rejected by contemporary art criticism. Such associations pose problems for acceptance of visual mathematics (or computer art) in high-art circles.

Thus we are led to this question: Is visual mathematics art? Well, if "by art we mean something that extends an accepted tradition of icons and images, and restates the inherited beliefs of our culture", then one can consider visual mathematics in terms of this definition. Mathematical abstractions, if for no other reason, are pure reflections of human consciousness; this, in and of itself, restates the inherent belief that true art is a reflection of culture, which is a reflection of mind. Mathematics has permeated culture and left a legacy of images and icons for future generations. "If by art we mean, as we have for more than a century, a self-propelled and self-generating competition in style, a serious game that begins as an in-group game that gives meaning to the life of the maker and to his enthralled small audience, and ends by producing new and widely shared styles" [30], then we can gain the perspective that visual mathematics is a serious 'in-game' that has and is still generating new and widely shared styles.

Venus & Milo is a collaborative work that provides humorous commentary on some of the issues relevant to high versus low art. It layers meaning and symbols for a wide-ranging, cross-cultural audience, while it employs visual mathematics as the centerpiece of the narrative. Finally, *Venus & Milo* borrows from Marcel Duchamp and other artists to place visual mathematics in the context of art and to reveal some of the contradictions in contemporary art criticism.

Acknowledgments

I thank the collaborators who have shown that it is possible to create innovative, meaningful art through a synergistic, creative team process: Robin Bargar, Chris Landreth, Bob Patterson, Fred Daab, Marc Olano, Chris Waegner, Gisela Kraus; the original collaborators of the 'Venus' Project, including Ray Idaszak and George Francis; (Art)n Lab directors Ellen Sandor and Stephen Meyers; and Dan Sandin, Tom DeFanti and Maxine Brown.

References and Notes

1. M. C. Escher, *The Graphic Work of M. C. Escher* (New York: Hawthorn/Ballantine Books, 1971); H. S. M. Coxeter, M. Emmer, R. Penrose and M. Teuber, eds., *M. C. Escher: Art and Science* (Amsterdam: North-Holland, 1986, 1987, 1988); D. Schattschneider, *Visions of Symmetry: Notebooks, Periodic Drawings and Related Work of M C. Escher* (New York: Freeman, 1990).

2. Michele Emmer, ed., *L'occhio di Horus, Itinerari nell'immaginario matematico* (Rome: Instituto della Enciclopedia Italiana, 1989); M. Emmer, *La perfezione visibile: arte e matematica* (Rome: Theoria edizioni, 1991); M. Emmer, "Math-Art: New Technologies for a New Art", in G. Careri and E. Amaldi, eds., *La dimensione scientifica della sviluppo culturale* Atti convegni Accademia dei Lincei **83** (1990) pp. 63–75.

3. H.-O. Peitgen, D. Saupe et al., *The Science of Fractal Images* (New York: Springer-Verlag, 1988).

4. J. Gleick, *Chaos, Making a New Science* (New York: Penguin Books, 1987).

5. "NOVA" is a popular science television program that appears on the Public Broadcast Station (PBS).

6. H. Franke, "Refractions of Science into Art", in H.-O. Peitgen, P. H. Richter, eds., *The Beauty of Fractals* (New York: Springer-Verlag, 1988) p. 186.

7. K. Varnedoe and A. Gopnik, *High and Low: Modern Art, Popular Culture,* J. Leggio, ed. (New York: Museum of Modern Art, 1991) p. 15.

8. M. Rosler, "Lookers, Buyers, Dealers and Makers: Thoughts on Audience", in M. Tucker, ed., *Art After Modernism* (Boston: David R. Godine, 1984) pp. 311–339.

9. Varnedoe and Gopnik [7] p. 15.

10. Varnedoe and Gopnik [7] p. 372.

11. Franke [6] p. 184.

12. D. Cox, "The Tao of Postmodernism: Computer Art, Scientific Visualiza-

tion and Other Paradoxes", *Computer Art in Context, Leonardo* Supplemental Issue: SIGGRAPH '89 Art Show Catalog (1989) pp. 7–12.

13. *Discussions in Contemporary Culture,* Dia Art Foundation **1**, H. Foster, ed. (Seattle, WA: Bay Press, 1987).

14. Varnedoe and Gopnik [7] pp. 375, 391.

15. (Art)n Laboratory is a group of collaborative artists who work with high-technology tools, creating holographic-like artworks from computer graphics: phscologram 3-dimensional images. Ellen Sandor is founder and director, (Art)n Laboratory, Illinois Institute of Technology, Chicago, IL, U.S.A. Represented by Feature Gallery, New York.

16. Varnedoe and Gopnik [7] p. 369.

17. G. Wead and G. Ellis, *Film: Form and Function* (Boston, MA: Houghton Mifflin, 1981) p. 446.

18. D. Crimp, "Pictures", in M. Tucker, ed., *Art After Modernism* (Boston, MA: David R. Godine, 1984) pp. 175–188.

19. M. Segard, "Artists Team Up for the Future," *New Art Examiner* **11**, No. 4 (1984) p. 1.

20. Segard [19] p. 26.

21. A Renaissance team is a group of specialists with complementary areas of expertise who interact synergistically by pooling their technological, analytical and artistic abilities to increase the domain of available problem-solving options. Teams of artists and scientists in the fifteenth and sixteenth centuries produced classic advances in botany and anatomy; their published works are milestones in the history of science. See C. Ronan, *A Science, Its History and Development among the World's Cultures* (New York: Hamlyn, 1982).

22. See D. Cox, "Using the Supercomputer to Visualize Higher Dimensions: An Artist's Contribution to Scientific Visualization", *Leonardo* **21**, No. 3, 233–242 (1988); and G. Francis, *A Topological Picturebook* (New York: Springer-Verlag, 1987).

23. From these characters, Dan Sandin, University of Illinois at Chicago, and Ellen Sandor, (Art)n Lab, Illinois Institute of Technology, collaborated to create phscolograms.

24. F. Ward, "Images for the Computer Age," *National Geographic* **175**, No. 6, 720–721 (1989). This article describes the many developing areas of computer graphics, including visual mathematics, scientific visualization and computer animation.

25. Varnedoe and Gopnik [7] p. 112.

26. Varnedoe and Gopnik [7] p. 113.

27. Varnedoe and Gopnik [7] p. 79.

28. Varnedoe and Gopnik [7] p. 278.

29. Varnedoe and Gopnik [7] p. 395.

30. Varnedoe and Gopnik [7] p. 382.

Number as Form and Content: A Composer's Path of Inquiry

Brian Evans

ABSTRACT

The traditions of absolute music provide a foundation for today's composer. In the twentieth century these traditions have been stretched to a breaking point, opening new avenues of artistic exploration. The author here explores the grammatical tool of visual consonance, using mathematics as a mechanism for the generation and composition of abstract materials. The idea of form and content as inseparable aspects of Western musical practice is applied to visual art. The golden section is used as a continuous thread throughout the discussion, and several works are analyzed. Also included are a historical survey and a sampling of the author's work.

The straight and narrow path he showed me turned into a thousand winding roads.

—A. Spooner and F. Lehner

In tonal music, time passes through the interplay of harmonic forces striving for stability—tension to resolution, dissonance to consonance. Over the past century many new musical grammars have been invented and investigated with the aim of building temporal architectures with sound.

Chromaticism has made possible extremes of harmonic, and consequently emotional, manipulation. From the late Romantics to the American conservatives to Hollywood film composers, common-practice tonality has been stretched to its atonal limits [1]. In 1911, 12 years before developing his 12-tone system, Schoenberg said,

> [It] must also be possible to make progressions out of the tone colors of the other dimensions, out of that which we call simply 'tone color', progressions whose relations with one another work with the same kind of logic entirely equivalent to that logic which satisfies us in the melodies of pitches. That has the appearance of futuristic fantasy and is probably just that. But it is one which, I firmly believe, will be realized. I firmly believe it is capable of heightening in an unprecedented manner the sensory, intellectual, and spiritual pleasures offered by art [2].

Twelve-tone and serial techniques freed nonpitch musical elements from subservience to harmony. As a result, rhythm, dynamics and instrumental color are often the primary structural controls in the passing of musical time in contemporary works.

Fig. 1. Analysis of the exposition of *Mozart's Symphony in G Minor*, showing a temporal expression of φ using register. The first instance of the highest pitch in the exposition, G6, occurs at the beginning of bar 63 of 100 total bars (point B).

Fig. 2. Analysis of the first 62 measures of Mozart's *Symphony in G Minor* shows a retrograde expression of the golden section of point B of Fig. 1.

Techniques of chance and indeterminacy released all elements from the dictates of the composer, leaving compositional decisions to serendipity, the toss of a coin or the improvisatory skill of the performer—a trail blazed by John Cage and his followers.

According to Cage,

> First of all, . . . a composer at this moment frees his music of a single overwhelming climax. Seeking an interpretation and nonobstruction of sounds, he renounces harmony and its effect of fusing sounds into a fixed relationship. . . . [H]is 'counterpoints' become superimpositions, events that are related to one another only because they take place at the same time. . . . [H]e either includes silences in his work or gives to his continuity the very nature of silence (absence of intention).

In addition, musicians, since they are several people rather than one person as a painter or a sculptor is, are now able to be independent each from another. A composer writes at this moment indeterminately. The performers are no longer his servants but are freemen. A composer writes parts but, leaving their relationship unfixed, he writes no score. Sound sources are at a multiplicity of points in space with respect to the audience so that each listener's experience is his own [3].

For many contemporary composers, the invention of new vocabularies and grammars is a significant part of their method in musical problem-solving. From the development of computer graphics comes the ability to structure time with visual materials. Abstract animation extends the possibilities of temporal design and brings challenging new problems to those working in the time-based arts. As a new resource, abstract animation, too, will require grammatical tools in order to be effectively used. For the composer, the need to develop and codify new compositional methods has extended into the visual domain.

As a composer investigating these new problems, I initially embraced the dichotomy of consonance/dissonance while looking for ways to apply these percepts to graphic materials. The ability to establish visual consonance implies the ability to create visual dissonance, and by directing

Brian Evans (composer, artist), Vanderbilt University Computer Center, 105 Stevenson Center, Nashville, TN 37235, U.S.A.

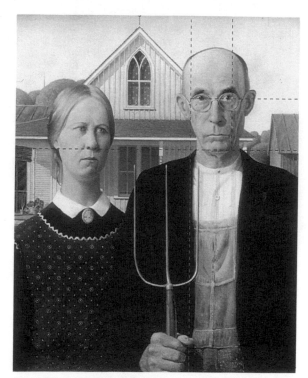

Fig. 3. Grant Wood, *American Gothic*, oil on beaverboard, 76 × 63.3 cm, 1930. Simple compositional analysis of *American Gothic* using φ. (© Estate of Grant Wood/VAGA, New York, 1992. Friends of American Art Collection, 1930.934. Photo: The Art Institute of Chicago.)

Fig. 4. Analytic framework of *American Gothic* showing a recursive, retrograde expression of φ from point E to point J.

movement between the two extremes, time can be compositionally controlled.

To ensure abstraction of materials, and so avoid the complexities of representation, connotation and narration, I choose to visualize mathematical processes. Mathematics provides a rich array of materials from which to select, limit and control, and therefore compose. Mathematics not only supplies materials but can also be applied to the problem of visual consonance, consequently contributing both to the form and to the content of the work.

As a thread of continuity through this report I use the ubiquitous mathematical constant φ, the golden section. It is not the purpose of this paper to detail its myriad derivations or to validate its use. It has played a role in a body of my work and often serves as a catalyst for other directions of study. For those interested in the details of the golden section, there is a wealth of reference material available on the subject [4].

As φ is an irrational number, it is immeasurable in real units. In the analyses that follow, expressions of equality are obviously approximate. I also freely assume that the golden section and the Fibonacci series are related so closely that the use of one often implies the other. One of the luxuries of the artist is that art is validated by the work itself and does not require subservience to the rigors of mathematics or logical proof. As an artist I allow myself full indulgence in that luxury.

Though my work as a music composer is temporal in nature, I will discuss primarily static imagery, in order to define some essential elements of visual consonance. The basic premise in this research is simple: if abstract visual consonance is possible, then so is the composition of visual music. Looking to the history of art there are some mathe-

matical constants that recur frequently enough to bear consideration in the search for a generalized understanding of visual consonance.

THE MUSICAL VERSUS THE LITERARY

Describing his painting *Manao Tupapau,* Gauguin said, "The musical part: undulating horizontal lines; harmonies of orange and blue, united by the yellows and purples (their derivatives) lit by greenish sparks. The literary part: the spirit of a living person linked to the spirit of the dead. Night and Day" [5]. Gauguin interprets the formal aspects of the work as musical, and the content as literary.

It is not unusual to think of music in a purely formal sense. The classical concept of absolute music approaches art as a formal activity. It is the inner logic and the balanced unfolding of a structure that is important, with no extra-musical issues expressed. A Scarlatti sonata is about key relationships delineating a simple sonata form. A Bach fugue is about linear independence of voices in harmonic agreement. Both are explorations of temporal structure. The composer often sees form and content as the same thing.

Through analysis, it is possible to understand the architectural framework of a composition and perhaps determine the composer's method and intent. Musical analysis involves measurement of the sound dimensions, with the hope of discovering significant relationships.

Pitch is the primary dimension articulated in Western music; this was particularly true during the common practice period of the eighteenth and nineteenth centuries. Pitch was always defined and measured within tonal theories. A more objective look at pitch as simple frequency can uncover intriguing surprises and insights.

Figure 1 shows an analysis of the exposition from the first movement of Mozart's *Symphony in G Minor.* Mozart has simplified this analysis by composing his exposition at exactly 100 measures in length and demarking it with repeat signs (segment AC). Point B on the figure, the beginning of measure 63, is where the note G6, the highest note of the exposition, first occurs. With the length of a musical bar as the smallest unit, segments AB = 62 and BC = 38. A simple, balanced and familiar proportion is expressed as follows:

AC/AB = AB/BC.

Through analysis, a temporal expression of the golden

section is shown to contribute to the structural coherence of the piece.

Continuing this analysis, by zooming in on time segment AB, it is possible to see a retrograde, recursive expression of φ (see Fig. 2). Here, again with the musical measure as the smallest unit, moving in retrograde from point B to point A,

BA/BD = BD/DA ≅ φ.

Point D marks the first occurrence of the lowest note of the exposition (E1) with segment BD equal to 38 measures and segment DA equal to 24 measures.

The two most obvious notes of the exposition, the highest and lowest, delineate multiple expressions of φ. The analysis indicates a counterpoint of formal contours between the typical period and phrase structures and the framework defined by the golden section.

I am not suggesting that Mozart's *Symphony in G Minor* is about the golden section, or even suggesting that it was consciously applied. However, it is one of his most enduring works, and the subtle qualities of dynamic balance attributed to φ contribute to the work's beauty and popularity. At the least, by this analysis we learn more about the structural basis of Mozart's work and about the ways in which the composition of materials, whether instinctual or designed, creates a valuable aesthetic experience.

Exploration of the use of elegantly defined proportions in temporal structure is a natural part of a composer's training. In the past century it has become a standard technique. Bartok was especially fond of using φ on several levels of a composition, from the macrostructure to the microlevel of chord construction. Analysis of pieces such as *Sonata for Two Pianos and Percussion* and *Music for Strings, Percussion and Celeste* shows an apparently conscious application of the golden section and the Fibonacci series in the larger temporal structures and in the small details of the vertical harmonic shape [6].

The Fibonacci series (1, 2, 3, 5, 8, 13, 21, 34, 55, . . .) is also used as a catalyst for many of Stockhausen's pieces. In

Klavierstucke III, for example, "there are 55 notes, 34 different pitches and a total pitch range, traversed at a stroke between the last two notes, of 50 (3 + 5 + 8 + 13 + 21) semitones. Furthermore, intervals of three, eight or 13 semitones often appear at significant junctures" [7].

In the search for a consonant visual space, as in musical structure, proportion is widely known and used. In analysis, the dichotomy of form and content, and of the musical and the literary, comes more obviously into consideration. Figure 3 shows a formal analysis of Grant Wood's *American Gothic*, in the context of φ. Figure 4 shows the proportions as follows:

AC/AE = AE/EC = BD/ED = ED/BE = FH/JH

= JH/FJ = GI/GJ = GJ/JI ≅ φ.

As in the Mozart exposition, this is an example of recurring structure in its application of the golden section—a visualization rather than a sonification of φ. The line segments AC and BD show a balanced division of the overall frame with the resultant upper-left rectangle divided into the same proportions. In this rectangle, the focus is inverted from upper right of the total frame with point E, to lower left of the small rectangle with point J. Point J and line segment FH have obvious attraction in the painting.

The works of Jay Hambidge and his ideas of design and dynamic symmetry using the golden section were well known and popular by the 1920s [8]. As a travelled artist and teacher, Wood was probably aware of Hambidge's work and so might have consciously applied the compositional techniques. Again whether the structure is a result of instinct or design is not important. What is important is that the piece works, and I believe that the use of the golden section contributes to its success.

Returning to Gauguin's descriptions of musical and literary components, we see we have discussed only the musical aspects of *American Gothic*. The painting is obviously not about φ. Wood was known for his love of satire and irony, both of which are apparent in this work. Some Iowans felt offended by his depiction of the rural pair, and Wood said in his own defense, "All I attempted was to paint a picture of a Gothic house with the kind of people I fancied should live in that house" [9]. The painting is now an American icon as a result of its literary aspect—a rendition of the rural American spirit.

Is it possible for form and content to be as inseparable in painting as they are in music? Just a few years before Wood painted *American Gothic*, Piet Mondrian painted *Composition with Blue* (Figs 5, 6). Mondrian managed a happy marriage

Fig. 5. Piet Mondrian, *Composition with Blue*, oil on canvas, 59.8 × 59.8 cm, 1926. (Philadelphia Museum of Art, A. E. Gallatin Collection. © Estate of P. Mondrian/E. M. Holtzman Trust, New York, New York)

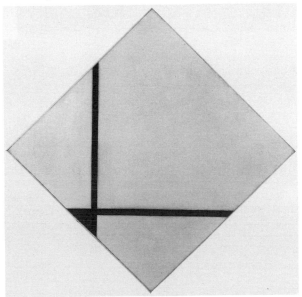

Fig. 6. Compositional analysis of Mondrian's *Composition with Blue*, 1926.

Fig. 7. Botticelli's *Madonna with Child and Two Angels*, tempera on wood, 100 × 71 cm, c. 1469. The author performs a simple compositional analysis of this Renaissance painting. (Collection of Gallerie Nazionali di Capodimonte, Naples. Courtesy of the Soprintendenza per i B.A.S. di Napoli, Italia.)

of form and content in this painting and also applied the golden section. I believe the real dynamism here is achieved by our need to complete the proportional balance that is implied by the minimal amount of material used.

In completing the square suggested by the intersecting black lines, ϕ is expressed in the relative placement and areas of the squares:

$$c/a = a/b = c^2/d^2 \cong \phi.$$

While the use of golden section is the formal basis of *Composition with Blue*, the economy of materials used might indicate that ϕ is what the painting is about. This is consistent with Mondrian's relationship with the de Stijl group in the Netherlands and with his writings on his personal aesthetic philosophy.

He wrote:

[I]n nonfigurative art, to recognize and apply natural laws is not evidence of a retrograde step; the pure abstract expression of these laws proves that the exponent of nonfigurative art associates himself with the most advanced progress and the most cultured minds, that he is an exponent of denaturalized nature, of civilization. . . . [I]n art, content and form have alternately been overemphasized or neglected because *their inseparable unity* has not been clearly realized. To create this unity in art, *balance of the one and the other must be created* [10].

Despite the clean analysis of this painting, Mondrian is known to have contradicted his use of mathematical devices. "[Michel] Seuphor recalls that Vantongerloo once brought Mondrian a notebook to show Mondrian's geometric sys-

tems. 'This is very interesting,' said Mondrian, 'but it is not how I paint'" [11]. Nonetheless, *Composition with Blue* is a good example of number as form and content—a dynamic yet consonant image.

THE MEANING OF NUMBER

In 1509 the Franciscan monk Luca Pacioli published his treatise *De Divina Proportione* in Venice [12]. In this book, Pacioli discussed ϕ, ascribing mystical and metaphysical properties to it. These are detailed by Charles Bouleau:

1. Like God, it is unique.

2. As the Holy Trinity is one substance in three persons, it is one single proportion in three terms.

3. As God cannot be defined in words, it cannot be expressed by any intelligible number or rational quantity, but is always occult and secret and is called by the mathematicians irrational.

4. Like God, it is always similar to itself [13].

Pacioli, walking the fence between the metaphysical outlook of the Middle Ages and the humanist, rational thinking of the Renaissance, wanted to demystify and logically explain what he considered an expression of the perfect, or the divine. Number had meaning—a divine meaning.

A few decades before the publication of *De Divina Proportione*, Botticelli, still leaning to the mystical philosophies of the Middle Ages, painted *Madonna and Child with Two Angels* (Fig. 7). As the analysis shows, he made use of the divine proportion in the composition. Its symbolic significance grants a natural structural focus in the composition of divine subjects. The musical and the literary aspects of the painting express this same divinity.

Pacioli's book marked the beginnings of secularization of the secret knowledge of number—a knowledge that had ancient origins. Looking back to the ancient Egyptians, some authors describe a mystical or universal symbolism for many mathematical constants, including π and ϕ [14]. This symbolism was significant enough that it required no representational overlay to express its truth. A favorite example is the Great Pyramid of Cheops, circa 4000–2000 B.C. It has been said to depict the pharaonic concept of the creative function or reproduction in an endless series and also, by its measure, to symbolize Earth [15]. The Fibonacci series has been proposed as an Egyptian symbol for the spiral of reincarnation, of the imperfect soul to divine perfection [16].

Figure 8 shows a simple analysis of a cross-section of the Great Pyramid: triangle CDB. A variety of relationships are manifested, building from the ratio of the half-base, CA, to a sloping side BC,

$$BC/CA \cong \phi.$$

Measurements of the pyramid can be normalized such that

$$AC = 1, BC = \phi, \text{ and } AB = \sqrt{\phi}.$$

This relationship is a result of the fact that the perimeter of the pyramid's base is equal to the circumference of a circle whose radius is the pyramid's height—the squaring of a circle:

$$EH + HG + GF + FE \cong 2\pi(AB).$$

The inscription of a circle inside the base of the pyramid

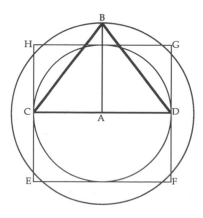

Fig. 8. An analysis of the Great Pyramid, Egypt, showing a cross-section CBD and a construction of the squaring of a circle. The circumference of the circle defined by radius AB equals the perimeter of square EHGF.

expresses another golden section relationship, between the area of the inner circle (defined by radius AC) and the outer circle (with radius AB). This is a relationship that appeared approximately 1,000 years later in another religious/scientific monument—Stonehenge.

The analysis of Stonehenge (Fig. 9) shows the area of the outer circle (radius EG, defined by the Sarsen Stone Circle) in a φ relationship to the inner circle area (radius EF, defined by the Bluestone Circle). The perimeter of the inner circle's inscribing square ABCD equals the circumference of the Sarsen Stone Circle. The structure suggests an astronomical function and is also considered an expression of symbolic and sacred geometries [17]. Similar to the Great Pyramid, it uses proportion to express mathematical truths in the abstract, with the numbers themselves given spiritual meaning. (This same squaring of the circle is described in the book of Revelation in the *Bible* as the plan for the 'New Jerusalem' [18].)

This spiritual ideal of number was passed on to the ancient Greeks. The Pythagoreans' quasi-religious reverence for number was reflected in their dictum—*All is Number*. Plato saw number and geometry as an appropriate language for distilling philosophic truth to its essentials. 'True reality' could not be perceived by the senses, but only through rational thinking. Through the language of geometry this metaphysical reality could be described.

> And do you not also know that they [geometers] make use of visible forms and talk about them, though they are not thinking of them but of the things of which they are a likeness, pursuing their inquiry for the sake of the square and the diagonal as such, and not for the sake of the image of it they draw. And so in all cases. The very things which they mould and draw, which have shadows and images of themselves in water, these things they treat in their turn as only images, but what they really seek is to get sight of those realities that can only be seen by the mind [19].

This faith in a divine reason that structures nature held sway through the Middle Ages. The Medieval *quadrivium* of the seven liberal arts consisted of the subjects of astronomy, arithmetic, geometry and music. Number was highly regarded. Even music was a study of number—the harmony of the spheres reflected in laws of musical proportion.

Number maintained a metaphysical power until the Renaissance. Pacioli's book was one sign of the shift away from faith in divine reason. Reason was now a human trait, a way to explain the mysteries of nature and so to elevate humanity's position in the world.

At the beginning of the twentieth century the well-oiled, mechanistic world that Galileo and Newton had established began to be suspect. The scientific search for universal truth required the research of things beyond those that could be perceived by the senses. The visual arts also returned to this search for a reality beyond that which could be seen. According to Mondrian,

> To love things in reality is to love them profoundly; it is to see them as a microcosmos in the macrocosmos. *Only in this way can one achieve a universal expression of reality.* Precisely on account of its profound love for things, nonfigurative art does not aim at rendering them in their particular appearance.
>
> Precisely by its existence, nonfigurative art shows that 'art' *continues always on its true road.* It shows that 'art' is *not the expression of the appearance of reality such as we see it, nor of the life which we live,* but that *it is the expression of true reality and true life . . . indefinable but realizable in plastics* [20].

The Mondrian analysis in Fig. 6 shows that one aspect of the Modernist era in art was the visualization of number,

with the numbers themselves having meaning—expressing 'true reality'. These ideas were not much different than those of the ancients, and although ancient metaphysics had been replaced with an inner search for universal truth, the expression of beauty with number was still paramount, with the idea of the 'spiritual in art' sometimes lurking nearby.

As Schoenberg cut the path away from the 'materialism' of tonal music, so did Kandinsky announce the departure from the "mere imitation of nature" to abstraction and towards an "inner feeling expressed in natural form" [21]. Kandinsky considered the Modernist impulse a rediscovery of inner, spiritual necessity: "This 'what' (which will show the way to the spiritual food of the newly awakened spiritual life) is the internal truth which only art can divine, which only art can express by those means of expression which are hers alone" [22]. In the search for solutions to the problems of expressing this 'nonmaterial' necessity, Kandinsky turned to music:

> In each manifestation is the seed of a striving towards the abstract, the nonmaterial. . . . And the natural result of this striving is that the various arts are drawing together. They are finding in Music the best teacher. . . . A painter, who finds no satisfaction in mere representation, however artistic, in his longing to express his inner life, cannot but envy the ease with which music, the most nonmaterial of the arts today, achieves this end. He naturally seeks to apply the methods of music to his own art. And from this results that modern desire for rhythm in painting, for mathematical, abstract construction, for repeated notes of colour, for setting colour in motion [23].

By finding a tradition in the musical and literary use of number, and by feeling a resonance with Modernist thought, I established a foundation upon which to begin to explore the composition of visual music.

POINTS OF ARRIVAL AND DEPARTURE

Rudolf Arnheim, discussing proportion, says, "One of the basic visual experiences is that of right and wrong" [24]. Upon that simple premise, a grammar can be built that will allow the composition of a visual music. The conceptual leap required is from the subjective percept of right and wrong to a more objective, syntactical dichotomy of consonance/dissonance. As in tonal music, the idea of consonance versus dissonance establishes departure and destination points, a basis for building a temporal structure—an aesthetic itinerary.

In my work I have been looking for ways of establishing visual consonance in an abstract and relatively objective manner. From this I can construct a vocabulary with enough generality to be compositionally useful. Proportional division based on mathematical truths, combined with abstract,

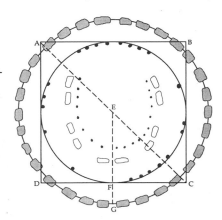

Fig. 9. An analysis of Stonehenge showing a construction of the squaring of a circle. The circumference of the circle defined by the radius EF equals the perimeter of square ABCD.

117

aesthetically pleasing and mathematically derived imagery, offers some interesting possibilities.

I naively saw the use of φ as a panacea for building visual consonance and first applied it in a direct and typical way. Following the example of the Renaissance painters (see Fig. 7), I placed points of focus on the obvious divisions of the golden section of the image plane. Figure 10 shows an image taken from a movement of my musical/animation piece *Marie Sets* [25]. The center of the spiral marks φ on both the horizontal and the vertical dimensions. The image is fractal based, and uses well-documented procedures [26].

In simple fashion the image creates a visual consonance (a visual percept of compositional correctness). Initially I used this method to create punctuation points within a time-based piece. Another example of this is seen in Fig. 11, a frame from my animation *Color Study #7* [27]. This image visualizes trajectories of points as they are processed through a simple function. Again the compositional focus of the shapes is placed on a φ division of the horizontal and the vertical dimensions. The image marks the end of the animation with a visual equivalence to a final cadence in music.

In my animations there are several dimensions that contribute to the structure. There is a strong correlation between the sound score and the visual elements, as the music is derived from the same mathematical processes that create the images [28]. Color also evolves under tight control as it

delineates the temporal design [29]. Formal progression of the abstract shapes is often accomplished by movement through φ, punctuating temporal phrases with points of visual consonance. Together the evolution of the shapes, color and sound in these early works describe a single, unified macrostructure.

As each of the dimensions is individually controllable, a dimensional counterpoint within the overall structure of a work is possible. I explored this idea in my animation *Marian Vectors* [30]. Here the time-dynamics of color, sound and shape unfold with independent formal contours, while maintaining agreement with the guiding mathematical process generating the materials. Color Plate F No. 1 shows the end frame from the *adagio* movement of *Marian Vectors* and illustrates an enhanced application of the golden section. Visual consonance is again used to provide a handle for solutions in the visual music composition.

An analysis of Color Plate F No. 1, shown in Fig. 12, reflects my studies of some of the works of the ancients, such as Stonehenge and the Great Pyramid, and the Moderns such as Mondrian. The φ equivalences are:

$$AE/EC = DE/EB = EH/EF = (EG)^2/(EF)^2$$
$$= (EH)^2/(EG)^2 \cong \phi.$$

I am using proportion to establish relationships beyond those of simple object placement, for a more elegant visual consonance. The concentric circles express the golden section with both area and circumference. In addition, the complete area of the circles, not included on the image, can be easily inferred, adding another level of viewer involvement.

Color Plate F No. 2 shows another variation. The proportional relationship of objects is again more important than the placement. An analysis is shown in Fig. 13. While tile **e** is placed using φ, the golden section is more pointedly expressed in the relationship of the color areas. The image displays the additive primary colors red, blue and green in a Fibonacci series relationship of 3:5:8 with tile areas (**c** + **d**):**e**:(**a** + **b**). With a refreshing shift of method, I intuitively placed the grey-scale ground and all tiles except **e**.

While the materials in my pieces are always mathematically generated, each mathematical process functions metaphorically as a musical vocabulary. While writing a musical

Fig. 10. *Marie Sets*, video, 1987. **A fractal-based image from the animation** *Marie Sets* **with the center of the spiral in an obvious golden-section placement.**

Fig. 11. *Color Study #7*, video, 1990. **This work was composed using** φ **as a visual focus. The end frame of the animation is shown.**

Fig. 12. An analysis of an image from the *adagio* **movement of animation** *Marian Vectors* **(1989), shown in Color Plate F No. 1. The golden section is expressed through relative circumferences and areas.**

Fig. 13. An analysis of the image seen in Color Plate F No. 2. The relative areas of the additive primary colors (red:blue:green) are composed, based on the Fibonacci triplet 3:5:8, with the tiles (c + d):e:(a + b).

Fig. 14. The left square shows a dot cutting the frame at the golden section horizontally and vertically. The right square shows a deliberate avoidance of φ in the dot placement.

score, a composer might explore harmonic material intuitively, searching for interesting relationships. From these relationships, the composer builds the composition. I investigate the potentials of a process and then illustrate the more interesting aspects with visual consonance and temporal coherence. Mathematics provides material for both intuitive exploration and rigorous construction.

Color Plate F No. 3 is a study for a painting entitled *Penrose Green*. Here the basic composition of the image is 'atonal' [31]. A collection of many similar objects distributed evenly over the image establishes no definite 'structural key' or hierarchy of objects. As Schoenberg's serial techniques broke down the prominence of musical pitch, the equality of objects here brings other visual dimensions of the image to the fore—in this case the color.

This painting is a construction of Penrose tiles and takes advantage of their inherent φ relationships to express color-area proportions [32]. These tiles have some particular properties. They fill the infinite plane with aperiodic patterning of only two shapes—a thin rhombus and a fat rhombus. The area of a thin tile is in a φ proportion to a fat tile and, as the tiles fill an infinite space, the ratio of the number of thin diamonds to the fat ones is also φ.

There are 392 fat tiles and 243 thin tiles in the image. All the thin tiles are yellow. There are 81 fat rhombi each of the subtractive primary colors red, yellow and blue (a painter's primary colors). The 149 remaining fat tiles are also blue. The painting illustrates number play revolving around φ.

Equal amounts of red, yellow and blue balance and therefore cancel each other on the color wheel—creating black. This 'eliminates' 243 fat color tiles (81 each of red, yellow and blue). The remaining blue tiles ($1/\phi^2$ of the total tile area) and the remaining yellow tiles (all the thin tiles, also $1/\phi^2$ of the total tile area) are left. Equal amounts of the subtractive primaries yellow and blue, when combined, make green—hence the title of the painting.

I organized the surface of *Penrose Green* using the golden section and color proportion. This figure, as do the other figures, reflects the multilayered use of number and proportion in the generation and structure of materials in my work. Mathematics generates the imagery and is simultaneously used to organize the images in space and time.

Although φ has proven itself a workable tool for constructing a balanced image, it is the interplay of shape, color and composition that creates visual consonance. The use of the golden section does not guarantee good art or even good composition.

In discussing balance, Arnheim tells us "that by stabilizing the interrelations between various forces in a visual system, the artist makes his statements unambiguous" [33]. Which of the two squares in Fig. 14 frame a less ambiguous image? I placed the dot in the left-hand square at the horizontal and vertical cut of φ on the square. On the right-hand square, I placed the dot intuitively, with a desire to avoid the golden section.

In an informal investigation, a preference was found for the right-hand image. This preference is not right or wrong, but the right-hand image was considered to be more interesting and pleasing. If I had to hang one of the squares on my wall, I, too, would choose the right-hand one. While the study was not a rigorous one, it indicates the danger in making aesthetic prescriptions about the use of φ or any other mathematical constants.

The golden section in the left-hand square could actually be contributing to some uncertainty. Is the dot stable or under a force of attraction from one of many directions? The interplay of object and composition creates ambiguity. Conversely, the right-hand image shows a definite pull to the lower left and expresses a "character of necessity in all its parts" [34].

Arnheim also says, "Equilibrium . . . is attained when the forces constituting a system compensate one another. Such compensation depends on all three properties of forces: the location of their point of attack, their strength and their direction" [35]. These forces, each built on complex interactions, cannot be controlled by simple use of mathematical

Fig. 15. A simple analysis of the Moholy-Nagy painting *K. VII*, oil on canvas, 115 × 136 cm, 1922. The dotted lines show the use of a vanishing point in the structuring of the image. (Tate Gallery, London)

constants. Number provides a place to start in compositional problems, but it does not always offer dependable solutions.

FINAL REMARKS

The study of codified music theory helps the composer through the decision-making process in music composition. An understanding of what has worked in the past can minimize the number of wrong turns down the road to solving aesthetic problems. The same is true of visual composition.

Simple mathematic constants that can be used to illustrate relations in the natural world have, almost by definition, aesthetic value. When applied to art, however, too much separation of the musical and the literary creates a danger of neutralizing both. Moholy-Nagy reiterates the Modernist premise:

> Our special problems . . . surely cannot be solved by any insistent posing of the question of 'content and form'. The unity and totality of a work is manifest in the total interdependence of 'form and content'. That is to say, this 'interdependence' is merely a fictive dualism because for me 'form and content' are indissoluble [36].

Figure 15 shows a cursory analysis of one of Moholy-Nagy's early works, the painting *K.VII* (1922)—the dotted lines show a mathematical basis. Another method of number and proportion is used to accomplish the 'interdependence' of the musical and the literary. The concept of vanishing point is used to organize the recursive aspect of the painting. Perspective is another mathematical idea codified during the Renaissance. A technique inspired by the desire to accurately depict the material world is being used by Moholy-Nagy to give structure to the abstract. It opens a whole new path of inquiry in the study of visual consonance.

Gauguin, in a letter to his friend Emile Schuffenecker, offers this advice: "[D]o not paint too much after nature. Art is an abstraction; derive this abstraction from nature while dreaming before it, and think more of the creation which will result than of nature" [37].

Is nature best understood through reasoned mathematical thinking or through instinct? The mixture of rationality and intuition is volatile yet perhaps necessary for constructing pieces that can catalyze aesthetic experience. The employment of techniques and a balance in their use is a problem that all artists face. While artists might never agree on the literary aspect of their work, a quick glance through history indicates the value of number in the musical construction.

Some artists have found number to be of value for both. Whether the meaning of number for them is divine, a true expression of nature and reality, or simply a rational principle of organization and a generator of materials, many of these works endure. Number has proven itself, not as the solution to all problems, but as a worthwhile contributor to artistic discourse and aesthetic experience.

Acknowledgments

This work is made possible through the support of the Computer Center at Vanderbilt University in Nashville, Tennessee, United States, and with the help of a grant from the National Center for Supercomputing Applications (NCSA) at the University of Illinois at Urbana-Champaign, United States.

References

1. V. Persichetti, *Twentieth Century Harmony* (New York: W. W. Norton 1961).

2. A. Schoenberg, *Theory of Harmony,* Roy E. Carter, trans. (London: Faber and Faber, 1978) p. 421. Originally published in 1911 as *Harmonielehre.*

3. J. Cage, "Happy New Ears!", *A Year from Monday* (Middletown, CT: Wesleyan Univ. Press, 1969) pp. 31–32.

4. M. Ghyka, *The Geometry of Art and Life* (New York: Dover, 1977). Originally published in 1946. See also H. E. Huntley, *The Divine Proportion, A Study in Mathematical Beauty* (New York: Dover, 1970).

5. H. B. Chipp, ed., *Theories of Modern Art* (Berkeley, CA: Univ. of California Press, 1968) p. 69.

6. E. Lendvai, "Duality and Synthesis in the Music of Bela Bartok", in Gyorgy Kepes, ed., *Module, Proportion, Symmetry, Rhythm* (New York: Braziller, 1966) pp. 174–193.

7. P. Griffiths, *Modern Music, the Avant Garde Since 1945* (New York: Braziller, 1981) p. 85.

8. J. Hambidge, *The Elements of Dynamic Symmetry* (New York: Dover, 1926).

9. "Iowans Get Mad", *Art Digest* V, No. 7 (1931) p. 9.

10. P. Mondrian, "Plastic Art and Pure Plastic Art", in J. L. Martin, Ben Nicholson and Naum Gabo, eds., *Circle: International Survey of Constructive Art* (New York: Praeger, 1971) pp. 41–56. Originally published in 1937. See also Ad Petersen, ed., *De Stijl,* reprint in offset lithography, De Jong, Hilversum (1968).

11. E. A. Carmean, *Mondrian, the Diamond Compositions* (Washington, D. C.: National Gallery of Art, 1979) p. 69.

12. L. Pacioli, *De Divina Proportione* (Vienna: Winterberg, Quellenschriften, 1889; Milan: Fontes Ambrosiani XXXI, 1956). Originally published in 1509.

13. C. Bouleau, *The Painter's Secret Geometry* (New York: Harcourt, Brace and World, 1963) pp. 75–76.

14. R. Lawlor, *Sacred Geometry, Philosophy and Practice* (London: Thames and Hudson, 1982).

15. P. Tompkins, *Secrets of the Great Pyramid* (New York: Harper and Row, 1971) pp. 189–200.

16. P. Lemesurier, *The Great Pyramid Decoded* (Longmead, U.K.: Element Books, 1977).

17. B. Gaunt, *Stonehenge . . . a Closer Look* (Ann Arbor, MI: Braun-Brumfield, 1979); J. Michell, *The Dimensions of Paradise* (London: Thames and Hudson, 1988) pp. 29–33.

18. Michell [17] pp. 21–29.

19. Plato, *The Republic*, VI, 510, d, e, Paul Storey, trans. (London: William Heinemann, 1935) p. 113.

20. Mondrian [10] p. 53.

21. W. Kandinsky, *Concerning the Spiritual in Art,* M. T. H. Sadler, trans. (New York: Dover, 1977). Originally published in 1914.

22. Kandinsky [21] p. 9.

23. Kandinsky [21] pp. 19–20.

24. R. Arnheim, "A Review of Proportion", in Kepes [6] pp. 218–230.

25. B. Evans, *Marie Sets,* video, 10 min (Champaign, IL: Univ. of Illinois Film Center, 1987).

26. H.-O. Peitgen and P. H. Richter, *The Beauty of Fractals* (New York: Springer-Verlag, 1986).

27. B. Evans, *Color Study #7,* video, 2 min (Champaign, IL: Univ. of Illinois Film Center, 1990).

28. B. Evans, "Integration of Music and Graphics Through Algorithmic Congruence", *Proceedings of the 1987 International Computer Music Conference* (San Francisco, CA: Computer Music Association, 1987).

29. B. Evans, "Temporal Coherence with Digital Color", *Digital Image, Digital Cinema, Leonardo* Supplemental Issue, SIGGRAPH '90 Art Show Catalog (1990) pp. 43–49.

30. B. Evans, *Marian Vectors,* video, 9 min (Champaign, IL: Univ. of Illinois Film Center, 1989).

31. R. Arnheim, *Art and Visual Perception* (Berkeley, CA: Univ. of California Press, 1974) p. 29.

32. See Roger Penrose, "Pentaplexity", *The Mathematical Intelligencer* 2, No. 1, 32–37 (1979). Reprinted from *Eureka* 39. See also F. C. Holroyd and R. J. Wilson, eds., *Geometrical Combinatorics* (London: Pitman, 1984) pp. 55–65; I. Peterson, *The Mathematical Tourist* (New York: Freeman, 1988) pp. 200–212.

33. Arnheim [31] p. 36.

34. Arnheim [31] p. 20.

35. Arnheim [31] p. 26.

36. L. Moholy-Nagy, "On the Problem of New Content and New Form", in K. Passuth, ed., *Moholy-Nagy* (New York: Thames and Hudson, 1985) p. 287.

37. Chipp [5] p. 60.

Carpets and Rugs: An Exercise in Numbers

Dann E. Passoja and Akhlesh Lakhtakia

God himself made the whole numbers: everything else is the work of man.

—Leopold Kronecker

Most, if not all, of us make sense of our respective environs by imposing our personal templates on our sensory perceptions [1]. The structure of the individual's template is determined partly by personal experiences and partly by heritage [2]. In the end, however, there is an underlying unity among all templates: though a Bokhara carpet is very different from a Navajo rug at first glance, both of these articles are patterned using the same geometrical principles.

Not only are numbers aesthetically appealing to the pure mathematician, they pervade all aspects of our lives. All of us know of mathematically illiterate persons who possess an almost uncanny ability to count. This is particularly exemplified by the handweavers of rugs and carpets. Over the centuries, families of weavers have perfected designs that have passed from one generation to the next. Every so often, a master weaver has created new designs without the use of a loom upon which to weave except that within his or her mind's eye. This skill implies not only an ability to count,

but also the talent to arrange elemental patterns in some geometric fashion to achieve a fabulous effect. No wonder the Ionians declared that whole numbers are the elements of the universe.

In this article, we describe an experiment with square arrays of integers that was begun simply with the intention of studying some properties of prime numbers, but that has yielded spectacular patterns. In many ways these designs could not have been obtained by either of us if the computer revolution had not taken place. Therefore, we have still more cause to wonder at the capabilities of the human mind in general and those of master weavers in particular.

ABSTRACT

An algorithm based on square arrays of positive integers, which was created for the purpose of constructing visually appealing designs for carpets and rugs, is described by the authors. A discussion of several examples follows.

THE ALGORITHM

We generated an $N \times N$ array of integers $a(m,n)$ defined by the simple rule:

$$a(m,n) = a(m-1,n) + a(m,n-1) + a(m-1,n-1) \quad (1)$$

where $0 \le m \le N-1$ and $0 \le n \le N-1$. To initiate the process, we defined the first row of numbers $a(0,n)$ for all n, and set $a(n,0) = a(0,n)$. Once the entire array had been generated, the next step consisted of replacing $a(m,n)$ by the number p_{mn}, defined by

$$p_{mn} = a(m,n) \bmod Q \quad (2)$$

which is the remainder obtained after dividing $a(m,n)$ by the integer Q. The final step was to let $q_{mn} = 1$ if $p_{mn} = 0$, and $q_{mn} = 0$ if $p_{mn} \ne 0$, resulting in a distribution of 0's and 1's on a square lattice. Parenthetically, at a later stage we ascertained that the operation given together by equations (1) and (2) can be performed entirely in modular arithmetic, since equation (1) can be replaced by

$$a(m,n) = a(m-1,n) + 2\Sigma_{r=0,1,2,\ldots,n-1} a(m-1,r) \quad (3)$$

Fig. 1. *G = 9 (cool series),* **Group 1 carpet design, inkjet print, 1990. This carpet design was produced through the authors' algorithm with** $Q = 9 = 3^2$.

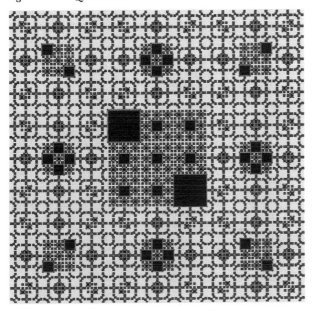

Dann E. Passoja (artist, scientist), 410 East 73rd Street, New York, NY 10021, U.S.A.

Akhlesh Lakhtakia (educator), Department of Engineering Science and Mechanics, Pennsylvania State University, University Park, PA 16802, U.S.A.

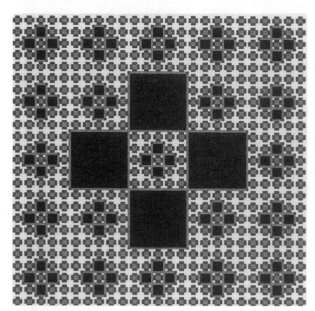

Fig. 2. *G = 5* (warm series), Group 2 carpet design, inkjet print, 1990. This carpet design was produced through the authors' algorithm with *Q = 5*.

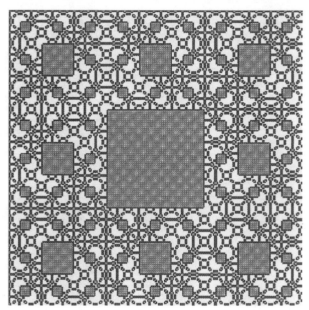

Fig. 3. *G = 6* (warm series), Group 2 carpet design, inkjet print, 1990. This carpet design was produced through the authors' algorithm with *Q = 6 = 2 × 3*.

The color pertinent to the location (m,n) was chosen using q_{mn} as well as the sum

$$s_{mn} = p_{mn} + p_{m-1,n} + p_{m,n-1} + p_{m-1,n-1} \qquad (4)$$

while the palette for each carpet was determined by questioning several independent observers regarding the *harmoniousness* of the final product. The resulting palette, therefore, was not unique but did show some systematic trends that will be described later.

THE GALLERY OF CARPETS

Two separate groups of experiments were performed. In Group 1, later called the *cool series*, the elements $a(0,n)$ and

$a(n, 0)$ of the initial row and column were all set equal to 1, which resulted in all integers $a(m,n)$ being odd, as is evident from the recursion relation of equation (3). In Group 2 (later called the *warm series*), on the other hand, we set $a(0,n) = n \bmod 2$ and $a(n, 0) = n \bmod 2$, so that the initial row and column were composed of alternating 0's and 1's, beginning with 0 at the left; again, it follows from equation (3) that odd and even numbers alternate in the succeeding rows of the array of integers $a(m,n)$. There is no point in having an even Q for Group 1 since in it all integers $a(m,n)$ are odd.

The gallery of carpets begins with Color Plate L No. 3 and Fig. 1, which belong to Group 1; the values of Q in these figures are, respectively, 5 and 9. It should be noted that the value of Q selected for Color Plate L No. 3 is a prime number. This has a particular result: visual inspection shows that the carpets of Group 1 for prime Q are self-similar [3]. In other words, the same motif is present at different scales. Due to limitations on the maximum value of N (here 625) that can be entertained for purposes of graphical display on our video screen, the self-similar nature could be best seen for $Q = 3$, 5 and 7. Furthermore, the special nature of using prime Q becomes clear when contrasting Color Plate L No. 3 with Fig. 1, which has $Q = 9$, a composite number. This does not mean that the carpet with $Q = 9$ or some other composite number is not visually attractive; the point is that the use of a prime Q gives a coherent self-similar structure to the carpets of Group 1.

Since Group 2 contains both odd and even integers $a(m,n)$, both odd and even Q's can be used; however, $Q = 2$, 4, 8, 16, . . . , do not result in appealing designs, yielding merely orthogonal grids. Again, when Q is an odd prime, the resulting pattern is self-similar; this is exemplified in Fig. 2 for $Q = 5$. When Q is neither prime nor a power of 2, very exquisite designs result that, however, are not self-similar; these are exemplified in Fig. 3 for $Q = 6$.

NOTES ON COLOR

With the algorithmic description over, we now turn attention to the colors used for the production of the carpets of both Group 1 and Group 2. The algorithm was run and viewed on the monitor of a minicomputer with a 256-color palette. The carpet designs were printed on an inkjet printer with a more limited color palette. Although photographic slides of the terminal screen were taken with 35-mm color transparency film for chromaticity measurements, the images reproduced here as Color Plate L No. 3 and Figs 1–3 were originally produced as color inkjet prints.

As noted earlier, for ease of identification, carpets of Group 1 were constructed as a blue-green-yellow, or cool, series, and those of Group 2 were constructed as a red-brown-yellow, or warm, series. It was found that certain color schemes were more successful than others. The criteria used to determine color followed the geometry of the carpet; thus, the color of the carpet on a global scale was dependent upon the color derived on a local scale from geometry. Since the carpets with prime Q exhibit self-similarity, we observed that those containing fine details required particular color schemes in order to appear harmonious.

The color harmonies that evolved in the course of our studies appeared to be related to interactions of colors [4] at the boundaries of the geometric subunits that constituted the overall structure of each carpet. Due to the dilational

invariance of coherent self-similar structures, the local color could not be divorced from the global color harmony.

The chromaticity coordinates of the individual colors resulting in the most pleasing carpets were studied using the standard method [5]. The average of five readings at 80 equally spaced wavelengths in the 3800–7800 Å range was recorded. At each wavelength, a background correction spectrum was measured on a black standard; it was then scaled and subtracted from the measured spectrum of the carpet. This corrected spectrum was then ratioed back to one measured for a white standard, thus eliminating the influence of the illuminating source. Standard observer curves were used to calculate the u, v and w coordinates in the Commission Internationale de l'Eclairage (CIE) 1976 chromaticity space.

Chromaticity measurements were made for the three colors used for the cool series and for the four colors used for the warm series. Both inkjet prints and color transparencies were utilized for this purpose. The results for the transparencies are shown in Fig. 4. These results are typical for the carpets judged 'harmonious' by several observers. Paths in the chromaticity space were found to be more or less along straight lines for both warm and cool series carpets.

References and Notes

1. T. E. H. Allen and T. B. Starr, *Hierarchy* (Chicago, IL: Univ. of Chicago Press, 1982).

2. S. J. Gould, "The Horn of Triton", *Natural History* (December 1989) pp. 18–27.

3. B. B. Mandelbrot, *The Fractal Geometry of Nature* (Boston, MA: Freeman, 1982).

4. M. E. Chevreul, *The Principles of Harmony and Contrast of Color and Their Applications to the Arts* (New York: Reinhold, 1967). This work was first published in French in 1839.

5. F. W. Billmeyer, Jr., and M. Saltzman, *Principles of Color Technology* (New York: Wiley, 1981).

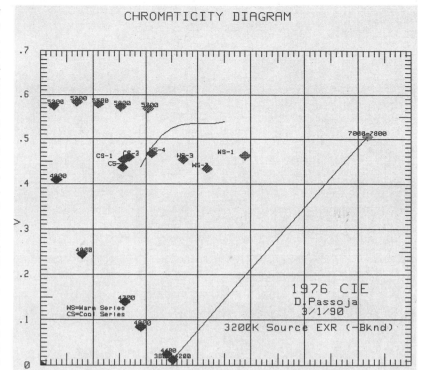

Fig. 4. Measured chromaticity diagram for cool and warm series carpet designs. The three colors used for the cool series (CS) and the four colors used for the warm series (WS) are identified.

On Computer Graphics and the Aesthetics of Sierpinski Gaskets Formed from Large Pascal's Triangles

Clifford A. Pickover

ABSTRACT

The author provides an overview of the field of computer graphics, followed by an example of his own work. The mathematical characterization of patterns in Pascal's triangle is useful and can be achieved by a variety of brute-force computations, but sometimes at a cost of the loss of an intuitive feeling for the regularities and irregularities in the structure. The graphic and mathematical approach described here reveals a visually striking and intricate class of patterns that make up a family of regular fractal networks known as Sierpinski gaskets. The figures indicate self-similarity of the gasket structures for several orders of dilational invariance.

Some people can read a musical score and in their minds hear the music. . . . Others can see, in their mind's eye, great beauty and structure in certain mathematical functions. . . . Lesser folk, like me, need to hear music played and see numbers rendered to appreciate their structures.

—Peter B. Schroeder, 1986

ON COMPUTER GRAPHICS

Since their rapid growth following the Second World War, computers have changed the way we perform scientific research, conduct business, spend our leisure time and create art.

The line between science and art has always been a fuzzy one. Today, computer graphics helps unite these philosophies by providing scientific ways to represent natural, mathematical and artistic objects. From my own experience [1], I have found that computer graphics is a powerful vehicle for artistic expression. It is notable, however, that some artists and scientists have attempted to squeeze beauty out of dry formulas without the aid of a computer. One early example is Dutch graphic artist M. C. Escher, who represented many complex and repeating geometrical forms by hand. Escher's preoccupation with symmetry is well known, and his periodic plane-filling patterns have been analyzed by many mathematicians.

Computers have made new forms possible. Through a new process called stereolithography, artists and engineers can create three-dimensional (3D) models in plastic from computer data. Sculptors using this technique in conjunction with computer graphics tools can discover new aesthetic

Clifford A. Pickover (researcher), IBM Thomas J. Watson Research Center, Yorktown Heights, NY 10598, U.S.A.

Fig. 1. Pascal's triangle (mod 2). The arrows indicate a size change in the internal triangles every k^m rows ($m = 0, 1, 2, 3, \ldots, \infty$), where k is the modulus index (in this figure, $k = 2$). This size change relation holds for all PTs (mod p) where p is a prime number. The arrows shown indicate $2^3, 2^4, 2^5, 2^6$ and 2^7.

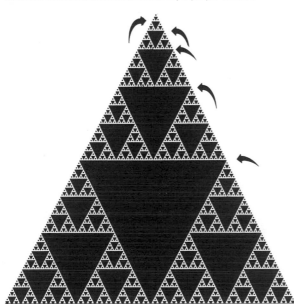

Table 1. Chaos and fractal article explosion. A review of the world scientific literature between 1974 and 1990 shows the number of chaos and fractal articles rising dramatically between the years 1982 and 1990. (From *Computers and the Imagination* by C. Pickover. Copyright 1991 St. Martin's Press. All rights reserved.)

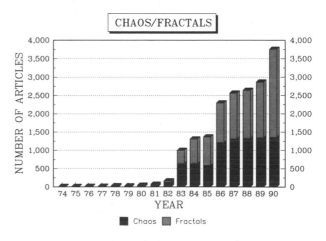

```
numeric digits (100)    /* set the precision of variables    */
do n = 0 to 200         /* n = number of rows                */
  string = ' '          /* initialize output row             */
  do r = 0 to n         /* r = number of columns             */
    c = 1               /* initialize entry in triangle      */
    do x = n to n-r+1 by -1 /*generate all the entries in a row*/
      c = c*x/(n-x+1)
    end
    /* check remainder after division by 2 */
    /* write a dot if c is an even number  */
    if c // 2 = 0 then string = string || '*'
    else string = string || ' '
  end /*r*/
  /* Write the line of the triangle            */
  EXECIO 1 DISKW 'PASCAL DECK A 0 F 255 (STRING' STRING
end  /* n */
```

Fig. 2. Algorithm to compute Pascal's triangle (mod 2) via method 1. Variables: *c* has the value of the Pascal triangle for a given row *n* and column *r*. This pseudocode is written in the REXX programming language. However, the method works well even in BASIC if the triangle is not very large.

```
1
255
32385
2731135
172061505
8637487551
359895314625
12801990477375
396861704798625
10891649009473375
267934565633045025
596763350728145 7375
121341881314722966625
226815978149828 3145375
392067619373274657 98625
629921975126394617164575
944882962689591925 7468625
132839428284007335443235375
1756432440644096990860556625
219091836017184729912606 27375
2585283665002779812968754 03025
28930555298840631240364 62843375
307715906360395805011151 04788625
3117295920955314024678182 35467375
3013386056923470223855576276184625
27843687165972864868425524791945935
2463095403143753430668411808 51829425
2089069804888590872678023348706 256975
17010996982664239963235332982322 378225
133155045347061464539807606447833788175
10031013416145296995332173019070 14537585
72805742536538445933862546106 15428095375
50964019775576912153703782274307996667625
3443932245440500042735634649914263128996375
2248685172022914984920908596499012195211625
14198840657630406047643451423608048432621975
```

Fig. 3. Beginning entries in the first half of row 255 of Pascal's triangle (the last row for many of the figures in this paper). For convenience, the numbers are plotted down the paper. Note that these numbers exceed the precision of integer variables in many common programming languages.

```
a(*) = 0; c(*) = 0;             /* initialize c and a arrays   */
do n = 1 to 255;                /* 255 rows                    */
  do r = 2 to n;                /* generate the entries in a row*/
    c(r) = mod(a(r)+a(r-1),imod);/*imod=modulus index chosen  */
    if c(r) = 0 then PLOTDOT(n,r); /* place at position (n,r) */
  end;
  a(*) = c(*);                  /* update a array for next row  */
end;
```

Fig. 4. Algorithm to compute Pascal's triangle using modular arithmetic via method 2. Variables: *c* has the modular value of the PT for a given row *n* and column *r*.

forms in the mathematical fabric of undulating surfaces and twisting shapes. Stewart Dickson, for example, is an artist who represents mathematical forms in plastic. The process employs laser-based tools and photosensitive liquid resins that harden as they form beautiful, computer-generated 3D sculpture.

Some readers may wonder why scientists and mathematicians use computer graphics to display mathematical results. Science writer James Gleick said it best in his book *Chaos* [2]:

> Graphic images are the key. It's masochism for mathematicians to do without pictures. . . . [Otherwise] how can they see the relationship between that motion and this. How can they develop intuition?

I know of no subject in mathematics that has intrigued both the young and old as much as the idea of a fourth dimension. For decades, there have been many popular science books and science-fiction novels on this subject. In the early 1960s the television show "The Outer Limits" impressed viewers with a creature from the galaxy Andromeda who lives in a higher dimension than ours. Although the creature is both wise and friendly, its visit to our world causes quite a pandemonium. My favorite short science-fiction story on the subject is Robert Heinlein's "And He Built a Crooked House", first published in 1940 [3]. It tells the tale of a California architect who constructs a four-dimensional house. He explains that a four-dimensional house would have certain advantages:

> I'm thinking about a fourth spatial dimension, like length, breadth, and thickness. For economy of materials and convenience of arrangement you couldn't beat it. To say nothing of ground space—you could put an eight-room house on the land now occupied by a one-room house.

Unfortunately, once the builder takes the new owners on a tour of the house, they cannot find their way out. Windows and doors that normally face the outside of the house now face inside. Needless to say, some very strange things happen to the poor people trapped in the house.

Thomas Banchoff and Davide P. Cervone have shown readers that the fourth dimension need not remain confined to the realm of science fiction, beyond the range of exciting experiment and careful thought. As is apparent in this book, computer programmers can interact with artists to produce higher-dimensional models.

These days computer-generated fractal patterns are everywhere. From squiggly designs on computer-art posters to illustrations in the most serious of physics journals, interest continues to grow among scientists and, rather surprisingly, artists and designers. The word 'fractal' was coined in 1975 by scientist Benoit Mandelbrot [4] to describe a set of curves—many of which were never seen before the advent of computers—that can perform massive numbers of calculations quickly. Fractals are bumpy objects that usually show a wealth of detail as they are continually magnified. Some of these shapes exist only in abstract geometric space, but others can be used to model complex natural shapes such as coastlines and mountains.

Chaos and fractal geometry go hand-in-hand. Both fields deal with intricately shaped objects, and chaotic processes often produce fractal patterns. To ancient humans, chaos represented the unknown, the spirit world—menacing, nightmarish visions that reflected the human fear of the irrational and the need to give shape and form to apprehensions. Today, chaos theory is a growing field involving the study of a range of phenomena exhibiting a sensitive dependence on initial conditions. This means that some natural systems, such as the weather, are so sensitive to even small, local fluctuations that we will never be able to accurately predict what they will do in the future. For certain mathematical systems, if you change a parameter ever-so-slightly, the results can be very different. Although chaos seems totally 'random', it often obeys strict mathematical rules derived from equations that can be formulated and studied. One important research tool to aid in the study of chaos is computer graphics. From chaotic toys with randomly blinking lights to wisps and eddies of cigarette smoke, chaotic behavior is irregular and disorderly. Other examples include certain neurological and cardiac activity, the stock market and some electrical networks of computers. Chaos theory has also often been applied to a wide range of visual art.

So extensive is the interest in fractals and chaos that keeping up with the literature on the subject is rapidly becoming a full-time task. In 1989 the world's scientific journals published about 1,200 articles with the words 'chaos' or 'fractal(s)' in the title. Table 1 shows the number of papers with titles containing the words chaos or fractal(s) published during 1974–1990, the 1990 values estimated from data for January–June 1990.

Fig. 5. Pascal's triangle (mod 2), 'anti' version. This triangle results from a logical 'not' operation on Fig. 2. The numbers on the figure indicate the number of dots that make up each triangle in the central stack. All perfect numbers appear in this central pattern (see text).

Fig. 6. Pascal's triangle (mod 3), right-triangle plot. This figure and Figs 7–19 are plotted so that the 1's that make up the last entry in each row fall beneath one another. Note a size change in internal triangles every 3^m rows ($m = 0, 1, 2, 3, \ldots, \infty$).

Fig. 7. Pascal's triangle (mod 4).

Fig. 8. Pascal's triangle (mod 5), 'anti' version.

Fig. 9. Pascal's triangle (mod 6).

Fig. 10. Pascal's triangle (mod 7).

Fig. 11. Pascal's triangle (mod 8).

Fig. 12. Pascal's triangle (mod 9).

Fig. 13. Pascal's triangle (mod 10).

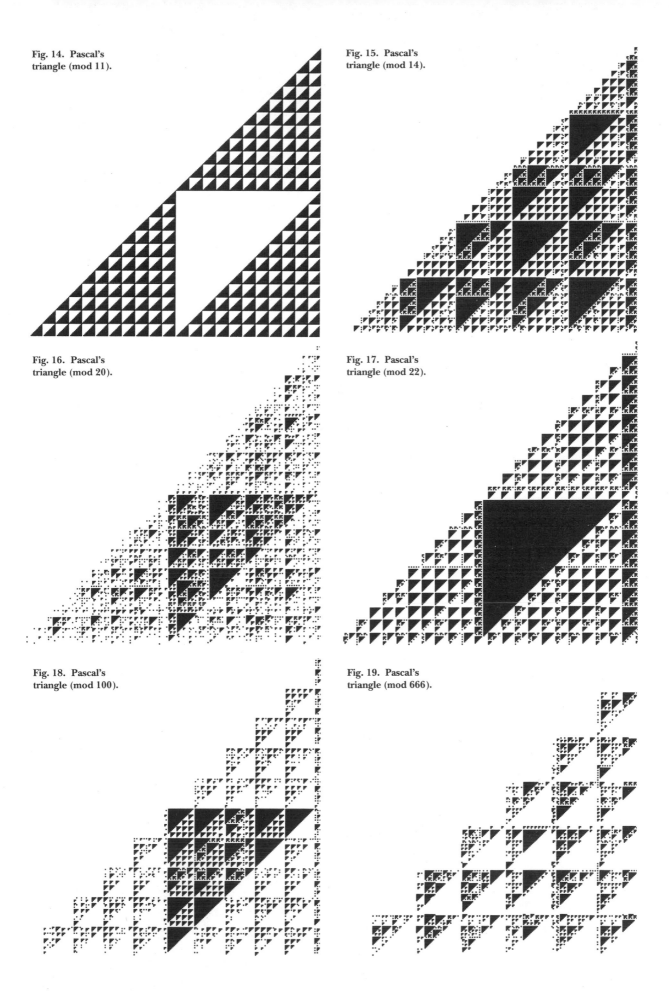

Fig. 14. Pascal's triangle (mod 11).

Fig. 15. Pascal's triangle (mod 14).

Fig. 16. Pascal's triangle (mod 20).

Fig. 17. Pascal's triangle (mod 22).

Fig. 18. Pascal's triangle (mod 100).

Fig. 19. Pascal's triangle (mod 666).

The line between art and science has become indistinct. Computer graphics makes this particularly apparent and adds a new element to the field of mathematics. Science writer Ivars Peterson [5] has the right idea. He has noted that mathematicians have begun to enjoy and present bizarre mathematical patterns in new ways—ways sometimes dictated as much by a sense of aesthetics as by the needs of logic. Moreover, computer graphics allows nonmathematicians to experience some of the pleasure mathematicians take in their work and to better appreciate the complicated and interesting graphic behavior of certain simple formulas.

PASCAL'S TRIANGLES

The integers are the primary source of all mathematics.

—Hermann Minkowski

Mathematics, rightly viewed, possess not only truth, but supreme beauty—a beauty cold and austere, like that of a sculpture.

—Bertrand Russell

Number theory—the study of properties of integers—is an ancient discipline. Much mysticism accompanied early treatises [6]; however, today integer arithmetic is important in a wide spectrum of human activities and has repeatedly played a crucial role in the evolution of the natural sciences [7].

One of the most famous integer patterns in the history of mathematics is Pascal's triangle (PT). (Blaise Pascal was the first to write a treatise about this progression in 1653, although the pattern had been known by Omar Khayyam as far back as A.D. 1100.) The first seven rows of PT can be represented as follows:

```
     1
    1 1
   1 2 1
  1 3 3 1
 1 4 6 4 1
1 5 10 10 5 1
1 6 15 20 15 6 1
```

The role that PT plays in probability theory, in the expansion of binomials of the form $(X+Y)^N$, and in various number theory applications has been discussed previously [8].

Mathematician Donald Knuth once indicated that there are so many relations in PT that when someone finds a new identity, there are not many people who get excited about it anymore, except the discoverer. Nonetheless, several novel approaches have revealed patterns in the triangle that include geometric patterns in the diagonals [9], the existence of perfect-square patterns with various hexagonal properties [10] and an extension of the triangle and its patterns to negative integers [11].

MOTIVATION

Researchers have noted that the Pascal sequence contains within it a variety of patterns, some very obvious, others extremely subtle and hard to recognize. Computer graphics is an excellent method by which patterns in PT can be made obvious to both the mathematician and interested layperson. Unfortunately, high-resolution computer graphics has

been little exploited in the past PT work, though in other branches of mathematics graphics have played a critical role in helping mathematicians form the intuitions needed to prove new theorems or simply to reveal intricate behavior of simple mathematical functions [12,13]. In number theory, graphics has been useful in revealing patterns in prime numbers [14] and in $3n+1$ ('Collatz') numbers [15]. In this paper, computer graphics is used to catalog and reveal patterns in PT.

A second goal of this paper is to demonstrate how research in PT reveals an inexhaustible new reservoir of magnificent shapes and images. Indeed, structures produced by using modular arithmetic in computing this simple triangle include shapes of startling intricacy. The graphics experiments presented are good ways to show some of the complexities of PT.

COMPUTATION

The figures in this article represent PT computed with modular arithmetic. For example, Fig. 1 is PT (mod 2), i.e. points are plotted for all even numbers occurring in the triangle. (In many programming languages, this is represented by conditions satisfying 'mod $[i,2] = 0$', where i is the number in PT.) Patterns computed in this way reveal many surprises, some of which are discussed later.

There are many different ways to compute the triangle: trigonometric methods, combinatorial methods and the binomial theorem method. I present two methods, which readers should be able to implement in most programming languages. Method 1 (Fig. 2) is an easy way of constructing the triangle using the REXX programming language [16]. REXX was used primarily because of its novel 'infinite precision' capability, allowing the user to compute the triangle to any depth. (The programming language LISP also has this feature.) Indeed, as Fig. 3 shows, the integers become extremely large very rapidly. The values in PTs grow so fast (see Fig. 3) that it only would be possible to compute a few score rows before exceeding the precision of variables in most programming languages. In method 1, I used 100-digit precision. Nevertheless, the code is so simple to implement that readers are encouraged to use whatever languages are available, such as BASIC, since low-order PTs also yield fascinating shapes. For a similar program in BASIC, see [17]. Color capability further enhances the graphics presentation and allows the human analyst to detect important features in the data. For example, points (mod 2) and (mod 3) can be displayed in different colors in the same triangle.

Method 2 for computing PT does not require the user to compute actual values for entries in the triangle. Rather, the user computes the triangle using modular arithmetic (Fig. 4). Methods 1 and 2 can both be used to plot the figures in this paper; however, using method 2, super-large integers are not generated, and method 2 is faster. Either of these programs should be easy to convert to the reader's language of choice. Figures 5–19 display the triangle for a variety of moduli.

OBSERVATIONS AND CONCLUSIONS

The mathematical characterization of patterns in PT is useful and can be achieved by a variety of brute-force computations, but sometimes at a cost of the loss of an intuitive feeling for the regularities and irregularities in the struc-

ture. The graphic and mathematical approach described here reveals a variety of conspicuous Pascal number patterns in a visual manner.

Among the methods available for the characterization of complicated mathematical and physical phenomena, computers with graphics are emerging as an important tool [18]. In contrast to previous systems where mathematical and aesthetic beauty relies on the use of imaginary numbers, these calculations use integers, which also facilitate their study with programming languages having no complex data types on small personal computers. The forms in this paper contain both symmetry and stochasticity, and the richness of resultant forms contrasts with the simplicity of the generating formula.

Pascal portraits contain a beauty and complexity corresponding to behavior that mathematicians may not have been able to fully appreciate before the age of computer graphics. This complexity makes it difficult to objectively characterize structures such as these, and, therefore, it is useful to develop graphics systems that allow the maps to be followed in a quantitative and qualitative way. The Pascal Triangle Graphics Program allows the researcher to display patterns in any modularity, to any depth, with variable dot size, with variable 'skew factor' (which controls how the rows line up, i.e. right or equilateral triangles can be produced) and in normal or 'anti' modes (see below). Color options provide additional insight into the complicated behavior. Though the triangles seem to display what might be called 'bizarre' behavior, there nevertheless seems to be a limited repertory of recurrent patterns.

Nomenclature

Before considering the figures, it is useful to provide additional background to traditional PT nomenclature. Each entry in the triangular array consisting of n rows and r columns can be denoted by the symbol

$$\binom{n}{r},$$

for example,

$$\binom{3}{2} = 3.$$

One way these patterns can be defined is algebraically when $n \geq 0$ and $0 \leq r \leq n$, that is,

$$\binom{n}{r} = \frac{n!}{r!(n-r)!}.$$

Other authors [19] have extended the triangle to negative values for n.

In this paper, high-resolution graphs are constructed by drawing a dot at positions

$$\binom{n}{r} = \frac{n!}{r!(n-r)!} \text{ when } \binom{n}{r} = 0 \,(\text{mod } k),$$

for $(0 < n < 255)$ where k is the modulus index. 'Anti-triangles' are computed by plotting the inverse of the triangle defined in the equation just given, for example, by plotting points when

$$P(n,r) \neq 0 \,(\text{mod } k)$$

(these anti-triangles look like photographic negatives). These were found to give viewers a useful alternative visual perspective when searching for patterns. Values of k for the figures range from 2 to 666.

Gaskets

The resulting shapes are of interest mathematically, and they reveal a visually striking and intricate class of patterns that make up a family of regular fractal networks. Fractals are patterns that have increasing 'detail' with increasing magnification (e.g. the edge of a coastline). The fractals often of most interest are self-similar, for example, if we look at any one of the triangular motifs within PT, we notice that the same pattern is found at another place in another size. The two-dimensional networks revealed in the figures in this paper are known as Sierpinski gaskets [20], which share important geometrical features with percolation problems [21] and cellular automata. The Sierpinski gasket consists of triangles nested in one another "like Chinese boxes or Russian dolls" [22], outward to infinity. The figures indicate self-similarity of the gaskets for several orders of dilational invariance (defined below).

Size Changes of Internal Triangles

By studying the figures in this paper, several interesting observations can be made. Starting with Fig. 1 (modulus index $k = 2$), we observe that internal triangles undergo a size change (starting at the top triangle with one dot) every 2^m rows, where m is an integer. Note that in Fig. 6 ($k = 3$) a size change occurs at 3^m rows. The relationship for Fig. 7 is not as simple: a size change occurs not at 4^m but at 2^m. In fact, for nonprime k, size changes occur at one of the prime *factors* raised to a power. Also, once a size change occurs for nonprime PTs, smaller triangles still remain intricately interspersed with the new larger breeds.

In general, the PTs with the simplest symmetries and patterns are of the form

$$\binom{n}{r} = 0 \,(\text{mod } p),$$

where p is a prime number. Starting from the top of these p-PTs, notice that the internal triangular motif undergoes its first size change after $p - 1$ triangles (or p triangles in the anti version). Readers can check this for themselves by observing Figs 8, 10 and 14.

Symmetries

As mentioned in the Gaskets section, these figures possess what is known as nonstandard scaling symmetry, also called dilation symmetry, i.e. invariance under changes of scale (for a classification of the various forms of self-similarity symmetries, see [23]). Dilation symmetry is sometimes expressed by the formula $\vec{r} \Rightarrow \overrightarrow{ra}$. Thus, an expanded piece of the Pascal's Sierpinski gasket can be moved in such a way as to make it coincide with the entire gasket, and this operation can be performed in an infinite number of ways. Other more trivial symmetries in the figures include the bilateral symmetry of all equilateral PTs, and the various rotation axes and other mirror planes.

Another observation is that, in general, the higher the modulus index k, the more intricate and difficult to define are the symmetries. Figure 19 shows PT for a large k ($k = 666$).

By visually familiarizing oneself with the basic internal motifs for various modulus indices, it is possible at a glance to determine the prime factors of k for many PTs. For

example, in Fig. 9 one can see a '2-motif' (triangle surrounded by three dots), and a '3-motif' (three triangles touching at their vertices). With training, PTs can be used as a visual method for factorization of the k-index.

On a similar line of thought, it is possible to construct higher-k PTs from several lower-k PTs. As just one example, let P_{12} be the PT for $k = 12$. Let $\neg P_{12}$ be the anti-triangle (black dots interchanged with white dots). We can then perform logical operations on PTs for $k = 4$ and $k = 3$ (note that 4 and 3 are factors of 12), obtaining

$$\neg P_4 \text{ or } \neg P_3 = \neg P_{12}.$$

Equivalently, P_4 and $P_3 = \neg P_{12}$. Readers are encouraged to explore these logical operations by constructing pictures of $\neg P_4$ and $\neg P_3$ and holding the pictures, one behind the other, up to a light and observing the resultant portrait. This is a simple way for performing a logical 'or', and it reveals $\neg P_{12}$. This approach only works if the two generating PTs do not have factors in common. For example, $\neg P_{12} \neq P_6$ and P_2 since 6 has 2 as one of its factors.

Complete PT Generation

How far (i.e. number of rows n) should the PT be computed to yield a useful, 'complete' and aesthetically pleasing pattern? By observing the figures, it was also found that $n_{max} = k^m$ (where k is the modularity index and m an integer power) provides an artistically and mathematically useful stopping point, since the internal triangular network terminates on the tips of internal triangles rather than being cut off somewhere in between. If this is not possible, due to size, resolution and computation limitations, then, any prime factor raised to a power provides a useful stopping point.

Perfect Numbers

Finally, an additional interesting observation by Martin Gardner [24] is made obvious in Fig. 5. That is, if we were to count the number of dots in the central triangles starting from the top, we would find that each was made up entirely of even-numbered dots. At the top is 1 dot, then 6, 28, 120, 496, . . . , dots. The numbers 6, 28 and 496 are perfect because each is the sum of all its divisors excluding itself ($6 = 1 + 2 + 3$). The formula for the number of dots in the nth central triangle, moving along the apex, is

$$2^{n-1}(2^n - 1).$$

Because every number of the form

$$2^{n-1}(2^n - 1),$$

where ($2^n - 1$) is a prime, is an even, perfect number, all even, perfect numbers appear in the central stacked triangular pattern in Fig. 5. Other patterns and curious relations can be found in these figures, and these are left for readers to discover.

Practical Importance

Dilation symmetry has been discovered and applied in different kinds of phenomena in condensed matter physics, diffusion, polymer growth and percolation clusters. One example given by Kadanoff [25] is petroleum-bearing rock layers. These typically contain fluid-filled pores of many sizes, which, as Kadanoff points out, might be effectively understood as Sierpinski gaskets.

These figures may have a practical importance in that they can provide models for materials scientists to produce entirely new structures with entirely new properties. For example, Gordon et al. [26] have created wire gaskets on the micron-size scale almost identical to the (mod 2) structure in Fig. 1. The area of their smallest triangle was $1.38 \pm 0.01 \ \mu m^2$, and they have investigated many unusual properties of their superconducting Sierpinski-gasket network in a magnetic field (see their paper for details). In addition, because of the dilation symmetry of modular PTs, statistical mechanical and transport problems are exactly solvable on these fractals, making them counterparts of the regular arrays and attractive candidates as model systems. As Gordon et al. indicated for their wire mesh, the study of gaskets in general is inherently interesting because of their 'anomalous' fractal dimensionalities.

Future Work

Provocative avenues for future graphics include the plotting of these figures for Pascal's pyramid (a three-dimensional extension presented by Liu Zhiqing of the Peoples Republic of China [27]), negative PT (presented by James Bidwell of Central Michigan University [28]), hexagonal clusters (presented by Zalman Usiskin of the University of Chicago [29]) and complex number PTs. Readers wishing to explore some recent and fascinating theoretical work on these triangles should consult [30,31]. Lastly, interactive programs that allow the user to view Pascal's pyramids from within, like a worm tunneling through Swiss cheese, will provide an amusing, artistically interesting and possibly mathematically useful exploration tool. Such a tool is described in [32], which also describes other related oddities such as the Bernoulli and Vieta triangles, Dudley's triangle, and four-dimensional extensions of Pascal's pyramid. For example, the Dudley triangle array, proposed in 1987, is represented by another bilaterally symmetric triangle, the values of which grow more slowly than those of Pascal's triangle.

A report such as this can only be viewed as introductory; however, it is hoped that the techniques, equations and system will provide a useful tool and stimulate future studies in the graphic characterization of the morphologically rich structures of extreme complexity produced by iteration in number theory. One can only speculate that Blaise Pascal would have been intrigued by the beauty and complexity of the infinite spaces represented by these graphs. As Pascal once said, "When I consider . . . the small part of space which I can touch or see engulfed by the infinite immensity of spaces that I know not and that know me not, I am frightened and astonished."

References

1. C. Pickover, *Mazes for the Mind: Computers and the Unexpected* (New York: St. Martin's Press, 1992).

2. J. Gleick, *Chaos* (New York: Viking, 1987).

3. Robert Heinlein, "And He Built a Crooked House", in C. Fadiman, ed., *Fantasia Mathematica* (New York: Simon & Schuster, 1958).

4. B. Mandelbrot, *The Fractal Geometry of Nature* (New York: Freeman, 1982).

5. I. Peterson, "Portraits of Equations", *Science News* **132**, No. 12, 184–186 (1987).

6. C. Dodge, *Numbers and Mathematics* (Boston: Prindle, Weber, 1969).

7. For a description of the use of number theory in communications, computer science, cryptography, physics, biology and art, see M. Schroeder, *Number Theory in Science and Communication* (New York: Springer-Verlag, 1984).

8. M. Gardner, *Mathematical Carnival* (New York: Vintage Books, 1977).

9. L. Jansson, "Spaces, Functions, Polygons, and Pascal's Triangle", *Mathematics Teacher* **66** (1973) pp. 71–77.

10. Z. Usiskin, "Perfect Square Patterns in the Pascal Triangle", *Mathematics Magazine* **7**, No. 1, 203–208 (1973).

11. J. Bidwell, "Pascal's Triangle Revisited", *Mathematics Teacher* 66 (1973) pp. 448–452.

12. C. Pickover, *Computers, Pattern, Chaos and Beauty* (New York: St. Martin's Press, 1990).

13. C. Pickover and A. Khorasani, "Fractal Characterization of Speech Waveform Graphs", *Computers and Graphics* 10 (1986) pp. 51–61.

14. M. Stein, S. Ulam and M. Wells, "A Visual Display of the Distribution of Primes", *Mathematical Monthly* 71 (1964) pp. 516–520.

15. C. Pickover, "Hailstone (3n + 1) Number Graph", *Journal of Recreational Mathematics* 21, No. 2, 112–115 (1989).

16. *System Product Interpreter User's Guide,* release 4. IBM manual (SC24-5238-2) (1984).

17. D. Spencer, *Computers in Number Theory* (New York: Computer Science Press, 1982).

18. Pickover [12].

19. Bidwell [11].

20. B. Mandelbrot, *The Fractal Geometry of Nature* (New York: Freeman, 1982).

21. J. Gordon, A. Goldman and J. Maps, "Superconducting-Normal Phase Boundary of a Fractal Network in a Magnetic Field", *Physics Review Letters* 56 (1986) pp. 2280–2283.

22. L. Kadanoff, "Fractals: Where's the Physics?", *Physics Today* (February 1986) p. 6.

23. Pickover [12].

24. Gardner [8].

25. Kadanoff [22].

26. Gordon et al. [21].

27. L. Zhiqing, "Pascal's Pyramid", *Mathematical Spectrum* 17, No. 1, 1–3 (1985).

28. Bidwell [11].

29. Usiskin [10].

30. N. Holter, A. Lakhtakia, V. Varadan, V. Vasundara and R. Messier, "On a New Class of Planar Fractals: The Pascal-Sierpinski Gaskets", *Journal of Physics A: Mathematics General* 19 (1989) pp. 1753–1759.

31. A. Lakhtakia, V. Vasundara, R. Messier and V. Varadan, "Fractal Sequences Derived from the Self-Similar Extensions of the Sierpinski Gasket", *Journal of Physics A: Mathematics General* 21 (1988) pp. 1925–1928.

32. C. Pickover, *Computers and the Imagination* (New York: St. Martin's Press, 1991).

Soap Bubbles in Art and Science: From the Past to the Future of Math Art

Michele Emmer

It's because I don't do anything, I chatter a lot, you see, it's already a month that I've got into the habit of talking a lot, sitting for days on end in a corner with my brain chasing after fancies. Is it perhaps something serious? No, it's nothing serious. They are soap bubbles, pure chimerae that attract my imagination.

—Fedor Dostoevsky, *Crime and Punishment*

A soap bubble is the most beautiful thing, and the most exquisite in nature. . . . I wonder how much it would take to buy a soap bubble if there was only one in the world.

—Mark Twain, *The Innocents Abroad*

These quotations capture the two aspects of soap bubbles that are encountered most frequently in literature and the figurative arts: their fragility and their eternal fascination. There is no doubt that soap bubbles evoke memories of childhood games. Who has not played at making soap bubbles or stopped to admire these small iridescent globes that drift through the air? However, a famous scientist, Sir William Thomson (Lord Kelvin), as if challenging their unmerited fame as 'pure chimerae', said: "Make a soap bubble and observe it; you could spend a whole life studying it."

Soap bubbles have proven a constant source of fascination. Scientific interest in soap bubbles is so vast that it is difficult to deal with all aspects, as it would require a wide knowledge of many different disciplines ranging from mathematics to physics, chemistry and biology [1]. Equally interesting is the presence of soap bubbles in literature, painting and the graphic arts and, more recently, in photography and the cinema.

It is quite reasonable to suppose that this interest, whether scientific or artistic, derives from the observation of children's games. Scientific literature mentions an Etruscan vase in the Musée du Louvre in Paris depicting children playing with soap bubbles [2]. This story is also mentioned in recent books dealing with the scientific aspects of soap bubbles [3]. However, in 1986, one of the heads of the museum's Greek and Roman department wrote me that there was no trace of such a vase.

In any case, there is no doubt that playing with soap bubbles is an ancient game. This comes as no surprise given the ease with which bubbles can be created. Nor is it surprising that in most of the paintings or prints in which soap bubbles appear, there are also children playing with them.

Even more interesting is the fact that scientists working on bubbles never forget "the carefree existence of making soap bubbles" [4], as observed by André Schaaf, a French expert on the morphology of Radiolaria, protozoa forming a part of marine plankton. In his classic work *On Growth and Form* [5], D'Arcy Thompson tried to explain some of the shapes of Radiolaria as in the classic drawings of Haeckel [6] by means of soap film models.

We should speak not only of soap bubbles but more specifically of soap films. When we wash dishes with a liquid detergent, a layer of foam made up of a large number of soap bubbles all touching one another forms on the surface of the water. In other words, by touching one another, bubbles that were originally spherical in shape have changed shape to become soap films enclosing small amounts of air entrapped in the soapy water.

The study of the geometry of thin films and soap bubbles is one of the most interesting sectors of modern mathematics. Furthermore, new techniques such as computer graphics have provided us with a 'new soap' with which it is possible to construct models of the 'soap film type' otherwise unobtainable with real soapy water.

Mathematicians began to take an interest in thin films and soap water around 1873, the date when the Belgian physicist Joseph Plateau published the results of his experiments in his two-volume work *Statique expérimentale et théorique des liquides soumis aux seules forces moléculaires* [7]. If this is the official beginning of research on the geometrical properties of thin film structures, the artistic and literary aspects began much earlier.

SOAP BUBBLES IN ART AND LITERATURE

The image of the soap bubble is associated with the idea of 'Vanitas Vanitatum'—the fragility of human ambition, the

ABSTRACT

The author examines the parallel history of soap bubbles and soap films in art and science. Noting that mathematicians in particular have been intrigued by their complex geometry, he traces the research in this field from the first experiments by Joseph Plateau in the late nineteenth century to recent work using computer graphics in the theory of minimal surfaces. He identifies the beginnings of what could be called 'Math Art'.

Michele Emmer (mathematician), Dipartimento di Matematica, Università Ca' Foscari, Dorsoduro 3825 Ca' Dolfin, 30123 Venice, Italy.

Fig. 1. D. Bailly, *Vanitasstilleven*, oil on canvas, 1651. (Stedelijk Museum de Lakenhal, Leiden)

vanity of human aspirations, the transiency of life itself. 'Homo Bulla'—man is a bubble—is an idea that is explored in classical and Renaissance literature. One of the most quoted examples is a passage from a Dialogue of Luciano of Samosata (130–200 A.D.):

> Caronte: I'd like to tell you, Mercury, that to me all men and their lives seem alike. Have you ever watched those bubbles that form in the pool of a waterfall? The foam which is made up of bubbles? The tiny ones break and vanish immediately. . . . That's what man's life is like.

Soap bubbles first appeared in art in 1574 in a painting by the Dutch master Cornelis Ketel. In his article "Homo Bulla", Wolfgang Stechow provides the following description of Ketel's painting:

> A small circular portrait by Ketel in the collection of Mr. de Bruyn at Spiez [Switzerland] [8] painted in 1574 (thus during Ketel's stay in England), shows on its back the representation of a husky putto standing against a cloudy sky on a ground covered with grass and tiny underbrush, blowing bubbles from a small vessel in his right hand: the inscription above runs (in Greek) ΠΟΜΦΟΛΥΞ Ο ΑΝΘΡΩΠΟΣ that is, 'Man is a bubble' [9].

It is likely that Ketel's painting provides the first appearance of a soap bubble, as opposed to the more traditional air bubble on a water surface (as in the Dialogue of Luciano).

A series of engravings made in 1594 by Hendrik Goltzius on the theme of bubbles had a strong influence in making soap bubbles one of the genre themes of the Dutch school followed then by many European painters. One of the engravings is entitled *Quis evadet* (whosoever escapes); another, in a more traditional fashion, *Homo Bulla*.

In his article "The Putto with the Death's Head", H. W. Janson discusses Goltzius's engravings:

> A living variety was created at the same time in the Netherlands by combining the Putto with the skull with the traditionally Northern type of the Putto as a symbol of vanity. This ingenious synthesis has been achieved in an engraving of 1594 designed by H. Goltzius. . . . The content of the design . . . is that of the Putto with the skull as conceived in the North during the early sixteenth century; it is conveyed by the flame as well as the flower, the withering tree, and preeminently by the soap bubble which the Putto is blowing [10].

Throughout the seventeenth century, the theme of 'Vanitas', and therefore of soap bubbles, became widely diffused in the Dutch Mannerism school. One finds examples of the more traditional representation of the Putto or child figure blowing bubbles as well as the more symbolic representation of bubbles alone, recognizable for its allegorical significance. An example of the latter is evident in David Bailly's *Vanitasstilleven* of 1651 (Fig. 1), one of the most successful works of the period according to the art historian Svetlana Alpers [11].

In many of the paintings of the Dutch school, the focus is no longer on Putti but rather on children blowing bubbles and watching them drift in the air. Even the bubbles themselves are portrayed with greater attention, showing the iridescences on their surfaces and the fact that they are not perfectly transparent (as in Bailly's painting).

In 1672 the English scientist Hook made this observation to the Royal Society in England:

> A mass of bubbles was created in a soap solution by blowing into it through a glass tube. At the beginning of the experiment, one could easily see that the soap film enclosing each

bubble of air was a clear white colour, without any trace of other colours. But after a while as the film gradually became thinner, one began to see all the colours of the rainbow on the surface of the bubbles.

While Hook, together with Boyle, was the first to draw the attention of scientists to the colours of thin films, it was Newton who, in *Opticks*, described in great detail the phenomena that take place on the surface of bubbles [12]. It is probably not insignificant that this same period saw soap bubbles achieve their greatest fame as a subject for painting. It is thus likely that children's games and works of art stimulated scientists to try to understand the workings of these phenomena that were so attractive and entertaining.

The complexity of soap bubbles made them difficult to paint. The nineteenth-century Pre-Raphaelite artist John Everett Millais said that he had to use a specially constructed glass globe in order to observe and paint the colours of bubbles. His painting *Bubbles* (Fig. 2) became the official poster for the first publicity campaign to make use of bubbles—the campaign for 'Pears' transparent soap. Since then, bubbles have always been present in the publicity for soaps and shampoos; however, they no longer symbolize 'Vanitas' but rather the more down-to-earth qualities of freshness and cleanliness.

Jean-Baptiste Chardin's painting *Les Bulles de Savon* (about 1735) marked an important moment in the history of soap bubbles. Comparing him with previous painters on the same subject, Pierre Rosenberg remarks of Chardin:

> One must say that the artist observes the world of adolescence with great tenderness and comprehension; in his works, there is no need to search for complex moral or philosophical significance, beyond the evident allusion to the fragility of human life, to Vanitas [13].

Chardin's painting catches two children who are playing at the moment when the bubble, already formed, still has to be separated from the pipe.

Chardin's painting was certainly known to Edouard Manet who painted his *Les Bulles de Savon* in 1867 (Fig. 3). Both Hanson [14] and Mauner [15] state that Manet was aware of Bailly's painting, at least in the version given in the volume by Blanc [16]. In his analysis of Manet's work, F. Cachin states:

> Of all representations since then connected with the theme of the Vanitas, Manet preserves the traditional elements: the small tube to which is stuck a bubble ready to break out, and the youth of the model. But he corrects them, giving them a new frontality and, most of all, eliminating any trace of melancholy. . . . More than a philosophical or moral meditation, is it not a strictly pictorial investigation, a naturalistic answer to the painting of his master, eliminating any sentimental components, and moreover a wanted confrontation with the Great Art of the seventeenth century? [17]

THE GEOMETRY OF SOAP BUBBLES AND SOAP FILMS

The importance of the work of Joseph Plateau is so great that one of the most interesting mathematical problems in studying soap bubbles is called, in his honor, 'the Plateau problem'. The problem can be formulated as follows: "Given a closed curve in three-dimensional space, how can one span onto it a surface with the smallest possible area." In mathematics these kinds of problems are called 'minimal surface problems', and the theory to investigate them 'minimal surface theory'. Fred Almgren in his article "Minimal Surface Forms" states:

> A collection of surfaces, interfaces or membranes is called *minimal* when it has assumed a geometrical configuration of least area among those configurations into which it can readily deform subject to its constraints. A *minimal surface form* is the shape of such a least area configuration [18].

It is well known that the sphere is the simplest minimal surface form: it has the least area among all deformed images subject to the constraint of enclosing the same

Fig. 2. J. E. Millais, *Bubbles*, oil on canvas, 1885. (Courtesy of A.&F. Pears Limited, London)

Fig. 3. Manet, *Les Bulles de Savon*, oil on canvas, 1867. (Museu Colouste Gulbenkian, Lisboa)

volume. Because of the effect of surface tension, soap bubbles have a spherical form containing the volume of air blown inside. Surface tension plays an important role in several physical phenomena: the rise of water in capillary tubes; the formation of sessile, pendent and rotating drops; and, of course, the geometry of soap bubbles and soap films. Many of these phenomena have been observed since ancient times, but a convenient mathematical approach capable of giving a suitable and general enough model for their behaviour has been achieved only recently using the 'minimal surface theory' [19].

Soap films and soap bubbles are used frequently as abstract minimal forms. Jean Taylor and Fred Almgren have explained the reasonableness of the least area principle in determining the structure of soap films and bubbles in their paper "The Geometry of Soap Films and Soap Bubbles" [20]. An analogous investigation was described in the mathematical segment of the movie *Soap Bubbles*, which was realized in 1979 as part of the series *Art and Mathematics* [21].

A large variety of natural phenomena exhibit what is called the minimum principle; the 'Calculus of Variations'

is the branch of mathematics that deals with these kinds of problems. Karl Menger, in his article "What is Calculus of Variations and What Are Its Applications", wrote that "the Calculus of Variations belongs to those parts of mathematics whose details it is difficult to explain to a nonmathematician. It is possible, however, to explain its main problems and to sketch its principal methods for everybody" [22].

The first person to solve a problem of Calculus of Variations seems to have been Queen Dido of Carthage:

> They landed at the place where now you see
> the citadel and high walls of new Carthage
> rising: and then they bought the land called Byrsa,
> 'The Hide', after the name of that transaction
> (they got what they were able to enclose inside
> a bull's skin) [23].

Dido cut the hide into many thin strips, put them together into one long strip, the ends of which she united. History does not describe the form of the territory she chose, but if she was a good mathematician she covered the territory in the form of a circle: of all surfaces bound by curves (in the plane) of a given length, the circle is the one of largest area.

Fig. 4. Three flat surfaces meeting along a straight line at angles of 120°, 1986. (Photo copyright © 1986 Bisignani-Emmer. Reprinted by permission.)

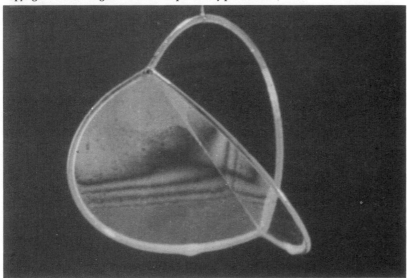

Fig. 5. Six flat surfaces meeting three along four straight line segments that meet at a vertex at angles of about 109°, 1986. (Photo copyright © 1986 Bisignani-Emmer. Reprinted by permission.)

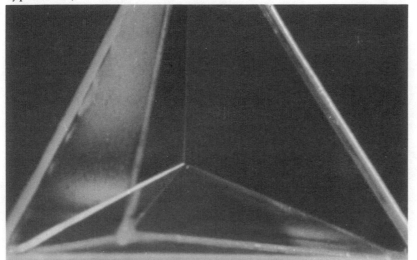

An analogous formulation of the problem is the following: to find a plane curve that surrounds a given area with the smallest length, the answer is the circumference. An analogous formulation can be given for the sphere. Thus the circle is the solution to the Plateau problem in the case of a plane curve. With soap films it is easy to obtain the result experimentally: dip a wire in the form of a circumference into the soapy water and then dip it out: the soap film will form a circle spanning into the circumference. The two examples of the circle and the sphere are only the most simple cases, but Plateau realized by numerous examples that whatever the geometric form of the closed curve (the wire), it bounds at least one soap film.

Plateau was also able to observe experimentally the rules that determine the geometry of soap bubbles and soap films:

> A compound soap bubble or a soap film spanning a wire frame consists of flat or smoothly curved surfaces smoothly joined together; the surfaces meet in only two ways: either exactly three surfaces meet along a smooth curve or six surfaces (together with four curves) meet at a vertex; when surfaces meet along curves or when curves and surfaces meet at points, they do so at equal angles. In particular, when three surfaces meet along a curve, they do so at angles of 120 degrees with respect to one another [Fig. 4], and when four curves meet at a point, they do so at angles of close to 109 degrees [Fig. 5] [24].

It is important to point out, however, that the mathematician Richard Courant, an eminent researcher on minimal surfaces, has noted:

> Empirical evidence can never establish mathematical existence—nor can the

mathematician's demand for existence be dismissed by the physicists as useless rigor. Only a mathematical existence proof can ensure that the mathematical description of a physical phenomenon is meaningful.

In fact, as recently as 1976, Jean Taylor, using the 'Geometric Measure Theory', gave the first proof of the geometric laws governing the structures of soap bubbles and soap films [25]. The techniques of both the 'Geometric Measure Theory' [26] and the 'Perimeter Theory', introduced first by the Italian mathematician Ennio De Giorgi and then by Enrico Giusti and Mario Miranda, have allowed important results to be obtained for the Plateau problem [27]. A first general result was obtained by Jessie Douglas in 1936 [28].

Nevertheless, it is Plateau's work that has made possible all these important results in mathematical research. This is how Plateau states the principle at the base of his results:

Given a surface of mean curvature zero [29], let us trace on it a closed contour subject to the following constraints: first that it circumscribes a finite part of the surface, second that this part is compatible with the stability limit if the surface has one; then consider a wire of the exact shape of the closed contour ... dip it in the liquid and then dip it out; you will find it spanned by a soap film which represents the part of surface you have considered. . . . It is possible to realize in this way, *like by an enchantment*, several surfaces, many of which are really interesting [30].

The conditions that Plateau imposes, as he himself explains, are reasonable. The first concerns the surrounding frame, the boundary, which should be such as to contain in its interior a limited part of the given surface. The second condition is also evident, in the sense that if the surface has such a limit, the surrounding frame must be compatible with it. Otherwise, the desired surface will not be obtained by dipping a wire in the soap solution; instead, another surface will be obtained.

It is clear that the procedure can then be applied to solve the most interesting problem: when the answer is not known beforehand, i. e. when the surface is not known. The wire is dipped into the soap solution and, when it is taken out, one has an idea of the solution to the problem.

Plateau used particularly complicated wires so as to demonstrate experimentally that it is always possible to find a surface that is a solution for any wire, and also to observe the fact, far less intuitive, that there can be more than one solution for a particular problem. In addition, he wanted to verify that, however complex the resulting surfaces were, the films always intersected according to the laws that he had established for the geometry of soap bubbles and films.

One of the experiments that Plateau carried out involved a wire in the shape of the skeleton of a cube. By dipping it into the soapy water and extracting it, one obtained a system of films that intersected at angles of 120 and 109 degrees (Color Plate L No. 1). The films stood on segments that formed the edges of the cube and intersected at the center

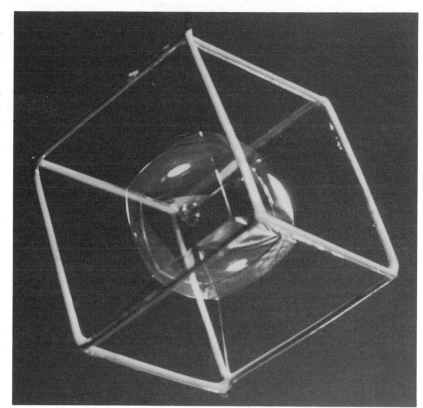

Fig. 6. Soapy hypercube, 1986. (Photo copyright © 1986 Bisignani-Emmer. Reprinted by permission.)

in a square-shaped film (which is always parallel to one of the faces of the cube). The sides of the square film at the center are in fact curved. If they were straight, they would give rise to angles that would contradict Plateau's rules. Observing the results, Plateau could not help adding:

The system of films obtained in this way has aroused the admiration of everyone to whom I have demonstrated it; the films are in fact perfectly regular, the corners that they form are of a *finesse extrême* and moreover after a short time the films are covered with dazzling colours.

The wires that Plateau used subsequently were in the shape of a tetrahedron, a triangular prism and an octahedron. What interested him most of all was that in every case he tried, there were no exceptions to the rules. As mentioned previously, when one washes dishes, a large number of soap films are formed. A similar thing happens in the foam on beer. On this subject Plateau observed:

The foam that forms on various liquids, such as champagne (!), beer, soapy water when it is shaken up, is an agglomeration of films composed of a large number of intersecting surfaces which enclose small quantities of gas; as a result, even though everything seems to be at random, such foam must obey the same laws.

To verify this, Plateau suggested dipping the tip of a straw into the liquid and blowing continuously so as to produce a large quantity of bubbles: "One obtains, as *do the children with soapy water*, the formation of a structure that is very similar to foam."

Among other experiments that Plateau conducted, some gave *"des résultats très jolis"*. For instance, by dipping the cubic frame into soapy water, one obtains the structure described above; when the wire is dipped again so as to trap an air

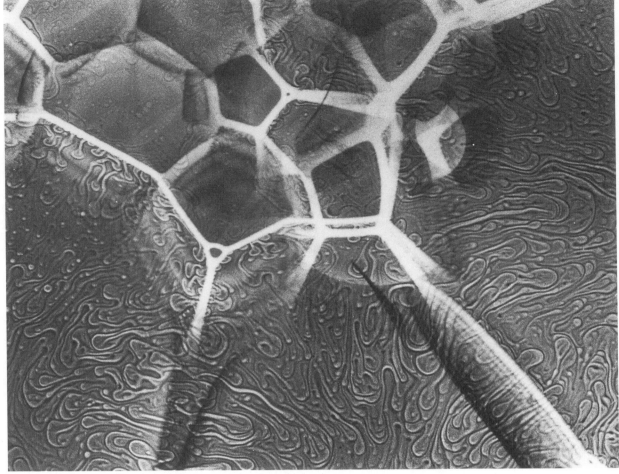

Fig. 7. B. Miller, *Soap Bubbles*, photograph, 1979. (Photo copyright © 1979 B. Miller. Reprinted by permission.)

bubble in the film structure, this additional bubble positions itself at the center of the structure, thus creating a cube of film with slightly curved faces (Fig. 6) [31].

SOAP BUBBLES AND CONTEMPORARY ART

As far as I know, Plateau's experiments did not attract the attention of contemporary artists. It is clear that Plateau's book, being one of scientific research, was not widely known beyond the narrow circle of scientists interested in problems of that type. However, toward the end of the nineteenth century, several scientists, including the afore-mentioned Lord Kelvin, held conferences on the geometry of soap bubbles. The series of conferences that attracted the most attention, in part because a book was published immediately afterward, was given by Vernon Boys [32].

Thanks to Boys's publication, soap bubbles have become a classic of scientific divulgation, while still remaining one of the most interesting fields of modern mathematics. In toy shops nowadays one can find quite complicated devices for making soap bubbles, including ones that even repeat some of Plateau's experiments.

With the development of photographic and cinematographic techniques, artists too have become interested not merely in simple bubbles but in the complexity of their geometry. The Italian painter Luisa De Giuli has studied their chromatic properties closely, starting with photographs of groups of bubbles and conducting a type of scientific investigation into their shape and colours, using techniques involving different materials such as sand, glue and plaster to realize her own artistic work.

Bradley R. Miller began to be interested in soap bubbles while he was doing his thesis as an art student: "Of all the 'close packing' systems, soap bubbles are the easiest to create and the most beautiful. Their beauty is a function of their random nature" [33]. Miller introduced a special technique for photographing the structure of soap films. It might seem that photography would not give much choice to an artist, but Miller's work makes it clear that this is not so. Even though he does not use colour, he gets results that are impressive and that demonstrate clearly the structure of soap films (Fig. 7).

Some of the phenomena regarding soap bubbles take place in a very short time. Slow-motion cinematographic techniques are useful to show what is happening. One can show the formation of film structures, their composition and the appearance of luminous fringes. In many cases, the images obtained go beyond their mere scientific interest to become, in a sense, works of art. It is significant that a film entitled *Soap Bubbles* [34] was presented at the 1986 Biennale of Art of Venice [35]. One of the first holographic movies, *Christiane et les holobulles* (1986), shows a girl making soap bubbles [36].

Soap Bubbles Linking Art and Science: The Future

The parallel history of soap bubbles in art and science is a story that began long ago and still continues. As far as science is concerned, and mathematics in particular, soap bubbles pose interesting problems that have yet to be solved. In respect to art, has their interest been exhausted? Can we still expect anything new? In my opinion, the answer is yes. In fact, this new role of minimal surfaces has already begun. It is often said that the art of the future can only depend on new technologies, computer graphics in particular. In recent years, thanks to the ever-increasing sophistication of computer graphics, a new sector of mathematics has developed. It could be called 'Visual Mathematics'.

In considering the problems in which visualization plays an important role, mathematicians have obtained images whose aesthetic appeal has also concerned people who are not strictly interested in the scientific questions that originated them. It is enough to think of the computer-animated images of the hypercube produced by Thomas Banchoff and Charles Strauss. A short segment of their film was presented at the 1986 Biennale of Venice in the section of 'Space' in the room dedicated to the fourth dimension [37]. Or one could think of the fascinating images of fractals and Julia sets [38]. It is not too hazardous to talk of the beginning of a 'Math Art'.

For minimal surfaces, interesting results have also been obtained using computer graphics. One can even say that the soap of the future for producing minimal surfaces is computer graphics. In fact, thanks to this new tool, it has been possible not only to obtain a visualization of the minimal surfaces already known, but also to generate images of minimal surfaces that cannot be obtained with soapy water, and, even more interesting from the point of view of scientific research, to 'see' new surfaces whose shapes were previously unknown. It thus has been possible to solve open problems in the theory of minimal surfaces; and, not a secondary result, the generated images have shown an impressive 'aesthetic' impact. In a way, the images have a sort of double life—artistic and scientific—and the two aspects are not separable.

Until 1982, only three complete, embedded minimal surfaces of finite topology were known—'complete' meaning more or less with no boundaries and 'embedded' meaning that the surfaces do not fold back and intersect themselves. The three known surfaces were the plane, the catenoid and the helicoid.

Surfaces can be classified according to their topology, where two surfaces have the same topology if they can be twisted, stretched or deformed in such a way as to convert one form to the other without tearing, cutting or gluing the surface. It can be shown that the plane has the same topology as a sphere with one hole (the hole could be infinitely widened and the surface flattened out). The same can be shown for the helicoid. The catenoid can be deformed in a sphere with two holes. All surfaces topologically equivalent to a sphere are called of genus zero. If one takes a sphere and puts a handle on it, one obtains a surface of genus one. A torus (doughnut) is a surface of this type, while a pretzel is a surface of genus two. Thus the only known complete embedded minimal surfaces with finite topology were all of genus zero.

In 1982, the Brazilian mathematician Celso Costa published an example of a surface that was minimal [39]. David

A. Hoffman and William H. Meeks III, by considering the equations obtained by Costa and with the help of the graphics programming of James T. Hoffman, were able to 'see' the surface on their video terminal and convince themselves that the surface was free of self-intersections and therefore embedded (Color Plate L No. 2). Then David Hoffman and Meeks were able to obtain a formal mathematical proof (remember Courant) of the topological property of the surface. David Hoffman has said, "This collaboration of art and science produced something significant to both fields" [40]. In fact, apart from the obvious interest in mathematics, the computer-generated images obtained by Hoffman, Meeks and Hoffman at the University of Massachusetts are so 'beautiful' that an exhibition based on them was organized in 1986 by the National Academy of Sciences in Washington with the title "Getting to the Surface". The exhibition's presentation starts with the words: "Remember what great fun it was, when you were a kid, to fool around with a bucket of soapy water and a circular piece of wire? You dipped the wire in the bucket, then pulled it out...." A never ending story! [41]

References and Notes

1. M. Emmer, *Bolle di sapone: un viaggio tra arte, scienza e fantasia* (Florence: La Nuova Italia editrice, 1991); see also M. Emmer, "Des bulles aux Radiolaires: une brève histoire entre art et science", *Alliage* 13 (1992) pp. 78–87.

2. See H. Berthoud, "Les petites chroniques de la science", Année 1866, Paris, p. 265. Quotations from Berthoud's paper can be found in J. Plateau, *Statique expérimentals et théorique des liquides soumis aux seules forces moléculaires* (Paris: Gauthier-Villars, 1873). All quotations by other authors, unless otherwise noted, are from this work by Plateau.

3. J. C.C. Nitsche, *Vor Lenscungen über Minimal Flächen* (Berlin: Springer-Verlag, 1975) p. 8.

4. A. Schaaf, "Introduction à la morphologie évolutive: une application à la classe des Radiolaires", *N. Jb. Geol Paläont. Abh.* 161 (1981) pp. 209–253.

5. D'Arcy W. Thompson, *On Growth and Form*, 2nd Ed. (Cambridge: Cambridge Univ. Press, 1942).

6. Sir C. W. Thomson and J. Murray, eds., "Report on the Scientific Results of the Voyage of the H. M. S. Challenger during the Years 1873–1876" (Edinburgh: Adams & Charles Black, 1887); *Zoology* 18, Tables.

7. Plateau [2].

8. Actually, the painting is in the Rijksmuseum-Stichting in Amsterdam.

9. W. Stechow, "Homo Bulla", *Art Bulletin* 20 (1938) pp. 227–228.

10. H. W. Janson, "The Putto with the Death's Head", *Art Bulletin* 19 (1937) pp. 423–430.

11. S. Alpers, *The Art of Describing: Dutch Art in the Seventeenth Century* (Chicago, IL: Univ. of Chicago Press, 1983).

12. I. Newton, *Opticks or a Treatise of the Reflections, Refractions, Inflections and Colour of Light*, D. H. D. Rolle, ed. (New York: Dover, 1979) pp. 214–224.

13. P. Rosenberg, *Chardin 1699–1779*, exh. cat. (Paris: Edit. de la Réunion des Musées Nationaux, 1979) p. 206.

14. A. C. Hanson, *Manet and the Modern Tradition* (New Haven, CT: Yale Univ. Press, 1977) pp. 69–70.

15. G. Mauner, *Manet peintre-philosophe. A Study of the Painter's Themes* (University Park, PA: Pennsylvania State Univ. Press, 1975).

16. C. Blanc, *Histoires des peintres de toutes les ecoles: Ecole Hollandaise* (Paris: Librairie Renonard, 1876).

17. F. Cachin, "Les Bulles de Savon", in *Manet 1832–1883*, exh. cat. (Paris: Edit. de la Réunion des Musées Nationaux, 1983) pp. 268–269.

18. F. J. Almgren, Jr., "Minimal Surface Forms", *The Mathematical Intelligencer* 4, No. 4, 164–172 (1982).

19. R. Finn, *Equilibrium Capillary Surfaces* (Berlin: Springer-Verlag, 1986).

20. F. J. Almgren and J. E. Taylor, "The Geometry of Soap Films and Soap Bubbles", *Scientific American* (July 1976) pp. 82–93.

21. M. Emmer, *Soap Bubbles*, film, 16 mm, 27 min, series *Art and Mathematics*, (Rome: FILM 7, 1979). *Soap Bubbles* was realized at Princeton University with the assistance of Fred Almgren and Jean Taylor of the Mathematics Department.

22. K. Menger, "What is Calculus of Variations and What Are Its Applications", in *The World of Mathematics,* J. R. Newman, ed. (New York: Simon & Schuster, 1956) pp. 886–890.

23. Publius Vergilius Maro, *Aeneid,* A. Mandelbaum, trans. (New York: Bantam Books, 1981) Book 1, pp. 517–522.

24. Almgren and Taylor [20] p. 82.

25. J. E. Taylor, "The Structure of Singularities in Soap-bubbles-like and Soap-film-like Minimal Surfaces", *Annals of Mathematics* **103** (1976) pp. 489–539.

26. See H. Faderer, *Geometric Measure Theory* (Berlin: Springer-Verlag, 1969); and F. J. Almgren, Jr., *Plateau's Problem: An Invitation to Varifold Geometry* (New York: A. Benjamin, 1966), and *The Theory of Varifolds—A Variational Calculus in the Large for K-Dimensional Area Integrand* (Princeton, NJ: Notes, 1965).

27. See E. De Giorgi, F. Colombini and L. C. Piccinini, *Frontiere orientate di misura minima e questioni collegate* (Pisa: Scuola Normale Superiore, 1972); E. Giusti, *Minimal Surfaces and Functions of Bounded Variations* (Boston: Birkäuser, 1984); and G. Anzellotti, M. Giaquinta, U. Massari, G. Modica and L. Pepe, *Note sul problema di Plateau* (Pisa: Editrice tecnico scientifica, 1974).

28. J. Douglas, "Solution of the Problem of Plateau", *Trans. of the Amer. Math. Soc.* **33** (1931) pp. 263–321. Douglas received the Field Medal for his work. In 1974, Enrico Bombieri received the same award also for his work on minimal surfaces.

29. In order to define the mean curvature of a surface let us consider all normal sections passing through a fixed point P on the surface. Then it is possible to prove that there exist two special sections with curvature H_1 and H_2 such that H_1 is the largest and H_2 the smallest curvature that a normal section at the point P can have. The mean curvature is the arithmetic average of the two curvatures H_1 and H_2, that is

$$H = \frac{H_1 + H_2}{2}.$$

At each regular point, a minimal surface must have mean curvature zero. This result was proved by Lagrange and extended by Meusnier in 1776. So the minimal surfaces satisfy the equation

$$H = 0.$$

30. Plateau [2] pp. 213–214.

31. Three pictures of this cubic structure with the title *Soapy Hypercube* were shown at Hypergraphics '87, at Rhode Island College, Providence, RI, May 1987.

32. C. V. Boys, *Soap Bubbles: Their Colours and the Forces Which Mold Them,* reprinted from the original 1911 edition (New York: Dover, 1959).

33. B. Miller, *Close Packing and Cracking* (Los Angeles, CA: Craft and Folk Art Museum, 1978).

34. Emmer [21]; see also M. Emmer, "Lo spazio tra matematica ed arte", in *Arte e Scienza: Spazio,* G. Macchi, ed., exh. cat., Biennale of Venice (Venice: Edizioni la Biennale, 1986) pp. 37–39,72.

35. R. Ascott, ed., *Tecnologia e informatica,* exh. cat., Biennale of Venice (Venice: Edizioni la Biennale, 1986) p. 83.

36. J. Stoll, ed., *Aux frontières du Reel: holographie, art et technique* (Mulhouse: CESTIM-Musée des Beaux-Arts, 1986) p. 37, n. T63. The film was produced by P. Smigielski, H. Fagot, F. Albe, 40 sec.

37. See *Arte e Scienza: Spazio* [34] p. 72.

38. H.-O. Peitgen and P. H. Richter, *The Beauty of Fractals* (Berlin: Springer-Verlag, 1986); B. B. Mandelbrot, *Fractals: Form, Chance and Dimension* (San Francisco: Freeman, 1977); and S. Ushiki, "Chaotic Phenomena and Fractal Objects in Numerical Analysis", *Studies in Math. and Its Applications* **18**, (1986) pp. 221–258.

39. C. Costa, "Imersoes minimas completas em R^3 de genero um e curvatura total finita", Doctoral Thesis, Rio de Janeiro, IMPA, 1982.

40. See D. Hoffman, "Embedded Minimal Surfaces, Computer Graphics and Elliptic Functions," in *Global Differential Geometry and Global Analysis,* A. Dold and B. Eckmand, eds. (Berlin: Springer-Verlag, 1986) pp. 204–215; see also J. Hooper, "Math-Art", *Omni Magazine* (April 1986) pp. 88–91.

41. See Emmer [1].

PART III

Symmetry

Symmetry is a simple concept that has a lot of meaning, even for the person on the street. It is a fundamental concept in science—it is present not only in basic equations, models and theories, but it is also capable of uniquely connecting seemingly far-away domains of our knowledge. When we speak of symmetry we do not always consider its presence but often refer to the lack of it or, rather, the absence of some of its elements. The concept of symmetry has been visible from time immemorial in human endeavor, and during the past few decades its role has been further enhanced. In physics, the lack of parity in the world of elementary particles was discovered in 1957. The mid-1960s witnessed the emergence of symmetry rules for chemical reactions, and, in material science, symmetry considerations played a pivotal role in the discoveries of quasicrystals and buckminsterfullerenes during the mid-1980s.

One of the most practical applications of symmetry is tiling—the seemingly endless repetition of some basic motifs following some rules, simple or sophisticated, to cover an entire available surface. When covering a surface with tiling, symmetry tools are two-dimensional space groups. Table 1 shows a simple system of classification [1,2].

Tilings can be used to decorate walls or textiles or to investigate properties of geometrical shapes. Islamic and Moorish arts have fascinated people for centuries with their intricate patterns. Branko Grünbaum and G. C. Shephard investigated Islamic and Moorish interlace patterns and found that most of them are formed by strands of a small number of shapes. A wealth of patterns is then created by the economical power of symmetry. Repetition by symmetry operations is utilized. Grünbaum and Shephard provide a simple explanation for the creation of complicated interlaces.

A few artists have displayed some interest in the curious ways of tiling a surface by a single motif or by only a few motifs of interesting shapes, without gaps and overlaps. The most famous of these artists was the Dutch graphic artist M. C. Escher (1898–1972). Doris Schattschneider researched and described the development of Escher's own theory of tiling and his classification system in a fascinating book [3]. Her chapter in this volume demonstrates the problems of tiling (there is now a 'tiling industry' in mathematics that is showing phenomenal growth).

Table 1. Dimensionality (m) and Periodicity (n) of Symmetry Groups G_n^m

Periodicity ⟶ Dimensionality ↓	$n = 0$ No Periodicity	$n = 1$ Periodicity in One Direction	$n = 2$ Periodicity in Two Directions	$n = 3$ Periodicity in Three Directions
$m = 0$ Dimensionless	G_0^0			
$m = 1$ One-Dimensional	G_0^1	G_1^1		
$m = 2$ Two-Dimensional	G_0^2	G_1^2	G_2^2	
$m = 3$ Three-Dimensional	G_0^3	G_1^3	G_2^3	G_3^3

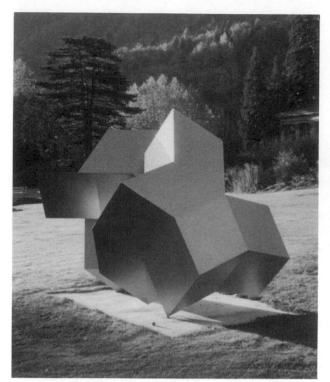

Fig. 1. Peter Hächler, metal sculpture (Lenzburg, Switzerland).

Fig. 2. Werner Witschi, elongated tetrahedron moiré sculpture (Bolligen, Switzerland).

Tiling fittingly lends itself to computerization, as is shown in Silvio Levy's description of the automatic generation of hyperbolic tilings. Also in this section, Goffredo Haus and Paolo Morini describe a system they created for animated tessellations. They utilize the organic relationships between music and the visual arts and create computer-programmed translations from graphic tessellations to music.

Hyperbolic tiling returns in J. F. Rigby's coloring exercises. The introduction of coloring into symmetry considerations, of course, opens new dimensions. The simplest case occurs with color reversal, e.g. a change from black to white, accompanying a reflection. For a more complicated example, consider Rubik's cube, which in complete darkness feels as if it possesses all the symmetries of a regular cube. When visible, however, the Rubik cube has no symmetry at all—even in its unscrambled state—due to its differently colored faces, unless the color changes accompanying a rotation or a reflection are built into the symmetry operations. Rigby describes not only the coloring of tilings but of three-dimensional bodies as well, such as a regular icosahedron.

Loreto, Farinato and Tonetti describe a sophisticated multi-window computer-graphics program system for illustrating and explaining two-dimensional crystallography by means of examples. Their versatile, interactive and user-friendly graphics not only aided the construction of patterns but facilitated their own investigation as well. I would like to stress the didactic/pedagogical value of their approach.

Regarding art and mathematics, symmetry is possibly the simplest and most elegant connection between them. It may be manifested in more than one way. The uncompromising rigor of geometrical symmetry can be present, as well as harmony and proportion. The interaction may also appear in many different ways, for example, it may be intuitive, recreational or economical, to name a few. It is possible that entertaining 'doodles' led mathematical physicist Roger Penrose [4] to the creation of the Penrose tiling consisting of a nonperiodic pattern of five-fold symmetry. Crystallographer Alan L. Mackay [5] then extended these considerations into the third dimension. Finally, what we know today as quasicrystals were discovered with Dan

Shechtman's electron diffraction experiment in 1982 [6]. The above description is an oversimplification but gives a feeling of the process of moving from doodles to a discovery via symmetry considerations. I attended the First Interdisciplinary Conference on Art and Mathematics (AM '92), organized by mathematician and sculptor Nat Friedman at the State University of New York at Albany. The quasicrystal topic seemed to be very much on the mind of sculptors—several showed related work, and all of them seemed to be aware of its importance. A couple of years earlier I found a sculpture (Fig. 1) that could have also been modelled after a quasicrystal [7], although it was not. Sculptor Peter Hächler of Lenzburg, Switzerland, had never heard of quasicrystals or of regular nonperiodic tilings. It may be far-fetched, but the progress of the sciences and the arts may have some parallels, and recently we are witnessing the reemergence of the importance of geometry in both.

Another example of the relationship between art and mathematics of a different nature is found in the moiré phenomenon, based on purely geometrical principles. According to the Swiss mathematician Hans Giger [8], its aesthetic delight comes from creating visible order out of unobserved order and even out of chaos. The moiré pattern produced by two fabrics pressed together or by two railings appearing nearly eclipsed when viewed from a distance register merely as physical phenomena whose mathematical description is well understood. Truly artistic moirés have added dimensions—they are artifacts beyond simple sculpture due to their added elements of painting, graphics or even music [9]. These works require mobility—the object itself is mobile or the spectator must move around for full appreciation—and through mobility an element of time is often involved as well. The possibility of rigorous mathematical treatment does not diminish the aesthetic pleasure that we can derive, for example, from the Swiss sculptor Werner Witschi's moiré sculptures (Fig. 2).

ISTVÁN HARGITTAI
Leonardo Editorial Advisor, Chemist
Budapest Technical University and Hungarian Academy of Sciences
H-1521 Budapest
Hungary

References

1. W. Engelhardt, *Mathematischer Unterricht* **9**, No. 2 (1963) p. 49.

2. I. Hargittai and M. Hargittai, *Symmetry through the Eyes of a Chemist* (New York: VCH Weinheim, 1989).

3. D. Schattschneider, *Visions of Symmetry: Notebooks, Periodic Drawings and Related Work of M. C. Escher* (New York: Freeman, 1990).

4. R. Penrose, "Pentaplexity: A Class of Non-Periodic Tilings of the Plane", *The Mathematical Intelligencer* **2** (1979/1980) pp. 32–37. This paper originally appeared in *Eureka* **39**. The paper was recently reproduced in *Periodico di Mineralogia* **59** (1990) pp. 95–100.

5. A. L. Mackay, "Crystallography and the Penrose Pattern", *Physica* **114A** (1982) pp. 609–613.

6. D. Schectman, I. Blech, D. Gratias and J. W. Cahn, "Metallic Phase with Long-Range Orientational Order and No Translational Symmetry", *Phys. Rev. Lett.* **53** (1984) pp. 1951–1953.

7. I. Hargittai, "Quasicrystal Sculpture in Bad Ragaz", *The Mathematical Intelligencer* **14**, No. 3 (1991) p. 58.

8. H. Giger, "Moirés", in I. Hargittai, ed., *Symmetry: Unifying Human Understanding* (New York: Pergamon Press, 1986) pp. 329–361.

9. W. Witschi, "Moirés", in I. Hargittai, ed., *Symmetry: Unifying Human Understanding* (New York: Pergamon Press, 1986) pp. 363–378.

Interlace Patterns in Islamic and Moorish Art

*Branko Grünbaum and
G. C. Shephard*

Interlace patterns occur frequently in the ornaments of various cultures, especially in Islamic and Moorish art. By *interlace pattern* we mean a periodic pattern that appears to consist of interwoven *strands* (see Figs 1 and 2). (The exact meaning of the term 'periodic pattern' will be explained later.) The largest published collection of interlace patterns is that of J. Bourgoin [1]; more precisely, the majority of Bourgoin's diagrams can be interpreted as representing such patterns, and it appears that they were, in fact, created with interlace patterns as originals. Other examples can be found in works by d'Avennes, El Said and Parman, Wade, and Humbert [2–5]. A number of authors have relied on the Bourgoin drawings in their research; for example, they have been used by Makovicky and Makovicky in their analysis of the frequencies with which various classes of symmetry groups are represented in Islamic patterns [6].

This article has three main goals. First, we will observe that most of the interlace patterns shown by Bourgoin consist either of identical (congruent) strands or of two shapes of strands. This is unexpected because in many cases the strand patterns are very complicated—some of them are so intricately interwoven that a repeat is unlikely to have been visible in any actual ornament.

The complications of an interlace pattern can be measured in several ways—for example, by the number of different shapes of strands or by the number of crossings in a repeat. Our second aim is to relate these measures to the symmetry properties of the pattern. The results that we obtain lead to our third goal: a plausible explanation of the frequent appearance of interlace patterns consisting of strands of a single shape or of just two different shapes in Islamic art.

BACKGROUND EXPLANATIONS

Two of Bourgoin's diagrams appear in Figs 1a and 2a. It can be observed in each of these diagrams that pairs of lines appear to *cross* at various points, but in no case do three or more lines pass through the same point. In the following discussion we shall restrict our attention to those drawings for which this condition holds—as it does in nearly 85% of Bourgoin's diagrams. By interpreting the lines as strands of small but positive width, we can obtain an interlace pattern by assigning an ordering of the strands at each crossing point—in other words by specifying which strand is *uppermost* or 'passes over' the other strand. (In the type of interlace pattern known as a 'fabric', multiple crossings are

ABSTRACT

Repetitive interlace patterns are one of the hallmarks of Islamic and Moorish art. Through the study of various collections of such patterns, it is easy to verify that, despite the considerable complexity of the designs, most of the interlaces are formed by strands of a small number of shapes—often just a single shape stretching over many repeats of the design. This observation is described and documented by the authors, who present a simple explanation for this phenomenon.

Branko Grünbaum (mathematician), University of Washington, Seattle, WA, U.S.A.

G. C. Shephard (mathematician), University of East Anglia, Norwich NR4 7TJ, United Kingdom.

Fig. 1. (a, left) An often-used Islamic ornamental pattern, taken from Bourgoin [18]. It is the design from which the two interlace patterns shown in (b, center) and (c, right) can be obtained. The strands in these interlace patterns are unbounded, and all are congruent. The two interlace patterns differ only in the way the strands cross; at corresponding crossings, the strand that is on top in one pattern is on bottom in the other. In each of the two interlace patterns, all strands play equivalent roles under symmetries of the interlace pattern.

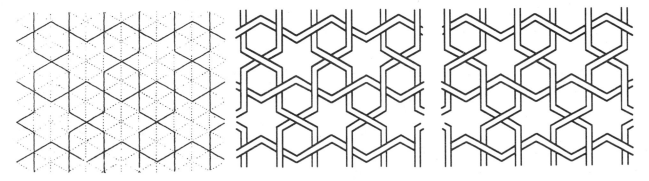

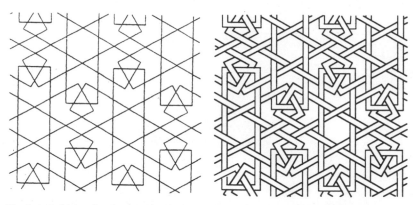

Fig. 2. (a, left) Another frequent Islamic ornamental pattern, from Bourgoin [19]. (b, right) One of the two interlace patterns that can be obtained from the design in (a). Here the strands are bounded (that is, they are closed loops); all strands are equivalent under symmetries of the interlace pattern.

sometimes admitted [7], but we shall not consider this possibility here.)

In the overwhelming majority of interlace patterns occurring in actual ornaments, the strands weave alternately under and over each other [8]. Therefore we shall also restrict our attention to interlace patterns with this property. It follows that the specification for which strand is uppermost at just one crossing point determines the ordering of the two strands at all others. Thus a diagram such as Fig. 1a represents two interlace patterns according to the choice at one crossing point, as shown in Figs 1b and 1c. A simple argument shows that, for the kinds of patterns under consideration, once the ordering at one crossing point has been chosen, the ordering at every other crossing point can be assigned in a consistent manner, that is, so that every strand weaves alternately over and under each of the strands it meets. One consequence is that Bourgoin's diagrams, though not directly showing interlace patterns, determine them uniquely, apart from the possibility of interchanging all the under- and over-crossings. Any such diagram will be called a *design* for the interlace pattern. Note that all the properties of an interlace pattern can be deduced from its

design; from now on we shall be concerned almost exclusively with investigating the designs rather than with the interlace patterns themselves. Since the strands in interlace patterns do not have ends, they must be either unbounded (as in Fig. 1) or closed loops (as in Fig. 2), or a mixture of both.

Now imagine the design for an interlace pattern as being unbounded, that is, extending arbitrarily far in every direction. By a *symmetry* of a design we mean any rigid motion that maps the design onto itself. Every rigid motion, other than the identity, is of one of four kinds: a translation, rotation, reflection or glide-reflection. Each of the patterns, and therefore each of the designs that we are considering, is *periodic*. This means that the design possesses at least two independent (nonparallel) translations as symmetries. It also means that a part of the design in the shape of a parallelogram is repeated over and over again, these parallelogram-shaped patches fitting together edge to edge so as to cover the whole plane. For the designs shown in Fig. 3, the parallelograms are indicated by heavy lines. If such a parallelogram is chosen to be as small as possible, it is referred to as a *translational repeating unit* for the design under consideration [9].

The set of all symmetries of a periodic design, with the usual method of composition, forms what is known as a *crystallographic* or *wallpaper group*; these are of 17 kinds [10,11]. It is easily verified that many of the designs of interlace patterns illustrated in Bourgoin's book have wallpaper groups of one of two types, usually designated by their crystallographic symbols *p4m* and *p6m*. In Fig. 3a,b we illustrate these two kinds of symmetry groups. It is clearly impossible to indicate all the symmetries in these figures, but we show all the lines of reflection (mirrors) that, as can be seen in Fig. 3, cut the plane into congruent triangles. The representation is adequate since every symmetry in either group can be expressed as a product (composition) of a finite

Fig. 3. Two designs of interlace patterns, redrawn after Bourgoin [20]. In each we show by dashed lines mirrors for reflections in the symmetry group of the design. The symmetry group of the design in (a, left) is *p4m* and of that in (b, right) is *p6m*. A translational repeating unit (parallelogram) for each symmetry group is indicated in heavy lines.

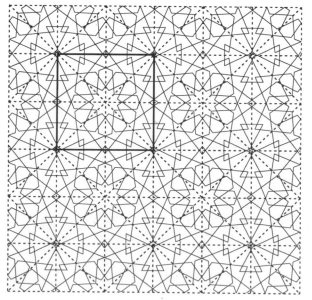
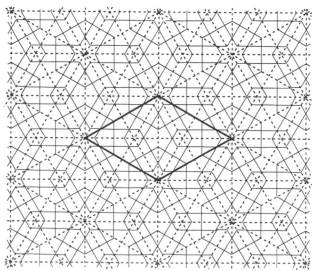

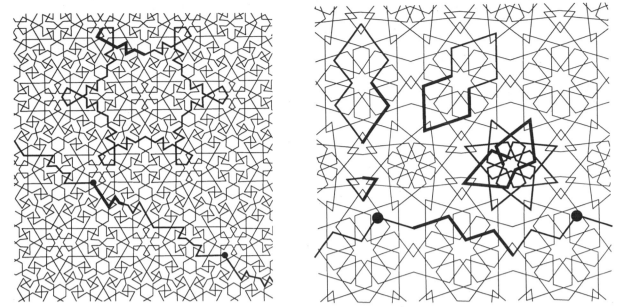

Fig. 4. Designs of interlace patterns, redrawn after Bourgoin [21]. The heavily drawn lines emphasize various strands. The thickened parts show a fundamental region for each of the strands, with respect to the induced group. In the case of unbounded strands, the portion between the heavy dots is a transitional repeating unit.

number of reflections. For this reason, the groups *p4m* and *p6m* are said to be *generated by reflections*. Moreover, each such triangle is a *fundamental region* for the group, which simply means that, once the part of the design in one triangle is known, then the whole design can be constructed by simply copying this into each of the other triangles in an appropriate manner, as in a kaleidoscope. This is clearly shown in both parts of Fig. 3, where it will also be seen that a translational repeating unit can be built up from the triangles, eight in the case of *p4m* and 12 in the case of *p6m*.

It is possible to construct fundamental regions for each of the other 15 kinds of crystallographic groups (although not all of them can be chosen to be triangles), but the details are more complicated, and as the groups *p4m* and *p6m* are by far the most common (about 75% of Bourgoin's designs have these symmetry groups) we shall restrict attention to them here. The reader is invited to investigate the other cases by suitable modifications of the steps explained below.

We shall also be concerned with the symmetries of a design that map a strand *S* (or, more precisely, the representation of *S* in the design) onto itself. These form what is known as the *induced group* of the strand *S*. If a strand is bounded, then its induced group must either be a *cyclic group cn* of order *n*, or a *dihedral group dn* of order 2*n*, where *n* = 1, 2, 3, 4 or 6. If a strand is unbounded, then its induced group must be one of seven kinds (known as *strip* or *frieze groups*) [12]. The distinction between the induced group of a strand and its symmetry group is illustrated in Fig. 4b. The 'rosette' by itself has symmetry group *d8*, but its induced group is *d2*. Of the two heavily drawn congruent octagonal strands in the upper part of Fig. 4b, one has induced group *d2*, and the other *c2*. Concerning strands, in each case there are direct analogues of the terms 'translational repeating unit' and 'fundamental region'. A *fundamental region* of the strand is the smallest part of a strand that can be used to build up the whole strand by application of operations in the induced group. In Fig. 4 the fundamental regions of a number of strands are indicated by thickened lines. A *translational repeating unit* of a strand is the smallest part of a strand that can be used to build up the whole strand using only transla-

tions in the induced group. In Fig. 4, limits of translational repeating units are indicated by large dots. For a bounded strand, the translational repeating unit is the strand itself.

Systematically tracing the strands in the design of an interlace pattern and examining their shapes is often not easy. In many cases Bourgoin's figures do not show a sufficiently large 'patch' of the design for a complete bounded strand, or a translational repeating unit of an unbounded strand, to be shown. It is of course possible to make copies of each of Bourgoin's diagrams and carefully paste several of them together to obtain a sufficiently large patch of the design. If this is done, then we can see the complicated shapes in which a strand can occur (see Fig. 5), and also the large number of crossings involved—as many as 138 for the looped strands (Fig. 5a) and 120 for each translational repeating unit of an unbounded strand (Fig. 5b). These numbers also give a measure of the intricacy of the patterns.

In addition to the symmetry groups of the designs, another method of classification is by the number of *shapes* in which the strands occur, as well as the induced group of each shape. We shall say that two strands are of the *same shape* if there exists a symmetry of the design which maps one onto the other. If the strands are of *n* different shapes then we call it an *n-strand pattern*. (In cases such as the octagonal strands in Fig. 4b, or Bourgoin's Figs 134 and 135, two strands may be congruent, but if there is no symmetry of the design that maps one onto the other, then we consider them as being of different shapes.) It is a surprise to observe that, in spite of the complicated structure of many of the designs, in most of them the number of different shapes of strands is very small. Out of the 169 diagrams shown in Bourgoin that can be interpreted as designs of interlace patterns, 44 are 1-strand patterns, 61 are 2-strand patterns, and only 40 are *n*-strand patterns with *n* ≥ 3.

Below we shall explain how (in the two cases under consideration, namely where the symmetry group of the design is *p4m* or *p6m*) it is possible to determine the number of different shapes of strands, their groups and the number of crossings by looking at the triangular fundamental region for the symmetry group of the design. Similar considera-

149

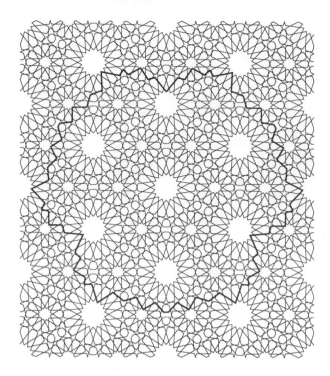

Fig. 5. Designs of 1-strand interlace patterns, redrawn after Bourgoin [22]; one strand in each is emphasized by heavy line. The looped strand in (a, left) crosses other strands 138 times, and each translational repeating unit in (b, right) (the portion of the strand between the heavy dots) crosses other strands 120 times. The large number of crossings indicates the complexity of these interlace patterns.

tions apply to the other 15 symmetry groups, but we shall not discuss these here. The reader is again invited to investigate them independently.

THE GROUPS *p4m* AND *p6m* AND THEIR CAYLEY DIAGRAMS

Before we explain the procedures involved, it is necessary to recall some of the properties of the groups *p4m* and *p6m*. In Fig. 6a we show the arrangement of mirrors in the group *p4m* (compare to Fig. 3a); a fundamental region is shaded [13]. The mirrors forming the sides of this fundamental region are labelled *a, b, c,* and we shall use these same letters, with no danger of confusion, for reflections in the corresponding mirrors. As each reflection is of period 2 we have

$$a^2 = b^2 = c^2 = e \tag{1}$$

where *e* is the group identity. The product *ab* is a rotation about the vertex *C* through angle $\pi/4$, the product *bc* is a rotation about *A* through angle $\pi/4$, and the product *ca* is a rotation about *B* through angle $\pi/2$. We deduce that:

$$(ab)^4 = (bc)^4 = (ac)^2 = e. \tag{2}$$

It is well known that (1) and (2) form a complete set of relations for the group *p4m* in the sense that every algebraic relation between the elements *a, b* and *c* can be deduced from these six. Although this is theoretically true, it is not always easy to perform the necessary algebraic manipulations, as we can show by an example. We wonder how long it would take the reader to deduce, using relations (1) and (2) only, that

$$(c\,a\,b\,a\,b\,c\,b\,c\,b\,a\,b\,a)^4 \tag{3}$$

is equal to the identity! We shall now show that manipulations of this kind can be performed very easily using a *Cayley diagram* for the group. For the group *p4m*, part of the Cayley diagram is shown in Fig. 6b. It appears as a tiling of the plane by squares and regular octagons; however, it is the edges that chiefly interest us. These have been labelled *a, b* and *c,* and

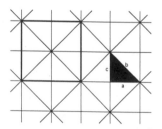

a

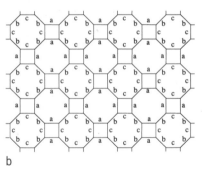

b

Fig. 6. Diagrams illustrating [in (a) and (c)] the concepts of fundamental region (shaded) and translational repeating unit (heavily drawn parallelogram), and [in (b) and (d)] the concept of Cayley diagram; parts (a) and (b) concern the group *p4m*, parts (c) and (d) the group *p6m*.

d

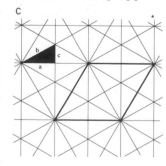

c

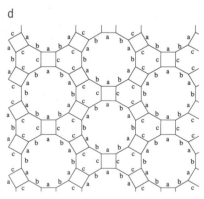

150

it will be observed that one edge of each type is incident with each vertex. Moreover, if we go round the sides of one of the squares we get $acac = (ac)^2$, which, by (2), is the identity e. As we go round each of the two kinds of octagons we get, in a similar manner, $abababab = (ab)^4$ and $bcbcbcbc = (bc)^4$, both of which are equal to the identity. Thus the algebraic identities (2) are represented in the Cayley diagram by circuits (closed paths). In fact, every circuit in the Cayley diagram represents a product of reflections a, b, c, which is equal to the identity, that is, it can be reduced to the identity using relations (1) and (2).

Now consider the vertices in the Cayley diagram. If we choose one vertex to represent the identity e, then each vertex represents a distinct element of the group. Various paths leading from the vertex e to a given vertex x, say, correspond to different products of reflections that are equal to the element x. Thus the Cayley diagram represents the group in a remarkably simple and convenient way, and we shall make extensive use of this representation in the following discussion.

In Figs 6c and 6d we show, in a similar manner, the arrangement of mirrors and the Cayley diagram for the group $p6m$. Here the relations are

$$a^2 = b^2 = c^2 = (ab)^6 = (bc)^3 = (ac)^2 = e, \qquad (4)$$

and the Cayley diagram is a tiling using squares, regular hexagons and regular 12-gons. Exact analogues of the equations stated above hold here also, and we shall make use of these later.

THE USES OF SYMMETRIES

The procedure for determining the types of strands, and other data, from the designs will be illustrated by means of four examples. These will clarify the meaning of the various assertions, for which formal proofs would be inappropriate in this framework. We chose them to show various combinations of symmetry groups and induced groups.

Example 1.

Consider the design of Fig. 7a with group $p4m$. The fundamental region of this design is shown in Fig. 7b. There is a path $P Q R S \ldots$ that we may think of as the track of a billiard ball on a triangular table with cushions a, b and c, as shown. Starting from P on cushion c, the ball goes to Q where it 'bounces' on cushion a, then via R to S where it bounces on cushion b. The ball then bounces on a at T, passes through R, bounces at U on b, at V on c, and then arrives at W. Here it bounces back on b and retraces the track going via $V U R T S R Q$ back to P. We notice that every part of the design in the fundamental region has been covered by this one track,

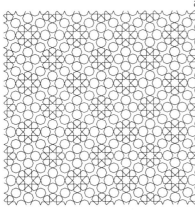

a

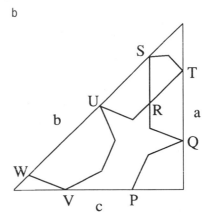

b

Fig. 7. Illustration of the analysis of an interlace pattern, as discussed in Example 1.
(a) A design of the interlace pattern, redrawn from Bourgoin [23]. (b) A fundamental region for the design in (a), with a track for the design. (c) The element of the symmetry group that corresponds to the word representing the track in (b) is the portion between adjacent solid dots on the heavily drawn loop in the Cayley diagram of the group. The loop consists of four repetitions of that element. (d) A strand in the design that corresponds to the track in (b) and the loop in (c) is heavily drawn; a translational repeating unit of the design is indicated by the dotted square.

c

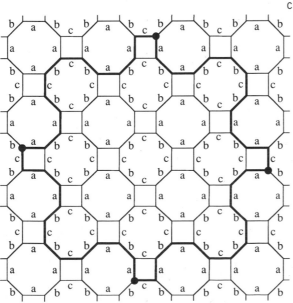

d

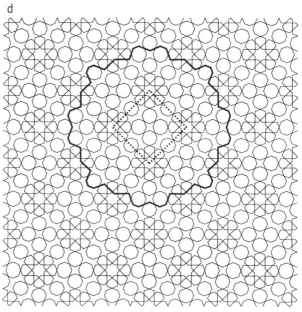

151

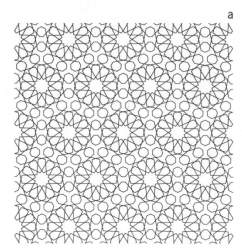

a

Fig. 8. Illustration of the analysis of another 1-strand interlace pattern, as discussed in Example 2. The four parts correspond to the parts of Fig. 7. (a) A design, redrawn from Bourgoin [24]. (b) A fundamental region, and a track for the design. (c) The element corresponding to the track in (b), in the Cayley diagram of the symmetry group. (d) A strand in the design, and a translational repeating unit.

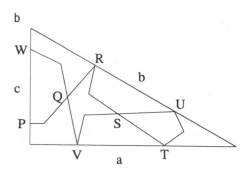

b

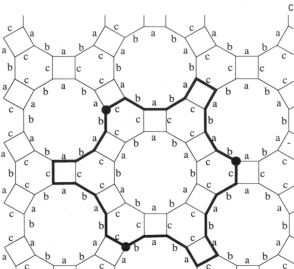

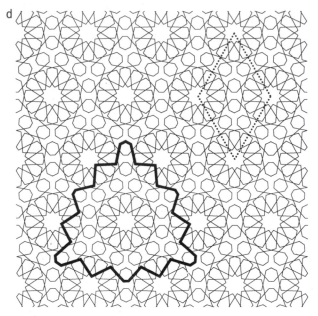

d

and so we deduce that this is a 1-strand pattern. More generally, we arrive at Proposition 1.

Proposition 1.

If the number of tracks in a fundamental region of a design D is n, then D represents an n-strand pattern.

Examples with $n > 1$ will be given later (Examples 3 and 4). (Of course, one may complain that a billiard ball does not behave in such a bizarre fashion, with crooked paths across the 'billiard table', and with bounces occurring with no regard to the laws of dynamics! One should regard this wording as merely a convenient fiction, remembering the Mikado in the Gilbert and Sullivan musical of that name, who set up games of billiards "on a cloth untrue with a twisted cue, and elliptical billiard balls" [14].)

The track described above can be represented by

$$P\,Q\,R\,S\,T\,R\,U\,V\,W\,V\,U\,R\,T\,S\,R\,Q, \qquad (5)$$

repeated indefinitely each time the billiard ball goes round it or bounces on the cushions like this:

$$c\,a\,b\,a\,b\,c\,b\,c\,b\,a\,b\,a. \qquad (6)$$

Clearly the 'word' (6) represents an element of the group $p4m$, and properties of the strand can be determined from this. To do so, we represent this element on a Cayley diagram of the group (see Fig. 7c). We start at one of the marked

vertices, and then go along the edges specified in (6), which will bring us to the next marked vertex. Thus the path in the Cayley diagram between two marked vertices corresponds to the word (6). We repeat this operation and find that after three repetitions we arrive back at the vertex from which we started. The complete path thus obtained is called the extended path corresponding to the word. We deduce that element (6) is of finite period (four in this case); in the general case we shall denote the period of the word corresponding to a strand S by $p(S)$. This illustrates our next proposition.

Proposition 2.

If the group element corresponding to a strand is of finite period, then the corresponding strand is finite, that is, a loop. We can say more.

Proposition 3.

The strand has the same induced symmetry group as the extended path in the Cayley diagram corresponding to the associated word.

In our example, Fig. 7c shows that the looped strand has, as induced group, the dihedral group $d4$ of order 8, as can be verified by Fig. 7d.

Using (5) we can discover the number of strands that the given strand S crosses. We count (i) bounces on the sides of the fundamental region except where the track turns back

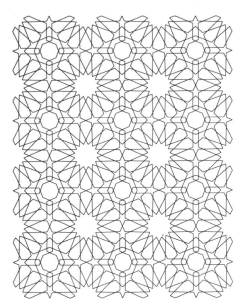

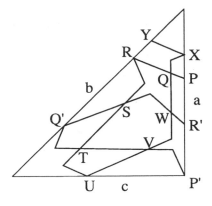

Fig. 9. Illustration of the analysis of a 2-strand interlace pattern, as discussed in Example 3. The four parts correspond to the parts of Fig. 7. (a, left) A design, redrawn from Bourgoin [25]. (b, right) A fundamental region, and a track of the design. (c, center right) The element corresponding to the track in (b), in the Cayley diagram of the symmetry group. (d, bottom right) A strand in the design, and a translational repeating unit.

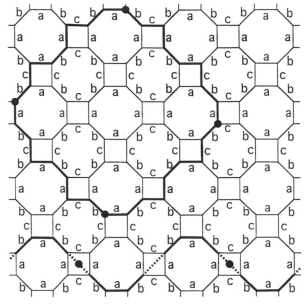

on itself and (ii) crossings within the fundamental region, as we go once round the track corresponding to the given strand. In our example we see there are two bounces at each of Q, S, T, U and V, and four crossings at R (since we go through R twice when traversing the track in each direction), making a total of 14. Let us denote this total by $c(S)$; then we come to Proposition 4.

Proposition 4.

A finite strand S crosses a total of $c(S) \times p(S)$ times.

In our example, $c(S) = 14$ and $p(S) = 4$, so S has 56 crossings, which can be easily verified from Fig. 7d. Later we shall give the analogue of Proposition 4 for unbounded strands.

We can also deduce the number of crossings in a period parallelogram for the symmetry group of the design.

Proposition 5.

The number of crossings in a translational repeating unit of a design with group $p4m$ corresponding to a 1-strand pattern is $2c(S)$. If the group is $p6m$ the number of crossings is $3c(S)$. If there is more than one strand, we replace $c(S)$ in these formulae by the sum of the crossing numbers for each of the strands in the fundamental region.

In the case of our example, this yields 2×14 crossings, as can be easily verified from the period parallelogram marked in Fig. 7d. (Notice that crossings occurring on the common boundary of two or more fundamental regions are shared, and each region is assigned only the appropriate fraction of such crossings.)

Example 2.

This is similar to Example 1 except that here the group is $p6m$ (see Fig. 8a–d). The design has one track, namely

$$P\,Q\,R\,S\,T\,U\,S\,V\,Q\,W\,Q\,V\,S\,U\,T\,S\,R\,Q$$

and so, by Proposition 1, this is the design of a 1-strand pattern. Denote the strand by S. The corresponding group element is

$c\,b\,a\,b\,a\,c\,a\,c\,a\,b\,a\,b,$

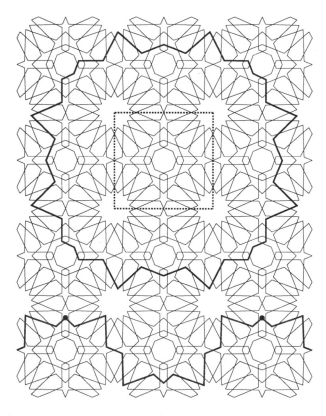

153

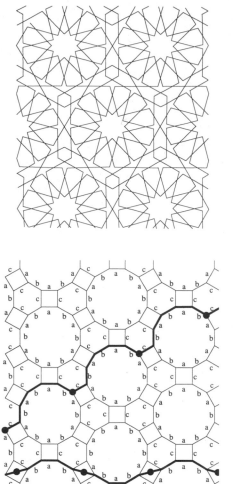

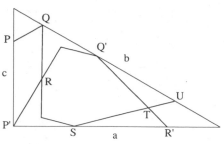

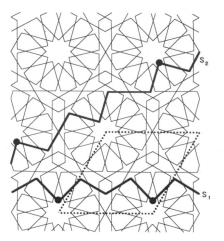

Fig. 10. Illustration of the analysis of another 2-strand interlace pattern, as discussed in Example 4. The four parts correspond to the parts of Fig. 7. (a, far left) A design, redrawn from Bourgoin [26]. (b, left) A fundamental region, and a track for the design. (c, below left) The element corresponding to the track in (b), in the Cayley diagram of the symmetry group. (d, below right) A strand in the design, and a translational repeating unit.

and, as can be seen from Fig. 8c, it is of period 3, so $p(S) = 3$. By Proposition 2 the strand is a loop, and by Proposition 3 its induced group is $d3$. A count of the number of crossings gives $c(S) = 16$, so by Proposition 4 the strand S crosses other strands $16 \times 3 = 48$ times and, by Proposition 5, the number of crossings in a period parallelogram is $3 \times 16 = 48$. These numbers can be verified from Fig. 8d.

Example 3.

The design in Fig. 9a is a 2-strand design. This is clear from Proposition 1 and from the fact that the fundamental region shown in Fig. 9b contains two tracks. The first, corresponding to strand S_1 is

$$P\,Q\,R\,S\,T\,U\,V\,W\,Q\,X\,Y\,X\,Q\,W\,V\,U\,T\,S\,R\,Q$$

(of which Q, S, T, V and W are crossings, and P, R, U, X and Y are bounces) so that $c(S_1) = 18$. The second, corresponding to S_2, is

$$P'\,V\,T\,Q'\,S\,W\,R'\,W\,S\,Q'\,T\,V$$

of which P', Q' and R' are bounces and $c(S_2) = 11$. The word corresponding to strand S_1 is

$$a\,b\,c\,a\,b\,a\,c\,b$$

and, looking at the Cayley diagram (Fig. 9c), we see that this

strand is a loop (Proposition 2) with induced group $d4$ (Proposition 3) (see Fig. 9d). The other track introduces a new feature since it starts from P', which is a corner of the fundamental region. This clearly counts as a bounce against both a and c, and the question 'which does it bounce against first?'. As there is no answer to this question, we write the corresponding word

$$(ac)\ b\ a\ b \tag{7}$$

and then employ the artifice shown in the lower part of Fig. 9c, namely, we make the path go diagonally through the $acac$ square as shown; also we count this as a crossing in the calculation of $c(S_2)$. The path in the Cayley diagram does not close up, so we deduce from Proposition 2 that the strand is unbounded, and from Proposition 3 that the induced group of this strand is $pma2$. Notice that under the restrictions imposed at the beginning, it is only possible for a track to go through the intersection of two mirrors if those mirrors are perpendicular to one another.

Since $c(S_1) = 18$, the strand S_1 crosses other strands $18 \times 4 = 72$ times (see Fig. 9d). As a translational repeating unit of the extended path corresponding to the strand S_2 in the Cayley diagram needs two applications of the word (7), we deduce that the number of crossings in a translational repeating unit of the strand S_2 is $11 \times 2 = 22$ (see Fig. 9d).

In all, the fundamental region contains $c(S_1) + c(S_2) = 18 + 11 = 29$ crossings. As the group is $p4m$, the number of crossings in a translational repeating unit is $29 \times 2 = 58$ (see Fig. 9d).

Example 4.

The design in Fig. 10a has two unbounded strands S_1 and S_2, corresponding to the tracks $P\,Q\,R\,S\,T\,U\,T\,S\,R\,Q$ and $P'\,R$

154

$Q'\,T\,R'\,T\,Q'\,R$ in Fig. 10b. The corresponding paths in the Cayley diagram are shown in Fig. 10c, from which it will be observed that the first has symmetry group *pma2*, and the second has the group *pm11*. In the second the track goes through the intersection of mirrors *a* and *c*, and we deal with this situation as in the previous example. Here $c(S_1) = 8$ and $c(S_2) = 7$, hence the two strands have 8 and $7 \times 2 = 14$ crossings in a translational repeating unit, respectively. The number of crossings in a fundamental region is $8 + 7 = 15$, so the number of crossings in a translational repeating unit of the design is $15 \times 3 = 45$, as can be verified by inspection of Fig. 10d.

WHY SO FEW SHAPES OF STRANDS?

An explanation of the empirical fact that many Islamic interlace patterns contain only one or two shapes of strands is now at hand. Since it is likely [15] that early artisans employed stencils in drawing these patterns, and since, for practical reasons, these stencils were probably made as small as possible for a given pattern, they may well have consisted of just one translational repeat unit. That unit itself was probably obtained by repeating a geometric construction that was carried out in a fundamental region, or by some equivalent procedure. If so, by our Proposition 1, the number of strands in a pattern would be the same as the number of tracks used in the fundamental region—and it is easy to understand why this number was often chosen to be small. Once it was realised that visually interesting and attractive patterns can arise from a fundamental domain that is not very complicated, the traditional approach of training by means of apprenticeships would naturally tend to preserve both the patterns and their methods of generation. The possibility of producing different patterns by slight changes in the fundamental regions (and therefore the stencils) may also have had an influence on the choice of motifs. Thus, we feel, the mystery of how the very complicated interlaces were designed has a reasonably simple explanation. Creation of such ornaments relies only on geometry and technology that were readily available to medieval artists; the fact that 1-strand or 2-strand interlaces result is an accidental consequence, probably neither noticed by the designers nor relevant to them.

The reader may find it interesting to experiment in various ways with the procedures described above. On the one hand, the designs shown in Figs 1–5 can be analysed as to their symmetry groups, fundamental domain and so on. It should be noted that the designs in Figs 4b and 5b have symmetry groups different from the two studied here, so that some independent work is necessary. On the other hand, creation of new designs—whether simple or complicated—can be easily done by the methods shown, or by easy variations of them. Moreover, the use of color greatly enhances the possibilities for experimentation; see Color Plate A

No. 1 [16] for a colored version of one of the two interlace patterns that arise from the design shown in Fig. 5a [17].

Acknowledgment

Research for these studies was supported in part by National Science Foundation (NSF) grants DMS-8620181 and DMS-9008813.

References and Notes

1. J. Bourgoin, *Les éléments de l'art arabe: Le trait des entrelacs* (Paris: Firmin-Didot, 1879). Paperback reprint of plates: *Arabic Geometrical Pattern and Design* (New York: Dover, 1973).

2. P. d'Avennes, *L'art arabe d'après les monuments du Kaire depuis le VIIe siècle jusqu'à la fin du XVIIIe* (Paris: A. Morel et Cie, 1877). Selection of plates reissued as *Arabic Art in Color* (New York: Dover, 1978).

3. I. El-Said and A. Parman, *Geometric Concepts in Islamic Art* (London: World of Islam Festival, 1976).

4. D. Wade, *Pattern in Islamic Art* (Woodstock, NY: Overlook Press, 1976).

5. C. Humbert, *Islamic Ornamental Design* (New York: Hastings House, 1980).

6. E. Makovicky and M. Makovicky, "Arabic Geometrical Patterns—A Treasury for Crystallographic Teaching", *Jahrbuch für Mineralogie Monatshefte 1977*, No. 2, 58–68 (1977).

7. B. Grünbaum and G. C. Shephard, "Isonemal Fabrics", *American Mathematical Monthly* **95** (1988) pp. 5–30.

8. See Bourgoin [1] plate 7, and the upper parts of plates 6 and 8; see also the illustrations in d'Avennes [2]; El-Said and Parman [3]; Wade [4]; Humbert [5]; and Makovicky and Makovicky [6].

9. For discussions of the concepts of symmetry, periodic patterns, and translational repeating units, see G. E. Martin, *Transformation Geometry: An Introduction to Symmetry* (New York: Springer-Verlag, 1982).

10. B. Grünbaum and G. C. Shephard, *Tilings and Patterns* (New York: Freeman, 1987).

11. D. K. Washburn and D. W. Crowe, *Symmetries of Culture: Theory and Practice of Plane Pattern Analysis* (Seattle, WA: Univ. of Washington Press, 1988).

12. For descriptions and illustrations of all of these groups, see Grünbaum and Shephard [10].

13. For more on the various concepts and facts discussed in this section, see H. S. M. Coxeter and W. O. J. Moser, *Generators and Relations for Discrete Groups* (Berlin: Springer-Verlag, 1980).

14. W. S. Gilbert, *The Mikado and Other Plays* (New York: Boni and Liveright, 1917) p. 43, lines 14–16.

15. W. K. Chorbachi, "In the Tower of Babel: Beyond Symmetry in Islamic Design", *Computers Math. Appl.* **17** (1989) pp. 751–789. This article was also published in I. Hargittai, ed., *Symmetry 2: Unifying Human Understanding* (New York: Pergamon, 1989) pp. 751–789.

16. A detailed discussion of perfect and other systematic colorings of various kinds of patterns is given in chapter 8 of Grünbaum and Shephard [10].

17. An example of a 2-colored interlace pattern from the Alhambra is shown in B. Grünbaum, Z. Grünbaum and G. C. Shephard, "Symmetry in Moorish and Other Ornaments", *Computers Math. Appl.* **12B** (1986) pp. 641–653. This article was also published in I. Hargittai, ed., *Symmetry: Unifying Human Understanding* (New York: Pergamon, 1986) pp. 641–653.

18. Bourgoin [1] Fig. 1.

19. Bourgoin [1] Fig. 11.

20. Bourgoin [1] Figs 71 and 6.

21. Bourgoin [1] Figs 39 and 109.

22. Bourgoin [1] Figs 137 and 187b.

23. Bourgoin [1] Fig. 151.

24. Bourgoin [1] Fig. 74.

25. Bourgoin [1] Fig. 57.

26. Bourgoin [1] Fig. 76.

The Fascination of Tiling

Doris Schattschneider

Dutch artist M. C. Escher (1898–1972) often described regular divisions of the plane as "the richest source of inspiration I have ever struck" [1]. Interlocking shapes displayed in majolica tile, inlaid wood, brickwork, carved stucco, stone pavement, sewn patchwork or printed fabric hold a special fascination for many people that goes far beyond the aesthetic pleasure that these patterns provide. Tiling can serve as a paradigm: it is wholly visual (and perhaps seems to be purely in the provenance of design) yet incredibly rich as a source of mathematical questions. Many of these questions have implications for those who (like Escher) design intricate and unusual tilings. Other questions probe the limits of possibilities for tilings, investigate the structure of tilings, aim to produce methods of classification or link tilings to physical structures in nature or to invented mathematical structures.

Mathematicians seek to know how tiles can pave surfaces—not just the Euclidean (flat) plane, but also the hyperbolic plane and the surfaces of three-dimensional objects such as spheres, tori (doughnuts) or Möbius bands [2]. They also investigate tilings on surfaces impossible to fully represent in our three-dimensional world, such as a Klein bottle or surfaces in higher dimensions. And tiling problems are not only restricted to surfaces—there are marvelous problems that ask questions about how three-dimensional 'tiles' (such as polyhedra) can pack space, or how higher-dimensional spaces can be packed with tiles.

Most of these problems are difficult, and most are unsolved, but people are working on them. If we restrict ourselves to questions about tiling the Euclidean plane, the subject is still very rich and far from complete. In this article, I will highlight some of the different kinds of mathematical questions that can be posed with regard to tilings of the Euclidean plane. Some have been answered fully, others only partially, and some not at all. Although mathematicians and scientists have investigated these questions (and still do), many are accessible to those with little or no formal mathematical training. Playing with the possibilities can provide much pleasure and may even lead to important discoveries.

A *tiling* is a covering of the plane by closed shapes that is without gaps or overlaps; two other synonymous terms are *tessellation* and *parquetry*. Of course, a real tiling has a small space between adjacent tiles that is filled with cement, glue or just plain dirt; mathematically, this space is treated as a heavy outline of tiles that (in theory, at least) fit perfectly together. The fitting together of shapes to fill an area is a pleasurable challenge—play with colored polygon shapes or the completion of a jigsaw puzzle are examples in which the shapes are given, and we expect them to fit together in at least one way. Simple polygon shapes produced for children's explorations of tilings are known to fit together in many different ways; jigsaw-puzzle shapes are guaranteed to fit together because they have been simultaneously cut with a die whose cutting edge outlines a tiling of a rectangle equal in size to the completed puzzle.

But what if we are presented with a box of tiles with no guarantee that they will fit together? Can we predict if a region can be tiled with them? [3] If we allow an infinite number of copies of the tiles, can we predict if we can tile the whole plane with them? Of course, if none of the pieces can fit snugly against each other (such as circular discs, or tiles with indentations that do not match their protrusions), it is easy to decide that the tiles will not fit together to fill

ABSTRACT

Mosaics that cover surfaces have long been of interest to designers and artists. Recently, however, mathematicians have turned their attention to these visual displays and found them a fascinating source of interesting problems, many of which are still unsolved.

Fig. 1. A tiling by a convex pentagon discovered by Marjorie Rice. Each pentagon is joined to its mirror-image, yet the reflection that interchanges them is not a symmetry of the whole tiling.

Doris Schattschneider (mathematician), Moravian College, Bethlehem, PA 18018, U.S.A.

Fig. 2. Edges of these tiles fit together in only one way; this determines a unique tiling of the plane. Note that the bilateral symmetry of the tile induces reflection symmetry into the whole tiling. The alternate black-white coloring produces a counterchange pattern.

out a region. But if there are many 'fits' of edges, can we decide? These basic questions about tiling have a simple (though perhaps unsatisfying) answer: there is no test or algorithm that will show if an arbitrary set of tiles will tile a region equal to their collective area (or the whole plane, if their collective area is infinite). Even when all tiles in the set are copies of a single shape, the answer is the same; this simply means that tiling is not predictable. That is part of the fascination. Mathematicians (and artisans) know there is a rich variety of shapes that *do* tile the plane, and so they pose questions about tiles and tilings with special properties [4]. Answers to some of these questions can be surprisingly useful.

The simplest tilings are those with tiles that are all copies of a single shape. Called monohedral tilings, these have been the most thoroughly investigated by mathematicians, yet there are still many unanswered questions. When we discuss monohedral tilings, we can ask many questions about the single shape (the 'prototile') whose copies fill out the plane. Perhaps the simplest tile shape is a convex polygon, so we first ask which convex polygons can tile the plane. (In more precise mathematical phrasing we ask which convex polygons can be prototiles in a monohedral tiling.) It is easy to show that any triangle can tile the plane, as can any quadrilateral (even nonconvex). But only certain convex pentagons can (regular pentagons, for instance, cannot), and certain hexagons can. It can also be shown that no convex polygons having seven or more sides can tile the plane [5]. The discovery of exactly which convex hexagons can tile the plane (there are exactly three types; they are described by conditions on their sides and their angles) is credited to K. Reinhardt, whose 1918 thesis contains the solution to this problem. The discovery of convex pentagons that can tile the plane is a saga that spans many years and involves discoveries by mathematicians Reinhardt (in 1918)

and R. Kershner (in 1968), as well as discoveries by 'amateurs' Richard James (in 1975) and Marjorie Rice (in 1976–1980) and graduate student Rolf Stein (in 1985) (see Fig. 1). Although at least three times in the saga it was claimed that the list of pentagons that tile the plane was complete (and then more were found), there is not yet definitive proof that the known 14 types are all that are possible [6]. Martin Gardner's article "Tiling With Convex Polygons" [7] gives a good overview of the story, and the article "In Praise of Amateurs" [8] tells the story of how Rice pursued the problem after reading about it in Gardner's column in *Scientific American*. This article is a testimony not only to her perseverance, but also to her ingenuity in investigating the problem.

The question of *whether* a shape can tile the plane is inseparable from the question of *how* a shape can tile the plane. Almost all mathematical questions (as well as design questions) that concern tiling by a single shape must take into account the possible ways in which a tile can surround itself. In the simplest case in which a tiling is possible, there is only one way that the tile can be surrounded, and this is the only way that the congruent pieces can continue to fit together to tile the whole plane. This kind of tile is easy to produce and may be the most desirable for those who want a simple and totally predictable job of filling the plane (Fig. 2). But when there is more than one way for congruent pieces to fit together, the possibilities for tiling become very interesting and pose many questions. If copies of a tile can fill out a patch of the plane (even a very large one), can the tiling be continued to fill the plane? If the whole plane can be filled with copies of a tile, is that tiling unique? If not, how many other different tilings with that tile are possible? Although sometimes these questions can be answered, they can be extremely difficult to answer for certain tiles; there is no general algorithm or test that can be applied to any tile [9].

A cross made from five squares is an innocuously simple tile that can fill out any size patch of the plane, but for which there is essentially only one way to fill out the whole plane. If just one cross is wrongly placed, the tiling cannot be completed (Fig. 3). The discovery of a tile for which there is a unique tiling brings special pleasure—especially if the tile is one for which there are many 'false starts' in which the tile fills out a patch and then no additional pieces can be added. Roger Penrose has devised some ingenious tiles with simple shapes (using portions of the boundary of a regular hexagon) so that copies of a single tile 'fit' in a myriad of ways but there is only one way to completely tile the plane with them. He presented a box of wooden cutouts of one such tile (Fig. 4) to Escher in 1962 and challenged him to solve the puzzle. Not only did Escher solve the puzzle (finding the unique way to fit the tiles so the pattern could be continued to fill the plane), but he made his own version, a 'ghost' based on Penrose's geometric piece, and made a color drawing of the interlocked creatures [10].

For specific tiles, simply trying to fit their copies together may yield a tiling, but this approach rarely gives insight into the properties of large classes of tilings. For mathematicians, it is natural to try to discover constraints on tilings, to describe as precisely as possible various types or classes of tilings that satisfy certain properties and fine-tune definitions to rule out anomalous exceptions to what seems to be generally true. It is perhaps surprising that there are geometric constraints that must be obeyed by any 'ordinary'

Fig. 3. There is essentially only one way to tile the whole plane by this cross tile: the continued arrangement shown for the white crosses, or the mirror image of this arrangement. If just one tile is wrongly placed (shaded cross), the tiling cannot be continued to fill the plane. Although each cross tile has four axes of reflection symmetry, there is no reflection symmetry in the plane tiling.

tiling of the plane, whether the tiles are all alike, some different, or all different. One such constraint is that for any tiling of the plane by convex polygons, there must be at least one tile that has six or fewer vertices. In fact, even if the tiles are not convex polygons, a much stronger condition usually holds: the tiling must contain an infinite number of tiles with at most six vertices (a vertex of a tiling is a point where three or more tiles meet) [11]. It is interesting to note here

Fig. 4. A tile devised by Roger Penrose that can only tile the plane in one way. A tile and its mirror image (shaded) form a unit that can be rotated repeatedly 60° to fill out a snowflake shape; this patch of 12 tiles can fill the plane by translations. The tiling is nonisohedral since no symmetry of the tiling can map a tile to its mirror image.

159

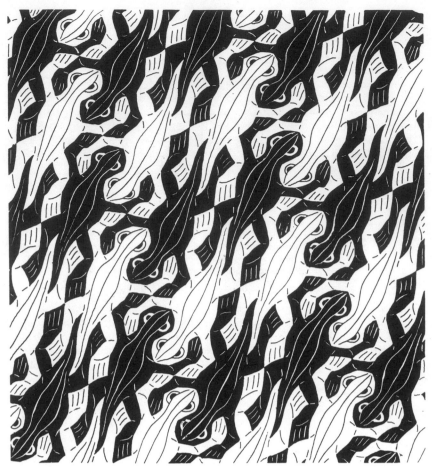

Fig. 5. M. C. Escher, *Symmetry Drawing No. 75*, india ink, pencil, black-and-white paint, 223 × 206 mm, 1949. (© M. C. Escher Foundation—Baarn—Holland. All rights reserved) (top left) One of Escher's isohedral tilings by lizards. Each lizard in the tiling is surrounded in the same way; this provides a signature that determines the tiling. Three ways of depicting this signature—(bottom left) by Escher, (bottom center) by Heesch and (bottom right) by Grünbaum and Shephard—are illustrated.

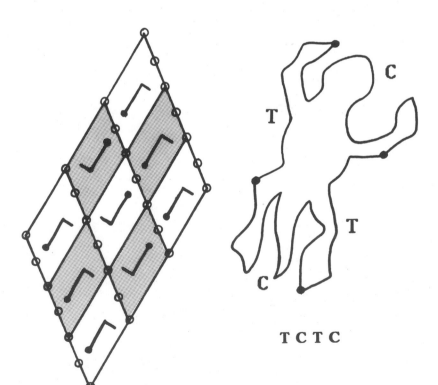

T C T C

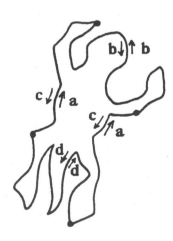

Tile symbol: a⁺b⁺c⁺d⁺
Adjacency symbol: c⁺b⁺a⁺d⁺

that although one might expect constraints on plane tilings to easily lead to similar constraints on packings of three-space, that is not often the case. Although a convex polygon that tiles the plane can have no more than six vertices, the upper bound on the number of faces of a convex polyhedron that can pack space is not known. A convex space-filler with 38 faces found in 1981 by Peter Engel holds the current record for the most faces, but there is no proof that this is the largest number of faces possible [12].

Another constraint that is true for any finite tiling of a patch of the plane is Euler's theorem, which says $v + t = e + 1$, where v is the number of vertices in the tiling, t is the number of tiles, and e is the number of edges in the tiling. (An edge is a portion of the common boundary of two tiles and joins two adjacent vertices.) Under appropriate assumptions, this constraint can be extended to a tiling of the whole plane by forming the ratios v/t and e/t for a patch of the tiling, and then taking the limit as the patch grows larger to cover the whole plane [13].

To be able to describe and classify large classes of tilings, it is natural for mathematicians to restrict questions to tilings with special structure and orderliness. The mathematical model for the internal structure of crystals is one in which atoms are aligned in a periodic lattice, so (until very recently) almost all mathematical investigations of tilings have been restricted to those that are periodic. In a periodic tiling, there is always a minimal patch of the tiling that fills the whole tiling by translating it again and again in two different directions. (One can first fill out an infinite strip with the patch, then translate the strip to fill out the plane.)

In their quest to find out how many different kinds of periodic tilings there are, investigators concentrated on the global order of these tilings. Mathematicians use geometric transformations of the plane that preserve shape—isometries—to describe this global order. These transformations are translation, rotation, reflection and glide-reflection. To analyze a particular periodic tiling, mathematicians seek to learn which isometries transform the tiling so that it will superimpose exactly on itself. Each such geometric transformation is called a *symmetry* of the tiling; the collection of all symmetries of a tiling is called the *symmetry group* of the tiling. Symmetry groups are not just collections of geometric transformations but also have algebraic structure. Periodicity of a tiling severely limits the possibilities for symmetries other than translations; there are only 17 different types of symmetry groups of periodic tilings. Classification by symmetry group provides a convenient and straightforward method of categorizing periodic tilings. Symmetry groups also provide a way of generating periodic tilings (as well as periodic patterns) since each group is generated by just a handful of isometries. If one draws any asymmetric figure in the plane, and the isometries that generate one of the 17 groups act repeatedly on the figure, a periodic design will result that has the prescribed symmetry group [14]. This means that computer programs can be written that will automatically generate periodic tilings or patterns of any of the designated 17 types [15].

The problem with classification of tilings by symmetry groups is that it gives no information whatsoever about the shapes of the tiles, about whether all tiles are of the same shape or of several different shapes, nor any information about how an individual tile is surrounded by other tiles. To test to see if two periodic tilings are 'the same' under this classsification is like putting the same mask on each one—the mask shows reflection axes, rotation centers and glide

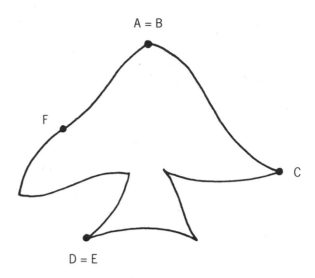

Fig. 6. A Conway Criterion tile can fill the plane by successive 180° rotations. The tile shown here has exactly four centrosymmetric edges; compare to Escher's lizard in Fig. 5, another example that has two centrosymmetric edges joined by two edges that match by translation.

axes for the whole tiling. If the mask (scaled separately in two directions if necessary) fits both, they are the same. We learn no visual information about the design of the tiling, only information about its symmetry.

When we consider tilings with all congruent tiles, classification by symmetry groups seems especially inadequate. When all tiles in a tiling are copies of a single shape, portions of the edges of the tile must match, and so a signature of matching can be assigned to the consecutive edges of a tile that describes how those edges match the edges of the tiles that surround it. Merely knowing how one tile can be surrounded is rarely enough to determine a whole tiling (see the cross tile and the Penrose tile in Figs 3 and 4). But for periodic tilings that have the special property that *every* tile is surrounded in the *same* way by its copies, this signature is enough to determine the whole tiling. Escher called such periodic tilings 'regular'; mathematicians call them 'isohedral', or 'tile-transitive'. In 1977 Branko Grünbaum and G. C. Shephard answered the question of how many different isohedral tile types there are—81 distinctly different types. These mathematicians introduced the notion of an 'adjacency symbol' for an isohedral tiling. To produce the symbol, edges of one tile are labeled consecutively with letters, and then the letters corresponding to the shared edges of the tiles that surround the first tile are listed in sequence. It is interesting to note that, earlier, the mathematician H. Heesch and the graphic artist Escher had each (independently) developed classification systems for some of these tilings, based on a 'local signature' that described how each tile was related by isometries to its surrounding tiles. These isometries not only give information on how the tiles fit, but also constrain the allowable shapes for the edges of the tile. Figure 5 shows one of Escher's isohedral tilings by a single lizard and illustrates how it would be described by Escher, by Heesch and by Grünbaum and Shephard [16]. Escher's own schematic diagram (in which a parallelogram marked with a hook represents a lizard) shows half-turn centers as small circles and indicates by the orientation of the hooks how a given tile is surrounded by other tiles. Each lizard tile has four vertices, marked by black dots in the

outline of the tile. Heesch's labeling of a tile shows that two edges match by translation (T), and two are centrosymmetric (C)—a half-turn about the midpoint of either of these edges matches the edge to itself. The adjacency symbol of Grünbaum and Shephard shows how directed edges consecutively labeled (a, b, c, d) fit against edges of adjacent tiles with the same labeling; the + indicates same orientation.

This description of local (rather than global) structure is a natural one for an artisan who wishes to design a tile that will fill the plane isohedrally. By reading the coded shapes in Heesch's chart, or in Grünbaum and Shephard's diagrams of isohedral tilings, found in their book *Tilings and Patterns,* one can easily create original isohedral tiles. A particularly simple recipe to follow is the Conway Criterion, which produces tiles that will fill the plane simply by applying 180° rotations to some vertices and the centers of some tile edges. The boundary of a Conway Criterion tile has six consecutively labeled vertices (A, B, C, D, E, F) and satisfies the condition that the edge from A to B matches the edge from E to D by translation, and the remaining edges BC, CD, EF and FA are centrosymmetric. Some of the vertices can coincide; at least three distinct vertices are necessary. Escher's lizard in Fig. 5 fits this recipe; another tile that satisfies the criterion is shown in Fig. 6 [17]. A computer program called Mosedit has been developed at the University of Montreal by J. Baracs and N. Chourot to assist in the creation of isohedral tiles, based on the classification of Grünbaum and Shephard. The user chooses a tile type and then can design an original shape of that type, with the computer program forcing the outline of the tile to obey the necessary constraints.

In his classification of regular tilings based on the relation of each tile to its adjacent copies, Escher did not consider reflection symmetries; this was probably because his creature-shaped tiles rarely had straight edges that would allow them to reflect into an adjacent tile. Yet several of his tilings have reflection symmetry, introduced by the use of a tile that is bilaterally symmetric (such as a fish, an angel or a bat). The tiling in Fig. 2 shows such induced reflection symmetry. This raises the interesting question of when the symmetry of an individual tile would necessarily introduce similar symmetry into an isohedral tiling. Certainly not always: the cross tile in Fig. 3 has four reflection axes that intersect in a four-fold center of rotation, yet the unique plane tiling with this cross has no reflection symmetry (it does have four-fold rotation symmetry). The cross tile is an example of a *hypersymmetric* tile—it possesses additional symmetry that is not present in any tiling by the tile. Some of Escher's birds and fish are hypersymmetric or nearly so; he noted this on his drawings by saying that they were 'apparently symmetric'. The question of when a symmetric tile introduces symmetry into an isohedral tiling (and when it does not) is an open one. In fact, both the question of for which isohedral types do hypersymmetric tiles exist and the question of what extra symmetries are possible for a tile of a given isohedral type are not yet answered [18].

It is easy to produce nonisohedral tilings by a single tile (even something as simple as a triangle will work), that is, not every tile is surrounded in exactly the same way. But are there tiles that can fill the plane *only* in a nonisohedral way? In 1900, at the International Congress of Mathematicians in Paris, David Hilbert posed a list of important mathematical problems, and among these was a suggestion that he thought the answer was probably 'no' [19]. Yet the answer is yes; Heesch provided the first examples of such tiles in 1935. These were nonconvex polygons with interlocking teeth. Penrose's tile in Fig. 4 is another example of such a tile—this tile can only fill the plane if the shapes are surrounded in

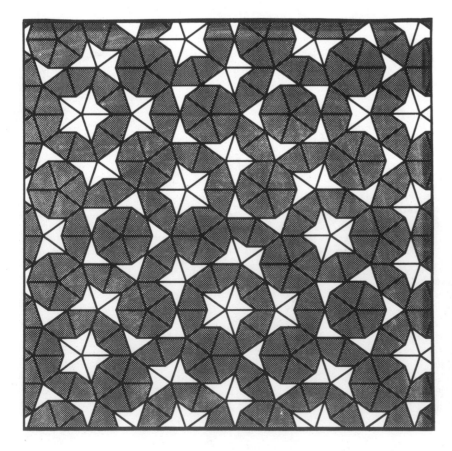

Fig. 7. (left) The Penrose kite and dart tiles can be obtained by dissecting (above right) a single rhombus with angles 72° and 144°; the ratio of the long edges to the short edges of the tiles is the golden number τ = (1 + √5)/2. Vertices of the two tiles are colored as shown; only vertices of the same color are allowed to match. Although there is an infinite number of tilings that follow these rules, every one is aperiodic. The drawings here were produced by Stan Wagon, using the computer software program *Mathematica* [33].

Fig. 8. Two 'rep-tiles' (above and below), each able to fill a similar shape that has scale twice that of the original tile.

patches of a tiling repeat an infinite number of times throughout the tiling. Yet this repetition is not periodic, not stamped out by repeated translation (see Fig. 7). The attempt to understand how such tilings can arise—how certain shapes, together with matching rules, can only tile aperiodically—is just one of the challenging problems in this field [21].

Another area in which there has been much recent investigation concerns colored tilings—the colors of the tiles can be used as a code for information or to make individual tiles recognizable through contrast or purely for the purpose of a pleasing design. Just as symmetry groups can be used to classify tilings, they can also be used to classify symmetric colorings of tilings. These classifications are used by crystallographers and can also be useful to classify colored periodic designs, particularly the frequently encountered two-color 'counterchange' designs in which the same motif occurs in black and in white, such as the ones in Figs 2 and 5 [22]. Escher made many such two-color tilings; they were a principal device in many of his prints in which the same motif (repeated alternating in two colors) serves both as figure and as ground. Yet symmetry groups do not seem to be a wholly adequate tool to describe and classify colored tilings. There are many examples of very orderly arrangements of colors in certain tilings, yet the classification by symmetry groups completely fails to recognize this orderliness. This particular area is one in which new ideas are sought in order to understand the possibilities for integration of two kinds of orderliness: the arrangement of tiles and the arrangement of colors.

Although most of the problems I have discussed concern tilings by a single tile, there is much interest in tilings by more than one type of tile. The same kinds of classification and symmetry questions mathematicians ask about isohedral tilings can be posed for tilings by two or more types of tiles. Some of these (such as how many 'two-isohedral' tilings there are) have recently been answered, but there are more open questions than answered ones. Escher's original approaches for creating tilings by two different tiles that contrast in both form and in color [23] and Escher's investigations into how to derive new tilings from given tilings by a process that he called 'transition' have only recently been published [24]. There is no doubt that mathematicians will find new questions posed by his work.

Tiling problems are a favorite domain of those who enjoy solving problems and puzzles, and are found in many articles and books on 'recreational' mathematics. Most of these problems do not have straightforward solutions, and those with advanced mathematical backgrounds do not necessarily have an advantage in solving them. Special tiles made by matching the edges of congruent squares (such as the cross tile in Fig. 3) are called polyominoes. This type of tile invites questions such as: Which of these can tile the plane? Which of these can tile a rectangle? Can a particular set of polyomino shapes (such as all those made from five squares) tile a rectangle? Can copies of one shape be put together to form a larger but similar shape? Analogous questions can be asked for tiles formed by matching congruent equilateral triangles or congruent regular hexagons [25]. A single tile that can fill a larger region that has the same shape as the tile has been called a 'rep-tile' by Solomon Golomb; finding rep-tiles (not just among the polyominoes) is an enjoyable challenge [26] (Fig. 8.). This problem can also be posed in the opposite way: Given a particular tile, is it possible to dissect it into congruent pieces that are similar in shape to

two distinctly different ways. Two of the tiles together can form a unit that tiles isohedrally—this unit fills out a patch that fills the plane by translations. In 1968, Kershner published even more surprising news: he had found three different types of *convex* pentagons that could tile the plane, but only nonisohedrally. Until then, it was generally believed that all convex polygons that could tile the plane must be able to do so isohedrally. The later discoveries of other types of convex pentagons that tile the plane provided still more examples of polygons that can only tile nonisohedrally (see Fig. 1) [20]. So far, for every tile that has been found that can only tile nonisohedrally, a unit can be formed from a few copies of the tile so that the unit *can* tile isohedrally. It is not known if this phenomenon must be true for every tile that can only fill the plane in a nonisohedral way.

The requirement of a high degree of some kind of special structure in a tiling makes it more tractable for the mathematician to examine and catalog, and periodic tilings have received the most attention by investigators. But recently, there has been growing interest in understanding *aperiodic* tilings—those formed from sets of tiles whose copies can fill the plane in many different ways, but that can never form a periodic tiling. The most famous of these tilings was discovered by Penrose about 15 years ago, and is formed (in one version) by copies of two shapes of tile—a kite and a dart—that have strict rules concerning how their edges can match. Locally, the tilings have a great deal of symmetry (some portions have the symmetry of a regular pentagon), and

the given tile? 'Rep-tiling' has an interesting consequence: it provides a process of tiling the plane that is wholly different than the periodic process of repeated translation. Dubbed 'inflation' by John Conway, this process begins with a single shape, uses a finite number of copies of it to fill out a similar but larger shape, then repeats the process with these larger shapes—as the process continues *ad infinitum,* the tiling must grow to fill the whole plane. This kind of process can describe a way for patches of the known aperiodic tilings to fill the plane, and that is the key to proving their aperiodicity [27].

Historically, interest in tiling has never seemed to flag among designers and artisans. There seems to be no period in which tilings have not been used in both utilitarian and decorative ways; cultures freely borrowed ideas from others and developed their own particular styles in the design of tilings. Yet, until recently, there has been little interest in the subject among mathematicians. With only a few notable exceptions (e.g. Johannes Kepler), mathematicians ignored the subject or relegated it to the category of frivolous, or recreational, mathematics. In the late nineteenth century, questions of crystallographic structure and classification brought some mathematical attention to the subject of tiling, but in the first half of this century, only a handful of mathematicians pursued mathematical questions of tiling.

Today, the 'tiling industry' in mathematics is one of phenomenal growth. The wide variety of difficult and mathematically interesting problems that the subject poses has been brought to the attention of the mathematical community by researchers such as Grünbaum, Shephard, Conway and Penrose. Now many mathematicians and scientists in seemingly unrelated fields of research have discovered that other problems often translate into tiling problems, and so new vigor and insight have enriched the subject. And surprising applications of tiling abound: 'Dirichlet', or 'Voronoï', tilings can illustrate or help solve problems of distribution (of data, supplies, particles or people) [28]; aperiodic tilings are examined for analogies with newly discovered 'quasicrystals'; tilings are investigated to understand structures in nature and to create architectural structures; tilings can be used in teaching to visually illustrate abstract algebraic concepts [29]; tilings are used to 'automatically' generate groups [30]; symmetry classifications of tilings can be used by archeologists to understand cultural styles [31]; tilings are used to understand, simplify or create circuits and other connections; and tilings provide a graphic way of illustrating difficult logical questions of 'undecidability' [32]. And, of course, tiling is fun, a never-ending source of creative diversion. Today, many mathematicians might join Escher in his enthusiastic endorsement, that tiling is the richest source of inspiration ever struck.

References and Notes

1. M. C. Escher, *The Graphic Work of M. C. Escher* (New York: Ballantine Books, 1967) p. 9.

2. For an explanation of how some interesting nonplanar surfaces can be tiled, see Marjorie Senechal, "Escher Designs on Surfaces", in H. S. M. Coxeter, M. Emmer, R. Penrose and M. Teuber, eds., *M. C. Escher: Art and Science* (Amsterdam: North Holland, 1986) pp. 97–122; in the same book, see also Douglas Dunham, "Creating Hyperbolic Escher Patterns", pp. 241–248.

3. Mathematicians use the word *tile* as both noun and verb, just as in common usage: "I tiled my kitchen floor with square tiles."

4. For the most comprehensive source of information on all aspects of tiling,

see Branko Grünbaum and G. C. Shephard, *Tilings and Patterns* (New York: Freeman, 1987).

5. Ivan Niven, "Convex Polygons which Cannot Tile the Plane", *American Mathematical Monthly* **85**, No. 10, 785–792 (1978).

6. Doris Schattschneider, "Tiling the Plane with Congruent Pentagons", *Mathematics Magazine* **51**, No. 1, 29–44 (1978). See also *Mathematics Magazine* **58**, No. 5 (1985) p. 308 and cover.

7. Martin Gardner, "Tiling with Convex Polygons," in *Time Travel and Other Mathematical Bewilderments* (New York: Freeman, 1988) pp. 163–176.

8. Doris Schattschneider, "In Praise of Amateurs", in David Klarner, ed., *The Mathematical Gardner* (New York: Wadsworth, 1981) pp. 140–166.

9. See Grünbaum and Shephard [4] section 1.5.

10. Roger Penrose, "Escher and the Visual Representation of Mathematical Ideas", in Coxeter et al. [2] pp. 143–157.

11. See Grünbaum and Shephard [4] sections 3.2 and 3.10.

12. Ludwig Danzer, Branko Grünbaum and G. C. Shephard, "Does Every Type of Polyhedron Tile Three-Space?", *Structural Topology* **8** (1983) pp. 3–14.

13. See Grünbaum and Shephard [4] chapter 3.

14. Doris Schattschneider, "In Black and White: How to Create Perfectly Colored Symmetric Patterns", *Computers and Mathematics with Applications* **12B**, Nos 3/4, 673–695 (1986); Also published in István Hargittai, ed., *Symmetry: Unifying Human Understanding* (New York: Pergamon, 1986) pp. 673–695.

15. Several such programs are described in the Software Review section of this issue.

16. For their classification of isohedral tilings, see Grünbaum and Shephard [4] chapter 6. For Heesch's classification system, see Heinrich Heesch and Otto Kienzle, *Flächenschluss. System der Formen lückenlos aneinanderschliessender Flachteile* (Berlin: Springer, 1963). For the story of Escher's development of his own theory of tiling and classification system, see Doris Schattschneider, *Visions of Symmetry: Notebooks, Periodic Drawings and Related Work of M. C. Escher* (New York: Freeman, 1990). This volume includes color photos of Escher's symmetry drawings, and also a reproduction of Heesch's classification chart.

17. Doris Schattschneider, "Will it Tile? Try the Conway Criterion!", *Mathematics Magazine* **53**, No. 4, 224–233 (1980).

18. Branko Grünbaum, "Mathematical Challenges in Escher's Geometry", in Coxeter et al. [2] pp. 53–68.

19. See Felix E. Browder, ed., *Mathematical Developments Arising from the Hilbert Problems*, 3rd Ed. (Providence, RI: American Mathematical Society, 1979).

20. See Schattschneider [6].

21. Martin Gardner, "Penrose Tiling", and "Penrose Tiling II", in *Penrose Tiles to Trapdoor Ciphers* (New York: Freeman, 1989) pp. 1–29; and Grünbaum and Shephard [4] chapter 10.

22. For detailed information on the symmetry analysis of two-color patterns, see Dorothy Washburn and Donald Crowe, *Symmetries of Culture: Theories and Practice of Plane Pattern Analysis* (Seattle, WA: Univ. of Washington Press, 1988). This volume contains many examples of patterns from archeological sources.

23. Escher's tilings by two tiles that contrast in form and in color (such as birds and fish) invite animation. The movie *M. C. Escher: Symmetry and Space* explores this. See Michele Emmer, "Movies on M. C. Escher and their Mathematical Appeal", in Coxeter et al. [2] pp. 249–262.

24. See Schattschneider [16].

25. See Martin Gardner, "Tiling with Polyominoes, Polyiamonds and Polyhexes", in Gardner [7] pp. 177–187.

26. See Grünbaum and Shephard [4] section 10.1.

27. This process is demonstrated with several pairs of tiles discovered by Penrose, and with a pair of triangle tiles discovered by Raphael Robinson, as described in Grünbaum and Shepard [4] section 10.3.

28. For definitions and illustrations of these tilings, see Marjorie Senechal, *Crystalline Symmetries: An Informal Mathematical Introduction* (Bristol: Adam Hilger, 1990) section 3.3. For references to literature on applications, see Grünbaum and Shephard [4] pp. 265–266.

29. Marjorie Senechal, "The Algebraic Escher," *Structural Topology* **15** (1988) pp. 31–42.

30. William Thurston, "Conway's Tiling Groups", *American Mathematical Monthly* **97** (1990) pp. 757–773.

31. See Washburn and Crowe [23].

32. See Grünbaum and Shepard [4] chapter 11.

33. This tiling is a portion of one that appears in Stan Wagon, *Mathematica in Action* (New York: Freeman, 1991).

Automatic Generation of Hyperbolic Tilings

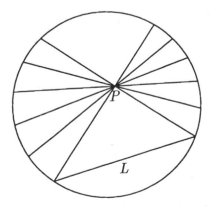

Silvio Levy

Regular tilings of the Euclidean plane are a very common pictorial motif, marvelously represented, for example, by the patterns on the walls of the Alhambra in Spain, and by several of the works of M. C. Escher [1].

Many readers will also be familiar with Escher's woodcut entitled *Circle Limit III,* a computer-generated replica of which is shown in Color Plate G No. 1. This picture can be thought of as a tiling of the hyperbolic plane, as we will see in the next section.

According to H. S. M. Coxeter, Escher used an ad hoc approach to generate this tiling, without fully understanding the mathematics behind it [3]. This in no way detracts from the breathtaking artistry that went into its making. The two most remarkable features of this and other works by Escher are the use of living forms that blend perfectly with one another according to a prescribed symmetry pattern, and the sheer number of tiles that make up each picture; *Circle Limit III* has close to 1,000 individually discernible fishes, color coded according to their relative positions.

Although it takes an immense amount of work to create such a tiling by hand, the job can be easily automated if one has an understanding of the tiling's underlying group of symmetries, the group of transformations that take one tile to another. In this article I give a brief introduction to hyperbolic geometry and symmetries and then explore a method, based on the theory of automatic groups developed by Cannon, Epstein, Thurston and others, to automate the creation of hyperbolic tilings.

HYPERBOLIC GEOMETRY

The discovery, in the early nineteenth century, that the parallel axiom is independent of the other assumptions

underlying Euclid's treatment of geometry opened the door to a rich world of hitherto unimaginable geometric structures. The parallel axiom says that, given a line and a point outside it, there is exactly one parallel to the line going through the point. Although it certainly appears to be true, this axiom is much less intuitive than Euclid's other assumptions (such as the one that states that two points determine exactly one line), and for a long time people tried to prove its redundancy within the Euclidean framework.

However, by the 1820s at least three people had independently discovered that a self-consistent geometry that does not satisfy the parallel axiom could be built: János Bolyai in Hungary, Carl Friedrich Gauss in Germany and Nikolai Ivanovich Lobachevskii in Russia [4]. Their creation became known as *Lobachevskiian geometry* until Felix Klein, at the turn of this century, introduced the now more common term *hyperbolic geometry.* (The term *non-Euclidean geometry* is also commonly used, but it encompasses geometries other than the hyperbolic.)

The denial of one of Euclid's axioms remained a profoundly disturbing idea, and it was not until the second half of the century that the general mathematical public started to get a clear grasp of the nature of hyperbolic geometry. This understanding was much aided by the construction by Eugenio Beltrami [5], in 1866, of an explicit model of hyperbolic geometry—something like a map of hyperbolic space that can be drawn on a piece of Euclidean paper. This model, now known as the *projective,* or *Klein* model, after its popularizer, represents *n*-dimensional hyperbolic space by an open ball

$$\left\{ (x_1, \cdots, x_n) \in \mathbf{R}^n : x_1^2 + \cdots + x_n^2 < 1 \right\}$$

in Euclidean space, and hyperbolic lines by Euclidean straight-line segments in the ball. Figure 1 shows that, given a line *L* and a point *P* outside of *L,* there are infinitely many

ABSTRACT

The author discusses the fundamentals of plane hyperbolic geometry and describes a method for generating hyperbolic tilings by computer, based on the recently developed theory of automatic groups.

Fig. 1. Hyperbolic straight lines in the Klein model appear as straight line segments, extending to the boundary of the unit disk or ball. Through a given point *P* one can draw infinitely many lines that do not intersect a given line *L,* in contradiction with Euclid's parallel axiom.

Silvio Levy (mathematician, editor), Geometry Center, University of Minnesota, 1300 S. Second St., Suite 500, Minneapolis, MN 55454, U.S.A.

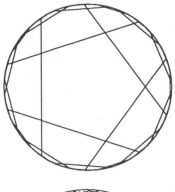

Fig. 2. A tiling of the hyperbolic plane, shown in the Klein model. All the pentagons shown here are congruent and right-angled. The sum of the angles of a hyperbolic polygon is always less than what it would be for a Euclidean polygon of the same number of sides, and the difference is equal to the polygon's hyperbolic area.

Fig. 3. The same tiling of Fig. 2, shown in the Poincaré disk model.

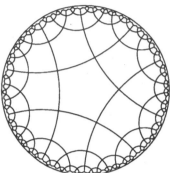

parallels to *L* through *P*, that is, lines that are coplanar with *L* but do not intersect it. (Sometimes only lines that meet *at infinity*, that is, on the circle that bounds the Klein model, are called parallel, while lines that meet outside infinity are called *ultraparallel*. I will not enforce this distinction.)

Although the Klein model is projectively correct—that is, it represents straight lines by straight lines—it distorts shapes drastically. As one moves away from the center of the disk, an object of constant hyperbolic size quickly starts looking very small in the model and also gets flattened against the edge. Figure 2 shows a number of identical regular pentagons, which tile the hyperbolic plane much as squares tile the Euclidean plane. The tile at the center appears much bigger than its closest neighbors, and just a few layers out the triangles are already too small to make out. The figure also makes clear how the Klein model

distorts angles: although all angles are exactly 90°, they appear different, depending on where they are and which way they face.

Another very useful model was invented by Poincaré [6]. It has the advantage of being *conformal*, that is, it preserves angles (exactly) and shapes of small objects (approximately). It, too, maps the hyperbolic plane onto the unit disk (or hyperbolic space onto the unit ball), and it represents hyperbolic lines by arcs of circles perpendicular to the bounding circle (or, as a particular case, by diameters), as seen in Fig. 3. It is easy to go from the Klein model to the Poincaré model and vice versa: to transform Fig. 2 into Fig. 3, for example, just map the point with polar coordinates (r,θ) to

$$\left(\left(1-\sqrt{1-r^2}\right)/r,\theta\right).$$

One advantage of working with a conformal model is that a single number expresses the ratio between apparent (Euclidean) size and true (hyperbolic) size for a small object. For the Poincaré ball model this ratio is $(1-r^2)/2$, where r is the distance to the origin in the model. For r close to 1 we have $(1-r^2)/2 \approx 1-r$, so that near the edge apparent sizes decrease in proportion to the apparent distance to the edge. Some calculus then shows that the true distance to the center grows logarithmically with the inverse of the apparent distance to the edge. This means that the circumference and the area of a circle centered at the origin increase exponentially with the radius.

SYMMETRIES AND TILINGS

Hyperbolic geometry has a rich group of symmetries (a *symmetry*, or *isometry*, is a transformation that preserves distance). This group is big enough to ensure that hyperbolic space is *homogeneous* (that is, all of its points are equivalent and can be mapped to one another by an isometry) as well as *isotropic* (all directions are equivalent). The two properties of homogeneity and isotropy are familiar from Euclidean geometry; they mean that it does not really matter where the origin is placed or which way the frame of reference faces.

In the Euclidean plane, orientation-preserving symmetries, or *rigid motions*, are of two types: translations and

Fig. 4. Circles centered at *P* are mapped to themselves by rotations around *P*. Notice that a hyperbolic circle in the Poincaré model appears round, although other shapes are preserved only approximately.

Fig. 5. The locus of points equidistant from a fixed hyperbolic line (heavier) appears as an arc of circle in the Poincaré model, but it does not intersect the edge orthogonally; therefore it is not a hyperbolic line. The points marked on the curves form two straight lines, one mapped to the other.

Fig. 6. Parabolic transformations preserve horocycles—circles that have one point at infinity—just as rotations preserve concentric circles and translations preserve curves equidistant from the axis.

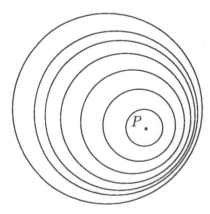

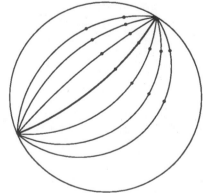

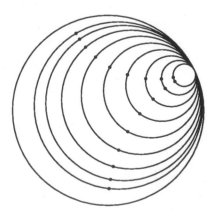

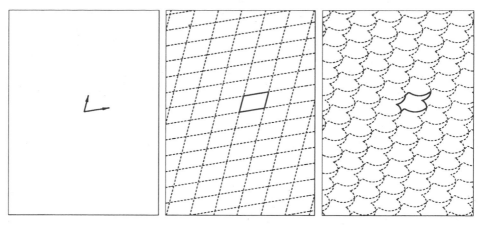

Fig. 7. Two Euclidean translations not in the same direction generate the group Z^2, because they commute. Here are two possible fundamental domains for the action of this group.

rotations. The two types are distinguishable because a rotation fixes some point, and a translation does not. In the hyperbolic plane, too, a rigid motion that fixes a point is called a rotation. A Euclidean rotation about the origin in the Poincaré model is a hyperbolic rotation; if we conjugate by a change of coordinates that takes the origin to some other point, we get a rotation around the other point. Figure 4 shows a family of concentric circles around a point P in the Poincaré model; each circle is mapped to itself by any rotation that fixes P.

There are also hyperbolic translations, but unlike their Euclidean counterparts, they do not displace all points by the same amount. Instead, there is a single line, called the *axis* of the translation, along which points move the least; the further one is from this line, the further one is displaced by the translation. The axis is the only straight line mapped to itself by the translation: curves equidistant to the axis also map to themselves (since translations preserve distances), but they are not straight lines, as can be seen in Fig. 5.

A third type of rigid motions of the hyperbolic plane has no Euclidean counterpart. They are called *parabolic transformations,* and they fix a single point on the circle at infinity, rather than two (like translations) or none (like rotations). A parabolic transformation is a limit of rotations whose fixed point goes to infinity, and also the limit of translations whose axis goes to infinity (so the two endpoints tend to a single point). Figure 6 shows the curves that are left invariant by a parabolic transformation; they are called *horocycles* and, like circles and equidistant curves, they appear round in the Poincaré model.

We are interested in *discrete subgroups* of the group of all hyperbolic (or Euclidean) isometries. This means that, given any point in the plane, the images of this point under the elements of the group do not crowd each other: there

are only a finite number of images inside a disk of any given radius. The group generated by a rotation by an angle of $2\pi/n$ radians is discrete (as is any finite group); the group generated by a rotation by an irrational multiple of 2π is not. In the Euclidean plane, the group generated by any two translations in different directions is discrete; the group generated by the three translations $(0, 1)$, $(1, 0)$ and $(\sqrt{2}, \sqrt{3})$ is not.

Discrete groups of symmetries are nice because they admit regular *tilings:* if we take a region of the plane having the right shape, and look at its images under the elements of the group, they tile the plane evenly. Such regions are called *fundamental domains.* For a group of Euclidean motions generated by two translations, a parallelogram whose sides correspond to the translation vectors is a fundamental domain. But so is a *curvilinear parallelogram,* like the one shown on the right in Fig. 7, so long as opposite edges match after the appropriate translation. In some sense the two tilings of Fig. 7 are equivalent, because they come from the same group of motions. (Formalizing this observation, and even the definition of a tiling, is not entirely trivial, since there are several natural notions of equivalence that one might use [7].)

Likewise, each fish in Color Plate G No. 1 is a fundamental domain for a certain group of hyperbolic motions, called (334), because it is generated by three rotations: two of order three (that is, through an angle of $2\pi/3$) and one of order four. The centers of these rotations are indicated in Fig. 8 by P, Q and R. A rectilinear fundamental domain can be obtained as the union of the triangle PQR, which has angles $\pi/3$, $\pi/3$ and $\pi/4$, and its image under reflection in any of the sides.

To specify a tiling, then, it is sufficient to give a group of motions and a fundamental domain that tiles under that

Fig. 8. Given a hyperbolic triangle of angles π/k, π/m and π/n, the rotations by angles $2\pi/k$, $2\pi/m$ and $2\pi/n$ around the vertices generate a group denoted by (kmn). Here are two possible fundamental domains for (334).

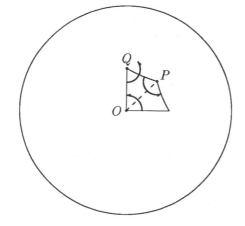
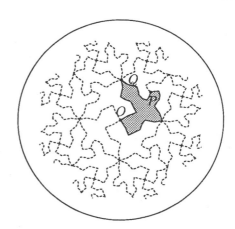

	a	A	b	B
1	2	3	4	5
2	2	0	4	5
3	0	0	4	0
4	0	3	4	5

Table 2. Transition table for the automaton that accepts shortest words for the hyperbolic symmetry group of Fig. 2. The same conventions are used as in Table 1.

	a	b	c	d	e
1	2	3	4	5	6
2	0	3	4	5	6
3	0	0	4	5	6
4	3	0	0	5	6
5	2	7	0	0	6
6	0	3	8	0	0
7	0	0	0	5	6
8	3	0	0	0	6

group. The group of motions is generally given by a *presentation:* a list of generators and a list of relations satisfied by them. I have implicitly used presentations in the two examples above. For the group of Fig. 7, I chose as generators the two translations shown on the left; if we call them *a* and *b*, a possible group presentation is

$$\langle a, b : aba^{-1}b^{-1} \rangle,$$

which means that the single relation $aba^{-1}b^{-1} = 1$ implies all other relations that hold between compositions of these generators; thus $aba^{-1} = b$, $ab = ba$, $aba = ba^2$, and so on. In particular, this group is abelian, that is, the order in which one multiplies two elements does not matter. (We nonetheless denote the composition law multiplicatively, for consistency with the general case.) Notice that there is a lot of arbitrariness in the choice of a presentation: we could have used $\alpha = a^{774}b^{82813}$ and $\beta = a^{619}b^{66229}$ as generators.

For the group of Fig. 8, a possible presentation is

$$\langle p, q, r : p^3, q^3, r^4, pqr \rangle,$$

where *p*, *q* and *r* are rotations by $\pi/3$, $\pi/3$ and $\pi/4$ around the points *P*, *Q* and *R*.

AUTOMATIC TILINGS

How does one create a tiling automatically? One answer involves the theory of *automatic groups,* developed over the last few years by Jim Cannon, David Epstein, Bill Thurston and others [8]. We assume that we have a single tile (fundamental domain), and a presentation of the corresponding discrete group of isometries. The point, then, is to make copies of the tile under the elements of the group. If the group is infinite, which is generally the interesting case, we need a cutoff criterion: for example, we may be interested in all the tiles that lie within some bounded set, such as the page. (A bounded set is one that can be enclosed in a box.) The problem is to enumerate the isometries that map the initial tile somewhere within this bounded set.

For a Euclidean tiling it is fairly simple to do this. For example, to generate the tilings in Fig. 7, I made a rough calculation of how many rows and columns of tiles would be enough to cover the picture and created the rows one by one, drawing one tile at a time within each row. (In computer jargon, I did the equivalent of two nested DO loops.) I then trimmed the picture at the edges, discarding those tiles that fell outside of the desired bounds.

The reason this works is that the group of isometries is abelian: in terms of the generators *a* and *b*, any element

of the group can be written uniquely in the form $a^m b^n$, for *m* and *n* integers. What I did was list the elements $a^m b^n$ for $-M \le m \le M$ and $-N \le m \le N$, after choosing large enough values of *M* and *N*.

In the hyperbolic case the enumeration is not so simple: we cannot use DO loops. A naive alternative would be to compute all products of two generators, then all products of three generators, and so on, until we run out of patience (or computer memory). More formally, this means listing all the words of up to a certain length on the alphabet consisting of the group's generators, and finding their images in the group under the natural homomorphism. (A *word* on an *alphabet* X is simply a finite sequence of elements of X. The set of words on X, which we denote by X^*, has a composition law given by juxtaposition, and an identity element given by the empty sequence. If the elements of X are taken from a group G, we obtain a homomorphism from X^* into the group by interpreting juxtaposition as group multiplication.)

This approach is wasteful because several different words can represent the same element in the group: for the group presentation given at the end of the previous section, the length-three words $ppp = p^3$, q^3, pqr, qrp and rpq all map to the same group element, the identity (which, moreover, is also represented by the word of length 0, that is, the empty sequence). There might be 500 elements of the group that move the initial tile by less than a certain distance, but we will have to compute many tens of thousands of words to find them. And, in all but very simple cases, things get exponentially worse as longer and longer words are considered.

What we need, then, is a way to identify exactly one word representing each element of the group. In the case of Fig. 7, as we saw above, such distinguished words might be exactly those of the form $a^m b^n$, for *m* and *n* integers. Actually, if *m* or *n* is negative $a^m b^n$ is not a word on the alphabet {*a, b*}; from now on, to avoid this sort of problem, we make the convention that if a letter is in our set of generators, so is its inverse, which we denote by the corresponding capital letter. In terms of the enlarged alphabet {*a, A, b, B*}, the distinguished words are those of the form $a^m b^n$ or $A^m b^n$ or $a^m B^n$ or $A^m B^n$, for *m* and *n* non-negative integers.

Of course, we could also take as distinguished words those of the form $b^m a^n$, etc.; any set of representatives would do just as well, so long as there is a well-defined procedure to determine whether or not a word belongs to the set. From now on we will work with minimal words in the so-called *short-lex*

order, that is, among all words representing a given group element, we choose the ones with minimal length, and, among those, we choose the first one in lexicographical order.

The set of short-lex minimal words has the important property that, if a word W belongs to it, so does every initial subword, or *prefix*, of W. Suppose that $W = UV$; if U is not short-lex minimal, there is some other word U' representing the same group element as U and coming before U in short-lex order. But then $U'V$ represents the same element as $UV = W$, and it comes before W, so W is not short-lex minimal.

If we have a procedure to recognize short-lex minimal words (from now on I will just call them minimal, without mentioning the order explicitly), we can easily list one word for each element of the group that satisfies some cutoff criterion, provided that the criterion is also preserved by prefix-taking (that is, if the group element represented by a string W meets the criterion, so do the elements represented by prefixes of W). The idea is that if we do a depth-first search, giving up on a particular branch whenever the corresponding element fails the criterion, we will not be missing any words that meet the criterion.

Strictly speaking, the criterion that interests us in generating hyperbolic tilings does not satisfy the condition of the previous paragraph. Recall that we have a discrete group of automorphisms of the unit disk, given by explicit generators. We want to obtain those elements that move the origin a distance at most r. It is not quite true that if (the symmetry represented by) a word W moves the origin by at most r, then so does any prefix of W. But there is some $R > r$ such that, if W moves the origin by at most R, any prefix of W moves the origin by at most r. So when we do our depth-first search, we lop off a branch when we get to an element that moves the origin beyond R, because we know that we will not come back any closer than r. Then we filter the elements obtained in this way, in order to throw out those that take the origin between r and R. This filtering process is similar to the trimming we did in the Euclidean case.

The last piece of the puzzle, then, is how to recognize minimal words. I should start by saying that it is not possible to do this for all groups; if it were, the word problem for groups would be always solvable, and that, as is well-known, is not the case [9]. But there is a large class of groups for which this is possible, the so-called *automatic groups*. (More precisely, the groups for which this is possible are called *short-lex automatic*, and are just a subclass of all automatic groups, but we will not worry about the distinction here.) Such groups are called automatic because information about them can be encoded in a *finite-state automaton*.

A finite-state automaton is a system that is always in one of a certain number of states, and moves from state to state according to instructions that are input into it. There are a finite number of possible instructions, and a finite number of states. Each time it reads an instruction, the system goes from its current state to some other (or the same) state, depending only on the current state and on the instruction. Two states are special: the *initial state* is where the system is before any instructions arrive, and the *reject state* is such that, if the system ever gets to it, it is stuck there forever, no matter what input it receives.

Now if a group, with a certain set of generators, is automatic, there is an automaton that recognizes exactly those sequences of generators (words) that are minimal in the sense above. By 'recognize' I mean the following: the automaton's instructions are the generators of the group. A

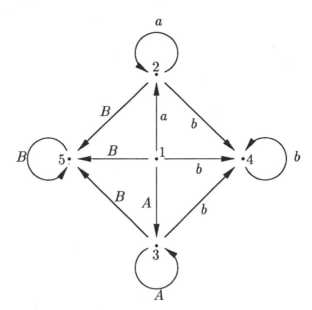

Fig. 9. This is the word-accepting automaton for the group given by presentation (1). It accepts exactly those words that are minimal representatives (in short-lex order) of their group elements.

word is read by the automaton one generator at a time, causing it to go from state to state. If the reject state is ever reached, the word is rejected. If the whole word is read without the reject state being reached, the word is recognized, or accepted.

As a simple example, consider the abelian group underlying the tiling of Fig. 7; a presentation for it, as we have seen, is given by

$$\langle a, A, b, B : aA, bB, abAB \rangle \qquad (1)$$

(remember that we want generators to appear in pairs with their inverses). A word-accepting automaton for this group is shown in Table 1.

Each row corresponds to a state, and each column after the first to a generator. The initial state is 1, and the reject state is 0 (row 0 need not be written down: it consists of 0's only). To test a word like $aabAB$, we start in state 1 and look up a; the table tells us to go to state 2. Another a causes us to remain in state 2, then b takes us to state 4. From there A takes us to state 0. Since we have hit the reject state, we can stop: we know that the word $aabA$ is not minimal, and consequently neither is $aabAB$. (It is easy to see that ab is a shorter word representing the same group element as $aabA$.)

Uncomplicated finite-state automata can be neatly depicted as graphs, with nodes representing the states and oriented edges (arrows) representing the transition. Each arrow is labeled by an instruction. Normally the reject state and arrows leading to it are not drawn, a convention that makes graphs considerably less messy. Figure 9 shows the graph for the automaton of the previous paragraph. From the figure it is easy to recover the general form of a minimal word, discussed earlier in this section: something of the form $a^m b^n$ or $A^m b^n$ or $a^m B^n$ or $A^m B^n$.

A less obvious example is given by the pentagon group underlying the tiling of Fig. 2, a presentation of which is

$$\langle a, b, c, d, e : a^2, b^2, c^2, d^2, e^2, abab, bcbc, cdcd, dede, eaea \rangle.$$

Geometrically, the generators represent reflections in the sides of a pentagon. The first five relations, $a^2 = 1$ and so on,

translate the fact that reflections have order two, and the other five, *abab* = 1 and so on, translate the fact that reflections in adjacent sides commute (the sides meet at right angles). A word-accepting automaton for this group is shown in Table 2.

Each row corresponds to a state, and each column after the first to a generator. Again, the initial state is 1, and the reject state is 0. Since *a, b, c, d, e* have order two, they equal their own inverses; otherwise there would be columns for the inverses *A, B, C, D, E* as well. The table tells us that *dbc*, for example, is not minimal: starting from state 1, we move to 5 under the action of *d*, then to 7, then to 0. One can work out that *dbc* equals *dcb* equals *cdb*, which comes first in lexicographical order; but it is not nearly as obvious as in the abelian case that this automaton really does describe the group.

It is even less obvious how to obtain the word-accepting automaton in the first place, given a group presentation. In the last few years, algorithms have been developed to do this [10], but it must be emphasized that they are not guaranteed to give a result; sometimes a result does not exist (if the group is not automatic), and, even if it does, the computational effort needed to arrive at it may be unimaginably great. David Epstein and his associates have written a CWEB program, called 'automata', that implements the best-known algorithms and works very well for surface groups like the ones discussed in this article; but groups of hyperbolic three-manifolds, for example, are outside its reach at the time of this writing [11].

I conclude with a basic *Mathematica* program [12] that takes a set of generators **gen**, a word-accepting automaton **wa** and a cutoff criterion **cutoff**, and returns a list of all the elements of the group satisfying the cutoff condition:

```
doit[element_,state_,{gen_,wa_,cutoff_}] :=
  Prepend[
    Cases[Range[Length[gen]],
      j_?(wa[state,#] !=0 && cutoff[element.gen[[#]]]&):>
        doit[element.gen[[j]], wa[state,j]]],
    element]
doit[identity,1,{gen,wa,cutoff}]
```

The group composition law is expressed here by the operator '.', which is appropriate if the generators are given as matrices (in the projective model of hyperbolic space, for example). Thus, if there are five generators as in the case of the pentagon group above, **gen** would be given by a list of five 3×3 matrices:

```
gen = {
  {
    {-0.89443, 1.37638, 1.30170},
    { 1.37638, 0,       -0.94574},
    {-1.30170, 0.94574, 1.89443}
  },
  (* four more generators go here *)
}
```

The word acceptor **wa** is stored as a function with two indices: the state and the number of the generator. Again using the pentagon group as an example, with generators numbered 1 through 5 instead of labeled *a* to *e*:

```
fsa[1,1]=2;fsa[1,2]=3;fsa[1,3]=4;fsa[1,4]=5;fsa[1,5]=6;
fsa[2,1]=0;fsa[2,2]=3;fsa[2,3]=4;fsa[2,4]=5;fsa[2,5]=6;
(* six more lines corresponding to states 3 to 8 *)
```

The cutoff condition is a rule that examines a group element and returns **True** or **False**. If group elements are projective matrices, we might write, for example,

```
cutoff[x_] := x[[3,3]] > 15.
```

(This was the criterion used to generate Fig. 2.)

The call **doit[element,state,{gen,wa,cutoff}]** performs a depth-first search, looking at each generator in turn. It checks if the generator, composed with the current **element**, still satisfies the cutoff criterion. If not, or if the generator would send the automaton to the reject state, the generator is forgotten. Otherwise **doit** is called again recursively, with **element** replaced by its composition with the generator, and 'state' replaced by the new state.

The way to start the process is to say

```
doit[identity,1,{gen,wa,cutoff}],
```

where 1 indicates the initial state and **identity** represents the identity of the group; for example,

```
identity=IdentityMatrix[3]
```

if we are using matrices.

References and Notes

1. See, for example, M. C. Escher, *The Graphic Work of M. C. Escher* (New York: Gramercy, 1984); and H. S. M. Coxeter, M. Emmer, R. Penrose and M. Teuber, eds., *M. C. Escher: Art and Science* (Amsterdam: North-Holland, 1986).

2. D. Dunham, "Creating Hyperbolic Escher Patterns", in Coxeter et al. [1] pp. 241–248.

3. H. S. M. Coxeter, "The Non-Euclidean Symmetry of Escher's Picture 'Circle Limit III'", *Leonardo* **12**, No. 1, 19–25 (1979); M. Emmer, *M. C. Escher: Geometries and Impossible Worlds*, 16mm film, 27 min (Rome: FILM 7 Int., 1984). Coxeter explains in the movie the structure of Escher's series *Circle Limit*.

4. For more extensive historical notes and references to the original sources, see H. S. M. Coxeter, *Non-Euclidean Geometry*, 5th Ed. (Toronto: Univ. of Toronto Press, 1965).

5. E. Beltrami, "Risoluzione del problema di raportare i punti di una superficie sopra un piano in modo che le linee geodetiche vengano rappresentate da linee rette", *Annali di Matematica*, Series 1, **7** (1866) pp. 185–204.

6. H. Poincaré, "Théorie des groupes fuchsiens", *Acta Mathematica* **1** (1882) pp. 1–62.

7. See, for example, Marcel Berger, *Geometry* (Heidelberg: Springer, 1987); and Branko Grünbaum and G. C. Shephard, *Tilings and Patterns* (New York: Freeman, 1987).

8. D. B. A. Epstein, Jim Cannon, Silvio Levy, Derek Holt, Mike Patterson and William Thurston, *Word Processing in Groups* (Boston, MA: Jones and Bartlett, 1992).

9. P. S. Novikov, "On the Algorithmic Unsolvability of the Word Problem in Group Theory", *Amer. Math. Soc. Transl.*, Series 2, **9** (1958) pp. 1–122.

10. See Epstein et al. [8]; and D. B. A. Epstein, D. F. Holt and S. E. Rees, "The Use of Knuth-Bendix Methods to Solve the Word Problem in Automatic Groups", *Journal of Symbolic Computation* **12** (1991) pp. 397–414.

11. The 'automata' program is available free of charge. For more information about 'automata', contact David Epstein, Maths Institute, University of Warwick, Coventry, CV4 7AL, U.K., or Silvio Levy, Geometry Center, University of Minnesota, 1300 S. Second St., Minneapolis, MN 55454, U.S.A. To contact them through electronic mail, use <dbae@geom.umn.edu> for Epstein and <levy@geom.umn.edu> for Levy.

12. S. Wolfram, *Mathematica: A System for Doing Mathematics by Computer*, 2nd Ed. (Reading, MA: Addison-Wesley, 1991); S. Levy and T. Orloff, "Automatic Escher", *The Mathematica Journal* **1**, No. 1, 34–35 (1990).

TEMPER: A System for Music Synthesis from Animated Tessellations

*Goffredo Haus and
Paolo Morini*

THE QUESTION OF PAINTING AND MUSIC

Much literature has been written and many works have been completed in the area of audio-visual composition and performance. Most of these works start with the implicit assumption that sound and images can run concurrently without any kind of interaction and correlation. Usually only the synchronization of elements in time—sound linked with video or film—is attempted. However, there are a number of works that, while not specifically devoted to audio-visual objectives, have given more importance to correlating graphic and musical information, such as work involving the graphic representation of musical information, either to define notational systems [1] or to automatically produce traditional [2] or auditory [3] scores. In this article, we use the term 'traditional score' when referring to a common music notation score; and the term 'auditory score' when referring to a kind of music notation used to help listeners understand musical sequences and structures—particularly when the music either cannot be or is not represented by means of a traditional score (e.g. electronic, computer, ethnic musics).

Some of Kandinsky's written works are illuminating with respect to analogies between graphics and music [4]. Several articles published in *Leonardo* provide rich overviews of work in music visualization [5]. The stimulating work of Whitney [6] involves the synthesis of audio-visual processes, with a high correlation between auditory and visual aesthetic information. The work of Brian Evans is also significant in this field [7]. In addition, paintings have inspired the structure of music in many works: in the work of Cervetti, paintings by Bosch are depicted in music [8]; in the work of Brecker, the structure of a painting by M. C. Escher determines the process with which one rhythmic pattern gradually transforms into a second one [9]. Yet other works are based on fractals as the generative structures both for graphics and music.

Our research can be considered within the framework of the works we have mentioned, but our aim is to go beyond the traditional; we wish to investigate several kinds of aesthetic expressions—literature, painting, music, architecture and other forms of art—in order to find out if common structures exist among them. Our ultimate goal is the definition of a knowledge base suitable for the description of multimedia compositions and performances in which there is a high level of correlation among different media.

We conducted a series of experimental works devoted to building our knowledge base. Some of our experiences bear mentioning: in one work, the metric-rhythmic structure underlying the dialog between Othello and Iago in Shakespeare's *Othello* was translated into music; another project involved the development of the computer program Traslitteratore [10], which allows the translation of any literary text (i.e. any text file) into a musical composition that respects metrics and accentuations of natural language. Other projects are in progress: for example, data received from the galaxy UGC 9567 have been translated into sound by means of temporal compression and the application of suitable scale factors for amplitude and frequency values [11]. All of this work concerns correlations between graphic animation and musical processes.

Within the framework of our general project for the definition of a knowledge base, we are concentrating on flows and limits in the process of aesthetic perception. A central point in the design of new kinds of aesthetic works is certainly the definition of suitable audio-visual 'stews'. Viewers must not be bored by information flows that are either too poor or too repetitive (which is the same), or overwhelmed by too rich or too varied an informative flow [12]. Our working hypothesis is that the whole audience can enjoy the audio-visual work only if the quality and quantity is within a certain range, which may vary from individual to individual but cannot exceed certain limits. Note that even

ABSTRACT

The authors discuss the results of research carried out since 1987 at Laboratorio di Informatica Musicale (LIM) involving the association of graphics and music, with special attention to drawings based on tessellations. After a theoretical investigation primarily devoted to the creation of a conceptual framework, the authors developed a prototypal computer program, TEMPER. This program allows for the editing of tessellations and for the definition of performance paths that include the animation of tessellations and the synthesis of music

Goffredo Haus (researcher), Laboratorio di Informatica Musicale, Dipartimento di Scienze dell'Informazione, Università degli Studi di Milano, via Comelico, 39, I-20135 Milan, Italy.

Paolo Morini (researcher), Laboratorio di Informatica Musicale, Dipartimento di Scienze dell'Informazione, Università degli Studi di Milano, via Comelico, 39, I-20135 Milan, Italy.

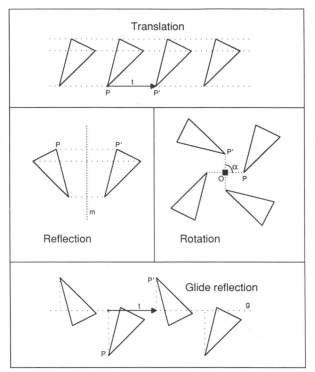

Fig. 1. Examples of the four symmetry operations allowed in the plane. Each point in the plane is transformed into another (for example P into P′) by the symmetry operations; these are outlined by the vector t for the translation, the mirror line m for the reflection, the angle α for the rotation and the mirror line g together with the vector t for the glide reflection. The illustrations for the translation and glide reflection operations should be considered as infinitely and repeatedly extended in the direction of the vector t.

when the quantity of information given to members of an audience is equal, receiving capabilities may differ, depending on qualities of the information itself. A trivial but effective example would be that the same phrase, expressed in different natural languages, is of quite different value depending on the listener's mother-tongue. In other words, we think that the design of audio-visual works may be regarded as a kind of qualitative and quantitative 'information-flow engineering'.

CORRELATIONS BETWEEN GRAPHICS AND MUSIC

We are interested in a special kind of graphic process known as *tessellations,* or tilings—drawings made up of one or more shapes that fill the plane without gaps between them when appropriate symmetry operations such as rotations, reflections and translations are applied to them. Drawings of this kind are well known in the works of Dutch artist Escher [13–15].

From a certain point of view, tessellations show surprising affinity to musical pieces; in particular, graphic symmetry operations are closely related to common musical operations: there are mirror-like musical pieces that are similar to graphic reflections, tonality transposition and time repetitions in music that are similar to translation, cyclic tonality changes that recall rotations, and so on [16].

We were interested in checking to see if these affinities

are only superficial or if they have deeper roots. If the latter, we also wanted to discover if it is possible to associate a tessellation to a musical piece. If so, then we wanted to know if this association would correlate the artistic contents of the graphics with the music; last, we wished to investigate whether this process can be enacted by a computer program.

In dealing with these problems, we intended to obtain a work that presented a solid theoretical base as well as practical results. This requirement brought some additional difficulties, so that some ideas were temporarily shelved because of implementation problems. On the other hand we discovered things not strictly linked to theory. We accompanied these studies with a program; our aim was not only to obtain a practical demonstration of the theory, but also to develop a graphic and musical instrument that can actually be utilized for audio-visual performances [17].

Gathering together practical and theoretical requirements, we mainly followed these development guidelines:

1. The association between graphic and musical elements should be attempted only from graphics to music. The reverse, or a one-to-one correspondence, is possible, but could not easily be done in a proper manner because of quantizing problems.

2. Graphic-to-music transformation must be done according to an exact function, whose behaviour can be modified by the 'composer' through special parameters. There should not exist any casualness in the transformation; neither should it be possible to work on the music independently from the graphics.

3. The association should be easily perceived by the audio-visual observer; therefore it is important to note the limitations of the human brain relative to the capabilities of perception, abstraction and concentration.

4. The software should be able to perform the graphics and music in real time; only in this manner is it possible to obtain results that can be utilized for a demonstrative or artistic purpose.

Tessellations

The graphic side of our work consists of the study of tessellations. In particular we considered a kind of tessellation called *isohedral*. A tessellation can be obtained through the partition of an unlimited plane in sets of limited and connected points, so that every point in the plane belongs to one and only one set. From a graphic point of view every set is a shape; if all the shapes on the plane are directly or reflectively congruent—that is, they can be superimposed by an isometry—the tessellation is said to be monohedral; if, on applying the isometry needed to superimpose any two shapes, the whole tessellation superimposes on itself, then the tessellation is isohedral.

For the study of tessellations, we used the crystallographic theory of symmetry groups [18]. The details can be found in several publications, but we will point out here that in accordance with this theory we start from the concept of isometry [19], the operation that relates two congruent objects in the space. An isometry is called a symmetry operation if it can be applied to the whole space instead of to a single object, that is, if the spaces before and after the application of the isometry are identical.

There are only four kinds of symmetry operations in the plane: translations, reflections, rotations and glide reflections (Fig. 1). The combination of two symmetry operations is another symmetry operation; so interaction between a set

of operations generates other operations—however, there are limits on the kinds of operations possible. For tessellations, it is compulsory to have two non-parallel translation operations because otherwise it would not be possible to fill up the plane.

As a result of these considerations, there are 17 allowed combinations of symmetry operations. It is possible to demonstrate that every set of allowed symmetry operations, joined to the binary operation of composition (that yields another symmetry operation), forms a group (in the mathematical sense of the word). For this reason these combinations are named symmetry groups [20]. The ones in which we are interested are called bidimensional (with exactly two translations) and monochromatic (no symmetry operations will change the shapes' colour).

This leads to an important demonstration: to any isohedral tessellation we can apply all the symmetry operations in one of the 17 bidimensional monochromatic spatial groups. We say that the tessellation belongs to that symmetry group [21,22].

To define a tessellation we first need a shape and a group of symmetry operations. But we have some more points to develop. It is obvious that a generic shape cannot belong to any group; hence it is not easy to build a tessellation starting from an isolated shape. Besides, every attempt to modify a shape to fit to the adjacent one will also modify all the other shapes, creating holes that are difficult to fill.

Furthermore, consider the fact that the border of a shape is also part of the border of the adjacent one; we call the common border between two adjacent shapes a *side,* and we call the ends of sides *vertices.* Sides join only in vertices, and three or more sides necessarily join in a vertex. It is easy to find out that two tessellations belonging to the same symmetry group can be topologically different—that is, we cannot stretch one into the other. There are 81 different ways to build topologically distinct tessellations, as is shown in a study by Grünbaum and Shephard [23].

We looked for and found a method, suitable to be implemented on a computer, to facilitate the building of tessellations. We start from a set of 81 models of tessellations, supplying a single shape that is a simple example for every scheme; then we allow the sides of this shape to stretch. In fact, it is enough to stretch only some parts of the sides, because the other parts are obtained by transpositions; every stretch of a part should be reproduced on all the parts of the sides that can be reached through the application of a symmetry operation. Because this mechanism does not modify the symmetry operations, the shapes so obtained necessarily belong to the same tessellation schema and can then tile the plane.

The information needed to maintain this kind of formulation belongs to five hierarchically ordered categories:

Symmetry group: one of the 17 bidimensional monochromatic spatial groups.

Tessellation scheme: one of the 81 isohedral tessellation schemes, chosen in accordance with the symmetry group.

Translation vectors: the two vectors corresponding to the shortest symmetry operation of non-parallel translation, defining the scale and the orientation of the tessellation. Some symmetry groups impose bounds on the ratio length of the vectors and on the angle subtended by them.

Vertices: the joining points of sides of adjacent shapes; the symmetry group and translation vectors impose bounds on the vertices' reciprocal position.

Sides: the lines defining a path between the adjacent vertices of a shape. Some parts are defined by a symmetry operation applied on another part; the independent parts are free from bounds, even if in special cases crosses and coincidences of sides cause the main shape to break into several.

This method proved to be particularly suitable to build tessellations; the 'weft' of the symmetry operation is implicit (in a computer program it is automatic); therefore it is possible to concentrate on the shape to be built without wasting attention on its insertion into the whole drawing.

The Graphics and Music Connection

The main problem was how to associate graphic and musical elements. To settle the question with a correct theoretical approach and at the same time with an association that is

Fig. 2. A three-step transformation from birds to winged horses (shapes are inspired by Escher's works) performed by the TEMPER program. Notice that lines that appear curved are in fact composed by short straight segments.

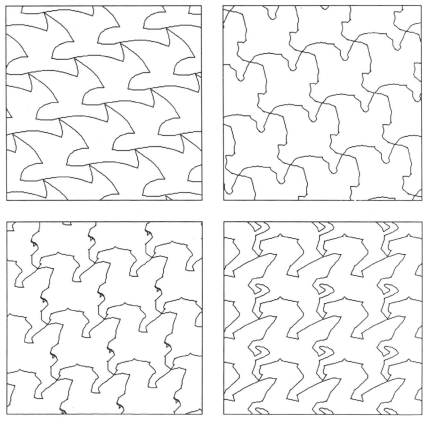

not too hidden to an observer-listener, it was necessary to begin a study of the nature of graphics observation and music listening.

The first phase of this study was an analysis of the dimensions defining graphic and musical spaces; the decomposition into dimensions can be made in several ways, but we thought that every attempt should fall within one of the following ways:

Spatial: the events to be examined are simple elements (i.e. points and segments in graphics; notes in music); these elements have to be lying on a coordinate system such as a bidimensional plane in graphics or time and pitch in music.

Functional: the events to be examined are complex elements on which compositional and transformational functions can operate; examples of this kind of function could be symmetry operators in graphics, or transposition and mirroring in music.

After an opportune choice for the decomposition of the two representational spaces is made, it is necessary to establish pairs between the chosen dimensions, so that a given event in a space can be translated into a corresponding event in the other space only by transforming its coordinates. The choice of dimensions and the coupling of them is without doubt the most critical phase of the whole work because it defines the transformation between graphics and music; so the results strictly depend on these choices.

At this point we met a serious problem: how to treat the temporal dimension. In fact this dimension is usually absent in graphic work (except for subjective aspects), while it is a fundamental component in music. This difference is the main cause of the dissimilar kinds of mental images that form in our minds in the two cases. Since one of our aims is to make as evident as possible the association between graphics and music, a careful examination of the temporal question is needed.

To properly treat the temporal dimension, it is necessary to balance the quantity of information contained in the graphics and music, relative to the capabilities of the human brain receiving this information, and to compare it with previously received information. This balancing operation is difficult and delicate because reception capabilities [24] and short-term associative memory have dissimilar characteristics for visual and auditory information.

In accordance with the work's requirements, and bearing in mind the problems previously illustrated, we had to make some decisions about which methods to use for the association of graphics and music.

In deciding between the spatial or functional approach, we chose the former for several reasons:

1. The functional approach is surely more significant; indeed it is related to the spatial one as semantics is to syntax; nevertheless this advantage works against itself for the more complex and less intuitive association.

2. Operations work on composite entities that cannot be directly associated with a single musical event; therefore a second level of interpretation is necessary for every entity. For this step the spatial approach becomes indispensable.

3. A translation made with the spatial approach will implicitly reflect the behaviour of the operations that define the functional approach; without recognizing the underlying structure, every element of original and transformed entities is translated in the same way.

For these reasons the results of a spatial approach are simpler than the results of a functional approach, without a notable loss of significance.

Following the choice of adopting the spatial approach it was compulsory to use horizontal and vertical dimensions to define the drawing plane, and to associate these dimensions with tempo and pitches, respectively. The result is a scan of the plane from left to right; graphic elements are translated into musical ones as they are touched by the scan; the higher the graphic element in the drawing, the higher the pitch of the note generated.

This solution could seem oversimplified, but the pairing of dimensions obtained a good balance of graphic and musical psychoperceptive aspects. Indeed we notice that an observer of a graphic work usually considers it more natural to find the more solid objects in the lower part of a drawing, because it creates a feeling of gravity and, from a musical point of view, low-pitched notes give a heavier feeling.

Another important consideration was that horizontal time scanning could be made from right to left, although, for Western people, reading from left to right (including musical staves) is a more natural motion [25–27].

We have yet to define the graphic elements necessary to be translated. In accordance with the spatial approach, these elements are the strokes of the drawing, that is, the sides of the tessellating shapes. But if we notice that music is commonly perceived as a sequence of discrete events (notes), not as a continuously varying sound [28], a better choice is to consider the sides made up only of broken lines; then their vertices can easily be associated with single discrete musical events. Therefore a curved line should be approximated by a sequence of straight segments.

All these choices express the metaphor of the melodic line (a graphic word—line—for a sequence of notes) in a way that calls to mind the musical stave. This means that the interpretation of the music generated by tessellations is not dissimilar to that used by musicians performing a piece, so the brain can apply a well-stated mechanism.

In addition, we considered it to be of great importance to define the musical scale used during translation, that is, which pitch values correspond to the scale degrees, or notes. It is useful to note that for music, once the key or tonality with which one is playing is fixed, every degree does not have the same importance. We can roughly set two groups: pitches inside and outside of the scale. The latter are generally used only as intermediate notes, because otherwise they could easily result in unpleasant dissonance. To further justify this choice we note that there are instruments, especially the wind instruments, that are tuned in a particular tonality, and that even common music notation makes a distinction between pitches inside the scale and outside the scale, specifying the second pitches with special symbols like sharps and flats.

We have yet to solve the problem of the temporal dimension: left-to-right scanning is a valid choice, but it is usually completed in too short a time to provide a feeling of completion. Rather, the corresponding graphics are generally perceived as the finished work. This causes a lack of balance in informational content.

To eliminate this problem we decided not to use a fixed image, but, rather, to gradually transform one tessellation into another one with a sequence of intermediate tessellations. In this way the graphics are supplied with a temporal dimension comparable to the musical one, since a still image

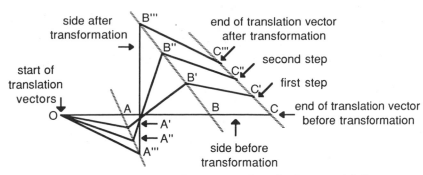

Fig. 3. The transformation function: a three-step transformation from a straight line to a three-segment broken line. The relative length of the segment OA with respect to the total length of the broken line OC is the same as the length of the segments OA′, OA″ and OA‴ with respect to the lines OC′, OC″ and OC‴, respectively. The same relationship applies to all the corresponding segments within the broken lines.

is changed into a slow animation, whose steps are scanned from left to right at a constant speed. The contemporaneous performance of sequences of tessellations and of the corresponding sequences of notes result in a greater feeling of completion and satisfaction.

For this purpose we studied a special transformation function that acts on the sides (broken lines) of the tessellations. This function is able to continuously generate tessellations between any two tessellations; therefore it is possible to execute a gradual transformation (with the required number of intermediate steps) from one tessellation to a second one, from the second to a third, and so on (at this point the function applies only to tessellations of the same tessellation scheme). The quality of the transformation function was also evaluated in an experimental way, by observing the sequence of steps produced. Our aim was to avoid a feeling of variation in speed or discontinuity in motion (Fig. 2).

The transformation function is based on a linear interpolation of a pair of points belonging to the corresponding sides of the starting and final tessellations. One of these points is a vertex of the broken line defining a side; the other point lies on the other side at the same distance, measured relative to the total length of the lines (Fig. 3).

A CASE STUDY: THE TEMPER PROGRAM

Based on the theoretical work described above we developed a computer program named TEMPER (TEssellating Music PERformer). We gave priority to the musical aspects, which are the more original parts of the work, rather than to the graphics, which reflect already existing theories. Therefore at present only one of all the possible schemes of tessellations is implemented: the one with four-sided shapes joined in vertices and with no symmetry operations other than two translations (symmetry group 'p1' [29], tessellation scheme 'IH41' [30]).

The program consists of two logical sections: (1) A *graphics editor,* which allows one to build, save and modify tessellations composed of translation vectors with broken lines as sides. The tessellations are organized in an ordered sequence; every sequence can be saved on mass storage. (2) A *performer* of sequences of tessellations, which shows on the screen every step of the transformation between the first and the second tessellations, according to the tempo required;

this is immediately followed by the transformation between the second and the third tessellations, and so on until the end of the sequence. When the scanning of a step reaches a vertex of a side that is required to be translated into music, a note is generated according to the musical parameters supplied.

To improve the capabilities of the program, some user-defined parameters are supplied to change the behaviour of the translation function; a group of parameters is associated with every tessellation in the sequence. Such parameters are divided into three groups:

Temporal parameters: these parameters allow one to set the speed of the graphic transformation and, as a consequence, the tempo of the music generated; it is possible to specify the number of steps to be shown and the time required to scan every step.

Scale parameters: these parameters make it possible to decide which musical scale and tonality to use and which pitch interval should relate to a certain variation in the height on the drawing.

Voice parameters: these parameters permit one to choose which sides should contribute to sound generation; a distinct voice can be assigned to every side to obtain polyphonic and polytimbric effects. For instance, it is possible to assign two voices, one with a melodic function and one with a rhythmic function, to different sides, or to assign two voices repeating the same melodic line with a fixed delay. Changing voices could completely change the perception of a musical piece.

Sound generation is carried out by external devices such as synthesizers and samplers, driven by a Musical Instrument Digital Interface (MIDI).

CONCLUSION

Musical performances produced by TEMPER were encouraging, because the pieces were often pleasant. We experimented with varying the available musical parameters on the same sequence of tessellations to obtain significant technical and aesthetic differences. Through careful choice of parameters, every tessellation produced satisfactory melodies. This result was surprising considering the low level of musical knowledge included in the program, however, it was justified, considering the characteristics of the drawings.

It would be a mistake to think that a translation between tessellations and music, carried on in the manner described in these pages, produces a sequence of disconnected notes. Music generated from a drawing will reflect certain characteristics in the musical structure; if we analyze these characteristics we will find properties that are usually found in musical pieces.

Periodicity is a constant factor in the tessellations. For musical pieces, the concept of period is fundamental, too, in reference either to time—supplying rhythmical bases—or to pitch—allowing existence of harmony (e.g. octave repetitions and frequency ratio). It is not an accident that the association of graphic, musical and temporal dimen-

sions involves the pairing of periodic elements. The result is that musical pieces generated by tessellations in this way are to our ears rhythmic and harmonic.

Furthermore we consider it significant that we obtained interesting musical pieces from drawings created only for graphic purposes. On the other hand, we successfully treated strictly geometric tessellations; in this case the variety of shapes and melodies produced is surprising, even if the drawings are very simple and defined by a mimimum of information.

As a related result, we have noticed that when we set the transformation speed at a high value, we obtain an animation (i.e. we cannot distinguish between one frame and the following one), however, we cannot concurrently synthesize music due to the excess amount of musical information produced with this method.

We have recently proposed audio-visual works made by TEMPER to be used in the context of multimedia performances; we wish to continue this activity to better understand TEMPER's potential and to improve its functions. Many audio-visual works and performances have to be created with the fundamental involvement of a new kind of artist—a creator of both music and graphics.

Acknowledgments

Many thanks are due to Antonio Rodriguez for the constructive discussions we have had and to the Laboratorio di Informatica Musicale staff for the scientific and technical support provided. This project has been partially supported by the Italian National Research Council in the frame of the LRC C4 MUSIC: "Intelligent Music Workstation", Subproject 7 "Support Systems for Intellectual Activities", Finalized Project "Computer Systems and Parallel Computing".

References and Notes

1. G. Ligeti, "Artikulation", *Elektronische Music: Eine Hornpartitur von Reiner Wehinger* (Cologne: Schott, 1958).

2. B. Galler, M. Piszczalski, "Automatic Music Transcriptor", *Computer Music Journal* 1, No. 4, 24–31, (1977).

3. G. Haus, "EMPS: A System for Graphic Transcription of Electronic Music Scores", *Computer Music Journal* 7, No. 3, 31–36 (1983).

4. W. Kandinsky, *Point and Line to Plane* (New York: Museum of Non-Objective Paintings, 1947).

5. B. M. Galeyev, "The Fire of Prometheus: Music-Kinetic Art Experiments in the USSR", *Leonardo* 21, No. 4, 383–396 (1988); K. Peacock, "Instruments to Perform Color-Music: Two Centuries of Technological Experimentation", *Leonardo* 21, No. 4, 397–406 (1988); and L. Pocock-Williams, "Toward the Automatic Generation of Visual Music", *Leonardo* 25, No. 1, 29–37 (1992).

6. J. Whitney, *Digital Harmony* (Peterborough, NY: McGraw-Hill, 1980).

7. B. Evans, "Relazione tra matematica e arte: sentire e vedere i numeri", in M. Emmer, ed., *L'occhio di Horus: Itinerari nell'immaginario matematico* (Rome: Istituto dell'Enciclopedia Italiana, 1989) pp. 243–249. See also in this issue: B. Evans, "Number as Form and Content: A Composer's Path of Inquiry".

8. S. Cervetti, *The Hay Wain* (Periodic Music: compact disc (CD) PE-1361).

9. M. Brecker, *Now you see it . . . (Now you don't)* (GRP Records: compact disc (CD) GRD-9622, 1990).

10. P. Morini and A. Rodriguez, "The Power of Metaphors", *Wheel for the Mind Europe* 2 (1988) pp. 34–39.

11. See Morini and Rodriguez [10].

12. A. Moles, *Théorie de l'Information et Perception Esthétique* (Paris: Flammarion, 1967).

13. J. L. Locher, ed., *The World of M. C. Escher* (New York: Abrams, 1972).

14. *M. C. Escher's Universe of Mind Play* (Tokyo: Odakyu Department Store, 1983).

15. H. S. M. Coxeter, M. Emmer, R. Penrose and M. Teuber, eds., *M. C. Escher: Art and Science* (Amsterdam: North-Holland, 1988).

16. Pozzi Escot, "The Hidden Geometry of Music", *Proceedings of 5th Colloquio di Informatica Musicale* (Ancona, Italy: Università di Ancona, Dipartimento di Elettronica e Automatica, 1983) pp. 343–390.

17. P. Morini, "Interpretazione Musicale di Divisioni Regolari del Piano", master's thesis in computer science, Università degli Studi di Milano, 1986–1987.

18. The crystallographic theory of symmetry groups is based on the mathematical concepts of 'isometry' and 'group'; the term was introduced by crystallographers to classify crystal models. It is a system used for classification of all the different symmetry models in *n*-dimensional spaces. For more information, see *International Tables for X-Ray Crystallography I* (Symmetry Groups) (Birmingham: Kynoch Press, 1952).

19. I. M. Jaglom, *Geometric Transformations* (New York: Random House, 1962).

20. E. H. Lockwood and R. H. McMillan, *Geometric Symmetry* (Cambridge: Cambridge Univ. Press, 1978).

21. C. H. MacGillavry, *Fantasy and Symmetry—The Periodic Drawings of M. C. Escher* (New York: Abrams, 1976).

22. D. Schattschneider, *Visions of Symmetry: Notebooks, Periodic Drawings and Related Work of M. C. Escher* (New York: Freeman, 1990).

23. B. Grünbaum and G. C. Shephard, "The 81 Ways of Plane Isohedral Tilings", *Mathematical Proceedings of the Cambridge Philosophical Society* 82 (1977) pp. 177–196.

24. D. Deutsch, ed., *The Psychology of Music* (Orlando, FL: Academic Press, 1982).

25. See Ligeti [1].

26. See Haus [3].

27. See Kandinsky [4].

28. See Moles [12].

29. See Lockwood and McMillan [20].

30. See Grünbaum and Shephard [23].

Compound Tilings and Perfect Colourings

J. F. Rigby

ABSTRACT

This article is mainly concerned with visual mathematics: the delight of regular colourings of patterns and the way in which shapes (some of them strange) fit together. A regular tiling, such as the tiling of squares or of equilateral triangles, is made up of regular shapes fitting together in a regular way. It is sometimes possible to combine a number of regular tilings to make a regular compound tiling: imagine the tilings drawn on transparent sheets and laid on top of each other. There is a close connection between regular compound tilings and tilings in which the tiles are coloured to form an orderly, regular pattern. But regularly coloured tilings, usually called perfect colourings, are not always associated with regular compounds in the normal sense. The author's discussion of the hyperbolic plane encourages the reader to contemplate tilings made up of tiles that are not regular, or made up of tiles that are regular but infinite and much more complex than the regular polygons of elementary geometry.

REGULAR TILINGS

Figure 1a shows the familiar tiling, or tessellation, of a plane surface by squares. (In this figure and in many of the figures in this article, tilings must be regarded as extending to infinity; only small portions of them can be shown.) The squares are the *faces* of the tiling, the sides of the squares are the *edges* of the tiling, and the points where four edges meet are the *vertices*. Since squares are four-sided polygons and four of them meet at each vertex, this tiling is denoted by the symbol {4,4}. Figure 2a shows the tiling of equilateral triangles (three-sided polygons) meeting six at each vertex, denoted by {3,6}; in Fig. 3 this same tiling is shown, together with the tiling {6,3} of hexagons indicated by dotted lines. Note that there is a vertex of the tiling {6,3} at the centre of each triangle and a vertex of {3,6} at the centre of each hexagon; for this reason {3,6} and {6,3} are said to be *duals* of each other.

There are five solid bodies known as *regular polyhedra:* the cube {4,3} has six square faces, three of them meeting at each vertex; the dodecahedron {5,3} (Fig. 4a) has twelve pentagonal faces, three meeting at each vertex; the icosahedron {3,5} (Fig. 5) has twenty triangular faces, five meeting at each vertex; the tetrahedron or triangular pyramid {3,3} has four triangular faces, three meeting at each vertex; the octahedron {3,4} has eight triangular faces, four meeting at each vertex. Each of these regular polyhedra can be blown up like a balloon to produce a tiling on a sphere; Fig. 6 shows the blown-up versions of the tetrahedron {3,3} (Fig. 6a), the cube {4,3} (Fig. 6b), and the dodecahedron {5,3}, and the icosahedron {3,5}, indicated in Fig. 6c by solid and dotted lines. Figure 6c shows that {5,3} and {3,5} are duals of each other; compare Fig. 6c with Fig. 3.

Each of these tilings, in a plane and on a sphere, is said to be *regular* because all its faces are regular polygons with the same number of sides, and the same number of faces meet at each vertex. All the faces have the same size.

PERFECT COLOURINGS

The tiling of triangles in Fig. 2a is coloured in four colours. This is what is called a *perfect* colouring; there is a mathematical way of defining what this means (which will be explained later), but it will be more helpful here to describe a simple property of perfect colourings that is used when one sits down with a paintbox to produce such a colouring. *Starting from any face of a particular colour, there is a simple rule or rules determining which of the nearby faces should have the same colour.* Thus in Fig. 2a, starting from any black triangle, the triangle directly opposite to it *at any of its three vertices* is also black. Using this rule we can colour all the black faces; then colouring another face red, say, we can use the same rule to colour all the red faces, and so on.

The colouring of the square tiling in Fig. 1a is of a slightly different type. Starting from any black square, we get to the neighbouring black squares by using what chess players

J. F. Rigby (mathematician, educator), University of Wales College of Cardiff, Senghennydd Road, Cardiff CF2 4AG, Wales, U.K.

This article is based on a talk presented at the Strens Memorial Conference on Intuitive and Recreational Mathematics and Its History, Calgary, Alberta, Canada, 27 July–2 August 1986.

Fig. 1. (a) Chirally perfect colouring, in five colours, of the square tiling {4,4}; (b) a 'fundamental region' of the colouring.

Fig. 2. (a) Fully perfect colouring, in four colours, of the triangular tiling {3,6}; (b) compound of four hexagonal tilings, {6,3}[4 {6,3}], derived from (a).

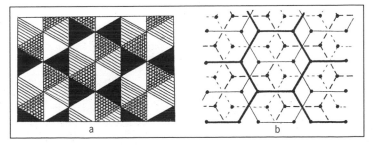

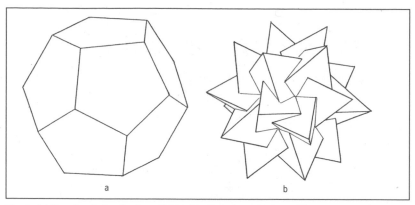

might call a 'right-handed knight's move': standing on the square and facing any one of its edges, we move two squares forward and one to the right. Using this rule we can produce the complete colouring using five colours. If instead we use a 'left-handed knight's move', we obtain a different colouring, the mirror image of the other. So this colouring exists in right-handed and left-handed versions; for this reason it is called a *chirally perfect* colouring (from the Greek *cheir* 'hand'). In contrast, we shall call the previous colouring a *fully perfect* colouring.

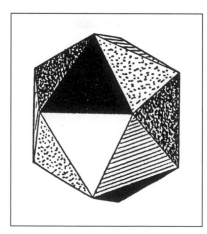

THE HYPERBOLIC PLANE

Most of us are familiar with Euclidean geometry, the elementary geometry that is taught in school, whose basic laws were first formulated by the ancient Greeks. In this geometry the angles of a triangle sum to 180°, and the Pythagorean theorem is true; we tacitly assumed these basic laws when we accepted the existence of plane tilings of squares, triangles and hexagons. There is another type of geometry, called *hyperbolic geometry*, which differs in some respects from Euclidean geometry. Whether or not our physical universe obeys the laws of Euclidean or hyperbolic geometry is a question for applied mathematicians, physicists and philosophers; but engineers, architects and draughtsmen know that for all practical purposes that part of the universe with which we are familiar obeys the laws of Euclidean geometry. So, *any picture of hyperbolic plane geometry that we attempt to draw on a sheet of paper must perforce be distorted.*

The intricacies of hyperbolic geometry, and the way in which the distorted pictures in this article have been drawn, are too complicated to explain here, but a preliminary discussion of some of the pictures will perhaps help to explain what is going on. The mathematician Poincaré devised a method (the *Poincaré model*) of depicting the entire hyperbolic plane inside a bounding circle. (We speak of *the* hyperbolic plane rather than *a* hyperbolic plane because one such plane is exactly like any other.) This is similar to, yet different from, the distortion that occurs when we view

Fig. 6. Regular polyhedra blown up onto a sphere: (a) tetrahedron; (b) cube; (c) dodecahedron and icosahedron. In (a) and (b) the broken lines show the edges hidden at the back of the sphere; in (c) the broken lines show the visible edges of the icosahedron, dual to the dodecahedron.

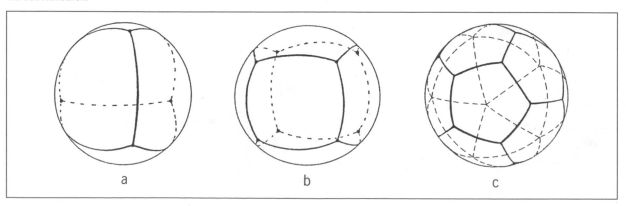

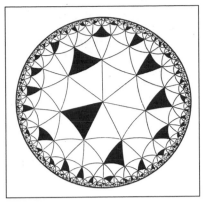

Fig. 7. The black faces of a chirally perfect colouring of {3,7} in seven colours.

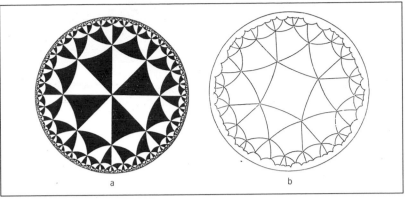

Fig. 8. (a) {3,8}, two colours; (b) one component of the corresponding nonregular compound.

a scene in a convex mirror: we can interpret what we see and can accept it as a distortion of reality.

Figure 7 shows a tiling of the hyperbolic plane by triangles; let us see what distortion has done to this figure. First, the edges of the triangles are straight lines in 'hyperbolic reality', but in the Poincaré model straight lines are represented by arcs of circles that, when extended, meet the bounding circle at right angles. Second, all the triangles are the same size in hyperbolic reality, but in the model they appear to get smaller as we approach the boundary. Third, all the triangles are regular in hyperbolic reality, that is, their sides are equal in length, and their angles are equal, but because of the distortion of length they do not look regular. But angles are not distorted in the Poincaré model; every angle of every triangle in the figure is an angle of $360/7°$. So the angles of these triangles add up to only $154.29°$, not to $180°$ as in Euclidean geometry; and seven triangles meet at each vertex of this tiling, so the tiling of the hyperbolic plane in Fig. 7 is denoted by {3,7}.

In hyperbolic geometry, the larger a triangle (or any other polygon) becomes, the smaller its angles become. Thus, in Fig. 8a (see also Color Plate K No. 2), the triangles are larger than those in Fig. 7, and eight of them meet at each vertex, producing the tiling {3,8}. Figures 9a and 10 illustrate the tilings {4,6} and {7,3}, respectively.

PERFECT COLOURINGS OF HYPERBOLIC TILINGS

Figure 8a shows the simple 'chess-board' perfect colouring of {3,8} in two colours, and Figs. 11a and 9a show perfect colourings of {8,3} and {4,6} in three colours. But the number of colours will frequently be more than three, so all we shall then do is show the faces of one colour. In Fig. 12a, for example, we can deduce from the figure the rules for moving from one black face to the neighbouring ones; then we can apply the same rules to the remaining faces using other colours, and it will be found that four colours are needed for this particular perfect colouring.

In Fig. 12a we can clearly move from one black face to the face directly opposite to it at each of its vertices. This is one rule for moving to neighbouring

Fig. 9. (a) {4,6}, three colours; (b) the regular tiling of backbones derived from the black faces in (a); (c) one of the backbones, showing its spinal cord and its other axes of symmetry.

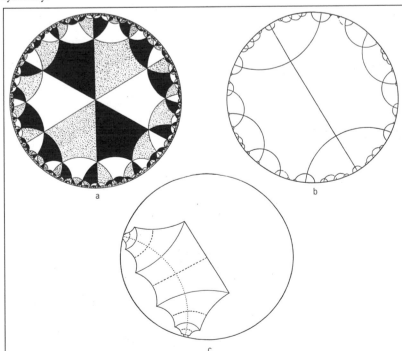

Fig. 10. {7,3}, eight colours. A, B, C and D are labels for four faces of the same colour. But if the whole colouring in eight colours is completed, faces A, B and C are inequivalent in colour surrounding, and faces B and D are equivalent (see text discussion for explanation).

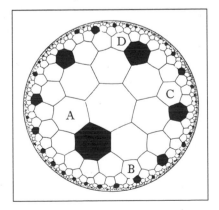

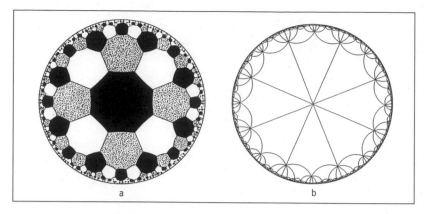

Fig. 11. (a) Perfect colouring of {8,3} in three colours; (b) one component of the corresponding regular compound {3,8}[3 {4,8}].

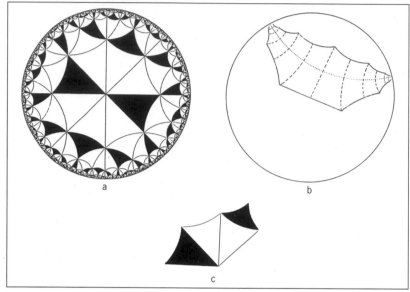

Fig. 12. (a) {3,8}, four colours; (b) one of the backbones derived from the black faces in (a), showing its spinal cord and its axes of symmetry; (c) a knight's move from one black face to another.

black faces, but it is not sufficient for obtaining all the black faces; there is a type of 'knight's move' rule too (Fig. 12c), which must be applied in both left- and right-handed versions. The first rule can be deduced by two applications of the second rule, but it useful to remember the first rule as well. In Fig. 13 two rules of procedure are necessary. In Fig. 14a one suitably chosen rule will suffice, but again for practical purposes it may be convenient to use more than one.

(The reader may like to complete the colourings in these various figures, in order to appreciate them visually.)

PERFECT COLOURINGS AND COMPOUND TILINGS

We have seen that the icosahedral and dodecahedral tilings are dual tilings on a sphere. This means that the centres of the triangular faces of the icosahedral tiling {3,5} form the vertices of a dodecahedron {5,3}. Thus, the colouring of the faces of {3,5} in five colours shown in Fig. 5 provides a colouring of the vertices of the dodecahedron {5,3} in five colours. The four vertices of any one colour form the vertices of a tetrahedron; thus, we can construct five tetrahedra whose vertices together form the 20 vertices of the dodecahedron (Fig. 4b). We say that the five tetrahedra are *inscribed*

in the dodecahedron, and they form a *compound polyhedron*, denoted by the symbol

{5,3}[5 {3,3}].

This symbol shows that the vertices of {5,3} are used as the vertices of five {3,3}s. Since the colouring from which we started was chirally perfect, this compound polyhedron is called a *chirally regular* compound.

If we combine the previous compound with its mirror image (so that we are using both the left- and the right-handed versions of the compound), we obtain 10 tetrahedra inscribed in a dodecahedron, for which the symbol is

2 {5,3}[10 {3,3}],

because each vertex of {5,3} is now used twice, as a vertex of two of the tetrahedra; this is called a dichiral compound. It is also possible to inscribe five cubes in a dodecahedron; the symbol for this is

2 {5,3}[5 {4,3}].

In both these compounds, each vertex of the original polyhedron is used twice; but most of the compounds that we

180

shall consider are plain compounds, in which each vertex is used just once.

The eight vertices of a cube can be divided into two sets of four in such a way that adjacent vertices always belong to opposite sets; the four vertices in each set then form the vertices of a tetrahedron, and we have Kepler's *stella octangula,* two tetrahedra inscribed in a cube, for which the symbol is

$$\{4,3\}[2\{3,3\}].$$

Let us now do something similar starting with the perfect colouring of Fig. 2a. The centres of the faces of this triangular tiling {3,6} form the vertices of the dual hexagonal tiling {6,3}, so the four colours in Fig. 2a provide a colouring of the vertices of {6,3} in four colours. If we join each black vertex to its three nearest black neighbours, we obtain the hexagonal tiling shown by heavy unbroken lines in Fig. 2b. Similarly, the three other colours in Fig. 2a provide the three other hexagonal tilings of Fig. 2b. Thus, the vertices of the original hexagonal tiling have been divided up to form the vertices of four new tilings, the four *components* of a compound of four hexagonal tilings, for which the appropriate symbol is

$$\{6,3\}[4\{6,3\}].$$

This compound tiling is *fully regular,* because the colouring that we started from is fully perfect. We shall say that this compound is *inscribed in* {6,3}, just as the five tetrahedra were inscribed in {5,3}. Figure 2b, even if we draw the edges in four different colours, lacks the visual appeal of the compound polyhedra discussed above (the five tetrahedra of Fig. 4b inspired the artist Escher to create the carving *Polyhedron with Flowers;* see [1], for example); the colouring of the triangle tiling {3,6} from which we started is much easier to appreciate visually.

A COMPOUND TILING IN THE HYPERBOLIC PLANE

Figure 11a shows the unique perfect colouring of {8,3} in three colours. (The colours used are not unique, but the manner in which the three colours are arranged is.) If we join the centre of each black octagon to the eight nearest black centres, we obtain the tiling {4,8} shown in Fig. 11b. The other two colours yield two more {4,8}s, giving the regular compound tiling

$$\{3,8\}[3\{4,8\}].$$

(Note that {3,8} occurs as part of this symbol because the centres of the octagonal faces of {8,3} are the vertices of the dual tiling {3,8}.) We can similarly use the perfect colouring of {2n,3} in three colours to obtain the regular compound tiling

$$\{3,2n\}[3\{n,2n\}].$$

DO PERFECT COLOURINGS ALWAYS YIELD REGULAR COMPOUNDS?

Coxeter [2] made a list of known regular compound tilings, to which additions have recently been made [3]. The list is quite long and need not be reproduced here. We have not yet defined what we mean by saying that a compound tiling is *regular;* there are various mathematical ways of doing this, and different authors have slightly different ideas about what is meant by regularity [4]. But as long as we consider only those compound tilings in which each vertex of the original tiling is used only once (we called these *plain* compounds earlier), we can say that a compound tiling inscribed in the tiling {p,q} is *fully regular* or *chirally regular* if it is obtained in the way we have described from a colouring of the dual tiling {q,p} that is fully perfect or chirally perfect. The full name for the regular compounds obtained in this way from perfect colourings is *vertex-regular* compounds, but generally we shall use the shorter name.

So, every regular compound tiling inscribed in {p,q} is obtained from a perfect colouring of the dual tiling {q,p}. But what about the converse situation: does every perfect colouring of {q,p} yield a regular compound tiling inscribed in {p,q}? Let us look at the question in more detail. Suppose we are given a perfectly coloured regular tiling. In order to attempt to convert it into a regular compound tiling, we join the centre of each black face, for instance, to all the black centres nearest to it, thus creating a 'black tiling'; we then

Fig. 13. (a) {4,6}, six colours; (b) one of the dendroids derived from the black faces in (a), showing the branched spinal cord and the other axes of symmetry; (c) another way of piecing together the dendroid.

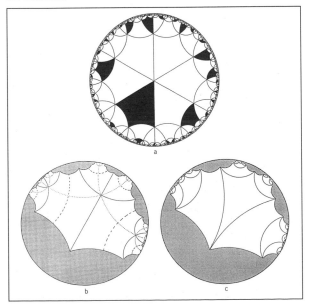

Fig. 14. (a) Another perfect colouring of {4,6} in six colours; (b) part of the transitive tiling of octahedra derived from the black faces in (a).

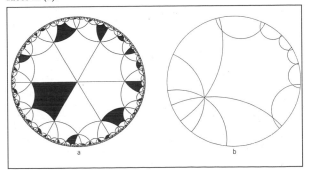

do the same for every other colour. Do the resulting coloured 'tilings' form a regular compound?

Consider first the perfectly coloured tilings on a sphere. The colouring of the eight faces of an octahedron in two colours, adjacent faces always having different colours, gives rise to Kepler's *stella octangula* mentioned earlier, and the colouring in Fig. 5 gives the regular compound of five tetrahedra (Fig. 4b). There are colourings of the cube, octahedron, dodecahedron and icosahedron using three, four, six and ten colours, respectively (in which opposite faces have the same colour). These colourings do not give rise to regular compounds in the normal sense, but they are connected with regular compounds in which the components are *hosohedra*, having just two diametrically opposite vertices like a beach ball [5]. The only other perfect colourings are the colourings of all five regular polyhedra in which different faces always have different colours; these can be regarded as trivial cases.

In the Euclidean plane, every perfectly coloured regular tessellation gives rise to a regular compound; all of them are in Coxeter's list [6], but it is worth mentioning that some are more regular than others. For instance, one of the simplest perfect colourings, shown in Fig. 15a, gives rise to the compound shown in Fig. 15b. The triangular faces in Fig. 15b are of two different types: some faces have a vertex of the other component of the compound at their centres, but other faces do not. For this reason we say that the compound is *not face-regular*.

Let us now consider various colourings of hyperbolic tilings:

Example 1.
Figure 8a shows the unique perfect colouring of {3,8} in two colours. If we join the centre of each black triangle to the six nearest black centres, we obtain the tiling shown in Fig. 8b. This is called a *quasiregular* tiling. Since the six faces meeting at a vertex are alternately triangles and squares (regular quadrangles), we can denote the tiling by 3.4.3.4.3.4 or $(3.4)^3$; it was used by Escher as the basis of his woodcut *Circle Limit III* (see, for instance, [7]). The white triangles in Fig. 8a give another tiling of the same type, and the two together give the nonregular compound

$$\{8,3\}[2\,(3.4)^3].$$

(It is the component tilings that are not regular; the two components fit together in as regular a way as possible.) We can similarly use the perfect colouring of {k,2n} in two colours to obtain the compound

$$\{2n,k\}[2\,(k.n)^k].$$

Fig. 15. (a) Perfect colouring of {3,6} in two colours; (b) the corresponding regular compound {6,3}[2 {3,6}].

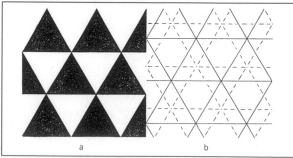

If k = n, this compound is vertex-regular but not face-regular (like the compound in Fig. 15b, for which k = n = 3), and the notation for it then becomes

$$\{2n,n\}[2\,\{n,2n\}].$$

Example 2.
Figure 9a shows the unique perfect colouring of {4,6} in three colours. If we join the centre of each black square to the four nearest black centres, we obtain the situation shown in Fig. 9b; the regions bounded by the edges are infinite regions, not polygons, but they are still convex.

One such region is analyzed in Fig. 9c. The dotted axis running down the entire length of the region is a line of symmetry of the region (remember that the picture is distorted). The vertices of the region are all equidistant from this central axis. There are other lines of symmetry also, of two types, indicated by broken and unbroken lines and all perpendicular to the central axis. The region can be regarded as an infinite version of a regular polygon; in technical language it is regular *because its symmetry group is transitive on its flags* (a flag consists of a vertex and an edge incident with the vertex). We shall call it an *infinite backbone;* the central axis is its *spinal cord,* and the broken or the unbroken lines divide it up into *vertebrae.*

Since Fig. 9b shows a tiling of infinite backbones rather than polygons, four meeting at each vertex, the natural symbol for it would be {∞,4} (∞ standing for 'infinity' as usual). But this notation is already in standard use to denote the tiling of right-angled infinite polygons whose vertices lie on horocycles [8], so we shall use ω here instead of ∞ and denote this particular tiling by {2ω,4} (the reason for 2ω rather than ω is explained later). This is only a partial notation, since a backbone with a right angle at each vertex is not unique. The compound tiling obtained from Fig. 9a is

$$\{6,4\}[3\,\{2\omega,4\}].$$

Example 3.
Figure 12a shows the black tiles in the unique perfect colouring of {3,8} in four colours. The same procedure as before produces a tiling formed from backbones like that shown in Fig. 12b. This differs from Fig. 9c in that the central axis is no longer a line of symmetry but rather an axis of glide reflection. Also, all the lines of symmetry perpendicular to the central axis are of the same type, joining a vertex to the midpoint of the opposite side. In Fig. 9c these lines of symmetry are of two types, either joining two vertices or joining two midpoints. This is precisely the distinction that occurs between regular polygons with an odd number of vertices and those with an even number of vertices. We can therefore think of the backbone in Fig. 9c as having an even number of vertices, which is why we denote the tiling by {2ω,4}, and the backbone in Fig. 12b as having an odd number of vertices, which is why we denote the corresponding tiling by {2ω+1,3}.

On the central axis in Fig. 12b, midway between adjacent lines of symmetry, are centres of (twofold rotational) symmetry. The compound tiling obtained from Fig. 12a is

$$\{8,3\}[4\,\{2\omega+1,3\}].$$

Example 4.
Figure 13a shows the black tiles in one of the perfect colourings of {4,6} in six colours. Using the centres of the black

tiles as vertices, we obtain a tiling of shapes like that shown in Fig. 13b. This shape also is convex; instead of a single central axis, it has a spinal cord (shown by dotted lines) that is branched like a tree, so we shall mix our metaphors and call it a *convex dendroid*. Each section of the spinal cord is a line of symmetry. The broken lines of symmetry divide the dendroid into vertebrae, each of which is joined to four others. There are other lines of symmetry, indicated by unbroken lines in Fig. 13b.

Figure 13c shows another way of piecing together the dendroid: squares with side-length b and quadrilaterals with side-lengths b and c alternately, where $b > c$, joined along the sides of length b. Although it has lines of symmetry in many directions, the dendroid can still be regarded as an infinite version of a regular polygon. Let us denote it simply but incompletely by $\{\omega,4\}$. The compound tiling obtained from Fig. 13a is then

$$\{6,4\}[\,6\,\{\omega,4\}].$$

Example 5.
Figure 14a indicates another perfect colouring of $\{4,6\}$ in six colours. Calculations show that there are eight black centres nearest to any given black centre, and we obtain the tiling of octagons indicated (only partially) in Fig. 14b. These octagons are not regular; they are equilateral but their angles are alternately of two different sizes. We shall call this a *transitive* tiling because, in mathematical terminology, the symmetry group of the tiling is transitive on vertices, edges and faces. In simpler terminology, all the vertices of the tiling look the same, all edges look the same and all faces look the same.

If we wish to compare this with a more familiar example, the only (nonregular) transitive tiling in the Euclidean plane is the rhombic tiling of Fig. 16a; another example of a transitive tiling in the hyperbolic plane is shown in Fig. 16b. We denote the tiling of Fig. 14b by trans$\{8,8\}$, although such a tiling of octagons meeting eight at a vertex is not unique. The compound tiling obtained from Fig. 14a is then

$$\{6,4\}[\,6\,\text{trans}\{8,8\}].$$

The tilings of Figs. 8b and 14b are similar in that in both cases angles of two different sizes occur alternately at each vertex. It is the way in which the vertices are joined that produces a quasiregular tiling in the one case and a transitive tiling in the other.

Example 6.
If we relax the condition that says that we must join the centre of each tile to the *nearest* centres of the same colour, but still require that two joined centres must be at a fixed distance apart, we can obtain variants of some of the above tilings. For instance, suppose that in Example 3 above we join each vertex of each backbone (Fig. 12b) to the two nearest vertices on the opposite side of the backbone and delete the original sides of the backbones; each component of the compound then becomes a transitive tiling of rhombuses, trans$\{4,6\}$.

Example 7.
The component tilings here are more difficult to visualize. The centres of the tiles of $\{6,8\}$ are the vertices of the dual tiling $\{8,6\}$. The perfect colouring of $\{6,8\}$ in two colours gives rise to a compound tiling with two components. To obtain one of the components, choose alternate vertices of $\{8,6\}$ and join each chosen vertex to its 12 nearest chosen neigh-

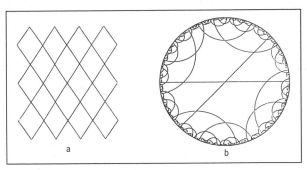

Fig. 16. (a) Transitive tiling of rhombuses in the Euclidean plane; (b) transitive tiling of hexagons in the hyperbolic plane.

bours; this gives the quasiregular tiling $(4.6)^6$, which is transitive on its vertices.

If we colour alternate vertices of each of these two components in two different colours, this is equivalent to a perfect colouring of $\{6,8\}$ in four colours. A component of the corresponding compound is obtained by choosing alternate vertices of $(4.6)^6$ and joining each to its nearest chosen neighbours. A drawing of this in the Poincaré model is not helpful; each chosen vertex is joined to the opposite vertices of the six quadrangles to which it belongs, but it is not joined to the two other chosen vertices of the hexagons to which it belongs because these are not nearest neighbours. Each (infinite) tile of the component tiling can be constructed by joining dodecagons and equilateral triangles; the dodecagons have edges of lengths b and c alternately, where $b > c$, and the triangles have edges of length b; each edge of length b in a dodecagon is joined to an edge of a triangle, and conversely; the edges of the infinite tile have length c. The tiles are convex and regular, but they are more complicated than the previous infinite tiles (cf. Fig. 13c).

The reader may like to perform a similar operation, starting with $\{8,12\}$, and investigate the four components of the corresponding compound. Each component is a quasiregular tiling of triangles and dendroids. It should not be difficult to find perfect colourings leading to quasiregular tilings of two different types of dendroid, and to transitive tilings of nonregular dendroids, but I have not yet carried this particular investigation any further.

PERFECT COLOURINGS
OF $\{7,3\}$ AND $\{3,7\}$

Figure 10 indicates a perfect colouring of $\{7,3\}$ in eight colours, from which we obtain the regular compound

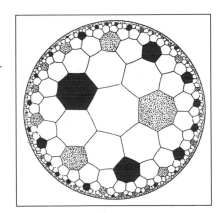

Fig. 17. $\{7,3\}$; **the black faces indicate a chiral colouring in nine colours, giving the chirally regular compound** $\{3,7\}[\,9\,\{7,7\}]$. **The centres of the black and stippled faces are the vertices of one component of** $2\{3,7\}[\,9\,\{4,7\}]$.

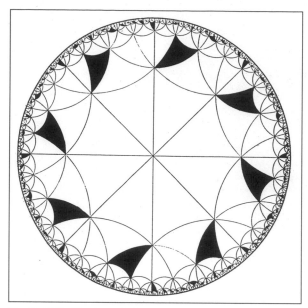

Fig. 18. {3,8}, 10 colours (fully perfect).

$\{3,7\}[8\{3,14\}].$

The faces labelled A, B, C and D in Fig. 10 all have the same colour, but when the whole colouring in eight colours is completed, A and B are surrounded in different ways by the seven other colours; the cyclic order in which the seven other colours occur in the faces surrounding A is different from the cyclic order in which the colours occur in the faces surrounding B. We say, therefore, that the faces A and B are *not equivalent,* or *inequivalent* or *of different types;* we can also check that C is not equivalent to A or B. But B and D are *equivalent* or *of the same type:* the other colours surround B and D in the same way, and to observers standing at B and D the complete colouring appears identical.

In Fig. 10 there are just three types of face of any particular colour, so there are 24 types of face altogether. We can create a new colouring by *colouring equivalent faces with the same colour, and inequivalent faces with different colours* (i.e. we use a different colour for each type of face). This gives a perfect colouring of {7,3} with 24 colours, which gives rise to the regular compound tiling

$\{3,7\}[24\{7,14\}].$

Figure 7 indicates a chirally perfect colouring of the dual tiling {3,7} in seven colours, from which we obtain a chirally regular compound of seven regular tilings of backbones. The backbones themselves are only chirally regular; this means that they have no axes of symmetry as did the previous backbones that we encountered, but they do have centres of (twofold rotational) symmetry regularly spaced along their spinal cords.

The chirally perfect colouring of {7,3} in nine colours indicated by the black tiles in Fig. 17 gives rise to the chirally regular compound tiling

$\{3,7\}[9\{7,7\}].$

Figures of the type that we have been using can also be employed to show one component of a regular compound that is not a plain compound, i.e. a compound in which each vertex of the underlying tiling is used more than once. (We considered such compounds briefly before.) For instance, the centres of the black tiles in Fig. 17 are also the vertices of one component of the dichiral compound

$2\{3,7\}[18\{7,7\}]$

(obtained by combining the previous compound with its mirror image), and the centres of the stippled tiles are the vertices of a second component, the dual of the first. If the black and stippled tiles are imagined to have the same colour, their centres are the vertices of one component of

$2\{3,7\}[9\{4,7\}].$

KLEIN'S MAPS {7,3}$_8$ AND {3,7}$_8$

This section involves more sophisticated geometrical ideas and some knowledge of the theory of groups. Some of the geometrical terms are explained in the glossary, and an account of groups as applied to symmetry can be found in [9].

It is appropriate to start by defining the notions of perfect colourings and equivalent faces in a more mathematical way. A colouring of a regular tiling is *fully perfect* if every symmetry of the tiling permutes the colours (i.e. if every symmetry maps tiles of the same colour to tiles of the same colour), and it is *chirally perfect* if every direct symmetry permutes the colours but opposite symmetries do not. Two faces of a tiling are *equivalent* (with respect to a particular colouring) if there is a symmetry of the tiling that maps one face to the other and induces the identity permutation on the colours (i.e. maps each colour to itself). This definition

Fig. 19. (a) The configuration 7$_3$, the projective plane of seven points and seven lines; this is an abstract plane, and one of the 'lines' has to be distorted in any illustration; (b) the Pappus configuration 9$_3$; (c) the Desargues configuration 10$_3$.

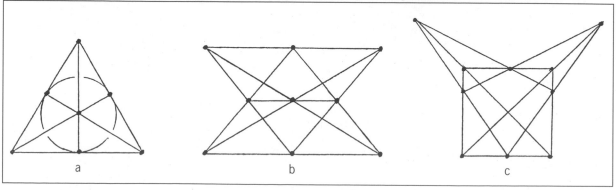

of equivalence of faces still makes sense if the *vertices* of a tiling, rather than the faces, are coloured.

The colouring of Fig. 10 contains 24 types of face, and each face has seven edges. It follows that the group of permutations of the eight colours induced by the direct symmetries of {7,3} has order 168 (= 24 × 7). This group is known to be the simple group LF(2,7) of order 168, and the group of permutations induced by *all* the symmetries (direct and opposite) of {7,3} is PGL(2,7) of order 336 [10,11].

Now, LF(2,7) is most easily thought of as the group of all collineations of the finite projective plane PG(2,2) of seven points; this is a group of permutations of the seven points. Also, PGL(2,7) is the group of all collineations and correlations of this plane. Is it therefore possible to find a colouring in *seven* colours, maybe of vertices or edges, that is in some sense 'equivalent' to this perfect colouring of faces in eight colours?

Such a colouring of the vertices in seven colours does exist and can be derived from one of the colourings that we discussed in the previous section. The centres of the faces of the tiling {3,7} in Fig. 7 form the vertices of the dual {7,3}, so the colouring in Fig. 7 immediately gives us a colouring of the *vertices* of {7,3}. It can easily be checked that equivalent faces in the face colouring of {7,3} in Fig. 10 are equivalent in the vertex colouring of {7,3} derived from Fig. 7, and vice versa. For this reason we say that the face colouring and the vertex colouring are *equivalent*. (We are using the word 'equivalent' in two senses, equivalence of faces and equivalence of colourings, but this should not cause confusion.)

We can now prove that the groups mentioned above are in fact LF(2,7) and PGL(2,7). We observe first that the equivalence of the two colourings implies that the symmetry groups of {7,3} and {3,7} induce isomorphic groups of permutations of the two sets of colours, so we can consider instead the induced groups of permutations of the colours in Fig. 7. Denote the seven colours used to colour {3,7} in Fig. 7 by $P_1, P_2, P_3, \ldots, P_7$. If we reflect this chiral colouring in a line of symmetry of {3,7}, we obtain another colouring, for which we shall then use seven other colours $m_1, m_2, m_3, \ldots, m_7$. It is easily checked that each tile of any one *P*-colour is coloured by one of four *m*-colours, and vice versa. We say that the colours P_a and m_b are *incident* if they are never used to colour the same tile. It is then easily checked that the P_i and the m_j satisfy the incidence relations for a projective plane with seven points and lines. Any direct (rotational) symmetry of {3,7} permutes the *P*'s and also the *m*'s, and preserves incidence; any opposite (reflectional) symmetry interchanges the *P*'s and the *m*'s and preserves incidence.

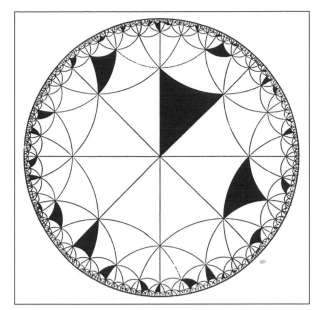

Fig. 20. {3,8}, 10 colours (chirally perfect).

Since the groups of permutations of the seven colours induced by the rotational symmetries, and by all symmetries, of {3,7} have orders 168 and 336, it now follows that these groups are isomorphic with LF(2,7) and PGL(2,7).

The colouring of {7,3} in Fig. 10 first came to my attention as a coloured illustration in [12]. The way in which I first found the equivalent colouring of {3,7} is worth explaining in the paragraphs below. Only later did I realize that this is in fact the *only* perfect colouring of {3,7} in seven colours.

We need the notion of a *regular map,* so we shall consider a simple example of a regular map first. The perfect colouring shown in Fig. 1a contains five inequivalent tiles. If we cut out the small portion of the tiling shown in Fig. 1b, join two opposite edges of this square together to form a cylinder, then bend and stretch the cylinder in order to join its ends together, we obtain a regular tiling of (distorted) squares on a torus (or 'anchor ring').

Another way of explaining this operation is to say that we *identify equivalent tiles of the colouring.* To 'identify' two tiles means to superimpose one tile on the other as a result of bending and stretching the surface. If we take a large finite portion of the tiling, we can identify some of the equivalent tiles by rolling up the portion into a cylinder, and then push one end of the cylinder into the other until all equivalent

Fig. 21. Three Euclidean tilings that fail to be transitive for various reasons: (a) is transitive on vertices and edges (all edges look alike, having a triangle on one side and a hexagon on the other) but has faces of two different types; (b) is transitive on edges and faces but has vertices of two different types; (c) is transitive on vertices and faces but has edges of two different types (short and long).

a

b

c

tiles are identified. The idea of identifying equivalent tiles, regarded as an abstract notion, becomes useful in more complicated situations when the physical processes of cutting and joining, or of bending and stretching, become impossible to visualise.

Although the five squares on the torus are distorted, we still say that the resulting tiling is regular because of the regular way in which the distorted squares fit together. Any regular tiling (such as this one) with only a finite number of tiles is called a *regular map;* so the regular tilings on a sphere are regular maps also. The original tiling {4,4} in Fig. 1a is the *universal covering* of this map.

We can deal similarly with the perfect colouring of Fig. 10, with its 24 types of face. If we identify equivalent faces of the colouring, we obtain a regular map, with 24 faces, on a surface that is more complicated than a torus. This is Klein's map; it has 84 edges and 56 vertices. The surface has Euler characteristic $24 - 84 + 56 = -4$, and therefore its genus is 3, so it is a sphere with three holes. The universal covering of the map is {7,3}, and the map is denoted by $\{7,3\}_8$ [13]. The colouring of {7,3} in eight colours immediately provides a perfect colouring of $\{7,3\}_8$ in eight colours.

The dual map on the same surface is $\{3,7\}_8$; if we can find a perfect colouring of $\{3,7\}_8$ in seven colours, this will then give us a perfect colouring of its universal covering {3,7} in seven colours. Schulte and Wills have shown that a model of the map $\{3,7\}_8$ can be constructed, in three-dimensional space, in which the faces are flat triangles with straight edges [14]. (This is surprising: no such similar model exists of $\{7,3\}_8$ or of the map of five squares on a torus described earlier.) It is this map of 56 triangles that we wish to colour perfectly in seven colours, with eight triangles of each colour. The tetrahedral rotational symmetry of the model immediately suggests a successful method of making the colouring. The corresponding perfect colouring of {3,7} in seven colours is the one indicated in Figure 7.

It follows from this discussion that the groups of symmetries, and of direct symmetries, of Klein's maps $\{7,3\}_8$ and $\{3,7\}_8$ are PGL(2,7) and LF(2,7), respectively. Further discussion of the connection between regular tilings, perfect colourings and regular maps is beyond the scope of this article.

TWO PERFECT COLOURINGS OF {3,8} IN TEN COLOURS

This subject is full of surprises; each time I think about it I find something new. Most recently, I was considering the easiest method of colouring {3,8} perfectly in 10 colours. The result is indicated in Fig. 18, and it gives a new regular compound [15] not listed by Coxeter:

$$\{8,3\}[\,10\,\{8,6\}].$$

The group of permutations of the colours in Fig. 7 induced by the direct symmetries of {3,7}, which we can simply call the *group of the colouring,* is the group of collineations of the finite projective plane PG(2,2). This abstract plane is a 7_3 configuration of points and lines (Fig. 19a). Can we find chirally perfect colourings whose groups are the groups of collineations of the 9_3 Pappus configuration (Fig. 19b) and the 10_3 Desargues configuration (Fig. 19c)? My initial unsuccessful attempts to answer this question produced the colouring indicated in Fig. 20, but there are in fact fully perfect colourings whose groups are the groups of collineations and correlations of the Pappus and Desargues configurations; these can be derived from regular maps (see [16]). Having found the chirally perfect colouring of Fig. 20 in ten colours, I looked for equivalent faces of the colouring; but it turns out that the group of the colouring is A_{10}, the alternating group of order 10!/2. The colouring therefore contains 604,800 different types of face; since we are considering aspects of the subject that can be appreciated visually, this is a good point at which to come to an end!

References

1. B. Ernst, *The Magic Mirror of M. C. Escher* (New York: Random House, 1976) p. 97.

2. H. S. M. Coxeter, "Regular Compound Tessellations of the Hyperbolic Plane", *Proceedings of the Royal Society of London* A **278** (1964) pp. 147–167.

3. J. F. Rigby, "Some New Regular Compound Tessellations", *Proceedings of the Royal Society of London* A **422** (1989) pp. 311–318.

4. Rigby [3].

5. J. F. Rigby, "Regular Hosohedral Compound Tessellations" (1988), unpublished manuscript.

6. Coxeter [2].

7. Ernst [1] p. 109.

8. L. Fejes Toth, *Regular Figures* (Oxford: Pergamon Press, 1964) p. 97.

9. E. H. Lockwood and R. H. Macmillan, *Geometric Symmetry* (Cambridge: Cambridge Univ. Press, 1978).

10. H. S. M. Coxeter and W. O. J. Moser, *Generators and Relations for Discrete Groups*, 4th Ed. (New York: Springer Verlag, 1980) Chap. 7.

11. F. A. Sherk, "The Regular Maps on a Surface of Genus Three", *Canadian Journal of Mathematics* **11** (1959) pp. 452–480.

12. *Mosaïque Mathématique*, Horizons Mathématiques (Paris: Musée de la Villette, 1981) p. 43.

13. Coxeter and Moser [10].

14. E. Schulte and J. M. Wills, "A Polyhedral Realization of Felix Klein's Map $\{3,7\}_8$ on a Riemann Manifold of Genus 3", Mathematische Forschungsberichte 135 (Siegen: Universität-Gesamthochschule, 1984).

15. Rigby [3].

16. H. S. M. Coxeter, "Desargues Configurations and Their Collineation Groups", *Mathematical Proceedings of the Cambridge Philosophical Society* **78** (1975) pp. 227–246.

Crystallography and Plane Ornaments: Interactive Multi-Window Computer Graphics

L. Loreto, R. Farinato and M. Tonetti

ABSTRACT

Two-dimensional crystallography and mathematics of periodic plane ornaments share translational periodicity and space group symmetry. The authors describe the interactive computer program SYMPATI, which allows production and comparison of patterns of symmetry in a multi-window arrangement of freely chosen windows on a video screen. Automatic generation of patterns is also provided by sequences of 'slides'.

Geometric crystallography, especially plane crystallography, is a good example of the natural connection between mathematical abstraction and the richness of visual representation. Although in crystallography (as well as in mathematics) it is possible to write entire books without pictures, this is rarely done.

The majority of crystallographic topics can be illustrated by an extraordinary variety of images—not necessarily technical—taken from different sources, such as regular designs and patterns taken from everyday life, ancient and modern ornaments and so on. Such an abundance of illustrative possibilities arises from the fact that atoms or molecules in solid matter usually satisfy spatial arrangements marked by even distributions of elements, as in a design. Atoms in molecules and in crystals have well-defined mutual relationships in space. In particular, the arrangement of atoms and molecules in crystals is largely dominated by translational periodicity and, as a rule, by symmetry [1,2].

Moreover, the recent, huge expansion of the field of quasi-crystallography [3–5] has further enriched the domain of possible patterns with many aperiodic ornaments present only in the domain of mathematics till a few years ago.

Hand drawings and illustrations that we see in books on crystallography (or in many papers dealing with crystallographic topics) are the result of the patient work of authors and graphic designers. The use of computer graphics has increased the range of drawings that can be created and easily changed if needed. Moreover, computer graphics is more than just a tool for making pictures—it may be an effective aid when patterns of symmetry have to be produced or studied. It is not by chance that most of the diagrams representing periodic tilings in the book *Tilings and Patterns* [6] were made using computer graphics.

In this paper we shall describe how interactive computer graphics can be used to illustrate two-dimensional (2D) crystallography. We use the generic term 'ornament' to mean any kind of plane periodic designs, including 2D crystal structures. The difference between an ornament and the conventional representation of a 2D crystal structure by means of circles, ellipses, etc. is that ornaments can be made of intersecting figures whereas atoms, for example, cannot intersect.

THE MULTI-WINDOW APPROACH

In the study or production of ornaments, it is very important to be able to see, compare and modify many figures and symmetrical patterns at the same time. To this end, we have used an approach in which it is possible to work with both

Fig. 1. (a) Fragment of a lattice of points generated with a vector basis. (b, c, d) Systems of intersecting lines used to label points by integer coordinates regardless of whether (b,c) they are or (d) are not points of a lattice. (e) *P*-cells and multiple cells: numbers are cell weight, and lines through lattice points are lattice rows. (f) Indexing lattice rows, considered as planes, with respect to reference axes *x*, *y* taken in different *p*-cells. As usual for planes in 3D crystallography, Miller indices are in the form (hk).

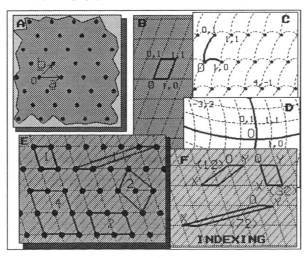

L. Loreto (crystallographer), Dipartimento di Scienze della Terra, Università degli Studi di Roma 'La Sapienza', P.le A. Moro 5, 00185 Rome, Italy.

R. Farinato (crystallographer), Dipartimento di Scienze della Terra, Università degli Studi di Roma 'La Sapienza', P.le A. Moro 5, 00185 Rome, Italy.

M. Tonetti (mathematician), Vector s.r.l., Via di Saponara 650, 00125 Acilia, Rome, Italy.

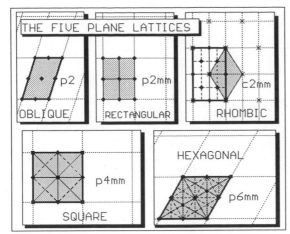

Fig. 2. Multi-window presentation of the five plane lattices. The cell shown in each case is that which is usually used as representative of the lattice. In the rhombic lattice both the *p*-cell and the *c*-cell are shown (note that a star marks each lattice point). The diagram of the symmetry elements is fully displayed (rhombi, triangles, squares and stars are rotation points of order 2, 3, 4 and 6, respectively; solid lines [except the edges in the oblique and rhombic *p*-cell] are mirror lines; dashed lines are glide-reflection lines; space group symbols are indicated according to the international crystallographic notation [15]).

Table 1. The Five Plane Lattices

Lattice Type	Generating *p*-cell
Oblique	Generic parallelogram
Rectangular	Rectangle
Rhombic	Rhombus of angle α
Square	Square
Hexagonal	Rhombus of angle 120°

explain some crystallographic terminology that could otherwise cause misunderstandings among nonspecialists [7,8].

The illustrations in this article were produced with SYMPATI (SYMmetry PATtern Interaction), an interactive graphics package for use in a IBM-compatible personal computer with MS-DOS environment, using a mouse/pull-down menu interface. SYMPATI allows scientific visualization concerning geometrical symmetry. In particular, SYMPATI was designed to study, illustrate and teach crystallography using examples, concepts and notions from 2D crystallography, including ornaments and, where necessary, the traditional circles and ellipses used in structural crystallography. An earlier version of SYMPATI, with relatively rudimental capabilities, was discussed in a previous article [9].

FUNDAMENTALS OF MULTI-WINDOW CRYSTALLOGRAPHY

Let us start by describing the basic concept underlying both crystals and periodic plane ornaments, i.e. the crystal lattice.

Let $\mathbf{V}(O,\mathbf{a},\mathbf{b})$ be a vector basis of the plane, with origin O and unit vectors \mathbf{a}, \mathbf{b}. A 2D crystal lattice L^2 is the set of points given by the position vectors $\mathbf{v} = m\mathbf{a} + n\mathbf{b}$ with m, n \in **Z**. Figure 1a displays a portion of a planar crystal lattice. More generally, a crystal lattice L^2 is also called a *translational lattice*, or *lattice of points*. In the following, L^2 will sometimes be called, simply, lattice.

So L^2 could be defined as the set of points of the plane with integer coordinates (Fig. 1b). Note, however, that if the explicit specification of rectilinear Cartesian reference axes is missing, it is possible to introduce frames where the points m, n \in **Z** do not necessarily form a translational lattice. In fact, Fig. 1c shows a network of wavy lines whose intersec-

calculations and pictures in separate windows on a computer screen.

The figures accompanying this article reflect this approach. They are made of several parts, each of which is one 'window'—that is, a work area on the computer screen where drawing and measurement can take place. We will therefore refer to windows a, b, . . . , or to windows 1, 2,

We have implemented procedures for the automatic modification of ornaments by the variation of certain parameters. In this way, it is quite simple to make drawings and periodic ornaments without having to draw too many things too many times. The visual effect on the screen is a bit like a movie or a series of slides. This will be illustrated with some examples of the manipulations that can be carried out on ornaments repeated in a 2D periodic structure.

To make our approach clearer, we shall show how our procedure works, one step at a time, and also discuss regular systems of points and crystallographic space groups as though watching pictures form on a computer screen. We will also

Fig. 3. (a, left) A display of all 17 two-dimensional symmetry groups together. The letter R is repeated by appropriate generators of a pertinent crystallographic point group and by two independent translations. The shaded area in each space group is a possible fundamental region. (b, right) The same display as in Fig. 3a, but with emphasis on the content of the unit cell to stress the symmetry of each space group.

a

b

Fig. 4. In general, no strict rules exist to produce a periodic pattern (unless, say, overlap of figures is to be avoided or other constraints are to be considered). The ornamentation of one or more initial fundamental regions (FR) is a matter of choice and convenience. To obtain the pattern in window 3, it is clearly convenient to draw a single segment (bold) inside an FR of the group p6m (windows 1 and 2). The pattern in window 5 could be produced using one or two FRs (segments AB and BC, as in window 4; and segments AB, BD, as in window 6); however, window 4 seems simpler. The pattern drawn in window 8 springs from the two perpendicular segments shown in window 7. It would be rather useless or impractical to draw a system of smaller segments in only one FR, as shown in window 9.

tions are points that have integer coordinates forming a lattice, while Fig. 1d shows a net whose points have integer coordinates *without* lying on a crystal lattice.

A primitive cell p of L^2 (or p-cell) is any parallelogram that has points of L^2 only in its corners. All the p-cells congruent to a given p-cell and having corresponding sides parallel constitute a tiling of the plane. In a lattice L^2 there are infinitely many families of p-cells of different shapes and orientation but all of the same area Ap (Fig. 1e). The p-cells are important elements of L^2, as any of them is a *generating cell* of the whole lattice. Indeed, their sides can be used as a vector basis of L^2. Only a quarter of each lattice point coincident with the corners of a p-cell belongs to it, so that the p-cell is said to be of weight $wp = 4(1/4) = 1$.

If a parallelogram q of L^2 has lattice points not only at its corners but also on its boundary and/or in its interior, its weight increases (Fig. 1e). In this case the parallelogram is called a nonprimitive cell, or 'multiple cell', and its area $A_q = w_q A_p$.

Every straight line through two lattice points is a *lattice row* (or, simply, a *row*), for it contains infinitely many evenly spaced lattice points. The minimum distance between two lattice points of a row is the *identity period* of that row and of the rows parallel to it. A row r and all the rows parallel to it form a set S_r; the minimum distance between two elements of S_r is the *spacing* of S_r.

For convenience, here we treat the rows as planes of 'crystal faces' in 2D crystallography. Thus, each set S_r can be labelled with a *Miller symbol* (hk) where h,k ∈ **Z** are the *Miller indices* of S_r. Geometrically, the Miller indices represent the number of parts into which S_r divides the sides of a reference cell, or *unit cell*, taking the sides of the cell as reference axes (Fig. 1f). In order to have Miller symbols, the unit cell need not be a p-cell. Of course, the values of h and k for a given S_r depend on the unit cell chosen. If the unit cell is a p-cell, the Miller indices have no factor in common.

Infinitely many rows pass through a lattice point but, of course, the intersection of two rows is not necessarily a point on the lattice (Figs 1e, 1f).

Drawing two rows r_i and r_j on the screen, which belong to two different sets of rows S_i and S_j, we can easily inspect how the Miller indices change by changing the sets S_i, S_j,

The Miller indices of S_i, S_j, . . . , can also be calculated using the standard mathematical relations of the morphological crystallography, i.e. ratios of intersections of rows with the rows passing through the sides of the generating p-cell taken as reference axes.

(By the way, SYMPATI allows many other kinds of calculations, such as distances, angles, perimeters and areas. Among other things, areas are important in patterns formed by simply connected figures to estimate *packing coefficients* of a periodic structure.)

In the plane there are only five different types of lattice points. The five lattices of points can be classified on the basis of their symmetry or, more simply, using a characteristic generating p-cell, according to Table 1.

Figure 2 shows five windows, each of which displays a portion of an infinite lattice of points and the conventional diagram of the elements of symmetry of its characteristic p-cell.

Incidentally, it should be noted that the rhombic lattice is often referred to in crystallography as the 'centered rectangular lattice' because it admits rectangular cells with a lattice point in their center. Centered rectangular cells are useful unit cells, indeed. However, centered rectangular cells occur also in the hexagonal lattice. Moreover, centered cells are not an intrinsic property [10] of a particular lattice, for *every* lattice admits infinitely many centered cells (and cells that are 'double', 'triple', etc.—that is, cells of weight two, three, and so forth). So, to avoid possible misunderstanding, the denomination 'rhombic lattice' should be used in all instances.

THE 17 TWO-DIMENSIONAL SPACE GROUPS

The multi-window approach is effective when many different situations have to be compared simultaneously. There are 17 space groups G_i (i = 1, . . . , 17) in the plane. Thus it is convenient to insert their descriptions in 17 different windows, as in Fig. 3a. Sixteen of the 17 windows needed are generated automatically, and one more window is added on top. (Actually, up to 26 windows can be displayed at once). In Fig. 3b we have indicated the type of lattice and the set of generators [11] used to obtain each orbit of G_i—that is, every non-empty set {O}G_i of points mapped onto one another by all of the symmetries of G_i.

The capabilities of SYMPATI notwithstanding, we have chosen to use as ornamentation a simple shape—a letter of the alphabet. R is an asymmetrical shape, which is useful to reveal the presence of reflections in mirror or glide-mirror lines [12]. Certainly, with other, more complex pictures we would have obtained a prettier but less comprehensible

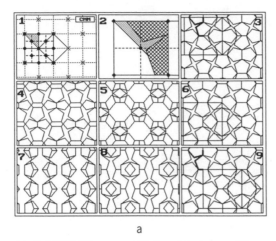

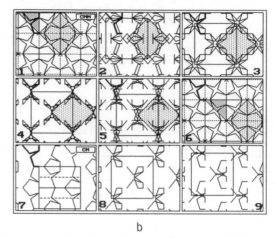

a

b

Fig. 5. ASHIFT fixes a motif in its original place while translating the lattice. The sequence of windows 1–9 shows, as in a series of slides, what happens when an initial motif (here two half-pentagons, shown hatched and enlarged in window 2) are left unmoved while the initial cmm cell is translated automatically downward (windows 4, 5 and 6) and from left to right (windows 6, 7, 8, 9). Many different intermediate patterns develop before a pattern like the initial one appears again. (b, right) Windows 1–6 show the initial motif as in Fig. 5a. Composition of two orthogonal translations of the cmm unit cell (solid lines, c-cell; shaded area, p-cell) from the upper-left border of window 1 to the bottom-right border of window 6, until the initial pattern appears again. Windows 7–9 show the unit cell back in its initial position but carrying symmetry cm.

pattern, particularly with 17 windows all together in such a limited area. In Fig. 3a the symmetry point group associated with the space group is indicated. In the plane there are 10 crystallographic point groups.

The shaded part in each cell represents a *Fundamental Region* (FR) of the space group under consideration. The FR of a symmetry group is a very general concept in the theory of symmetry. Each FR of a symmetry group G is a portion of space (in our case, the plane) that can be defined in terms of maximum space (in which case it is the area of the plane containing only one point of each orbit of G) or in terms of minimum space (in which case it is the smallest region of the plane that, under the action of G, covers the plane without gaps or overlap, i.e. tiles the plane).

In the case of space groups, each one has infinitely many fundamental regions that can, in some cases, have infinitely many different shapes. All the possible FRs of a same symmetry group are plane regions that have the same area. The converse is false [13].

In crystallography the FR is called an *asymmetric unit*. This term is rather misleading because it can suggest that the shape of an FR (whether using maximum or minimum definitions) must necessarily be asymmetrical.

Curiously, instead it happens that highly symmetrical groups such as p6m have right-angled scalene triangles (shape of point group 1) as their FRs, whereas other less symmetrical groups such as p1, pm, p4 have more symmetrical FRs such as parallelograms or rectangles or squares, respectively. The group p1 has both centrally symmetrical FRs and asymmetrical FRs.

Therefore, the term *asymmetric unit* in its crystallographic sense describes the *content* and not the shape of the region of space considered. Indeed, the form of an FR may be, depending on the symmetry group, completely fixed (for instance, in the space group p6m) or even very variable and not uniquely determined (for instance, in p2).

The windows in Fig. 3b clarify this point further, showing that in every FR of a group G_i there is only one of the R's from the orbit generated by the original R (and also only one point from every other orbit of G_i).

The FR of a symmetry group can be regarded as being more or less important depending on the subject under discussion or the problem to be solved. For example, together with the generators, the FR can form the basis for the mathematical construction of space groups. The FR can also be used to make ornaments with shapes that can be guaranteed not to overlap. This last point is important for both crystallographic and physical approach as, unlike drawings, atoms cannot overlap to any great extent.

It can be convenient to work with FRs, for example when producing known periodic ornaments [14], but only if the content of the FR is not too complicated.

Let us consider, for instance, the space group p6m (shown in the 9 windows of Fig. 4); in window 1 we see the elements of symmetry, and window 2 'zooms' in on a small area, showing an FR. Inside this FR there is a line segment (in bold). It is not hard to see that the pattern generated by this line is that which appears (although not in bold) in window 3. Similarly, the two segments AB, BC in window 4 generate the pattern in window 5 and, in close-up view, in window 6. In both cases, the FR allows the generation of an apparently complicated pattern using a very simple design. The choice of, let us say, AB, BD in window 6 as the initial motif does not introduce complications.

Now let us consider window 7. We have two perpendicular segments that cross three fundamental regions (only one of which is the original shaded one). They originate the pattern in window 8. Thus, one passes from window 7 to window 8 in a rather simple way, but it would have been very difficult to go the other way, i.e. to consider the way the segments are arranged in just one FR (which, as we see in window 9, is rather complicated).

So, drawing entirely within an FR or crossing its boundaries can represent two very different approaches.

AUTOMATIC PATTERN-CHANGING

Design and production of periodic ornaments rely greatly on the ability of the artist or upon the mathematical experience of the student. However, it is possible to make interesting observations even when creating patterns automatically—this does not mean at random. Rather, it is a sort of

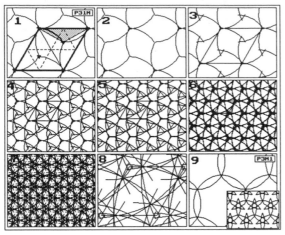

Fig. 6. ADIM leaves a motif fixed in its original place while changing the dimensions of the unit cell. Windows 1 and 2 show the p31m pattern: the initial motif (shown in bold) is an arc of a circle inside the dashed FR. In windows 3–7 the sides of the cell become smaller and smaller, and the pattern tends to uniformly fill the window; however, an enlargement (window 8) reveals the underlying regularity. Window 9 and the inset in it show the complete change produced by changing the symmetry group (i.e. from p31m to p3m1).

trial-and-error process in which the results of each step are examined before deciding what to do next.

In SYMPATI, there are two automatic procedures called Automatic SHIFT (ASHIFT) and Automatic DIMension (ADIM).

In ASHIFT we leave a design fixed in the plane and translate, in small steps, the generating cell of the lattice. This assigns different positions to the crystal lattice in the plane. Figures 5a and 5b illustrate two different possibilities.

Figure 5a shows in window 1 the elements of symmetry of the space group cmm and one of its FRs (shaded). The lattice is rhombic even if actually, in this particular case, the generating p-cell is a square, i.e. a special parallelogram compatible with cmm.

In the enlarged FR in window 2, two half-pentagons have been drawn (hatched regions). An initial pattern is shown in window 3. From now on, leaving the half-pentagons in their original position, the lattice is again and again moved downwards along T_x (the identity period of the left side of the p-cell) until it takes up the position seen in window 6.

The images in windows 4 and 5 show two intermediate patterns chosen from those that, in a progressive series of pictures, are seen during the operation of ASHIFT. In an analogous way, we pass from windows 6 to 9 by moving the lattice from left to right.

During these movements many different patterns are formed on the screen but the initial pattern is seen again periodically (see patterns in windows 3, 6, 9). One can suppose that congruent patterns are *obviously* obtained by translations of integer numbers of generating cell side-lengths T_x and T_y. However, it is also possible (as in this case) that patterns will repeat after only $(T_x)/2$ and $(T_y)/2$ because there are mirror lines half-way down the cell.

Figure 5b shows a combination of rigid motions of the same amount along T_x and T_y. The lattice moves along the diagonal $T_x + T_y$ from window 1 to 6. Now the patterns are again different from the previous ones and show more surprising changes. Both centered lattice and primitive lattice (shaded) are shown.

The figures in windows 7 to 9 show what happens if the cell in window 6 is assigned the space group cm and then the cell is shifted back to the original position in window 1.

In Fig. 6, ADIM is demonstrated. In this case, the design and the origin of the starting lattice do not leave their original place, but the lengths of the periods T_x and T_y change progressively. The example concerns hexagonal space groups (p31m and p3m1) so T_x and T_y must change simultaneously in the same way.

From the starting situation, windows 1 and 2, we move to windows 3 to 7 with the lattice becoming finer and finer. The resulting pattern becomes more dense; to see its detail it must be enlarged, as in window 8. Thus, we see a sequence of patterns, some of them quite interesting, others absurdly intricate. It is possible, however, to discover the hidden underlying regularity (at least within a reasonable degree of approximation).

The last window—window 9—is actually made up of two windows. The larger window shows the effect of passing from p31m (as in window 1) to the space group p3m1. The inset area shows a step in the progressive reduction of T_x and T_y with this new space group.

ADIM acts on every space group. ASHIFT cannot change any p1 pattern.

Acknowledgment

This work has been carried out with the financial support of the Italian C.N.R. (CTB 92.000.CT12) and of the Italian Minister of the Scientific and Technological Research (MURST).

References and Notes

1. I. Hargittai and M. Hargittai, *Symmetry through the Eyes of a Chemist* (Weinheim: VCH, 1986).

2. I. Hargittai, ed., *Symmetry: Unifying Human Understanding* (New York: Pergamon Press, 1986).

3. M. V. Jaric', ed., *Introduction to Quasicrystals* (Boston, MA: Academic Press, 1988); M. V. Jaric', ed., *Introduction to the Mathematics of Quasicrystals* (Boston, MA: Academic Press, 1989).

4. D. P. di Vincenzo and P. J. Steinhardt, eds., *Quasicrystals: The State of the Art* (Singapore: World Scientific, 1991).

5. L. Loreto and M. Ronchetti, eds., *Topics on Contemporary Crystallography and Quasicrystals*, Special Issue, *Periodico di Mineralogia* **59** (Rome, 1990).

6. B. Grünbaum and G. C. Shephard, *Tilings and Patterns* (New York: W. H. Freeman, 1986).

7. For the fundamentals of crystallography, see T. Hahn, ed., *International Tables for Crystallography* **A** (Dordrecht: Kluwer Academic Publishers, 1992); B. K. Vainshtein, *Modern Crystallography I* (Berlin: Springer-Verlag, 1981); P. Engel, *Geometric Crystallography* (Dordrecht: D. Reidel, 1986); and M. B. Boisen, Jr., and G. V. Gibbs, "Mathematical Crystallography", *Reviews in Mineralogy* **15** (Washington, D.C.: Mineralogical Society of America, 1985).

8. For the mathematics (and crystallography) of ornaments and patterns, see D. Schattschneider, "The Plane Symmetry Groups: Their Recognition and Notation", *Am. Math. Monthly* **85** (1978) pp. 439–450; D. Schattschneider, *Visions of Symmetry: Notebooks, Periodic Drawings and Related Works of M. C. Escher* (New York: W. H. Freeman, 1990); D. Schattschneider, "The Fascination of Tiling", in this book; A. Gavezzotti, "The 17 Two-Dimensional Space Groups: An Illustration", *Atti Accad. Naz. Lincei, Memorie (Ser. VIII)* **13** (1976) pp. 107–119; A. Gavezzotti and M. Simonetta, "On the Symmetry of Periodic Structures in Two Dimensions", *Comp. and Math. with Applic.* **12B**, No. 1/2, 465–476 (1986); M. Senechal, "A Brief Introduction to Tilings", in M. V. Jaric', ed., *Introduction to the Mathematics of Quasicrystals* (Boston, MA: Academic Press, 1989) pp. 1–50.

9. L. Cervini, R. Farinato and L. Loreto "Interactive Computer Graphics (ICG) Production of the 17 Two-Dimensional Crystallographic Groups, and Other Related Topics", in H. S. M. Coxeter, M. Emmer, R. Penrose and M. L. Teuber, eds., *M. C. Escher: Art and Science* (Amsterdam: North Holland, 1986) pp. 269–284.

10. H. Brown, R. Bülow, J. Neubuser, H. Wondratschek and H. Zassenaus, *Crystallographic Groups of Four-Dimensional Space* (New York: Wiley, 1976) p. 19.

11. H. S. M. Coxeter and W. O. J. Moser, *Generators and Relations for Discrete Groups* (Berlin: Springer-Verlag, 1984).

12. For a table with a motif of colour figures but without symmetry diagrams, see C. Giacovazzo, H. L. Monaco, D. Viterbo, F. Scordari, G. Gilli, G. Zanotti and M. Catti, *Fundamentals of Crystallography*, C. Giacovazzo, ed., IUCr Book Series (Oxford: Oxford Univ. Press, 1992) p. 34.

13. For more details, see Grünbaum and Shephard [6]; and Coxeter and Moser [11].

14. P. S. Stevens, *Handbook of Regular Patterns: An Introduction to Symmetry in Two Dimensions* (Cambridge, MA: The MIT Press, 1981).

15. See Hahn [7].

Reflections on Symmetry-Dissymmetry in Art and in Art Studies

V. A. Koptsik

Prejudice against the use of scientific methods for studying artistic phenomena has not yet been overcome among artists. This prejudice is based on the incorrect idea that even the acknowledgment of scientific laws in art might in some way interfere with the direct perception of artistic compositions. In 1927 A. V. Shubnikov wrote that artists had

> a horror of the words law, order, symmetry, geometry; they prefer harmony, beauty, style, rhythm, unity, although the true meaning of these words differs very little from that of the former. Words, of course, are not really the point; the essence of the hostility of art towards science lies in the conviction that a fully discovered law will introduce triviality into poetry. This might indeed be true to a certain extent, but it is certainly not entirely so: only he who is prepared to feel, and as far as possible understand, the laws of art can really enjoy it [1].

This paper, starting from our previous volume [2], deals with the problem of manifestation of the symmetry-dissymmetry phenomena in art and in artistic knowledge. The concept of symmetry arises in the theory of art through the concept of structure. Art, as a depiction of the cognition and modeling of the world around us, should reflect and, indeed, does reflect the structural aspect of that world. Structure is truly a broad law relating to both the existence and motion of matter, and the products of both scientific and artistic creativity are subject to this law. Artistic products—literature, poetry, music, painting, architecture, etc.—have a complex artistic structure, presenting an organic interweaving and interpenetration of a variety of substructures constituting individual components of artistic expressiveness.

The application of symmetry to art has so far been of a limited nature, with the concept of symmetry having been restricted to orthogonal groups and groups of motions relating to congruent and mirror-equivalent geometric shapes. The range of application has been limited to 'nondescriptive' art forms: architecture and decorative, ornamental and pictorial construction and design.

A transition to color groups greatly extends the possibilities of using the ideas and methods of symmetry theory in scientific research and artistic creativity. The possibilities increase still further upon dispensing with the condition that the metric properties of the objects under consideration must be preserved during transformation—we can then, for example, study the properties of objects that are preserved during affine, projective, combinatorial or topological transformations.

The color groups of generalized transformations are the composite groups of the material spaces and objects that have external (space) and internal (material point) structure. We shall define the symmetry group of a material object as the highest possible group of automorphic transformations (on both space and point levels) mapping any integral structural object (consisting of elements equivalent in the sense of relative equality) onto itself. In this way, we define *symmetry* as the law of composition (construction) of structural objects or, more precisely, as the group of permissible one-to-one transformations that preserve the structural integrity of the systems under consideration. A still more general concept of symmetry semigroups arises for the case of mapping an arbitrary set x onto itself when the mapping $x \rightarrow x$ is not necessarily one-to-one.

Nature knows no structureless objects. The essential generality of the category of structure and the possibility (in principle) of distinguishing equivalent (in one sense or another) parts within the whole make the concept of symmetry of just as much general significance for contemporary natural science as for art.

Structure, understood in the broad sense of the word, is an invariant aspect of any integral system at a specific stage of its development. The movement of matter should be represented as a dialectic unity of moments of change and conservation. The mathematical apparatus of group theory provides an excellent reflection of this specific feature of motion. In order to define a group of transformations, in fact, we have to specify an invariant object (or system of objects), the internal structure of which consists of elements that are equivalent in a certain specified sense. On the other hand, each of the groups of transformations has its own system of conserved quantities.

Any material object is characterized by interpenetration, by a specific coordination or subordination of substructures. The composite character of the organization of integral

ABSTRACT

The author discusses the general principles of applying his generalized method of color symmetry to the qualitative analysis of art language and structure in poetry, music, painting, fiction, architecture, decorative art and design. Similar to synergetics, the color symmetry method provides a tool for the description of qualitative variations of artistic structures. It can be used together with mathematical tools of synergetics for searching group-invariance solutions of nonlinear equations that simulate artistic phenomena and processes.

V. A. Koptsik, Dept. of Physics, Moscow State University, 117234, Moscow, Russia.

systems stimulates the methodological problem of isolating systems and separating their structural sublevels. Divide to unite—such is the motto and method of scientific research. Freeing itself from nonessential relationships or interesting itself solely in the separate properties of systems with specific relationships, science constructs simplified models of real systems, and these form the subjects for subsequent investigation in both science and art.

These days the art and music schools insist that their students become acquainted with the methods of structural art analysis. In the textbook for the students of the Moscow Conservatory [3], the following basic idea was clearly formulated: "From complete perception to logical analysis and then again to the complete synthetic grasp of the phenomenon on a higher basis". The understanding of the completeness of this idea is the contribution of science to art.

Ideas of symmetry (literally, commensurateness or proportionality) arose among the ancient Greek philosophers and mathematicians in connection with their study of the harmony of the world. Ancient sculptors, artists and architects created their masterpieces in accordance with the canons of harmony (the concept of which changed with the centuries).

The extension of the concept of symmetry, as mentioned earlier, greatly broadens the range of its applications in art. In fact the laws of perspective in drawing and preparing diagrams are none other than the laws of the groups of projective transformations, which can be accepted as similarity or color similarity transformations at the levels of the corresponding substructures. The harmonic proportionality of antique sculptural and architectural forms is the result of the old masters' strict observance of the canons of projective groups. Groups of transformations in four-dimensional space-time, together with color groups, define the specific laws of composition for the arts that incorporate time: music, poetry, dance and motion pictures.

The application of the extended concept of symmetry in art is associated with finding specific equivalent relations between the elements of artistic substructures and finding groups of artistic automorphisms that keep a distinct structural level invariant. Transformations and their invariants—these are the most important concepts in both science and art!

SYMMETRY IN MUSIC AND POETRY

The first Russian scientists who applied the idea of classical symmetry to music and poetry were G. E. Conyas (a great musician and teacher) and G. V. Wulff (the founder of the Russian physical science of crystals). "The spirit of music is rhythm", wrote Wulff in 1908,

> It consists of the regular periodic repetition of parts of the musical composition (the parts of the bar within a bar, the bar in the musical phrase, the phrase in the period, and so on); the regular repetition of identical parts in the whole constitutes the essence of symmetry. We are all the more justified in applying the concept of symmetry to a musical composition in view of the fact that it is written in terms of notes, i.e. it takes a spatial geometric form, so that we can inspect its constituent parts. Symmetry applies to literary composition as well as to music, and especially to verse. If the concept of symmetry can be applied to musical and literary compositions, far more directly and obviously can it be applied to art and architecture [4].

Let us analyze the substructures of poetic text and determine their symmetry groups, taking one of the stanzas from A. Pushkin's novel in verse *Eugene Onegin* as an example [5].

Poetic forms are based on the alternation of strong and weak syllables natural to audible speech, syllables that ensure clarity in the reproduction and reception of the spoken word ('prosody of language'). By joining the 14 lines in the *Onegin* stanza (in one's imagination) into a single line, we obtain a one-dimensional sound pattern, the unit cell of which is marked by an iamb, $| \cup - |$, which occurs four times in each line of verse. At the junctions between the lines, on seven occasions we encounter trochees $\mathbf{t} = | - \cup |$, and six times a weakened iamb $\mathbf{i} = | \cap \cup |$ in the sequence **itit iitt itti t(t)** (the parentheses indicate a trochaic consonance linking the stanza given above to the next one).

The transitions between the lines are intensified by the rhymes—that is, the consonances forming the next level of the sonic structure: **AbAbCCddEffEgg.** The capital letters indicate lines with feminine endings, while the lower-case letters indicate lines with masculine endings. We note that the sound structure of the *Onegin* stanza is asymmetric: the unit cell is made up of the set of rhymes indicated by the letters, and these are repeated translationally from stanza to stanza. Hence the novel *Eugene Onegin* as a whole constitutes at this level a one-dimensional translational structure similar to a one-dimensional single-crystal!

The third (melodic-intonational) sound sublevel forms a system of 'sound waves': alternations of rising and falling intonations of the 'question-and-answer' type. The degree of regularity of this translational structure depends on the level of abstraction: it is more regular if we pay no attention to the different heights of the crests of the sound waves, and less regular if we do.

The three sound substructures thus distinguished carry no logical significance, but they give the poetic composition a certain emotional timbre—they form, as it were, an accompaniment to the verse. The very changes that occur—the speeding up and the slowing down, the monotonous repetition of rhymes and rhythms, the melodious pattern of question-and-answer intonations, the voice-distinction of the especially emotional places—all these create a specific mood, like a song without words.

The individual substructures of sound in the verse are by no means independent of one another. They cannot exist without a relationship with the expressive agency of language. The joining of syllables into words, words into sentences, sentences into sections, etc., leads to the formation of qualitatively new 'sense' or 'meaning' (syntactic and subjective-thematic) substructures, at the level of which the poetry itself is created.

The lowest sense unit of poetic speech is one line of verse. The 'short-range-order' symmetry at this level is poor. "The true life of a verse lies in its motion", said B. Tomashevsky [6]. Placed side by side, words equivalent in meaning show no development of thought—that is, classical translation is rarely encountered at the verse level, unless repetition is a means of emphasizing a word. Sense antisymmetry within a verse is encountered in antonyms ("Wave and stone, Poetry and prose, Ice and flame"—A. Pushkin) and antitheses ("I am a king, I am a servant, I am a worm, I am a god"—G. Derzhavin). A greater scope for the development of thought is provided by color symmetry, e. g. the intensification or weakening of expression on passing from word to word can be considered as the assignment of a new quality of the word ("I sorrow not, nor cry, nor weep"—S. Esenin; "I find. I take. I destroy. I enfilth"—V. Mayakovsky).

The highest poetic unit is formed by the stanza. The main characteristics of this are a fixed sequence of rhymes and

rhythmic-intonational closure. The *Onegin* stanza and the sonnet, which also has 14 lines, form an upper limit for a stanza. Other examples of stanzas are: The distich (**ab ab**), the ghazel (**aa ba ca da**), the terzarima (**aba bcb edc ded**), the sextine (**abbacc**), the septime (**aabcccb, ababccd** or **ababccb**), the octave (**abababcc**), and so forth. The stanza characteristics give wholeness, thematic finality and metric unity to the whole composition.

The *Onegin* stanza is not only a rhythmically syntactic unit but also a subjective-thematic, miniature chapter in the narrative. The internal structure of the stanza consists of four substructures. The first four-line verse has overlapped rhymes (the classical translation, **Ab → Ab**), the second has contiguous structure (color translation, **CC → dd**), and the third has embracing rhymes (antitranslation, **Ef → fE**). As a whole, the rhythmic asymmetry of the stanza, emphasized by the final **gg**, is polar. If we select a direction along the time axis, we find that the rhythmic sound sequence agrees in its principal features with the direction of development of the subject. We can thus compare the development of the theme within the stanza with a 'color' translational variation.

A further enlargement of the scale of the color translation occurs at the composition level, when the stanzas are combined into a whole novel. Whereas repetitive groups of sounds were the invariants of the translational groups at the nondescriptive sublevels of the verse, at the thematic subjective level the invariants of the enlarged color groups are constant characters and themes, plots and subjects varying from author to author and from age to age.

Ideas of varied development are central features in all forms of art. Finding sense invariants in a literary composition is no chance matter. It is shown in works of mathematical linguistics that *sense is an invariant of the synonymical transformations* of language. Finding invariants of stylistic transformations is the forte of V. V. Vinogradov. Tracing the creation of "new stylistic patterns on an old canvas", he notes that groups of words, characters and themes, constituting the fundamentals and supports of the subject's construction and guiding its movement, stand out (in Pushkin's works) "symmetrically, almost with a mathematical regularity in their relations". Moving to and fro, in a zigzag manner, the subject "forms symmetrical patterns, drawn together by relationships of parallelism, contrast and semantic mutual dependence". The very "principle of symmetric disposition, reflection and variation of the characters and themes in the structure of a literary composition constitutes the peculiar 'law' of Pushkin's artistic system" [7].

It can be demonstrated that the deep-seated unity of the laws of composition acting at different structural levels in all temporal forms of art is a consequence of the homo- or isomorphisms of the symmetry groups of the corresponding structures—translational classical and color groups and groups of similarity symmetry. All structural levels of true artistic composition (worthy of the name) are fused together into a single artistic system, and each makes its own specific contribution to the overall artistic effect.

Passing now from poetry to music we shall use the analogy between them, which has more than just metaphorical significance ("poetry is the music of words, music is the poetry of sound"). The deep-seated unity of poetry and music is founded on their common temporal nature, their structural peculiarities and the existence of certain common laws of composition. These laws can be reduced to three basic principles: the translationally identical (or similar), the contrasting (antisymmetrical), or the varied (color) repetitions of structural elements in time (or space).

Constructive form, in the wider sense, constitutes an organized embodiment of the content of all musical characteristics: harmony, melody, tempo, meter, rhythm, concord, polyphony, timbre, register, texture, dynamics, nuances of execution, and so forth. Being possessed of so extensive a language, music can reflect the dynamics of phenomena, their development, the struggle between opposing forces, and convey not only the world of feelings, but also that of thoughts and ideas, according to Vinogradov and Krasovskaya [8]. These authors make extensive use of symmetry considerations. They present some exquisite examples of complete analyses of musical compositions. The unity in the principles underlying the construction of the finest and most comprehensive parts of the composition is convincingly demonstrated. Also demonstrated is the fact that music's obedience to the organizing laws is as important an aspect as music's refusal to follow them too exactly. Once again we encounter the unity between symmetry and dissymmetry!

In our work [9] we showed that, to a certain approximation, the note-by-note recording of a musical composition can be converted into the language of the transformations of a two-dimensional space group of color similarity, the axis of time translations being horizontal and that of color translations (the changing pitch of the sound) being vertical. The local transformations that change the duration, loudness and timbre of the sound, combined with the translations in time, may be also introduced. Then our two-dimensional space groups become poly-dimensional ones. The mirror reflections in ordinary or color horizontal and vertical planes of symmetry, as well as inversions in symmetry centers, also manifest themselves in the structure of musical texts.

If now in the correspondingly defined 'unit cell' we have a certain basic set of sound combinations—the 'grains' of motifs, chords, musical phrases, periods and other constructions—then by using the transformations of music variation, we can derive the substructure of a musical text ('regular' system of sounds and their combinations), invariant with respect to the corresponding color symmetry groups. The structure of the musical composition as a whole is represented then formally as the superposition (association and intersection) of appropriate substructures. The analysis of the aesthetic sense of such compositions can be also performed [10].

SYMMETRY IN VISUAL ART

The analysis of the symmetry relations acting at various structural levels in subjective-thematic visual art is usually a more complicated problem than the cases we have so far considered. It is comparatively easy to dissect the structural sublevels themselves. We shall present an overall view of the following: levels of geometric composition, of graphical outline, of light and shade, of coloring and subjective-thematic levels. The first four 'nondescriptive' levels determine, to a greater or lesser degree, the decorative qualities of the artistic canvas. At the same time, being elements of the composite semiotic structure, they are also material carriers of specific aspects of content.

If we provisionally withdraw our attention from the con-

tent aspect, we can associate specific groups of symmetry transformation with each of these levels. As in network patterns, orthogonal groups with vertical symmetry planes will define the general static characteristic of the composition. With orthogonal axial groups we shall associate cyclic motion enclosed within the space of the picture. The idea of infinite motion is brought into the artistic structure by projective groups defining linear perspective and translational rhythms associated with space groups of similarities. Special antisymmetry groups can be associated with the distribution of light and shade at the level of the topological equivalence relations between 'shapeless' spots. In exactly the same way, the generalized color groups determine the color matching between topologically equivalent color spots. In all cases, symmetry is not followed with mathematical accuracy, but only with some degree of approximation.

In order to find the sense invariants of the corresponding transformations, let us first formulate the basic laws (or principles) of composition that composite artistic systems obey. In each of these, some particular feature of the fundamental laws of materialist dialectics finds its reflection. The law of unity of form content at the level of art can be formulated as the principle of completeness (integrity) of artistic composition.

The principle of development, which at the level of the temporal arts appears as the principle of color variation and the development of the subject, appears at the level of nontemporal arts as the culmination·principle. This principle requires that the artist, in his or her thematic composition, provide indications of the previous and subsequent states, even at the culminating moment of the subject, by all artistic artifices available to the particular art form in question.

The principle of contrast—the law of artistic dramaturgy—represents the extreme expression of color nuances.

The principle of correspondence requires the existence of relationships of isomorphism ($A \leftrightarrow A'$) or homomorphism ($A \rightarrow A'$) between the object A and its model A'. Art as a descriptive form of the reflection and reproduction of reality, and as the homomorphic model of that reality, should preserve the essential relationships that reality contains. Hence the requirement of generalization—the expression of the typical in terms of the specific, which is sometimes formulated as an independent principle of art.

CONCLUSION

In conclusion, the reader should note two important things: (1) the connection of symmetry groups of material systems with physical conservation laws and (2) the leading role of symmetry-breaking in physical processes. According to the Curie principle [11], it is dissymmetry that creates phenomena. In the theory of knowledge, symmetry enters as a method of observing and describing invariant laws (laws of conservation). The principles of symmetry have this to say to us: In every material process (the process of perception [12] is among them), find the governing laws, the interrelationships, the quantities that are conserved! At the same time, if a model of the phenomenon in question (for example, the transformation of perceptions into thoughts [13]) is created, these principles make it clear to us precisely what properties are forbidden in the system so specified. It is in these two properties of the principles of symmetry reflecting causal relationships that their heuristic role lies.

The possible applications of the symmetry-dissymmetry theory for the qualitative analysis of language subsystems of art systems are based on the community of science and art laws known to be invariants of transformations of appropriate generalized symmetry groups [14–17]. Besides similarities in the systems' nature, science and art are drawn together by the dialectic unity of concrete and abstract, aesthetic and theoretical aspects in art and science information. The applications of mathematical models and methods in art studies is not counterindicative to art, provided the models and methods being applied at the proper level to art phenomena ensure adequate description. I am sure that the color symmetry approach answers such demands.

APPENDIX

Every group of transformations $G = \{g_1, g_2, \ldots, g_n\}$ is by definition a symmetry group because the law of multiplication of the elements in the group $g_i g_j \in G$ maps the set G onto itself, $g_k G = \{g_k g_1, g_k g_2, \ldots, g_k g_n\} = G$ (one understands the multiplication $g_i g_j$ as the sequence of two transformations—g_j is the first, g_i is the second). If some other set $R = \{r_1, r_2, \ldots, r_n\}$, made up of the elements r_i of a different nature, maps onto itself under the action of $g_k \in G$, $g_k R = \{g_k r_1, g_k r_2, \ldots, g_k r_n\} = R$, $g_k r_i = r_{i(k)} \in R$, then the object R will also be symmetrical with the abovementioned symmetry group G.

Let us consider some structures that a regular triangle can have on the plane. Three edges of the triangle (Fig. 1a), each divided in half and assigned a number, constitute the triangle's external structure $R = \{1, 2, 3, 4, 5, 6\}$. This structure maps onto itself under the action of mirror reflections in three symmetry planes—$\hat{m}_1, \hat{m}_2, \hat{m}_3$—and under three rotations—$\hat{3}, \hat{3}^2, \hat{3}^3 = 1$ at the angles $120°$, $2 \times 120° = 240°$, $3 \times 120° = 360° \equiv 0° \pmod{2\pi}$—around the three-fold symmetry axis in the center of the figure. The abovementioned transformations carry out the rearrangements (substitutions) of numbers inside the set R:

$$\hat{m}_1 R = \hat{m}_1\{1,2,3,4,5,6\} = \{\hat{m}_1 1, \hat{m}_1 2, \hat{m}_1 3, \hat{m}_1 4, \hat{m}_1 5, \hat{m}_1 6\}$$
$$= \{2,1,6,5,4,3\} = R,$$
$$\hat{m}_2 R = \{6,2,4,3,2,1\} = R,$$
$$\hat{m}_3 R = \{4,3,2,1,6,5\} = R,$$
$$\hat{3} R = \{3,4,5,6,1,2\} = R,$$
$$\hat{3}^2 R = \{5,6,1,2,3,4\} = R,$$
$$\hat{1} R = \{1,2,3,4,5,6\} = R.$$

Therefore, the totality of such isometric transformations constitutes the symmetry group of the triangle, which can be designated by the symbols of the generators of the group $G = \hat{3}\hat{m}_1$. The same symmetry group describes the regular triangle with the internal structure consisting of six small regular triangles (Fig. 1b). If the internal structure is different, for example as shown in Fig. 1c, the symmetry group of the regular triangle decreases to the subgroup $H = \hat{3} = \{\hat{1}, \hat{3}, \hat{3}^2\}$ of the group $G = \hat{3}\hat{m}_1$.

The same isometric symmetry group $H = \hat{3}$ includes the triangle consisting of three black (b) and three white (w) right triangles, as shown in Fig. 1d. Nevertheless, one has the feeling that the symmetry group of Fig. 1d must be higher. And this is indeed so at the level of the two-color (anti)symmetry group $G^{(p)} = \hat{3}\hat{m}_1^{(bw)}$, isomorphic with the group $G = \hat{3}\hat{m}_1$ of Fig. 1b. Here the operator $p = (bw)$ gen-

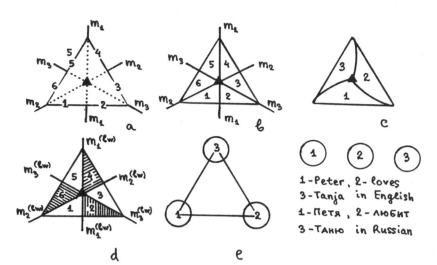

Fig. 1. Symmetry groups of regular triangles with different internal structures.

(a) $G = \hat{3}\hat{m}_1$;

(b) $G = \hat{3}\hat{m}_1$;

(c) $H = \hat{3} \subset \hat{3}\,\hat{m}_1 = G$;

(d) $G^{(p)} = \hat{3}\hat{m}_1{}^{(bw)} \leftrightarrow \hat{3}\hat{m}_1 = G$;

(e) $G = \hat{3}\hat{m}_1$ for six Russian sentences $R = G(123)$; $G^{(p)} = \hat{3}^{(p_2)}\hat{m}_1{}^{(p_1)}$ for six English sentences;

— is the graphic symbol of symmetry planes m_i,

▲ is the symbol of the three-fold axis of rotation (see explanation in the Appendix).

erates the cyclic permutation of the colors b → w, w → b, which accompanies the geometric transformations of the mirror reflections \hat{m}_i (i = 1, 2, 3). Under the isomorphism of the two groups $\hat{3}\hat{m}_1 \leftrightarrow \hat{3}\hat{m}_1{}^{(bw)}$, the one-to-one correspondence of their elements $\hat{m}_i \leftrightarrow \hat{m}_i{}^{(bw)}$, $\hat{3} \leftrightarrow \hat{3}^{(bw)}$ is understood, together with their products, e.g.

$$\hat{m}_2\hat{m}_1\left(= \hat{3}^2\right) \leftrightarrow \hat{m}_2{}^{(bw)}\hat{m}_1{}^{(bw)}.$$

The action of the combined operator $m_1{}^{(bw)} = [(bw)/m_1]$ $\in G^{(p)}$ on the color structure $R^{(bw)} = \{(\text{color, position of small triangle})\} = \{(w,1), (b,2), (w,3), (b,4), (w,5), (b,6)\} = G^{(p)}(w,1)$, the orbit of the group $G^{(p)}$, transforms the set $R^{(bw)}$ onto itself:

$$\hat{m}_1{}^{(bw)}R^{(bw)} = \left\{\left((bw)\cdot\text{colour}, \hat{m}_1\cdot\text{position}\right)\right\} =$$
$$\left\{(b,2),(w,1),(b,6),(w,5),(b,4),(w,3)\right\} = R^{(bw)}.$$

Consequently, $R^{(bw)}$ simultaneously includes the symmetry group $G^{(p)}$ and the isometric group $H = \hat{3} \subset G^{(p)}$ (dissymmetric in comparison with $G^{(p)}$).

The final example deals with the sense structure of sentences composed of three words:

1 = Peter, 2 = loves, 3 = Tanja,

the Russian equivalent being

1 = Петя, 2 = любит, 3 = Таню

(see Fig. 1e). Every permutation of the three words in the orbit of the group $G = \hat{3}\hat{m}_1$, R = {123, 312, 231, 132, 321, 213} = G(123) preserves the general sense "Boy loves girl" in Russian, with some nuances. The translation of these sentences into English can be performed only by means of phraseological construction, with the exception of the first sentence:

123 – Петя любит Таню	↔	Peter loves Tanja.
312 – Таню Петя любит	↔	It is Tanja whom Peter loves.
231 – ЛюбитТаню Петя	↔	In love with Tanja is Peter.
132 – Петя Таню любит	↔	Peter with Tanja is in love.
321 – Таню любит Петя	↔	Tanja is loved by Peter.
213 – Любит Петя Таню	↔	In love is Peter with Tanja.

Now the collection of six English sentences is the orbit of positional color symmetry group $G^{(p)} = \hat{3}^{(p_2)}\hat{m}_1{}^{(p_1)}$, $R^{(p_i,p_j)} =$ $G^{(p)}(123)$, where p_i, p_j are the complex instructions about the necessary changes in language.

We can conclude that the color symmetry method turns out to be adequate and informative for the analysis of the 'language' of artistic structures because color groups simultaneously carry information about symmetry-dissymmetry properties.

Acknowledgments

I am much indebted to Michele Emmer for the presentation of my paper to *Leonardo* and for his comments, and to Patricia Bentson, Senior Editor of *Leonardo*, for her technical assistance.

References

1. A. V. Shubnikov and V. A. Koptsik, *Symmetry in Science and Art* (New York: Plenum Press, 1974); translated from the Russian edition (Moscow: Nauka, 1972).

2. Shubnikov and Koptsik [1].

3. L. A. Mazel' and V. A. Tsukkerman, *Analysis of Musical Compositions* (in Russian) (Moscow: Muzyka, 1967).

4. Shubnikov and Koptsik [1] p. 353.

5. This short analysis is from Shubnikov and Koptsik [1] pp. 353–360.

6. Shubnikov and Koptsik [1] p. 357.

7. Shubnikov and Koptsik [1] p. 360.

8. G. V. Vinogradov and I. M. Krasovskaya, *An Entertaining Theory of Music* (in Russian) (Moscow: Soviet Composer, 1991); see also Mazel' and Tsukkerman [3].

9. Shubnikov and Koptsik [1].

10. See Vinogradov and Krasovskaya [8].

11. Shubnikov and Koptsik [1] pp. 282–311.

12. Giuseppe Caglioti, *Broken Symmetries in Science and Art* (Berlin and Heidelberg: Springer-Verlag, 1991); G. A. Golitzin and V. M. Petrov, *Information-Behaviour-Creative Work* (in Russian) (Moscow: Nauka, 1991).

13. Shubnikov and Koptsik [1].

14. V. A. Koptsik, "Invariants and Symmetry Transformations of Art Structures", in *Transactions of the Symposium on the Second Model Systems* 1, No. 5, 151–159 (1974) (Tartu, USSR); see also Shubnikov and Koptsik [6].

15. V. A. Koptsik, "New Group-Theoretical Methods in Physics of Imperfect Crystals and the Theory of Structural Phase Transitions", *J. Physics* **C16** (1983) pp. 1–22; "Symmetry Principles in Physics", *J. Physics* **C16** (1983) pp. 23–35.

16. V. A. Koptsik, "Generalized Symmetry in Crystal Physics", *Comput. Math. Appl.* **16** (1988) pp. 407–424.

17. V. A. Koptsik, "Crystallography of Quasicrystals: The Problem of Restoration of Broken Symmetry", in *Lecture Notes in Physics*, Vol. 382 (Berlin: Springer-Verlag, 1991) pp. 588–600.

Perspective, Mathematics and Art

DEVELOPMENTS IN PERSPECTIVE

Arnason, in his standard *History of Modern Art,* described Renaissance art as "imitations of nature" and claimed that "perhaps the greatest revolution of early modern art lay in the abandonment of this attitude and the perspective technique that made it possible" [1]. Such claims have led to a widespread view that interest in perspective died in the twentieth century. Even a quick glance at the number of books published on perspective since the fifteenth century [2] reveals that this is not the case (Table 1).

This trend partly reflects a growing historical awareness. There have been more editions of fifteenth- and sixteenth-century authors on perspective in our century than ever before, including first critical editions of Alberti, Filarete, Francesco di Giorgio and now Piero della Francesca [3]. Piero is all the more interesting because his *Flagellation of Christ* (Fig. 1) is one of the very few Renaissance paintings that has a carefully determined perspectival construction. Ever since Wittkower and Carter's classic article [4], scholars have been fascinated with finding new ways to reconstruct the perspectival lines in this painting, as witnessed by the first contribution in this section by Laura Geatti and Luciano Fortunati, which uses computer graphics. In Renaissance treatises on perspective, certain themes such as the regular solids were particularly popular. The second and third contributions in this section, by Michele Emmer and Lucio Saffaro, respectively, can be seen as a direct continuation of that tradition. The fourth contribution, by A. S. Koch and T. Tarnai, can be seen as poetic variations on this theme of symmetry and regularity.

Fig. 1. Piero della Francesca, *The Flagellation of Christ,* **circa 1458 (Urbino, Galleria Nazionale delle Marche, Palazzo Ducale). (Copyright © 1990 Archivi Alinari/Art Resource, NY. All Rights Reserved.)**

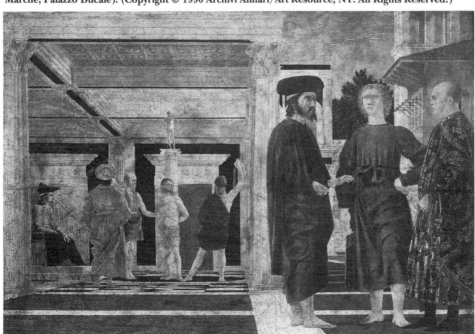

Table 1. Books on perspective, 1400–1989.

1400–1499	1
1500–1599	456
1600–1699	732
1700–1799	849
1800–1899	2714
1900–1989	2801

Antiquarian and nostalgic interest comprise but one aspect of modern concern for perspective. Partly because there are now a number of different goals of art, artists are exploring a whole range of alternative methods of perspective. Some of these experiments relate perspective to what might be termed a personalized optics. Others reflect a new awareness of transformations brought about by mapping, computers and virtual reality. Meanwhile, the advent of fractals has raised but not answered new philosophical problems concerning the parameters within which perspective is valid. It will be useful to review briefly the context for and characteristics of Renaissance perspective before considering each of these topics in turn.

RENAISSANCE PERSPECTIVE

In antiquity, Euclid's *Optics* focussed on how things appear to the eye: a concern that is now termed psychological optics. Euclid's treatise also contained four propositions on surveying, which introduced a quantitative dimension into an otherwise qualitative discussion. In the course of the Middle Ages, with particular thanks to thinkers such as Ibn al-Haytham (known to the Latin West as Alhazen) in the Arabic tradition, this concern with potentially quantitative, objective aspects of sight gained greatly in importance [5]. By the 1270s, when Witelo wrote his great compendium on optics (termed *perspectiva* in Latin), he was concerned not just with the eye but also with instruments "for the certification of sight", such as quadrants and astrolabes. A nexus thus evolved that linked optics, surveying, astronomy and instrumentation. This concern with certification of sight led to practical demonstrations that involved representation. Brunelleschi's demonstration was in this tradition. In the fifteenth and sixteenth centuries this became known as practical (linear) perspective, for which Euclidean optics was assumed to provide the theory.

VISION AND GEOMETRY

Basic to the Euclidean theory of vision was an angle axiom that denied a simple inverse relation between (apparent) size and distance. Linear perspective introduced an inverse size-distance axiom. Panofsky assumed that theories of vision and representation were necessarily linked and hence believed that the advent of linear perspective required a change in the theory of vision [6]. He cited Pena's 1557 edition of Euclid's *Optics* as evidence. In fact the Euclidean theory of vision remained unaffected by perspective. Perspective, which had been linked with optics, became linked increasingly with geometry. In the sixteenth century, this occurred particularly in Urbino, with mathematicians such as Federico Commandino, Giovanni Battista Benedetti and Guidobaldo del Monte, who was one of the teachers of Galileo.

In the seventeenth century, Paris became the world centre for mathematical perspective through mathematicians such as Jacques Aleaume and Girard Desargues and artists such as François Niceron and Abraham Bosse. Thus Bosse, the first professor of perspective of the French Academy, could urge painters that they must draw what is there (Euclidean geometry) and not what is seen (Euclidean theory of vision) [7]. His colleagues, particularly Charles Le Brun, preferred to expel Bosse

from the academy rather than face the consequences of this clear statement of logic. From the 1660s to the 1820s, artists either (1) chose limited conditions in which the effects of vision and perspective coincided or (2) spoke in general terms about (Euclidean) vision and (linear) perspective. The rise of descriptive geometry, which claimed to offer universal principles for representation, led to the first serious claims that representation and vision must be coincident. Hence Panofsky was reading back into the sixteenth century a development that occurred in the early nineteenth century.

The nineteenth century also brought other developments. Mathematicians explored various alternatives to (rectilinear) Euclidean space. These experiments eventually had consequences for modern art, as Linda Dalrymple Henderson and Manuel Corrada show in the fifth and sixth contributions to this section. Meanwhile, physiologists became aware of serious problems with earlier analogies between the eye and camera obscura through Leonardo, the astronomer Johann Kepler and the Jesuit scientist Christopher Scheiner. Helmholtz discovered that curved lines seen from nearby appeared straight, and hence he suggested a distinction between physical space, which was Euclidean, and visual space, which was non-Euclidean (and possibly Riemannian). Mach explored this distinction in his *Analysis of Sensations* and devoted a chapter to it in his *Knowledge and Error* (1905). The emergent schools of psychology focussed on different aspects of this distinction. The Berlin school, later known as the Gestalt school, emphasized geometrical space. The Leipzig school, with psychologists such as Wilhelm Wundt and E. B. Titchener, emphasized visual space. In the twentieth century this distinction has remained with physiologists such as Gezenius ten Doesschate. Sometimes the names for the elements have changed. Ernst Gombrich, for example, referred to visual space as the optical world or the mirror and to geometrical space as the physical world, the experienced world or the map [8].

The late J. J. Gibson called visual space the visual field and linked geometrical space with the visual world [9]. There is more to this change of terms than is at first apparent. In the nineteenth century it was generally assumed that visual space was subjective and geometrical space was objective. In Gibson's approach both are susceptible to measurement and hence in some sense objective. In Gibson's formulation there is also no opposition between vision and geometry. Geometry applies both to physical space and to (psychological) visual space. The question remains whether the same branch of geometry applies to both kinds of space. Those who claim that (linear) perspective is dead often mean that artists have given up trying to record physical space and are focussing on visual space with its non-Euclidean surfaces. There is something to this, but it is not the whole story.

MULTIPLE GOALS

The history of art is often told as if art had only one goal. Arnason's *History of Modern Art* can easily be read as if this were the case: for a long time the goal was imitation of nature and hence perspective was important. Then artists discovered the challenge of abstraction as a goal and abandoned perspective. One of the enduring contributions of Gombrich has been to emphasize multiple functions or goals of art: e.g. magic (which used to be termed primitive art), pattern (*Sense of Order*), mimesis (*Art and Illusion, Image and the Eye, Illusion in Nature and Art*), expression and abstraction (*Meditations on a Hobbyhorse*) and symbolism (*Symbolic Images*) [10]. In this approach some functions of art do not need and sometimes even preclude perspective, while others encourage its use.

The twentieth century has added new functions or goals. One might be termed exploring, which can be subdivided into the mental world, the perceptual world and chance. The third of these, of which Jackson Pollock is an excellent example, aims to remove any clear one-to-one correspondence between artist and art. This

goal, which results in abstract painting, was for a time frequently identified with modern art. It is becoming ever more obvious, however, that the other two areas being explored, namely, the mental and the perceptual world, have inspired a much richer repertoire of images. Exploration of the mental world has led to depiction of dreams, fantasies and other psychological dimensions. As a result realism has been applied to new realms, and in the process it has also been transformed into sur-realism, magic-realism, super-realism, hyper-realism.

Sometimes these new versions of realism involve a deliberate mixing of external elements (from the world of nature) and internal elements (from the world of the psyche). Linear perspective continues to play a significant role in these explorations. However, it is often used in conjunction with other methods. Delvaux frequently uses curved perspective in his depiction of streets. Dalí moves subtly between regular perspective and anamorphosis. Magritte uses what appears to be linear perspective but then deliberately plays with its underlying principles of occlusion and transparency. Hence, walls, which traditionally block out objects, are often transparent, and windows, which are traditionally transparent, often block a view in Magritte's paintings. These experiments are spreading to other media. The recent film *Toys* (1992) [11] adapts Magritte's painting *Golconda* (Menil Foundation, Houston) while playing on the paradox of the window as a mirror.

Implicit in these experiments is an insistence that artists are not bound to a one-to-one correspondence between object and representation. Or, to put it positively, artistic freedom is increasingly seen in terms of demonstrating alternatives. Hockney's combinations of photography and painting are another expression of these trends. In Hockney's case there is also another explicit concern. Linear perspective, he claims, created a wall between the viewer and the object represented. Inverted perspective, according to Hockney, offers a way of removing that wall and integrating both viewer and representation within the same space [12]. Artists such as Rauschenbach have offered another reason for inverted perspective: it corresponds, they claim, to visual experience [13]. This idea emerged in the circle of Florenskij in the 1920s and has become accessible to the West largely through the writings of Shegin [14].

ALTERNATIVE PICTURE PLANES

Since the early nineteenth century there has been a growing fascination with recording visual space as opposed to geometrical space, and this has been an important stimulus in the exploration of alternative picture planes. The most obvious versions entail imitating the convex surface of the eye, as in the work of Barre and Flocon recently made accessible through an excellent translation by Robert Hansen [15], who developed his own method of hyperbolic perspective and subsequently explored the history of the subject. According to Hansen, his is not simply a fascination with subjective, psychological factors. The challenge lies in developing objective methods to record visual experience.

A recent exhibition organized by Marcia Clark [16] confirms that this quest is about more than simply recording visual space from a single viewpoint as was traditionally the case. Some artists are intent on capturing a series of viewpoints simultaneously. This is one of the incentives not only for Dick Termes's spheres (see the seventh contribution in this section), but also for his work in photography and painting on polyhedral surfaces. Other artists, Hockney among them, are explicitly searching for means to incorporate the dimension of time into their representations of space. This new interest in dynamic aspects of vision accounts for many of the recent experiments with alternative picture planes using spherical perspective, cylindrical perspective, hyperbolic, fish-eye [17], tetraconic [18] polyconic and many another variants.

Seventeenth-century artists developed a perspectival peep show (*perpektyfkas*) that invited viewers to use a 'roving eye' to explore interiors. The work of Emilio Frisia (see the eighth contribution in this section) continues this tradition with a curious twist. His work shows us the interiors of rooms and environments from a viewpoint outside of these rooms. Indeed there is a curious way in which the work of Frisia and other twentieth-century experiments can be seen as exterior- or externalizations of spaces. If linear perspective was traditionally used to capture a particular viewpoint, new alternative projection methods are attempts to integrate a series of viewpoints.

TRANSFORMATIONS

The incentives for exploring alternative projection methods have not been simply perceptual. The rise of photogrammetry, particularly with the advent of satellite photography, has raised a series of practical challenges. How does one translate a view of the spherical earth from space onto the flat surface of a map? Even serious cartographical publications have explored the humorous consequences of projecting a human face onto a series of map projections [19]. Meanwhile, artists such as Barre and Flocon have studied Renaissance projections, such as those of the cartographer Guillaume Postel, and Frisia has incorporated Mercator projections and planisphere projections into his work. The rise of holography has seen new uses of spherical, cylindrical, conical and other curved surfaces, both for recording and viewing of these images.

AMBIGUITIES AND ILLUSIONS

In the nineteenth century, a series of geometrical optical illusions drew attention to the ambiguities of visual space. In the twentieth century we have continued to be fascinated by these, and there have been some attempts to explain them in terms of perspectival illusions. Some artists recognized that these illusions lend themselves to artistic treatment. Reutersvärd (1934) was among the first to do so with the impossible figure that came to be known as the Penrose tribar (1958) [20] and, as Ernst [21] has shown, inspired a whole series of visual commentaries including Escher's famous *Waterfall* (1961). Indeed a number of Escher's works are deliberate juxtapositions of sections in linear perspective that, when combined, result in impossible spaces. This is yet another expression of explorations of non-correspondence between object and representation.

VIRTUAL REALITY

In the Renaissance, artists used instruments such as the mirror and the perspectival window as a means of recording the visible world with linear perspective. In the twentieth century, images of the mirror and the looking glass continue to be used—now in the context of the computer screen—with a new goal of seeing the hitherto invisible. As Ivan Sutherland put it:

> We lack corresponding familiarity with the forces on charged particles, forces in non-uniform fields, the effects of non-projective geometric transformations, and high energy, low friction motion. A display connected to a digital computer gives us a chance to gain familiarity with concepts not realizable in the physical world. It is a looking glass into a mathematical wonderland [22].

This visionary statement in 1965 was one of the starting points for Sutherland's head-mounted display (first published in 1968) and experiments at the National Aeronautics and Space Administration (NASA) and led to the emerging fields of visualisation and virtual reality. Renaissance perspective sought to look through the window: virtual reality is attempting a new type of immersion "through the looking glass" [23].

203

Virtual reality raises new problems of perspective. Even very simple systems such as the personal-computer–based Superscape Virtual Realities System entail a basic perspectival space for the general environment within which there are other viewpoints that can be manipulated simultaneously: from either inside or outside an automobile, from behind a person or off to the side of a helicopter. Renaissance perspective typically involved either interiors or exteriors. Virtual reality is introducing new, dynamic interplays between egocentric and exocentric viewpoints, including the ability to move through both walls and windows, enabling seamless transitions between interiors and exteriors. In the emerging field of cyberspace these principles are being extended as navigational tools among data cells in visual databases [24]. In the eighteenth century Kant described verbally how we use perspectival space as a tool for orientation in our mind [25]. Virtual reality and cyberspace are helping us visualize this process. Spatial, perspectival coordinates are basic, not only in the virtual cockpit, but in all our activities.

SCALE AND FRACTALS

As mentioned earlier, one of the fundamental tenets of Renaissance perspective was the inverse size-distance law, which stated that if one doubled the distance to an object, its represented size was one-half its actual size; if one trebled the distance, the size was one-third, and so on. Mandelbrot's article about the size of the coast of Britain [26] implicitly introduced a spanner into this assumption by showing that size was a function of scale as well as distance. In a sense we have been vaguely aware of this ever since the seventeenth century. The shape of an ordinary image is transformed entirely when we change the scale of its image radically in a telescope or a microscope. Fractals may have brought this problem into focus, but fractals assume a principle of iteration, i.e. their basic patterns are repeated and hence remain independent of scale. Hence they do not solve the problem that they have raised. What is needed is a new approach to perspective that takes into account scale as well as distance, whereby any given shape only applies within a given range of scales. This is increasingly important in a world where we travel between scales with greater frequency.

CONCLUSION

If perspective is defined in a narrow sense as linear perspective, then one of the major reasons for its continued popularity is a growing historical awareness that seeks both to understand methods developed in the Renaissance and to apply new technologies in the analysis thereof. Some of the major themes of the earlier treatises, such as those about regular solids, remain significant to this day.

Yet there are significant contrasts between Renaissance methods and modern developments. Renaissance artists paid lip service to equations between perspective and vision while at the same time linking perspective increasingly with geometry and committing themselves to recording geometrical space of the physical world. Some twentieth-century artists have continued this tradition in their explorations of realism, hyper-realism and surrealism. Others have abandoned this commitment and focussed increasingly on the exploration of visual space, both exterior and interior. This has led to new goals of art in terms of exploring perceptual, mental, dream, psychological and even psycho-pathological states. As a result, whereas Renaissance artists focussed attention on linear picture planes, twentieth-century artists are exploring many alternative shapes of picture planes. They are also contradicting the traditional transparency-occlusion principles of perspective in their quest for artistic freedom. Hence, whereas Renaissance artists established a one-to-one correspondence between object and representation, twentieth-century artists strive to demonstrate the contrary.

The rapid development of computer graphics, which allows one to transform one kind of picture plane into another simply by altering the algorithms for the perspectival grids, has added new vigour to these experiments. So, too, has the continued study of psychological aspects of spatial representation and perception. Optical illusions and visual ambiguities have instilled a new playfulness into these explorations of space, as has the development of virtual reality. The rise of fractals has made us aware that scale is a factor that needs to be taken into account. Perspective in this sense has yet to be developed, even though linear perspective is now some 570 years old. Whether in the old or the new sense, perspective remains one of the most fascinating expressions of links between mathematics and art.

KIM H. VELTMAN
Scholar and Educator
Perspective Unit, McLuhan Program
University of Toronto
39A Queens Park Crescent East
Toronto M5S 1A1
Canada

References and Notes

1. H. H. Arnason, *History of Modern Art* (London: Thames and Hudson, 1969, 1983) p. 9.

2. This list is from K. Veltman, *Sources of Perspective*, which, along with K. Veltman, *Literature of Perspective* and two volumes of bibliography, is to be published by Saur Verlag.

3. This is being prepared by a team under the direction of Marisa Dalai Emiliani, Cecil Grayson and Pier Luigi Maccagni.

4. R. Wittkower and B. A. R. Carter, "The Perspective of Piero della Francesca's *Flagellation*", *Journal of the Warburg and Courtland Institutes* **3–4** (1953) (cited in note 10 of the article by Geatti and Fortunati).

5. See the remarkable English edition by A. I. Sabra, *The Optics of Ibn Al-Haytham* (London: Warburg Institute, 1989) Vols 1–2. Two further volumes are expected.

6. For a discussion of these theories, see K. Veltman, "Panofsky's Perspective: A Half Century Late", in Marisa Dalai Emiliani, ed., *La prospettiva rinascimentale* (Florence: Centro Di, 1980) pp. 565–584.

7. Abraham Bosse, *La maniere universelle de Monsieur Desargues* (Paris, 1665) p. 58: "Pour prouver qu'il ne faut pas dessiner n'y peindre comme l'oeil voit".

8. See, for instance, Ernst Gombrich, "Review Lecture: Mirror and Map", *Philosophical Transactions of the Royal Society, B. Biological Sciences* **270**, No. 903, 119–149 (London, 1975).

9. See, for instance, J. J. Gibson, *Ecological Optics* (1979). For a discussion of how Gibson changed his terms several times in the course of his writings, see Veltman [2] *Literature on Perspective*.

10. Ernst Gombrich, *The Sense of Order* (Oxford: Phaidon, 1979); Ernst Gombrich, *Art and Illusion* (Princeton, NJ: Princeton Univ. Press, 1960); Ernst Gombrich, *The Image and the Eye* (Oxford: Phaidon, 1982); R. L. Gregory and Ernst Gombrich, eds., *Illusion in Nature and Art* (London: Duckworth, 1973); Ernst Gombrich, *Meditations on a Hobbyhorse* (London: Phaidon, 1963); Ernst Gombrich, *Symbolic Images* (London: Phaidon, 1972).

11. *Toys* (Barry Levinson, director; 20th Century Fox, distributor, 1992) is a film about an eccentric toymaker (Robin Williams) and his 'sister' (an automaton) whose family tradition of making peaceful toys is threatened by an intruder wishing to produce war toys.

12. See, for instance, David Hockney, "Perspective", in *An Art Design Profile: David Hockney* (London: St. Martin's Press, 1988) pp. 84–89.

13. See B. V. Rauschenbach, "On My Concepts of Perceptual Perspective that Accounts for Parallel and Inverted Perspective in Pictorial Art", *Leonardo* **16**, No. 1, 28–30 (1983).

14. See, for instance, L. F. Shegin, *Die Sprache des Bildes* (Dresden: VEB Verlag der Kunst, 1980).

15. André Barre and Albert Flocon, *Curvilinear Perspective,* Robert Hansen, trans. and ed. (Berkeley, CA: Univ. of California Press, 1987).

16. Marcia Clark, ed., *The World Is Round: Contemporary Panoramas* (New York: The Hudson River Museum, 1987).

17. Michael Moose, "Guidelines for Constructing a Fish-Eye Perspective", *Leonardo* **19**, No. 1, 61–64 (1986).

18. Kenneth R. Adams, "Tetraconic Perspective for a Complete Sphere of Vision", *Leonardo* **9**, No. 4, 289–291 (1976). A more thorough discussion of these alternatives is found in chapter three of Veltman [2] *Literature of Perspective*.

19. See, for instance, W. R. Tobler, *An Experiment in the Computer Generalization of Maps* (Ann Arbor, MI: Office of Research Administration, 1964) 2 Vols.

20. See R. Penrose, "On the Cohomology of Impossible Figures", in this volume.

21. Bruno Ernst, *Abenteuer mit unmöglichen Figuren* (Berlin: Taco, 1987).

22. Ivan Sutherland, "The Ultimate Display", *Proceedings of the IFIP Congress* (1965) pp. 505–508.

23. Ken Pimentel and Kevin Teixeira, *Virtual Reality: Through the Looking Glass* (New York: Windcrest/McGraw Hill, 1993).

24. See, for instance, plates 1–3 in Michael Benedikt, ed., *Cyberspace: First Steps* (Cambridge, MA: MIT Press, 1991).

25. Immanuel Kant, "Was heisst sich im Denken orientieren?", *Berliner Monatsschrift* (October 1786). For a discussion in English, see Ernst Cassirer, *The Philosophy of Symbolic Forms* (New Haven, CT: Yale Univ. Press, 1955) Vol. 2, p. 93.

26. B. Mandelbrot, "How Long Is the Coast of Britain? Statistical Self-Similarity and Fractional Dimension", *Science* **155** (1967) pp. 636–638.

The Flagellation of Christ
by Piero della Francesca:
A Study of Its Perspective

Laura Geatti and
Luciano Fortunati

ABSTRACT

This article discusses a method for taking measurements on artworks, a process that is useful in the perspectival analysis of a painting or a drawing. This method involves the use of a digital image of an original artwork that is viewed on a computer monitor and processed by computer software that reads the coordinates of points in the artwork. Once measurements have been expressed in terms of the coordinates of points on the digital image, perspectival analysis is obtained by algebraic calculations. The authors used this method to analyze the perspective of the painting *The Flagellation of Christ* by Piero della Francesca. Results include the determination of the vanishing point and of the projection point.

Artists throughout the ages have dealt in different ways with the problem of representing objects in three-dimensional (3D) space on a two-dimensional (2D) picture plane. Renaissance artists departed from long-standing tradition that symbolically placed figures in the foreground or background according to their importance or rank. Rather, they attempted to represent space as it was perceived by the eye of an observer. To correctly portray the positions of objects in space, these artists investigated the relationships between the dimensions of the objects, their distances from the observer and the dimensions of the images. They therefore established a tight relationship between painting and perspective [1–4].

In his *De prospectiva pingendi* (circa 1482) Piero della Francesca wrote:

Painting is nothing but a representation of surfaces and bodies diminished or enlarged. . . . It is necessary to use perspective, which detects proportions as real science and determines the increasing or the diminishing of the various quantities by means of straight lines [5].

In Piero della Francesca's treatise, as in those that appeared during the Renaissance, problems of perspective were approached scientifically, with perspectival rules receiving a universal formulation. It is interesting to note, however, that in the practice of perspective, the artists did not always rigorously adhere to the rules theorized in their treatises—for they also followed their expressive needs. In this way, next to paintings conceived in a rigorous central setting, such as *The Trinity* (circa 1427) by Masaccio or *The Flagellation of Christ* (circa 1458) by della Francesca, one finds works, such as *The Miracle of Saint Antonio* (circa 1445–1450) by Donatello, or *Saint George and the Dragon* by Paolo Uccello, in which the perspectival construction is based on several simultaneous vanishing points. This suggests that the various perspective experiences deserve individual analyses [6,7].

It is clear that a systematic study of this kind requires appropriate methodology. The first step involves techniques for taking measurements on works of art: (1) production of a high-quality reproduction of the original, (2) a method for taking the measurements and (3) evaluation of the accuracy of the results.

This article presents a new measuring method and the results of an experiment of its use in a study of the perspective of *The Flagellation of Christ*. Our experiment was completed in 1989. The process starts with a digital image of the painting—a discrete approximation of the original, formed by a finite number of points whose position and color are numerically quantified. Thanks to its numerical form, a digitized image can be processed by computer software. For our purposes, we wrote a software program that, for example, enabled us to project the image onto a monitor and automatically read the coordinates of its points. In this way, the measurements required for perspectival analysis of the painting could be obtained in terms of the coordinates of

Fig. 1. Perspectival analysis of a digitization of Piero della Francesca's painting *The Flagellation of Christ*. For their measurements, the authors fixed a coordinate system (x, y, z) with the origin on the lower-left corner of the image and the (x, y) plane on the image plane.

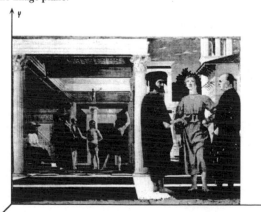

Laura Geatti (educator), Dipartimento de Matematica, 2 Università di Roma, via della Ricerca Scientifica, 00133 Rome, Italy.

Luciano Fortunati (researcher), CNUCE-Consiglio Nazionale delle Ricerche (CNR) Institute, Via S. Maria 36, 56126 Pisa, Italy.

Fig. 2. Perspectival analysis of Piero della Francesca's *The Flagellation of Christ*. If P is a point in space, the perspective image of P on π is the intersection of the straight line joining the projection point (PP) and P with π.

Fig. 3. Perspectival analysis of Piero della Francesca's *The Flagellation of Christ*. The diagonals of the quadrangles in π, arising as perspective images of squares lying on horizontal planes and having one side parallel to the projection plane, meet the horizon line at the distance points LDP and RDP. The distance points are symmetrically placed with respect to the vanishing point VP, at a distance equal to the distance between the projection point and the projection plane.

points on the digital image. The main advantage of this technique is that it allows a rather precise estimate of accuracy. The approximation error, depending on the resolution of the digitization and on the calculations with the coordinates of points involved in the measurements, can be quantified and controlled in advance. At the same time, the manual error involved is negligible.

We chose *The Flagellation of Christ* for our experiment for several reasons. This work was done in connection with the 1992 celebration of the 500th anniversary of della Francesca's death. Moreover, the literature of similar studies of della Francesca's work allowed us to compare others' results with our results [8–11]. Our results include the determination of the vanishing point and of the projection point.

INFORMATION ON THE PAINTING AND ON THE DIGITIZATION

The dimensions of *The Flagellation of Christ* are 81.5 × 59 cm. In order to generate a digital image of the painting, a reproduction of the painting with dimensions 13.96 × 10.53 cm was first obtained by contact print from a slide of the same dimensions [12]. This was later scanned into the computer, generating a digital image of 1630 × 1180 pixels, with a resolution of 4 pixels per sq mm. (Image resolution is the number of pixels assigned per unit of surface.) Our choice of resolution was based on the fact that the original is a painting. Higher resolution would have created greater

ambiguity in the identification of points and edges within the image.

For the measurements, a coordinate system (x, y, z) was fixed, with the (x, y) plane coinciding with the plane of the image, and the point of origin coinciding with the lower-left corner of the image. Figure 1 shows the position of the original painting in the coordinate system; the unit length on the coordinate axis is 0.01 mm. Remember that a pixel on the digital image represents a 0.5-mm square on the original painting. The coordinates of a pixel coincide with the coordinates of the center of this square. For example, the coordinates of the pixel on the lower-left corner are (25, 25, 0), while the coordinates of the pixel on the upper-right corner are (81475, 58975, 0).

THE GRAPHICS WORKSTATION

For processing the digital image, we used the Personal Computer-Image Processing Workstation (PC-IPW) developed at the CNUCE-CNR Institute in Pisa. It was based on a personal computer equipped with a high-resolution graphics card on which the software written for this study (an extension of the basic package originally developed for Geographic Information Systems [13]) was implemented. This software performed full-color image visualization, creation of an overlay image of geometric entities by graphics editing, enhancement of the digital image, and printing. These functions enabled us to interactively obtain from the screen the coordinates of any point on the image and, if necessary, to enlarge details of the picture up to 16 times the size of the original. Furthermore, they provided the option of tracing polygonals on the overlay image and saving them in the program for later use, of producing black-and-white or color prints of the image with the traced segments, or of plotting the segments only.

VANISHING POINT, DISTANCE POINTS, CENTER OF PROJECTION

Linear perspective is based on a *projection point* (PP) and a *projection plane* (π). For simplicity, π can be assumed to be a vertical plane. If P is a point in space, the perspective image of P on π is the intersection of the straight line joining PP and P with π (Fig. 2). The perspective images of any two parallel lines lying on a horizontal plane admit an intersection point. When the directions of the lines vary, these intersection points describe a horizontal line on π called the *horizon*. Relevant points on the horizon are the vanishing point (VP), corresponding to lines orthogonal to π, the left

Fig. 4. A 3D object can be reconstructed from its 2D projected image only up to scale. The height of the projection point above the ground is determined only when the absolute size of the 3D object S is known.

Fig. 5. Perspectival analysis of Piero della Francesca's *The Flagellation of Christ*. Consider a k*l*-×-*l* rectangle lying on a plane through the vanishing point and perpendicular to the projection plane. Consider the segments that are perspective images of its vertical sides; the height of the projection point above the ground can be expressed in terms of *l* and of their end-points.

Fig. 6. Perspectival analysis of Piero della Francesca's *The Flagellation of Christ*. For the purposes of this experiment, the rectangles obtained by sectioning the spans of the loggia were used. Here *l* represents the height of the ceiling.

and right *distance points* (LDP and RDP), corresponding to lines forming angles of 45° or 135° with π, and the left and right *reduced distance points* of type 1:k, corresponding to lines forming angles of 90°/k or (180° − 90°/k) degrees with π (for k = 2, 3, . . . ,). The distance points are symmetrically placed with respect to the vanishing point, at a distance from it equal to the distance between the projection point and the projection plane. They are the meeting points of the diagonals of the quadrangles in π, arising as perspective images of squares lying on horizontal planes and having one side parallel to the projection plane. Because of these properties, distance points were used by Renaissance artists in the actual layout of the perspective representation of these squares. Similarly, the reduced distance points of type 1:k are the meeting points of the diagonals of the quadrangles in π, arising as perspective images of rectangles whose sides are in the ratio of 1:k. Their distances from the vanishing point are equal to 1/k the distance between PP and π (Fig. 3).

One of the aims of perspectival analysis of a work of art is the 3D reconstruction of the perspective scene. In this way, the determination of points, such as the projection point, the vanishing point or the distance points, is very important. One must observe, though, that the actual possibility of determining such points depends on the presence of suitable geometric patterns on the painting. For the vanishing point, for example, segments that are perspective images of lines orthogonal to the projection plane are needed. Some assumptions on the geometry of a represented 3D object are therefore necessary.

In *The Flagellation of Christ*, we assume the spans of the loggia, the tiles of the floor and the bases of the columns to be square. Similarly, we assume the ceiling to consist of 7-×-7 square coffers. All these squares are also supposed to have one side parallel to the projection plane. These assumptions are common to most studies of the *Flagellation* [14]. They enable us to exploit the patterns of the floor and the ceiling to determine the vanishing point and the distance points.

As we have already observed, the distance of the projection point from the projection plane coincides with the length of the segments LDP-VP and RDP-VP. Its height above the ground, on the other hand, cannot be recovered merely by measurements on the painting. This is because a 3D object can be reconstructed from its 2D projected image only up to scale. In other words, the height of the projection

point above the ground can only be determined when the absolute size of the 3D object is known (Fig. 4).

We conclude this section by describing a method for calculating the distance between PP and the projection plane without using the distance points, and for expressing the height of PP above the ground in terms of the height of the ceiling of the loggia. The method is based on the following observation: Let τ be the plane through the vanishing point VP = (VP$_x$, VP$_y$, 0) and orthogonal to the projection plane π. On the intersection of τ with π, let S$_1$ and S$_2$ be the projections of the vertical sides of a rectangle with height *l* and base k*l*. The coordinates of the end-points of S$_1$ and S$_2$ are given by (VP$_x$, a$_1$, 0), (VP$_x$, b$_1$, 0) and (VP$_x$, a$_2$, 0), (VP$_x$, b$_2$, 0), respectively. If (PP$_x$, PP$_y$, PP$_z$) are the coordinates of the projection point, (A$_{1x}$, A$_{1y}$, A$_{1z}$) those of the vertex A$_1$ and (B$_{1x}$, B$_{1y}$, B$_{1z}$) those of the vertex B$_1$ of the rectangle (Fig. 5), the following relations hold:

$$PP_z = k\, l_2\, l_1/(l_2 - l_1) \tag{1}$$
$$A_{1y} = VP_y - l(a_1 - VP_y)/l_1 \qquad A_{1z} = B_{1z} = k\, l_2(l_1 + l)/(l_2 - l_1) \tag{2}$$
$$B_{1y} = A_{1y} - l = VP_y - l(b_1 - VP_y)/l_1, \tag{3}$$

for $l_1 = (b_1 - a_1)$ and $l_2 = (b_2 - a_2)$.

In our reference system, PP$_z$ coincides with the distance between PP and the projection plane. If we use as the rectangles in the above construction those obtained by sectioning the spans of the loggia (Fig. 6), then y = B$_{1y}$ is the equation of the ground plane, and the quantity PP$_y$ − B$_{1y}$ coincides with the height of PP above the ground.

Here, *l* represents the height of the ceiling, and the constant k the ratio between the width of the span of the loggia and the height of the ceiling. The constant k can be obtained by suitable measurements.

ERROR ANALYSIS

As we already observed, a digital image is a discrete approximation of an original image. Consequently, the coordinates of its points already contain a certain error. This error is defined by the resolution of the digitization and can be easily quantified. With a resolution of 4 pixels per sq mm, as in our case, it is at most 0.25 mm on each of the coordinates. But when a certain quantity is obtained from those coordinates by a sequence of algebraic calculations, then the additional error produced by such a processing must be considered. In order to insure some accuracy in the results, all the intervening steps must allow a reasonable bound on the error.

Fig. 9. Perspectival analysis of Piero della Francesca's *The Flagellation of Christ*. With two intersecting lines, the amount of error depends on their directions and may become very large if the lines are almost parallel.

Fig. 10. Perspectival analysis of Piero della Francesca's *The Flagellation of Christ*. If the lines are perpendicular, an upper limit for the error at the intersection point is roughly given by E + E'.

Fig. 7. Perspectival analysis of Piero della Francesca's *The Flagellation of Christ*. The line r joining two pixels P_1 and P_2 represents all the lines joining a point in the neighborhood of P_1 with a point in the neighborhood of P_2 on the original.

Fig. 8. Perspectival analysis of Piero della Francesca's *The Flagellation of Christ*. The quantity E may be taken as an upper bound for the deviation of r from the original line at X.

For example, consider the case of the vanishing point and the distance points. As we saw in the previous section, the procedure to obtain them consists essentially of tracing pairs of segments S_1 and S_2 on the image, extending them as straight lines and taking their intersections. If $P_1(x_1,y_1)$, $P_2(x_2,y_2)$ and $Q_1(u_1,v_1)$, $Q_2(u_2,v_2)$ are the coordinates of the end-points of S_1 and S_2 respectively, then the intersection of the lines determined by S_1 and S_2 has coordinates

$$IP = [(b_2c_1 - b_1c_2) / (a_1b_2 - a_2b_1),$$
$$(c_2a_1 - a_2c_1) / (a_1b_2 - a_2b_1)]$$

for $a_1 = y_2 - y_1$, $b_1 = x_1 - x_2$, $a_2 = v_2 - v_1$, $b_2 = u_1 - u_2$, $c_1 = x_1y_2 - y_1x_2$, $c_2 = u_1a_2 + v_1b_2$. It is clear from the above formulas that there is no way of uniformly bounding the error induced on the coordinates of IP, even by a small error on the coordinates of P_1, P_2, Q_1, Q_2. In order to keep the error reasonably small, restrictions must be placed on the segments S_1 and S_2.

Let r be the line joining two pixels P_1 and P_2 on the digital image. As we know, a pixel represents all the points of a 0.5-mm square on the original. Hence r represents all the lines joining a point in the square of P_1 with a point in the square of P_2. It is already clear from Fig. 7 that the closer P_1 and P_2 are, the more r may differ from the original line. Also, the further away one goes from P_1 and P_2, the more r differs from the original line. To make these remarks more precise, let us consider the circles of radius ε = 0.25 mm centered in P_1 and P_2, respectively. If we draw the tangent lines to the circles as in Fig. 8, they intersect each other at the middle point M between P_1 and P_2. Now, given a point X on r, let us draw the perpendicular to r through X. Its intersections with the above tangent lines determine two segments of length E. The quantity E can be taken then as an upper limit for the deviation of r from the original line at X or the *error* at X. From the obvious relation

$$\varepsilon : E = MP_2 : MX,$$

one gets

$$E = \varepsilon \, MX/MP_2 = 0.25 \, MX/MP_2 .$$

In this way, the error at X can be estimated to be less than or equal to 0.5 mm, provided MX is at most twice MP_2. In the case of the intersection of two lines r and r', the error depends also on their directions. As Fig. 9 shows, it may become quite big if the two lines are almost parallel. If the lines are perpendicular (Fig. 10), arguments similar to those above show that an upper bound for the error at the intersection point is roughly given by

$$\sqrt{E^2 + E'^2} \leq E + E'.$$

Starting from segments that are *almost perpendicular* and that are not too far from the corresponding intersection point, we can expect an error within similar bounds. In conclusion, starting from pairs of segments forming angles of not less than 60° and such that the distances of their middle points from the corresponding intersection point

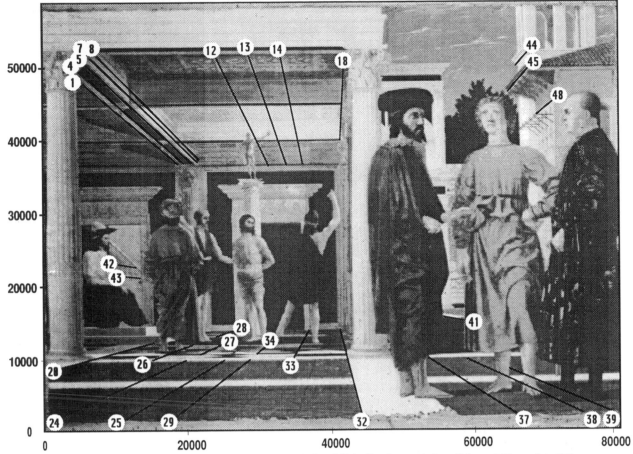

Fig. 11. Perspective analysis of Piero della Francesca's *The Flagellation of Christ.* For determination of the vanishing point, all the segments that are perspective images of straight lines orthogonal to the projection plane have been traced on the image.

are less than or equal to $1\frac{1}{2}$ times their length, we can reasonably count on an accuracy within 1 or 2 mm.

THE VANISHING POINT AND THE DISTANCE POINTS: NUMERICAL RESULTS

For the determination of the vanishing point, we trace on the image all the segments that are perspective images of straight lines orthogonal to the projection plane (Fig. 11). Then we select from them the longest and the sharpest ones (Fig. 12). In determining points of intersection we also keep in mind, along with the remarks of the previous section, that segment 32 is the most reliable segment. This is because segment 32 is among the longest segments, and it is the closest one to the area where the vanishing point presumably is. We therefore tend to pair the other segments with segment 32. The results of these calculations are summarized in Table 1. They clearly suggest the pixel VP = (41175, 17425, 0) as a vanishing point. To confirm it, we verify that the distances from VP of the extensions of these selected segments are indeed very small (Table 2). We are left now with the segments on the floor in the background (26, 27, 28, 34, 41), the ones on the stairs on the left (42, 43) and the ones on the buildings on the right (44, 45, 48) (see Fig. 11). Unfortunately, these are three groups of short segments, almost parallel in pairs, and not sharply defined on the image. Furthermore, they are far from point VP = (41175, 17425, 0). In this case, we observe that, for a suitable choice of their end-points, their extensions run quite close

to this VP. In conclusion, VP = (41175, 17425, 0) is a plausible vanishing point, and the use of other vanishing points beside VP seems quite unlikely.

Concerning the distance points, the situation is less satisfactory. First, we must point out that all the horizontal lines of the floor lean slightly toward the lower left. As a consequence, the intersections of the diagonals of different squares with the horizon line do not agree, nor are they symmetrical with respect to the vanishing point. Further, we must remember that the distance points are intersections that are very far from the segment initially determined on the image.

Fig. 12. Perspective analysis of Piero della Francesca's *The Flagellation of Christ.* The longest segments of those chosen in Fig. 11 are shown here.

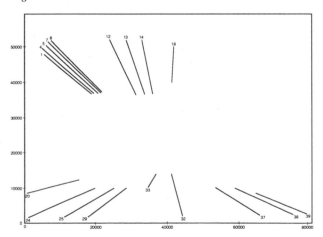

211

Table 1. The coordinates of the intersection points of the extensions of the longest segments. Their values suggest VP = (41175, 17425, 0) as the vanishing point.

Seg. No.	Seg. No.	Coordinate of Intersection	Pixel Coordinate
1	32	41176, 17352, 0	41175, 17375, 0
4	32	41160, 17424, 0	41175, 17425, 0
5	32	41134, 17532, 0	41125, 17525, 0
7	32	41139, 17512, 0	41125, 17525, 0
8	32	41150, 17466, 0	41175, 17475, 0
20	32	41164, 17407, 0	41175, 17425, 0
24	32	41157, 17434, 0	41175, 17425, 0
25	32	41169, 17383, 0	41175, 17375, 0
39	32	41162, 17415, 0	41175, 17425, 0
38	32	41162, 17413, 0	41175, 17425, 0
29	32	41161, 17420, 0	41175, 17425, 0
12	39	41122, 17429, 0	41125, 17425, 0
13	39	41199, 17401, 0	41175, 17425, 0
14	39	41149, 17419, 0	41125, 17425, 0
18	39	41109, 17434, 0	41125, 17425, 0
12	20	41137, 17400, 0	41125, 17425, 0
13	20	41195, 17414, 0	41175, 17425, 0
14	20	41153, 17404, 0	41175, 17425, 0
18	20	41192, 17414, 0	41175, 17425, 0

Hence they are very unstable under the smallest perturbations of the initial data. Consider, for example, the span of the loggia with the black-and-white floor in the foreground. Its diagonals meet the horizon line at a distance from the vanishing point of 162.4 cm on the left and of 136.6 cm on the right. Such intersections vary up to 5 cm when the end-points of the diagonals are altered even by a single pixel.

Similar results arise with the reduced distance points. This time, though, the slope of the horizontal lines of the floor has milder effects on the results. For example, the rectangles of the floor, formed by 1-×-8 arrays of tiles (Fig. 13), yield distance points ranging from 145–155 cm from the vanishing point.

THE PROJECTION POINT: NUMERICAL RESULTS

This section contains the results for the projection point PP obtained by the method described earlier. First we use the span of the loggia with the geometrically designed floor in the foreground, then the span where the figure of Christ stands.

The measurements taken in the first case give the following values for a_1, a_2, b_2, b_1:

$a_1 = 57575$, $a_2 = 48325$, $b_2 = 10875$, $b_1 = 8925$,

corresponding to

$l_1 = b_1 - a_1 = -48650$ and $l_2 = b_2 - a_2 = -37450$.

The constant k can be evaluated (Fig. 14) as

$k = d(M,N) / (a_1 - b_1) \cong 0.9$.

By equations (1), (2) and (3), we obtain

$PP_z \cong 146000$,

as the distance between the projection point and the projection plane, and

$y \cong 17425 - l\ 0.175$,

as the equation of the ground plane, in terms of the height of the ceiling. In the second case, we have

$a_1 = 48235$, $a_2 = 42325$, $b_1 = 10875$, $b_2 = 12125$

corresponding to

$l_1 = -37450$ and $l_2 = -30200$.

For the constant k (Fig. 15), we get

$k = d(M,N) / (a_1 - b_1) \cong 0.9$.

This time, the corresponding value of PP_z is

$PP_z \cong 140000$,

and the equation of the ground plane is

$y \cong 17425 - l\ 0.175$.

It is worth noting that the results obtained in the first case are more stable under small perturbations of the initial data a_1, b_1, a_2, b_2. Hence we consider them more reliable.

We conclude the section with a simple check. By elementary geometric considerations the quantities a_1, a_2, b_1, b_2 and the y coordinate of the vanishing point VP_y must satisfy the following relation:

$(a_1 - VP_y) / (a_2 - VP_y) = (b_1 - VP_y) / (b_2 - VP_y)$.

Fig. 13. Perspectival analysis of Piero della Francesca's *The Flagellation of Christ*. The reduced distance points, obtained from 1-×-8 rows of floor tiles, suggest a distance between projection point and projection plane ranging from 145–155 cm.

Fig. 14. Perspectival analysis of Piero della Francesca's *The Flagellation of Christ*. The constant k is the ratio between the width of a span of the loggia and the height of the ceiling. For the span with the geometrically designed floor in the foreground, k can be evaluated as shown in text.

M = (10725,8725) N = (54475,8975)

Fig. 15. Perspectival analysis of Piero della Francesca's *The Flagellation of Christ*. For the span where the figure of Christ stands, the constant k can be evaluated as shown in text.

M = (8325,10675) N = (42775,10875)

Table 2. The distances of point VP = (41175, 17425, 0) from the extensions of the longest segments are calculated. Their small values confirm VP as a plausible vanishing point.

Segment No.	Distance (mm)
1	0.53
4	0.10
5	0.51
7	0.37
8	0.11
12	0.44
13	0.13
14	0.25
18	0.41
20	0.14
24	0.15
25	0.33
29	0.43
32	0.14
33	0.10
37	0.67
38	0.16
39	0.13

It follows that

$$VP_y = (a_1b_2 - a_2b_1) \,/\, (b_2 - b_1 + a_1 - a_2) = 17395,$$

in the first case, and

$$VP_y = 17332,$$

in the second case. Both values are very close to the one previously obtained for VP_y.

CONCLUSIONS

The results of our study on the perspective of *The Flagellation of Christ* can be summarized as follows. The coordinates of the vanishing point are

$$VP = (41175, 17425, 0)$$

and they can be considered accurate within 1 or 2 mm (Color Plate D No. 3).

The localization of the vanishing point agrees with that of Wittkower and Carter [15]. There is a small discrepancy with the coordinates of the vanishing point obtained by Leoni [16]. Our coordinates, however, are based on a larger number of measurements.

Concerning the *distance of the projection point from the projection plane*, we estimate it to be 145–150 cm. Considering the discrepancies among the results obtained by different methods, it is hard to conclude more than this. Wittkower and Carter estimate this distance to be about 148 cm, while Leoni estimates it to be about 150 cm.

The *equation of the ground plane* in terms of the height of the ceiling of the loggia l is given by

$$y = 17425 - l\ 0.175.$$

The *height of the projection point* above the ground is given by

$$PP_y = l\ 0.175.$$

In conclusion, our study on the perspective of *The Flagellation of Christ* is not meant to be considered to be exhaustive. More than anything else, it is an experiment with these measuring techniques [17].

References and Notes

1. E. Panofsky, *La prospettiva come forma simbolica e altri scritti* (Milan: Feltrinelli, 1961).

2. A. Parronchi, *Studi sulla dolce prospettiva* (Milan: A. Martello, 1964).

3. M. Dalai Emiliani, "La questione della prospettiva 1960–1968", *L'Arte* **2** (1968) pp. 96–105.

4. R. Wittkower, "Brunelleschi and Proportion in Perspective", *Journal of the Warburg and Courtland Institutes* **3–4**, (1953) pp. 275–291.

5. Piero della Francesca, *De prospectiva pingendi* (Stresbourg: 1899; Florence: G. Nicco Fasola Editions, 1942; Florence: E. Battisti Edition Le Lettere, 1984).

6. C. L. Ragghianti, "Pluralità della prospettiva", *Critica d'Arte* **3** (1984) pp. 93–96.

7. C. L. Ragghianti et al, "Reports on Analysis and Reconstruction of the Formative Process of Works of Art with Electronic Instruments", *Sound-Sonda* **1** (March 1978); *Sound-Sonda* **2** (April 1978); *Sound-Sonda* **3–4** (May 1978); *Sound-Sonda* **5** (July 1978).

8. F. Casalini, "Corrispondenze fra teoria e pratica nell'opera di Piero della Francesca", *L'Arte* **2** (1968) pp. 62–95.

9. C. Verga, "L'architettura nella Flagellazione di Urbino", *Critica d'Arte* **147** (1976) pp. 7–19.

10. R. Wittkower and B.A.R. Carter, "The Perspective of Piero della Francesca's *Flagellation* ", *Journal of the Warburg and Courtland Institutes* **3–4** (1953) pp. 292–302.

11. T. Zanobini Leoni, "La Flagellazione di Urbino di Piero dei Franceschi", *Sound-Sonda* **3–4** (May 1978) pp. 92–96.

12. This slide was provided by Scala Laboratories in Florence, Italy.

13. L. Fortunati and P. Mogorovich, *Un sistema integrato di ausilio all'aggiornamento di carte tematiche; Atti 1° Convegno Nazionale Associazione Italiana di Telerilevamento (AIT)* (Parma: AIT, 1987). The authors used the structure of this program extended with other routines to perform the functions required by their experiment.

14. See Casalini [8], Verga [9], Wittkower and Carter [10], Leoni [11].

15. Wittkower and Carter [10].

16. Leoni [11].

17. For a description of another analysis of an artwork, see Frederic Chordá, "Computer Graphics for the Analysis of Perspective in Visual Art", *Leonardo* **24**, No. 5, 563–567 (1991).

Art and Mathematics: The Platonic Solids

Michele Emmer

The mathematician's patterns, like the painter's or the poet's, must be beautiful; the ideas, like the colours or the words, must fit together in a harmonious way. Beauty is the first test: there is no permanent place in the world for ugly mathematics.

—G. H. Hardy [1]

It can be said that for thousands of years there has been an interest in geometrical plane shapes and solid forms, in particular, those possessing regular features of proportion and symmetry. In the famous battles by the painter Paolo Uccello (1397–1475) *The Rout of San Romano,* panels of which are now distributed among the National Gallery in London, the Louvre in Paris and the Uffizi in Florence, we can see the great fascination geometric forms had for the artist (Fig. 1).

This fascination was so great that Vasari, in his biography of Uccello [2], wrote that he seemed more a mathematician than an artist. He might have made the same observation about many Renaissance artists who took particular interest in the perspective of geometric shapes. Uccello was particularly attracted by the form called *mazzocchio* (Fig. 2), which we can find not only in *The Rout of San Romano* but also in *The Flood and the Recession of the Flood* in Santa Maria Novella in Florence [3]. This drawing by Uccello is now preserved at the Uffizi in Florence. Others are at the Louvre in Paris.

The words of the mathematician G. H. Hardy can be applied to many other artists, not only in ancient times but also to contemporary artists who have been interested in mathematics [4], in particular the *regular,* or *Platonic solids.* Nobody knows who was the first who noted that the number of regular polygons, like triangles, squares, pentagons, hexagons and so on, goes on to infinity; but the really fascinating discovery was that the number of regular solids is finite.

Fig. 1. P. Uccello, *The Rout of San Romano,* painting, oil on wood, 182 × 322 cm, 1451–1457.

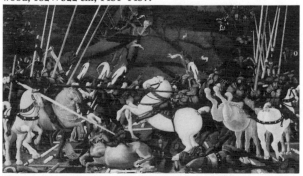

This fact fascinated Plato (427–348 B.C.), who related the regular solids to the structure of the world and the elements of the physical space. In his dialogue *Timaeus* we find the oldest known description of the five regular solids, although they were well known to the Pythagoreans. In ancient times the use of objects with polyhedral forms was widespread. The mathematician H. S. M. Coxeter, in his book *Introduction to Geometry* [5], says that "a pair of icosahedral dice of the Ptolemaic dynasty can be seen in one of the Egyptian rooms of the British Museum in London." Coxeter, in his *Regular Polytopes* [6], says that "excavations on the Monte Loffa near Padova have revealed an Etruscan dodecahedron, which shows that this figure was enjoyed as a toy at least 2,500 years ago." While Coxeter and I were making a movie for the series *Art and Mathematics* on Platonic Solids, he told me that he was unable to remember where he had seen this object. Paola Gario, in her book on the history of polyhedra [7], gives other information on the ancient polyhedra. She speaks of two perfectly regular dodecahedra of Celtic origin, in the Louvre [8].

A more recent example (2nd c. B.C.) is preserved in the Rheinisches Landesmuseum in Bonn. It is the only one of its kind in Western Germany. It has a dodecahedral form with holes of different shapes on its faces. We do not know what it was used for (Fig. 3).

The article by F. Lindemann "Zur Geschichte der Polyedere und der Zahlzeichen" [9] gives additional interesting information about ancient polyhedra. This is how Plato himself describes the five regular solids in the *Timaeus.* First, the Creation: "But when the world began to get into order, fire and water and earth and air had only certain fair traces of themselves and were altogether such as everything might be expected to be in the absence of God" (*Timaeus,* 53b) [10].

Then: "Let it be consistently maintained by us in all that we say that God made them as far as possible the fairest and best, out of things which were not fair and good" (*T.,* 53b).

ABSTRACT

The author discusses the history of interest in the Platonic solids—the tetrahedron, the octahedron, the icosahedron, the cube and the dodecahedron. Artworks in which the Platonic solids have been depicted, including those by Leonardo da Vinci, Albrecht Dürer, Jacopo de' Barbari and Paolo Uccello, are discussed.

Michele Emmer (mathematician), Dipartimento di Matematica, Università Ca' Foscari, Dorsoduro 3825 Ca' Dolfin, 30123 Venice, Italy.

Fig. 2. P. Uccello, *Mazzocchio*, drawing, 1430–1440. (Photo: Gab. fot. Soprintendenza Beni Artistici e Storici di Firenze)

"In the first place, then, as is evident to all, fire and earth and water and air are bodies" (*T.*, 53c). "And next we have to determine what are the four most beautiful bodies which are unlike one another and of which some are capable of resolution into one another" (*T.*, 53e).

"And then we shall not be willing to allow that there are any distinct kinds of visible bodies fairer than these" (*T.*, 53e).

The construction by Plato of the five regular solids is based on the "most beautiful of all the many triangles" (*T.*, 54a), the one of "which the double forms a third triangle which is equilateral".

It is a rectangular scalene triangle *ABC*

with $BC = \dfrac{AB}{2}$.

"I have now to speak of their several kinds, and show out of what combinations of numbers each of them was formed" (*T.*, 54e). Then he constructed the five solids: "The first will be the simplest" (*T.*, 54e–55a), the tetrahedron, "which is the original element and seed of fire" (*T.*, 56b).

"The second species of solid is formed out of the same triangles..." (*T.*, 55a), "and let us assign the element which was next in the order of generation to air" (*T.*, 56b), the octahedron.

"And the third body is made up of 120 triangular elements, forming twelve solids angles..." (*T.*, 55b) and "the third to water" (*T.*, 56b), the icosahedron.

"But the isosceles triangle produced the fourth elementary figure..." (*T.*, 55b) "and the figure of the body thus composed is a cube, having six plane quadrangular equilateral bases" (*T.*, 55c). "To earth let us assign the cubical form", for "earth is the most immovable of the four" (*T.*, 55d–55e).

"There was yet a fifth combination which God used in the delineation of the Universe", the dodecahedron.

A very interesting book on the cosmological theory of Plato is P. Duhem's *Le système du monde* [11].

In Book XIII of the *Elements of Euclid* (3rd c. B.C.) we can find the construction of the five regular solids, all of them

Fig. 3. Anonymous, *Dodecahedron*, 8 × 7 × 7 cm, 2nd century B.C. (Rheinisches Landesmuseum, Bonn, Germany)

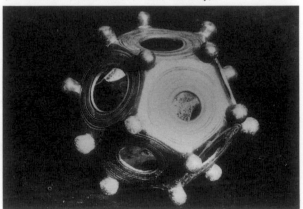

inscribed in a sphere. Euclid noted also that there exist only five regular solids in three-dimensional 'Euclidean' space.

In four-dimensional Euclidean space six regular 'polytopes' exist [12].

It is possible to demonstrate in various ways that the number of Platonic solids is exactly five. The simplest is based on a principle of elementary geometry that states that the angles of the face of a solid angle that converge at a vertex must add up to less than 360°. A solid angle is the inside angle enclosed by the three faces of a pyramid [13].

I have already stated that many Renaissance artists were interested in Platonic solids. One of the most famous of these is Albrecht Dürer. In the famous engraving *Melencolia I* (Fig. 4), an engraving done in 1514, there are also many alchemistic and cabalistic symbols; even the title suggests several interpretations [14,15]. Perhaps the composition suggests the artist's solitude. The solid shown is enigmatic. It is not at all easy to understand from which perspective it was drawn. Many people have amused themselves by trying to reconstruct it [16–18].

I received all this information from the Dutch crystallographer C. H. MacGillavry, well known for her book on M. C. Escher [19]. She wrote to me that "All these people realize that the polyhedron is a truncated rhombohedron; also, that the rhombohedral angle can be neither 60° (octahedron) nor 90° (cube), so they *assume* it should be 72°, because of a possible connection with the *sectio aurea*. My solution is 80°, I showed that 72° is outside the limit of error."

In the popular and widely read treatise *Underweyssung der Messung mit dem Zyrkel und Rychtscheyd* [20], A. Dürer "affirmed that the perspective basis of a picture should not be drawn free-hand but constructed according to mathematical principles" [21]. In the same treatise he gave instructions on how to construct regular solids. Carl B. Boyer wrote that in the work of Dürer it is possible to recognize the influence

of Luca Pacioli, especially in the engraving *Melencolia I*. There we can see a magic square, which is considered the first example in the Western world; but Pacioli wrote an unpublished manuscript "De Viribus Quantitatibus" in which his interest in magic squares is evident [22]. W. S. Andrews, in his book *Magic Squares and Cubes* [23], says that

magic squares have had in centuries past a deeper meaning for the minds of men than that of simple mathematical curios we may infer from the celebrated picture by A. Dürer entitled *Melencolia I*. The symbolism of this engraving has interested to a marked degree almost every observer. The figure of the brooding genius sitting listless and dejected amid her uncompleted labors, the scattered tools, the swaying balance, the flowing sands of the glass, and the magic square of 16 beneath the bell—these and other details reveal an attitude of mind and a connection of thought, which the great artist never expressed in words, but left for every beholder to interpret for himself.

Luca Pacioli (1445–1514) was a mathematician who wrote his *Summa de Arithmetica, Geometria, Proportioni et Proportionalità* [24], which presents important commercial applications, very useful for the most famous town of merchants of the time, Venice [25].

The book of Pacioli *De Divina Proportione* (1509) is also very famous for the designs of regular solids attributed to Leonardo da Vinci. The 60 plates of the Platonic solids and other solids *"facte e formate per quella ineffabile mano sinistra a tutte discipline mathematici accomodatissima del prencipe oggi fra i mortali, pro prima fiorentino, Leonardo da Vinci"* [26] (done by the incredible left hand, suited to all mathematical disciplines, of the prince of all human beings, that great Florentine, Leonardo da Vinci) (Fig. 5). The cooperation between Pacioli and Leonardo was "beyond doubt" [27].

A part of the *De Divina Proportione* is attributed to Piero della Francesca (1410–1492). Piero wrote a treatise called "De Corporibus Regolaribus", which Pacioli included in his book.

Fig. 4. A. Dürer, *Melencolia I*, engraving, 24 × 17 cm, 1514.

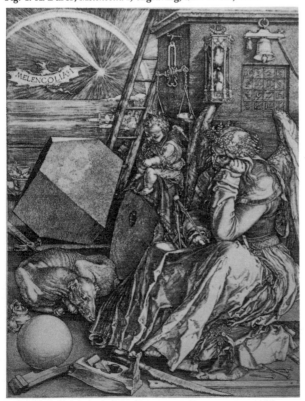

Fig. 5. Leonardo da Vinci, *Duodecedron Planus Vacuos*, drawing, 1498.

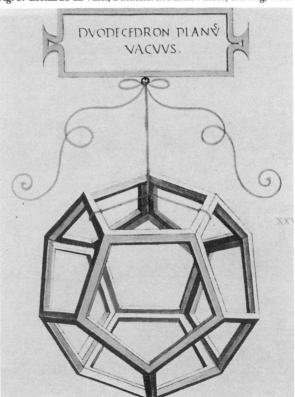

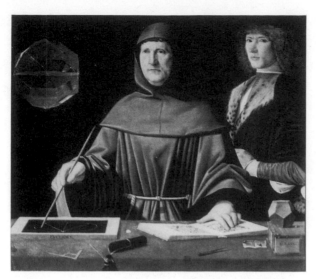

Fig. 6. J. de' Barbari, *Ritratto di Fra Luca Pacioli*, painting, 99 × 120 cm, 1498–1500.

The discussion about the so-called plagiarism by Pacioli of Piero's treatise has been very extensive [28–32].

The first comment was by Vasari, who said that Piero della Francesca

> was regarded as a great master of the problems of regular bodies, both arithmetical and geometrical, but he was prevented by the blindness that overtook him in his old age, and then by death, from making known his brilliant researches and the many books he had written. The man who should have done his utmost to enhance Piero's reputation and fame, since Piero taught him all he knew, shamefully and wickedly tried to blot out his teacher's name and to usurp for himself the honour which belonged entirely to Piero; for he published under his own name, which was Fra Luca dal Borgo (Pacioli), all the researches done by that admirable old man, who was a great painter as well as an expert in the sciences I mentioned [33].

Fig. 7. J. Kepler, Untitled, engraving from *Harmonices Mundi* [40], 22 × 18 cm, 1619.

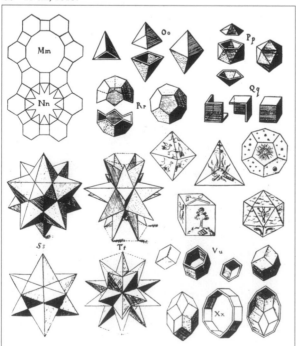

Piero painted a portrait of Luca Pacioli as Saint Peter in the *Madonna with the Egg*, now at the Brera Museum in Milan.

Their relationship must have been "very cooperative" [34]. Also the artist Jacopo de' Barbari (c. 1440–c. 1516) painted a portrait of Luca Pacioli in Venice during the years 1498–1500 [35] (Fig. 6). The painting is particularly interesting because in the upper-left-hand corner there is a semiregular solid, of which the faces are regular polygons but not of the same type: the rhombicuboctahedron, which corresponds to the plate XXXV *Vigintisex basium planus solidus* of *De Divina Proportione*. Another solid, a dodecahedron or a *duodecedron planus solidus*, rests on top of a volume of the elements of Euclid at the right-hand corner of the painting.

In various books of the Renaissance we can find perspective treatments of the regular solids and many other figures, like the mazzocchio. This solid figure was very well known in this period (See Figs 1 and 2). Vasari, in his "Vita di Paolo Uccello", said that

> he [Uccello] used to show Donatello, the sculptor, who was a close friend of his, the mazzocchi (wooden circles or hoops which, covered with cloth, formed part of a man's headgear in 15th-century Florence) that he had drawn with their points and surfaces shown from various angles in perspective, and spheres showing seventy-two facets like diamonds . . . on which he wasted all his time. And Donatello would often say "Ah Paolo, this perspective of yours makes you neglect what we know for what we don't know. These things are no use except for marquetry" [36].

Also Vasari The Younger was interested in Platonic solids, like Barbaro Sirigatti and many others [37–39].

Kepler was the first to notice that Platonic solids appear in dual pairs:

> *Sunt autem notabilia duo veluti conjugia harum figurarum ex diversis comninata classibus: Mares, Cubus et Dodecaëdron ex primarijs; foeminae, Octoëdron et Icosiëdron ex secundarijs, quibus accedit una veluti coelebs aut Androgynos, Tetraëdron; quia sibi ipsi inscribitur, ut illae foemellae maribus inscribitur et veluti subjiciuntur, et signa sexus foemina masculinis oppostia habent, angulos scilicet planiciebus.*

> *Praterea ut Tetraëdron est elementum, viscera et veluti costa Cubi Maris; sic Octaëdron foemina, est elementum et pars Tetraëdri, aliâ ratione: ita mediat Tetraëdron in hoc coniugio* [40].

> (However, there are, as it were, two noteworthy weddings of these figures, made from different classes: the males, the cubes and the dodecahedron, among the primary; the females, the octahedron and the icosahedron, among the secondary, to which is added one, as it were, bachelor or hermaphrodite, the tetrahedron, because it is inscribed in itself, just as those female solids are inscribed in the males and are, as it were, subject to them, and have the signs of the feminine sex, opposite the masculine, namely, angles opposite planes.

> Moreover, just as the tetrahedron is the element, bowels, and, as it were, rib of the male cube, so the feminine octahedron is the element and part of the tetrahedron in another way; and thus the tetrahedron mediates in this marriage.) [41]

So, as Coxeter says, "In other words, the cube and the octahedron are reciprocal solids, and he knew that the dodecahedron and the icosahedron provide another instance of the same phenomenon" [42].

Of course Kepler did agree with the Platonic correspondence among the regular solids and the elements of the physical world: *"In cubo . . . proprietas est et materiae terrestris"*, *"Octaedron Aeris symbolum"*, *"Tetraedron Ignis symbolum"*, *"Icosaedron Aquae symbolum"*, *"Dodecaedron Coeli symbolum"* [43] (Fig. 7).

If we indicate each regular solid using the Schläfli symbol {*p,q*}, which means that it has *p*-gonal faces, *q* at each vertex, then we have

Tetrahedron	{3,3}
Cube	{4,3}
Octahedron	{3,4}
Icosahedron	{3,5}
Dodecahedron	{5,3}

So each of the Platonic solids {*p,q*} has a reciprocal, which may be defined as the polyhedron that has *q*-gonal faces, *p* at each vertex; thus the reciprocal of {*p,q*} is {*q,p*} and vice versa. For example, the octahedron {3,4} is the reciprocal of the cube {4,3}. The tetrahedron is obviously a self-dual "bachelor or hermaphrodite", as Kepler wrote. The combination of two reciprocal tetrahedra forms a star-shaped figure, which Kepler called a "stella octangula" (see Fig. 7). *"XXVI Propositio: Addi possunt congruentijis perfectissimis regularibus, duae etiam aliae congruentiae, stellarum duodecim planarum Pentagonicarum: et duae semisolidae, Stellarum Octangulae, et decangulae"* [44].

But, as Coxeter has noted [45], the stella octangula appears also in *De Divina Proportione* by Luca Pacioli, where it is called the "Octaedron elevatum" [46].

Also the stellated dodecahedron *stellarum duodecim planarum pentagonicarum* [47] is attributed to Kepler who has described its construction: *"Habet hoc conjugium et stellam solidam, cujus genesis est ex continuatione quinorum planorum Dodecaëdri, ad concursum omnium in puncto unico"* [48]. ("This wedding also comprehends the solid star too, the generation whereof arises from the continuation of five planes of the dodecahedron till they all meet in a single point" [49]). It is possible to see two stellated dodecahedra in the mosaic floor of the San Marco Cathedral in Venice: one at the entrance of the church, the other in the center of the church. The first one was reproduced in an article by Lucio Saffaro [50]. The two mosaics were probably done by Paolo Uccello, during his stay in Venice (Color Plate J No. 2).

Paolo Uccello was in Venice during the years 1425–1430. M. Muraro was the first to consider Uccello as the author of these mosaics [51]. E. Sindona agrees with Muraro in his book on Uccello [52]. In the paper by Muraro, "The Venetian Experiences of Uccello", the author speaks of different "geometric shapes" to be found in the floor and the vaults of San Marco and considers that this experience was fundamental for the art of Uccello. The solid is called "rhomb with geometric elements". In the book by Sindona it is called "Litostrato" [52].

I think this is a good example of non-cooperation between the historians of art and the scientists, mathematicians in this case. More recently, in the exhibition on Architecture and Utopia in Venice during the Sixteenth Century, there was no mention of these solids of Uccello, although it was possible to see regular solids by Barbaro in his *Trattato della prospettiva* [53,54]. In the catalogue there is a reproduction of the portrait of Luca Pacioli by Jacopo de' Barbari (see Fig. 6) [55]. In the comment it is written that in the portrait one can see "a dodecahedron and an icosahedron". As already mentioned, the dodecahedron appears on the table. The icosahedron is more difficult to see; Coxeter has noted that the other solid in the painting is *not* an icosahedron, but a rhombicuboctahedron [56]. It is my belief that a closer collaboration between scientists and historians of art would be beneficial.

References

1. G. H. Hardy, *A Mathematician's Apology* (London: Cambridge Univ. Press, 1940) p. 25.

2. G. Vasari, *Le vite* (Florence: 1550, 1568). See Refs. 32 and 36.

3. J. Pope-Hennessy, *Paolo Uccello,* Complete Edition (London: Phaidon, 1969) plates 31, 38, 40, 42.

4. M. Emmer, "Visual Art and Mathematics: The Moebius Band", *Leonardo* 13, No. 2, 108–111 (1980).

5. H. S. M. Coxeter, *Introduction to Geometry* (London: John Wiley, 1969) p. 149.

6. H. S. M. Coxeter, *Regular Polytopes* (New York: Dover, 1973) p. 13.

7. P. Gario, *L'immagine geometrica del mondo, Storia dei Poliedri* (Turin: Stampatori Didattica, 1979) p. 94.

8. L. Hugo, "Note sur deux dodecaédres antiques du Musée du Louvre", *C.r. Acad. Sci., Paris* 43, 420 (1873).

9. F. Lindemann, "Zur Geschichte der Polyedere und der Zahlzeichen", *Sitzungsberichte der math.-physik. Classe der k.b., Akademie der Wissenschaften zu München* 27, 625 (1896).

10. Plato, *Timaeus,* in *The Great Books of the Western World* (London: Encyclopaedia Britannica, 1952) Vol. 7, *Plato*, pp. 442–477.

11. P. Duhem, *Le systeme du monde* (Paris: Herman et fils, 1913) ch. 2.

12. See Coxeter [5] pp. 396–400.

13. J. V. Bruni, *Experiencing Geometry*, based on a book by E. Castelnuovo (Belmont: Wadsworth Publ., 1977) pp. 271–280.

14. M. Calvesi, "A noir (Melencolia I)", *Storia dell'Arte* 1 (1/2), 37–96 (1969).

15. R. Klibansky, E. Panofsky and F. Saxl, *Saturn and Melancholy* (London: 1964).

16. P. Grodzinsky, "Diamond Geometry", *Ind. Diamond Rev.* 15, 66 (1955).

17. S. Rösch, *Fortschritte d. Mineralogie* 48, Beiheft 1, 83 (1970).

18. D. P. Grigoriev and I. I. Sjafranovsky, *Fortschritte d. Mineralogie* 50, 205 (1973).

19. C. H. MacGillavry, *Fantasy and Symmetry: The Periodic Drawings of M. C. Escher* (New York: Abrams, 1976).

20. A. Dürer, *Underweyssung der Messung mit dem Zyrkel und Rychtscheyd* (Nuremberg: 1525).

21. M. Kline, *Mathematics in Western Culture* (Harmondsworth: Penguin Books, 1977) p. 158.

22. C. Boyer, *A History of Mathematics* (New York: John Wiley, 1968); *Storia della Matematica* (Milan: 1976) p. 342.

23. W. S. Andrews, *Magic Squares and Cubes* (New York: Dover, 1960) pp. 146–147.

24. L. Pacioli, *Summa de Arithmetica Geometria Proportioni et Proportionalita* (Venice: 1494).

25. F. C. Lane, *Venice: A Maritime Republic* (Baltimore: Johns Hopkins Univ. Press, 1973); *Storia di Venezia* (Turin: 1978) pp. 168–169.

26. T. R. Castiglione, "Un prezioso manoscritto del Rinascimento in Svizzera", *Cenobio* 3 (3/5), 271–288 (1954); L. Pacioli, *De Viribus Quantitatis,* codex 250, Library, University of Bologna (not yet published).

27. S. Guarino, *La posizione di Alvise Vivarini nella cultura figurativa Veneziana,* dissertation, University of Rome, Faculty of Letters, 1978, p. 97. A part of the dissertation is dedicated to the painter J. de' Barbari and his portrait of Luca Pacioli, pp. 89–141.

28. G. Arrighi, "Piero della Francesca e Luca Pacioli. Rassegna della questione del 'plagio' e nuove valutazioni", *Atti della Fondazione Giorgio Ronchi* 23 (5), 613 (1968).

29. G. Arrighi, "Attorno ad una denuncia vasariana di plagio", in *Il Vasari storiografo ed artista, Atti del Congresso Internazionale del 1974, Firenze* (1976) pp. 479–487.

30. M. D. Davis, *Piero della Francesca's Mathematical Treatise* (Ravenna: Univ. of North Carolina, 1977).

31. See Guarino [27] p. 92.

32. G. Vasari, *Le vite de' più eccellenti Architetti, Pittori e Scultori italiani, da Cimabue insino a' tempi nostri descritte in lingua Toscana, da G. V. Pittore Aretino, con una sua utile e necessaria introduzione alle arti loro* (Florence: 1550); *Le vite de' più eccelenti Pittori Scultori ed Architetti scritte e di nuova ampliate da M. G. V., Pittore et Architetto Aretino, co'ritratti loro, e con le nuove vite dal 1550 insino al 1567* (Florence: 1568).

33. G. Vasari, "Vita di Pier della Francesca dal Borgo a San Sepolcro, Pittore", in Vasari [32], and in *Lives of the Artists* (New York: Penguin Books, 1979) p. 191.

34. E. Battisti, "Bramante, Piero e Pacioli", in *Atti del Convegno Internazionale del 1970, Roma* (1974) pp. 267–282.

35. See Guarino [27] p. 108.

36. G. Vasari, "Vita di Paulo Uccello, Pittor Fiorentino", in Vasari [32], and in Vasari [33] *Lives of the Artists* p. 96.

37. G. Vasari (The Younger), *Prospettiva* (Florence: 1593).

38. L. Sirigatti, *La pratica della prospettiva* (Venice: 1596).

39. D. Barbaro, *La pratica della prospettiva* (Venice: 1569); *La pratica della prospettiva*, codex, cod. It. Cl. IV, 39 (5446) Bibl. Naz. Marciana, Venice.

40. J. Kepler, *Harmonices Mundi Libri V,* Linz, 1619, Liber V, "De Harmonia Perfectissima motuum coelestium", p. 292.

41. J. Kepler, *The Harmonies of the World, Book Five,* in *The Great Books of the Western World* (London: Encyclopaedia Britannica, 1952) Vol. 16, p. 1011.

42. H. S. M. Coxeter, "Kepler and Mathematics", in *Vistas in Astronomy* Vol. 18 (Oxford: Pergamon Press, 1975) pp. 661–670.

43. J. Kepler, *Harmonices Mundi Libri V,* Linz, 1619, Liber II, "De Congruentia figurarum harmonicarum", p. 80.

44. See Kepler [43] p. 82.

45. See Coxeter [5] p. 158.

46. L. Pacioli, *De Divina Proportione,* Fontes Ambrosiani in luce editi cura et studio Bibliothecae Ambrosianae XXXI, Milano, 1956, based on one of the two original codices; *De Divina Proportione* (Venice: 1509).

47. See Kepler [43] p. 82.

48. See Kepler [40] p. 293.

49. See Kepler [41] p. 1012.

50. L. Saffaro, "Dai cinque Poliedri platonici all'infinito", in *Enciclopedia Scienze e Tecnica Mondadori* (1976) pp. 473–484.

51. M. Muraro, "L'Esperienza Veneziana di Paolo Uccello", *Atti del XVIII Congresso Internazionale di Storia dell'Arte, Venezia, 1955.*

52. E. Sindona, *Paolo Uccello* (Milan: 1st Editoriale Italiano, 1957) pp. 25–26.

53. Architettura e Utopia nelia Venezia del 500, Venice, July 1980–January 1981.

54. See Barbaro [39] codex.

55. See [53] p. 239.

56. See Coxeter [42] p. 667.

On Some New Platonic Forms

Lucio Saffaro

It is well known that only five regular convex polyhedra can exist in a three-dimensional Euclidean space. These polyhedra have been known from ancient times: Plato (427–348 B.C.) used them as elements to construct his theory of the physical world—this is the reason they are called Platonic Solids [1]. Euclid gave a complete mathematical description of the five solids in his *Elements* (circa 300 B.C.). In the same period Archimedes (287–212 B.C.) discovered new polyhedra, starting from the five regular solids. He found 13 polyhedra in all; today these are still called *Archimedean* polyhedra [2].

For many centuries the number of discovered polyhedra did not change. Only at the end of the fifteenth century did interest in the study of polyhedra rekindle in Italy. Piero della Francesca, Leonardo da Vinci and Luca Pacioli, as well as other great painters and architects, wrote several treatises on Platonic and Archimedean polyhedra; but the painter Paolo Uccello, great scholar of the new science of perspective, discovered something new. During the period 1420–1430 A.D., he made several preparatory drawings for marble tarsias to be inserted in the mosaics in the floor of the San Marco Basilica and in the church of San Pantalon in Venice [3]. In these drawings he represented two star-shaped dodecahedra. The discovery of these new polyhedra is officially attributed to the great astronomer Kepler, who made them known in his volume *Harmonices Mundi* [4], published in 1619. Since then, many new polyhedra have been discovered, all with a connection to the five regular solids. The five Platonic solids define all possible symmetries of a three-dimensional space, so every new class of polyhedra can only be a generalization of the main class of five regular polyhedra.

Here we propose a generalization that is based on the symmetry of each regular polyhedron. Every one of them has symmetry axes with respect to which the polyhedron can be rotated—for each axis there is a rotation angle that transforms the polyhedron in itself. For example, a cube has three symmetry axes, each passing through the centers of two opposite faces. After rotating by an angle $\alpha_1 = 90°$ with respect to one of these axes, the cube returns to its initial position. Moreover, a cube has four symmetry axes passing through the pairs of opposite vertices and six symmetry axes passing through the middle points of opposite edges. The rotation angles are $\alpha_2 = 120°$ and $\alpha_3 = 180°$, respectively. Now let us consider three cubes, homocentric with a main cube that defines the rotation axes, and rotate them on these axes by angle $\beta_1 = \alpha_1/2 = 45°$. We obtain a new concave-convex polyhedron, made of four cubes and that has the symmetry of a cube. In the same way we can construct a concave-convex polyhedron made of four cubes rotated by angle $\beta_2 = \alpha_2/2 = 60°$ with respect to the axes passing through the vertices of a central cube. And we can construct a polyhedron made of six cubes rotated by angle $\beta_3 = \alpha_3/2 = 90°$ on the axes passing through the middle points of the opposite edges of a central cube.

The same operation can be carried out for the remaining four regular polyhedra. A total of 14 polyhedra can be constructed in this way, each of them having the same symmetry of the generating regular polyhedron. These composite concave-convex polyhedra will be called first-order regular polyhedra. The same operation can be repeated indefinitely: it is sufficient to substitute a first-order polyhedron for each polyhedron in the construction. So a new polyhedron is obtained that, again, has the symmetry of the generating polyhedron. It will be called a second-order

ABSTRACT

In this article some generalizations of the classic concepts of polyhedra are proposed. The author, an artist, obtained some of these concepts with a classic technique (oil on canvas), and others he obtained through the use of computer graphics.

Fig. 1. *Platonic Forms*, **computer graphics, 1986. A first-order cube is shown, made of six cubes.**

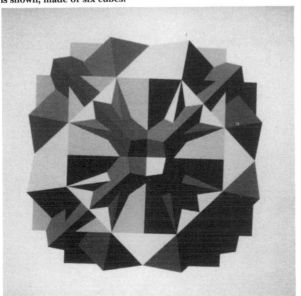

Lucio Saffaro (artist), via Guidotti 50, 40134 Bologna, Italy.

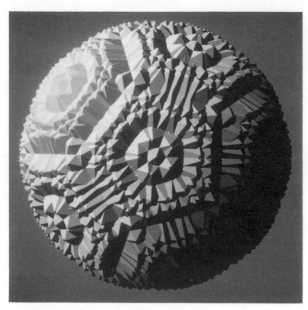

Fig. 2. *Platonic Forms*, computer graphics, 1986. This second-order icosahedron, made of 100 hycosahedra, has a structure similar to that of a dodecahedron.

regular polyhedron. And so on: from an n-order polyhedron, an $(n+1)$-order polyhedron can be obtained (Fig. 1).

In Color Plate A No. 3, two polyhedra are shown. On the left, there is a first-order dodecahedron that is made of six regular dodecahedra rotated 36° with respect to the axes passing through the centers of the opposite faces of the starting dodecahedron. Every single dodecahedron is marked by a different color. A cross-section of the same dodecahedron, showing its interior, can be seen on the right. A second-order icosahedron, made of 100 hycosahedra, is shown in Fig. 2. This polyhedron is interesting because its structure is similar to that of a dodecahedron. Among its many peaks, rectilinear hollows can be distinctly seen, exactly forming the edges of a dodecahedron.

As far as I know, a theory does not exist that can foresee the shape of regular polyhedra of the third or fourth order and so on. Only through the use of a very powerful computer can such complex objects be constructed [5].

References and Notes

1. M. Emmer, "Art and Mathematics: The Platonic Solids", *Leonardo* **15**, No. 4, 277–282 (1982).

2. H. M. Cundy and A. P. Rollet, *Mathematical Models* (Oxford: Clarendon Press, 1954).

3. For more information, see L. Saffaro, "Dai cinque poliedri all'infinito", in E. Macorini, ed., *Annuario EST* (Milan: Mondadori, 1976) pp. 473–484; L. Saffaro, "Anticipazioni e mutamenti nel pensiero geometrico", in M. Emmer, ed., *L'occhio di Horus: Itinerari nell'immaginario matematico* (Rome: Instituto della Enciclopedia Italiana, 1989) pp. 105–116; M. Emmer, *Platonic Solids*, color-sound film from the series *Art and Mathematics*, 27 min (Rome: FILM 7 International, 1979).

4. J. Kepler, *Harmonices Mundi Libri V* (Linz: 1619).

5. The images were obtained using a computer-aided design (CAD) Intergraph connected to a VAX 750 computer of Centro Elaborazioni Scientifiche e Grafiche (CESG), Ente Nazionale Energie Alternative (ENEA), Bologna, Italy. See L. Saffaro, "Nuovissime operazioni sui poliedri platonici", in E. Macorini, ed., *Annuario EST* (Milan: Mondadori, 1986–1987) pp. 323–331; G. Macchi, ed., *Spazio*, exh. cat. (Venice: Edizioni of the Biennale di Venezia, 1986) pp. 36, 45–46; L. Saffaro, "Per un'estetica dei poliedri", in E. Macorini, ed., *Annuario EST* (Milan: Mondadori, 1988–1989) pp. 359–367; M. Emmer, *Computers,* color-sound film from the series *Art and Mathematics,* 27 min (Rome: FILM 7 International, 1987). (Partially filmed in the rooms of the section *Spazio* [Space] of the Biennale di Venezia, 1986).

The Aesthetics of Viruses

A. S. Koch and
T. Tarnai

THE AESTHETICS OF EVIL

Viruses as pathogenic agents have gained a notorious reputation as mysterious, invisible enemies of health and life. Although to some the idea of speculating about the aesthetics of viruses might seem slightly morbid, the aesthetics of the demonic and evil is, nevertheless, not alien to art. Let us remember the innumerable pieces of art inspired by St. Anthony's temptations, by the apocalypse, by the Last Judgement or by Hell itself. In these presentations the artists apparently indulged themselves with considerable involvement and pleasure (not infrequently even with a particular kind of humour) in painting or sculpting monsters, demons, ghosts, goblins and all sorts of fancy devils busily engaged in indiscriminate torture of saints as well as condemned sinners. Hieronymus Bosch, the sixteenth-century Adamite artist, spent much of his life painting metaphysical and transcendental sceneries and beings—albeit in a very 'naturalistic' way—clearly with the aim of inducing in the spectator the thrill and horror of curiosity for the unfathomable and incomprehensible.

The motivation of our approach, however, is essentially different. We wish the reader to forget her or his subjective prejudices against viruses and to look at viruses merely as special entities of nature's inexhaustible variety of material manifestations.

The laws of nature are concise descriptions of events exhibiting certain regularities and giving the global impression of a slow, macroscopically irreversible evolutionary drift of matter and space-time. This scenario does not exclude occasional, dramatic local changes in state and structure that are, despite appearances, neither catastrophes nor revelations, but rather other types of events controlled similarly by the laws of nature. These so-called 'chance' events are essentially also deterministic, since any potential event having a probability greater than 0 will unavoidably become actual if all necessary conditions are available.

Spinoza's speculations and von Neumann's evidence demonstrated that the human brain reflects the events of nature in an objective way, i. e. what we measure (observe) is true (real). There is no guarantee, though, that our interpretations—theories—are similarly true reflections of reality. In considering the laws of nature, we feel quite ready to accept Truth and Beauty as synonyms (at least in the Platonic sense), irrespective of our subjective feelings, which provide labels of 'good' or 'bad'. Health and pleasure, disease and death, are equally manifestations of nature's laws. This objective way of viewing the world is neither sterile nor inhuman; it merely provides the proper distance for one to perceive not only the chance irregularities of the individual trees, but also the deterministic global order of the forests.

THE VIRION AS A MESSAGE

The free (extracellular) virus, the virion, consists essentially of a close-packed linear sequence of code signals in the form of a nucleic acid macromolecule enclosed in a simple rod-like or spheroidal 'box' (some virions also have an envelope), exhibiting on its surface molecular patterns (antigenic and binding sites) specific for the given agent, much like a trademark for a product [1]. We deal in this paper with the simplest forms, the small 'naked' (envelopeless) virions of cubical symmetry. Others of a different or more sophisticated structure will not be discussed, although they are not devoid of aesthetics.

A virion is a 'message in a bottle', released by a host cell that is ill or dying from a viral infection. This message may be looked upon from the point of view of the cell or of the virus. The cell screams for the help of the immune system to rescue, if not itself, at least the other members of the cell population (or of the multicellular organism as a whole). The released virion ventures the 'ocean' (the extracellular space) with the hope of avoiding all Scyllas and Charybdises until reaching a new host (cell), which would provide for the survival (replication) of the message carried by the virion. As with other types of messages entrusted to the ocean, the chance of its reaching the proper destination is usually slim. Nature improves this chance by causing a host cell infected by a single virion to produce hundreds to several tens of thousands of identical progeny virions. The result is, however, uncertain. The majority of the 'bottles' floating in the ocean become lost or destroyed. Some of them meet patrol ships (cells of the immune system). Some,

ABSTRACT

The aesthetics of viruses is worthy of investigation even if these organisms represent a potential hazard for the health and life of living beings. The extracellular virus (virion) is a 'monumental' product of nature in that it contains a vast amount of information in its clear, concise and puritanic structure. In this paper, structures produced by evolutionary processes are compared and contrasted with those designed by humans. It is noted that discoveries in geometry and architecture have had beneficial influence on research on viruses, and vice versa.

A. S. Koch (virologist, educator), Semmelweis University of Medicine, 2nd Department of Pathology, Üllöi út 93, Budapest, H-1091 Hungary.

T. Tarnai (engineer, mathematician, educator), Technical University of Budapest, Dept. of Civil Engineering Mechanics, Müegyetem rkp. 3, Budapest, H-1521 Hungary.

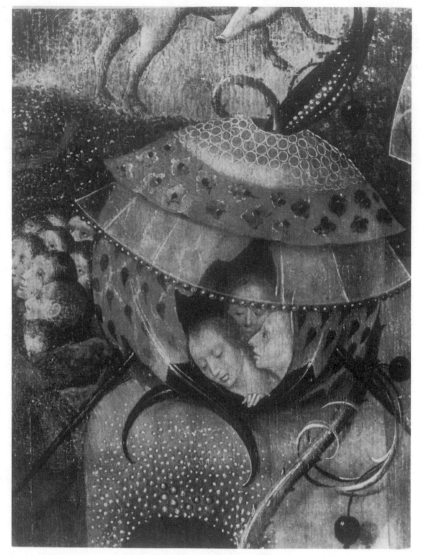

Fig. 1. Hieronymus Bosch, *Garden of Earthly Delights*, triptych, oil on wood, 220 × 195 cm in the folded position, date uncertain (probably the first decade of the sixteenth century). Shown: detail of the middle board. (Prado, Madrid)

virion, although only some hundreds of Ångströms (10^{-7} mm) in diameter, is certainly monumental.

Structural principles of small virions were first suggested by Crick and Watson [2] in 1957. Since at that time the details of genetic coding were only poorly understood, these authors deserve appreciation for their courage and acuteness in making use of "the powerful but dangerous weapon: the principle of simplicity" [3].

Crick and Watson found the virion's code-to-product ratio too small to allow for coding more than 3–5 types of proteins, while it was known that the protein 'box' (capsid) made up about 70% of the virion's total volume and that certain specific viral proteins (enzymes) were also required for replication. It was, therefore, reasonable to suppose (and this was later proved to be correct) that the capsid was constructed from either a single type or just a few types of structural subunit(s) (protein molecules). Based on morphological evidence presented by Franklin, Klug and Holmes [4] and Caspar [5], Crick and Watson put forth the question, "Given that the protein component is made of subunits, how will they be arranged?" [6].

THE SUBUNIT PRINCIPLE

The construction of buildings from quasi-identical subunits, e. g. quader stones (single regular blocks of stone cut directly from the rock), has been practised since prehistoric times (dolmens, menhirs, tumuli, etc.) and was utilised for building huge and robust constructions by the Egyptians, Aztecs, Mayas, Etruscans, Greeks, Romans, etc. The use of bricks, or even modern prefabricated elements for erecting tower-like skyscrapers, also is based essentially on the subunit principle. To ensure appropriate statics and stability of such constructions, builders have relied on the principles of symmetry (equilibrium of forces). It is, however, not a trivial problem to construct stable domes or shells from identical or quasi-identical subunits. The dome of the tomb of Theodoric the Great in Ravenna (Italy) was carved from a single block of a rock (subunit), which weighed many tens of tons. The principles applied by Anthemius and Isidorus in constructing the dome of Hagia Sophia (on order of the emperor Justinian in A.D. 532–537), and later by Brunelleschi in Florence (San Lorenzo) and Michelangelo in Rome (San Pietro), were different from those based on the use of identical subunits. In our time, the problem of erecting domes has been revived by the advent of modern lightweight construction materials. The technical and geometrical problems encountered in these fields proved to be essential also in the discovery of the structure of virions, and vice versa.

In the plane, the greatest rigidity of structure is obtained when identical structural subunits are close-packed. For instance, using equal circular discs as structural subunits,

however, meet pirates ready to support the proliferation of evil (the diseased host cell). Thus the virions may succumb to the second law of thermodynamics (destruction) or may act as antigens or as inducers of their own replication. All this necessarily specifies certain features of the virion.

A virion should be stable even under adverse conditions. It should be identifiable by the immune system as a 'non-self' entity inside the body. It should be able to recognize the gate of entry into its optimal host. Meeting all these requirements necessitates appropriate molecular structures and patterns on the virion's surface. This has to be done in the simplest possible way, for the information fitting into the 'bottle' is limited by the necessity for an optimal volume-to-surface ratio.

STRUCTURE OF A VIRION

At this point one may start speculating about the aesthetics of a simple virion. A piece of art is called 'monumental' not only for its size but also for its puritanic, disciplined way of presenting vast intellectual and emotional content (information) in a form reduced to a minimum. In this respect a

optimal close-packing is obtained in a regular triangular lattice-like arrangement in which each circle is touched by six other circles and the tangents passing through the touching points form a tessellation of equal regular hexagons entirely filling and covering the plane without gaps.

Unfortunately this principle of covering a surface does not work with spherical surfaces. With equal circles, the maximal possible touchings number only five. Hieronymus Bosch, who apparently enjoyed ornamenting doubly curved surfaces with quasi-equal circles, was well aware of this fact. A detail (Fig. 1) of his *Garden of Earthly Delights* triptych is convincing evidence of this. Here he covered the top of a strawberry with a more-or-less regular pattern of circles and let them dissipate into a random packing through the lower parts of the construction. Another such packing of circles can be seen in the centre of the left wing of the same triptych.

As a matter of fact, on a sphere any one circle can touch six of its neighbouring circles only by using circles of different sizes or by allowing for certain deformations of the sphere. However, these operations fail to solve the problem of folding a hexagonal planar lattice into a sphere. As shown by Thompson [7], it is actually impossible to construct on a spherical surface a tessellation consisting merely of hexagons. The use of hexagons of different sizes does not solve the problem either. Therefore, a spherical 'hexagonal' tessellation must always contain polygons with fewer than six sides. In the construction of a spherical tessellation out of hexagons and pentagons, the latter will always number exactly 12, regardless of the number of hexagons. The highest order of symmetry and the minimum number of different structural units (all uniform) are obtained if the 12 pentavalent vertices form an icosahedron. This is a regular polyhedron bounded by 20 equilateral triangles and having the highest possible number of edges (five) per vertex out of all regular (Platonic) polyhedra.

The above geometric facts and restraints are easily demonstrable on the 'spherical' radiolarian depicted by Ernst Haeckel (Fig. 2), the German biologist who also excelled in illustrating his observations by artistic, yet scientifically correct, drawings and paintings [8]. At first sight, the skeleton of that tiny animal appears to be constructed of quasi-identical hexagonal pyramids (subunits). However, on closer scrutiny, the first impression of a high-order symmetry vanishes and several non-identical subunits are detected. This is considered a good example of nature's versatility in producing 'quasi-perfect', yet (or exactly therefore) highly aesthetic, structures using that typical evolutionary method, trial and error, rather than the designer's board.

Radiolarians are giants compared to viruses, ranging in size from tenths of a millimetre to about 1 mm, while viruses are measured in Ångströms. Nevertheless, the basic principles of the construction of radiolarians and viruses are quite similar. Structural features of virions—the 'invisible' agents of contagious diseases—have been disclosed only during recent decades, with the advent of high resolution electron microscopy and sophisticated methods of (negative) 'staining'.

The apparently spherical shape of the small (and of some larger) virions proved to be a matter of poor resolution. Their structures are actually identical with, or closely resembling, the icosahedron. An electron micrograph of negatively stained NβV virions clearly shows the well-defined edges of an icosahedron (Fig. 3).

The capsid of these virions is constructed (mostly by self-assembly) from one type or just a few types of protein subunit(s). In the simplest case a single type of subunit and a single type of bonding are applied. Thus a total of 12 pentamers (structural units), i. e. 60 subunits, form the capsid, three subunits being present on each of the 20 triangular faces (Fig. 4a). This being the minimum, in most cases more subunits are required to encase the close-packed genome in the virion. This can no longer be achieved with a single type of bonding, but rather requires at least two types. Therefore, the subunits will be only 'quasi-equivalent' [9], i. e. pentamers and hexamers.

With the minimum of two types of bonding, the capsid may grow to practically unlimited size by constructing triangular faces from regularly increasing numbers of uniform equilateral triangles ('triangulation'). Such structures will always exhibit regular numbers of hexagons and exactly 12 pentagons at the vertices and will maintain the plane of symmetry and the rotational symmetry of the icosahedron.

Fig. 2. Ernst Haeckel, siliceous skeleton of the spherical radiolarian Sagenoscena stellata. From E. Haeckel, *Kunstformen der Natur*, 7th Ed. (Leipzig and Vienna: Bibliographisches Institut, 1904) Table 61, Phaeodaria; Fig. 9, Sagenoscena stellata.

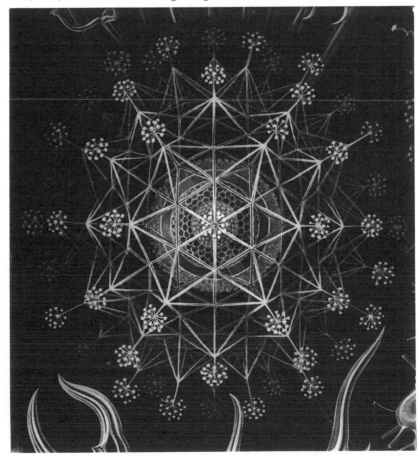

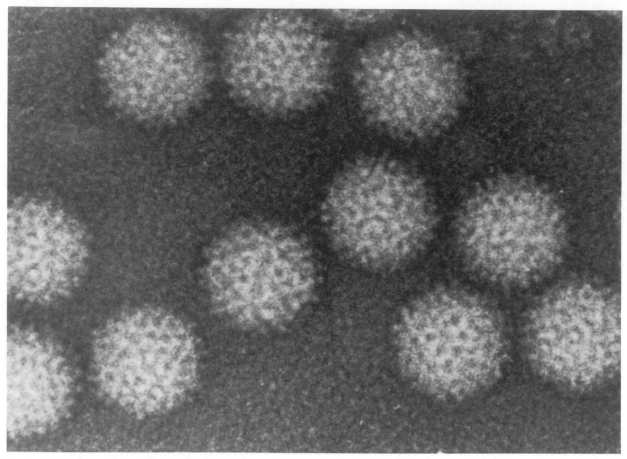

Fig. 3. J. T. Finch, negatively stained (field of) NβV virions, electron micrograph, 1974. (Courtesy of J. T. Finch, Cambridge, England)

There is, however, a possibility for increasing the volume of the polyhedral capsid by approximating its shape to that of a sphere, while the icosahedral symmetry is maintained. The general symmetry of the resulting polyhedra will become more and more distorted, the kinds of facets per face will

Fig. 4. Polyhedra with icosahedral symmetry (obtained by triangulation of the spherical surface). (a) Polyhedron with one kind of vertex, the icosahedron. (b–d) Polyhedra with two kinds of vertices and 60 facets (b), 80 facets (c), 140 facets (d).

increase, and new vertices will appear. This is essentially achieved by a 'skew' triangulation, which still conserves the principle of dividing the triangular faces into regular triangular facets which are, however, cut into different, exactly fitting, complementary pieces. This trick results in polyhedra with 60 (Fig. 4b), 80 (Fig. 4c), 140 (Fig. 4d), etc., facets and with a regularly increasing number of 'extra' vertices. Of these polyhedra, those with 60 and 80 facets still have a plane of symmetry, while having one and two kind(s) of facets, respectively. The next polyhedron will have 140 facets, still only of two kinds, but the structure will have lost its plane of symmetry.

However, the loss of a plane of symmetry may also be accompanied by a local modification of symmetry. It is

Fig. 5. (a) Arrangement of regular pentagons in the plane where each pentagon has six neighbours. (b) Polyomavirus capsid consisting only of pentamers, each of which, except the pentamers at the vertices of the icosahedron, has six neighbours.

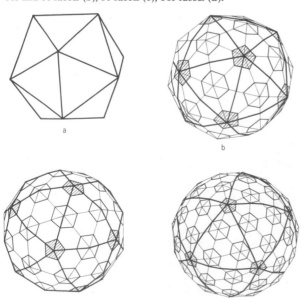

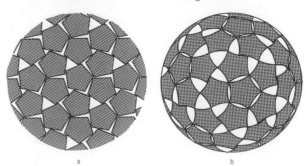

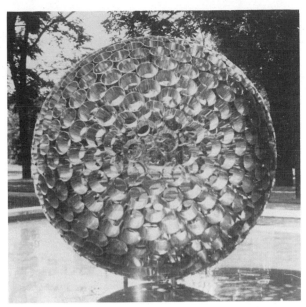

Fig. 6. B. Józsa's art object, stainless steel, diam. 3 m, 1974 (Hungarian Academy of Sciences in Szeged, Hungary). The sphere is composed of 536 identical truncated cones.

Fig. 7. Geodesic cabin, aluminum alloy, diam. 2.4 m, designed by S. Mester, exhibited at EXPO Budapest, 1971. (Photo: S. Mester)

Fig. 8. Full geodesic dome, aluminum alloy, diam. 15 m, designed by I. Kádár, erected in 1963 in Boglárlelle, Hungary. (Photo: Z. Szathmáry)

known that regular pentagons can be arranged in the plane so that each of them has six neighbours [10] (Fig. 5a). On a sphere, such an arrangement can be produced only if some pentagons have fewer than six (e. g. five) neighbours. Recent investigations [11] have demonstrated the existence of viral capsids of that type, corresponding to a polyhedron with 140 facets in which all 72 structural units are pentamers (modeled as regular pentagons in Fig. 5b). This local modification of symmetry, for which the pentagons are responsible, does not alter the global icosahedral rotational symmetry of the capsid and preserves the quasi-equivalence of the structural subunits.

The local symmetry properties of pentagons can nevertheless lead to a global change in symmetry, as demonstrated in quasi-crystals [12,13], in which symmetry is replaced by quasi-symmetry. A detailed discussion of this special form of the self-organization of matter would be, however, beyond the scope of the present paper.

PERFECTION OR QUASI-PERFECTION

Virions thus seem to be markedly regular and perfect structures. Perfection is, however, just a semblance. True perfection would make the virions 'frozen' structures, similar to crystals, and the information encased in the viral capsid would become trapped forever, as are the gas or fluid enclosures in crystals. The virion's ability to initiate infection by releasing the genetic (mis)information is in fact due to the imperfection (quasi-perfection) of its structure. As outlined above, the pentameric units forming the 12 vertices of all possible polyhedra of icosahedral symmetry are different from those forming the sides and the extra vertices of the (skewed) triangulated surfaces. The 12 vertices are singular, representing the sites of maximal 'stress' (one subunit of the hexagon is eliminated to permit bending). Therefore, under appropriate conditions, these may be the very sites where the virion becomes 'cracked' on specific interaction with the host cell's receptor.

The protein shell (capsid) of the small spherical virions is in fact a hierarchically ordered packing of molecules (subunits). Construction of a shell by packing identical or quasi-identical elements on a spherical surface is quite frequent in nature and recently also in the practice of art and technology [14]. An excellent example of random packing of equal circles on a sphere is the metal art object created by the Hungarian sculptor B. Józsa to decorate the park of the Biology Research Center, Hungarian Academy of Sciences, in Szeged (Fig. 6).

Modern architecture presents many examples of constructions erected from quasi-identical units (members or panels). The many types of geodesic domes all over the world are realizations of the fundamental research and design activities of R. B. Fuller [15]. The domes shown in

Figs 7 and 8 are constructed from only two types of triangular panels or frames. Actually the initial studies into virion structure were largely inspired and stimulated by geodesic domes [16], which at that time were designed so as to preserve their plane of symmetry. Later virologists discovered the occurrence in virions of 'skew' triangular lattices with no plane of symmetry. The geometric interpretation of these structural details was contributed by Coxeter [17] and Wenninger [18] and has recently inspired new architectural conceptions.

Thus, in this particular respect, viruses, the notorious invisible agents of disease (or often of disaster) in humans, animals, plants and microbes, seem to have made (at least partial) amends for their 'sins' by inspiring architects and geometers to decorate the human environment with attractive, modern and friendly constructions.

References

1. J. M. Hogle, Marie Chow and D. J. Fliman, "The Structure of Poliovirus", *Scientific American* 256, No. 3, 28–35 (1987).

2. F. H. C. Crick and J. D. Watson, "Virus Structure: General Principles", in *Ciba Foundation Symposium on the Nature of Viruses*, G. E. W. Wolstenhome and E. C. P. Millar, eds. (London: J. and A. Churchill, 1957) pp. 5–13.

3. Crick and Watson [2] p. 5.

4. R. E. Franklin, A. Klug and K. C. Holmes, "X-Ray Diffraction Studies of the Structure and Morphology of Tobacco Mosaic Virus", in Wolstenhome and Millar [2] pp. 39–51.

5. D. L. D. Caspar, "Structure of Tomato Bushy Stunt Virus", *Nature* (London) 177 (1956) p. 475.

6. Crick and Watson [2] p. 11.

7. D'Arcy W. Thompson, *On Growth and Form*, Vols. I–II, 2nd Ed., reprinted (Cambridge: Cambridge Univ. Press, 1963).

8. E. Haeckel, *Kunstformen der Natur* (Leipzig-Wien: Verlag des Bibliographischen Instituts, 1904).

9. D. L. D. Caspar and A. Klug, "Physical Principles in the Construction of Regular Viruses", *Cold Spring Harbor Symposia on Quantitative Biology* 27 (1962) pp. 1–24.

10. B. Grünbaum and G. C. Shephard, *Tilings and Patterns* (New York: W. H. Freeman, 1987).

11. D. M. Salunke, D. L. D. Caspar and R. L. Garcea, "Self-Assembly of Purified Polyomavirus Capsid Protein VP$_1$", *Cell* 46 (1986) pp. 895–904.

12. D. S. Shechtman, I. Blech, D. Gratias and J. W. Cahn, "A Metallic Phase with Long-Ranged Orientational Order and No Translational Symmetry", *Phys. Rev. Lett.* 53 (1984) p. 1951.

13. P. J. Steinhardt, "Quasicrystals", *American Scientist* 74 (1986) pp. 586–597.

14. T. Tarnai, "Spherical Circle-Packing in Nature, Practice and Theory", *Structural Topology* 9 (1984) pp. 39–58.

15. R. B. Fuller, "Geodesic Tent", U.S. Patent Office (Patent 2,914,074, 24 November 1959).

16. Caspar and Klug [9].

17. H. S. M. Coxeter, "Virus Macromolecules and Geodesic Domes", in *A Spectrum of Mathematics*, J. C. Butcher, ed. (Oxford: Oxford Univ. Press, 1972) pp. 98–107.

18. M. J. Wenninger, *Spherical Models* (Cambridge: Cambridge Univ. Press, 1979).

The Fourth Dimension and Non-Euclidean Geometry in Modern Art: Conclusion

Linda Dalrymple Henderson

THE NEW GEOMETRIES IN ART AND THEORY 1900–1930

During the first three decades of the twentieth century, the fourth dimension was a concern common to artists in nearly every major modern movement: Analytical and Synthetic Cubists (as well as Duchamp, Picabia, and Kupka), Italian Futurists, Russian Futurists, Suprematists, and Constructivists, American modernists in the Stieglitz and Arensberg circles, Dadaists, and members of De Stijl. While the rise of Fauvism and German Expressionism preceded the first artistic application of higher dimensions by the Cubists, Matisse himself later demonstrated a passing interest in the subject. And, even though the German Bauhaus was not an active center of interest in the fourth dimension, it, too, was touched by the idea through the propagandizing of Van Doesburg, Kandinsky's own awareness of the idea, and the growing interest in Germany in the space-time world of Einstein.

Although by the end of the 1920s the temporal fourth dimension of Einsteinian Relativity Theory had largely displaced the popular fourth dimension of space in the public mind, one further movement was to explore a fourth spatial dimension (and non-Euclidean geometry): French Surrealism. While acknowledging Einstein's theories, André Breton and various Surrealist painters during the 1930s and 1940s retained many of the pre-Einsteinian implications of 'the fourth dimension' and non-Euclidean geometry.

Non-Euclidean geometry never achieved the widespread popularity of the fourth dimension, which possessed many more nongeometric associations. As a result, the list of artists and critics actively interested in non-Euclidean geometry was considerably smaller. In addition to Duchamp and the Cubists Metzinger and Gleizes, the main advocates of non-Euclidean geometry were the Russian poet Khlebnikov and the painter El Lissitzky, and rebel spirits such as Benjamin de Casseres, Dada founder Tristan Tzara, and, later, the Surrealists. For all of these individuals, whether they explored its principles or not, non-Euclidean geometry signified a new freedom from the tyranny of established laws. Codified in Poincaré's philosophy of conventionalism, this recognition of the relativity of knowledge was a powerful influence on early twentieth-century thought. Thus, even artists who concentrated on the fourth dimension alone owed something to the non-Euclidean geometries that had prepared the way for the acceptance of alternative kinds of space.

Like non-Euclidean geometry, the fourth dimension was primarily a symbol of liberation for artists. However, the notion of a higher dimension lent itself to painterly applications far more easily than did the principles of non-Euclidean geometry. Specifically, belief in a fourth dimension encouraged artists to depart from visual reality and to reject completely the one-point perspective system that for centuries had portrayed the world as three-dimensional. The late nineteenth-century resurgence of idealist philosophy provided further support for painters to proclaim the existence of a higher, four-dimensional reality, which artists alone could intuit and reveal.

Among those who subscribed to this view of the fourth dimension were the Cubists, Kupka, the Futurists Boccioni and Severini, Max Weber, Malevich and his Russian colleagues, and Mondrian and Van Doesburg. For the artists of this group whose distrust of visual reality was most deepseated, belief in a fourth dimension was an important impetus to create a totally abstract art. Malevich's 'objectless' style was the most directly indebted to the fourth dimension, but both Kupka and Mondrian accepted the idea as a supplement to their Theosophical beliefs. And, even though the term *the fourth dimension* does not figure in Kandinsky's early writings, the belief of his era in the possibility of higher dimensions stands, along with Steiner's Christian Theosophy, behind his antimaterialist philosophy. Two last figures who were less inclined toward otherworldly beliefs, Picabia and Larionov, also identified total abstraction in art with the fourth dimension.

ABSTRACT

The author outlines twentieth-century artistic interest in the fourth dimension and non-Euclidean geometry. Starting with the first three decades of the twentieth century, she discusses the art movements and artists—such as Kandinsky, Breton, El Lissitzky, Picabia, Duchamp, Malevich, Mondrian, Eisenstein, Moholy-Nagy, Pereira and Dali—who were inspired by these new geometries.

Linda Dalrymple Henderson (teacher), Art Department, University of Texas, University Station, Austin, TX 78712, U.S.A.

From Linda Dalrymple Henderson, *The Fourth Dimension and Non-Euclidean Geometry in Modern Art.* Copyright © 1983 by Princeton University Press. Excerpts, pp. 339–352, reprinted by permission of Princeton University Press.

The fourth dimension also supported bold experimentation by those painters who did not reject visual experience entirely. Associated initially with the geometry of Cubism's faceted forms and multiple views, the fourth dimension was also variously identified with gravity (Duchamp, Schamberg) as well as antigravity (Malevich, Lissitzky, Van Doesburg), spirals (Boccioni, Severini), the airless Platonic realm of Synthetic Cubism, and, in America, with tactility and 'significant form' in the art of Cézanne. Because of the time element in hyperspace philosophy, motion also became an important attribute of the fourth dimension—in the motion studies of Kupka, Duchamp, and Boccioni, and in the abstract art of Malevich, Lissitzky, and Van Doesburg, as well as in architecture (Van Doesburg, Fuller) and film (Bruguière, Eisenstein).

Shadows, mirrors, and virtual images were added to the four-dimensional vocabulary of the artist by Duchamp, whose approach to the subject was unique in this period. If Duchamp at first shared his Cubist colleagues' idealist belief in the fourth dimension, his attitude quickly became more analytical. For Duchamp the n-dimensional and non-Euclidean geometries were a stimulus to go beyond traditional oil painting to explore the interrelationship of dimensions and even to reexamine the nature of three-dimensional perspective. Like Jarry before him, Duchamp also found something deliciously subversive about the new geometries with their challenge to so many long-standing 'truths'. The motives behind Duchamp's interest in the fourth dimension in fact represent an alternative strain to the idealist visions of a higher reality that supported the birth of abstract art.

This revolutionary aim was often combined with the more utopian, idealist view of the fourth dimension in the calls for a new 'language' that were widespread in this era. One or the other goal was usually dominant, however, according to the degree of the author's distaste for the three-dimensional world and the status quo. Thus, when Kupka, Weber, or even Pawlowski talked of a new language for the future, their criticisms of three-dimensional reality were benign in comparison to Ouspensky's arguments against current logic and reason. A similar militantly antirational intent was behind the advocacy of the new geometries by Kruchenykh, the Dadaists, and the Surrealists. Whether overtly subversive or an idyllic vision of higher truth, 'the fourth dimension' as a rationale for exploring new kinds of language in art, literature, and music justified some of the most advanced experimentation of the era. The rediscovery of 'the fourth dimension' thus provides specific links between the artistic avant-garde and pioneers such as Gertrude Stein and Varèse.

Ranging from a geometric, purely spatial concept in the hands of Poincaré to a mystical vision provisionally incorporating time in the hyperspace philosophy of Hinton, Bragdon, and Ouspensky, 'the fourth dimension' offered the possibility of a variety of artistic interpretations. Always signifying a higher dimension of space, 'the fourth dimension' nevertheless accommodated differing proportions of geometry and mysticism as well as space and time. As in the case of Van Doesburg, in the end it was hyperspace philosophy, with its temporal element as a means to higher space, which blended more easily with Einsteinian Relativity. When the popularization of Relativity Theory in the 1920s enthroned time as the fourth dimension and Einstein as supreme scientist and philosopher, both Poincaré and a purely geometric fourth dimension were soon largely forgotten by the public and artists alike. Generally, during the

1930s and 1940s only artists of a somewhat mystical nature or, as in the case of the Surrealists, an antirational attitude would continue to see validity in discussing a spatial fourth dimension in the face of Relativity Theory.

Yet, if by 1930 the widespread 'romance of many dimensions' between the public and the fourth dimension was over, this notion, along with non-Euclidean geometry, had played a vital role in the development of modern art and theory. By rediscovering the contemporary sources on the subject and, particularly, by restoring figures such as Poincaré and Hinton to their rightful prominence, our view of early twentieth-century thought is considerably enriched. More importantly, once the artistic impact of the new geometries is understood, the art and critical literature of the early modern era regain a unity and a level of meaning that has long been lost.

THE FOURTH DIMENSION AND NON-EUCLIDEAN GEOMETRY IN ART AND THEORY SINCE 1930

By the 1930s at least two factors militated against artistic interest in the spatial interpretation of the fourth dimension. Besides the redefinition of the fourth dimension as time in Relativity Theory, formalist art theory increasingly discouraged the presence of deep space in modern painting. Even Van Doesburg, the last major advocate of the fourth dimension, had carefully avoided violating the two-dimensional surface of his canvases and had found other means, such as the diagonal, to allude to higher dimensions. Thus, when the *Manifeste Dimensioniste* was published in Paris in 1936, over a collection of signatures ranging from Joan Miró and Hans Arp to Moholy-Nagy, Duchamp, Picabia, and Kandinsky, it was simply a generalized echo of earlier beliefs, recast in the terminology of space-time.

Written by the painter Charles Sirato, the *Manifeste Dimensioniste* was published by the *Revue N + 1* in 1936. After citing the theories of Einstein as one of the impetuses for "Dimensionisme", the manifesto declares,

Animated by a new conception of the world, the arts in a collective fermentation (Interpenetration of the Arts) have begun to stir. And each of them has evolved with a new dimension. Each of them has found a form of expression inherent in the next higher dimension, objectifying the weighty spiritual consequences of this fundamental change. Thus, the constructivist tendency compels:

I. Literature to depart from the line and move in the plane . . .

II. Painting to leave the plane and occupy space: Painting in space, Constructivism, Spatial Constructions, Multimedia Compositions.

III. Sculpture to abandon closed, immobile, and dead space, that is to say, the three-dimensional space of Euclid, in order to conquer for artistic expression the four-dimensional space of Minkovsky.

At first 'solid' sculpture (classical sculpture) broke open and, in introducing into itself the 'void' sculpted and determined from the interior space—and then movement—transformed itself: hollowed out sculpture, open sculpture, mobile sculpture, motorized objects.

Then must come the creation of an absolutely new art: cosmic art (Vaporization of sculpture, 'Syno-Sense' theater—provisional designations). The total conquest of the art of four-dimensional space (a 'Vacuum Artis' until now). Rigid material is abolished and replaced by gaseous materials [1].

The manifesto was signed by Ben Nicholson, Alexander

Calder, Vincent Huidobro, Kakabadzé, Kobro, Joan Miró, Moholy-Nagy, Antonio Pedro, Arp, P. A. Birot, Camille Bryen, Robert Delaunay, César Domela, Marcel Duchamp, Kandinsky, Fred Kann, Kotchar, Nina Negri, Mario Nissim, Fr. Picabia, Prampolini, Prinner, Rathamann, Ch. Sirato, Sonia Delaunay, and Sophie Taeuber Arp.

Sirato's text was vague enough in its references to both the fourth dimension and non-Euclidean geometry to be acceptable to the manifesto's wide range of signatories. Members of the Abstraction-Création group were satisfied, since the manifesto did not advocate space in painting, but rather that painting should move into three-dimensional space in the form of constructions [2]. It was sculpture that was to incorporate the fourth dimension—but initially, at least, in the form of motion, in line with Moholy-Nagy's interpretation of 'space-time' as well as with the 'Precision Optics' of Duchamp, who at that time was producing his *Rotoreliefs*. And for the more mystical or adventuresome members of the group, there was the prospect of the ultimate 'cosmic art', in which sculpture would be vaporized and consist entirely of gaseous materials. Kandinsky and others grounded in Symbolist thinking would certainly have responded to Sirato's evocation of a 'Syno-Sense' theater with possible affinities to earlier experiments in color music.

Although Sirato's prediction of a new, cosmic art produced few results at the time, the mystical component of the *Manifeste Dimensioniste* reflected what was to become the main thread of continuity with past thinking about the fourth dimension. Apart from the Surrealists, painters working in the other dominant mode of the 1930s, geometric abstraction, rarely demonstrated an interest in a fourth spatial dimension unless their personal philosophies inclined toward the spiritual or mystical.

A number of relevant sources published in the late 1920s and early 1930s reinterpreted hyperspace philosophy in the light of Relativity Theory [3]. The most important of these texts was the Symbolist Maurice Maeterlinck's *La Vie de l'espace*, a remarkable résumé of the early twentieth-century literature on the fourth dimension. Maeterlinck's lengthy section of *La Vie de l'espace* entitled "La Quatrième Dimension" deals with nearly all the major figures who wrote on the subject, including Hinton, Pawlowski, and Ouspensky, as well as Jouffret, Poincaré, and Boucher. Although Maeterlinck refers to Einstein's new theories and even quotes from A. S. Eddington's *Space, Time and Gravitation,* he considered Relativity Theory to be only one aspect of 'the fourth dimension'. Like Pawlowski before him, Maeterlinck refused to sacrifice the idealist and even mystical associations of a spatial fourth dimension in favor of time as the fourth dimension [4].

The American painter I. Rice Pereira, who matured in the 1920s, may well have read Maeterlinck's book or another of the contemporary reappraisals of hyperspace philosophy. Whatever the manner in which she was introduced to Hinton's writings, however, his books became a crucial source for her own double-edged investigation of the fourth dimension [5]. Sensitive to the mystical and intuitive aspects of the fourth dimension, Pereira also studied the physics of Einsteinian Relativity during the 1930s. The result was what she termed a "pure scientific or geometric system of esthetics", which sought "to find plastic equivalents for the revolutionary discoveries in mathematics, physics, biochemistry and radioactivity" [6]. Within this highly scientific-sounding philosophy of art, however, Pereira also incorporated elements of hyperspace philosophy.

Oblique Progression of 1948 illustrates the type of spatially complex works Pereira created in the 1940s, relying both upon spatial clues and upon various patterns of reflecting light. Light, space, and time were consistent themes in the philosophical texts Pereira subsequently published, along with a belief in the evolution of consciousness based on hyperspace philosophy. In *The Nature of Space* of 1956 she would write,

> The apprehension of space and the development of human consciousness are parallel. The more energy that is illuminated and redeemed from the substance of matter, the more fluid the perceptions become and the more the mind sums up into abstraction. The mind's capacity for dimensionality and the structure of consciousness become available through experiencing one's own action. . . . One cannot explore a dimension unless the constellation of one's own consciousness is prepared to apprehend it [7].

As late as 1966, in *The Transcendental Formal Logic of the Infinite: The Evolution of Cultural Forms,* Pereira still sounded much like one of the devotees of evolving consciousness and dimensional awareness in the Stieglitz circle in 1913 [8].

A closer examination of the writings of several abstract artists in the 1930s and 1940s may in the future reveal additional artists aware of the traditional 'fourth dimension'. The names of at least three such artists, all affected by the mystical possibilities of higher dimensions, can already be noted: the Russian-born painter Maurice Golubov, Mark Tobey, and Louise Nevelson, also of Russian birth [9]. The fourth dimension was also an element in the early art theory of Hans Hofmann, whose own artistic education had begun in pre-World War I Paris. Hofmann's familiarity with the ideas of Apollinaire and the Cubists is apparent in a 1930 *Art Digest* article, where he writes, "All profound content in life originates from the highest phenomenon of the soul: from intuition, and thereby is found the fourth dimension. Art is the expression of this dimension realized through the other dimensions" [10].

Typically, however, the fourth dimension did not continue as a major feature of Hofmann's thinking. While its spiritual implications were suited to Hofmann's aesthetic philosophy, the fourth dimension as a spatial phenomenon was in direct conflict with his dedication to the integrity of the picture plane. Indeed, in the face of the growing surface orientation of modern art, only one movement, Surrealism, openly declared an interest in deep space. As a result, it was through the Surrealists that the fourth dimension and non-Euclidean geometry had their last broad impact on early modern art.

In the tradition of Jarry and Duchamp, André Breton found the new geometries ideally suited to his arguments for a new 'surreality'. The advent of Einstein and Relativity did not negate for Breton the earlier significance of the new geometries. Instead, Relativity simply added a second, temporal definition to the fourth dimension and, in his view, further undermined accepted ideas about the nature of reality. Like the early twentieth-century advocates of the fourth dimension, Breton had inherited the Symbolist generation's distrust of the exterior world [11]. Although the major source for Breton's Surrealist theory was Freud's analysis of the unconscious mind, much of his thinking reflects earlier themes associated with higher dimensions as well as non-Euclidean geometry. Breton carried on the Dada attack on logic and reason in a manner much like that of Ouspensky's arguments for a new four-dimensional antilogic. Furthermore, he was actively interested in spiritual-

ism and mysticism as means for communication with the unconscious. As early as 1922 Breton and several colleagues had experimented with spiritualist trances as an alternative to dreams and automatic writing for escaping the control of reason [12].

Non-Euclidean geometry and Lobachevsky himself were officially incorporated into the Surrealist attack on reason and logic in 1936. In that year Gaston Bachelard's essay "Surrationalism" was published in the first and only number of the periodical *Inquisitions,* edited by, among others, the former Dadaist Tzara. Arguing that human reason must be restored to its function of turbulent aggression. [13], Bachelard cited Lobachevsky's non-Euclidean geometry as one of the sources for "surrationalism". Breton and a number of the Surrealist painters shared Bachelard's view. Their enthusiasm for non-Euclidean geometry as another support for rejecting established laws is reflected in the titles of works such as Yves Tanguy's *The Meeting of Parallels* of 1935 (Kunstmuseum, Basel) and Max Ernst's *Young Man Intrigued by the Flight of a Non-Euclidean Fly,* begun in 1942 (Private Collection, Zurich) [14]. Even Salvador Dali's famous limp watches in *The Persistence of Memory* of 1931 have non-Euclidean overtones. In his 1935 book *The Conquest of the Irrational,* Dali discussed the watches in the context of his comments on non-Euclidean versus Euclidean geometry and the theories of Einstein. Noting their immediate visual source in a plate of Camembert cheese, Dali described the melted watches as "the extravagant and solitary Camembert of time and space" [15].

In his own writings Breton dealt more specifically with the presence of higher spatial dimensions in Surrealist painting. In the 1939 essay "Des tendances les plus récentes de la peinture surréaliste", Breton noted a new current in painting that combined a renewed interest in automatism with the larger problem of depicting higher dimensions of space. Of these younger artists, Breton wrote,

> If, when they venture into the scientific realm, the precision of their language is somewhat unreliable, it cannot be denied that their common, fundamental aspiration is to move beyond the universe of three dimensions. Although that was one of the leitmotifs of Cubism in its heroic period, it must be admitted that this question poses itself in a much more pointed manner since Einstein's introduction of the notion of *space-time* into physics. The necessity of a suggestive representation of the four-dimensional universe asserts itself particularly in Matta (landscapes with several horizons) and in Onslow-Ford. Dominguez, motivated by similar preoccupations, now bases all of his researches in the domain of sculpture on obtaining *lithochronic surfaces.* . . .

> ("Certain surfaces, that we call *lithochroniques,* open a window on the strange world of the fourth dimension, constituting a kind of solidification. . . ." [Sabato and Dominguez] [16].)

Breton's reference to Cubism's fourth dimension, paired with his quotation from Oscar Dominguez's 1942 text "La Pétrification du temps", confirms the dual definition of the fourth dimension accepted by the Surrealists. The tradition of a spatial 'fourth dimension' possessed mystical and even irrational associations that supported the Surrealist outlook. Thus, in the face of the temporal fourth dimension of Relativity Theory, interested painters simply continued to treat the space-time continuum as if it possessed four spatial dimensions, as Van Doesburg and, for a time, El Lissitzky had done. Oscar Dominguez, on the other hand, working in sculpture, was fascinated by the life of objects in time.

Dominguez's writings on the fourth dimension may have been the most scientific of any of the Surrealists. His introduction to the idea of 'lithochronic surfaces' in "La Pétrification du temps" demonstrates a rather solid grounding in Relativity physics, as well as an awareness of the two-dimensional analogy that had been a frequent component of earlier discussions of a fourth dimension of space. By 1942, however, Dominguez was more interested in the 'lithochronic surface' itself, which he explained as follows:

> Let us imagine for a minute any three-dimensional body, an African lion for example, between any two moments of his existence. Between the lion L_0, or lion at the moment $t = 0$, and the lion L_1 or final lion, is located an infinity of African lions, of diverse aspects and forms. Now if we consider the ensemble formed by all the points of lion to all its instants and in all its positions, and then if we trace the enveloping surface, we will obtain an *enveloping super-lion* endowed with extremely delicate and nuanced morphological characteristics. It is to such surfaces that we give the name *lithochronic* [17].

While Dominguez recognized time as the primary definition of the fourth dimension, ideas closer to those of hyperspace philosophy's combination of time and space underlie his notion of the lithochronic surface. In the end, Dominguez's description seems more applicable to works such as Boccioni's *Unique Forms of Continuity in Space* than to Dominguez's Surrealist objects [18].

In addition to his creation of Surrealist objects and his experiments with the technique of decalcomania, during 1938 and 1939 Dominguez had produced a series of highly spatial 'cosmic' paintings, as he termed them. The polyhedral forms present in works such as *Nostalgia of Space* of 1939 have been connected to the geometrical models at the Institut Henri Poincaré, which were photographed by Man Ray for the 1936 exhibition of Surrealist objects [19]. If interest in the Institut Poincaré suggests one link to the 'heroic period' of the fourth dimension, Duchamp himself was another. A friend of the Surrealists in Paris during the 1930s, Duchamp became particularly close to the Chilean-born painter Matta Echaurren during the Surrealists' World War II 'exile' in New York. Matta collaborated with Katherine Dreier to write the essay *Duchamp's Glass: An Analytical Reflection,* published by the Société Anonyme in 1944, and in February 1948 Matta published Duchamp's *Large Glass* note "Cast Shadows" in his magazine *Instead* [20]. However, as Breton documents in "Des tendances les plus récentes de la peinture surréaliste", Matta's interest in the fourth dimension dated back at least to the late 1930s.

Matta had joined the Surrealist movement in 1937, after working for several years in the architectural office of Le Corbusier. Sharing with his friend Gordon Onslow-Ford a desire to discover an inner world, Matta (and Onslow-Ford) responded to Surrealism's Freudian orientation as well as to 'the fourth dimension' in both its mystical and scientific forms [21]. Matta soon began to explore the world of higher dimensions in a lush, organic style influenced by the biomorphic abstraction of Tanguy and, in part, by the 'cosmic' paintings of Dominguez.

By the early 1940s, Matta's depictions of a nebulous spatial realm also began to incorporate a number of angular, linear elements, as in *The Vertigo of Eros* of 1944. The lines in this painting are actually reminiscent of the maze of string Duchamp created in 1942 for the New York exhibition *First Papers of Surrealism* in one of his own latter-day experiments in dimensionality and curvature [22]. Indeed, Matta's

friendship with Duchamp in the 1940s was an important stimulus for the Chilean painter to persist in painting infinite space and to ignore the modernist preference for flatness.

Breton could have included one other painter in his 1939 discussion of the fourth dimension, had it not been for the ideological break between Dali and himself in the later 1930s [23]. In *The Conquest of the Irrational* Dali had also reflected a concern with higher spatial dimensions. Although this notion never dominated his art in the way it guided Matta, Dali, like Matta, was attracted by both the mystical and the scientific sides of 'the fourth dimension'. Dali's painting *Crucifixion (Corpus Hypercubicus)* of 1954 was actually inspired by the ideas of the twelfth-century Catalonian mystic Raimondo Lulio, as well as the sixteenth-century architect Juan de Herrera. In Dali's mind, his work with the hypercube was the culmination of Lulio's manipulation of two-dimensional forms and the three-dimensional researches Herrera presented in his manuscript treatise "Discurso de la figura cúbica" [24].

During the 1950s and 1960s artists such as Dali and Pereira were nearly alone in their continued interest in the traditional fourth dimension of space. Although the painters of the major movement of the 1950s, Abstract Expressionism, had learned a great deal from the Surrealists in New York during the 1940s, these lessons had little to do with the fourth dimension or non-Euclidean geometry. In fact, it was the very antipathy of the young Americans toward geometry, as represented by the art of the American disciples of Mondrian, which made Surrealist automatism attractive. Thus, Barnett Newman's 1942 painting entitled *The Death of Euclid* (Collection Betty Parsons, New York) is a generalized rejection of all geometry and not a tribute to non-Euclidean principles.

Historical distance also discouraged widespread enthusiasm for higher dimensions of space after 1940. Artists born around 1905, as were many of the Abstract Expressionists [25], had come of age as painters only in the late 1920s, at the end of an era dominated by 'the fourth dimension'. The next generation of painters, whose styles emerged in the 1960s, were so far removed from this period that they were, on the whole, totally unaware of the importance of the new geometries for early modern art. In addition, the modernist preoccupation with flatness continued to discourage purposeful evocations of space as a goal in painting. By the end of the 1960s, the Minimalist movement had banished spatial illusion from modern painting.

During the 1970s, however, there emerged a number of individuals, both artists and mathematicians, who share the goal of giving visual form to spatial fourth dimension. The 1978 volume *Hypergraphics: Visualizing Complex Relationships in Art, Science and Technology,* a symposium sponsored by the American Association for the Advancement of Science, presents the work of a group of these researchers, including Thomas Banchoff and Charles Strauss of the Mathematics Department of Brown University, and David Brisson of the Rhode Island School of Design [26]. . . . Banchoff and Strauss . . . manipulate four-dimensional figures on the display screen of a computer. The results of this technological advance are four-dimensional images of an intricacy and accuracy never dreamed of in the early twentieth century [27].

Similarly, the articles published by the painter Tony Robbin in the later 1970s chronicle a rise of interest in spatial complexity among contemporary painters [28]. Robbin believes in the reality of four-dimensional space, and his paintings, such as *79-8* are intended as metaphors for the complexity of the space-time world of the twentieth century. While the Cubists, in their pursuit of the fourth dimension of space, had introduced multiple viewpoints, those views were nevertheless fused into unified images. Robbin's work, on the other hand, makes a definitive break with the unities of the past. Against an indefinite background made up of impossible figures such as splayed-out Necker cubes, linear grids denoting independent planes in space overlap and interpenetrate. In combination with the painting's ground, these grids provide contradictory spatial clues and establish a tension that refuses to be resolved in three-dimensional space. Further supporting this effect is the interaction of the variety of patterned surfaces and . . . the solid color grid elements, which call to mind Malevich's free-floating planes of color.

Robbin's more recent works also explore the notion of a collapsing spatial metric, a principle that is only slightly indicated in the decreasing size of the Necker cube faces toward the edges of [Robbin's *79-8*]. The question of the geometrical metric of space is one of the many issues Robbin has derived from his reading in contemporary physics. Yet, like the Cubists before him, Robbin reminds his viewer that the purpose of his art goes beyond mathematics or physics *per se*. As he has written in a recent article,

> Artists who are interested in four-dimensional space are not motivated by a desire to illustrate new physical theories, nor by a desire to solve mathematical problems. We are motivated by a desire to complete our subjective experience by inventing new aesthetic and conceptual capabilities. We are not in the least surprised, however, to find physicists and mathematicians working simultaneously on a metaphor for space in which paradoxical three dimensional experiences are resolved only by a four dimensional space. Our reading of the history of culture has shown us that in the development of new metaphors for space artists, physicists, and mathematicians are usually in step [29].

Reminiscent of Matyushin's 1913 assertion that "artists have always been knights, poets, and prophets of space in all eras", Robbin's statement suggests that after a long hiatus 'the fourth dimension' may be on the verge of a new phase of influence.

References and Notes

1. Sirato, *Manifeste Dimensioniste* (Paris: *Revue N + 1,* 1936); reprinted in Waldemar George, *Kotchar et la peinture dans l'espace,* ex. cat. (Paris: Galerie Percier, 1966), n. pag.

2. On the Abstraction-Création group of abstract geometric painters with which many of the manifesto's signers were associated, see Gladys C. Fabre, *Abstraction-Création 1931–1936,* ex. cat. (Westfälisches Landesmuseum für Kunst und Kulturgeschichte, Münster, and Musée d'Art Moderne de la Ville de Paris, 1978).

3. In addition to Claude Bragdon's books of the 1920s, another typical reevaluation of hyperspace philosophy in the context of Relativity Theory was Richard Eriksen's *Consciousness, Life and the Fourth Dimension: A Study in Natural Philosophy* (Copenhagen and London: Gyldendal, 1923; New York: Alfred A. Knopf, 1923). In Eriksen's work the mysterious properties of the fourth dimension of space were transferred to the new temporal fourth dimension of Relativity Theory.

4. See Maeterlinck, *La Vie de l'espace* (Paris: Eugène Fasquelle, 1928; New York: Dodd, Mead & Co., 1928).

5. See John I. H. Baur, *Loren MacIver/I. Rice Pereira,* ex. cat. (Whitney Museum of American Art, New York, 1953; New York: The Macmillan Co., 1953) p. 52.

6. Pereira, in *ibid.*

7. Pereira, *The Nature of Space* (1956; reprint ed. Washington, D.C.: The Corcoran Gallery of Art, 1968) pp. 49–50. Even though by 1956 Pereira had returned to a more rectilinear and seemingly planar mode in painting, her goals remained multidimensional. Following upon a dream in 1954, described in *The Lapis* (Washington, D.C.: The Corcoran Gallery of Art, 1959),

Pereira developed a system of two-dimensional symbols with which to depict an infinite, space-time landscape free, in her view, of both Euclidean geometry and perspective.

8. See, for example, Pereira, *The Transcendental Logic of the Infinite: The Evolution of Cultural Forms* (New York: I. Rice Pereira, 1966) pp. 10, 20, 56, 57.

9. On Golubov's continuing concern with a mystical fourth dimension, see *Maurice Golubov: Paintings 1925–1980*, ed. Daniel J. Cameron, ex. cat. (The Mint Museum of Art, Charlotte, NC, 1980) pp. 5, 10, 11, 16. For the influence of hyperspace philosophy on Tobey, see, for example, "Mark Tobey Writes on His Painting on the Cover", *Art News*, **XLIV** (1–14 Jan. 1946), 22, where Tobey explains that "the multiple space bounded by involved white lines symbolizes higher states of consciousness". William Seitz discusses this statement in the context of Tobey's philosophy in *Mark Tobey*, ex. cat. (The Museum of Modern Art, New York, 1962) p. 27.

Nevelson encountered mystical views of the fourth dimension during the 1920s at the theater art school organized by Princess Matchabelli and Frederick Kiesler in New York. Nevelson, who was also a student of Hans Hofmann, today still uses the term 'fourth dimension', if somewhat offhandedly, in her definition of art. See the essay by Lori Wilson in *Louise Nevelson: The Fourth Dimension*, ex. cat. (Phoenix Art Museum, 11 Jan.–24 Feb. 1980) p. 12.

10. Hofmann, "Review of the Field of Art Education: Art in America", *The Art Digest*, **XIV** (Aug. 1930), 27. For an overview of Hofmann's art and theory, see William C. Seitz, *Hans Hofmann*, ex. cat. (The Museum of Modern Art, New York, 1963).

11. On the importance of Symbolist attitudes for Breton and his colleagues, see Anna Balakian, *Literary Origins of Surrealism: A New Mysticism in French Poetry* (New York: New York Univ. Press, 1947). On the Surrealists' appreciation of Jarry, see, in addition to Balakian, Maurice Nadeau, *The History of Surrealism* (1945), trans. Richard Howard (New York: The Macmillan Co., 1965) pp. 72–73.

12. Camfield, *Picabia: His Art, Life and Times*, p. 184.

13. Bachelard, "Surrationalism", trans. in Julien Levy, *Surrealism* (New York: The Black Sun Press, 1936) p. 186. For a critique of Bachelard's text, see Gauss, *The Aesthetic Theories of French Artists*, pp. 87–88.

14. Ernst's painting was made by letting a tin can, dripping paint, oscillate back and forth over his canvas, producing curved, but hardly non-Euclidean, tracings. See Diane Waldman, *Max Ernst: A Retrospective*, ex. cat. (The Soloman R. Guggenheim Museum, New York, 1975) pp. 54-55, Fig. 24.

15. Dali, "Les Pleurs d'Héraclite", in *La Conquête de l'irrationel* (Paris: Editions Surréalistes, 1935) p. 25.

16. In Breton, *Le Surréalisme et la peinture* (New York: Brentano's, 1945) p. 152.

17. Dominguez, "La Pétrification du temps", *in La Conquête du monde par l'image* (Paris: Editions de la Main a Plume, 1942); trans. in Lucy R. Lippard, ed., *Surrealists on Art* (Englewood Cliffs, NJ: Prentice-Hall, 1970) p. 109.

18. A selection of Surrealist objects by Dominguez is illustrated in Marcel Jean, *Histoire de la peinture surréaliste* (Paris: Editions du Seuil, 1959) pp. 245–48.

19. Jean, *Histoire de la peinture surréaliste*, p. 269.

20. For this note, discussed in Chapter 3 above in connection with *Tu m'*, see Duchamp, "Cast Shadows", in *Salt Seller*, pp. 72–73.

21. Gordon Onslow-Ford described his and Matta's goals in this period, as well as Matta's mystical leanings, in a 1969 interview with Irene Clurman, which formed the basis for her essay *Surrealism and the Painting of Matta and Magritte*, Stanford Honors Essay in the Humanities, No. 14 (Stanford: Stanford Univ., 1970) pp. 17–27.

22. Matta's paintings since the mid-1940s have usually included monsterlike personages, which often reduce the overwhelming spatial effects of his works of the early 1940s. See William Rubin, *Matta*, ex. cat. (The Museum of Modern Art, New York, 10 Sept.–20 Oct. 1957). For Duchamp's installation and Rubin's suggestion of this connection, see Rubin, *Dada, Surrealism, and Their Heritage*, ex. cat. (The Museum of Modern Art, New York, 27 Mar.–9 June 1968) pp. 160, 164.

23. On the differences between Breton and Dali which began with a left/right political split, see, for example, Nadeau, *The History of Surrealism*, p. 215.

24. Dali mentions both of these figures in his *Diary of a Genius*, trans. Richard Howard (Garden City, NY: Doubleday & Co., 1965). Dali's vision of himself as the third inspired Catalonian in this developing dimensional line was explained by Dali to Professor Thomas Banchoff of Brown University. A recent painting by Dali, *A la recherche de la quatrième dimension* (Private Collection), demonstrates that Dali, like Duchamp, has found stereoscopy a useful means for exploring dimensionality. For this work, and a discussion of Dali's recent perceptual experiments, see the essay by Robert Descharnes, "Dali, l'image de l'espace", in *Salvador Dali: Retrospective 1920–1980*, ex. cat. (Musée National d'Art Moderne, Centre National d'Art et de Culture Georges Pompidou, Paris, 18 Dec. 1979–14 Apr. 1980) pp. 390–402.

25. Although Dali was also born in 1905 and Pereira as late as 1907, by the end of the 1920s both of these figures were already closely in touch with older artists in the avant-garde. Except for Hofmann, this was not the case with the majority of the Abstract Expressionists.

26. See Brisson, ed., *Hypergraphics: Visualizing Complex Relationships in Art, Science and Technology*, AAAS Selected Symposium 24 (Boulder: Westview Press, 1978). This renewed interest in a spatial fourth dimension has been supported by new and more complex theories of cosmology in physics, as reported in such recent sources as Rudolf v. B. Rucker, *Geometry, Relativity and the Fourth Dimension* (New York: Dover, 1977) chs. 1–3, and Martin Gardner, *The Relativity Explosion* (New York: Random House, 1976) chs. 10–12.

27. See Banchoff and Strauss, "Real-Time Computer Graphics Analysis of Figures in Four-Space", in *Hypergraphics*, ed. Brisson, pp. 159–167. See also Kenneth Engel, "Shadows of the Fourth Dimension", *Science 80*, No. 5 (July–Aug. 1980) pp. 68–73. Banchoff and Strauss's work is a major step forward in a field pioneered by A. Michael Noll, who produced the first computerized films of four-dimensional figures at Bell Laboratories in the mid-1960s. See the 1967 article by Noll, "Displaying *n*-Dimensional Hyperobjects by Computer", reprinted in *Hypergraphics*, ed. Brisson, pp. 147–158.

28. See, e. g. Robbin, "The New Art of 4-Dimensional Space: Spatial Complexity in Recent New York Work", *Artscribe* (London), No. 9 (1977) pp. 19–22. See also the essay by Ellen Schwarz for the exhibition *Subject: Space* (Pratt Institute Gallery, New York, 27 Nov.–20 Dec. 1979).

Perceptual illusion had also functioned in the mainstream of modern painting to reopen the exploration of space. Al Held was among the first artists in the later 1960s to reintroduce definite spatial cues and even multiple viewpoints into avant-garde painting. It is thus no coincidence his pupils, such as Robbin, have been at the forefront of interest in spatial complexity and particularly four-dimensional space. On Held's spatial paintings from 1967 onward, see Marcia Tucker, *Al Held*, ex. cat. (Whitney Museum of American Art, New York, 1974). In her concluding remarks Tucker compares Held's space to the four-dimensional, non-Euclidean space-time of Relativity Theory, although, in fact, these ideas were not a conscious motivating force for Held.

29. Robbin, "The New Art of 4-Dimensional Space", p. 20.

On Some Vistas Disclosed by Mathematics to the Russian Avant-Garde: Geometry, El Lissitzky and Gabo

Manuel Corrada

ABSTRACT

Generally speaking, all avant-garde movements have had one characteristic in common: belief in the new. It is also true that all of those movements were aware of changes, progress and advances in science. As a consequence, non-Euclidean geometry was considered a manifesto for revolution in the arts. This article discusses the visualization of mathematics—the process of transferring concepts from mathematics to works of art—with examples from the artworks and writings of El Lissitzky and Naum Gabo.

Diderot, great character of the Enlightment, is one of the more remarkable scientific and humanistic symbols of the eighteenth century. His work, performed in collaboration with d'Alembert, *Encyclopédie* (1751–1765) [1] summarizes, although in hundreds of pages, the triumphs of the intellect and of the age—and of these two visionary men of genius. D'Alembert, the other half of that editorial adventure, in his article entitled "Dimension", alluded to the fourth dimension, in contrast to traditional learning [2]. And in Diderot's "Traité du Beau", contained in Volume II, we find the first example of an analogy of beauty with a mathematical theorem concerning a curve [3]. Nearly a century later, in the second stanza from the fifth song in Lautréamont's evil treatise *Les Chants de Maldoror*, the same analogy (although he does not refer to Diderot's work) is repeated: "beau comme un memoire sur la courbe que decrit un chien en courant apres son maitre" (as beautiful as the memory of the curve described by a dog running after its master) [4].

Note the view, especially popular among mathematicians, that beauty can be found in mathematical discourse. Of course, this idea could not occur to anyone without knowledge of mathematics, as Diderot and, to a lesser degree, Lautréamont had. However, the beauty of the visual image was not their business. Nevertheless, in the eighteenth and nineteenth centuries, the study of bizarre and mysterious curves became important.

It was only in the last half of the nineteenth century that an interest in visualizing contemporaneous mathematical ideas began. I shall make no attempt to describe that epoch called Modernism, whose genesis and strength are still matters under discussion [5]. However, there was at that time a general momentum that carried with it art, poetry, science, fashion, advertising and architecture. We can establish some interplay between these distinct types of activities. Consider the influence of mathematics upon the arts. It is my opinion that mathematics had three roles in the visual arts. First, it was a metaphor for progress. Second, it provided a language of forms and shapes. And third, mathematical concepts could enlighten, modify and penetrate art notions that were then reflected in the visual arts. My discussion of these roles will be best considered in the climate of the Russian avant-garde (Fig. 1), which constitutes one vigorous, optimistic and neat example of Modernism, and which perhaps served as a forerunner of some of the present attitudes in visual mathematics.

THE METAPHOR OF PROGRESS

In the 1920s Russian writer Iouri Tynianov, referring to Futurist poet Velimir Khlebnikov, wrote "the poet Khlebnikov becomes the Lobachevskii of words" [6]. In this sentence Tynianov is using Nicolai Lobachevskii as a metaphor for a founder of a new system or a novel theory—for this is what Lobachevskii had done. From Tynianov's point of view, the old theory was Euclidean geometry, the deductive theory founded upon Euclid's five postulates. The first four of Euclid's postulates are self-evident, and the fifth can be paraphrased as "there exists only one parallel to a given straight line through a given point". Tynianov's metaphor refers to Lobachevskii's idea about this postulate, which Lobachevskii introduced in his lecture delivered at the University of Kazan on 12 February 1826. That lecture replaced Euclid's fifth postulate without affecting the coherence of the geometrical discourse. Also proposed independently by J. Bolyai, the new postulate allowed the existence of an infinite number of parallels to a line through a given point. However, the general acknowledgment of Lobachevskii's ideas came many years later.

Meanwhile, another lecture questioned the dominant role of Euclidean Geometry. In fact, on 10 June 1854, Bernhard Riemann addressed the topic *On the Hypotheses which Lie at the Basis of Geometry* [7]. Indeed, this lecture, published 13 years later, introduced important mathematical concepts, such as the concept of manifolds, mentioned others (such as the fourth dimension), and contributed strongly to the philosophy of geometry [8]. Riemann also

Manuel Corrada (mathematician), Casilla 51058, Santiago, Chile.

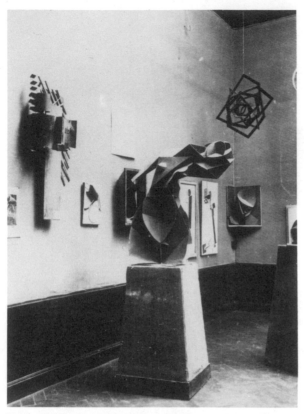

Fig. 1. First Russian Art Exhibition, Van Diemen Gallery, Berlin, 1922. Two of Lissitzky's pictures are barely visible on the left wall. In the corner of the room is Gabo's *Head of a Woman*, and at the centre is Gabo's sculpture *Torso*. Rodchenko's *Hanging Spatial Construction* hangs from the ceiling.

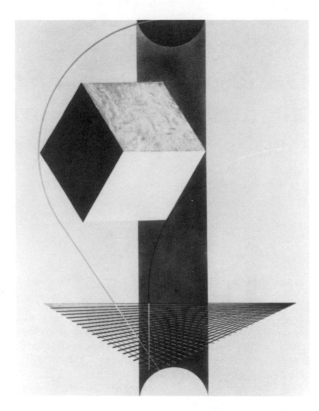

Fig. 2. El Lissitzky, *Proun 99*, oil on wood, 129.4 × 99 cm, 1923. (Courtesy of Yale Univ. Art Gallery, Gift of the Société Anonyme, New Haven, Connecticut) Lissitzky followed the logic of the avant-garde movements: to plunge into the waters of scientific progress. If the geometry of curved surfaces led to new conceptions of space, how is it possible that pictorial space looks so traditional?

discussed the geometry of spherical surfaces on which straight lines correspond to great circles, called equators. As a consequence, there is a geometry (popularly known as Riemann's Geometry) with no parallel lines, for two equators always meet at two points: the poles.

Riemann's ideas together with Lobachevskii's geometry have constituted the subject matter of philosophical and scientific debates since 1860. Thus, in the last half of the nineteenth century, the dominance of Euclidean geometry ended. A revolutionary change with respect to tradition had been accomplished.

Looking back on the turn of the century, we find signs of fundamental changes in science, in literature, in technology, in fashion—in short, everywhere. In the arts, the attacks on the role of representation followed one after another, from Impressionism to Cubism, which was the deepest criticism of the role of visual imagery as representations of reality. A never-ending story traverses all these 'isms'. Most simply, we can regard them as the emblems of change and of denial of tradition.

For artists there was a widespread feeling that behind these changes, science was the ultimate cause of this transforming world. And progress legitimated the process. Thus, a Futurist manifesto says: "Comrades, we tell you now that the triumphant progress of science makes profound changes in humanity inevitable, changes which are hacking an abyss between those docile slaves of past tradition and us free moderns" [9].

In these lines we note the assured volume of confidence in progress implanted by the contemporaneous scientific avalanche. These manifestos are evidence of how science imposed itself on artistic thought.

This tendency was common to several avant-garde movements bearing different banners. Cubism and Futurism in the West were no less involved with science as a metaphor of progress than were the avant-garde artists in Russia. For example, I refer to a passage from Vladimir Markov's *Principles of New Art* (1912): "It must be noticed that contemporary Europe which had done great conquests in the scientific and technological domains is very poor with respect to the evolution of plastic principles inherited from the past" [10].

This sentence could not have been written some years later. Indeed, the following years were years of increasing renewal in visual art, which achieved its chief goal in Constructivism.

Constructivism was the confluence of several diverse aspects of the avant-garde. As a collective ideology, it grew up in the years of 1917 to 1920. The Russian Revolution had provided the optimistic atmosphere sympathetic to new formulations in art. This was a period of discussion and of revolution extended to all spheres. Many explanations have been proposed for this historical avant-garde [11]. For our present purpose it suffices to scan the bundle of mathematical ideas involved in visual art practice. On the one hand, advance in mathematics contributed to support the metaphor of progress. On the other hand, mathematics represented a new way to approach visual arts problems and also created an appropriate place to look for non-naturalistic shapes according to the ideals of both Constructivism and Suprematism.

THE VISUALIZATION OF ABSTRACT MATHEMATICAL NOTIONS

El Lissitzky's essay *Art and Pangeometry* is an essential document for studying the mathematical issues discussed by the Russian avant-garde [12]. Although it was published in 1925 in Germany, from its first line we note it deals with our present situation: "In the period between 1918 and 1921 a lot of old rubbish was destroyed. In Russia we also dragged Art off its sacred throne" [13].

This tone, a typical denial of the past under Dadaist influence, is a rhetorical detour from the essay's aim of describing the parallel development of art and science—geometry—by means of analogies. For example, perspectival space, the representation of space that originated in the Renaissance, corresponds to the laws of three-dimensional Euclidean geometry. However, "in the meantime science undertook fundamental reconstructions" [14], for Euclid's laws had been destroyed by Lobachevskii, Gauss and Riemann. And, in the arts, Cubism had replaced perspective [15]. So said Lissitzky, and so wrote Apollinaire, 12 years earlier [16].

The spatial conception of Suprematism is expressed by the phrase 'irrational space' [17]. In order to explain it, Lissitzky began with an inquiry into non-Euclidean geometries and Gaussian curvature (Fig. 2). Let us pause to sketch this point. Descartes' translation of geometry into algebra allows us to state geometrical properties in terms of functions involving the coordinates of the points concerned. In this way, the study of purely geometrical, and to some extent visual, properties of figures is reduced to the study of functions. Since the seventeenth century this approach has been used to state and solve problems about curves. Consider the equality of shapes among figures. All will agree that for planar figures bounded by straight lines, equality of shape means equality of corresponding angles. But what if the borders are curved lines?

We can naively think that curvature at a point is, in some unprecise sense, like an angle. Thus, equality of shape would mean equality of curvature at the corresponding points. However much we stay on informal ground and understand curvature at a point as the index of the deviation of the curve from its tangent line in that point, or, in the case of surfaces, from its tangent plane, nevertheless a precise formal definition must refer to the functional translation of curves and surfaces.

For plane curves, curvature intuitively is the degree to which a curve is bent at each point. Consider the simplest plane curve, the circle. Because it is equally curved throughout, its curvature is constant and is measured by the reciprocal of the radius. So the smaller the radius, the larger the curvature. In all other curves the amount of curvature varies from point to point, therefore it must be measured with infinitesimals. Thus arises the necessity of using the functional translation of geometrical figures in order to deal with infinitesimals. Now consider a given plane curve and a point *P* on it. Let *Q* and *R* be two neighboring points of the curve.

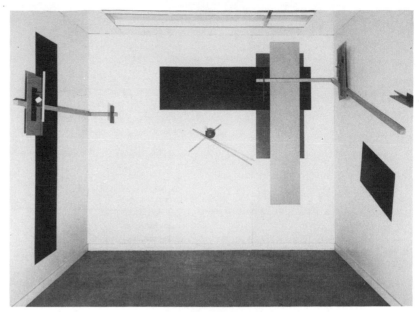

Fig. 3. El Lissitzky, *Proun Space*, painted wood, 300 × 300 × 260 cm, 1965 reconstruction of the 1923 original. (Courtesy of Stedelijk Van Abbemuseum, Eindhoven, The Netherlands) From theoretical speculation to a real environment: "The series of analogies which I am going to bring to your attention", writes Lissitzky, referring to analogies between art and mathematics, "is put forward not to prove, for the works themselves are there for that, but to clarify my views" [60].

Therefore, there exists a circle through *P*, *Q* and *R*. If *Q*, *R* approach *P*, then the curvature of the circle approaches a limiting number. This number is defined as the curvature of the given curve at *P* [18].

The measure of curvature for surfaces can now be reduced to the computation of the curvatures for plane curves. The method for determining the curvature of a surface is, briefly, as follows. Given a point on a surface, the lines tangent to this point lie on a plane. Draw the planes perpendicular to that plane through the point. Each of these planes will intersect the surface in a plane curve. As they are plane curves, their curvatures can be calculated in the way just shown. Thus we determine a set of real numbers, in which each number corresponds to the curvature of one of the plane sections. However this set has a minimum and a maximum, called the *principal curvatures* of the surface at the

Fig. 4. El Lissitzky, *Proun*, lithograph, 60.5 × 44.5 cm, 1923. (Published by Kestner Gessellschaft, Hanover, 1923) One of Lissitzky's purposes was the visualization of abstract concepts from mathematics. To do so, and strictly adhering to his much-quoted belief in the creation of a new conception of space, he designed *Proun Space*.

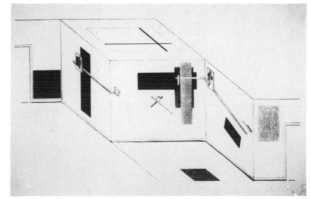

Fig. 5. El Lissitzky, *Proun*, lithograph, 60.5 × 44.5 cm, 1923. (Published by Kestner Gessellschaft, Hanover, 1923) Lissitzky's use of sections of geometrical objects might well have descended from popular ideas that considered material objects as sections of four-dimensional entities.

point considered [19]. The product of the principal curvatures is called the *Gaussian curvature of the surface* at the point under consideration [20]. This definition originated with the work of Gauss in 1827 [21].

It is by means of the Gaussian curvature, actually a number, that a very elegant characterization of non-Euclidean geometries can be formulated. In fact, if the sum of the internal angles of a triangle lying on a surface is less than two right angles (180°), then the surface has negative curvature. If the sum is greater than two right angles, then the surface has positive curvature. Euclid's law, which says that the sum of the internal angles of a triangle equals two right angles (Euclid, I. 32), holds in surfaces of zero curvature [22].

Now, let us come back to Lissitzky's essay. Its discussion refers to spaces of non-zero curvature [23]. More precisely, it says that spaces in which Euclid's postulates hold are the only spaces we can visualize. For spaces of non-zero curvature "only a mirage can simulate this" [24]. This constitutes Lissitzky's criticism of irrational space, which, for him, was the spatial concept of Suprematism. What does irrational space mean? Lissitzky's explanation can be easily and accurately expressed in mathematical terms [25]. For irrational space is a four-dimensional manifold. This was one of the fundamental notions introduced by Riemann's 1854 lecture, although Lissitzky does not mention it.

The definition of the concept of manifold is a difficult task [26]. Briefly, an n-dimensional manifold is a space M, which near each point is like the Euclidean space of dimension n, i.e. the set of all n-ples of real numbers [27]. Most geometrical forms whose points may be defined by n parameters are n-dimensional manifolds. Of course, Euclidean space of dimension n is the simplest n-dimensional manifold. Also, perceptible color qualities form a manifold of dimension three by virtue of the fact that all colors are produced by mixing three basic colors [28].

Riemann's 1854 lecture begins with the advice that manifolds are rare in ordinary life: "Color and the position of sensible objects are perhaps the only simple concepts whose instances form a multiply extended manifold" [29]. Compare Riemann's advice with Lissitsky's ideas about irrational

space: "In this space the distances are measured only by the intensity and the position of the strictly defined color areas" [30]. He thus continues with several remarks that simply yield to the coincidence of Suprematist or irrational space with a four-dimensional manifold [31].

There is no evidence that Lissitzky had read Riemann's lecture or any other book that contains such kinds of ideas. However, these ideas had become part of the philosophical and scientific knowledge of the time [32]. For instance, in *The Foundations of Geometry* (1897) Bertrand Russell wrote two passages dealing with color as an example of manifold [33]. Another account of Riemann's ideas was given by H. V. Helmholtz in *On the Origin and Significance of Geometrical Axioms* [34]. This was the first attempt to expose manifolds and curved spaces to an audience knowing only "the amount of geometry taught in our gymnasia" [35].

Despite the impossibility of determining the exact origin upon which Lissitzky built his explanation of irrational space, it is still possible to make some comments. To start with, manifolds, even if they are not explicitly mentioned, form the underlying mathematical concept that gives meaning to Lissitzky's account of Suprematist space. Second, it seems reasonable that the concepts are of a mathematical kind, for the essay is full of advice to artists not to use 'advanced' scientific concepts without a deep understanding of the corresponding theories. Third, as they are mathematical spaces, "Our minds are incapable of visualizing this, but that is precisely the characteristic of mathematics—that it is independent of our powers of visualization" [36]. From this Lissitzky concludes that those spaces, "cannot be conceived,

Fig. 6. Naum Gabo, *Head of a Woman*, construction in celluloid and metal, 62.2 × 48.9 × 35.4 cm, 1916–1917. (Courtesy of the Museum of Modern Art, New York) Gabo's Constructivist emphasis on economy of materials and his rejection of mass volumes challenged the solid-space tradition of sculptural forms. The technical device he used to make these sculptures is analogous to representing second-order surfaces by the use of intersecting planes.

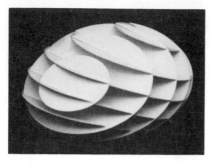

Fig. 7. A multi-faceted model of the ellipsoid: several circles create a curved surface built with planes. (Model and photo: Gonzalo Puga)

cannot be represented; in short, it is impossible to give them material form" [37].

This last sentence contains the refutation of a then-current belief that had oversimplified and confused the discussion of the interplay between art and mathematics during the avant-garde period. I am referring to the belief that avant-garde visual art is, ultimately, nothing more than a transference from mathematics or from a mathematical approach to relativist space to the visual arts [38]. But, Lissitzky's lines touch upon a concept essential to an understanding of the role of mathematics in avant-garde visual arts—the concept of mathematical visualization. Thus, visual images with mathematical notions underlying them do not depend on models or representations of those notions. Visual works may be generated from purely abstract mathematical notions that, of course, have no three-dimensional representation.

Malevich's *Black Square* illustrates the effect of abstract mathematical notions upon the arts [39]. Insightful critics have shown that behind this artwork are thoughts about the fourth dimension [40]. But *Black Square* is a picture—it can be seen, it can be photographed. This is not possible with the fourth dimension—it is a mathematical concept, it cannot be photographed. At most we can obtain designs of representations of objects belonging to four-dimensional space in spaces of fewer dimensions, but not designs of the abstract concept of dimension itself [41].

When Lissitzky refers to *Black Square,* he says it "has now started to form a new space" [42]—indeed, irrational space [43]. He then points out the impossibility of visualizing those new spaces. Here Lissitzky approaches visualization in its more straight meaning, which, he says, neither Malevich's *Black Square* nor Suprematist painting had achieved. How to visualize irrational or Suprematist space? Or, to use mathematical terms, How to visualize four-dimensional manifolds?

In Lissitzky's opinion, he has answered these last questions in *Proun Space* (Fig. 3) [44]. The trick, influenced by motion pictures and advertisements, was to transform the surfaces of an almost-cubic room by displaying objects on them. The movement of the viewer and daylight changes in this environment produced the temporal coordinate. The objects were very simple—parallelepipeds, cubes and spheres—and established a relationship with the walking viewer. Clearly, all this comes from the mathematical approach to relativity [45]. Lissitzky designed a series of six lithographs in *Proun* [46]. One of the lithographs (Fig. 4) is a perspective view of the *Proun Space*; another shows one of the objects (the object on the left wall in Fig. 3). Four other lithographs present planar sections of geometrical figures (Fig. 5). This probably comes from popular ideas that three-dimensional objects are sections of four-dimensional entities [47].

Proun Space was Lissitzky's visualization of a four-dimensional manifold—in his own words, the creation of 'imaginary space'. Whether or not he achieved it may be a subject of discussion. Yet his method of visualizing abstract mathematical notions was coherent, even if from these works alone it seems impossible to comprehend the mathematical concepts involved.

THE LANGUAGE OF NAUM GABO

Although Lissitzky's Suprematist ideas were in the sphere of a Constructivist tendency, his approach, similar to Malevich's, did not allow any kind of direct transference from mathematical concepts to visual artworks [48]. In order to discuss the analogical visualization of mathematical notions we must draw our attention outside Suprematism and appeal to Constructivism. A glance at Rodchenko's or Tatlin's works immediately reveals clear geometrical patterns. This does not mean that Constructivist works can be generally characterized by their resemblance to geometrical shapes.

Since the 1920s the controversy concerning who and what belongs to Constructivism has given rise to declarations, debates and writings. Rodchenko's spatial constructions, for example his *Hanging Spatial Construction* (see Fig. 1), and Tatlin's 'counter-reliefs' (a term coined by Tatlin in 1913 to describe assemblages of industrial materials) may have many elements in common with Pevsner's and Gabo's sculptures. Pevsner and Gabo declared their work to be Constructivist art; however, Gan called Rodchenko and Tatlin Constructivist artists at the same time that he excluded Pevsner and Gabo. It is a complex and many-sided topic. Art issues were, as always, confluent with social, ideological and political affairs [49]. However, for most artists, mathematics had an important role in the genesis of visual images. The role could be subtle, as was the case for Lissitzky and Malevich, or direct, as in Gabo's sculptures.

Gabo's proposal was stated in his *Realistic Manifesto* (1920), signed together with his brother Anton Pevsner [50]. The 1920s meant new days because of the Revolution, new knowledge thanks to science and technology and, as a

Fig. 8. Naum Gabo, *Construction in Space: Crystal,* celluloid, 7.6 × 7.6 × 3.8 cm, 1937. (Courtesy of the Tate Gallery, London) This piece is artistic, although it looks mathematical. The shape is a bit complex and the equation simple, but that is part of its interest.

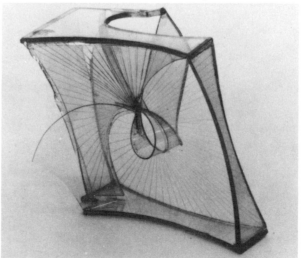

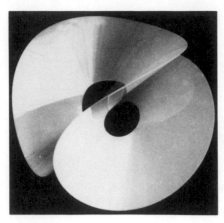

Fig. 9. The shape of Enneper's Minimal Surface provides the basic form for many different Gabo sculptures. (Model and photo: Gonzalo Puga)

consequence, new art for the new epoch. However, new art cannot be founded upon old principles. Accordingly, Gabo's manifesto presents five fundamental principles for Constructivist technique. Two of them, relevant to our discussion, reject mass volumes as spatial elements and explore the construction of volumes by means of planes, which, moreover, results in economic use of materials.

The sculptures made by Gabo in the period previous to the publication of his manifesto followed those principles. I refer to works he made in Norway, *Head of a Woman* (1917) (Fig. 6), *Torso* (1917) (see Fig. 1) and two works both entitled *Bust* (1915–1916). As, according to Gabo, "older sculpture was created in terms of solids; the new departure was to create in terms of space" [51], it was necessary to develop a construction device. The four sculptures I have mentioned show its use. They are constructed by the use of intersecting planes following a craft principle. Let me explain it with a simple example. If we take four cardboard squares and make slots in each, then the intersection at right angles of two parallel squares with the remaining two will produce a cube. By this principle it is very easy to build a sphere, for it suffices to take two families of concentric circles and fit them together in such a way that the planes of the circles intersect at right angles. What happens if we hinge one family of circles? We get a surface, called an ellipsoid, which has the same relation with the ellipse as does the sphere with the circle (Fig. 7). Namely, the plane sections of the ellipsoid are ellipses just as the plane sections of the sphere are circles.

The ellipsoid thus built fulfills one of the requirements of the *Realistic Manifesto*, the construction of volumes by means of planes. Gabo's technique was founded upon this particular way of constructing surfaces. He had studied physics and certainly had become acquainted with mathematics. In those years the use of models was the standard method to illustrate properties of surfaces, for in visualizing them, one gained the intuitive background needed to discuss more abstract notions [52]. The model of the ellipsoid we have described is a particular case of a second-order surface constructed with cardboard circles.

Second-order surfaces, also called quadrics, are surfaces satisfying a second-order equation in three Cartesian coordinates. In the eighteenth century Euler classified them into nine different types according to their equations. Another criterion for classification of quadrics is whether they intersect a plane in a circle. In this way we get two classes. The first sort consists of quadrics that do not intersect any plane in a circle. They are the parabolic and hyperbolic cylinders and the hyperbolic paraboloid. The second sort includes the elliptical cylinder, the elliptical paraboloid, the hyper-

boloids of one and two sheets, the cone and the ellipsoid. In other terms, surfaces of this kind have circular plane sections that, in turn, allow the construction of models for these surfaces with the use of cardboard circles, as was the case for the ellipsoid [53].

As we see, the Constructivist principle of Gabo's 1916–1917 sculptures rests upon free artistic variations of circle models for second-order surfaces. Gabo remained linked to the Moscow avant-garde and to Constructivism until he left Russia in 1922. Even if his subsequent works are not Constructivist in the historical sense, they are characterized by the use of geometrical forms. The basis of most of Gabo's sculptures can be traced back to his *Spheric Theme* (1936) and *Construction in Space: Crystal* (1937) (Fig. 8). These sculptures have analogous mathematical representations. For example, *Crystal* was inspired by a model of the cubic ellipse. This is a space curve defined by a third-degree algebraic equation. Furthermore, it can be proved that it is obtained from the intersection of two quadrics [54]—indeed, from the intersection of an elliptical cylinder and a cone [55].

Spherical Theme is, by far, Gabo's most popular sculpture and the basis upon which he constructed numerous works. Again, surprisingly, it corresponds to a mathematical representation of a surface, even if Gabo never made this claim. Indeed, its form coincides with the shape of the three-dimensional representation of Enneper's Minimal Surface (Fig. 9) [56].

Gabo's sculptures may be considered words in the artist's language, an alphabet containing mathematical forms and shapes. Thus, in my mind, mathematics supplies visual arts with a marvelous and almost infinite catalogue of mysterious, enigmatic and unknown figures. And art gives pleasure to us.

THE TEACHINGS OF APOLLINAIRE

Gabo's sculptures illustrate one of the roles mathematics plays in the visual arts. Visual mathematics supplied an alphabet of new forms that the epoch needed. For the sake of estimating the strength of scientific influence on Gabo's sculptures, we can cite a precise remark by Herbert Read:

> The creative construction which the artist presents to the world is not scientific, but poetic. It is the poetry of space, the poetry of time, of universal harmony, of physical unity. Art—it is its main function—accepts this universal manifold which science investigates and reveals, and reduces it to the concreteness of a plastic symbol [57].

This remark goes to the heart of our difficulty. How can we describe the process of visualizing mathematics? As we have seen there is not just one answer to this question. Gabo started from visual representations of mathematical elements and ended with sculptures. Lissitzky theorized concepts of art by means of mathematical notions that, in turn, resulted in visual works [58]. Both are attitudes resulting in visual mathematics. They are the more brilliant and extreme examples of an attitude common to the Russian avant-garde, and therefore to Modernism, for the Russian avant-garde was a compendium of Modernism.

Today's equivalent of cardboard, plaster and wire models are computer-generated images. They propose to us, among other things, a catalogue of forms and shapes, as models did to Gabo. Nondeterminist ideas explain a whole world of phenomena and can be the source of fresh insights—in the

same way that Lissitzky reached an understanding of Suprematist space by appealing to Riemann's ideas.

The effect of this convergence of art and science has a long history. Yet, in the age of Modernism a great period of direct mathematical influence upon the visual arts began. Mathematics provided the arts with an example of continuous progress—an encyclopedia of deep ideas, a cartography of forms. Apollinaire, perhaps the spokesperson of avant-garde movements, while meditating on art, concluded that art must advance as mathematics had done. He advised, "Geometry is to the plastic arts what grammar is to the art of the writer" [59]. Why not believe this idea to still be valid?

References and Notes

1. D. Diderot and J. L. d'Alembert, eds., *Encyclopédie* (Paris: 1751–1765).

2. J. L. d'Alembert, "Dimension", in Diderot and d'Alembert, eds. [1] Vol. IV, p. 1010.

3. D. Diderot, "Traité du Beau", in Diderot, *Oeuvres* (Paris: Editions Gallimard, 1951) pp. 1106–1107.

4. Comte de Lautréamont (I. L. Ducasse), *Les Chants de Maldoror* (Paris: Editions Gallimard, 1970) p. 195.

5. For a discussion of this point, see J. Habermas, "Modernism Versus Postmodernism", *New German Critique*, No. 22 (1981) pp. 3–22.

6. I. Tynianov, "Sur Khlebnikov", in *Art et Poessie Russes 1900–1930*, T. Andersen and K. Grigorieva, eds. (Paris: Centre Georges Pompidou, 1979) pp. 273–281. (Originally published in 1929).

7. B. Riemann, "Ueber die Hypothesen, welche der Geometrie zu Grunde liegen", *Abhandlungen der koniglichen Gesellschaft der Wissenschaften zu Gottingen*, Vol. XIII (1867) pp. 133–152. I quote from the English translation by Michael Spivak, "On the Hypotheses which Lie at the Foundations of Geometry", in M. Spivak, *A Comprehensive Introduction to Differential Geometry*, Vol. 2 (Boston: Publish or Perish, 1970) pp. 4A-4–4A-20.

8. For a detailed account of the influence of Riemann's lecture on the philosophy of geometry, see R. Torretti, *Philosophy of Geometry from Riemann to Poincaré* (Dordrecht: D. Reidel, 1978) pp. 67–109.

9. U. Boccioni, C. Carra, L. Russolo, G. Balla and G. Severini, "Manifesto of the Futurist Painters 1919", in U. Apollonio, ed., *Futurist Manifestos* (London: Thames and Hudson, 1973) pp. 24–25.

10. *Art et Poesie Russes 1900–1930* [6] p. 54. French translation by Manuel Corrada.

11. For the first systematic presentation of Constructivism, see C. Gray, *The Great Experiment in Russian Art, 1862–1922* (London: Thames and Hudson, 1962) chapter VII. A more recent and comprehensive account is C. Lodder, *Russian Constructivism*, S. Barron and M. Tuchman, eds. (New Haven, CT: Yale Univ. Press, 1983). The complexities involved in studying the Russian avant-garde are explained in Stephanie Barron, "The Russian Avant-Garde: A View from the West", in *The Avant-Garde in Russia 1910–1930* (Los Angeles, CA: Los Angeles County Museum of Art, 1980) pp. 12–17.

12. El Lissitzky, "K. und Pangeometrie", in *Europa-Almanach*, C. Einstein and P. Westhein, eds. (Potsdam: Gustav Kiepenheuer, 1925). Quotations and references are from El Lissitzky, "Art and Pangeometry", in Sophie Lissitzky-Küppers, *El Lissitzky: Life, Letters, Texts* (London: Thames and Hudson, 1968) pp. 348–353. On Lissitzky's writings, see A. Birnholz, "El Lissitzky's Writings on Art", *Studio International* **183**, No. 942, 90–92 (1972).

13. Lissitzky-Küppers [12] p. 348.

14. Lissitzky-Küppers [12] p. 349.

15. Lissitzky-Küppers [12] p. 349.

16. G. Apollinaire, *The Cubist Painters, Aesthetic Meditations 1913*, L. Abel, trans. (New York: Wittenborn, Schultz, 1949) pp. 13–14.

17. Lissitzky-Küppers [12] p. 350.

18. There are other ways to define curvature of a curve at a given point. However all the definitions are equivalent. For details, see D. Hilbert and S. Cohn-Vossen, *Geometry and the Imagination* (New York: Chelsea, 1952) pp. 172–178.

19. The existence of the principal curvatures is due to Euler (1760). For a proof of this fact see Theorem 1 in Spivak [7] p. 2.

20. This is not Gauss's definition of curvature, but it is equivalent to it. There are many different definitions of curvature, but they are all equivalent. For a discussion of the advantages of various definitions of curvature, see Torretti [8] p. 74.

21. C. F. Gauss, *General Investigations of Curved Surfaces*, A. Hiltebeitel and J. Morehead, trans. (New York: Raven Press, 1965) p. 9f.

22. Hilbert and Cohn-Vossen [18] p. 246.

23. Gauss applied the measure of curvature only to surfaces. Later, Riemann extended this term to space of *n* dimensions. However, while for surfaces it corresponds to an intuitive property, the measure of curvature of the space is a purely analytical expression. Furthermore, to speak of measure of curvature of the space is sheer nonsense unless the space is provided with a manifold structure (see [27] below). Note, however, that Lissitzky recognizes that curvature, when referred to space, is an abstract concept (Lissitzky-Küppers [12] p. 350).

24. Lissitzky-Küppers [12] p. 351.

25. For example, Lissitzky's irrational space is compared to the set theoretical construction of the real numbers in E. Levinger, "Art and Mathematics in the Thought of El Lissitzky: His Relationship to Suprematism and Constructivism", *Leonardo* **22**, No. 2, 227–236 (1989).

26. According to B. Russell, "there is, if I am not mistaken, considerable obscurity in the definition of a manifold." See B. Russell, *An Essay on The Foundations of Geometry* (New York: Dover, 1956) p. 66. In fact, Riemann's lecture was read to a nonmathematical audience, and all formal notions were omitted. For this reason, it is very difficult to understand what Riemann said even today. However, a formal definition that agrees with what Riemann had in mind when he spoke of manifold can be made (see [27] below). M. Spivak explained how this precise definition expresses Riemann's concept of manifold: see "What did Riemann say?", in Spivak [7] pp. 4B–1f. For a fuller discussion of the difficulties of understanding Riemann's concept of manifold, see Torretti [8] pp. 85–107.

27. An *n*-dimensional manifold is a metric space with the property that for each element *x* of *M* there is some neighborhood *U* of *x* such that *U* is homeomorphic to R^n. This means that manifolds are locally like *n*-dimensional space. For further details, see the entry "Manifolds", in S. Iyanaga and Y. Kawada, eds., Mathematical Society of Japan, *Encyclopedic Dictionary of Mathematics* (Cambridge: MIT Press, 1977) pp. 819–823. However, to deal with the geometry of curves and surfaces conceived as manifolds, a restricted kind of manifolds, differentiable manifolds, is required. Yet this new definition does not give meaning to the measure of curvature of the space of *n* dimensions. To this end, an even more restrictive class of manifolds must be considered: the so-called Riemannian manifolds. See Spivak [7] pp. 4B–3–4B–5; and M. do Carmo, *Differential Geometry of Curves and Surfaces* (Englewood Cliffs, NJ: Prentice-Hall, 1976) pp. 425–443.

28. On color space, see H. Weyl, *Philosophy of Mathematics and Natural Science* (New York: Atheneum, 1963) pp. 70–71.

29. Riemann [7] p. 4A-6.

30. Lissitzky-Küppers [12] p. 350.

31. In order to consider irrational space as a four-dimensional manifold, let the elements in the manifold be 4-ples of real numbers. The first three correspond to the intensities of blue, red and yellow, and the fourth coordinate is a real number that depends on the position of the element with respect to the canvas: negative in depth, positive in the frontal direction and zero in the picture's surface.

The perusal of Lissitzky's essay supports this interpretation. Art objects generate a space, the art space. Space conceptions precede forms of art (Lissitzky-Küppers [12] p. 353), and properties of the space constitute its geometry. But one of Riemann's ideas (explicitly expressed by Helmholtz, see Helmholtz [34] p. 656, below) was that the geometry of a space is determined by the notion of distance. Accordingly, "in this space [writes Lissitzky] the distances are measured only by the intensity and the position of strictly defined colour areas" (Lissitzky-Küppers [12] p. 350). Certainly Lissitzky was familiar with the geometry and the perceptual theory of the color space, for he wrote that "new optical experience has taught us that two areas of different intensities, even when they are lying in one plane, are grasped by the mind as being at different distances from the eye" (Lissitzky-Küppers [12] p. 350). Thus, three coordinates of the elements of irrational space are obtained. The fourth agrees with the following passage from Lissitzky's essay: "Suprematistic space may be formed not only forward from the plane but also backward in depth. If we indicate the flat surface of the picture as 0, we can describe the direction in depth by − (negative) and the forward direction by + (positive), or the other way around. We see that Suprematism has swept away from the plane the illusions of two-dimensional planimetric space, the illusions of three-dimensional perspective space, and has created the ultimate illusion of *irrational* space, with its infinite extensibility into the background and foreground" (Lissitzky-Küppers [12] p. 350).

According to Yve-Alain Bois, Lissitzky wanted to destroy the spectator's certainty and deconstruct any visual apprehension of depth. "In his *Prouns*, Lissitzky wanted to invent a space in which orientation is deliberately abolished: the viewer should no longer have a base of operations, but must be made continually to choose the coordinates of his or her visual field, which thereby become variable", writes Bois in "El Lissitzky: Radical Reversibility", *Art in America* **76**, No. 4, 160–181 (1988). The interpretation of irrational space as a four-dimensional manifold agrees with Bois's suggestion.

32. Torretti [8] pp. 67–68. For an excellent presentation of the general knowledge on geometry during that epoch, see the section "The Rise of Popular Interest in the New Geometries", in L. D. Henderson, *The Fourth Dimension and Non-Euclidean Geometry in Modern Art* (Princeton, NJ: Princeton Univ. Press, 1983) pp. 10–43.

33. Russell [26] pp. 15, 66–68. Russell attributes to Herbart's writings the comparison of space with the color series and "many of Riemann's epoch-

making speculations" (Russell [26] p. 63). Note that Herbart and Gauss were the only authors quoted in Riemann's 1854 lecture (Riemann [7]).

34. H. von Helmholtz, "Ueber den Ursprung und die Bedeutung der geometrischen Axiome", in Helmholtz, *Ueber Geometrie* (Darmstadt: Wissenschaftliche Buchgesellschaft, 1868) pp. 1–31. (This was a lecture delivered by Helmholtz in 1870 and first published in 1884.) Quotations and references are from the English translation, "On the Origin and Significance of Geometrical Axioms", in J. R. Newman, ed., *The World of Mathematics* (New York: Simon and Schuster, 1956) pp. 647–668.

35. Helmholtz [34] p. 648. Helmholtz was the most widely read writer on the foundations of geometry (see Russell [26] p. 23), and his article "On the Origin and Significance of Geometrical Axioms", the most influential source for the philosophical debates on geometry from the 1870s onward (see Torretti [8] p. 155). Peter Nisbet has suggested that most features of Lissitzky's writings in the early 1920s are drawn from the first volume of Spengler's *Decline of the West;* see P. Nisbet, "An Introduction to El Lissitzky", in *El Lissitzky 1890–1941* (Cambridge, MA: Harvard Univ. Art Museums, Bush-Reisinger Museum, 1987) p. 29. Spengler (in O. Spengler, *The Decline of the West*, Vol. 1, C. F. Atkinson, trans. [London: George Allen and Cluwin, 1926]) explains Riemann's spherical geometry (p. 88), *n*-dimensional manifolds (p. 74, p. 90) and many other mathematical subjects. According to him, Helmholtz is a "savant of the calibre of Gauss and Humboldt" (p. 424) whose lecture of 1870 "has become famous" (p. 377). It is interesting to compare Lissitzky's and Helmholtz's essays. There are numerous similarities between them. To start with, Helmholtz three times emphasizes that abstract mathematical concepts cannot be represented. Examples are: the fourth dimension (Helmholtz [34] p. 650 and p. 664) and the measure of curvature of the space (Helmholtz [34] p. 656). The same remark with the same examples is found in Lissitzky's article: "The space in our physical science is three-dimensional" (Lissitzky-Küppers [12] p. 351); and "we cannot change the degree of curvature of our space in a real way" (Lissitzky-Küppers [12] p. 351). Other similarities concern Riemann. Helmholtz's main aim was to expose and comment on Riemann's conception of space (Helmholtz [34] p. 655f). Considerations on *n*-fold extended aggregates, the color manifold, the measure of curvature of the space and the importance of distance all play important roles in Helmholtz's discussion of Riemann's ideas—and also in Lissitzky's essay (for example, see [31]). Thus, although we do not know whether Lissitzky read Helmholtz's essay, we suspect that he did.

36. Lissitzky-Küppers [12] p. 351.

37. Lissitzky-Küppers [12] p. 351.

38. See, for example, B. Zevi, *Architecture as Space (How to Look at Architecture)* M. Gendel, trans., J. A. Barry, ed., (New York: Horizon Press, 1957) p. 26: "The Cubist conquest of the fourth dimension is of immense historical importance", p. 26: "the mind of man discovered that a *fourth* dimension existed in addition to the three dimensions of perspective. This was the Cubist revolution in the concept of space, which took place shortly before the first World War".

39. Kazimir Malevich's *Black Square,* oil on canvas, 79 × 79 cm, 1913, was shown for the first time in The Last Futurist Exhibition of Pictures: 0–10, Petrograd, 19 December 1915–19 January 1916. *Black Square* entered the Tretiakov Gallery in Moscow in 1929 (No. 11225) and is still there. For a good photograph of this painting and commentaries, see J. C. Marcade, "Kazimir Malevich, Quadrangle, 1915", *Art Press* 111 (1987) pp. 84–85.

40. See Henderson [32] pp. 287–291; and S. Compton, "Malevich and the Fourth Dimension", *Studio International* 187, No. 965, 190–195 (1974).

41. As an example, consider polyhedra of 4-dimensional space (they are also called polytopes). Their representations into spaces of fewer dimensions depend on the center of projection and, eventually, the image plane. Therefore the designs of these polyhedra could be significantly different. For details, see Hilbert and Cohn-Vossen [18] pp. 145–157.

42. Lissitzky-Küppers [12] p. 350.

43. Through the interpretation of irrational space given in [31] above, Malevich's *Black Square* corresponds to the point (0, 0, 0, 0) of the manifold. This agrees with the view of Lissitzky: "It is only now in the twentieth century that the square is being acknowledged as a plastic value, as 0 in the complex body of Art. The solidly coloured square stamped out in rich tone on a white surface has now started to form a new space" (See Lissitzky-Küppers [12] p. 350).

44. PROUN is an acronym for *Proekt utverzhdeniya novogo* (Project for the Affirmation of the New). *Proun Space* was included in the exhibition Grosse Berliner Kunstausstellung, Berlin, 1923. Lissitzky's description of *Proun Space* is included in "Proun Room, Great Berlin Art Exhibition (1923)", in Lissitzky-Küppers [12] p. 361. For a detailed discussion of *Proun Space*, see A. C. Birnholz, "El Lissitzky: From Passivity to Participation", in Barron [11] pp. 98–101. For a detailed discussion of Lissitzky's works known under the neologistic acronym PROUN, see Nisbet [35] pp. 17–25.

45. In "Nasci", Lissitzky writes that "modern art, following a completely intuitive and obvious course, has reached the same results as modern science" because both have concluded that "every form is the frozen spontaneous image of a process. Thus a work is a stopping-place on the road of becoming and not the fixed goal" (from El Lissitzky, "Nasci", in Lissitzky-Küppers [12] p. 347). Clearly, this is a relativistic view. Further, it is identical with the last

paragraph in chapter 3 of A. N. Whitehead, *The Concept of Nature* (Cambridge: Cambridge Univ. Press, 1920).

According to P. Nisbet (Nisbet [35] p. 30), this sentence, cited as a central idea in Lissitzky's thought, is copied verbatim from Raoul Heinrich Francé's *Kie Pflanze als Erfinder*. Nisbet comments on the fact that some of Lissitzky's ideas are drawn from Spengler and Francé (see Nisbet [35] pp. 28–30).

46. El Lissitzky, *Erste Kestnermappe,* color lithographs (Hannover: Kestner Gesellschaft, 1923). Reproduced in *El Lissitzky 1890–1941*, exh. cat. (Hannover: Sprengel Museum, 1987–1988) pp. 160–163.

47. See Henderson [32] pp. 139–140. Henderson traces this view back to Poincaré and Jouffret.

48. See Gray [11] chapters 5 and 8, and A. Birnholz [12].

49. See the Introduction to Lodder [11]. For example, according to E. Levinger (Levinger [25] p. 231), Lissitzky initiated to study the correspondences between art and mathematics as a way to understand the denial of absoluteness. Lissitzky's ultimate aim was to install a new social order, as art and mathematics had done.

50. N. Gabo and A. Pevsner, "The Realistic Manifesto", in J. E. Bowlt, ed., *Russian Art of the Avant-Garde: Theory and Criticism, 1902–1934* (New York: Viking Press, 1976) pp. 209–214. For Gabo's views on art and science, see N. Gabo, "Art and Science", in *The New Landscape: In Art and Science*, G. Kepes, ed. (Chicago, IL: Paul Theobald, 1956) pp. 60–63.

51. I quote from page 17 of H. Read, "Constructivism: The Art of Naum Gabo and Antoine Pevsner", in *Naum Gabo—Antoine Pevsner*, exh. cat. (New York: The Museum of Modern Art, 1948) pp. 7–13. The relationship between Gabo's scientific background with his use of planes to describe volumes is discussed by Martin Hammer and Christina Lodder in "Naum Gabo and the Constructive Idea of Sculpture", in *Naum Gabo: The Constructive Idea*, exh. cat. (London: South Bank Centre, 1987) pp. 41–51. See also pp. 13–15 of S. A. Nash, "Sculptures of Purity and Possibility" in *Naum Gabo: Sixty Years of Constructivism*, S. A. Nash and J. Merkert, eds. (Munich: Prestel-Verlag, 1985) pp. 11–46.

52. At that time there were two big suppliers of mathematical models: Martin Schilling in Leipzig and B. G. Teubner in Leipzig and Berlin. They published catalogs: *Catalog mathematisher Modelle fur den Höheren mathematishen Unterrich* (Leipzig: Martin Shilling, 1911), and *Verzeichnis von H. Wieners und P. Treutleins Sammlungen Modelle fur Hochschulen, Höhere Lehranstalten und Techniche Fachschulen* (Leipzig and Berlin: B. G. Teubner, 1912).

53. For a discussion on circle models, see Hilbert and Cohn-Vossen [18] pp. 17–19. The analytical proof that the quadrics mentioned can be constructed with circles is in D. M. Y. Sommerville, *Analytical Geometry of Three Dimensions* (Cambridge: Cambridge Univ. Press, 1959) pp. 205–206. The construction of the ellipsoid using cardboard circles is explained in H. M. Cundy and A. P. Rollet, *Mathematical Models* (Oxford: Clarendon Press, 1954) pp. 154–156.

54. This result is due, mainly, to Möbius and Cremona. For a proof of it, see G. Salmon, *A Treatise on the Analytic Geometry of Three Dimensions*, Vol. I (New York: Chelsea, 1927) p. 345. The resemblance of *Crystal* to the cubic ellipse was suggested by A. Hill on p. 144 of "Constructivism—The European Phenomenon", *Studio International*, Vol. 171, No. 876, (1966) pp. 140–147. Compare also S. A. Nash [51] pp. 34–35, in particular marginal note 114.

55. Space curves can be determined as the intersection of two surfaces given by equations in homogeneous coordinates $F(x, y, z, w) = 0$ and $G(x, y, z, w) = 0$. In case of the cubical ellipse take the cone $F(x, y, z, w) = y^2 + z^2 - zx = 0$ and the elliptical cylinder $G(x, y, z, w) = y^2 + z^2 - yw = 0$.

56. Enneper's surface is the surface given in parametrized form as:
$$x = u - u^3/3 + uv^2$$
$$y = v - v^3/3 + u^2v$$
$$z = u^2 - v^2.$$
The principal curvatures are:
$$k_1 = 2/(1 + u^2 + v^2)^2 \text{ and } k_2 = -2/(1 + u^2 + v^2)^2.$$
Therefore $H = (k_1 + k_2)/2 = 0$. H is called the mean curvature. And $H = 0$ is the condition for minimal surfaces. See J. C. C. Nitsche, *Vorlesungen uber Minimalflachen* (Berlin: Springer, 1975) pp. 75–81. Because $H = 0$, it follows that $k_1 = -k_2$. Hence the Gaussian curvature of the surface, i. e. the product k_1k_2, is negative. This point made a difference between Gabo's *Spheric Theme* and Enneper's Minimal Surface, because Gabo's form is made with two flat circles (see Fig. 9) and, as a consequence, its Gaussian curvature is zero. However, from a purely visual point of view, both look very similar because their shapes are identical. For an account of minimal surfaces in art, see M. Emmer, "Soap Bubbles in Art and Science: From the Past to the Future of Mathematical Art", *Leonardo* 20, No. 4, 327–334 (1987). A computer-generated image of Enneper's surface appears in D. Hoffman, "The Computer-Aided Discovery of New Embedded Minimal Surfaces", *The Mathematical Intelligencer* 9, No. 3, 8–21 (1987).

57. Read [51] p. 11.

58. See Levinger [25]. Levinger argues that Lissitzky's analogy between pictorial space and mathematical concepts led to the foundations of the theoretical bases for nonobjective art, different from both Suprematism and Constructivism. Nonobjective art is discussed in Levinger [25] pp. 228–230.

59. Apollinaire [16] p. 13.

60. Lissitzky-Küppers [12] p. 348.

The Geometries behind My Spherical Paintings

Dick Termes

Termespheres are total, visual environments painted on the surfaces of spheres that hang and rotate from ceiling motors. These spherical worlds include all one could theoretically see from one point—everything up, down and all around. A six-point perspective system is necessary to make this view possible. During the past 24 years, I have painted more than 100 spheres, most of them created through the use of this perspective system. The use of six-point perspective, as well as other geometric systems within my spherical paintings, has added a dimension to my work I would never have found otherwise. The geometries help me create structures, or boundaries, for the painting. When I follow these structures, the results are, many times, a total surprise. I think it is this surprise, along with the new information and directions opened to me, that keeps me coming back to these geometric explorations. When I use these universal geometric orders, the paintings seem to be taken over by something bigger than my subjective self. I learn a great deal from the results.

Another interesting aspect of painting on the sphere is that the geometries that fit onto the sphere are totally different from the geometries that fit on a flat surface. Scientists and writers, such as R. Buckminster Fuller [1], Alan Holden [2], Arthur Loeb [3], Marjorie Senechal and George Fleck [4] and the many people involved in the book *M. C. Escher: Art and Science* [5], have explored polyhedral geometries. Several artists have also studied these geometries, including, of course, Escher [6]. My interest in spherical paintings required that I investigate the geometries of polyhedra to find substructures relating to the sphere. Mastery of six-point perspective also required studying the structures of polyhedra.

THE TOTAL VISUAL SPACE AROUND US

My paintings show my interest in both the order of the visual space around me and my chosen method for demonstrating this order. I wanted to see if I could capture all of the visual information around me in a drawing or painting—the 'up, down and all around'. Perspective is one of the major ways artists have tried to organize the world around them visually. I wanted to find out whether perspective could be expanded to organize more than a rectangular piece of the whole picture. Could an expansion of the rules of fifteenth- and sixteenth-century perspective provide a system by which I could express the total visual picture around me?

Spherical paintings are my method of expanding those early concepts. My interest in the evolution of early perspec-

tive systems led to my interest in six-point perspective on the surface of the sphere [7]. The study took several steps. I moved from the flat, straight-line perspective of one, two and three vanishing points to curved-line perspective with four and five vanishing points [8]. Then I moved to six-point perspective, which requires seeing, conceptually, a sixth vanishing point behind oneself. The idea of this point became logical when I 'located' it on the back side of the sphere. Each additional vanishing point allowed me to capture more and more of the visual world around me until, with six-point perspective, the whole scene was there. Six-point perspective is the logical system to use when dealing with our three-dimensional world and wanting to show the total, surrounding, visual space. The sphere has no edges or corners to obstruct the endless flow in all directions of the images surrounding the viewer.

ABSTRACT

The author describes some of the concepts behind his spherical paintings, as well as the six-point perspective system and geometries used in his work. He also explains his use of a sphere in motion as a canvas and the optical illusion that comes from this use. The subjects he paints range from the interiors of famous architecture to imaginary worlds that mix surrealism with geometry.

SIX-POINT PERSPECTIVE AND THE CUBE

Why six-point perspective? Why not seven or eight, nine or 10? What is so final about six? Six-point perspective results from the cube and the cubical worlds humans have built around themselves. The cubical polyhedron is made up of three sets of parallel lines. When these lines are projected away from the cube, they extend in six directions—north/south, east/west and up/down (zenith/nadir).

One-point perspective (Fig. 1a) uses one of the six directions, e. g. north, as a vanishing point to project one of these sets of lines of the cube. The other two sets of lines continue to run parallel and unaltered. In two-point perspective (Fig. 1b) the north and east directions are used as vanishing points. We could, however, use any two adjacent points. Two sets of the parallel lines of the cube now aim toward these vanishing points. One set aims toward the north, and the other set aims toward the east. In two-point perspective, the third set of lines continues to be parallel.

Three-point perspective (Fig. 1c) uses all three sets of

Dick Termes (artist), Rt. 2, Box 435B, Spearfish, SD 57783, U.S.A.

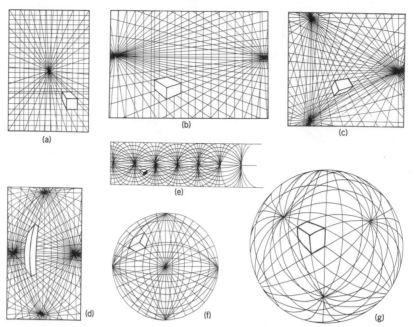

Fig. 1. (a) One-point perspective grid, (b) two-point perspective grid, (c) three-point perspective grid, (d) four-point perspective grid, (e) continuous four-point perspective grid, (f) five-point perspective grid, (g) six-point perspective grid.

parallel lines of the cube. Two of the sets aim toward the north and the east points, and the third set of lines project toward zenith or nadir (depending on whether the viewer is looking down or up at the cube). All of these lines can be projected with a straight edge.

We now move into some curved-line perspective. Four-point perspective can be thought of in a couple of different ways. First, we use the same logic as in three-point perspective. But if the cube we are looking at is very tall, projecting far above while also descending down below eye level, the vertical lines must project toward two points (Fig. 1d). Such a cube would look fat in the middle and would seem to get smaller as it extends up and above us; it also would seem to get smaller as it extends down and below us. The lines that once were the parallel vertical lines of the cube would now curve in, resembling the shape of a football with its ends at the zenith and nadir points. If the viewer were on the tenth floor of a skyscraper looking at another skyscraper 20 stories high, this is how the second skyscraper would appear.

In another type of four-point perspective, the vertical lines remain parallel and the north-to-south and east-to-west lines of the cube curve. In this system, one of the sets of lines of the cube remains parallel, while the other two sets curve (Fig. 1e).

Five-point perspective (Fig. 1f) is best imagined on a flat circular canvas. One of the points is in the middle (north) and four other points (east, west, zenith, nadir) are at equal distances around the outside edge of the circle. Lines connecting east and west points run horizontally by the north point, while zenith and nadir are found, respectively, running to the top and bottom of the circle. A cube or cubes drawn in this space project with straight lines into the center point in the same way as they would in one-point perspective. The second set of lines of the cube curve from the west point to the east point. Depending on where the cube is located within the circular canvas, the shapes of these lines change—a line will be straight if located in the center of the

circle, but the lines curve more and more as they move toward the edge of the circle. The other set of lines of the cube do the same but project from the zenith point to the nadir point. In other words, the lines of the cubes drawn in this canvas have two sets of the parallel lines curving and the other set projecting straight to the center point. A fish-eye lens shows us this kind of result.

In six-point perspective (Fig. 1g), the last straight line (which was projecting straight to the center point in five-point perspective) curves. For this effect to occur, the circular flat canvas of five-point perspective must become the three-dimensional space of a sphere. The missing south point, which is needed for all lines to curve, can now be located on the back side of the sphere. The other vanishing points of north, east, west, zenith and nadir are then arranged on the sphere so as to be equidistant from each other. The six points are spaced out on the sphere similar to the vertices of the octahedron. The logic of perspective on the sphere is the same in straight-line perspective and in curved-line four- or five-point perspective. However, six-point perspective does require that all parallel lines extend to two vanishing points, although the lines drawn can still be considered straight. All lines drawn on the sphere with six-point perspective are bisections of the sphere, or great circles. Therefore, these lines are straight when I draw them, but when viewed from off-center, they appear curved. It is more important to think about vertical eye levels with the sphere than with flat perspective. We now have two vertical great circles, which are used in the same way as the horizon line, or eye level, in flat perspective. These two vertical lines run through the vanishing points. These imaginary lines indicate that the cubes shift in space to show the opposite side of the cube. The straight parallel-line cube we started with in one-point perspective now curves and flows or aims toward all six points around the sphere. Now the cubical shapes that are found around us can be drawn and seen as they really are.

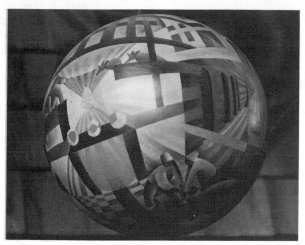

Fig. 2. *Point in Space*, acrylic on polycarbonate sphere, 16-in diameter, 1988. A rhombic dodecahedron substructure forms buildings in six-point perspective.

WHEN SIX POINTS ARE NOT USED

The cube is the main three-dimensional form humans have used to build their cities, homes and furnishings. Why this is true is a study in itself. Usually these cubical forms are organized so that they are parallel to each other.

If our world were not organized in relation to the cube, then six-point perspective would not be the system we would use to draw it. If the cubical images being drawn or painted are not parallel to each other, more points will be needed. If cubes were floating randomly in space, there could be many points involved. Each individual cube would still use six equidistant points (the octahedron) on the sphere but they would be shifted to different locations. Six-point perspective on the sphere is used when we are dealing with parallel cubical worlds. A natural forest would have a similar look upon the sphere, but the only parallel lines would be the vertical lines of the trunks of the trees. These projected lines would vanish at the zenith and nadir points on the sphere. The trees would get smaller as they reached the horizon but would not be organized to any certain number of points on that horizon. Rather, there would be an endless number of points. If the trees were planted in rows, one could render them in six-point perspective.

NATURE'S SPHERICAL ENVIRONMENTS

Termespheres bring to mind other visual phenomena, for example, the mirrored ball, the fish-eye lens and the crystal ball. George Escher once pointed out to me that his father, M. C. Escher, was fascinated with the mirrored ball because of the amount of reflection possible in it. The mirrored ball, as George pointed out, reflects all the images around except what is hidden behind the ball itself. (A Termesphere also shows the space behind itself.) Much of the environment toward the back side of the ball reflects with a great deal of distortion. George

used a flashlight one evening to show me that the flashlight was reflected in the mirrored ball as soon as it was not hidden by the ball.

If a Termesphere were opaque and the viewer were far enough away from it, only 180° would be seen at one time. The Termesphere shows the total environment all the way around the ball, so it has much less distortion. Similar to the mirrored ball, the fish-eye lens shows increased distortion toward its outside edge. The crystal ball's refracted image is most like the Termesphere, except that the image on the crystal ball is upside down. If somehow this image could be turned right-side up, the result would be quite similar to the Termesphere. I believe the spherical canvas, combined with six-point perspective to capture the total, environmental subject matter, has less distortion than any other canvas. There is some distortion on the spherical paintings toward the outside edges but when that part of the painting comes into the middle viewing area there is very little distortion. In my view, spherical paintings allow the most accurate copy of a scene.

OTHER GEOMETRIES USED ON THE SPHERE

Besides six-point perspective, I have explored and used many other spherical, geometric orders in this total-visual-environment adventure. The regular polyhedra, or Platonic

Fig. 3. *Order/Disorder*, acrylic on polycarbonate sphere, 7-$\frac{1}{2}$-ft diameter, 1985. This sphere is organized to a substructure of the five Platonic solids and depicts orderly and disorderly people building and destroying their world. (Wyoming Law Enforcement Academy, Douglas, Wyoming)

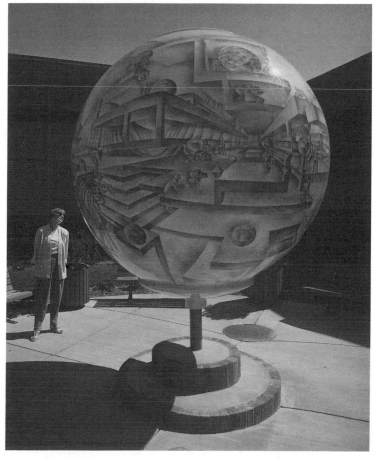

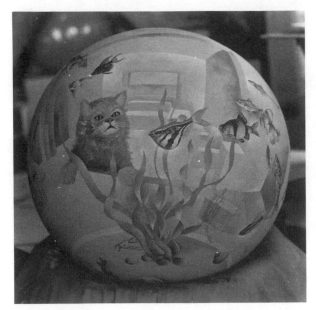

Fig. 4. *Fish Bowl*, acrylic on polycarbonate sphere, 16-in diameter, 1982. This sphere shows viewers what they might see from inside a fishbowl.

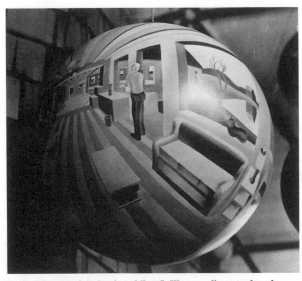

Fig. 5. *When North Is South and East Is West*, acrylic on polycarbonate sphere, 24-in diameter, 1979. In this work, the north side of the room is repeated on the south side, and the east side of the room is repeated on the west side. The point of view changes in each location.

solids, and their combined forms have provided me with many substructures for my work. The rhombic dodecahedron has the perfect linear structure for cubes in perspective. One of the spherical paintings I created with this structure is called *Point in Space* (Fig. 2). *Point in Space* also plays with a tight-fitting circular geometry as the substructure for the animal and human forms. Spirals also work well with the motion of the sphere.

Order/Disorder (Fig. 3) uses all five regular polyhedra overlapped in a tightly organized way for its substructure. Although this structure is not seen, I believe people can sense its order.

ROTATING MOTION ADDED TO THE SPHERES

The spherical paintings hang from ceiling motors. In most cases I use a motor with the speed of 1 revolution per min. This speed gives the spheres the appearance of floating and seems to be a speed with which people feel comfortable. The motion of the spheres allows the viewers to stand still while the sphere's total world rotates in front of them. On some of the spheres I have taken advantage of the motion by painting objects on them that seem to move, such as fish, birds, carousel horses or reflective balls. A less obvious effect of the motion on the spherical painting occurs when the position of the sphere changes a vertical line from a curved line on the outside to a straight line in the middle to a reverse curved line on the opposite side of the ball. This type of 'intermotion' and the foreshortening distortion that occurs as an image moves toward the edge of the sphere are exciting to watch and work with. The motion is also important for an optical illusion in which the convex sphere seems to flip into a concave surface. All of these visual phenomena add extra life to the paintings.

INSIDE-OUTNESS

Shortly after I discovered how six-point perspective fits on the sphere, I also realized I was taking the total, visual world around me and turning it 'inside-out' to get it on the surface of the sphere. Another way to consider this concept in painting is to imagine oneself floating inside a nonmoving transparent globe and painting what is seen outside the sphere onto the inside surface of the sphere. Moving outside of the sphere, the view of what was conceived from the inside will resemble a Termesphere. Most of my subjects come from my imagination rather than the real world, but I use the same thought process in either case. When I paint a real environment, such as *Paris Opera* (Color Plate J No. 1) or the total view shown in *Loretto Chapel in the Round* (Santa Fe, New Mexico), I want the arrangement of the images on the sphere to look just as the environment looks, not in reverse. In other words, a painted sphere held in front of its subject should look the same as the subject beyond. We are more comfortable and it feels more natural, I believe, seeing scenes from our visual world depicted on a concave surface than on any other surface. From an artistic standpoint I prefer to make the observer see these scenes wrapped around the surface of the (convex) sphere rather than as I believe we normally see it—on a concave surface. There is something magical and mathematical about capturing a complete world on the surface of a sphere and being able to hold it in one's hands.

CONCAVE ILLUSION

An optical illusion, mentioned earlier, happens when viewing the convex Termesphere for some time. When the sphere is in motion, the scene seems to 'flip' to a concave view, or have a 'dished-in' appearance. The direction of the sphere's motion also seems to reverse. This phenomenon has been studied by psychologists Allen R. Branum and Kendell C. Thornton [9] at South Dakota State University. Some interesting insights came from these studies. The speed of the rotation is important for this illusion. A realistically painted environment, such as the inside of a room,

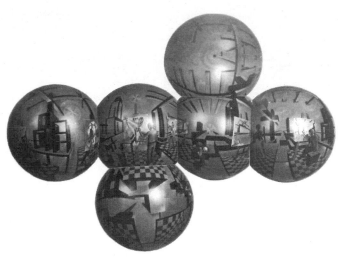

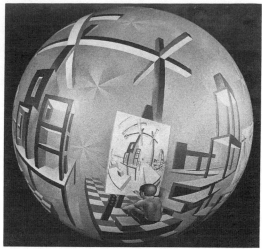

Fig. 6. *Pieces of the Whole*, acrylic on polycarbonate sphere, 24-in diameter, 1984. (left) Six views of this work show five artists, each painting with a different perspective system (one-point, two-point, three-point, four-point and five-point perspective); the sphere itself shows the complete view in six-point perspective. (right) Detail.

seems to flip to an illusion of a concave view more easily than does an abstract environment. I believe this is true because the viewer is more comfortable with concave views of the real world than with convex views.

The concave illusion requires the personal involvement of observers—moving inside and outside the sphere with their minds. This illusion helps to confirm to me that we do think of the visual world outside of ourselves as images on a concave celestial spherical surface. Making people feel comfortable and letting them see the painting on the concave is not the job of the artist. The artist's job is stretching viewers' minds.

EXAMPLES OF TERMESPHERES

When *The Fish Bowl* (Fig. 4) is first observed, it seems like a simple bowl of fish seen from the outside. One presumes the fish are in the bowl and that the room is being reflected on the outside of the glass of the fish bowl. After some study the viewer realizes that he or she must be inside the fishbowl watching the fish swimming around. The bowl is sitting on a table with fish food next to it; a cat has jumped up near the bowl. Beyond the table and cat is a complete room. The kitchen appears on one side. Someone has just finished eating fish for supper. The fish bones are all that are left. Two fish look as if they are swimming directly above the fish bones. Just when the viewers think they have figured it all out, another fish in the bowl visually denies it is in the bowl by swimming outside one of the structures in the window. The motion of the sphere is the direction the fish are swimming.

North Is South and East Is West (Fig. 5) uses a repeated image for its theme. The north end of the room is the same as the south end, and the east view of the room is the same as the west view. We are, however, closer to the south side than we are to the north side. We are also closer to the east side than to the west. This means we see the same information from two different places within the room. The scene takes advantage of a unique property of the sphere and its motion. The viewers at first think they are looking at a complete room. Later they might realize that what they are seeing is what they were looking at on the other side, but they are seeing it from a different view.

Pieces of the Whole (Fig. 6) is a 24-in-diameter sphere that shows five artists drawing and painting the environment around them. Each artist is using a different perspective system to capture a part of his surrounding world. The results show that the more points of perspective an artist uses, the more of the visual environment is captured. As all five artists are standing within the same environment, we can see how much of the total visual world each is able to reproduce. The first artist, using one-point perspective, includes the north direction of his world. The second artist uses the north and east vanishing points. These two points gather 90° of the horizon's circle around us. The third artist uses the north, east and nadir vanishing points of his visual environment. This allows him to see the visual space down to the nadir point, which gathers even more information. The next artist takes in the whole cylindrical view around him, which includes the north, east, south, west and back to north again. He is missing, however, what he can see above and below himself. The last artist uses five-point perspective

Fig. 7. *God's Eye View*, acrylic on polycarbonate sphere, 17-in diameter, 1988. This sphere shows the inside of Brunelleschi's Church of San Lorenzo in six-point perspective.

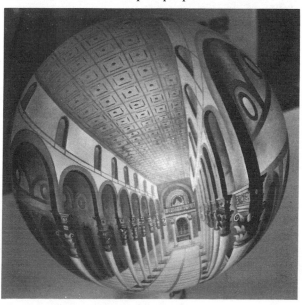

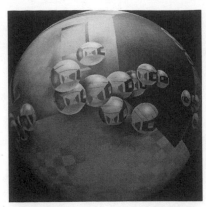

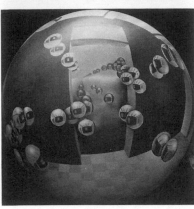

Fig. 8. *Concave Bubbles*, 24-in-diameter sphere, acrylic on polycarbonate, 1983. Two views of this sphere show some of the one hundred reflective bubbles depicted floating through a room. The bubbles reflect the room from various positions.

to gather all the visual information from the north to the south and from zenith to nadir. The only directional point missing from his view is what is behind him, the west direction. One of the five artists is sitting to the side of his canvas with a small ball. This ball has a six-point perspective grid on it. He is aware that there is a way to gather or enclose all the information around him onto one canvas. The viewer, also looking at the total environment, can see what the artist is discovering. As the title indicates, the artists are all painting 'pieces of the whole', while the sphere that the viewer is looking at is the whole picture.

God's Eye View (Fig.7) is a 16-in-diameter sphere. This globe shows the view from the inside of the Church of San Lorenzo, built by Brunelleschi, one of the early explorers of perspective. Because Brunelleschi designed this church in one of the earliest uses of perspective, I wanted to use six-point perspective to show this church's image. The church is in Florence, Italy. The viewer is put in the strange position of floating about halfway between the floor and the ceiling. My objective in this piece was to determine what kind of feeling this position of viewing would bring, how well the spherical perspective would handle this whole interior and how much distortion of realism would occur through the use of six-point perspective system. Would this kind of subject matter flip into a concave view more easily than would a more abstract subject? Would a vantage point suspended in the center of this cathedral make viewers feel like they were floating? Or, as in *Alice in Wonderland*, would the viewers feel large and the cathedral seem small, as if the viewers were giants standing on the floor?

Paris Opera (Color Plate J No. 1) was an attempt to capture one of the finest architectural buildings in the world on a sphere. Some of the greatest art that has ever been created is hidden in the interiors of buildings. I do not mean murals or sculpture—I mean the buildings themselves. One of my goals

is to paint some of these interiors around the world. It is exciting to bring to light the art of these neglected interiors.

Point In Space (see Fig. 2) is a spherical painting that uses the rhombic dodecahedron for its main substructure. Diamond shapes become the buildings in perspective, and diamond spaces between the buildings become roads and the sky. The sharper angles of these diamonds converge into six points around the sphere for six-point perspective. Many of the wider angles of the diamonds become the front edges for the buildings. This polyhedron seems to be perfect subject matter, and with little effort the rhombic dodecahedron can still be seen. Many of the animals and people found in this painting also come from a circle system that fits within these diamonds.

Concave Bubbles (Fig. 8) is a 24-in-diameter sphere depicting 100 small reflective spheres, or bubbles, floating through a door and out through a window on the other side of the room. Each mirrored ball reflects the room from wherever it is located within the room. If the ball is floating high through the room, it reflects and primarily shows us the floor area. If the ball floats low and close to the floor it primarily reflects the ceiling. All the images found on the balls are slightly different from those on neighboring balls. The little balls repeat parts of the whole image painted on the large sphere. To see what the small balls are reflecting, viewers (if they were really in this painted room) would have to turn around and look behind themselves. In reality, viewers can look at the back side of the sphere to see what would be reflected onto the back of the small balls. I realized after the painting was completed that the view I was 'pulling' from the back side to bring around to the front was not typical of bubble reflections. The balls showed concave reflections on two edges and convex reflections on the top and the bottom edges. This work shows a tight, yet impossible, perspective system.

CONCLUSION

My job continues to be a search for the order of the visual space around us. Six-point perspective still amazes me. Lately, I have started exploring how six-point perspective fits on regular polyhedra, or Platonic solids—another type of total environment. I also continue to be fascinated with the geometries that fit on the sphere and how they can be used to stimulate my subconscious, creative mind. The conclusions drawn from the spherical canvas are as endless as the sphere's surface.

References and Notes

1. R. Buckminster Fuller, *Synergetics* (New York: Macmillan, 1975).

2. A. Holden, *Shapes, Space and Symmetry* (New York and London: Columbia Univ. Press, 1971).

3. A.L. Loeb, *Space Structures, Their Harmony and Counterpoint* (Reading, MA: Addison-Wesley, 1976).

4. M. Senechal and G. Fleck, eds., *Shaping Space: A Polyhedral Approach* (West Hanover, MA: Birkhauser Boston-Basel, 1988).

5. H. S. M. Coxeter, M. Emmer, R. Penrose and M. Teuber, eds., *M. C. Escher: Art and Science, Proceedings of the International Congress on M. C. Escher*, Rome, Italy, 26–28 March 1985 (Amsterdam: North-Holland, 1986).

6. B. Ernst, ed., *The Magic Mirror of M. C. Escher* (New York: Random, 1976).

7. D. Termes, "Six-Point Perspective on the Sphere", *Leonardo* **24**, No. 3, 289–292 (1991).

8. Victor Flach was an instructor in a class called Theory and Structure at the University of Wyoming, 1968–1969. It was in this class that I started my investigation in perspective.

9. A. R. Branum and K. C. Thornton, "Illusion of Rotary Motion Reversal in a Sphere Is Facilitated by Increased Rotational Speed", *Perceptual and Motor Skills* **73** (1991) pp. 627–634.

New Representative Methods for Real and Imaginary Environments

Emilio Frisia

My drawings are the result of a program that I have developed over the last several years. I began to be interested in representing objects in space by means of mathematical procedures about 15 years ago when I started teaching graphic arts. Up to that point I had taught photography, and while my father was a well-known painter in his time, I did not have much artistic training, although I have a talent for freehand drawing. I started out using a simple pocket calculator with three memories to calculate the wide-angle perspective of a spiral staircase, but traditional representations did not totally satisfy my thirst for overcoming the limitations of photography. I needed more powerful tools, and in the end I became involved in the project of writing a complete modular program with a personal computer that summarized all I had discovered in the course of my studies. The program, called IMAGO, has two versions: with one version I can obtain the coordinates of the points of the object to be represented, and with the other version I can see the image of the object on the screen. IMAGO is written in the BASIC programming language and is certainly not what might be considered sophisticated computer science but represents a good example of 'poor' computer science.

IMAGO is divided into two fundamental parts: (1) The location of points in the 'object' space by means of a system of reference that gives the (X, Y, Z) coordinates for each single point; (2) the transformation of data relative to the environment to be represented in (XI, YI) values relative to the 'image space' and its final, two-dimensional, reference system.

The first part consists of a series of operations that are extensively described in standard textbooks of analytic geometry. Therefore, I shall describe only the second part in detail, which is the part that allowed me to generate drawings that cannot be included within 'traditional' representative schemes. The development of the software moved along two lines: on one side, I explored all the possibilities given by traditional representative methods, such as perspective, and on the other side, my quest was research for new methods.

Before IMAGO, I probably would not have thought that the perspective from an interior space consisting of orthogo-

ABSTRACT

The author presents a personal software program that enables artists to create environments through various methods, some of which, such as perspective, are traditional. Other uses of this program are new, such as the projection of an environment onto a sphere that, with subsequent transformation, becomes a 'planisphere' of various shapes. This software allows a range of results—from a world viewed with a narrow field angle (as through a telephoto lens) to a vision of a total environment.

Emilio Frisia (artist, educator), via Paolo Sarpi 41, 20154, Milano, Italy.

Fig. 1. *Museum Room*, pen-and-ink drawing calculated through the IMAGO computer program, 50 × 70 cm, 1982. View from one of the vertices of an environment, with a parallelepipedon and rectangular base. In perspective, the view becomes a triangle, the sides of which represent the surfaces meeting at the vertex of a trihedron.

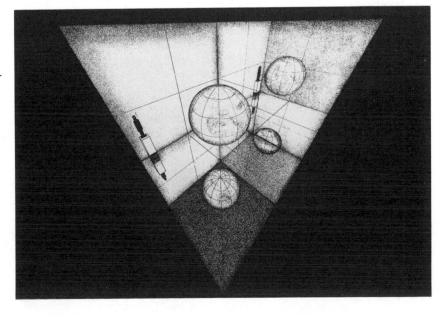

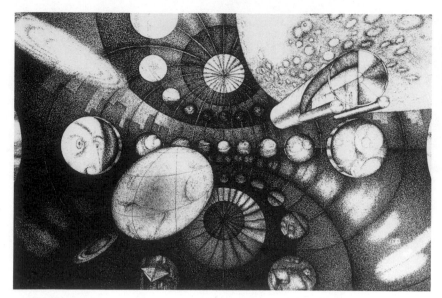

Fig. 2. *Gaja Lost*, pen-and-ink drawing calculated through the IMAGO computer program, 50 × 70 cm, 1983. This drawing represents the view of an observer placed inside a sphere, with the optic axis passing through the sphere's centre.

nal planes would result in a triangular form. However, if I set the 'observer', or point of view, at one of the vertices of a parallelepipedon, I obtain an image limited by a triangle, which may be equilateral, isosceles or scalene, according to the direction of the *optic axis* (Fig. 1). (The optic axis is the straight line along which the observer's view is oriented; it corresponds to the Z coordinates of the depth of field.)

Without the possibilities provided by computer software, I could not have imagined that the perspective from within a sphere—with the observer placed on the inside surface and the optic axis passing through the center—is possible within perfectly circular images [1]. Meridians, parallels and any circumference limiting the spherical cap can be drawn with a compass. Even the rectilinear image of the circumference where the observer is placed may be considered a circumference of infinite radius (Fig. 2).

With IMAGO, I introduced the concept of optic axis to indicate the straight line along which the observer's point of view is oriented. Because my background is in photography and I have written several photography handbooks, I borrow terms from that field, as well as from optics, when I move into the domain of representation by means of mathematical methods. Mathematics provides the possibility of obtaining perspectives without limitation with respect to the *field aperture,* or view. One can draw perspectives of environments that are located behind the observer. Everything may be represented, provided the distance Z of the point P from the (X, Y) plane (where the observer is located) is not zero.

The most interesting parts of IMAGO are those that allowed me to pass completely beyond the limits of tradi-

tional representative methods by means of other paths not related to common techniques of projective geometry.

IMAGES OBTAINED BY REFRACTION

I first developed the program to obtain images of environments observed from the interior of a transparent body with a refraction index higher than that of the external environment. This allowed me to obtain images with a field aperture of 180°, a problem in which I was interested because of my background as a photographer.

This program has a fundamental characteristic: a change in the refraction index of the medium, or environment, in which the observer is located varies the structure of the final image. The higher the refraction index, the more the central parts of the image are magnified. There are no limits with respect to the refraction index—one can give it a value unattached to any reality of physics. The alteration of the structure of the image, however, approaches a limit. If we vary the refraction index beyond 2 (the index of the refraction of a diamond), the image tends to change very little—in other words, the value of the image approaches a limit in the mathematical sense. With the mathematical objectives

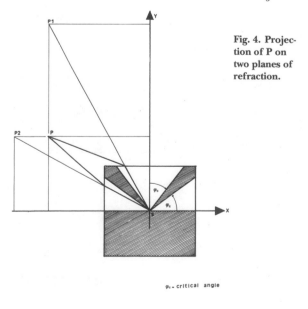

Fig. 4. Projection of P on two planes of refraction.

Fig. 3. Optic scheme drawn to obtain the perspective of an environment viewed from within a transparent body.

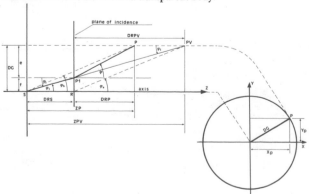

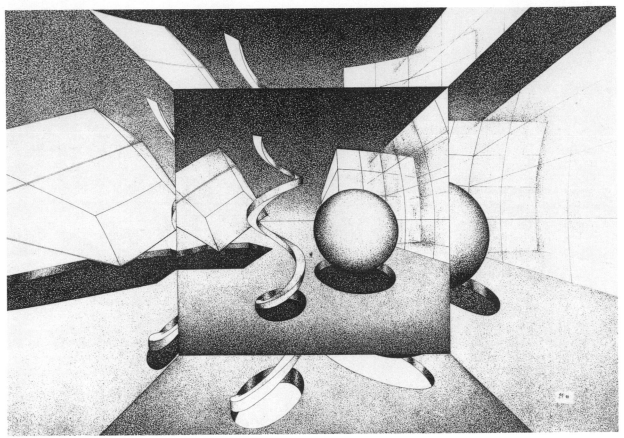

Fig. 5. *The Cubic Mineral Cave*, **pen-and-ink drawing calculated through the IMAGO computer program, 50 × 70 cm, 1988. View of an environment from within a transparent cube.**

'constructed' by the program, we have at the same time *fish-eye* and *zoom* 'lenses' with which to make our pictures.

When the refraction index approaches 1 while also approaching the absence of a refracting surface, the image is similar to that obtained with a perspective in which the distance Z approaches zero. The latter case is limited only by the shape of the support on which it is projected, while the former case is always limited by a circumference.

The core of the problem lies in how to find in space the virtual position PV of the point P as a consequence of the deviation of the path of the ray coming from P, when this ray has to pass through the refraction plane R separating the two media to reach the observer's 'eyes', or point of view (Fig. 3).

In the first part of the program IMAGO, I calculated the XP, YP, ZP coordinates of the point P. Its distance DG from the optic axis remains the same both for P and PV. The distance PV from the refraction plane is given by the following equation:

$$DRPV = DRP \cdot (v \cdot \cos \varphi^1 / \cos \varphi)$$

where DRP is the distance of P from the refraction plane, v is the refraction index, φ is the incident angle of the ray and φ^1 is the refraction angle. In order to solve the equation, since we only know the distance DRP and the refraction index v, we need to find the angles φ and φ^1. The problem can be solved by means of successive approximations after fixing the reference angles to establish for φ_a, a value that is less than φ, and for φ_b, a value that is greater than φ.

Furthermore, we need to set a value $\varepsilon > 0$, representing

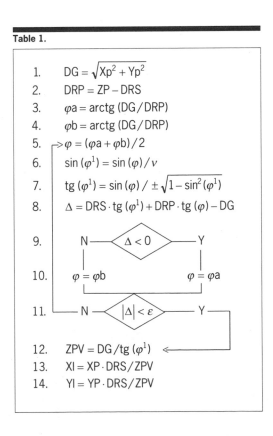

Table 1.

1.	$DG = \sqrt{Xp^2 + Yp^2}$		
2.	$DRP = ZP - DRS$		
3.	$\varphi a = \text{arctg} (DG / DRP)$		
4.	$\varphi b = \text{arctg} (DG / DRP)$		
5.	$\varphi = (\varphi a + \varphi b) / 2$		
6.	$\sin (\varphi^1) = \sin (\varphi) / v$		
7.	$\text{tg} (\varphi^1) = \sin (\varphi) / \pm \sqrt{1 - \sin^2 (\varphi^1)}$		
8.	$\Delta = DRS \cdot \text{tg} (\varphi^1) + DRP \cdot \text{tg} (\varphi) - DG$		
9.	$N \quad \Delta < 0 \quad Y$		
10.	$\varphi = \varphi b \qquad \varphi = \varphi a$		
11.	$N \quad	\Delta	< \varepsilon \quad Y$
12.	$ZPV = DG / \text{tg} (\varphi^1)$		
13.	$XI = XP \cdot DRS / ZPV$		
14.	$YI = YP \cdot DRS / ZPV$		

251

Table 2.

1.	$DG = \sqrt{Xp^2 + Yp^2}$
2.	$\alpha = \text{arctg}\,(DG/Z)$
3.	$\delta = \text{arctg}\,(Y/X)$
4.	$\alpha_1 = \alpha/2$
5.	$DG_1 = RF \cdot \text{tg}\,\alpha_1$
6.	$XI = DG_1 \cdot \cos \delta$
7.	$YI = DG_1 \cdot \sin \delta$

Table 3.

1.	$DG = \sqrt{Xp^2 + Yp^2}$	
2.	$\lambda = K\pi + \text{arctg}\,(DG/Z)$	$(K = 0,1)$
3.	$\eta = K\pi + \text{arctg}\,(Y/X)$	$(K = 0,1)$
4.	$LAL = \lambda \cdot RSI$	
5.	$XI = LAL \cdot \cos \eta$	
6.	$YI = LAL \cdot \sin \eta$	
(LAL is the metric length of the arc subtending λ)		

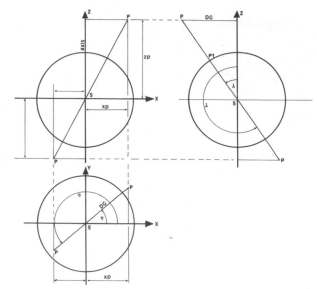

Fig. 6. Scheme of representation of an environment in a circular planisphere (Method A is used to find the points P on the primary image sphere).

the semi-amplitude of the interval within which the error Δ can be considered acceptable in order to continue our calculations. PVRZ, formed by PR and the optic axis, is chosen as the starting angle (φ_{a-}). PSZ, formed by PS and the optic axis, is the starting angle (φ_{b+}). The whole set of calculations (which are automatically calculated by the program) is given in Table 1.

With this program, which allows observation of the environment from inside a transparent body characterized by an optic density greater than that of the external medium, it is also possible to draw what an observer, located at the centre of a glass cube, or a diamond or any other media with a hypothetical optic density, would see. The program allows

representation not only of the frontal refraction plane, but also of the four planes of the cube normal to the frontal plane in perspective (Figs 4 and 5).

SPHERICAL PERSPECTIVE: PROJECTION ON A SPHERE AND SUBSEQUENT PROJECTION ON A TANGENT PLANE

One of the calculus programs in IMAGO permits portrayal of the environment with a field aperture of 180° of the points P projected on a hemisphere, resulting in a final planar image. The points P, located in front of the observer who is at the centre of a sphere, are projected on the surface of the sphere itself. The points P′, the image of P on the surface,

Fig. 7. *Cosmic Cathedral*, **pen-and-ink drawing calculated through the IMAGO computer program, 50 × 70 cm, 1990. Two 180° views of the interior of a vaulted-roof cathedral, from the point of view of an observer at the centre.**

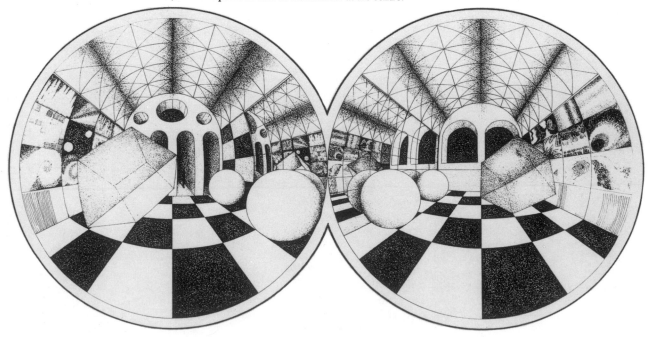

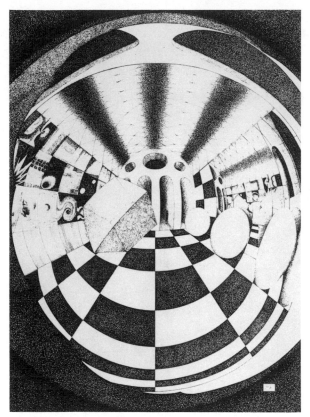

Fig. 8. *Cosmic Cathedral II*, pen-and-ink drawing calculated through the IMAGO computer program, 50 × 70 cm, 1990. The two images of Fig. 7 are combined into one single image of the whole environment. Spectacular deformation occurs at the margin of the circle that represents the intersection of the optic axis with the image sphere.

are then projected on the plane tangent to the sphere at its *anterior* intersection point (the intersection of the optic axis with the image sphere), which has as projection center its *posterior* intersection point (opposite to the anterior intersection point). The image is much more balanced with respect to that obtained by the projection of the points P′ on the equatorial plane to which the optic axis is normal. For example, the image of a sphere at any point in space in front of the observer is perfectly circular; therefore, it can be drawn with a compass. Because the radius RF of the circumference limiting the figure is equal to twice the length of the radius RSI of the image sphere, the calculations in the image field are as shown in Table 2. In the calculus program some conditions must be set regarding the quadrant where P is.

ENVIRONMENT IN PLANISPHERE

Once the problem of representing the environment with a field aperture of 180° is solved, we have the key to representing it in its entirety. We need to determine the projection of the ambient points on the surface of a sphere, having as a projection center S, the center of the sphere itself. The spherical image thus obtained is subsequently transformed into a planisphere.

The problem consists of: (1) localizing the points P′, image of P, at the surface of the sphere to ascertain their latitude and longitude; (2) choosing a method of obtaining the planisphere. It must be said that all cartography meth-

Table 4.

1.	Subroutine 1 (see Table 5)
2.	$RP = RSI \cdot \cos(\lambda) \cdot ROV$
3.	$XI = RP \cdot \sin(\eta/2)$
4.	$YI = RSI \cdot \sin(\lambda)$

Table 5. Subroutine 1

1.	$HS = \sqrt{Xp^2 + Zp^2}$	
2.	$\eta = K\pi + \text{arctg}(Xp/Zp)$	$(K = 0,1)$
3.	$\lambda = K\pi + \text{arctg}(YP/HS)$	$(K = 0,1)$

ods can be used. I provided IMAGO with several such methods, some of which are original.

The location of the points P on the surface of the image sphere can be dealt with one of two ways. We may consider as optic axis the straight line passing through the poles of the sphere. In this case the longitudinal meridian O lies in the reference plane (X, Z). In the second approach, we can consider as optic axis a straight line in the equatorial plane of the image sphere. Here the longitudinal meridian of reference O is in the *vertical* plane that contains the optic axis.

Circular Planisphere: Projection on the Sphere and Subsequent Transformation of the Meridians on the Plane

The image is limited by a circumference the radius of which has a length RF set by the operator and given as input data (Fig. 6).

The radius RSI of the image sphere is given by the following equation: $RSI = RF/\pi$. The longitude of the meridian on which P′ lies is given by the angle η formed by the straight line DG, perpendicular to the optic axis and passing through P′ and the reference plane (X, Z). The latitude of P′ is given by the angle λ formed by the optic axis and PS, in which the object point P and the observer are located. The calculations are given in Table 3.

Note that the position of the object point P in one of the octants of the tridimensional reference system determines a series of conditions for the value to be assigned to the

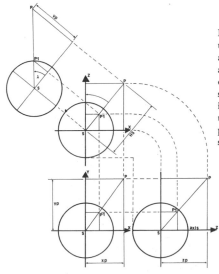

Fig. 9. Scheme used to represent an environment in a rectangular or elliptical planisphere (Method B is used to locate the points P′ on the primary image sphere).

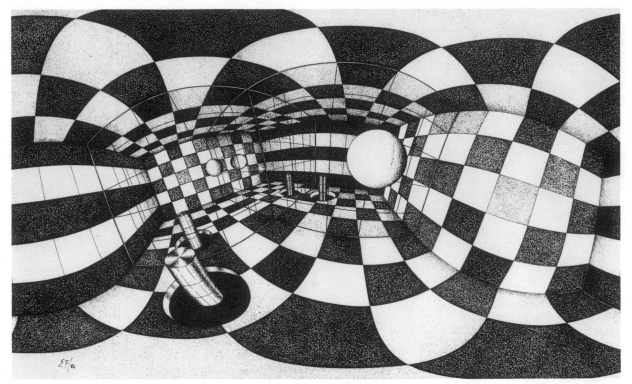

Fig. 10. *Gaja in a Chessboard,* **pen-and-ink drawing calculated through the IMAGO computer program, 50 × 70 cm, 1984. Representation of an environment in a planisphere using Mercator projection. The observer is at the centre of the room with a rectangular base and mirrored walls, which reflect each other. The representative method is Mercator projection.**

various quantities. With this program, the image of space located *behind* the observer undergoes spectacular deformations with respect to the represented reality. For example, the image of any object point P set on the optic axis behind the observer corresponds to a circumference that limits the image (not limiting a point on it). The position of these points cannot be calculated because the image of a point would be nonsense—a point has no dimensions, and here it would have the dimensions of the maximum circumference of the image. However, this program is interesting because of these deformations. Figures 7 and 8 illustrate the representation of the same environment (with the observer in the same position). Figure 7 has been obtained by means of the program described in Table 2. Figure 8 has been obtained by means of the program described in Table 4.

Elliptical and Rectangular Planispheres

In the calculus programs developed to obtain these planispheres, the meridians of the image sphere lie on vertical planes. In all of these programs there is a common group of operations, described in Table 5 (subroutine 1), by means of which the longitude and latitude of P′ on the primary image sphere can be found (Fig. 9). The signs of the variables are conditioned by the position P in one of the octants of the system of reference.

Rectangular Planisphere: Mercator Projection

The program has two phases. Point P is projected on the image sphere, with the center of primary projection coinciding with the center of the sphere itself. The primary image P′ is then projected on a cylinder tangent to the equatorial circumference, with secondary projection center point S1, the intersection of the meridian opposite the one

in which P′ lies with the optic axis, which is in the horizontal equatorial plane.

The image obtained is limited by a horizontal rectangle, the sides of which have the following ratio:

$$RVO = ALT/LUN = 2/\pi.$$

In relation to the dimensions of the drawing pad, the input is the value needed for the length of the secondary image rectangle—therefore the program calculates the length RSI of the radius of the primary image sphere: $RSI = LUN/2 \cdot \pi$. The calculus follows in Table 6.

The image thus obtained shows progressive deformations approaching the poles of the image sphere. In fact, these deformations are represented by two straight lines limiting the bottom and the top of the rectangle that frames the image (Fig. 10).

Elliptical Planisphere

The final image (resulting at the end of calculation) is limited by an ellipse, the axes of which bear a ratio that can be varied according to one's preference. The program gives an 'arbitrary' image from the point of view of the relationships between reality and representation; therefore, it cannot be used in cartography. Elliptical planispheres are not interesting because of their practical use—they are interesting because of the beautiful images possible (Fig. 11). In input the following values must be given: LAV = length of the vertical axis of the image ellipses and LAO = length of its horizontal axis. The length RSI of the radius of the image sphere is: $RSI = LAV/2$. ROV is the ratio between the two axes of the image ellipse, therefore: $ROV = LAO/LAV$.

The sequence of the calculations is as follows: First I found the latitude and longitude of P′ on the sphere with

subroutine 1. I then hypothesized an ellipsoid, the vertical axis of which has a length LAV equal to the length of the vertical axis of the final image ellipse. The final image ellipse is equal to the diameter of the image sphere, the equatorial circumference of which lies in the horizontal plane and has a radius with the same length of the image-sphere radius multiplied by the ROV ratio. The radius of the parallels of the ellipsoid is given by the following equation:

$$RP = RSI \cdot \cos \lambda \cdot ROV.$$

Finally, I imagined opening the primary image ellipsoid into a semi-ellipsoid, the semiparallels of which have the same length of the parallels of the primary ellipsoid (Fig. 12). The points P″ (secondary image of the point P′ on the semi-ellipsoid) are projected onto the final image plane by means of straight lines perpendicular to the latter. The final image plane consists of the *vertical* plane in which the polar axis of the ellipsoid limiting the secondary semi-ellipsoid lies. The location of points P″ on the semiparallel of the semi-ellipsoid is found by the following ratio: η/2.

Calculations to obtain the elliptical image are shown in Table 4.

Rectangular Planisphere: Variable Ratio of the Sides of the Image Rectangle

For creating rectangular planispheres, I use the same program already described, in which all the parallels of the image ellipsoid have a length equal to that of the equatorial circumference. IMAGO has a series of programs that allows the creation of plane and cylindrical anamorphoses. I found particularly interesting a cylindrical anamorphosis in which the observer S is at the surface of the image cylinder, and the optic axis intersects the central axis. With the program it is possible to draw on a normal sheet of paper, and then put the final image onto a cylinder in the position established to calculate the anamorphosis. The image is then viewed through one single hole. There is an extraordinary three-dimensional effect, even more convincing than that obtained by binocular systems. An explanation of this phenomenon would be interesting.

I have often asked myself what the practical use of my work could be, considering the amount of time I have spent in developing the program and in drawing with it. Surely, I have demonstrated to myself that a complex machine such as the computer can be used as if it were a brush: a necessary tool for the artist to realize his or her dreams and fantasies. I am not a painter, but a photographer who has found a method of taking pictures of an imaginary world. I have also asked myself if this approach to the representation of objects in space that, even if imagined, is still constrained by real laws, could be something intended to give more importance to three-dimensional representations of the world.

Fig. 11. *Gaja in a Chessboard II*, pen-and-ink drawing calculated through the IMAGO computer program, 50 × 70 cm, 1984. A projection of the environment shown in Fig. 10 onto a sphere, showing the subsequent transformation of the image in an elliptical planisphere.

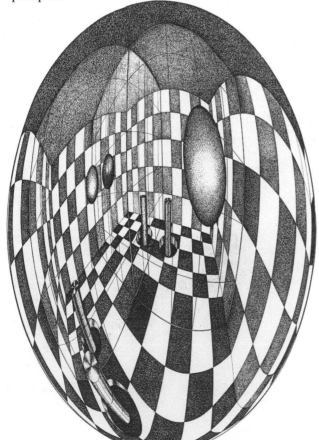

Table 6.

1.	Subroutine 1 (see Table 5)
2.	$\lambda_1 = \lambda / 2$
3.	$XI = RSI \cdot \eta$
4.	$YI = RSI \cdot 2 \cdot tg\,(\lambda_1)$

Fig. 12. Scheme to obtain an elliptical planisphere. This procedure was used to produce Fig. 11.

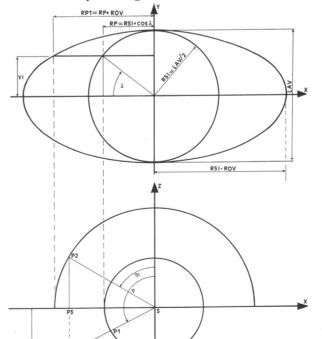

255

In the last decades, pictorial representation of the world has been losing its attractiveness as a possible consequence of the development of photographic techniques. Therefore, interest in carrying out research in the field of perspective and spatial representation has been considered obsolete, part of an academic culture that excludes that which is new. I believe that the computer opens infinite possibilities in this direction and allows the discovery of 'impossible' and 'improbable' points of views, besides bringing to an extreme the difference between vision and geometric representation. This representation of imaginary environments that can be created with photographic precision is very seductive. Art may express itself not only in the representation of imaginary worlds, but also in the creation of the imaginary world to be represented.

Reference

1. For other discussions of the use of spherical or 6-point perspective, see these *Leonardo* articles: Dick A. Termes, "Six-Point Perspective on the Sphere: The Termesphere", **24**, No. 3, 289–292 (1991); Michael Moose, "Guidelines for Constructing a Fisheye Perspective", **19**, No. 1, 61–64 (1986); Fernando R. Casas, "Comments on 'Guidelines for Constructing a Fisheye Perspective'", **19**, No. 4, 358–359 (1986); Fernando R. Casas, "Flat-Sphere Perspective", **16**, No. 1, 1–9 (1983); Kenneth R. Adams, "Tetraconic Perspective for a Complete Sphere of Vision", **9**, No. 4, 289–291 (1976).

Appendix: Glossary

Glossary definitions provided by H. S. M. Coxeter, Charles O. Perry, Angel Duarte, Harriet E. Brisson, Manuel Corrada, Robert Dixon, John Sullivan, Thomas Banchoff, Stewart Dickson, Herbert W. Franke and Horst E. Helbig, Donna J. Cox, Brian Evans, George K. Francis, Doris Schattschneider, Silvio Levy, Luciano Fortunati, Emilio Frisia, Michele Emmer, Lucio Loreto, Ervin Rodin, Clifford A. Pickover, and J. F. Rigby.

See the Subject Index to locate additional definitions.

abelian—in an abelian group, the result of applying two elements in succession does not depend on the order in which they are applied. The group of spatial translations is abelian, but the group of spatial rotations is not. For example, tilting an object first and then turning it 90° around a vertical axis leaves it in a different position than does turning it first and then tilting it around the same axis in space.

alphabet—a finite set; this term is generally used for the set of generators of a group.

amphicheiral—the quality of a knot that allows its deformation into its mirror image.

antiMercator—transformation of the form $z \to e^n$.

area-minimizing—a surface is called area-minimizing if no other surface satisfying the same constraints has smaller area. Constraints in a typical problem might be that the surfaces span a boundary wire or enclose a certain volume.

automorphic transformations—a transformation that brings the form or structure into coincidence. From the Latin word *morpha,* meaning form or structure, automorphic means "having the same form".

binomial coefficients—the coefficients in the expansion of $(x+y)^n$. For example, $(x+y)^2 = x^2 + 2xy + y^2$ so that the binomial coefficients of order 2 are 1, 2 and 1.

buckminsterfullerene (Buckminster Fullerene)—a new class of discrete molecules of carbon, C60, the third form of pure carbon, after diamond and graphite. (See truncated icosahedron.)

cellular automata—a class of simple mathematical systems that are becoming important as models for a variety of physical processes. Although the rules governing the creation of cellular automata are simple, the patterns they produce are complicated and sometimes seem almost random, like a turbulent fluid flow or the output of a cryptographic system. Cellular automata are characterized by the fact that they act on a discrete space or grid as opposed to a continuous medium.

centre of (twofold rotational) symmetry—if the appearance of a plane shape remains unchanged when the shape is rotated through 180° about a point, that point is a centre of symmetry of the shape. The letter *S,* for instance, has a centre of symmetry.

chaos theory—although there are a variety of definitions for chaos theory, many of the definitions include these charac-

teristics: a complicated dynamical system that is irregular, unpredictable, recurrent, nonlinear and deterministic.

cheirality—the handedness or twisting mode of a three-dimensional figure. The mirror image of a knot or surface appears to have the opposite cheirality. If a figure cannot be isotropically deformed in three-space into its mirror image, it is said to be properly cheiral. (See amphicheiral.)

chromaticism—an extension of tonality in which pitches other than those of the scale of the defining key are employed in a musical composition. In limited use, it does not detract from the tonal center, but extends the expressive possibilities of the musical materials. In extreme cases, the tonal center can be lost and thus the music becomes nontonal, or atonal; the hierarchical pitch relationships are lost. Chromaticism was heavily used in the late nineteenth century, leading to the eventual abandonment of tonality by many Western composers.

close-pack—(verb) to fit polygons or polyhedra together to fill space completely with no space between the forms.

close-packing—(noun or adjective) describes polygons and polyhedra that fit together without any space remaining between the forms. The regular polyhedra that close-pack are the Platonic Solids and the Archimedean Solids. Any distorted polyhedra may also close-pack.

colateral directrix—directrix that are on either side of the common directrix of two hyperbolic paraboloids. (See directrix.)

collineation—a collineation of a projective plane is a transformation permuting the points and permuting the lines in such a way that an incident point and line are always transformed to an incident point and line.

collision detection—an algorithm to prevent computer-generated three-dimensional objects from passing through one another. In computer graphics, objects are described by x, y, and z locations in a virtual space. Objects can literally pass through one another unless constraints are not described in the algorithm.

color groups—the set of all color symmetries of a color pattern form a group called a color group.

color symmetry—a color symmetry of a colored pattern is the combination of a symmetry of the pattern and a permutation of the colors that are compatible with the symmetry.

commute—two group elements are said to commute if the result of applying them successively in either order is the

same. For instance, plane reflection in the x-axis commutes with reflection in the y-axis, but not with rotation around the origin (for angles other than 180°).

configuration—an n_3 configuration of points and lines is a figure of n points and n lines with three of the lines passing through each point and three of the points lying on each line.

convex—a region in a plane is convex if it is like an island without any bays or inlets. For instance, the interiors of a circle, a square and an ellipse are convex, but a square with a smaller square cut out from one corner is not convex.

correlation—a correlation of a projective plane is a one-to-one transformation of points to lines and lines to points such that an incident point and line are always transformed to an incident line and point.

crystal lattice—also known as translational lattice and lattice of points. A lattice of points is every infinitely extended array of points called *lattice points*, such that no lattice point is arbitrarily close to any other lattice point, and each lattice point has the same environments as other lattice points, i.e. the lattice points are indistinguishable from one another. Two distinct lattice points determine a rigid movement called *lattice translation*. The lattice of points has *translational periodicity*, because its points are evenly spaced in rows, and *translational symmetry* for it can be brought into coincidence with itself by lattice translations. Other symmetries are possible in a lattice of points but not five-fold symmetry nor n-fold symmetry ($n > 6$) (the *crystallographic restriction* on symmetry). For example, a lattice of points can be obtained by performing all the integer linear combinations of the vectors of a vector basis of the space (two-, three-, . . . , n-dimensional) under consideration. A crystal lattice is every lattice of points concerned with the arrangement of the atoms in crystals.

crystallographic structure—refers to the internal molecular structure of crystals, that is, their atomic pattern. Crystals are a particular class of solid-state matter and are modeled as a periodic (regularly repeating) three-dimensional pattern. Mathematical crystallography classifies crystals by the symmetries of their atomic patterns.

crystallography—the study of the external form of the crystals and their internal structures, i.e. the arrangement of atoms in them. Crystals are solid matter in which atoms are essentially arranged according to an underlying crystal lattice, so that five-fold and n-fold ($n > 6$) symmetry as a whole are absent in them. The symmetry possible in a crystal is traditionally called *crystallographic symmetry*. Although crystallography originated from the study of minerals, it later was expanded to include more general topics—undergoing vigorous development into a broad area of pure and applied research. Crystallography is an interdisciplinary field that has close contacts with many branches of other sciences such as chemistry, mathematics and biology, as well as with other applied disciplines such as metallurgy and material sciences.

depth-first search—a procedure in which one recursively examines a case down to its last consequences before moving on to the next case.

directrix—a curve on which the generating lines of a cylinder or cone are supported. (See colateral directrix.)

Dirichlet tiling—also known as Voronoï tiling. Any finite set (or infinite discrete set) of points in the plane determines this special tiling, as follows: for each point P in the set, the tile T(P) determined by P is the polygon whose interior consists of all points closer to P than to any other point in the set. Edges of the polygon T(P) lie on some of the perpendicular bisectors of line segments that join P to other points of the set.

dodecagon—a polygon with twelve sides.

enneagonal—having the symmetry of a regular 9-gon (enneagon), just as 'hexagonal' means having the symmetry of a regular 6-gon (hexagon), like a snowflake. A figure is enneagonal if rotation through 20° leaves its appearance unchanged.

Euler characteristic—if a map on a surface has v vertices, e edges and f faces, the Euler characteristic of the surface is $v - e + f$.

fanning—transformation of the form $z \rightarrow z^n$, for any constant n.

Fibonacci series—a sequence of integers, in which each successive term is the sum of the two preceding terms *(1, 2, 3, 5, 8, 13, 21, 34, 55, . . . ,)*.

Fourier transformation—Fourier theory posits that an ordinary image can also be comprehensively described in a coordinate system of space frequencies and their amplitudes (frequency spectrum). By a mathematical process, the image is transformed from one system into another without loss of information. We can also say that the image is composed of a series of harmonic waves with different wavelengths and amplitudes.

frequency spectrum—the amplitude distribution of line frequencies (dimension, black-and-white line pairs per mm) in a Fourier image.

Fresnel effect—when light hits the boundary between two transparent materials (such as air and glass or water), some light is transmitted (or refracted), and the rest is reflected. The amounts depend on the angle of the incident light. The Fresnel effect, a readily observable effect, is that more light is reflected at a shallow angle. This effect can be computed explicitly from the equations of electromagnetic waves known as Fresnel's Laws. These laws exactly describe the behavior of light at such an interface and thus also predict further effects that seem qualitatively different, such as the rainbow colors seen in thin films.

fundamental region (FR)—each FR of a symmetry group G is a portion of space that can be defined in terms of maximum space (in which case it is the area of the plane containing only one point of each orbit of G) or in terms of minimum space (in which case it is the smallest region of the plane that, under the action of G, covers the plane

without gaps or overlap, i.e. tiles the plane). In crystallography an FR is called an asymmetric unit.

gasket—a piece of material from which sections have been removed. *Mathematical gaskets,* such as Sierpinski gaskets, can be generated by removing sections of a region according to some rule. Usually the process of removal leaves pieces that are similar to the initial region, thus the gasket may be defined recursively.

Gaussian curvature and mean curvature—a surface has positive Gaussian curvature at points where it is convex or concave, and has negative Gaussian curvature where it curves different ways, such as the seat of a saddle. The mean curvature at a point records the net direction of the surface's curvature and gives the force with which surface tension pulls. More precisely, at each point there is some direction in which the surface is most sharply curved. The curvatures in this direction perpendicular to it are called principal curvatures; the average of these two curvatures is the mean curvature, and their product is the Gaussian curvature.

generators—the group generated by a given set of transformations is the (generally larger) set of transformations that can be obtained by applying the given transformations cumulatively. The given set is a set of generators for the group.

genus—if a two-sided surface has Euler characteristic E, its genus is $n = 1 - \frac{1}{2}E$, and the surface is then a sphere with n holes.

geometric crystallography—branch of crystallography that deals mainly with the geometric properties of crystals. Both external morphology and internal atomic structure allow many kinds of geometric measurements and calculations. The arrangements of atoms in crystals comply with crystal lattices and follow rules of symmetry, therefore crystallography is an important area for studying geometrical symmetry. Because a crystal lattice cannot be brought into coincidence with itself by rotational symmetry of order five or orders greater than six (the *crystallographic restriction* on symmetry), five-fold symmetry and n-fold symmetry ($n > 6$) have been neglected in the domain of the crystallography.

glide reflection—a transformation consisting of a translation (or glide) along a line followed by a reflection in the same line. The print of a bare foot in wet sand is transformed into the next print of the other foot by a glide reflection.

group of transformations—a set of transformations of space or of the plane, with the property that the successive application of two transformations is equivalent to another transformation in the set (their composition), and any transformation can be canceled by the application of another transformation (its inverse). Examples are the group of all translations, which is infinite, or the group of symmetries of a snowflake, which is finite.

harmonic waves—see Fourier transformation.

homeomorphism—the application of one surface onto another without creasing or tearing. Temporary cuts are permitted provided they are sewn together again.

homomorphism—a group homomorphism associates to each element of a group an element of another group, respecting the composition law—that is, the image of the composition of two elements is the composition of the images.

homotopy, mathematical—in topology, also known as rubber-sheet geometry, a transformation from one topological or geometric surface to another surface.

horocycle—a type of curve in the hyperbolic plane, represented in the Poincaré model by a circle touching the bounding circle.

hyperbolic—refers to a type of non-Euclidean geometry in which the angles of a triangle add up to less than 180° and the area of a circle grows exponentially with the radius.

identity—a special element of a group of transformations, the application of which does not change anything. Applying an arbitrary transformation followed by its inverse gives the identity; that is, the two transformations cancel each other.

incident—a point and a line are incident if the point lies on the line.

instellation—the projection of stellated forms into the face of a polyhedron. (See stellation.)

integral object—an intact object having internal unity (the term is borrowed from Gestalt psychology).

integral working method—method in which an entire image is transformed into another image. Fourier transformation and conformal mapping are integral working methods.

iteration—repetition of an operation or set of operations. In mathematics, composing a function with itself, such as in $f(f(x))$, can represent an iteration.

Jitterbug Transformer—the name given by Buckminster Fuller for the rotation-translation of regular geometric solids. Fuller rotated the eight faces of an octahedron outward on their axes until they formed a cuboctahedron. This was achieved by rotating each of the eight triangles in alternating directions while the apexes of the triangles continued to touch one another.

Klein bottle—the abstract, necessarily one-sided surface obtained by 'sewing' two Möbius bands together along their borders. German mathematician Felix Klein, active in the latter half of the nineteenth century, was the originator of the Erlanger Program for basing the foundations of geometry on a pedagogically consistent, algebraic basis.

knot—a mathematical knot is an abstraction of a closed loop of string located in space so as not to touch itself anywhere.

linear—a function f(x) is linear, if it fulfills both of the following requirements: (1) $f(cx) = cf(x)$, for every constant c; (2) $f(x_1 + x_2) = f(x_1) + f(x_2)$ for every x_1 and x_2, for which f is defined.

loxodrome—a curve on the surface of any solid of revolution that cuts all meridians of the surface with constant angle.

mathographic—a drawing or picture that is formulated, as opposed to being manually executed or photographed.

Mercator—a transformation of the form z → log (z). It is a component part of Mercator's method for mapping the Earth's globe onto a plane.

Miller symbol, Miller indices—a Miller symbol is the crystallographic way (devised by W. H. Miller, 1839) to describe the planes of the faces in crystals by referring to an appropriate reference frame *x, y* and *z* (the *crystallographic axes*). It consists of three ordered whole numbers, the *Miller indices,* placed in parentheses, for example, (321), (100), where the first number refers to the *x*-axis, the second to the *y*-axis and the third to the *z*-axis. The Miller indices are related to the reciprocals of the intercepts that the plane of crystal faces makes with the crystallographic axes. For example, if a Miller index of a face is zero, the face is parallel to the corresponding reference axis. Applying the same description to a family of parallel lattice rows of a plane lattice of points, the Miller indices represent the number of parts into which that family of rows divides the sides of a reference cell.

Möbius band—an ancient, one-sided belt obtained by joining the ends of a long ribbon, made of paper, fabric or leather, after giving the ribbon an odd number of half-twists. German astronomer and mathematician August Ferdinand Möbius, active in the middle of the nineteenth century, was a pioneer in the topology of nonorientable surfaces. Möbius used this band to illustrate his theory.

modulo (modular) arithmetic—the application of fundamental operations to number systems that involve the use of numbers of the systems only. Therefore, the mod *q* system uses only the numbers 0, 1, 2, . . . (*q* - 1). The fundamental operations are the same as those of ordinary arithmetic except that if the number becomes greater than (*n* - 1), it is divided by *n* and the remainder is used in place of the ordinary result. Thus, 4 + 3 = 0 (mod 7).

moiré pattern—an optical phenomenon created by the interference of waves. The pattern can be observed by layering two pieces of striped transparent material (or screens) that are slightly offset.

nonlinear—a function f(x) is nonlinear, if it fails to fulfill the property of linearity.

objet trouvés—a term of the Dadaist period describing natural or artificial found objects that are aesthetically pleasing and that were presented by Dadaist artists in exhibitions.

optimality—in mathematics, a function is said to be at optimality whenever it reaches its absolute maximum (or absolute minimum) value, within the permissible values of its variable(s).

orientation-preserving—refers to a transformation, such as a translation or rotation, where the image of a right hand still looks like a right hand. Under an orientation-reversing transformation, such as a reflection, the image of a right hand looks like a left hand.

parallelepiped—a solid figure bounded by six parallelograms, with opposite pairs both identical and parallel.

periodic—a mathematical function f(x) is said to be periodic with period K, if there is a constant K, such that f(x) − f(x+K) = 0, for every x for which f is defined.

periodic ornament(s)—an attractive design in the plane or space whose parts obey the symmetry of a point group or of a space group.

permutation—a transformation of a finite set of objects to itself in such a way that distinct objects are transformed to distinct objects.

photorealism—painting style of the 1980s with a maximum of realistic reproduction that mimics photography.

phscolograms—a term coined from a combination of photography, sculpture and hologram. These are holographic-like artworks from computer-graphics imagery and photographic imagery, which have a nonholographic full-color appearance and use a barrier-strip method and off-axis perspective to create the illusion of holographic three-dimensional reality. Phscolograms have a full-color appearance superior to that of traditional holograms.

picture processing—processing of digitized images, with a computer using mathematical operations. A picture is a rectangular array of picture elements (pixels) stored in a disc-storage device. It is ordered by lines and columns (raster image), and each pixel has an attribute that describes it, here mainly the gray value or color tone or, for a Fourier image, the amplitude of the space frequency.

plane crystallography—branch of crystallography that deals with the lattice of points in the plane, with their possible groups of operations of symmetry (other than translation) and with their patterns of symmetry. Plane crystallography is also known as *wall-paper crystallography.*

point-for-point working method—method to generate raster images pixel by pixel, similar to the way in which a paint tool is used for drawing.

point groups—crystallographic terminology used to indicate the group of all the operations of geometric symmetry of an object that leave invariant at least one point of that object. An invariant point of an object is a point that is unaffected (i.e. it does not correspond to a distinct point) by the operations of symmetry of the object. So, point groups exclude translational symmetry. The point groups concerned with crystals are commonly called crystallographic point groups.

polygon—a plane shape bounded by straight sides.

power spectrum—part of the Fourier image that describes the square of the amplitudes for the different frequencies.

Pythagorean theorem—if a triangle *ABC* has a right angle at *A*, then $AB^2 + AC^2 = BC^2$ (where *AB* denotes the length of the side *AB*, etc.).

quadrangle—a polygon with four sides.

quasicrystallography—the complex of theories and experiments that attempt to fully explain formation, external shape, internal atomic structure and stability of solid matter

that exhibit long-range translational order and disallow crystallographic symmetry. In a broader sense, quasicrystallography deals with an ever-increasing number of ordered structures, real or ideal, which have some but not all of the characteristics of an ordinary crystal. In particular, they lack translational periodicity.

quasicrystals—first discovered in 1984, these crystalline-like substances (that have, so far, been alloys produced in a laboratory) display symmetries in their atomic patterns that are impossible in periodic patterns; thus they do not fit the traditional model of crystal structure. Their existence has prompted both the re-examination of the theory of crystallographic structure and intensive research to understand the theory of nonperiodic patterns.

quasi-periodic—a mathematical function f(x) is said to be quasi-periodic, with quasi-period K, if there exists a constant K and a positive number ε, such that $|f(x) - f(x + K)| < \varepsilon$, for every x for which f is defined.

raster-graphics—the creation of an image on a cathode ray tube (CRT) screen by instructions on the way each point should be colored or shaded, by changing the intensity as an electron beam scans the screen one horizontal line after another. By contrast, a vector-graphics image of a line segment is created by deflecting an electron beam from a beginning point to an end point chosen on the screen.

raster image—a digital image composed of pixels and arranged in lines and columns. Each pixel has a number that determines the gray value or color tone.

relation—an equality between elements of a group; for example, $r^3 = 1$ if r is a rotation by 120° around the origin (here 1 denotes the identity).

reverse transformation—transformation of a complex Fourier image to a 'normal' image. Also known as inverse or back transformation.

Romboy homotopy—this homotopy is a transformation between two topological surfaces, Jacob Steiner's Roman surface and Werner Boy's surface.

Schwarz surface—a periodic minimal surface named after Karl Herman Amadus Schwarz (1843–1921), who first described it. The surface divides space in half equally, such that the form and the space between the form are identical. It is a special surface said to have zero curvature, for curvature along one axis is exactly the opposite to the curvature along an axis at a right angle to the first angle.

serial music—music in which a musical dimension is organized in an ordered series. Twelve-tone music treats pitch serially. It is also possible to serialize duration, dynamics or instrumental color. A serial composition is usually non-tonal, with the serialized dimensions replacing tonal centers and keys as the organizing principle.

soliton—a soliton is a special solution of certain nonlinear partial differential equations that has the form of a traveling wave. One of the important properties of these special waves is that when two of them collide, they pass each other without any eventual change in their respective sizes or shapes.

space frequency—also known as line frequency, a variable of the Fourier image. The ensemble of all line frequencies with their amplitudes is called a frequency spectrum.

space group(s)—crystallographic terminology used to indicate the group of all the operations of geometric symmetry possible in a discrete pattern, infinitely extended in the plane or in space, which exhibits the translational periodicity of a lattice of points. Strictly speaking, the pattern obeying the symmetry of a space group must be considered as infinitely extended. In practice, however, the idea of 'translational symmetry' may also be applied to finite patterns. In two- and three-dimensional space, the symmetry operations of a space group cannot include five-fold or n-fold ($n > 6$) symmetry.

space-group symmetry—the symmetry characterizing a pattern that allows the operations of symmetry of a space group.

square—a regular quadrangle, with four equal sides and four equal angles. In Euclidean geometry these angles are all 90°, but in hyperbolic geometry the angles are less than 90°.

Steiner's Roman Surface—a topological surface discovered by nineteenth-century mathematician Jacob Steiner.

stellation—the projection of stellated forms out from the surface of a polyhedron. For example, it is posible to stellate an octahedron by constructing tetrahedra on each of its faces; this creates a stellated octahedron.

stereographic projection—to make a map of a sphere (like the Earth) on a plane (like a piece of paper) we must introduce distortion somewhere. One possible map is made by stereographic projection, for which the south pole of the sphere is placed on the plane. The image of any point p on the sphere is then the point where the line from the north pole through p intersects the plane. Objects near the north pole are immensely stretched in the map compared to those near the south pole. But stereographic projection is conformal, which means that there is no distortion of angles at any point, and circles are taken to be circles.

suboptimality—in mathematics, the value of a function is said to be suboptimal, whenever it is close to (by some standard) its optimal value, within the permissible values of its variable(s).

symmetry—a symmetry of a tiling is a transformation of the tiling to itself. In the Euclidean or hyperbolic plane, such a symmetry is either (1) a rotation or a translation (these are *direct* symmetries) or (2) a reflection or a glide reflection (these are *opposite* symmetries). Opposite symmetries involve reflection or turning over. On a sphere, the only direct symmetries are rotations.

symmetry group—the product of two symmetries is obtained by applying one symmetry followed by the other. For instance, if two lines meet at a point, the product of the reflections in the lines is a rotation about the point. With

this definition of 'product', all the symmetries of a tiling form a group, the symmetry group of the tiling.

tensegrity—a term coined by R. Buckminster Fuller from the words 'tensile integrity'. It is a principle of structural design and refers to self-support by means of tension distributed uniformly throughout the structure.

tetrahedral rotational symmetry—the overall shape of the model of {3,7}$_8$ is like a regular tetrahedron, with holes in it; the four vertices of the tetrahedron are cut off to form four triangular faces of the model, and there are four more corresponding faces inside. These eight faces of the model can be coloured with the same colour, to provide the basis for the colouring that we are looking for. The model does not have any planes of symmetry, so it only has the same *rotational* symmetry as the tetrahedron.

tonality—a musical system of hierarchical relationships between pitches and chords. A tonal system is organized around a central pitch called a *tonic* and a central scale called a *key*. Movement away from and back to the tonic, or tonal center, creates tension and resolution, moving the music forward in time. Tonality is the basis for most Western popular music and Western art music from the late seventeenth century to the early twentieth century (known as the common practice period).

torus—that mathematical surface most directly resembling the abstraction of an inner-tube of a bicycle tire. If the two border circles of a cylinder (open at both ends) are joined, the result is either a torus or a Klein bottle, depending on the relative orientation of the two edges of the suture.

transitive—a tiling is transitive on vertices, edges or faces if, for every choice of a pair of vertices, edges or faces, there is a symmetry of the tiling transforming one to the other. A tiling is *transitive* only if it is transitive on vertices, edges *and* faces.

trefoil—the simplest mathematical knot, also known as the cloverleaf knot. It may be drawn as three loops with three alternating crossings and three-fold symmetry. It is not amphicheiral.

truncated icosahedron—a regular geometric solid with 12 pentagonal faces and 20 hexagonal faces. It is the geometric configuration of the carbon molecule C_{60}, known as the Buckminster Fullerene.

twelve-tone system—a compositional system devised by composer Arnold Schoenberg in the early twentieth century. His system uses all 12 notes of the Western chromatic scale without regard to a tonal center. The 12 notes are arranged in a sequence, or ordered series. This series is manipulated to form the materials of the musical composition. The result is a nonhierarchical ordering of pitches in which no one pitch functions as a tonic. Twelve-tone music is non-tonal or atonal.

visual computer workstation—the integration of a general-purpose computer processor and special-purpose, high-performance hardware, specifically designed for interactive or real-time visual display.

Werner Boy's Surface—a topological surface discovered by Werner Boy, the only geometry student of mathematician David Hilbert.

Name Index

Author listings appear in bold. Individuals who are subjects appear in plain text.

Subject Index

See the Glossary in the Appendix for additional definitions of terms.